THE WATCH BOOK II

GISBERT L. BRUNNER

teNeues

Contents

Evolution and Revolution:
A Retrospective View of Watch History

The biography of the wristwatch is comprehensively chronicled in *The Watch Book*, which was published in 2015. The story began in 1571 with a wristwatch owned by Queen Elizabeth I of England. The tale continued in 1806 with a ticking present from the Parisian jeweler Marie-Étienne Nitot to celebrate the marriage of French Prince Eugène de Beauharnais to the Bavarian noblewoman Auguste Amalia. The narrative continued in the 20th century with the wristwatch's victory over the pocket watch. And it attained its greatest climax to date in the 21st century.

This long-lasting success story would scarcely have been possible without the wide-ranging creativity of many people, including watchmakers, technicians and savvy businesspeople. An important contribution was the invention of mechanical geared clocks in the late 13th century. Historians continue their unresolved debate about whether it was Peter Henlein of Nuremberg or some other craftsman who first endowed humankind with portable timepieces, but the fact remains that in 1511 there were already "timepieces which one can turn in any direction and which require no pendant weight whatsoever, yet continue to indicate and chime the time for 40 hours, even if they're hidden between the wearer's breasts or in a purse." The foregoing passage is a literal translation from *Cosmographia Pomponii Melae*, which was published in Nuremberg. If a ticking watch plunges to the floor, the delicate pivots of the balance's staff are liable to break. This prompted Abraham-Louis Breguet to devise a shock absorber in 1790. An essential key to the success of the wristwatch can be seen in the advent of keyless winding and hand-setting: the names of Louis Audemars, Charles Antoine LeCoultre and above all Jean-Adrien Philippe are very important in this context. All three of these men lived in the 19th century. The last-mentioned individual, a partner of Antoine Norbert de Patek, is credited with having perfected winding via the crown. His invention, which also enables its user to withdraw the crown and turn it backwards to conveniently set the watch's hands without affecting the tension of the mainspring, was granted patent protection after 20 years of developmental work on September 27, 1861. Until this time, personal portable timepieces were exclusively reserved for prosperous people, i.e., nobles, churchmen or other members of the upper classes. The watchmaker Georg Friedrich Roskopf democratized the watch in 1867 with his invention of a simply constructed and inexpensively producible movement with a pin-pallet escapement. It was appropriately named "La Prolétaire," i.e., "the watch for the working class." On commission from Germany's Kaiser Wilhelm II, who wanted watches for his naval officers, Girard-Perregaux manufactured in 1880 what were probably the world's first serially produced wristwatches with chain bracelets. During the Boer War from 1899 to 1902, soldiers were not only impressed by their ticking companions' ability to endure heat, cold, rain and violent sandstorms, but were also pleased with the user-friendliness and practicality of these watches on the forearm: a simple twist of the wrist now sufficed to read the time.

Louis Cartier deserves credit for emancipating the wristwatch from the circular shape of the pocket watch. Cartier created in 1904 the quadratic "Santos" with rounded corners for his friend Alberto Santos-Dumont, a Brazilian bon vivant and a pioneering airman. This timepiece went on to become the wristwatch with the longest history. Beginning in 1910, Hans Wilsdorf, who founded the Rolex watch brand, relied on official tests of accuracy to prove that his wristwatches function as precisely as significantly larger timepieces for the pocket. Metallurgical research conducted by the Swiss physicist Charles Édouard Guillaume led in 1919 to the development of a self-compensating hairspring made from a nickel-steel alloy. Bimetallic self-compensating balance rims, which use two different metals elaborately riveted together, were rendered obsolete by Guillaume's innovation. His invention marked a first step toward perfecting precise time measurement by portable watches. John Harwood repaired timekeepers of all varieties in his little workshop on the Isle of Man. Dissatisfied with poorly sealed wristwatch cases, he improved their water- and dust-resistance by designing a movement that automatically wound itself, which he combined with a mechanism for setting the hands by turning the bezel. The serial manufacture of the "Harwood" began in 1926, the same year that Rolex's founder Hans Wilsdorf applied for a patent on an extraordinarily watertight case. All components were screwed, including the sensitive crown. The well-chosen name "Oyster" intuitively communicated the characteristics of this innovative case. In 1928, a revolutionary invention called into question all previous assumptions associated with the idea of accuracy. The Englishman Warren Alvin Marrison had developed the world's first electronic quartz clock. It was as large as a cabinet, but it was fully functional. The revolutionary "Oyster" case positively demanded a self-winding movement so that it would no longer be necessary to unscrew the crown and wind the mainspring by hand. The creation of a small and reliable movement with an oscillating weight that's free to rotate without limits is credited to Emil Borer, a partner of Hans Wilsdorf, who achieved this ambitious objective in Bienne in 1931. Now nothing more stood between concept and reality for Rolex's "Oyster Perpetual." Today's metal hairsprings are usually made of Nivarox, a neologism coined from the phrase "neither variable nor oxidizing." Reinhard Straumann is credited with having created this alloy, which premiered in 1933. Alongside excellent temperature-compensating characteristics, Nivarox also has good antimagnetic properties. The perfect partner for a Nivarox hairspring is a Glucydur balance, which debuted in 1935. Glucydur is fabricated from copper admixed with circa three percent beryllium and 0.5 percent nickel. This alloy's great hardness makes it excellently well suited for riveting, balancing and fine adjustment. A weak point in self-winding systems for mechanical movements lay in the rotor's bearing, which was liable to malfunction. A remedy was devised by Heinrich Stamm, a technician at Eterna, whose intensive studies culminated in 1948 with the invention of a ball-borne rotor that still defines the worldwide standard today. The first portable quartz watch, which Longines debuted in 1954, could precisely indicate intervals to the nearest hundredth of a second. Ten years of research and development preceded the world premiere of this timekeeper, which was launched in Tokyo on December 25, 1969.

The world's first quartz wristwatch, the "Astron 35SQ," vibrated at a frequency of 8,192 hertz and was created by a team at Seiko under the direction of Tsuneya Nakamura. Girard-Perregaux never intended to build the world's first quartz wristwatch; but with support from the USA, this manufactory created digital circuitry and a baton-shaped quartz resonator which oscillated in a vacuum and anticipated the current industrial standard frequency of 32,768 hertz. A very long time passed before specialists in Japan and Switzerland successfully combined a self-winding mechanism and a chronograph. Finally, in 1969, i.e., the same year that quartz wristwatches premiered, both Seiko and Zenith unveiled chronograph watches with integrated self-winding mechanisms, central rotors and column wheels. Breitling, Hamilton and Heuer relied on a modular system with components from Dubois-Dépraz (coulisse chronograph) and Büren (automatic winding via a microrotor). In 1970, Edmond Capt and a small team of technicians began developing what would later become the bestseller among automatic chronographs: the Valjoux 7750 was ready for serial production in 1973 and has been manufactured by Eta since the mid 1980s. Unassailable proof of the turbulent renaissance of the mechanical wristwatch was forthcoming in 1985 at the Basel watch fair, where no fewer than 13 manufacturers presented a total of 16 different mechanical wristwatches with perpetual calendars. One year later in 1986, Audemars Piguet launched the world's first serially manufactured wristwatch with a tourbillon. This was made possible by state-of-the-art computer-aided manufacturing centers, which revolutionized micromechanics and thus also the art and science of watchmaking. Ulysse Nardin's Dual-Direct escapement, which debuted in 2001, made do without a pallet lever, an escape wheel, rubies to reduce friction, and oil for lubrication. Its two drive wheels, which act directly, are cut from pure silicon using the plasma process. Silicon, which is distinguished by its extraordinarily smooth surfaces, low weight and superlative antimagnetic properties, enabled watchmaking to take a veritable quantum leap forward. In the meantime, this material has been used for entire escapements and also for hairsprings. The latter are fabricated from oxide-coated and thus temperature-stable monocrystalline silicon. Due to patent restrictions which expire in 2022, they can presently be used only by Patek Philippe, members of the Swatch Group, Rolex and its affiliate Tudor, and Ulysse Nardin. These innovative technologies are complemented by remarkable case materials such as carbon, ceramic, titanium or transparent sapphire. Will the so-called "smartwatch," which can connect to a smartphone, lead to a radical and long-lasting change? Considering the exceedingly brief half-life of these products, this seems questionable, so it's far more likely that the classical mechanical wristwatch will continue to successfully defend its place on the wrist during the 21st century.

The publishers thank the brands Alpina, Ateliers deMonaco, Baume & Mercier, Bulgari, Frédérique Constant, Girard-Perregaux, de Grisogono, Hanhart, Junghans, Oris, Parmigiani Fleurier, Porsche Design, Seiko, TAG Heuer, Tutima Glashütte, and Ulysse Nardin, whose financial support helped to make this book's publication possible. ∘

Evolution und Revolution: Blick zurück in die Uhrengeschichte

Deutsch

Die umfassende Biographie der Armbanduhr, welche 1571 mit der stolzen Uhrenbesitzerin Königin Elisabeth I. von England begann, 1806 bei der Vermählung des französischen Prinzen Eugène de Beauharnais mit Auguste Amalia von Bayern – unterstützt durch ein tickendes Präsent vom Pariser Juwelier Marie-Étienne Nitot – ihre Fortsetzung fand, im 20. Jahrhundert zum Sieg über die Taschenuhr führte und schließlich im 21. Jahrhundert zur Höchstform aufläuft, ist im ersten *The Watch Book* von 2015 nachzulesen.

Ohne die weit reichende Kreativität vieler Menschen, darunter Uhrmacher, Techniker und auch clevere Kaufleute, wäre diese anhaltende Erfolgsgeschichte kaum möglich gewesen. Dazu gehört zunächst einmal die Erfindung der mechanischen Räderuhr im späten 13. Jahrhundert. Ob die Menschheit tragbare Zeitmesser dem Nürnberger Peter Henlein verdankt oder einem anderen Handwerker, wird ein Gelehrtenstreit bleiben. Auf jeden Fall gab es 1511 „Uhren, die, wie man sie auch wenden mag, ohne irgendein Gewicht 40 Stunden zeigen und schlagen, selbst wenn sie im Busen oder Geldbeutel stecken". So steht es wörtlich im Anhang der Nürnberger *Cosmographia Pomponii Melae* geschrieben. Wenn tickende Uhren herunterfallen, können die empfindlichen Zapfen der Unruhwelle brechen. Dem wirkte die 1790 von Abraham-Louis Breguet ersonnene Stoßsicherung entgegen. Ein wesentlicher Schlüssel zum Erfolg der Armbanduhr ist in der Möglichkeit des schlüssellosen Aufziehens und Zeigerstellens zu sehen. In diesem Zusammenhang sind die Namen Louis Audemars, Charles Antoine LeCoultre und vor allem Jean-Adrien Philippe von großer Bedeutung. Alle lebten im 19. Jahrhundert. Letzterem, einem Partner von Antoine Norbert de Patek, ist der vollkommene Kronenaufzug zu verdanken. Seine Kreation, welche auch das Zeigerstellen durch Ziehen sowie das komfortable „leere" Rückwärtsdrehen der Krone gestattet, erlangte am 27. September 1861 nach rund 20-jähriger Entwicklungsarbeit patentrechtlichen Schutz. Bis dahin blieben individuelle Uhren begüterten Menschen vorbehalten, also Mitgliedern des Adels, des Klerus oder der oberen Bürgerschicht. 1867 bewerkstelligte der Uhrmacher Georg Friedrich Roskopf die Demokratisierung durch ein simpel aufgebautes und kostengünstig herstellbares Uhrwerks mit Stiftankerhemmung. Sein Name: „La Prolétaire", also „Proletarieruhr" oder „Volksuhr". 1880 stellte Girard-Perregaux im Auftrag des deutschen Kaisers Wilhelm II. die wahrscheinlich ersten Serien-Armbanduhren mit Kettenbändern für dessen Marineoffiziere her. Und während des Burenkriegs zwischen 1899 und 1902 konnten sich Soldaten nicht nur vom Durchhaltevermögen der tickenden Begleiterinnen bei Hitze, Kälte, Regen sowie heftigen Sandstürmen überzeugen, sondern auch von ihrer praktischen Handhabung. Zum Ablesen der Zeit genügte nämlich ein kleiner Dreh des Handgelenks.

Die formale Emanzipation der Armbanduhr vom Rund der Taschenuhr ist Louis Cartier zu verdanken. Für seinen Freund Alberto Santos-Dumont, einen brasilianische Lebemann und Flugpionier, schuf er 1904 die quadratische „Santos" mit abgerundeten Ecken und damit auch die Armbanduhr mit der längsten Geschichte. Ab 1910 bewies Hans Wilsdorf, Gründer der Uhrenmarke Rolex, durch offizielle Genauigkeitsprüfungen, dass Armbanduhren ebenso präzise funktionieren wie die deutlich größeren Exemplare für die Tasche. Die metallurgischen Forschungen des Schweizer Physikers Charles Édouard Guillaume führten 1919 zur selbstkompensierenden Unruh-Spiralfeder aus einer Nickel-Stahl-Legierung. Selbige machten den aufwendig aus zwei Metallen zusammengenieteten, also bi-metallischen Kompensationsunruhreif überflüssig und repräsentierten einen ersten Schritt auf dem Weg zur Vervollkommnung der Präzisionszeitmessung mit Hilfe tragbarer Uhren. In seiner kleinen Werkstatt auf der Insel Man reparierte John Harwood Zeitmesser aller Art. Die von ihm bemängelten undichten Armbanduhr-Gehäuse optimierte er durch ein Uhrwerk mit Selbstaufzug und Lünetten-Zeigerstellung. 1926 startete die Serienfertigung der „Harwood". In besagtem Jahr meldete Rolex-Gründer Hans Wilsdorf das wasserdichte Uhrengehäuse par excellence zum Patent an. Alle Teile waren miteinander verschraubt, also auch die empfindliche Krone. Der Name „Oyster" brachte die Charakteristika dieser zukunftsweisenden Schale auf den Punkt. 1928 schickte sich eine revolutionäre Erfindung an, den bis dahin gültigen Genauigkeitsbegriff in Frage zu stellen. Der Engländer Warren Alvin Marrison hatte die erste elektronische Quarzuhr entwickelt. Noch groß wie ein Schrank, aber immerhin. Zur Perfektionierung verlangte das revolutionäre „Oyster"-Gehäuse förmlich nach einem Automatikwerk, damit die Krone nicht täglich zum Zweck des Handaufzugs gelöst werden musste. Die Kreation eines kleinen, zuverlässigen Uhrwerks mit unbegrenzt drehender Schwungmasse ist Emil Borer zu verdanken. 1931 hatte der Bieler Partner von Hans Wilsdorf sein ehrgeiziges Ziel erreicht. Der „Oyster Perpetual" von Rolex stand nichts mehr im Weg. Metallene Unruhspiralen bestehen heute meist aus Nivarox, was sich von „nicht variabel, nicht oxidierend" ableitet. Die 1933 vorgestellte Metalllegierung geht auf Reinhard Straumann zurück. Neben vorzüglichen temperaturkompensierenden Eigenschaften zeichnet sie sich durch gute amagnetische Werte auf. Der dazu ideal passende Partner ist die 1935 lancierte Glucydur-Unruh. Gefertigt wird sie aus Kupfer unter Beimischung von ca. drei Prozent Beryllium und 0,5 Prozent Nickel. Durch ihre hohe Härte lässt sie sich vorzüglich vernieten, auswuchten und feinregulieren. Ein Schwachpunkt des Selbstaufzugs mechanischer Uhrwerke bestand in der anfälligen Rotorlagerung. Abhilfe schuf Heinrich Stamm. Ab 1947 führte der Techniker im Hause Eterna intensive Studien durch, welche 1948 in den Kugellagerrotor und damit den heutigen Weltstandard mündeten. Die erste transportable Quarzuhr, vorgestellt 1954 von Longines, konnte Zeiträume auf die Hundertstelsekunde genau anzeigen. Ganze zehn Jahre Forschungs- und Entwicklungsarbeit waren einer Weltpremiere vorangegangen, welche am 25. Dezember 1969 in Tokio in den Handel gelange. Für die weltweit erste Quarz-Armbanduhr namens „Astron 35SQ", Frequenz 8192 Hertz, zeichnete bei Seiko ein Team unter Leitung von Tsuneya Nakamura verantwortlich. Die weltweit erste Quarz-Armbanduhr war nie das Ziel von Girard-Perregaux gewesen. Aber mit US-amerikanischer Unterstützung hob die Manufaktur digitale Schaltungen sowie einen stabförmigen, im Vakuum oszillierenden Quarzresonator aus der Taufe, welcher 1971 den aktuellen Industriestandard von 32768 Hertz vorwegnahm. Lange, ja sehr lange hatte es gedauert, bis Spezialisten in Japan und der Schweiz den Chronographen um einen Selbstaufzug bereichern konnten. 1969, also im Jahr der Premiere von Quarz-Armbanduhren, kam es dann aber gleich knüppeldick. Seiko und Zenith präsentierten

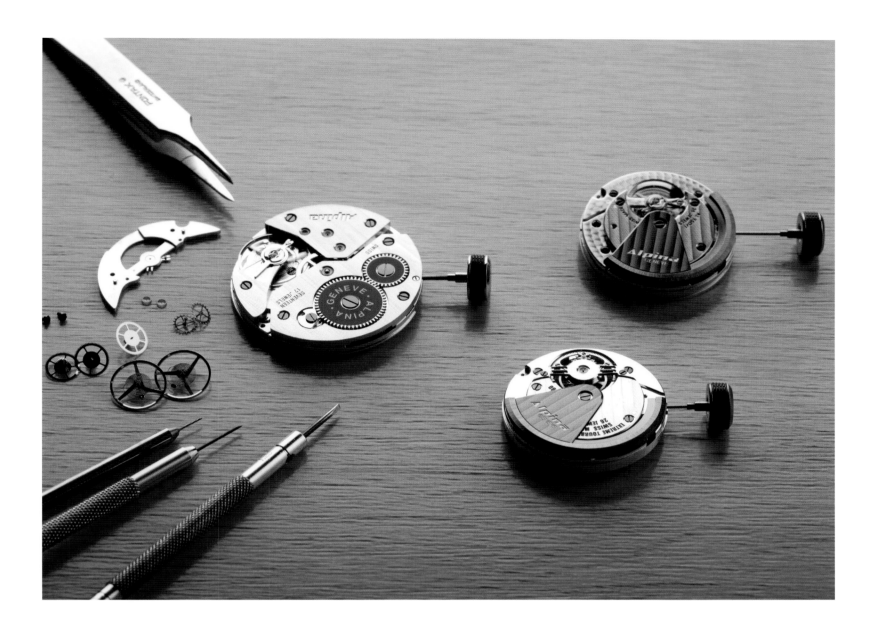

integriert konstruierte Automatik-Chronographen mit Zentralrotor und Schaltradsteuerung. Breitling, Hamilton und Heuer setzten auf ein modulares System mit Komponenten von Dubois-Dépraz (Kulissen-Chronograph) und Büren (Mikrorotor-Automatik). 1970 machten sich Edmond Capt und ein kleines Technikerteam an die Entwicklung des Bestsellers unter den Automatik-Chronographen. 1973 war das Kaliber Valjoux 7750 zur Serienreife gediehen. Seit Mitte der 1980er Jahre obliegt die Produktion der Eta. Einen schlagenden Beweis für die ungestüme Renaissance der mechanischen Armbanduhr lieferte die Basler Uhrenmesser des Jahres 1985. Nicht weniger als 13 Hersteller präsentierten insgesamt 16 verschiedene mechanische Armbanduhren mit ewigem Kalender. Ein Jahr später, also 1986, brachte Audemars Piguet die weltweit erste Serien-Armbanduhr mit Tourbillon auf den Markt. Möglich machten es modernste, computergestützte Fertigungszentren, welche die Mikromechanik und damit auch die Uhrmacherei revolutionierten. Bei der 2001 eingeführten Dual-Direct-Hemmung von Ulysse Nardin waren Anker und Hemmrad ebenso überflüssig wie Rubine zur Reibungsminderung und Öl zu Schmierung. Die beiden direkt agierenden Antriebsräder wurden im Plasmaverfahren aus reinem Silizium geschnitten. Dieses Material, welches sich durch immens glatte Oberflächen, geringes Gewicht und vorzügliche amagnetische Eigenschaften auszeichnet, verhalf der Uhrmacherei zu einem echten Quantensprung. Zwischenzeitlich bestehen komplette Hemmungen und auch Unruhspiralen aus diesem Werkstoff. Letztere, gefertigt aus oxidbeschichtetem und damit temperaturstabilem monokristallinen Silizium, dürfen bis 2022 aus patentrechtlichen Gründen nur Patek Philippe, die Mitglieder der Swatch Group, Rolex samt Tochter Tudor sowie Ulysse Nardin nutzen. Zu diesen innovativen Technologien gesellen sich bemerkenswerte Gehäusematerialien wie beispielsweise Karbon, Keramik, Titan oder transparenter Saphir. Ob die sogenannten Smart Watches, also Armbanduhren, welche sich mit dem Smartphone verbinden, zu einem nachhaltigen Umbruch führen, ist allein schon wegen der überaus kurzen Halbwertszeit dieser Produkte fraglich. Ergo wird die klassische mechanische Armbanduhr ihren Platz am Handgelenk aller Voraussicht nach auch während des 21. Jahrhunderts erfolgreich verteidigen.

Der Verlag dankt den Marken Alpina, Ateliers deMonaco, Baume & Mercier, Bulgari, Frédérique Constant, Girard-Perregaux, de Grisogono, Hanhart, Junghans, Oris, Parmigiani Fleurier, Porsche Design, Seiko, TAG Heuer, Tutima Glashütte und Ulysse Nardin, welche durch ihre finanzielle Unterstützung zum Erscheinen dieses Buches beigetragen haben. °

Évolution et révolution : retour en arrière sur l'histoire des montres

Paru en 2015, le premier volume de *The Watch Book* retrace l'impressionnante histoire des montres-bracelets, qui commence en 1571 avec Élisabeth Ire d'Angleterre, heureuse propriétaire d'une montre, pour se poursuivre en 1806 avec la montre offerte en cadeau de mariage à Eugène de Beauharnais et à Augusta-Amélie de Bavière par le joaillier parisien Marie-Étienne Nitot, puis par la consécration, au XXe siècle, de la victoire de la montre-bracelet sur la montre de poche, avant de déboucher sur les prouesses du XXIe siècle.

Sans la créativité débordante de nombreuses personnes, parmi lesquelles des horlogers, des techniciens, mais aussi des commerçants avisés, cette constance dans la réussite n'aurait guère été possible. Le premier jalon en est l'invention, à la fin du XIIIe siècle, de la montre mécanique en forme de tambour. La question de savoir si la paternité de la première montre à porter sur soi revient à Peter Henlein, artisan de Nuremberg, restera une querelle d'experts. Quoi qu'il en soit, il existe en 1511 des « montres qui, même retournées, indiquent l'heure et oscillent sans aucun poids pendant 40 heures, même quand on les porte en sautoir ou dans sa bourse », comme on peut lire dans l'annexe de la *Cosmographie de Pomponio Mela*, parue à Nuremberg. Les fragiles pivots de l'axe de balancier pouvant se briser à la moindre chute, Abraham-Louis Breguet imagine en 1790 un dispositif antichocs, le parachute. Autre jalon dans l'histoire de la montre-bracelet, le remontage et la mise à l'heure sans clé sont des progrès liés à des personnalités du XIXe siècle, tels Louis Audemars, Charles Antoine LeCoultre, et tout particulièrement Jean-Adrien Philippe. C'est à ce dernier, partenaire d'Antoine Norbert de Patek, que l'on doit le remontage complet par la couronne. Couronnement de quelque 20 ans de travaux de développement, un brevet lui est délivré le 27 septembre 1861 pour son invention, qui permet, en tirant la couronne, de mettre à l'heure ainsi que de faire tourner les aiguilles à rebours « dans le vide ». Jusqu'alors, posséder une montre est l'apanage d'une minorité privilégiée, issue de la noblesse, du haut clergé ou de la grande bourgeoisie. L'horloger Georges-Frédéric Roskopf initie la démocratisation en lançant en 1867 une montre équipée d'un mouvement à échappement à chevilles. Ce garde-temps simplifié et fabriqué avec des coûts de production réduits se prénomme « La Prolétaire ». En 1880, Girard-Perregaux produit ce qui est probablement la première montre-bracelet de série. Pourvue d'une chaîne en métal en guise de bracelet, cette montre a été créée pour les officiers de la marine impériale de Guillaume II. Et durant la Seconde Guerre des Boers (1899–1902), les montres bravent canicule, froid, pluie et même de violentes tempêtes de sable au poignet des soldats britanniques, qui peuvent à l'usage constater leur maniabilité. Pour lire l'heure, il suffit en effet d'effectuer une légère rotation du poignet.

Grâce à Louis Cartier, la montre-bracelet s'affranchit du boîtier rond hérité de la montre de poche. Pour son ami Alberto Santos-Dumont, bon vivant et pionnier de l'aviation brésilien, il crée en 1904 la « Santos », dotée d'un boîtier rectangulaire à angles arrondis, mais aussi la montre-bracelet le plus longtemps en production. À partir de 1910, Hans Wilsdorf, fondateur de la maison Rolex, prouve, certificats officiels à l'appui, que les montres-bracelets n'ont rien à

envier à la précision de marche des garde-temps nettement plus volumineux conçus pour la poche de gilet. Les recherches sur les métaux menée par le physicien suisse Charles Édouard Guillaume débouchent en 1919 sur un spiral fabriqué dans un alliage de nickel et d'acier, présentant une dilatation nulle. En sonnant le glas de la serge de balancier compensateur, c'est-à-dire constituée de deux métaux soudés ensemble, cet alliage représente un premier pas vers le perfectionnement du chronométrage de précision au moyen de montres. Dans son petit atelier sur l'île de Man, John Harwood répare des garde-temps en tous genres. Il optimise l'étanchéité des boîtiers de montres-bracelets en développant un mouvement à remontage automatique et mécanisme de mise à l'heure au moyen d'une lunette. La production en série de la « Harwood » débute en 1926. La même année, Hans Wilsdorf, le fondateur de Rolex, dépose un brevet concernant le boîtier de montre étanche par excellence. Tous ses composants, y compris la délicate couronne, sont vissés hermétiquement. Le nom « Oyster » (huître, en anglais) exprime on ne peut mieux les propriétés de ce boîtier d'avenir. En 1928, une invention révolutionnaire est sur le point de remettre en question la notion de précision qui a eu cours jusque-là : le Canadien Warren Alvin Marrison vient de concevoir la première pendule électronique à quartz. Bien qu'ayant la taille d'une armoire, cela représente un progrès. Le perfectionnement sur le plan formel du boîtier révolutionnaire du modèle « Oyster » requiert un calibre automatique qui évite d'avoir à tirer quotidiennement sur la couronne pour le remontage manuel. La création d'un mouvement fiable, de petite taille, doté d'une masse oscillante centrale sans butée, le « rotor », revient à Emil Borer. En 1931, le partenaire biennois de Hans Wilsdorf atteint son ambitieux objectif : plus rien ne s'oppose à l'« Oyster Perpetual » de Rolex. De nos jours, les spiraux métalliques sont généralement en Nivarox, acronyme de l'expression allemande « nicht variabel, nicht oxydierend » (non variable, non oxydable). Développé par Reinhard Straumann, cet alliage présenté en 1933 se caractérise par sa capacité de compensation thermique et ses excellentes propriétés amagnétiques. Le partenaire idéal de ce spiral est le balancier en Glucidur lancé en 1935. Obtenu à partir de cuivre additionné d'environ trois pour cent de béryllium et 0,5 pour cent de nickel, cet alliage d'une grande dureté se prête on ne peut mieux au rivetage, à l'équilibrage et au réglage fin. Le mécanisme de remontage automatique des mouvements mécaniques présente un point faible, l'usure rapide des paliers du rotor. Heinrich Stamm y remédie. En 1947, cet ingénieur de la maison Eterna entreprend des recherches intenses, qui déboucheront sur l'invention, en 1948, du rotor monté sur roulement à billes, désormais la norme. La première montre à quartz portative, présentée par Longines en 1954, affiche des intervalles de temps au centième de seconde près. Fruit de dix bonnes années de recherche et développement, la première montre-bracelet à quartz au monde, la « Astron 35SQ », oscillant à la fréquence de 8 192 Hertz, est commercialisée le 25 décembre 1969 à Tokyo. Elle a été conçue chez Seiko, par une équipe placée sous la direction de Tsuneya Nakamura. Si Girard-Perregaux n'a jamais eu pour objectif de lancer la première montre-bracelet à quartz, cette manufacture crée, avec l'aide d'une entreprise américaine, des commandes numériques ainsi qu'un résonateur à quartz de forme baguette oscillant dans un tube à vide,

qui préfigure en 1971 le standard universel actuel de 32 768 Hertz. Il a fallu bien des années à des experts, au Japon comme en Suisse, pour réussir à doter, en 1969, un chronographe d'un mécanisme de remontage automatique. Aussi cette année est-elle celle de grandes premières : outre la première montre-bracelet à quartz, des chronographes automatiques intégrés avec rotor central et roue à colonnes sortent des laboratoires Seiko et Zenith. Breitling, Hamilton et Heuer misent quant à eux sur des systèmes modulaires, intégrant des modules Dubois Dépraz (chronographe à commande à cames) et Büren (mouvement automatique à microrotor). En 1970, Edmond Capt, entouré d'une petite équipe de techniciens, s'attèle au développement du best-seller parmi les chronographes automatiques. En 1973, le calibre Valjoux 7750 est prêt pour la fabrication en série, ensuite assurée par Eta SA à partir du milieu des années 1980. En 1985, le Salon mondial de l'horlogerie à Bâle apporte la preuve éclatante du retour en puissance de la montre-bracelet mécanique : pas moins de 13 fabricants présentent un total de 16 montres-bracelets mécaniques à calendrier perpétuel. Un an plus tard, en 1986, Audemars Piguet commercialise la première montre-bracelet à tourbillon produite en série au monde. Cette prouesse a été rendue possible par des centres d'usinage assistés par ordinateur ultramodernes, qui révolutionnent la micromécanique, et par conséquent l'horlogerie. Nouveauté 2001 chez Ulysse Nardin, l'échappement Dual Direct évince l'ancre et la roue d'échappement, mais aussi les rubis destinés à limiter les frottements ainsi que le lubrifiant. Les deux roues d'impulsion qui transmettent l'énergie directement sont taillées dans du silicium pur obtenu par traitement plasma. Ce matériau, qui se distingue par des surfaces extrêmement lisses, une grande légèreté et d'excellentes propriétés amagnétiques représente un progrès décisif pour l'horlogerie. Des échappements complets, mais aussi des spiraux, sont désormais fabriqués dans ce matériau. En raison d'une protection par brevet, l'usage des spiraux en silicium monocristallin revêtus d'oxyde de silicium, par conséquent thermostables, est réservé jusqu'en 2022 à Patek Philippe, aux entreprises de Swatch Group, à Rolex et sa filiale Tudor, ainsi qu'à Ulysse Nardin.

Ces technologies de pointe vont de pair avec l'emploi de matériaux remarquables pour réaliser les boîtiers : carbone, céramique, titane ou encore saphir transparent. Il est permis de douter que les montres connectées ou smartwatches, qui communiquent avec le Smartphone, apporteront un changement durable, ne serait-ce que parce que ces produits sont très rapidement dépassés. La traditionnelle montre-bracelet mécanique a ainsi toutes les chances de conserver son hégémonie jusqu'au cœur du XXI^e siècle.

L'éditeur remercie les marques Alpina, Ateliers deMonaco, Baume & Mercier, Bulgari, Frédérique Constant, Girard-Perregaux, de Grisogono, Hanhart, Junghans, Oris, Parmigiani Fleurier, Porsche Design, Seiko, TAG Heuer, Tutima Glashütte et Ulysse Nardin, qui ont apporté une contribution financière à la parution de cet ouvrage. ○

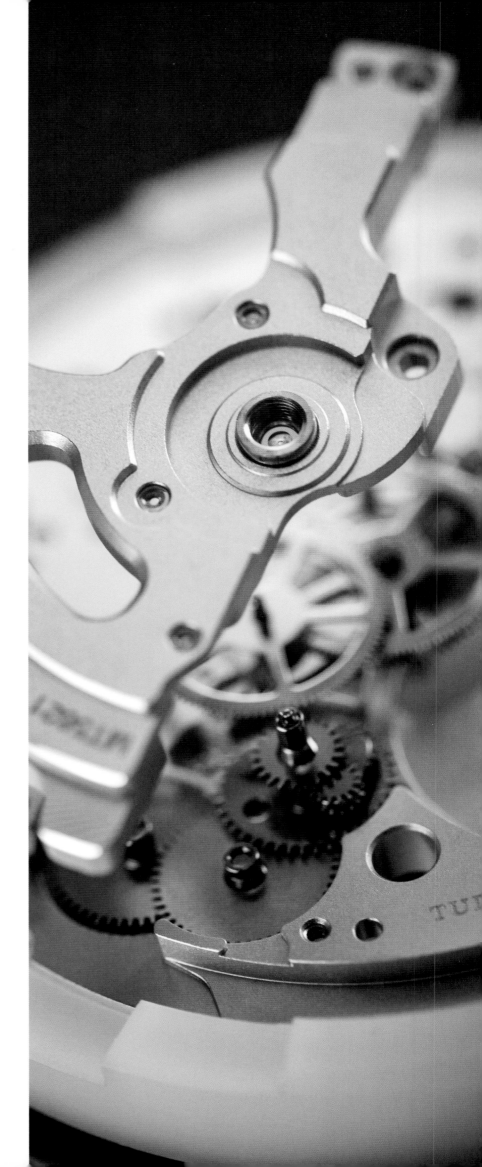

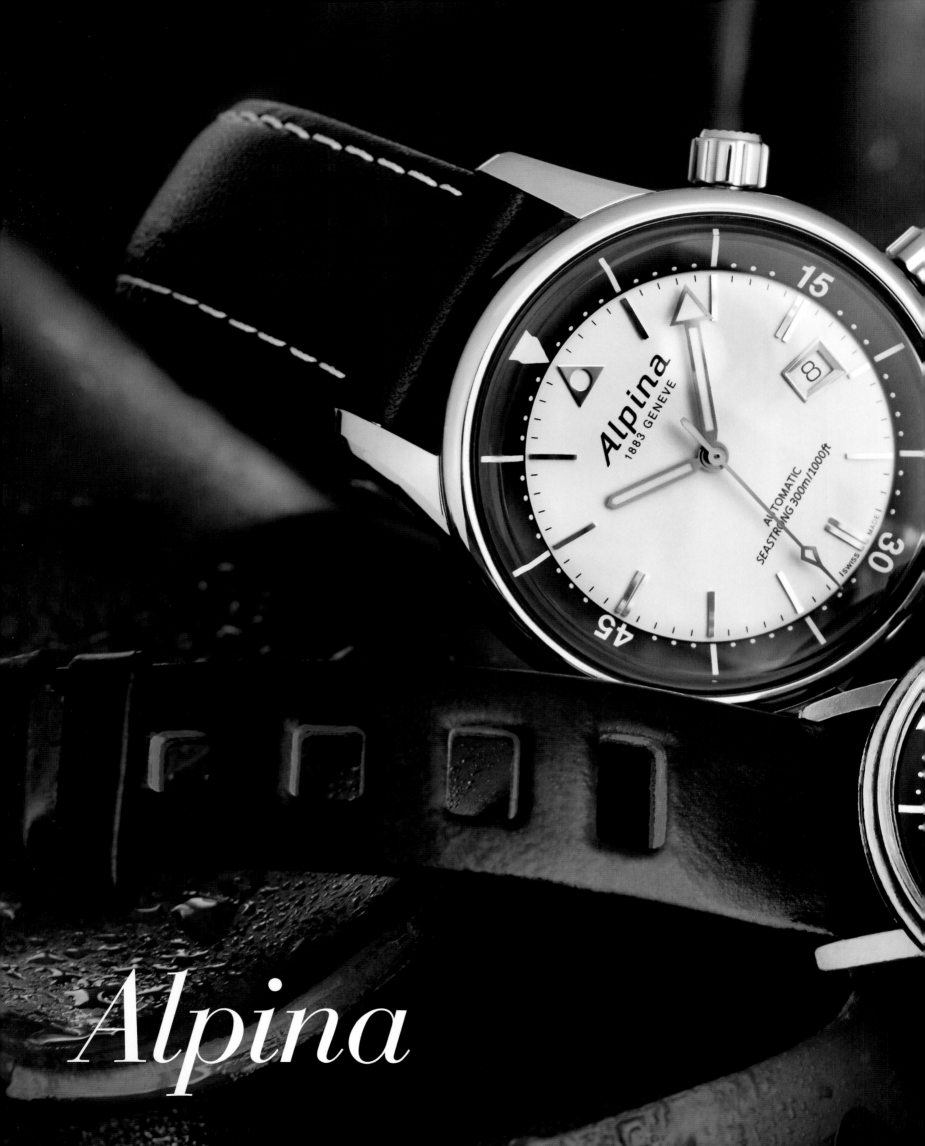

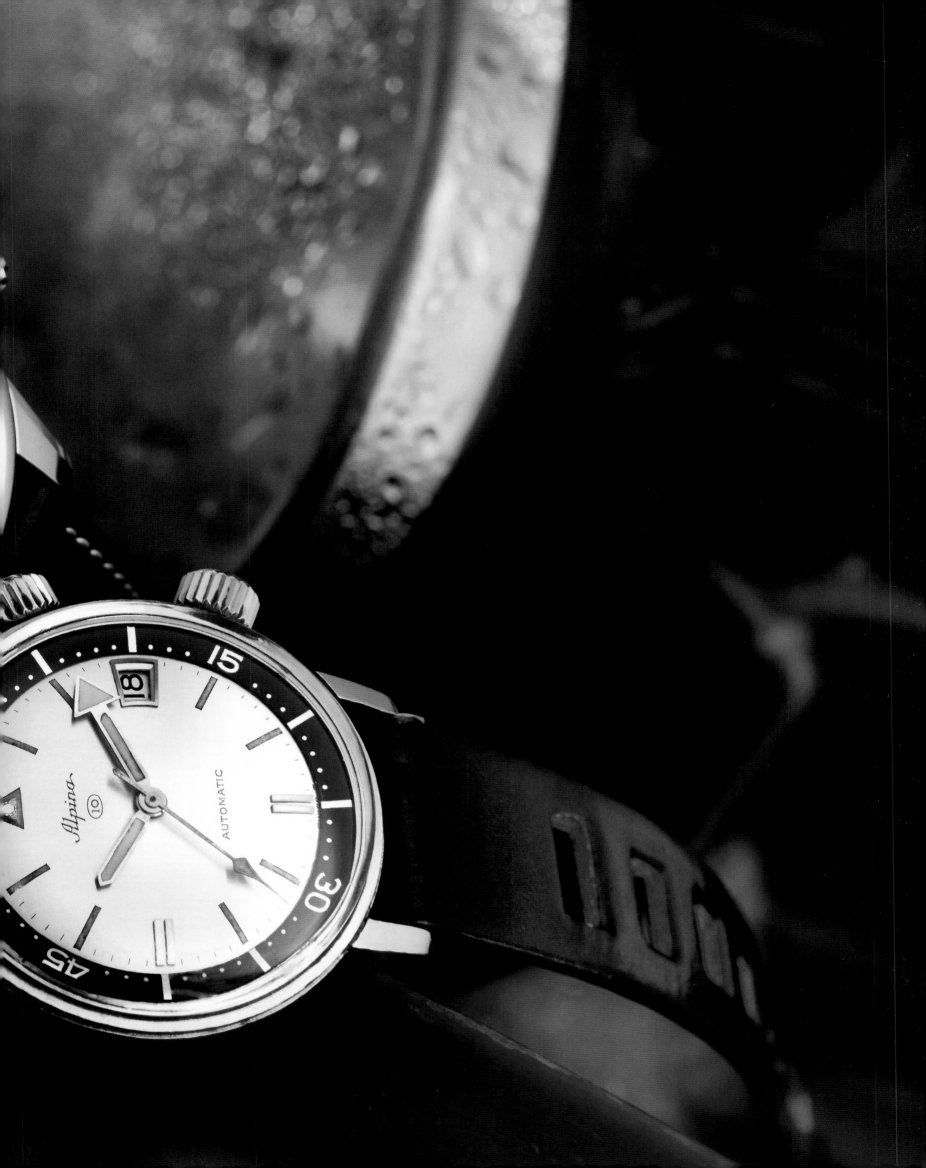

From a Cooperative Association to an Innovative Watch Manufactory

It's difficult to say what might have happened to Alpina without Peter C. Stas and wife Aletta. Blind speculations are fortunately unnecessary because at the beginning of the 21st century these two Dutch entrepreneurs, who had already boldly established Frédérique Constant and shepherded it to success, discovered the languishing Swiss traditional brand with the sporty touch. Alpina perfectly complemented the Stas' first brand Frédérique Constant, so the purchase took place relatively quickly in 2002. When the first collection in Alpina's new era debuted at the watch fair in Basel one year later, it was obvious that the elements of its design were clearly derived from Alpina's long tradition. But the new owners soon discovered that this reference to the brand's past didn't guarantee a successful future. After 17 lost years, Alpina's renaissance was tantamount to a complete new beginning. The rather uninspiring products from the epoch between 1985 and 2002 simply weren't worth mentioning, but collectors knew and appreciated Alpina timepieces from earlier epochs. Points of reference for the future could be derived from the brand's 120-year history, which began in 1883, when Gottlieb Hauser founded a cooperative association with a long German name that can be translated as the "Association of Swiss Watchmakers." His objectives were clearly defined: on the one hand, he wanted to foster collaboration among reliable manufacturers of high-quality timepieces and accessories; on the other hand, he hoped that group orders would lead to lucrative conditions for the association's members. The principle functioned well, both in Switzerland and in neighboring countries. After a contract was signed with the Straub & Cie. watch manufacturer, the association's headquarters were relocated to Bienne in 1890. Six years later, a change in the statutes resulted in a new name: "Union Horlogère, Schweizerische Uhrmachergenossenschaft, Association horlogère Suisse."

In the course of decades, orders placed by the association were profitable for various companies. Some of them were well known, others remained in the background. They included: J. Straub & Co., Bienne (complete timepieces), Favre of Geneva (complete timepieces), Kurth Frères of Grenchen (complete timepieces—later Certina), Duret & Colonnaz of Geneva (ébauches), Huguenin-Robert (cases), Schwob Frères & Co. of La Chaux-de-Fonds (Cyma—complete timepieces), Robert Frères of Villeret (complete timepieces—Minerva), Ali Jeanrenaud (pendants for pocket watches), and Numa Nicolet & Fils (dials). Harassing fire from uninvolved manufacturers and wholesalers caused occasional discomforts, but couldn't lastingly interfere with the successes. A second special caliber ticked inside many of the pocket watches around the turn of the 20th century. When the prosperous business celebrated its 25th anniversary in 1908, the name "Alpina," for which the Union Horlogère had received trademark protection in 1901, was registered as an independent watch brand. With this step, the association participated in the trend for short, catchy and thus successful brand names. The appellation kept its good reputation because the name "Alpina" was used only on selected watches with high-quality inner lives. A red triangle with a stylized dial and the cooperative signature served as a readily recognizable logo.

The attempt to establish a foothold in Germany, and especially at Glashütte in Saxony, began in 1909. The fine products made by the Präcisions-Uhrenfabrik Alpina Glashütte i. S. targeted the chronometric luxury segment. To achieve this goal, ébauches from Geneva underwent the necessary modifications and upgrading in the Müglitz Valley. Precisely this was a thorn in the eye of A. Lange & Söhne, which initiated a lawsuit that culminated in the termination of the competing company on July 17, 1922. The Alpina Gruen Gilde SA, which was cofounded with the American entrepreneur Dietrich Gruen in 1929, likewise had only a short lifespan: the self-proclaimed "largest syndicate of watchmakers of all times" ended its activities in 1937. Among the highlights of this era are the rectangular "Doctor's Watch" with the same baguette caliber from Aegler SA that was also encased in Rolex's legendary "Prince." But the intended win-win situation ultimately didn't arise. The subsequently founded joint-stock company, which was named Alpina Union Horlogère SA, was again headquartered in Bienne.

Alpina unveiled its steel "Block Uhr" as the first sport watch in 1933 and equipped it with a special crown that received patent protection in 1934. The "Alpina 4" was very successful on international markets in 1938 and afterwards. The number "4" in its name referred to four quality characteristics: antimagnetic; watertight "Geneva" case; Incabloc shock absorption; and the use of rustproof stainless steel for the sturdy case. The era of self-winding watches began at Alpina in 1944 with Caliber 582, which is also known as "P82."

Sanctions imposed after World War Two by the victorious Allies prohibited the use of the Alpina brand name in Germany, partly because seamen in the German navy had worn watches with this signature. Alpina was renamed Dugena. When the Quartz Tsunami arrived in the early 1970s, Alpina was nearly powerless to oppose it. Businesspeople from Cologne, who lacked the necessary affinity for watches, became the new owners. The rest of the sad story is well known.

Gradual but steady improvements began under the prudent aegis of Peter and Aletta Stas. Alpina currently produces circa 20,000 wristwatches per year and plans call for annual production to increase to 75,000 watches in the medium term. The price segment: affordable.

With an eye toward its history, Alpina feels equally at home on dry land, in the air and under water. The collection of pilot's watches, which premiered under the name "Startimer Pilot" in 2011, has been judiciously expanded. Diver's watches grew increasingly important too: the "Seastrong Diver Heritage" that debuted in 2016 recalls an eye-catching predecessor from the 1960s and the "Seastrong Diver 300" aptly embodies contemporary styling while remaining watertight to 300 meters. The electronic "Horological Smartwatch" with analogue time display is an ideal partner for a smartphone. The "Alpiner 4" line has a sporty touch, while the "Alpiner Heritage Manufacture KM-710" and other models perfectly embody the retro look. As in the past, Alpina presently encases two types of movements: one variety is purchased from suppliers

Pilot's chronograph, hand-wound movement, 1930s

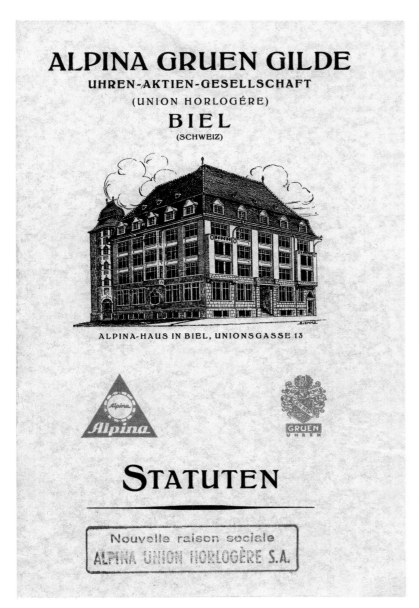

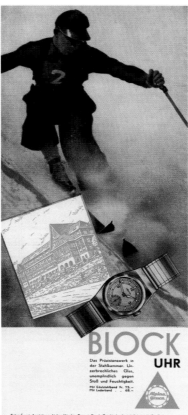

such as Eta or Sellita; the other is exclusively fabricated at Alpina's own manufactory in Geneva. The rotor of Caliber AL-710 is obviously similar to the oscillating weight in successful Caliber 582 from the 1940s. The AL-710 also provides power for Alpina's top-of-the-line model. Chief design engineer Pim Koeslag developed a unique chronograph module for the "Alpiner 4 Manufacture Flyback Chronograph." Koeslag's practicality and intelligence are evident in the fact that the cadrature requires only 96 components. A star-shaped construction replaces a conventional column-wheel. The coupling recalls elements of Edouard Heuer's oscillating pinion. The model's name refers to the flyback mechanism in Caliber AL-760.

Peter C. Stas has never regretted the purchase: "Alpina is a small child in a significantly larger business. We'll take pains to ensure that it continues to grow." ◦

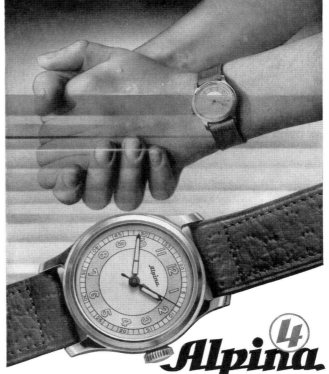

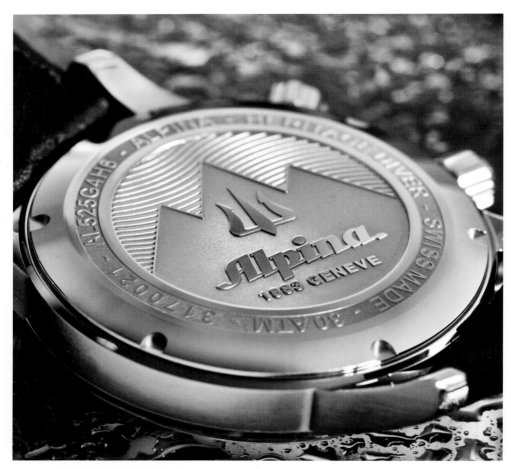

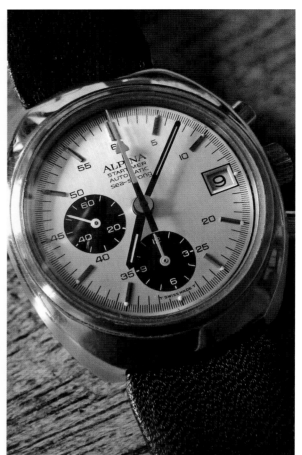

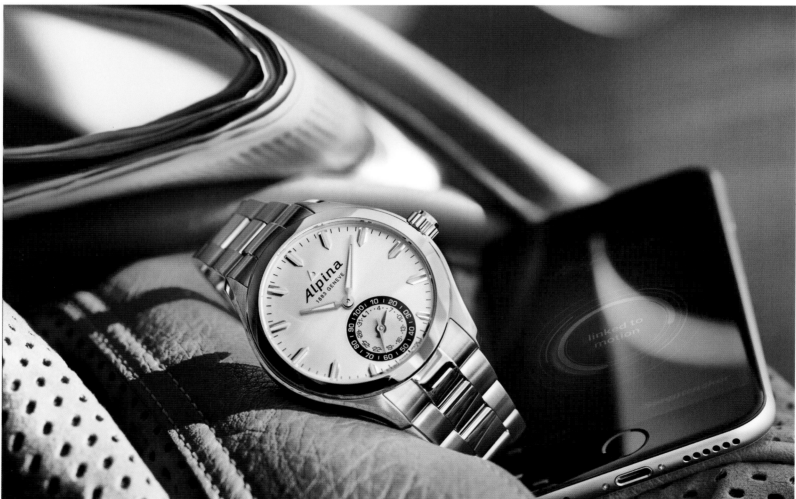

Clockwise from top left: Seastrong Diver Heritage, 2016 ◦ Seastrong Chronograph, 1960s ◦ Horological Smartwatch, 2015

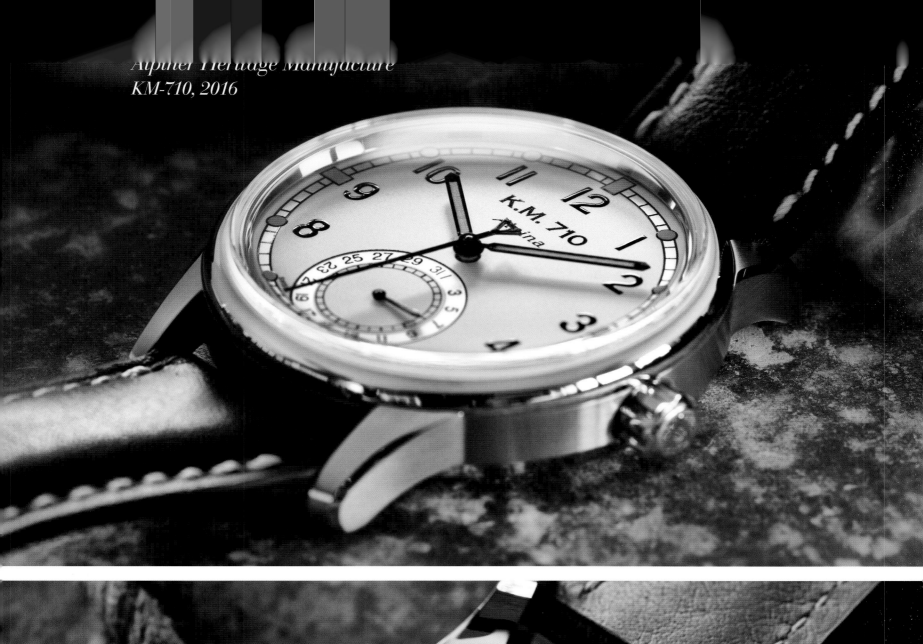

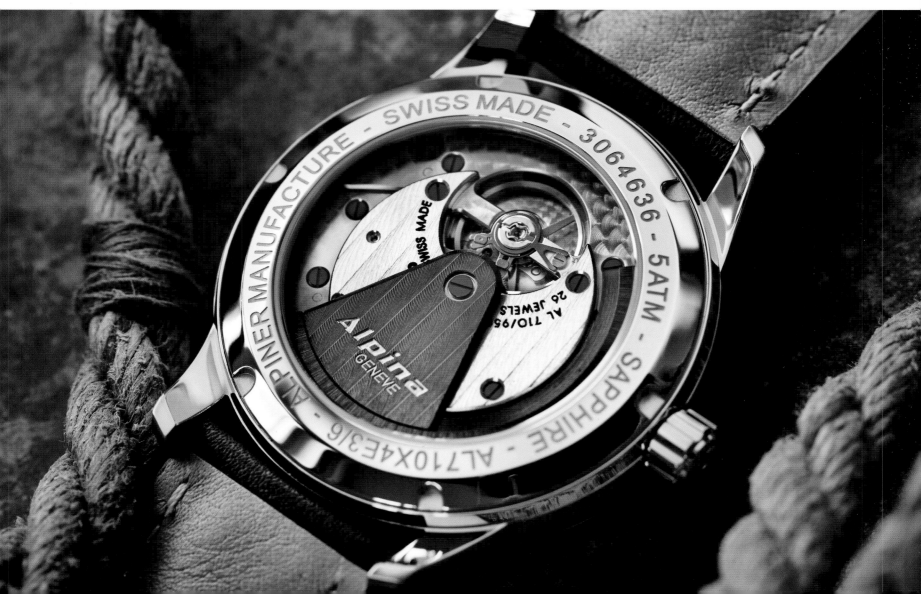

Von einer Genossenschaft zur innovativen Uhrenmanufaktur

Deutsch

Was ohne Peter C. Stas und seine Frau Aletta aus Alpina geworden wäre, lässt sich schwer sagen. Ein Stochern im Nebel ist zum Glück auch gar nicht nötig, denn zu Beginn des 21. Jahrhunderts entdeckte das holländische Unternehmerpaar, dem zuvor schon ein Gründungsabenteuer namens Frédérique Constant geglückt war, die dümpelnde Schweizer Traditionsmarke mit sportlichem Anstrich. Weil Alpina die Erstmarke Frédérique Constant perfekt ergänzte, kam der Kauf 2002 relativ zügig zustande. Bereits ein Jahr später war die erste Neuzeit-Kollektion während der Basler Uhrenmesse präsent. Unübersehbar die an das lange Erbe zurückreichenden Gestaltungselemente. Was jedoch kein Erfolgsgarant war, wie die neuen Eigentümer anschließend feststellen mussten. Wegen 17 verlorener Jahre kam die Alpina-Renaissance einem kompletten Neubeginn gleich. Die wenig erbaulichen Produkte aus der Epoche zwischen 1985 und 2002 waren nämlich nicht der Rede wert gewesen. Sammler kannten und schätzten die Zeitmesser aus früheren Epochen. Anhaltspunkte für die Zukunft ergaben sich aus der 120-jährigen Geschichte. Selbige reicht zurück bis ins Jahr 1883. Am Anfang stand die Vereinigung der Schweizer Uhrmacher, gegründet von Gottlieb Hauser. Seine Ziele waren klar definiert. Zum einen ging es um die Zusammenarbeit mit zuverlässigen Fabrikanten qualitativ hochwertiger Uhren und Zubehörteile. Zum anderen sollten Gruppenaufträge zu interessanten Konditionen für die Mitglieder führen. Das Prinzip funktionierte, und zwar auch in den Nachbarländern. 1890 bedingte ein Vertrag mit dem Uhrenfabrikanten Straub & Cie. die Verlegung der genossenschaftlichen Zentrale nach Biel. 1896 führte eine Statutenänderung zum neuen Namen Union Horlogère, Schweizerische Uhrmachergenossenschaft, Association horlogère Suisse.

Von den Aufträgen der Genossenschaft profitierten im Laufe der Jahrzehnte teils bekannte, teils im Hintergrund wirkende Firmen: J. Straub & Co., Biel (Fertiguhren), Favre, Genf (Fertiguhren), Kurth Frères, Grenchen (Fertiguhren – später Certina), Duret & Colonnaz, Genf (Rohwerke), Huguenin-Robert (Gehäuse), Schwob Frères & Co., La Chaux-de-Fonds (Cyma – Fertiguhren), Robert Frères, Villeret (Fertiguhren – Minerva), die Pendant- und Bügelfabrik von Ali Jeanrenaud und die Zifferblattfabrik von Numa Nicolet & Fils. Störfeuer nicht involvierter Fabrikanten und Großhändler brachten gelegentlich Unruhe, konnten die Erfolge auf Dauer aber nicht stören. Um die Wende zum 20. Jahrhundert tickte in etlichen der Taschenuhren schon ein zweites Spezialkaliber. 1908 zelebrierte das prosperierende Unternehmen sein 25. Jubiläum. Aus diesem Anlass erfolgte die Eintragung des von der Union Horlogère seit 1901 für hochwertige Taschenuhren geschützten Namens „Alpina" als eigenständige Uhrenmarke. Mit diesem Schritt folgte die Genossenschaft dem Trend zu kurzen, einprägsamen und deshalb erfolgreichen Signaturen. Banalisierung des Namens vermied die Beschränkung auf ausgesuchte Uhren mit hochwertigem Innenleben. Als Logo mit hohem Wiedererkennungswert diente ein rotes Dreieck mit stilisiertem Zifferblatt und Namenszug.

Der Versuch, in Deutschland und dort speziell im sächsischen Glashütte Fuß zu fassen, startete 1909. Die feinen Produkte der Präcisions-Uhrenfabrik Alpina Glashütte i. S. sollten das chronometrische Luxussegment besetzen. Zu diesem Zweck erfuhren Genfer Rohwerke im Tal der Müglitz die gebotene Modifikation und Aufwertung. Genau das kam speziell bei A. Lange & Söhne gar nicht gut an. Ein jahrelanger Rechtsstreit führte am 17. Juli 1922 zur Löschung der Firma. Auch die 1929 zusammen mit dem amerikanischen Unternehmer Dietrich Gruen gegründete Alpina Gruen Gilde SA hatte nur ein begrenztes Leben. 1937 endeten die Aktivitäten der selbsternannten „größten Interessengemeinschaft von Uhrmachern aller Zeiten". Zu den Höhepunkten dieser Ära gehörte die rechteckige „Doctor's Watch" mit Baguette-Kaliber der Aegler SA. Selbige fand man auch in der legendären Rolex „Prince". Von der intendierten Win-win-Situation war am Ende aber keine Rede mehr. Die Folge-Aktiengesellschaft mit Namen Alpina Union Horlogère SA residierte weiterhin in Biel.

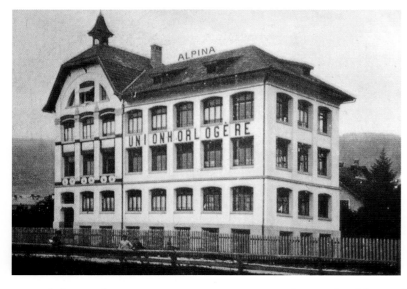 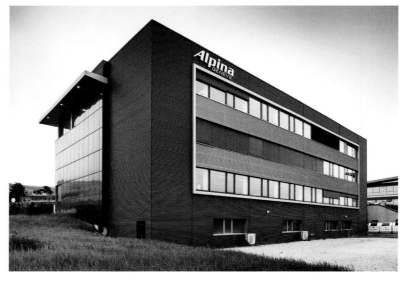

From left: Headquarters, Bienne, 1890 ◦ Manufacture building, Plan-les-Ouates, 2006 ◦ Von links: Hauptsitz in Biel, 1890 ◦ Manufakturgebäude, Plan-les-Ouates, 2006 ◦ De gauche à droite : Siège biennois, 1890 ◦ Bâtiment de la manufacture, Plan-les-Ouates, 2006

Bereits 1933 hatte Alpina die stählerne „Block Uhr" als erste Sportuhr mit der 1934 patentierten Spezialkrone vorgestellt. Ab 1938 agierte die Sportuhr „Alpina 4" höchst erfolgreich auf internationalen Märkten. Die Ziffer „4" wies dabei auf vier Qualitätsmerkmale hin: 1. antimagnetisch, 2. wasserdichtes „Geneva"-Gehäuse, 3. Incabloc-Stoßsicherung und 4. Verwendung von rostfreiem Edelstahl für die belastbare Schale. Mit dem Kaliber 582, auch P82 genannt, brach 1944 das Automatikzeitalter an.

Nach dem Zweiten Weltkrieg gipfelten Sanktionen der Alliierten darin, die Nutzung des Markennamens Alpina in Deutschland zu untersagen, weil u. a. Soldaten der deutschen Kriegsmarine auf Uhren mit dieser Signatur geblickt hatten. Aus Alpina wurde Dugena. Anfang der 1970er Jahre stand Alpina der ungestümen Quarz-Welle beinahe machtlos gegenüber. Kölner Unternehmer ohne ausgeprägte Uhren-Affinität wurden neue Eigentümer. Der Rest ist bereits bekannt.

Unter umsichtiger Ägide von Peter und Aletta Stas ging es langsam, aber kontinuierlich bergauf. Inzwischen produziert Alpina jährlich etwa 20 000 Armbanduhren. Mittelfristig sollen es rund 75 000 Exemplare werden. Preissegment: bezahlbar.

Mit Blick auf die Geschichte fühlt sich Alpina auf der Erde, in der Luft und unter Wasser zu Hause. Die 2011 eingeführte Flieger-uhren-Kollektion erfuhr unter dem Namen „Startimer Pilot" eine gezielte Ausweitung. Taucheruhren erlangten im Laufe der zurück-liegenden Jahre zunehmende Bedeutung. An ein markantes Vorbild aus den 1960er Jahren erinnert die 2016 vorgestellte „Seastrong Diver Heritage". Gegenwärtiges Designempfinden repräsentiert der bis 300 Meter wasserdichte „Seastrong Diver 300". Partner des Smartphones ist die elektronische „Horological Smart-watch" mit analoger Zeitanzeige. Sportlichen Touch verstrahlt die Linie „Alpiner 4", perfekter Retrolook zeichnet unter anderem die „Alpiner Heritage Manufacture KM-710" aus. Apropos: Wie

früher verbaut Alpina auch heute zwei Uhrwerk-Typen: zugekaufte von Eta oder Sellita und exklusive aus eigener Genfer Manufaktur. Der Rotor des AL-710 weist unübersehbare Ähnlichkeiten mit der Schwungmasse des erfolgreichen 582 aus den 1940er Jahren auf. Dieses Kaliber dient auch dem aktuellen Spitzenprodukt „Alpiner 4 Manufacture Flyback Chronograph" als Motor. Hierfür hat Chefkonstrukteur Pim Koeslag ein einzigartiges Chronographen-modul entwickelt. Von nutzbringender Intelligenz zeugt die Tatsache, dass die Kadratur mit gerade einmal 96 Komponenten funktio-niert. An die Stelle des klassischen Schaltrads tritt ein sternförmiges Gebilde. Die Kupplung lässt Elemente des Schwingtriebs von Edouard Heuer erkennen. Schließlich weist der Modellname auf die Temposchaltung im Kaliber hin.

Bereut hat Peter C. Stas den Kauf übrigens nie. „Bei Alpina handelt es sich um ein Kleinkind in einem deutlich größeren Geschäft. Wir werden dafür sorgen, dass es stetig wächst." ◦

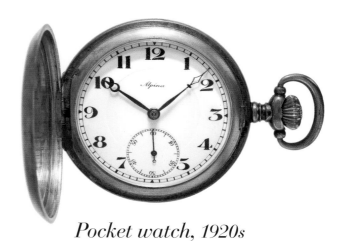

Pocket watch, 1920s

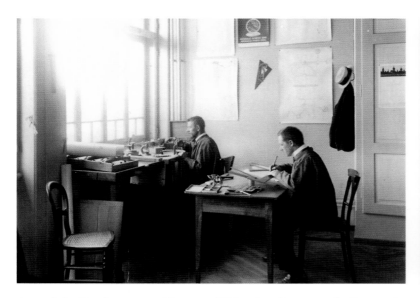
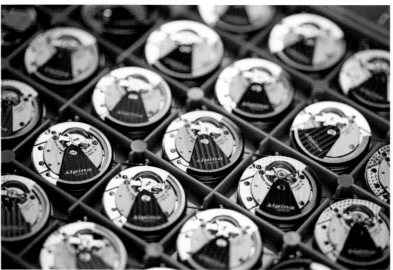

From left: Headquarters, Bienne, 1890 ◦ Quality control of manufacture movements ◦ Von links: Im Bieler Hauptsitz, 1890 ◦ Manufaktur-werke in der Qualitätskontrolle ◦ De gauche à droite : Au siège biennois, 1890 ◦ Mouvements de manufacture au contrôle qualité

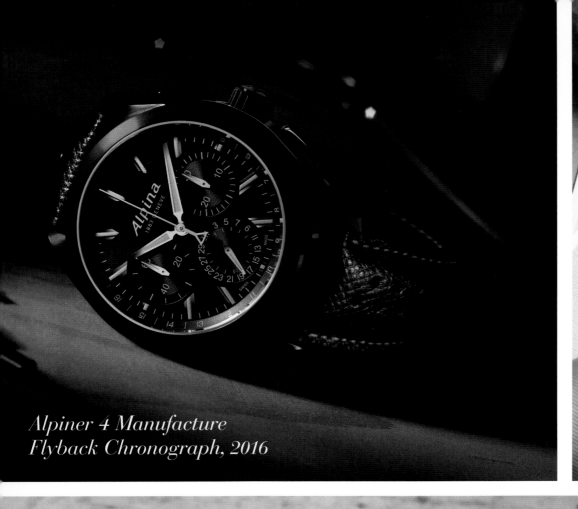

Alpiner 4 Manufacture
Flyback Chronograph, 2016

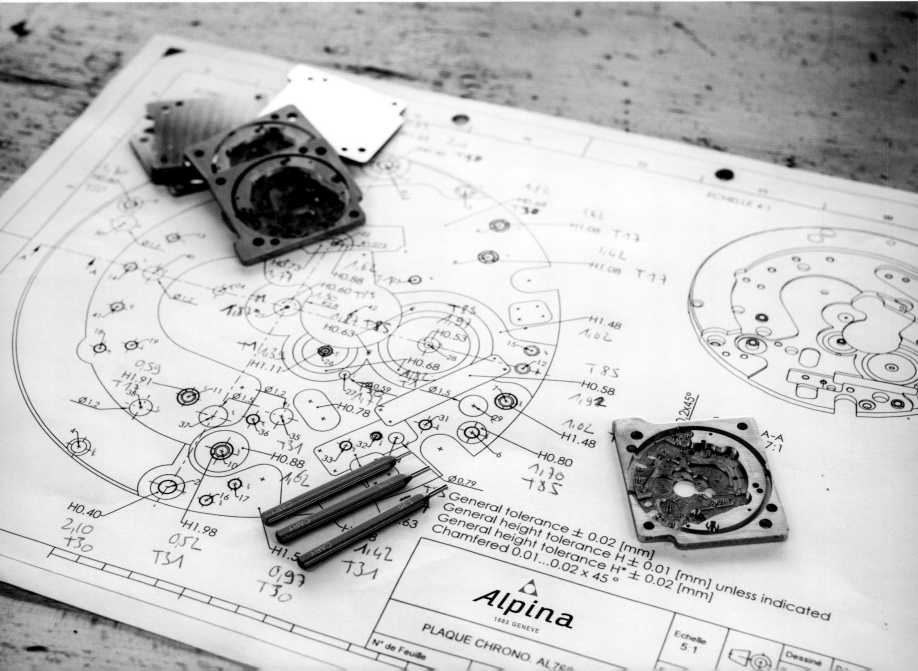

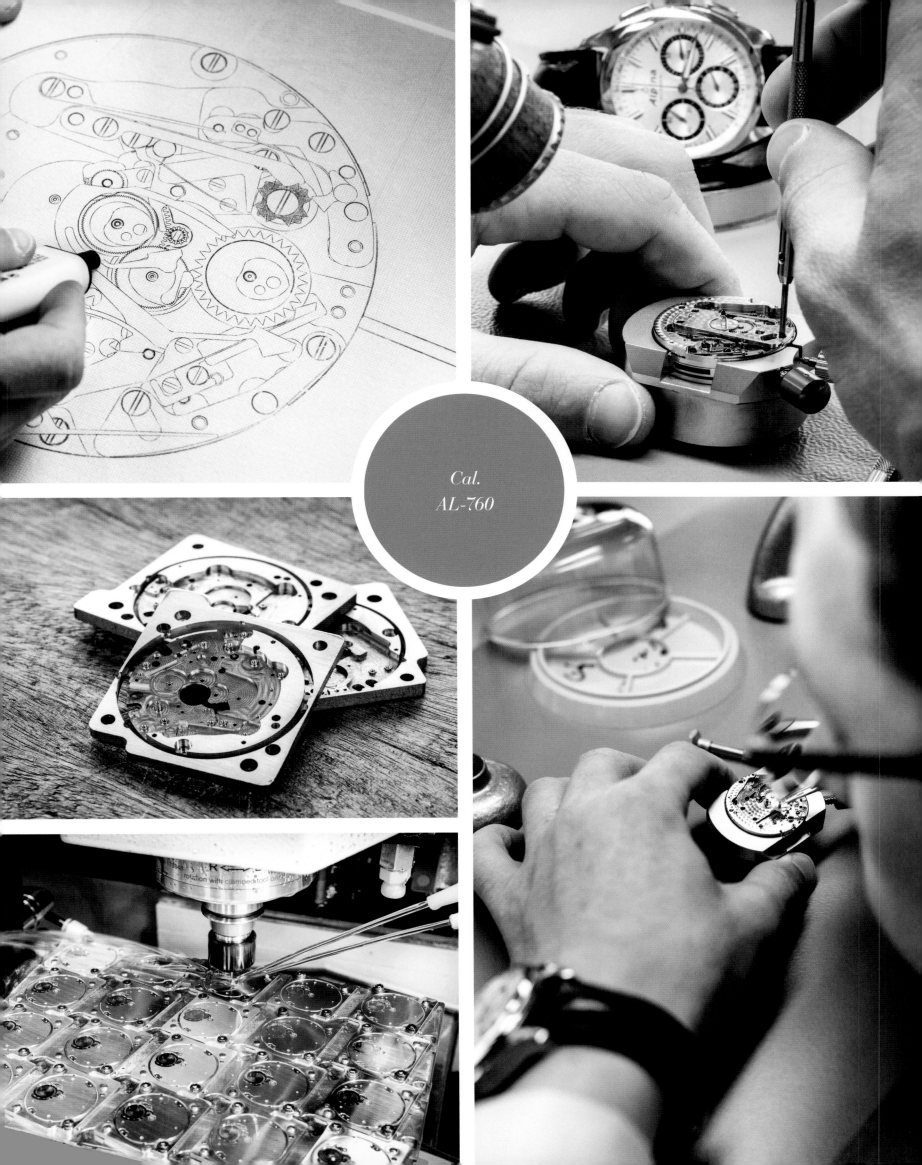

Cal.
AL-760

Une coopérative devenue manufacture horlogère innovante

Français

Il est difficile de dire ce qu'il serait advenu des montres sportives Alpina sans Peter C. Stas et son épouse Aletta. Heureusement, nul est besoin de se répandre en conjectures car ce couple d'entrepreneurs hollandais, qui a déjà créé avec bonheur la maison Frédérique Constant, découvre au début du XXIᵉ siècle cette marque suisse de tradition, alors qu'elle commence à tanguer. Alpina complétant à merveille la marque principale Frédérique Constant, le rachat en 2002 est mené rondement. Seulement un an plus tard, Alpina présente sa première collection de cette ère nouvelle au Salon mondial de l'horlogerie à Bâle (Baselworld). Si l'on reconnaît d'emblée l'esthétique héritière d'une longue tradition, le succès n'est hélas pas garanti, comme les nouveaux propriétaires doivent le constater au lendemain de la manifestation. En raison de 17 années perdues, faire renaître Alpina revient à repartir de zéro.

Les produits médiocres sortis entre 1985 et 2002 ne présentant guère d'intérêt, les collectionneurs apprécient plutôt les garde-temps plus anciens. Aussi faut-il rechercher des orientations pour l'avenir dans l'histoire de l'entreprise vieille de 120 ans, qui remonte à la création, en 1883, de l'Union horlogère (Vereinigung der Schweizer Uhrmacher) par Gottlieb Hauser. Ses objectifs sont clairement définis : d'une part travailler en partenariat avec des fabricants fiables de composants de montres et d'accessoires de haute qualité ; d'autre part faire des achats groupés pour obtenir des conditions intéressantes. Ce principe fonctionne jusque dans les pays limitrophes. En 1890, pour honorer un contrat avec le fabricant de montres Straub & Cie, la coopérative transfère son administration centrale à Bienne. Six ans plus tard, en 1896, elle modifie ses statuts et prend le nom d'Union Horlogère, Schweizerische Uhrmachergenossenschaft, Association horlogère Suisse.

Les bénéficiaires des commandes passées à la coopérative au fil des décennies sont des entreprises connues à des degrés divers : J. Straub & Co. à Bienne (montres complètes), Favre à Genève (montres complètes), Kurth Frères à Granges (montres complètes – deviendra Certina), Duret & Colonnaz à Genève (ébauches), Huguenin-Robert (boîtiers), Schwob Frères & Co. à La Chaux-de-Fonds (à l'origine de Cyma – montres complètes), Robert Frères, à Villeret (montres complètes – deviendra Minerva), le fabricant de pendants et bélières Ali Jeanrenaud et la fabrique de cadrans Numa Nicolet & Fils. Des attaques de la part de fabricants et de grossistes externes n'apportent que des perturbations occasionnelles, sans entraver durablement la réussite de l'association. Au tournant du XXᵉ siècle, un second calibre spécifique anime désormais nombre des montres de poche. En 1908, l'association florissante fête ses 25 ans d'existence. À cette occasion, elle procède à l'enregistrement à titre de marque autonome du nom « Alpina », déjà protégé en relation avec des montres de poche haut de gamme. La tendance est alors en effet aux griffes courtes et faciles à mémoriser, clés de la réussite. Pour éviter une dilution de la marque Alpina, son emploi est limité à des montres de qualité supérieure, animées par des calibres haut de gamme. Facilement reconnaissable, le logo représente un cadran stylisé enserré dans un triangle rouge, le tout surmontant le nom de la marque.

En 1909, Alpina tente de s'implanter en Allemagne, précisément à Glashütte, en Saxe, avec pour objectif la conquête du segment des garde-temps de luxe par les produits haut de gamme de la fabrique de montres de précision Alpina Glashütte. À cette fin, Alpina apporte à des ébauches genevoises les modifications et valorisations nécessaires dans la vallée de la Müglitz. Voilà qui est fait pour déplaire, à A. Lange & Söhne tout particulièrement. Au terme d'un an de procès, l'entreprise est radiée du registre

From left: Manufacture calibers ○ Blue screws ○ Old tooling machine ○ Von links: Manufakturkaliber ○ Blaue Schrauben ○ Alte Fertigungsmaschine ○ De gauche à droite : Calibres de manufacture ○ Vis bleuies ○ Machine-outil ancienne

des sociétés le 17 juillet 1922. Alpina Gruen Gilde SA, cofondée en 1929 avec l'entrepreneur américain Dietrich Gruen, ne sera pas non plus promise à un bel avenir : l'association qui se dit être le « plus grand groupement d'intérêts d'horlogers de tous les temps » cesse ses activités en 1937. Parmi les créations marquantes de cette ère figure la « Doctor's Watch » rectangulaire à mouvement baguette produit par Aegler SA, qui équipe aussi la légendaire Rolex « Prince ». La situation gagnant-gagnant escomptée au départ est restée un vœu pieux. La société anonyme qui prend la succession sous le nom d'Alpina Union Horlogère SA maintient le siège à Bienne.

Succédant à la première montre sportive présentée en 1933, la « Block Uhr » acier équipée de la couronne spéciale brevetée en 1934, la montre sportive « Alpina 4 » lancée en 1938 remporte un succès foudroyant sur les marchés internationaux. Le chiffre « 4 » fait référence aux quatre caractéristiques : 1. Antimagnétisme, 2. Boîtier étanche « Geneva », 3. Système antichoc Incabloc et 4. Acier inoxydable pour le boîtier résistant. En 1944, le calibre 582, aussi appelé P82, inaugure l'ère des mouvements automatiques. Au lendemain de la Seconde Guerre mondiale, les Alliés interdisent, à titre de sanction suprême, l'exploitation du nom de marque Alpina en Allemagne, notamment parce que la marine allemande avait lu l'heure sur des montres revêtues de cette signature. Alpina devient alors Dugena. Au début des années 1970, la marque est presque impuissante face à l'ouragan du quartz. Des entrepreneurs originaires de Cologne sans grande affinité pour l'horlogerie la rachètent. On connaît la suite de l'histoire.

Sous l'égide éclairée de Peter et Aletta Stas, l'entreprise remonte la pente, lentement mais sûrement. Alpina produit désormais quelque 20 000 montres-bracelets par an, un chiffre qui devrait atteindre à moyen terme les 75 000 exemplaires, et ce à des prix abordables.

Si l'on considère le passé, on peut dire qu'Alpina est actuellement dans son élément sur terre, sur mer et dans les airs. Lancée en 2011, la collection de montres de pilotes « Startimer Pilot » a été étoffée de manière ciblée. Par ailleurs, les montres de plongée ont gagné en importance au cours des dernières années : la « Seastrong Diver Heritage » présentée en 2016 n'est pas sans rappeler un modèle phare des années 1960, tandis que la « Seastrong Diver 300 » étanche jusqu'à 300 mètres de profondeur incarne la sensibilité contemporaine en matière de design. Au chapitre des montres connectées, la collection « Horological Smartwatch » est à affichage analogique.

Si l'allure sportive caractérise la collection « Alpiner 4 », le look résolument rétro est représenté entre autres par le modèle « Alpiner Heritage Manufacture KM-170 ». À noter : comme autrefois, Alpina recourt à deux types de mouvements différents : des calibres ETA ou Sellita, d'une part, et des produits exclusifs mis au point en interne à Genève, d'autre part. Le rotor du mouvement AL-710 a manifestement de nombreux points communs avec la masse oscillante du célèbre calibre 582 conçu dans les années 1940. C'est également ce calibre qui anime le produit phare actuel, le chronographe « Alpiner 4 Manufacture Flyback Chronograph », pour lequel le directeur technique Pim Koeslag a développé un module de chronographe inédit. Innovation aussi intelligente qu'utile, sa cadrature fonctionne avec tout juste 96 composants. La conventionnelle roue à colonnes est remplacée par une pièce en forme d'étoile. On reconnaît dans l'embrayage des éléments du pignon oscillant d'Édouard Heuer. Pour finir, le nom du modèle renvoie à la fonction retour-en-vol intégrée au calibre AL-760. Peter C. Stas n'a jamais regretté son achat : « Alpina est comme un jeune enfant perdu dans la cour des grands. Nous allons veiller à la faire grandir constamment. » ○

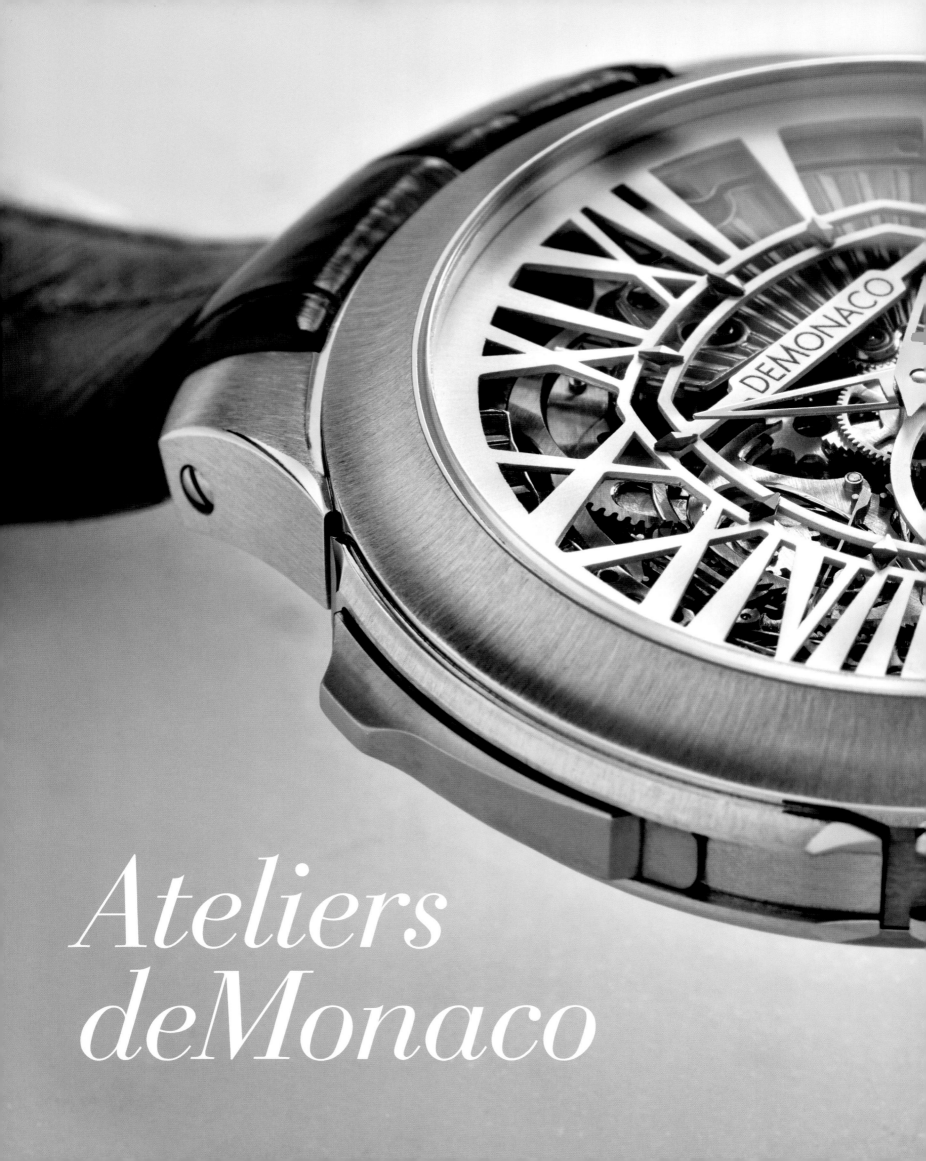

Ateliers
deMonaco

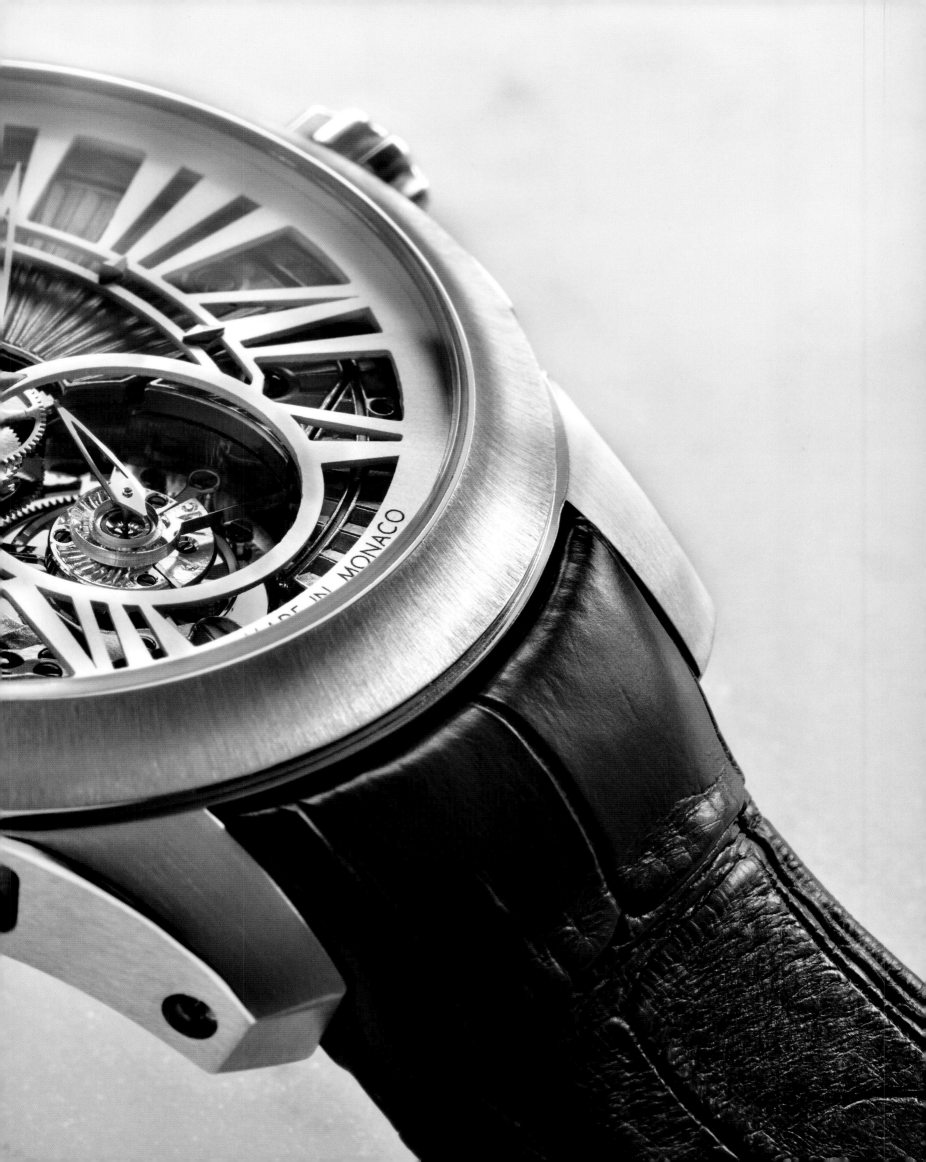

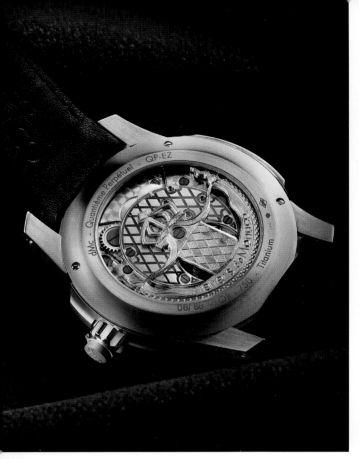
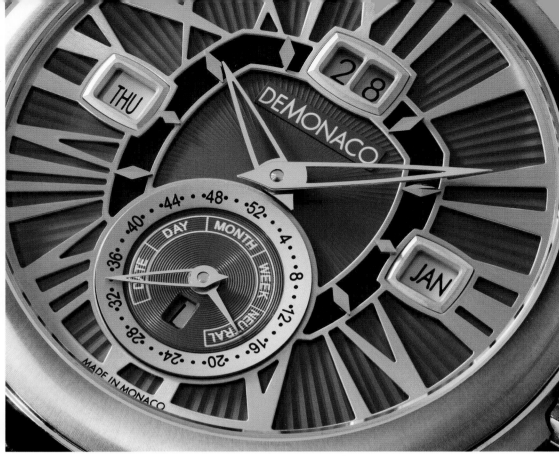

dMc-QP-RR-WG, Collection: Quantième Perpétuel Classique, in white gold, 2010

Horological Luxury from the Côte d'Azur

Blue ocean, gambling casinos, fascinating automobiles and an extraordinary Grand Prix are a few of the images that come to mind when one thinks about the little principality on the Côte d'Azur. Watches in Monaco primarily grace the wrists of beautiful and wealthy people or sparkle in the showcases of noble jewelry stores. But watch manufacturing was unknown here until 2009, when Peter Stas and the watchmaker Pim Koeslag opened a small but very fine watch atelier embodying a third pillar alongside Alpina and Frédérique Constant. With strictly limited series, useful complications and the utmost in the watchmaker's art, timepieces bearing deMonaco's signature were destined to play in the uppermost chronometric league. And they've done precisely that ever since 2009. Due to the extremely high proportion of manual craftsmanship, the artisans at Ateliers deMonaco annually produce only a homeopathically small number of exclusively mechanical timepieces. Nothing is left to chance, neither in the design nor in the craftsmanly fabrication of the cases, dials and hands. Each detail prioritizes meticulousness. But the special value of these watches is in their painstakingly finished and decorated movements. Every caliber assembled at Ateliers deMonaco was also developed and manufactured here, and each caliber has unique horological appeal. Already during the initial design and engineering phase, Pim Koeslag takes pains to implement small but ultimately decisive differences. For example, the patented "Quantième Perpétuel" not only has indicators which jump ahead punctually at midnight, but also hosts a convenient setting and correcting system, appropriately named "EaZy adjust." Turning the extracted crown lets the wearer select the display that he wants to adjust: date, day of the week, calendar week, or month. The preselected indicator

can then be reset by pushing the crown. The ultra-complicated "Tourbillon Répétition Minute" collection embodies the high art of watchmaking. This collection's name aptly expresses its message: the one-minute tourbillon compensates for the negative effects that gravity exerts on the accuracy of the rate of a watch in a vertical position. Borne beneath a transparent sapphire bridge, the tourbillon's cage rotates once per minute around its own axis. The minute-repeater mechanism is nearly imperceptible to the eye, but considerably more complex. When the wearer wants to hear the time, he operates the little slide on the left-hand flank of the case. The mechanism responds by first chiming the current hour, then ringing the number of quarter hours since the preceding full hour and finally tolling the number of minutes that have elapsed since the previous quarter hour. For example, 32 tones resound at 12:59— a dozen low-pitched chimes, three duos of low and high chimes, and finally fourteen high-pitched chimes. A silent centrifugal-force regulator ensures that the sequence of strikes against the gongs occurs regularly, i.e., neither too quickly nor too slowly. Approximately three strikes can be heard during each two-second interval. The audible performance at one minute before one o'clock accordingly lasts between 20 and 25 seconds. An aficionado who would like to observe the hammers striking the two meticulously tuned gongs must first slip the watch off his wrist. Instead of showing its tourbillon, the movement now reveals the lovingly crafted decorations on its back side. The remarkable sound quality is partly due to the well-conceived design of the case, for which titanium and gold are used. Whether the case is angular or round, each shape assures an equally thrilling sonic experience. ○

Uhrmacherischer Luxus von der Côte d'Azur

Deutsch

Blaues Meer, Spielcasinos, faszinierende Autos oder einen Ausnahme-Grand-Prix assoziiert man sehr spontan mit dem kleinen Fürstentum an der Côte d'Azur. Das Thema Uhren spielt sich in Monaco primär an den Handgelenken der Schönen und Reichen oder bei den zahlreichen Nobeljuwelieren ab. Uhrenfertigung war bis 2009 hingegen ein Fremdwort. Dann kamen Peter Stas und der Uhrmacher Pim Koeslag, um ein kleines, aber sehr feines Uhren-Atelier zu eröffnen. Und zwar als dritte Säule neben Alpina und Frédérique Constant. Durch winzige Stückzahlen, hilfreiche Komplikationen und allerhöchste Uhrmacherkunst sollten deMonaco signierte Zeitmesser in der obersten chronometrischen Liga spielen. Und das tun sie seit besagtem Jahr. Wegen des extrem hohen Anteils an zeitraubender Handarbeit entsteht bei Ateliers deMonaco jedes Jahr nur ein homöopathisches Quantum ausnahmslos konventionell tickender Zeitmesser. Schon beim Design sowie der handwerklichen Ausführung von Gehäusen, Zifferblättern und Zeigern bleibt nichts dem Zufall überlassen. Gestalterische Sorgfalt bis ins letzte Detail wird groß geschrieben. Der besondere Wert dieser Armbanduhren ist jedoch in den mit größter Sorgfalt finissierten Uhrwerken zu suchen. Jedes der in Monaco fertiggestellten Kaliber entstammt ausnahmslos eigener Entwicklung und Fertigung. Darüber hinaus besitzt jedes Uhrwerk aber auch seinen besonderen uhrmacherischen Reiz. Schon bei der Konstruktion achtet Pim Koeslag auf die Implementierung kleiner, letzten Endes aber entscheidender Unterschiede. In diesem Sinn besitzt der patentierte „Quantième Perpétuel" nicht nur pünktlich um Mitternacht springende Anzeigen, sondern auch ein komfortables, „EaZy adjust" genanntes Einstell- und Korrektursystem. Indem man an der gezogenen Krone dreht, lässt sich

auswählen, was verändert werden soll: Datum, Wochentag, Kalenderwoche oder Monat. Danach lässt sich das Gewünschte per Druck auf die Krone verändern. Ganz hohe uhrmacherische Schule, weil besonders kompliziert, verkörpert die Kollektion „Tourbillon Répétition Minute". Ihr Name ist Botschaft. Der Kompensation negativer Auswirkungen auf die Ganggenauigkeit in senkrechter Position dient das Minutentourbillon. Sein Käfig dreht sich unter einer transparenten Saphirbrücke jede Minute einmal um seine Achse. Optisch kaum wahrnehmbar, aber deutlich komplizierter tritt die Minutenrepetition in Erscheinung. Wer hören möchte, wie spät es gerade ist, muss den kleinen Schieber im linken Gehäuserand betätigen. Danach ertönt zuerst die Zahl der aktuellen Stunde, gefolgt vom Quantum der vollen Viertelstunden. Als Drittes gibt der Mechanismus noch die Zahl der seit der letzten Viertelstunde verstrichenen Minuten wieder. Um 12:59 Uhr sind also summa summarum 32 Töne zu hören: zwölf tiefe, drei Mal tief und hoch sowie abschließend noch 14 hohe. Für gleichförmigen, nicht zu schnellen, aber auch nicht zu langsamen Ablauf der Schlagfolge sorgt ein geräuschloser Fliehkraftregler. Während zwei Sekunden sind etwa drei Schläge zu hören. Ergo dauert das Hörspiel kurz vor eins 20 bis 25 Sekunden. Wer sehen möchte, wie die Hämmer dabei gegen ein Paar sorgfältig gestimmter Tonfedern schlagen, muss die Uhr vom Handgelenk nehmen. Anstelle des Tourbillons zeigt sich nun die Rückseite mit ihrer liebevollen Dekoration. Die bemerkenswerte Klangqualität ist aber auch der durchdachten Gehäusekonstruktion unter Verwendung von Titan und Gold zu verdanken. Egal ob eckig oder rund: In jeder Form liefert sie berauschende Klangerlebnisse. ○

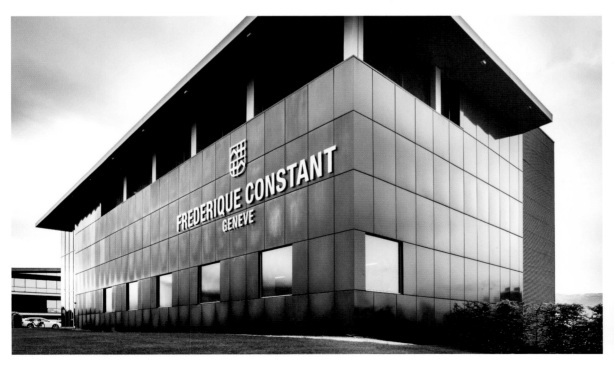

Top: Manufacture building, 2015 ○ Oben: Manufakturgebäude, 2015 ○ Ci-dessus : Bâtiment de la manufacture, 2015 ○ Right, from top: Pim Koeslag ○ Manuel Da Silva Matos and Pim Koeslag

Horlogerie haut de gamme sur la Côte d'Azur

Mer bleue, casinos, belles voitures ou Grand Prix d'exception, telles sont les images que l'on associe très spontanément à cette petite principauté de la Côte d'Azur. Au chapitre des montres, l'essentiel se joue aux poignets des stars et célébrités ou chez les nombreux grands joailliers. La production horlogère ne date en effet que de 2009. Cette année-là, Peter Stas et l'horloger Pim Koeslag ouvrent un atelier horloger, petit mais haut de gamme, qui constitue aujourd'hui le troisième pilier de la production horlogère dans la région, aux côtés d'Alpina et de Frédérique Constant. Avec une production confidentielle, des complications utiles et un art horloger d'exception, les ateliers deMonaco entendent jouer dans la cour des grands de l'univers horloger. Et c'est bien ce qu'ils font depuis le début. Compte tenu de la proportion élevée de travail artisanal chronophage, il ne sort chaque année des ateliers deMonaco qu'une quantité infime de garde-temps, exclusivement mécaniques. Rien n'est laissé au hasard, jusque dans la conception et la réalisation artisanale des boîtiers, cadrans et aiguilles. Le souci de l'esthétique est le maître mot jusque dans le moindre détail. Mais c'est dans les mouvements à la finition soignée à l'extrême que réside la valeur particulière de ces montres-bracelets. Tous les mouvements produits à Monaco sont de conception et de fabrication locales. Chacun d'eux possède en outre un attrait particulier sur le plan horloger. Dès la conception en effet, Pim Koeslag s'efforce d'intégrer des différences infimes mais décisives. Ainsi, la complication « Quantieme Perpetual » brevetée propose non seulement des affichages sautants à minuit précis, mais aussi un système de réglage et de correction très pratique baptisé « EaZy ». Il suffit de tirer le bouton-poussoir puis de tourner la couronne pour choisir la fonction que l'on désire ajuster : date, jour de la semaine, semaine civile ou mois. On peut alors la modifier, à toute heure du jour ou de la nuit, en appuyant sur le bouton-poussoir. Le « Grand Tourbillon Minute Repeater » est digne des plus hautes écoles d'horlogerie par ses nombreuses complications. Le nom de ce garde-temps est explicite. Le tourbillon, qui tourne une fois par minute sous un pont de saphir transparent, compense les influences négatives de la position verticale sur l'exactitude de la marche. La répétition à minutes, pratiquement invisible, se manifeste de manière bien plus complexe. Pour écouter l'heure qu'il est, il faut actionner le petit poussoir situé dans la tranche gauche du boîtier. On entend alors sonner autant de fois que le nombre d'heures écoulées, puis autant de fois que le nombre de quarts d'heure révolus. Le mécanisme donne pour finir le nombre de minutes écoulées depuis le dernier quart d'heure révolu. Ainsi, pour 12 heures et 59 minutes, on entend au total 32 sons : douze sons graves, trois sons alternant le grave et l'aigu et enfin 14 sons aigus. Un régulateur centrifuge silencieux veille à ce que la suite de tons soit régulière, ni trop rapide ni trop lente. Comme l'on entend environ trois sons toutes les deux secondes, la sonnerie qui retentit peu avant 13 heures dure donc 20 à 25 secondes. Pour voir les marteaux frapper sur les timbres soigneusement accordés, il faut retirer la montre et la retourner. Au lieu du tourbillon, on voit la face arrière décorée avec raffinement. L'excellente qualité du son résulte entre autres de la conception soignée du boîtier, réalisé en titane et en or. Quelle que soit sa forme, anguleuse ou ronde, il produit des sons enchanteurs. ∘

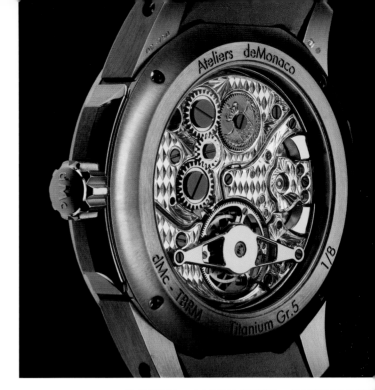

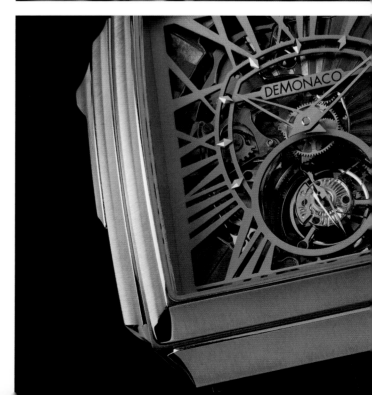

Top: dMc-TBRM-SR-GR, Collection: Tourbillon Répétition Minute, 2010
Middle and bottom: dMc-TBRM-SC-GR, Collection: Tourbillon Répétition Minute, 2010

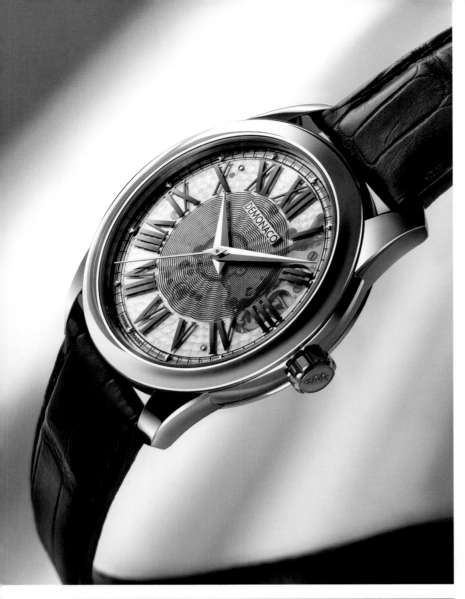

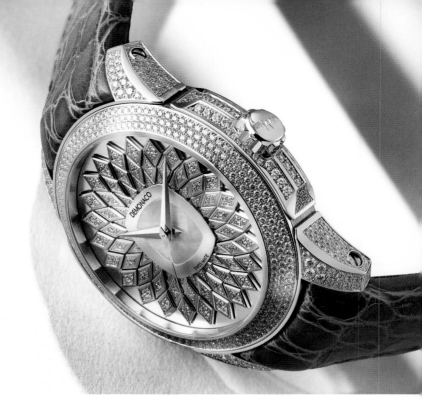

Clockwise from top left: dMc-PDG-SPH-WG, Collection: Poinçon de Genève, 2016 ◦ dMc-MC-LSD-WGP, Collection: Ronde de Monte-Carlo, 2016 ◦ dMc-TB-GP2-WG, Collection: Bespoke: Tourbillon, Grand Prix de Monaco 1966, 2016 ◦ dMc-TB-OCBL-RL-TI, Collection: Tourbillon, Sub-collection: Oculus 1297, 2016

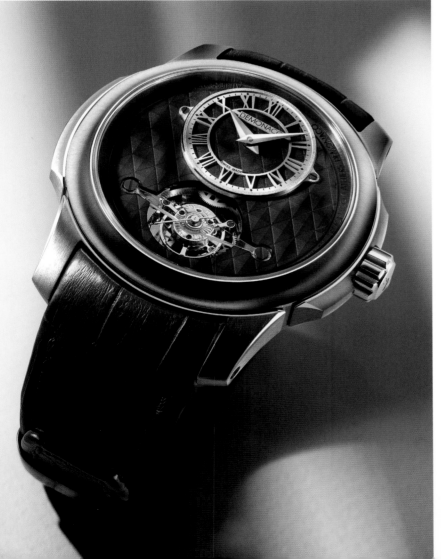

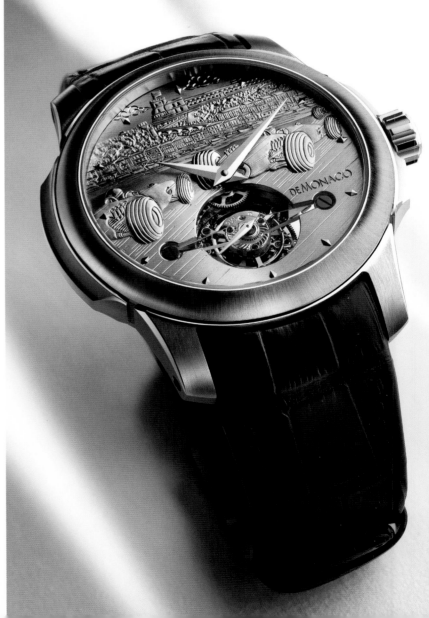

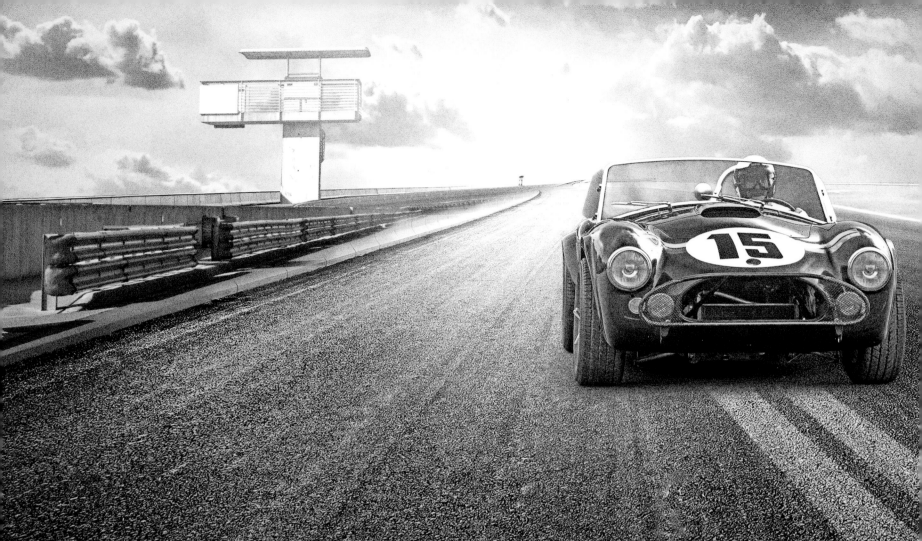

Baume & Mercier

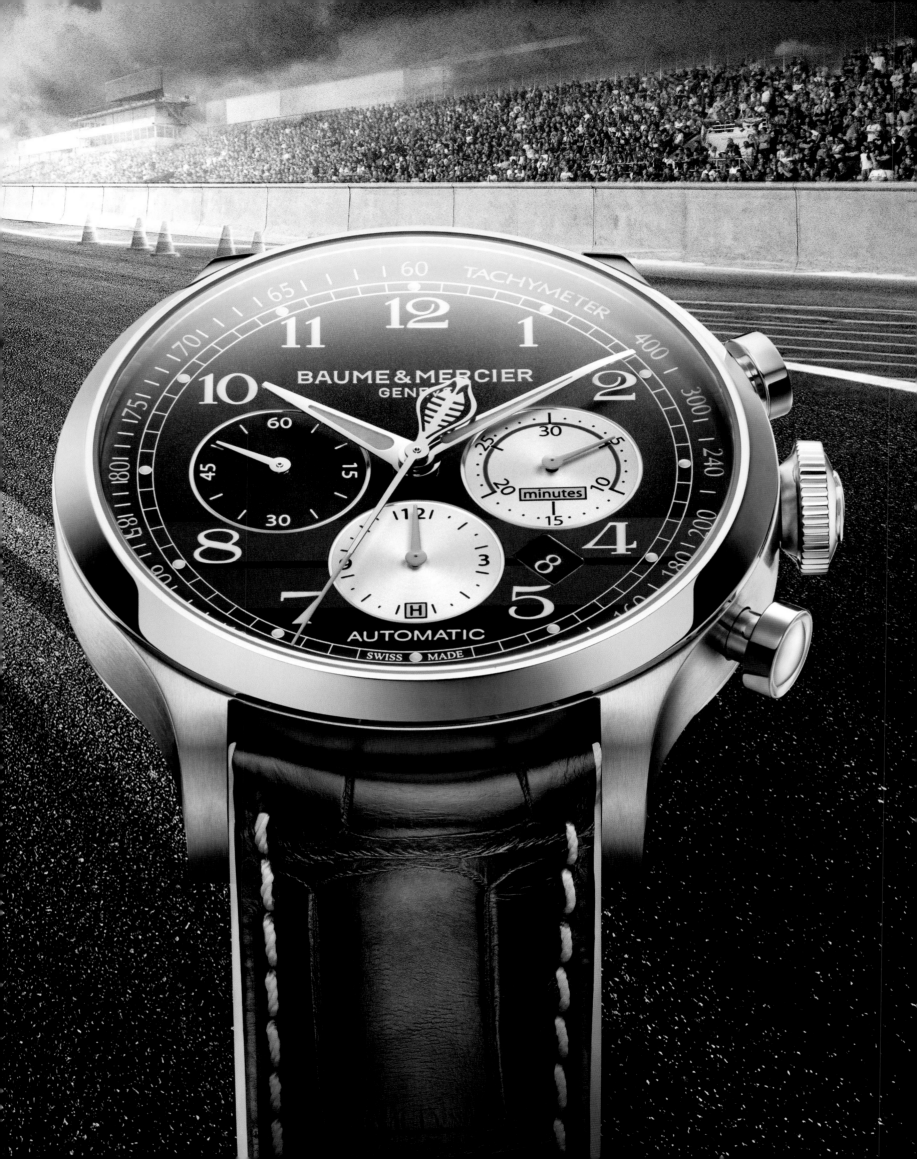

Fine Watches since 1830

English

Cultivate tradition, but renew it regularly: this credo runs like Ariadne's thread through the history of the Baume & Mercier watch brand, which was founded in 1830 at Les Bois, a little town in Switzerland's Jura region. These rather modest beginnings are linked with Joseph-Célestin and Louis-Victor Baume. Soon after the two brothers had established "Société Baume Frères," they became aware of the importance of international markets. "Baume Bros." was accordingly founded as a subsidiary in London in 1844. Not long afterwards, watches named "Waterloo," "Diviko" and "Sirdar" sparked enthusiasm among buyers in Australia and New Zealand. Innovation and an unconditional striving for quality and precision earned the duo no fewer than six medals at world expositions. A noteworthy pinnacle in the firm's history was reached in 1892, when a very fine tourbillon, which the famous Albert Pellaton-Favre had fabricated and regulated for the Baume Brothers, was awarded 91.9 of 100 theoretically possible points in the 44-day chronometer tests conducted at Kew Observatory in London. The importance of this sensational grade can be better appreciated when one considers the fact that 80 of 100 points suffice to earn the internationally recognized "Class A Certificate" with the qualifier "especially good." It's no wonder that this pocket tourbillon, which bore the number 103018, remained unbeaten for the next ten years. The second part of the brand's renowned name was added after the arrival of Paul Mercier in 1912. William Baume, a descendant of the firm's founder, was on a sales trip with a valise full of new products when he met the ambitious watchmaker and jeweler at Haas, a watch

and jewelry shop in Geneva. Originally named Tcherednitchenko, Mercier had earned an excellent reputation thanks to his savvy business practices and outstanding craftsmanly skills. The two men gradually realized that if they joined forces, they would be better equipped to cope with the big challenges that the future held in store for them. On November 26, 1918, their mutual amity and appreciation prompted them to sign a contract establishing the firm of Baume & Mercier, which would be headquartered in Geneva. After extremely successful careers, William Baume retired in 1937, followed by Paul Mercier several months later. The jeweler Constantin de Gorski began following in their great footsteps. The industry experienced a strong upswing after World War Two due to pent-up demand and the enormous popularity of decorative and precise wristwatches. Baume & Mercier primarily scored points with classical gents' watches, sporty chronographs and valuable ladies' watches. The Piaget Family became majority shareholders in 1965. Cartier Monde SA has made decisions for the label since 1988 because Christian and Yves Piaget sold 60 percent of Piaget Holding SA and Baume & Mercier SA to the French luxury corporation. The most recent chapter in the firm's history began in 1993, when Piaget and Baume & Mercier were wholly purchased by Vendôme Group, which watch lovers nowadays know as Richemont SA.

The course is presently steered by Alain Zimmermann, who learned—and learned to love—all aspects of the chronometric métier during the many years he spent at IWC in Schaffhausen. Avoiding both strict adherence to tradition and rash

Top: Tourbillon pocket watch awarded a "Class A Certificate," 1892 ∘ Oben: Mit dem „Class A Certificate" ausgezeichnetes Tourbillon, 1892 ∘ En haut : Tourbillon récompensé par un « certificat de classe A », 1892 ∘ Clockwise from top left: Louis-Victor and Joseph-Célestin Baume ∘ Paul Mercier ∘ Alain Zimmermann ∘ William Baume

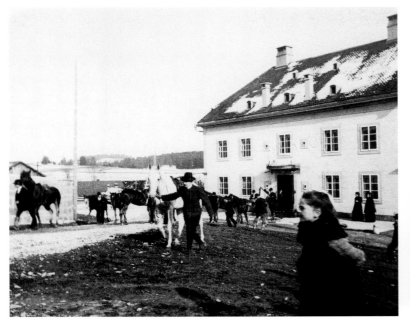

Pocket watch, 1940

Yellow gold key-winding watch with Poinçon de Genève *quality hallmark*
Uhr aus Gelbgold mit Schlüsselaufzug und Genfer Siegel
Montre en or jaune à remontage à clef, avec Poinçon de Genève, gage de qualité

stylistic experimentation, Zimmerman pursues a brand philosophy that embodies a healthy blend of clear, unadulterated design and the preservation of traditional values. Manufactory status is not presently planned for Baume & Mercier because this would propel its products far above their established price level. Commonly available and time-tested basic movements from Eta and Sellita ensure the quality and precision for which Baume & Mercier has been known worldwide since the 19th century. The undisputed bestseller is the "Classima" line, which was launched to celebrate the brand's 175th birthday in 2005. As its name states, "Classima" features gents and ladies watches that embody classicism in each of their details. For example, classicism is evident in the hands, which culminate in tips that extend all the way to their accompanying indices on the dial. The purest retro look is represented by "Hampton" and "Clifton": the rectangular shape of their cases aptly expresses the aristocratic lifestyle of high society on the American East Coast. Equally nostalgic but with an entirely different design, "Clifton" has a circular case and a combination of dial and hands that expressively conjures the currently trendy look of the 1950s. Distinguished by eye-catching horns, this watch line is offered by Baume & Mercier in many different variants ranging from a sleekly simple self-winding watch with a small second-hand, through models with full calendar and moon-phase displays, to a tourbillon wristwatch that recalls a prizewinning 19th-century pocket watch. (The tourbillon, which was patented in 1801, compensates for the ill effects that the Earth's gravity exerts on the accuracy of the rate of a mechanical watch in a vertical position.) The 30 specimens of the gold "Clifton" that debuted in 2013 with exclusive hand-wound Caliber P591 from ValFleurier are sold out, as are the same number of "Clifton" pocket watches, which premiered in 2015. The repeater movement inside the latter chimes precious time, which

it can audibly announce at five-minute intervals, if desired. Alain Zimmermann consoles aficionados who couldn't get their hands on the objects of their desire: "Other complicated timepieces, which similarly prove Baume & Mercier's time-honored horological competence, are already in the planning stages." Members of the fairer sex will surely appreciate the new "Promesse" or might opt instead for the "Linea," which debuted in 1987 and features a clever quick-change system for its wristbands. Without the need for a tool, a simple manipulation enables the sophisticated ladies who wear this watch to give it an impossible-to-overlook appearance. Last but not least, "Capeland" is a line of sportily elegant watches that pay homage to the popularity of the chronograph in various versions. Strictly limited and thus avidly coveted, these models were developed in a partnership, cultivated since 2015, with the American sportcar legend Shelby Cobra. Each model embodies the genetic code and indomitable spirit of a fascinating automotive mythos. This exciting theme, which is closely linked with the ingenious Carroll Shelby, obviously offers ample potential for Baume & Mercier. Despite the tremendous success of the limited-edition "Capeland Shelby® Cobra" collection, or perhaps because of its warm reception, Alain Zimmermann takes pains to avoid acting rashly. New models will be created judiciously and marketed only in limited quantities. With this in mind, we can look forward to wonderful surprises from Baume & Mercier in coming decades. ○

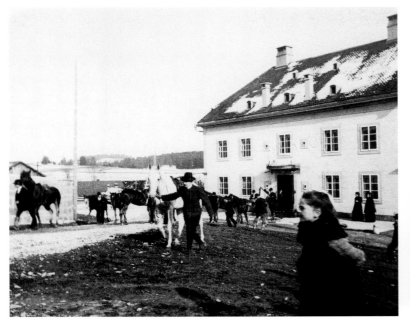 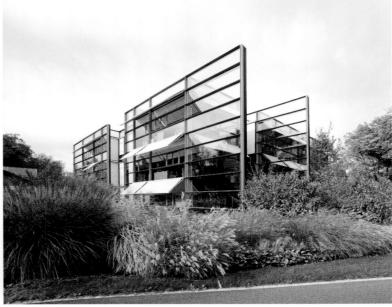

From left: Les Bois house, 1860 ○ Baume & Mercier headquarters in Bellevue, 2016 ○ Von links: Haus in Les Bois, 1860 ○ Hauptsitz von Baume & Mercier in Bellevue, 2016 ○ De gauche à droite : Le bâtiment aux Bois, 1860 ○ Le siège de Baume & Mercier à Bellevue, 2016

Pocket watch, 1892

Mechanical hand-wound movement, one-minute tourbillon, detent escapement chronometer, small seconds, 18-carat yellow gold case ○ Mechanisches Handaufzugswerk, Ein-Minuten-Tourbillon, Chronometerhemmung, kleine Sekunde, Gehäuse aus 18-karätigem Gelbgold ○ Mouvement à remontage manuel. Tourbillon minute, chronomètre à échappement à détente, petites secondes. Boîtier or jaune 18 carats

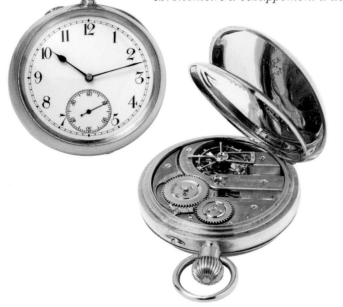

Rectangular wristwatch, 1940

Inspiration for the Hampton collection
Inspiration für die Kollektion Hampton
La source d'inspiration pour la collection Hampton

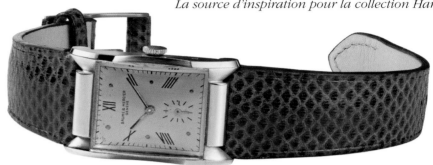

Rectangular wristwatch, 1920

Yellow gold case, manually wound movement
Gehäuse aus Gelbgold, Handaufzugswerk
Boîtier or jaune, mouvement à remontage manuel

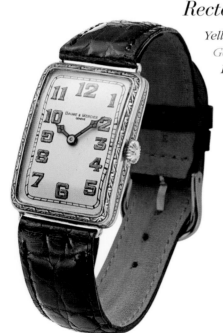

Wristwatch, 1920

Diamond-studded platinum case, manually wound movement
Diamantenbesetztes Platingehäuse, Handaufzugswerk
Boîtier platine serti de diamants, mouvement à remontage manuel

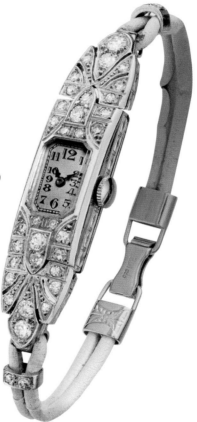

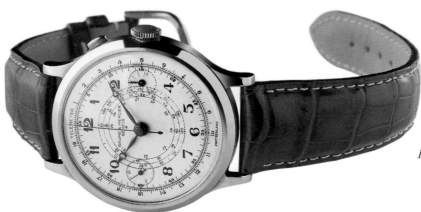

Chronograph, 1948

Inspiration for the Capeland collection
Inspiration für die Kollektion Capeland
La source d'inspiration pour la collection Capeland

Round wristwatch, 1965

Inspiration for the Classima collection
Inspiration für die Kollektion Classima
La source d'inspiration pour la collection Classima

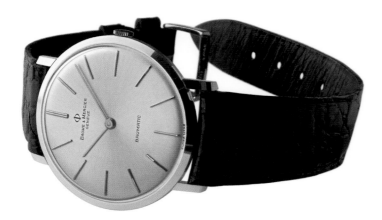

Tronosonic, 1971

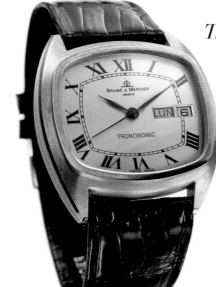

With day and date apertures,
yellow gold case, electronic
tuning-fork movement
Mit Tages- und Datumsanzeige,
Gehäuse aus Gelbgold, elektroni-
sches Stimmgabeluhrwerk
À deux guichets dateurs,
boîtier or jaune, mouvement
électronique à diapason

Galaxie, 1972

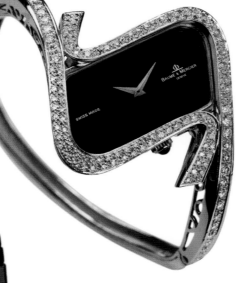
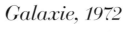

Diamond-studded white gold case and bracelet,
cabochon-cut sapphire
Diamantenbesetztes Gehäuse und Armband aus Weißgold,
Saphir im Cabochonschliff
Boîtier et bracelet or blanc sertis de diamants,
saphir taille cabochon

Catwalk, 1999

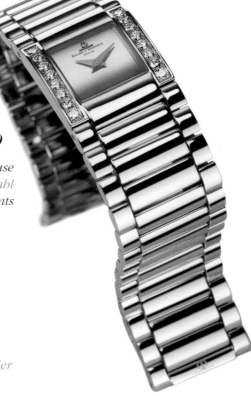

Diamond-studded steel case
Diamantenbesetzter Stahl
Acier serti de diamants

Riviera, 1987

Yellow gold case, chronograph, complete calendar function
Gehäuse aus Gelbgold, Chronograph mit komplettem Kalender
Boîtier or jaune, chronographe à calendrier complet

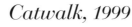

Feine Uhren
seit 1830

Das Überlieferte pflegen und sich trotzdem in schöner Regelmäßigkeit erneuern: Dieses Credo zieht sich wie ein roter Faden durch die Biographie der 1830 in Les Bois, einer kleinen Ortschaft im Schweizer Jura, gegründeten Uhrenmarke Baume & Mercier. Die eher bescheidenen Anfänge verknüpfen sich mit Joseph-Célestin und Louis-Victor Baume. Schon bald nachdem es die Société Baume Frères ins Leben gerufen hatte, erkannte das Brüderpaar die Bedeutung internationaler Märkte. 1844 wurde mit Baume Bros. eine Londoner Niederlassung etabliert. Danach begeisterten Uhren mit den Signaturen „Waterloo", „Diviko" und „Sirdar" Menschen in Australien und Neuseeland. Innovation sowie das unbedingte Streben nach Qualität und Präzision trugen dem Duo nicht weniger als sechs Medaillen bei Weltausstellungen ein. Einen bemerkenswerten Höhepunkt in der Firmengeschichte brachte 1892. In diesem Jahr erzielte ein hochfeines Tourbillon, welches der berühmte Albert Pellaton-Favre für die Gebrüder Baume gefertigt und reguliert hatte, bei den Chronometerprüfungen am britischen Observatorium in Kew bei London nach 44 Tagen die 91,9 von 100 theoretisch möglichen Punkten. Die Bedeutung dieses sensationellen Werts ergibt sich aus der Tatsache, dass bereits 80 von 100 Punkten die Zuerkennung des international anerkannten „Class A Certificate" mit dem Vermerk „besonders gut" nach sich zogen. Kein Wunder also, dass dieses Taschen-Tourbillon mit der Nummer 103018 zehn Jahre lang unübertroffen blieb. Den zweiten Teil des renommierten Markennamens brachte das Jahr 1912 in Person von Paul Mercier. William Baume, ein Nachfahre der Firmengründer, hatte sich einmal mehr mit neuen Produkten auf Reisen begeben. Den ambitionierten Uhrmacher und Juwelier lernte er im Genfer Uhren- und Juweliergeschäft Haas kennen. Durch umsichtige Geschäftsführung und außergewöhnliche handwerkliche Fertigkeiten hatte sich der geborene Tcherednitchenko in der Branche einen vorzüglichen Ruf erworben. Zug um Zug gelangten beide Seiten zur Erkenntnis, dass man die großen Herausforderungen der Zukunft gemeinsam besser bewältigen könne. Am 26. November 1918 fanden gegenseitige Sympathie und Wertschätzung ihren Niederschlag in der Unterzeichnung des Vertrags zur Gründung von Baume & Mercier mit Firmensitz in Genf. Nach überaus erfolgreichem Wirken zogen sich im Jahr 1937 zuerst William Baume und dann auch Paul Mercier aus dem operativen Geschäft zurück. In ihre großen Fußstapfen trat der Juwelier Constantin de Gorski. Großer Nachholbedarf und die enorme Beliebtheit schmückender und präziser Armbanduhren bescherten der Branche nach dem Zweiten Weltkrieg einen bedeutenden Aufschwung. Baume & Mercier punktete vor allem durch klassische Herrenuhren, sportliche Chronographen und wertvolle Damenuhren. 1965 gelangte die Familie Piaget durch den Erwerb der Aktienmehrheit ins Haus.

Clifton 1830 Pocket Watch
Five-Minute Repeater, 2015

Ab 1988 hatte die Cartier Monde SA das Sagen, weil Christian und Yves Piaget 60 Prozent der Piaget Holding SA und der Baume & Mercier SA an den französischen Luxusmulti veräußerten. Das vorläufig letzte Kapitel in der Firmengeschichte begann 1993, als Piaget und Baume & Mercier komplett ins Eigentum der Vendôme-Gruppe übergingen, welche Uhrenliebhaber heute als Richemont SA kennen.

Den gegenwärtigen Kurs steuert Alain Zimmermann, welcher das chronometrische Metier während vieler Jahre bei der Schaffhauser IWC in all seinen Facetten kennen und lieben gelernt hat. Eisernes Festhalten an der Tradition ist ihm ebenso fremd wie ungestümes gestalterisches Experimentieren. Vielmehr zielt die Marken-Philosophie auf einen gesunden Mix aus klarem, unverfälschtem Design unter Beibehaltung tradierter Werte. Eine eigene Manufaktur ist derzeit kein Thema, denn dadurch würde Baume & Mercier das angestammte Preissegment verlassen. Andererseits gewährleisten speziell die gleichermaßen gängigen wie bewährten Basis-Uhrwerke von Eta und Sellita jene Qualität und Präzision, für die das in der ganzen Welt vertretene Unternehmen seit dem 19. Jahrhundert bekannt ist. Als unangefochtener Bestseller gilt die 2005 anlässlich des 175. Geburtstags lancierte „Classima"-Linie. Damen und Herren bietet sie, wie der Name unschwer erkennen lässt, klassische, bis ins letzte Detail durchdachte Optik. Sie zeigt sich zum Beispiel bei den Zeigern, deren Spitze, wie es sich gehört, bis an die zugehörige Zifferblatt-Indexierung reicht. Retrolook in Reinkultur repräsentieren „Hampton" und „Clifton". Durch ihre rechteckige Form bringt erstere den distinguierten Lebensstil der gehobenen amerikanischen Ostküsten-Gesellschaft in vorzüglicher Weise zum Ausdruck. Das nicht minder nostalgisch wirkende, gestalterisch jedoch völlig andersartige Pendant heißt „Clifton". Im Rund des Gehäuses und in der Zifferblatt-Zeiger-Kombination leben die angesagten 1950er Jahre ausdrucksstark fort. Diese Uhrenlinie mit markanten Bandanstößen offeriert Baume & Mercier in ganz unterschiedlichen Ausführungen, angefangen bei der schlichten Automatik mit kleinem Sekundenzeiger über Modelle mit Vollkalendarium und Mondphasenanzeige bis hin zu einem Tourbillon, welches an die preisgekrönte Taschenuhr aus dem 19. Jahrhundert erinnert. Wirkungsvoll kompensiert der 1801 patentierte Drehgang die unliebsamen Auswirkungen der Erdanziehungskraft auf die Ganggenauigkeit mechanischer Uhren in senkrechter Position. Die nur 30 Exemplare der 2013 vorgestellten Gold-„Clifton" mit dem exklusiven Handaufzugskaliber P591 von ValFleurier sind ebenso ausverkauft wie genauso viele „Clifton"-Taschenuhren von 2015. Deren Repetitionsschlagwerk verkündet die kostbare Zeit, wenn gewünscht, alle fünf Minuten. Für zu kurz Gekommene hat Alain Zimmermann einen Trost parat: „Weitere komplizierte

Zeitmesser, welche die jahrzehntelange uhrmacherische Kompetenz von Baume & Mercier unter Beweis stellen, sind bereits in Planung." Das zarte Geschlecht kommt bei der neuen „Promesse" zu seinem Recht. Oder bei der bereits 1987 aus der Taufe gehobenen „Linea" mit ausgeklügeltem Bandwechsel-System. Mit wenigen Handgriffen und ohne jegliches Werkzeug kann Frau von Welt ihrer Armbanduhr einen unübersehbar anderen Auftritt verleihen. Bleibt schließlich „Capeland", eine sportlich-elegante Uhrenlinie, die dem beliebten Chronographen in unterschiedlichsten Ausführungen huldigt. Streng limitiert und deshalb besonders begehrt sind jene Modelle, welche aus der seit 2015 gepflegten Partnerschaft mit der amerikanischen Sportwagen-Legende Shelby Cobra erwachsen. In allen Modellen finden sich der genetische Code und der Spirit eines faszinierenden automobilen Mythos. Dieses bewegende Thema, welches sich mit dem nachgerade genialen Carroll Shelby verknüpft, birgt für Baume & Mercier jede Menge Potenzial. Trotz oder gerade wegen des riesigen Erfolgs der limitierten „Capeland Shelby® Cobra"-Kollektion möchte Alain Zimmermann aber nichts überstürzen. Neuigkeiten werden mit Bedacht kreiert und stets nur in begrenzten Quantitäten auf den Markt gelangen. In jedem Fall ist Baume & Mercier auch in den kommenden Jahrzehnten für große Überraschungen gut. ○

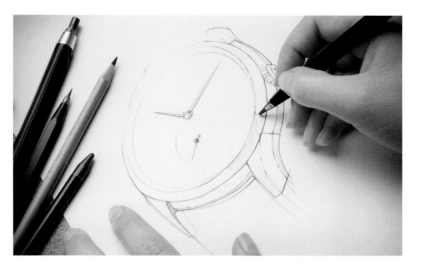

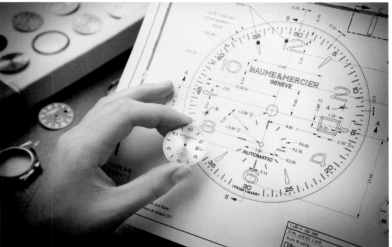

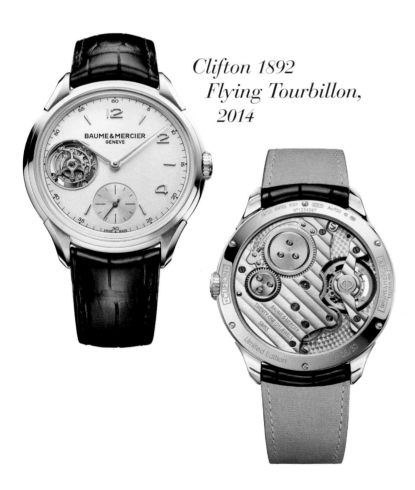

Clifton 1892
Flying Tourbillon,
2014

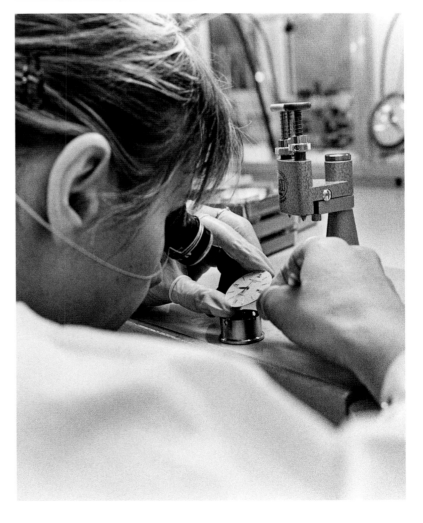

Top and middle: Design studio, Clifton watch ○ Bottom: Les Brenets watch workshops ○ Oben und Mitte: Designstudio, Modell Clifton ○ Unten: Uhrenatelier, Les Brenets ○ En haut et au milieu : Atelier de conception, la Clifton ○ En bas : Les ateliers horlogers aux Brenets

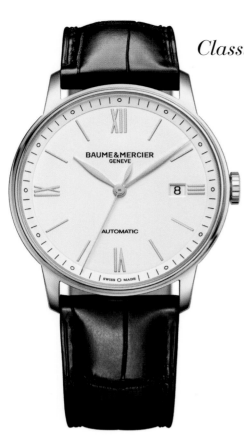

Classima Ref. 10271, 2016

Classima Ref. 10275, 2016

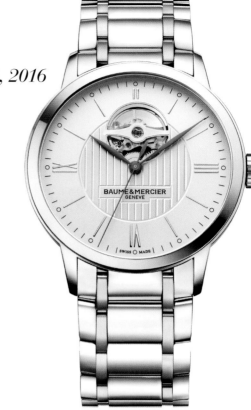

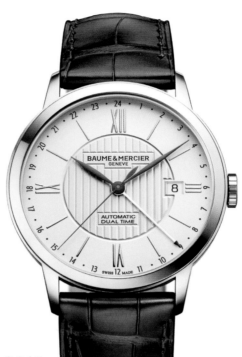

Classima Ref. 10272, 2016

Classima Ref. 10214 and 10225, 2015

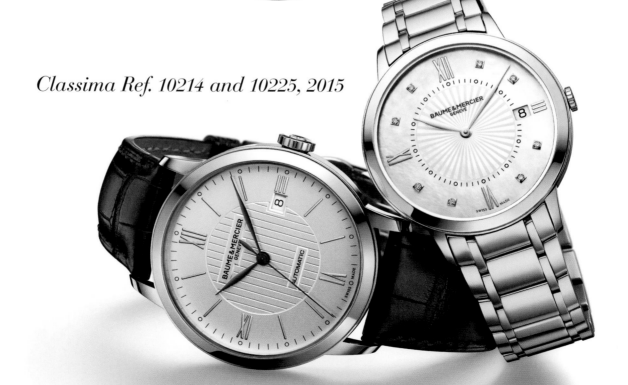

Clifton Ref. 10058, 2013

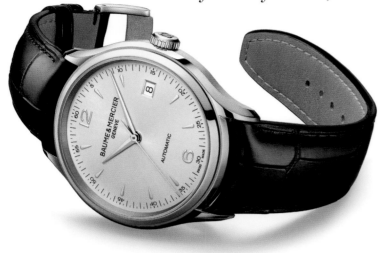

Clifton Ref. 10052, 2013

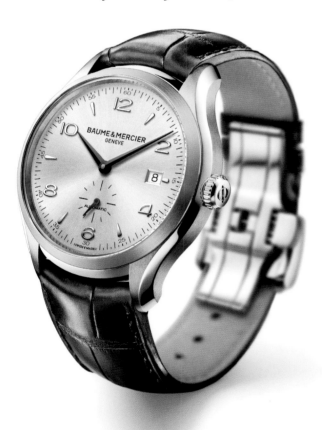

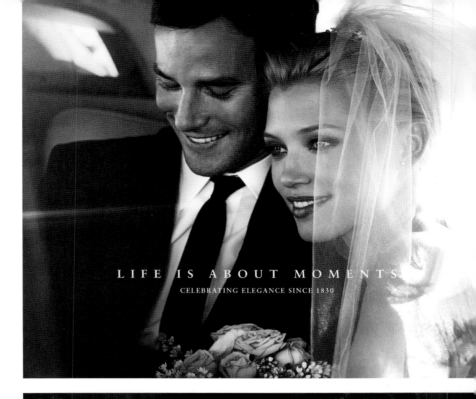

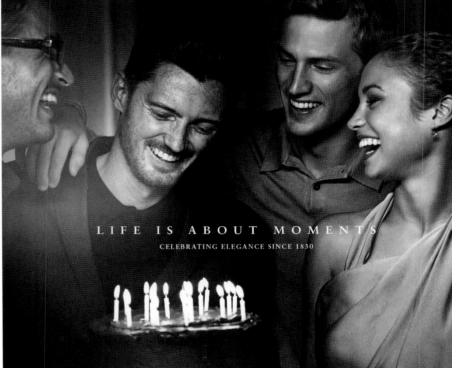

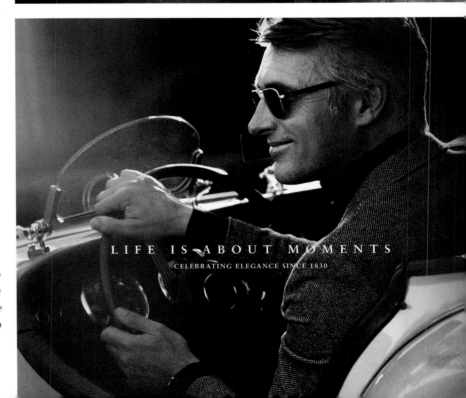

"Life is about moments" advertising campaign by Peter Lindbergh ○
Werbekampagne „Life is about moments", fotografiert von
Peter Lindbergh ○ « Life is about moments »– Campagne publicitaire
signée Peter Lindbergh

Des montres de haute précision depuis 1830

Rester fidèle à la tradition tout en se renouvelant avec une belle régularité, ce crédo fait figure de fil conducteur dans l'histoire de la marque horlogère Baume & Mercier, qui remonte à 1830. Tout commence modestement aux Bois, petite localité du Jura suisse, par la création du comptoir horloger Frères Baume par Joseph-Célestin et Louis-Victor Baume. Saisissant rapidement l'importance des marchés internationaux, ceux-ci ouvrent en 1844 une succursale londonienne, Baume Bros. Les modèles « Waterloo », « Diviko » et « Sirdar » partent alors à la conquête de l'Australie et de la Nouvelle-Zélande. L'innovation et la quête sans concession de la qualité et de la précision rapportent aux deux frères pas moins de six médailles dans le cadre d'expositions universelles. 1892 est un temps particulièrement fort dans l'histoire de l'entreprise : un tourbillon de haute précision, réalisé et réglé par le célèbre Albert Pellaton-Favre pour les frères Baume, obtient 91,9 points d'un maximum théorique de 100 points à l'issue de 44 jours de tests chronométriques effectués à l'observatoire de Kew, près de Londres. Ce score est sensationnel dans la mesure où 80 points correspondent déjà à une distinction reconnue dans le monde entier, le « certificat de classe A » assorti de la mention « très bien ». Rien d'étonnant donc à ce que ce tourbillon de poche numéro 103018 soit resté inégalé pendant dix ans. La seconde partie du nom de cette marque renommée est apportée en 1912 par Paul Mercier. Au cours de son énième voyage d'affaires pour présenter de nouveaux produits, William Baume, descendant des fondateurs, fait la connaissance de cet ambitieux horloger-joaillier dans l'horlogerie-joaillerie genevoise Haas. Gestionnaire avisé et artisan hors pair, Tcherednitchenko, dit Paul Mercier, s'est vite fait une excellente réputation dans la branche. De fil en aiguille, les deux hommes parviennent à la conclusion qu'ensemble il leur serait plus facile de relever les grands défis de l'avenir. Le 26 novembre 1918, ces sympathie et estime mutuelles se traduisent par la signature du contrat de fondation de Baume & Mercier, entreprise sise à Genève. Les artisans de son succès, William Baume et Paul Mercier, se retirent des affaires en 1937. Le joailler Constantin de Gorski prend leur difficile relève. Après la Seconde Guerre mondiale, la fin des privations et l'engouement pour les montres-bracelets à la fois esthétiques et précises sont à l'origine d'une reprise significative dans le secteur. Baume & Mercier doit son succès avant tout aux montres pour hommes, aux chronographes de sport et aux montres-bijoux pour femmes. Par une prise de participation majoritaire, la famille Piaget met un pied dans la maison en 1965. À partir de 1988, Cartier Monde SA préside aux destinées de l'entreprise, Christian et Yves Piaget ayant cédé à la multinationale du luxe française 60 pour cent de leurs actions dans Piaget Holding SA et Baume & Mercier. Le dernier chapitre en date dans l'histoire de la manufacture débute en 1993, quand Piaget et Baume & Mercier sont absorbées par le groupe Vendôme, que les passionnés de montres connaissent de nos jours sous le nom de Richemont SA.

Les rênes de la maison sont tenues à l'heure actuelle par Alain Zimmermann qui, au cours de ses nombreuses années d'activité chez IWC, à Schaffhouse, a appréhendé la mesure chronométrique sous toutes ses facettes et appris à l'aimer. N'étant pas homme à perpétuer la tradition coûte que coûte, ni à se lancer tête baissée dans le design d'avant-garde, il veille à un juste équilibre entre un design épuré et authentique, d'une part, et le respect des valeurs traditionnelles, d'autre part. Une manufacture maison, qui signifierait un changement de gamme de prix pour Baume & Mercier, n'est pas à l'ordre du jour. De plus, la qualité et la précision qui font la réputation de cette entreprise représentée dans le monde entier tiennent justement à des calibres à la fois courants et éprouvés sortis des ateliers d'Eta et de Sellita. Lancée en 2005 à l'occasion du 175e anniversaire de la maison, la ligne « Classima » est un best-seller incontesté. Comme son nom l'indique, elle propose aux hommes et aux femmes un design classique, étudié jusque dans le moindre détail. Les aiguilles, par exemple, effleurent comme il sied, l'index correspondant sur le cadran. Les amateurs trouvent la quintessence du style rétro dans les lignes « Hampton » et « Clifton ». Par sa forme rectangulaire, la première est la parfaite expression du style de vie distingué des Américains de la côte Est. Entouré d'une aura non moins nostalgique, son pendant « Clifton » a un design totalement différent : le boîtier rond et le couple cadran-aiguilles perpétuent de manière expressive le style années 1950, qui connaît un regain. Baume & Mercier décline cette ligne dotée de cornes protubérantes au niveau de l'extrémité du bracelet dans des variantes très diverses, du modèle à mouvement automatique et petite trotteuse jusqu'au tourbillon rappelant la montre de poche du XIXe siècle largement primée, en passant par des modèles à calendrier complet et phases de lune. Mécanisme breveté en 1801, le tourbillon compense efficacement les incidences négatives de la gravité sur la précision de marche des montres mécaniques dans la position verticale.

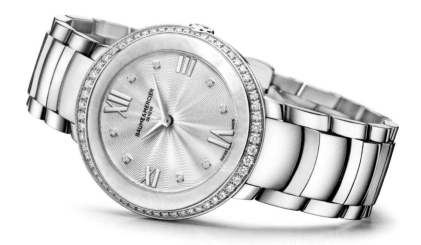

Promesse Ref. 10199, 2015

Produite à seulement 30 exemplaires, la « Clifton » or dotée de l'exceptionnel calibre à remontage manuel P591 de ValFleurier est épuisée, tout comme bien des montres de poche « Clifton » sorties en 2015, toutes dotées d'une sonnerie à répétition qui, si le propriétaire de la montre le souhaite, retentit toutes les cinq minutes. En guise de consolation pour tous ceux qui sont restés sur leur faim, Alain Zimmermann annonce : « Nous avons à l'étude d'autres garde-temps à complications témoignant du savoir-faire horloger qui est celui de Baume & Mercier depuis des décennies. » La gent féminine trouve son compte dans le nouveau modèle « Promesse » ou dans la collection « Linea », lancée en 1987, aux bracelets astucieusement interchangeables. En quelques manipulations et sans outillage spécifique, les femmes du monde changent l'aspect de leur montre-bracelet du tout au tout. Pour finir, la collection à la fois sportive et élégante « Capeland » rend hommage dans ses versions les plus diverses au chronographe très prisé. Les modèles issus du partenariat entretenu depuis 2015 avec le constructeur américain Shelby, auteur de la légendaire voiture de course Cobra, sont produits en édition limitée, ce qui en fait des produits très recherchés. Tous les modèles portent en eux l'ADN et l'âme d'un grand mythe automobile. Le thème du mouvement, lié à un homme vraiment génial du nom de Carroll Shelby, recèle des possibilités infinies pour Baume & Mercier. Malgré l'immense succès de la collection limitée « Capeland Shelby® Cobra » ou peut-être justement pour cette raison, Alain Zimmermann ne veut pas précipiter les choses. Les nouveautés sont créées avec circonspection et toujours produites en séries limitées. Quoi qu'il en soit, dans les décennies à venir, Baume & Mercier ne finira pas de nous surprendre. ○

Linea, 2016

A system lets the wearer easily remove one summery colored bracelet and insert another

System, bei dem die Trägerin das Armband im Handumdrehen selbständig wechseln kann, Sommerfarben

Système de bracelets interchangeables par la propriétaire au gré des saisons, coloris d'été

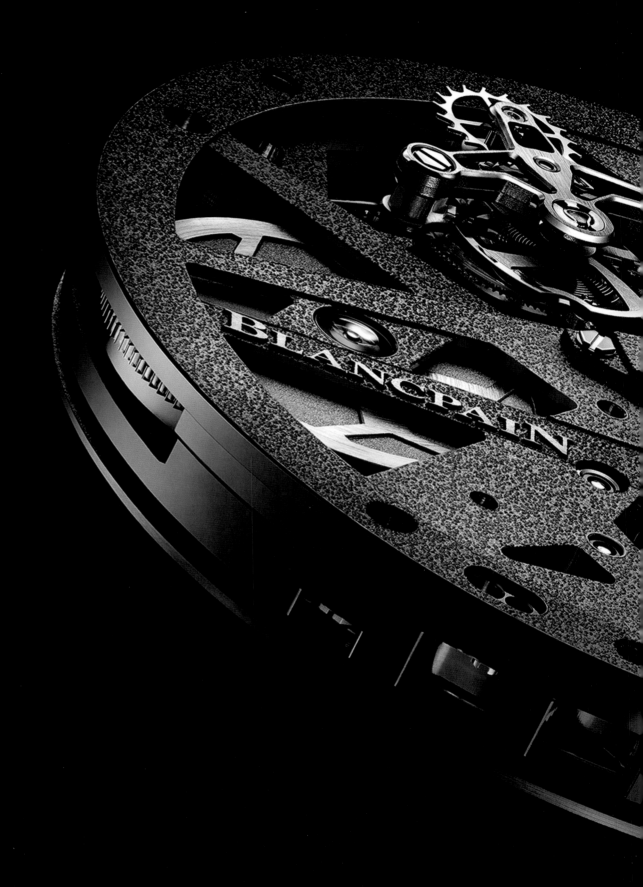

Blancpain

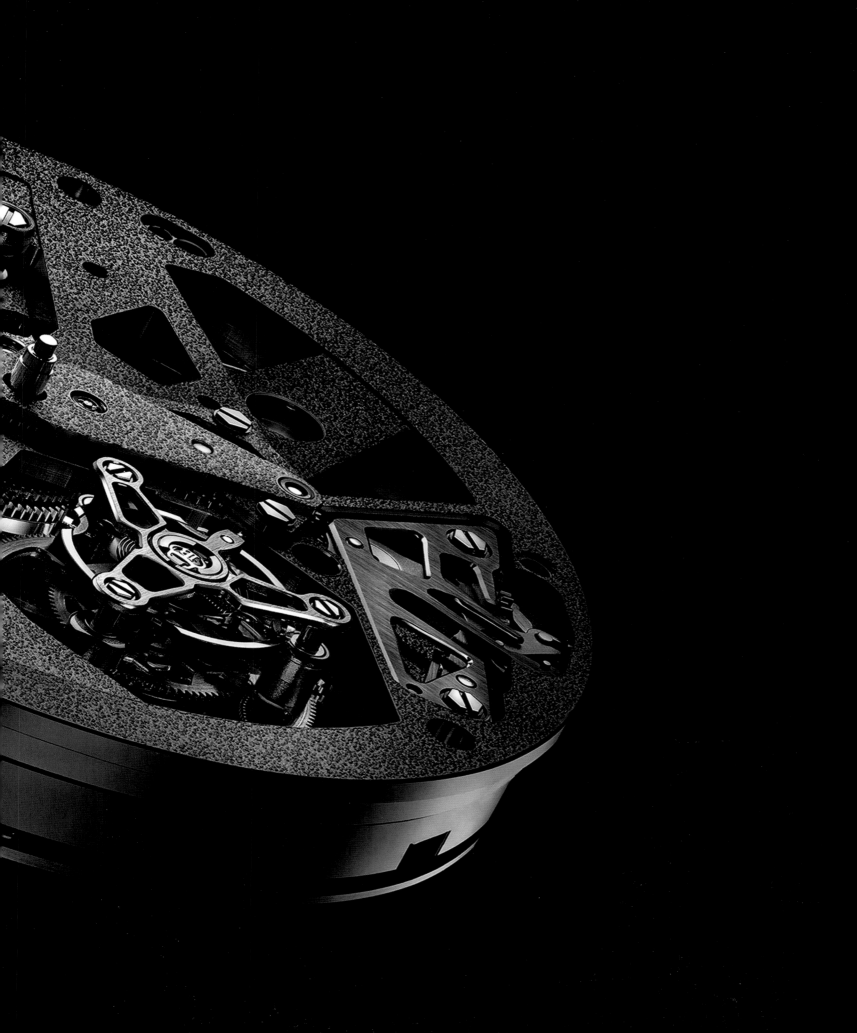

Mechanical Watchmaking Since 1735

English

Anyone who would like to explore Blancpain and its history must gaze far into the past. This watch brand's origins can be traced to 1735, when a certain Jehan-Jacques Blancpain lived and worked in Villeret, a little town in the Jura region of western Switzerland. Like many of his colleagues, this young watchmaker initially occupied himself with the fabrication of components. Many years would pass before complete pocket watches joined the product portfolio. The transformation from an artisanal operation to a small but partially mechanized watch factory named "Blancpain" occurred in 1815, but this brand's name was seldom heard among aficionados until the 20th century, e.g., with the fabrication in 1930 of the "Rolls," a rectangular wristwatch with unconventional self-winding inner workings. The aptly named "Fifty Fathoms" diver's watch set sail in 1953. Its special feature: a dive-time bezel that clicks authoritatively into place and is safeguarded against inadvertent repositioning. It's not surprising that Jacques-Yves Cousteau and his team consulted this wristwatch while filming the documentary *The Silent World*. The fabrication of tiny hand-wound movements was prioritized in the early 1950s. These include rectangular Caliber R 59, which has a total volume of less than 500 cubic millimeters. Circular Caliber R 550 is even smaller: a mere 425 cubic millimeters. It debuted with its crown positioned on its back under the name "Ladybird" in 1956. In 1983, when the renaissance of the mechanical wristwatch was gradually gaining momentum, Blancpain came under the aegis of Jean-Claude Biver and Jacques Piguet (the owner of the Frédéric Piguet ébauche manufactory) and began its modern era by unveiling a wristwatch with a moon-phase display. Two years later, Blancpain surprised aficionados with the debut of an extra-slim minute repeater wristwatch encasing a newly developed movement with a diameter of 20.3 millimeters and a low height of just 3.2 millimeters.

The world's smallest chronograph with date display, automatic winding and optionally also with split second-hand premiered in 1987. It was followed in 1990 by a tourbillon with an eight-day movement, a date display and a power-reserve indicator. This same year also brought the inarguable crowning touch to the fireworks of complications with the presentation of the "1735," which concatenates 740 components in its movement and was the world's most complicated wristwatch at the time of its debut. Another important year in this company's long history was 1992, when the Swatch Group took the traditional label under its capacious wings. "Léman," an alarm wristwatch that can also show the time in other time zones, was released in 2003. Blancpain shared automatic Caliber 1241 with Breguet, a fellow member of the Swatch Group, but couldn't yet claim the honor of being a full-fledged manufacture because Frédéric Piguet continued to supply the encased movements. This also applies to the "Carrousel Volant Une Minute," which debuted in 2008 with a "flying" (i.e., cantilevered) one-minute tourbillon. This mechanism embodies a remarkable evolutionary phase in a device invented in the late 19th century by the Danish watchmaker Bahne Bonniksen. Self-winding Caliber 225 combines 262 components and automatically winds itself. Under the aegis of Marc A. Hayek (the grandson of the great Nicolas G. Hayek), the movement manufacturer Frédéric Piguet merged with Blancpain to form a dyed-in-the-wool watch manufacture in 2010. In 2016, this manufactory presents a new model in the "Fifty Fathoms Bathyscaphe" family, which traces its ancestry to the 1950s. For the first time in Blancpain's history, gray plasma ceramic is used as the material for the watch's case and rotatable bezel. The indices are made of liquid metal, a deformation-resistant alloy. Self-winding Caliber 1315 with silicon hairspring and a five-day power reserve ticks inside the lightweight and scratchproof case, which is watertight to 30 bar. ○

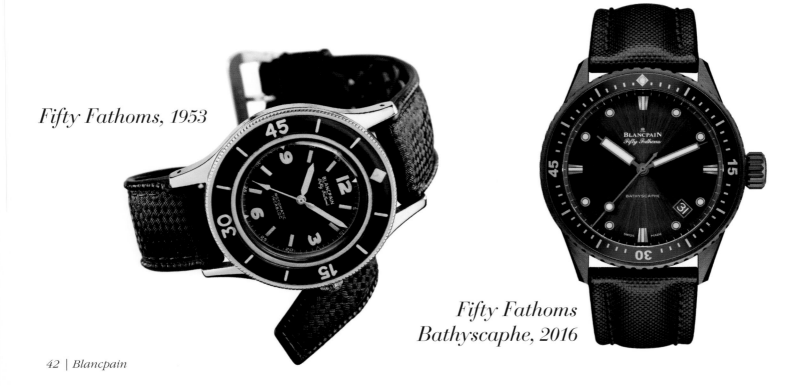

Fifty Fathoms, 1953

Fifty Fathoms Bathyscaphe, 2016

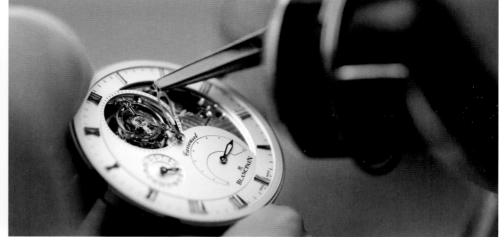

Opposite page: Cal. R 550 Ladybird ∘ This page, from left: The manufactory in Le Brassus ∘ Manually inserting a hand ∘ Diese Seite, von links: Manufaktur, Le Brassus ∘ Manuelle Montage eines Zeigers ∘ De gauche à droite : La manufacture du Brassus ∘ Montage manuel d'une aiguille

Mechanische Uhrmacherei seit 1735

Wer sich mit Blancpain und der Geschichte dieser Uhrenmarke beschäftigen möchte, muss sehr weit zurückblicken. Die Ursprünge liegen nämlich im Jahr 1735. Damals wohnte und arbeitete Jehan-Jacques Blancpain in Villeret, einer kleinen Ortschaft im Westschweizer Jura. Zunächst beschäftigte sich der junge Uhrmacher wie viele seiner Kollegen auch mit der Herstellung von Komponenten. Komplette Taschenuhren ließen noch auf sich warten. Die Umwandlung des Handwerksbetriebs in eine kleine, auf mechanisierter Basis arbeitende Uhrenfabrik namens Blancpain erfolgte 1815. Von sich reden machte Blancpain freilich erst im 20. Jahrhundert. Zum Beispiel 1930 durch die Herstellung der „Rolls", einer rechteckigen Armbanduhr mit ungewöhnlichem Selbstaufzugs-Innenleben. Die Vorstellung der Taucher-Armbanduhr namens „Fifty Fathoms" erfolgte 1953. Ihre Besonderheit: eine rastende, gegen unbeabsichtigtes Verstellen gesicherte Tauchzeit-Lünette. Kein Wunder, dass Jacques-Yves Cousteau und seine Mannschaft bei den Dreharbeiten zum Dokumentarfilm *Die schweigende Welt* auf diesen Zeitmesser blickten. Die frühen 1950er Jahre standen im Zeichen der Konstruktion winziger Handaufzugswerke. Ein Volumen von weniger als 500 Kubikmillimetern wies das rechteckige Kaliber R 59 auf. Das runde R 550 brachte es auf lediglich 425 Kubikmillimeter. Letzteres mit rückwärtig positionierter Krone debütierte 1956 unter dem Namen „Ladybird". 1983, als die Renaissance der mechanischen Armbanduhr zaghaft einsetzte, trat Blancpain unter der Ägide von Jean-Claude Biver und Jacques Piguet, Inhaber der Rohwerkemanufaktur Frédéric Piguet, mit einer Mondphasen-Armbanduhr in die Neuzeit seiner Existenz. Zwei Jahre später überraschte Blancpain mit einer extraflachen Armbanduhr mit Minutenrepetition, deren neuentwickeltes Werk bei 20,3 Millimetern Durchmesser lediglich 3,2 Millimeter hoch baute. Der seinerzeit weltweit kleinste Chronograph mit Datumsanzeige, automatischem Aufzug und – auf Wunsch – auch Schleppzeiger-Mechanismus erschien 1987 auf der Bildfläche. 1990 folgte ein Tourbillon mit Acht-Tage-Werk, Datums- und Gangreserveindikation. Als unangefochtene Krönung des Komplikationen-Feuerwerks kann die im gleichen Jahr vorgestellte „1735" gelten, welche, zusammengefügt aus 740 Werkskomponenten, damals als weltweit komplizierteste Armbanduhr gelten durfte. Ein ebenfalls wichtiges Jahr in der langen Firmengeschichte war 1992. Hier brachte die Swatch Group das Traditionsunternehmen unter sein Dach. 2003 erschien „Léman", ein Armbandwecker mit Zeitzonen-Dispositiv. Das Automatikkaliber 1241 teilte sich Blancpain mit der Schwester Breguet. Von einer Manufaktur konnte man indessen noch nicht sprechen, denn die verbauten Uhrwerke stammten weiterhin von Frédéric Piguet. Diese Feststellung gilt auch für das 2008 vorgestellte „Carrousel Volant Une Minute" mit fliegendem Minutenkarussell, dessen Mechanik eine bemerkenswerte Evolutionsstufe der Erfindung des dänischen Uhrmachers Bahne Bonniksen aus dem späten 19. Jahrhundert verkörpert. Das Kaliber 225 mit Selbstaufzug und 100 Stunden Gangautonomie besteht aus 262 Komponenten. Unter der Leitung von Marc A. Hayek, dem Enkel des großen Nicolas G. Hayek, erfolgte 2010 die Verschmelzung des Werkefabrikanten Frédéric Piguet mit Blancpain zu einer waschechten Uhrenmanufaktur. 2016 wartet das Unternehmen mit einem neuen Modell der Taucheruhrenlinie „Fifty Fathoms Bathyscaphe" auf, die auf die 1950er Jahre zurückgeht. Erstmals in ihrer Geschichte besteht das Gehäuse aus grauer Plasmakeramik. Ihre Drehlünette ist aus dem gleichen Material gefertigt. Für die Indexe findet Liquidmetal, eine verformungsstabile Legierung, Verwendung. Die leichte, kratzfeste Schale des bis 30 Bar wasserdichten Modells schützt das Automatikkaliber 1315 mit Silizium-Unruhspirale und fünf Tagen Gangautonomie. ∘

Rolls, 1930

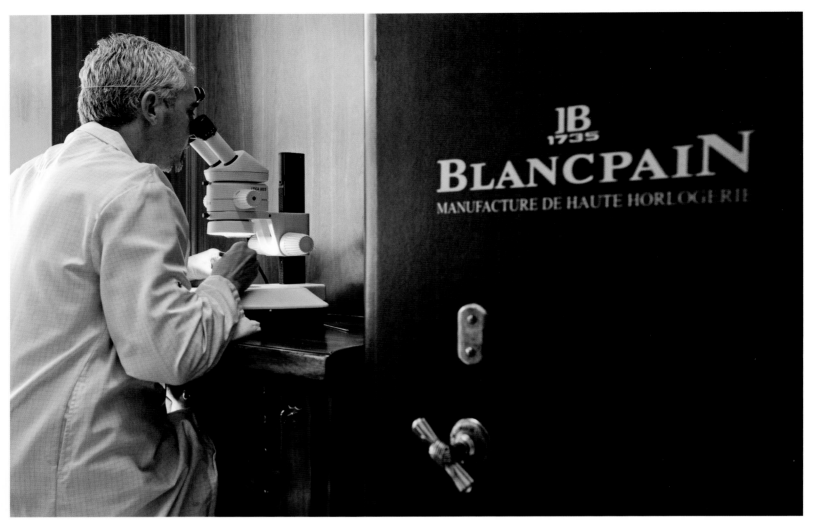

Haute horlogerie atelier in Le Brassus ○ Haute-Horlogerie-Atelier in Le Brassus ○ Atelier de haute horlogerie au Brassus

Horlogerie mécanique depuis 1735

Les origines de la marque horlogère Blancpain remontent à une époque très lointaine, à savoir à l'année 1735. Jehan-Jacques Blancpain vit et travaille alors à Villeret, petit village du Jura suisse. Comme nombre de ses confrères, le jeune horloger fabrique également des composants. Les montres de poche complètes ne viendront que bien plus tard. C'est en 1815 que la petite entreprise artisanale devient une fabrique horlogère mécanisée répondant au nom de Blancpain. Il lui faudra cependant attendre le XXᵉ siècle pour se faire connaître, notamment en 1930 par le biais de son modèle « Rolls », une montre-bracelet rectangulaire équipée d'un mouvement à remontage automatique inédit. Lancée en 1953, la montre-bracelet de plongée « Fifty Fathoms » se distingue par sa lunette unidirectionnelle crantée, qui la préserve de tout dérèglement intempestif. Rien d'étonnant à ce que Jacques-Yves Cousteau et son équipe aient confié à ce garde-temps le décompte de leur temps d'immersion pendant le tournage du documentaire *Le Monde du silence*. Le début des années 1950 est placé sous le signe des mouvements à remontage manuel miniatures : le calibre carré R 59 tient dans un volume inférieur à 500 millimètres cubes, son homologue rond R 550 dans seulement 425 millimètres cubes. Ce dernier fait ses débuts en 1956 dans le modèle « Ladybird », à couronne déportée

sur le fond du boîtier. En 1983, tandis que la renaissance de la montre mécanique en est encore à ses balbutiements, Blancpain entame un nouveau chapitre de son histoire avec une montre-bracelet à phases de lune, sous l'égide de Jean-Claude Biver et de Jacques Piguet, propriétaire de la manufacture d'ébauches Frédéric Piguet. Deux ans plus tard, Blancpain crée la surprise avec une montre-bracelet ultraplate à répétition minutes, pourvue d'un tout nouveau mouvement d'une hauteur réduite à 3,2 millimètres pour un diamètre de 20,3 millimètres. Ce qui est à l'époque le plus petit chronographe au monde avec date, remontage automatique et rattrapante (en option) voit le jour en 1987. Il est suivi en 1990 par un tourbillon à indication de la date et de la réserve de marche, et qui offre 8 jours d'autonomie. Le bouquet final incontesté de ce feu d'artifice de complications est sans doute la « 1735 » présentée la même année : assemblée à partir de 740 composants, elle est considérée à l'époque comme la montre-bracelet la plus compliquée au monde. 1992 représente une autre année clé dans la longue histoire cette entreprise de tradition, qui passe dans le giron du Swatch Group. 2003 voit la sortie d'une montre-bracelet réveil dotée d'une fonction GMT, la « Léman ». Blancpain partage le calibre automatique 1241 avec son entreprise sœur Breguet.

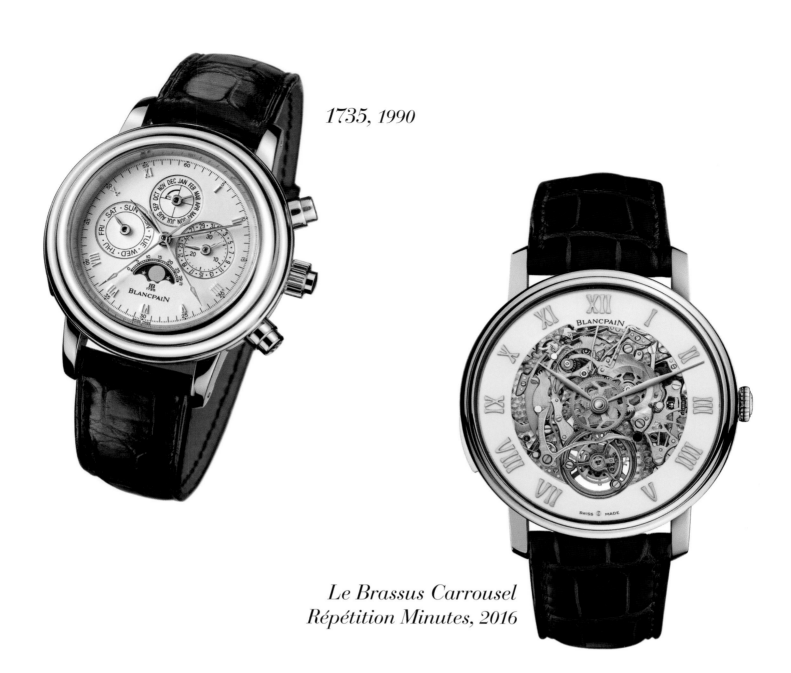

1735, 1990

*Le Brassus Carrousel
Répétition Minutes, 2016*

La société ne peut cependant toujours pas prétendre au titre de manufacture car elle continue d'équiper ses garde-temps de mouvements Frédéric Piguet. Ce sera encore le cas en 2008 du « Carrousel Volant Une Minute » qui, effectuant une rotation complète en une minute, incarne un perfectionnement remarquable de l'invention de l'horloger danois Bahne Bonniksen à la fin du XIXe siècle. Son calibre 225 à remontage automatique affichant 100 heures de réserve de marche est constitué de 262 composants. Sous la direction de Marc A. Hayek, petit-fils du célèbre Nicolas G. Hayek, Blancpain fusionne en 2010 avec le fabricant de mouvements Frédéric Piguet et devient une manufacture horlogère à part entière. En 2016, l'entreprise sort une nouvelle montre de plongée, la « Fifty Fathoms Bathyscaphe ». Pour la première fois dans l'histoire cette collection qui remonte aux années 1950, la boîte et la lunette sont toutes deux en céramique plasma grise. Les index sont en Liquidmetal, un alliage à l'épreuve des déformations. Une boîte légère, résistante aux éraflures et étanche jusqu'à une pression de 30 bars protège le calibre automatique 1315 équipé d'un spiral en silicium et offrant cinq jours d'autonomie. ◦

Cal. 1735

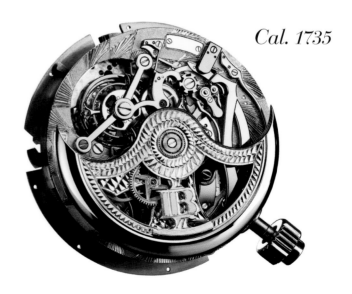

Carl F. Bucherer

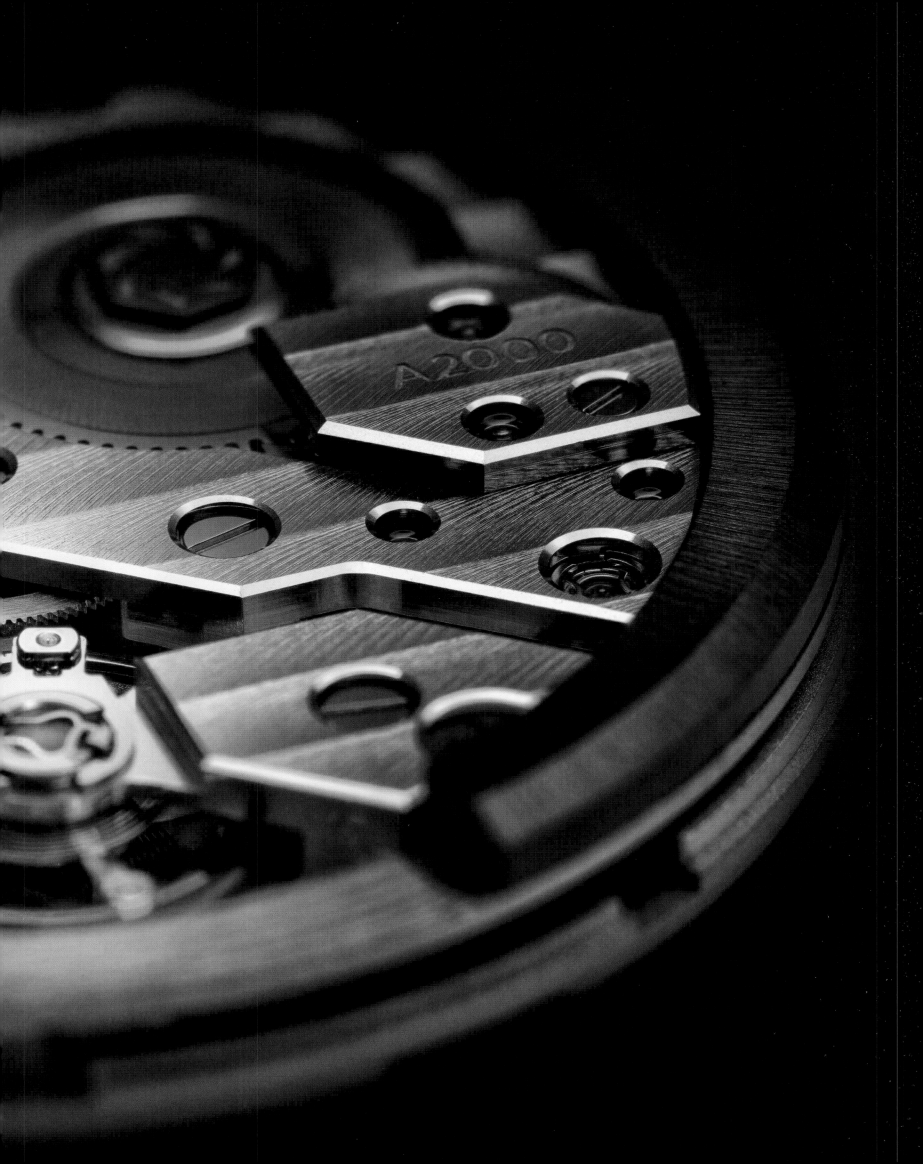

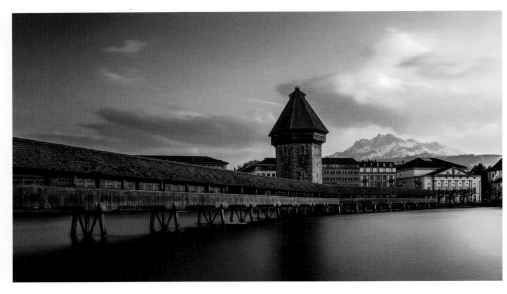

From left: Chapel Bridge, Lucerne ◦ Carl Friedrich Bucherer ◦ Von links: Kapellbrücke, Luzern ◦ Carl Friedrich Bucherer ◦ De gauche à droite : Pont de la Chapelle, Lucerne ◦ Carl Friedrich Bucherer

From Watch Dealer to Watch Manufactory

Carl Friedrich Bucherer opened his first specialized store at Falkenplatz in Lucerne in 1888. He interpreted his clientele's sometimes unusual wishes as commands which it was his privilege to carry out. His reputation soon spread beyond the canton's frontiers. He opened additional stores, which contributed their fair shares to the flourishing of his business ventures. Carl F. Bucherer began offering watches bearing his signature in 1919. His standards were quite high, so he wasn't content to sell private-label goods that had been anonymously manufactured for him. This prompted the savvy businessman to open his own manufacturing facility in the little town of Cortébert in the Jura region in 1919. The workshop wasn't a full-fledged manufacture, but a so-called *établissage*, where purchased components were assembled into ticking products, some of which were delivered together with official chronometer certificates. After an intermezzo with affordably priced watches that simply bore Bucherer's signature on their dials, the traditional label returned in 2001. With this step, the firm's current owner Jörg Bucherer pays due respect to his successful grandfather. Carl F. Bucherer's customers can now choose among watches in five different lines: "Adamavi," "Alacria" (for ladies), "Manero," "Pathos" (for ladies), and "Patravi." Additional functions make the watches in the last-mentioned line into the collection's leading models. The

beginning is marked by a steel automatic chronograph with outsize date display below the "12." Bucherer offered a similar self-winding model encasing the Venus 210 column-wheel caliber in the 1940s. People with wanderlust could opt for the "Patravi" chronograph in 2004. This "time-writer" has an additional 24-hour hand that can be reset in hourly increments via the crown. Time-zone watches weren't entirely new for Carl F. Bucherer: a "Worldtimer" with universal time indication and encasing a hand-wound Derby 7510 caliber as its basic movement joined the collection in 1960. Carl F. Bucherer presented the exclusively developed "Patravi TravelTec GMT" at Baselworld in 2005. Alongside its chronograph, this wristwatch with automatic Caliber CFB 1901 also includes a cleverly designed function to simultaneously show the time in several different time zones. The central 12-hour counter can be reset either forward or backward via the crown. The date in a window in the dial automatically changes to stay in synchrony with the time in a new time zone. An additional 24-hour hand continues to show the reference time or home time. For multifunctional mechanisms, Carl F. Bucherer collaborated with the specialists at Dubois Dépraz in the Vallée de Joux. Carl F. Bucherer joined the elite circle of genuine manufactures in 2008. It earned this distinction by acquiring both a little atelier for horological complications and automatic Caliber CFB A1000, which was developed in the Jura region. The oscillating weight that supplies energy to this slim (4.3-millimeters-tall) microcosm moves peripherally around the caliber. The rotor is borne on little rollers which are equipped with maintenance-free (ceramic) ball bearings. Another special feature is the so-called Central Dual Adjusting System (CDAS), a cunningly engineered fine-adjustment mechanism with a central controlling element. Optimized Caliber CFB A2000 followed in this movement's foot-steps in 2016. Unlike its predecessor, a balance with a variable moment of inertia and a freely breathing hairspring serves as the rate-regulating organ in this caliber. The balance's frequency was increased from three to four hertz. CFB A2050 is the first member of this evolutionary phase. It ticks inside the "Manero Peripheral." ◦

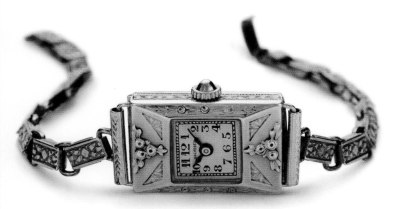

La Grande Dame, 1919

Vom Händler zur Uhrenmanufaktur

Deutsch

Die Kalender zeigten das Jahr 1888. Am Luzerner Falkenplatz eröffnete Carl Friedrich Bucherer sein erstes Fachgeschäft. Dort waren dem Kaufmann die mitunter recht ausgefallenen Wünsche seiner Kundschaft selbstverständlich Befehl. Bald schon reichte der Ruf über die Kantonsgrenzen hinaus. Weitere Läden förderten beständiges Wachstum. Ab 1919 offerierte Carl F. Bucherer auch Uhren mit eigener Signatur. Infolge seines Qualitätsanspruchs begnügte er sich nicht mit reinen Private-Label-Erzeugnissen, welche irgendwo anonym in seinem Auftrag hergestellt wurden. Stattdessen richtete der Unternehmer noch im gleichen Jahr eine eigene Fabrikationsstätte im Juraflecken Cortébert ein. Dort pflegte er keine eigene Manufaktur, sondern das, was man gemeinhin Etablissage nennt. Aus zugekauften Komponenten entstanden tickende Produkte, welche teilweise sogar mit offiziellem Chronometerzertifikat geliefert wurden. Nach einem Intermezzo mit preiswerten, lediglich mit der Signatur Bucherer versehenen Uhren kehrte 2001 das traditionelle Label zurück. Mit diesem Schritt erwies der gegenwärtige Firmeninhaber Jörg Bucherer seinem erfolgreichen Großvater die gebührende Referenz. Seinen Kundinnen und Kunden bietet Carl F. Bucherer derzeit Armbanduhren in fünf Linien an: „Adamavi", „Alacria" (Damen), „Manero", „Pathos" (Damen) und „Patravi". Letztere kann in punkto Zusatzfunktionen als Kollektions-Leader gelten. Den Anfang markierte ein stählerner Automatik-Chronograph mit Großdatum unterhalb der „12". Ohne Selbstaufzug hatte es so etwas bei Bucherer schon in den 1940er Jahren unter Verwendung des Schaltrad-Kalibers Venus 210 gegeben. Menschen mit Fernweh erhielten 2004 den Chronographen „Patravi GMT". Bei diesem Zeitschreiber ließ sich ein zusätzlicher 24-Stunden-Zeiger über die Krone in Stundenschritten verstellen. Gänzlich neu waren Zeitzonen-Armbanduhren für Carl F. Bucherer übrigens nicht. Schon 1960 fand sich ein „Worldtimer" mit Universalzeit-Indikation auf Basis des Handaufzugskalibers Derby 7510 in der Kollektion.

2005 präsentierte Carl F. Bucherer zur Baselworld die exklusiv entwickelte „Patravi TravelTec GMT". Neben dem Chronographen besitzt diese Armbanduhr mit dem Automatikkaliber CFB 1901 auch eine ausgeklügelte Funktion zur simultanen Darstellung mehrerer Zonenzeiten. Ihr zentraler 12-Stunden-Zeiger lässt sich per Krone beliebig vor- oder rückwärts verstellen. Das Fensterdatum vollzieht den Wechsel zu einer anderen Zonenzeit automatisch mit. Ein zusätzlicher 24-Stunden-Zeiger bewahrt die Referenz- oder Heimatzeit. Für die multifunktionale Mechanik kooperierte Carl F. Bucherer mit dem Spezialisten Dubois Dépraz aus dem Vallée de Joux. 2008 betrat Carl F. Bucherer den Kreis echter Manufakturen. Eintrittskarten waren der Erwerb eines kleinen Ateliers für uhrmacherische Komplikationen und das im Jurabogen entwickelte Automatikkaliber CFB A1000. Bei dem nur 4,3 Millimeter hohen Mikrokosmos bewegt sich die energiespendende Schwungmasse peripher rund ums Uhrwerk. Die Rotorlagerung erfolgt mit Hilfe kleiner Rollen, welche ihrerseits auch noch mit wartungsfreien (Keramik-)Kugellagern ausgestattet sind. Zu den Besonderheiten gehört ferner das sogenannte Central Dual Adjusting System (CDAS), eine ausgeklügelte Feinregulierung mit zentralem Steuerelement. In die Fußstapfen dieses Uhrwerks tritt 2016 das optimierte CFB A2000. Im Gegensatz zum Vorgänger dienen nun eine Unruh mit variablem Trägheitsmoment und eine frei schwingende Unruhspirale als Gangregler. Die Unruhfrequenz klettert von drei auf vier Hertz. CFB A2050 heißt das erste Mitglied der Evolutionsstufe. Es tickt in der „Manero Peripheral". ○

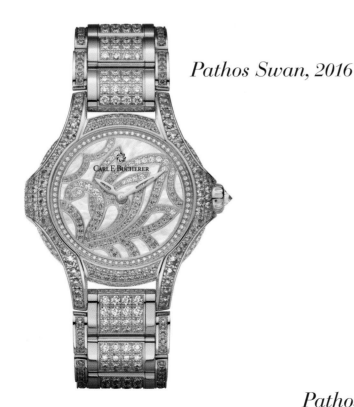

Pathos Swan, 2016

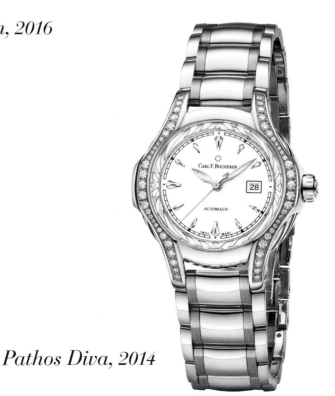

Pathos Diva, 2014

Du commerce à la manufacture de montres

Manero Flyback, 2016

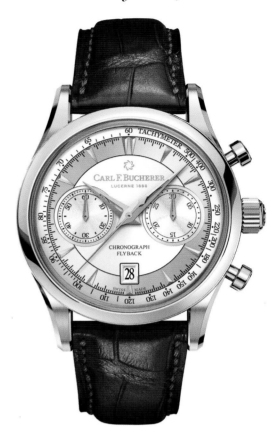

Nous sommes en 1888. Carl Friedrich Bucherer ouvre son premier magasin spécialisé à Lucerne, sur la Falkenplatz. Pour ce commerçant, les désirs parfois peu ordinaires de ses clients sont naturellement des ordres. Sa réputation s'étend par conséquent rapidement au-delà des frontières du canton. L'ouverture d'autres magasins favorise une croissance soutenue. À partir de 1919, Carl F. Bucherer propose également des montres de manufacture. Exigeant sur la qualité, il ne se contente pas de produits sous label privé fabriqués pour son compte, on ne sait où par un prestataire inconnu. L'entrepreneur fait construire la même année une usine à Cortébert, petite localité du Jura suisse. Cette usine n'est pas consacrée à la fabrication mais à ce que l'on appelle communément l'établissage, une activité qui consiste à assembler des composants achetés pour en faire des montres. Certaines seront même livrées avec un certificat de contrôle officiel suisse des chronomètres (COSC). Après un intermède avec des montres économiques simplement griffées Bucherer, le label d'origine est de retour en 2001. Jörg Bucherer rend ainsi dûment hommage à son brillant grand-père. Carl F. Bucherer propose à sa clientèle des montres-bracelets regroupées en cinq lignes : « Adamavi », « Alacria » (femmes), « Manero », « Pathos » (femmes) et « Patravi ». La dernière peut être considérée comme leader de la collection sur le plan des fonctions additionnelles. Le premier garde-temps proposé est un chronographe à remontage automatique et indication grande date à midi. Un modèle semblable était sorti chez Bucherer dès les années 1940, équipé du mouvement à roue à colonnes Venus 210. Sorti en 2004, le « Patravi GMT » est fait pour les gens ayant le mal du pays. Sur ce garde-temps, on peut régler par incrément d'une heure l'affichage 24 heures supplémentaire, à l'aide d'une couronne à poussoir. Les bracelets-montres avec indication de fuseaux horaires ne sont en fait pas une première pour Carl F. Bucherer. En 1960, on trouve déjà dans la collection le « Worldtimer », chronographe à remontage manuel et indication du temps universel fabriqué à partir d'un calibre Derby 7510. En 2005, Carl F. Bucherer présente au salon Baselworld le « Patravi TravelTec GMT », développé en exclusivité. Outre un chronographe, cette montre-bracelet, qui s'appuie sur le mouvement automatique CFB 1901, dispose d'un mécanisme astucieux permettant d'afficher simultanément plusieurs fuseaux horaires. L'aiguille centrale des heures peut être déplacée à volonté vers l'avant ou l'arrière grâce à la couronne à poussoir. Le quantième à guichet effectue automatiquement le changement de fuseau horaire. Une échelle 24 heures sur le réhaut conserve l'heure d'origine (ou de référence). Pour le mécanisme multifonctions, Carl F. Bucherer a collaboré avec l'entreprise spécialisée Dubois Dépraz, sise dans la Vallée de Joux. En 2008, Carl F. Bucherer entre dans le club des vraies manufactures grâce à l'acquisition d'un petit atelier spécialiste des complications horlogères et au développement du mouvement automatique CFB A1000 dans l'arc jurassien. Dans ce microcosme de seulement 4,3 millimètres de haut, la masse oscillante génératrice d'énergie (le rotor) tourne à la périphérie du mouvement. L'amortissement du rotor est assuré par de petits galets eux-mêmes équipés de roulements à billes en céramique n'exigeant aucune maintenance. Parmi les autres particularités du mouvement figure le CDAS (Central Dual Adjusting System), un système de réglage fin intelligent avec élément de commande central. Au mouvement CFB A1000 succède en 2016 une version optimisée, le CFB A2000. La régularité de marche est assurée en l'occurrence par un balancier à inertie variable et un spiral totalement libre. La fréquence d'oscillation du balancier passe de trois à quatre Hertz. Mouvement correspondant au stade d'évolution suivant, le CFB A2050 anime le « Manero Peripheral ». ○

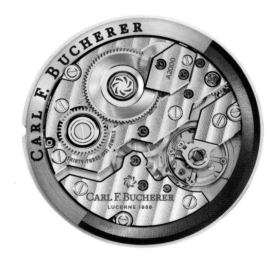

Right top: Cal. CFB A2000 ○ *Right bottom: Cal. CFB A1000*

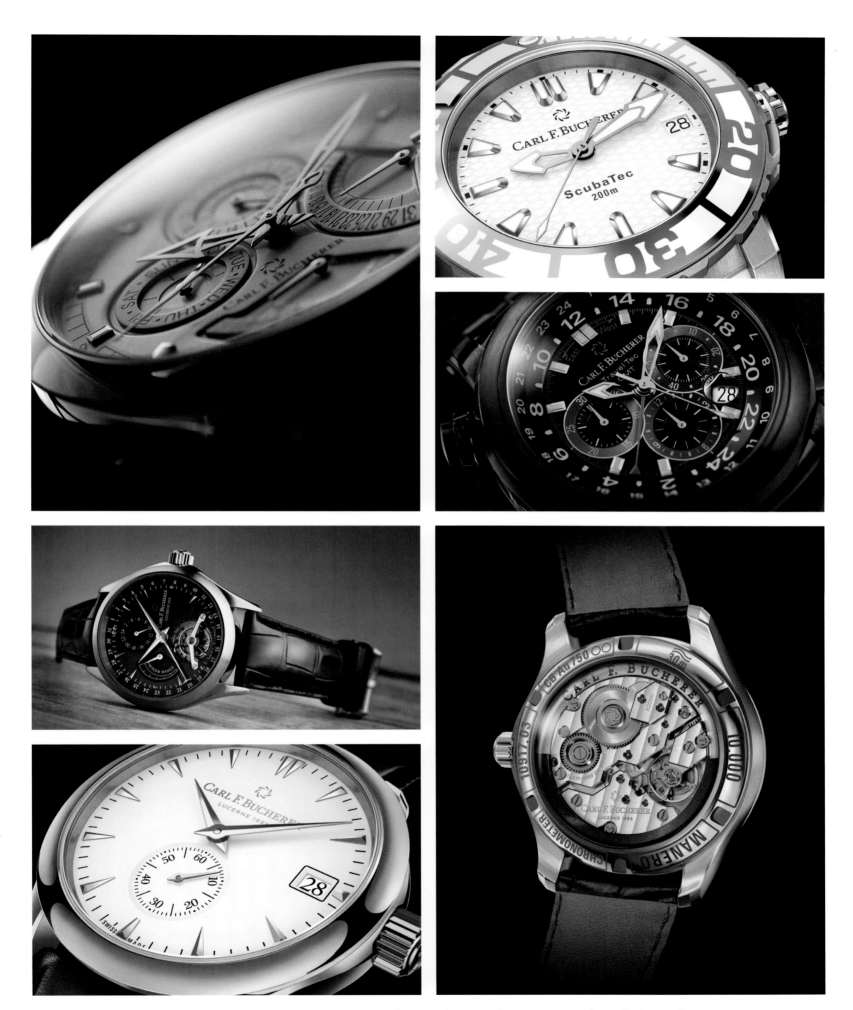

Clockwise from top left: Manero RetroGrade, 2011 ◦ Patravi ScubaTec White, 2016 ◦ Patravi TravelTec Black, 2016 ◦
Manero Peripheral, 2016 ◦ Manero Peripheral, 2016 ◦ Manero Tourbillon, 2015

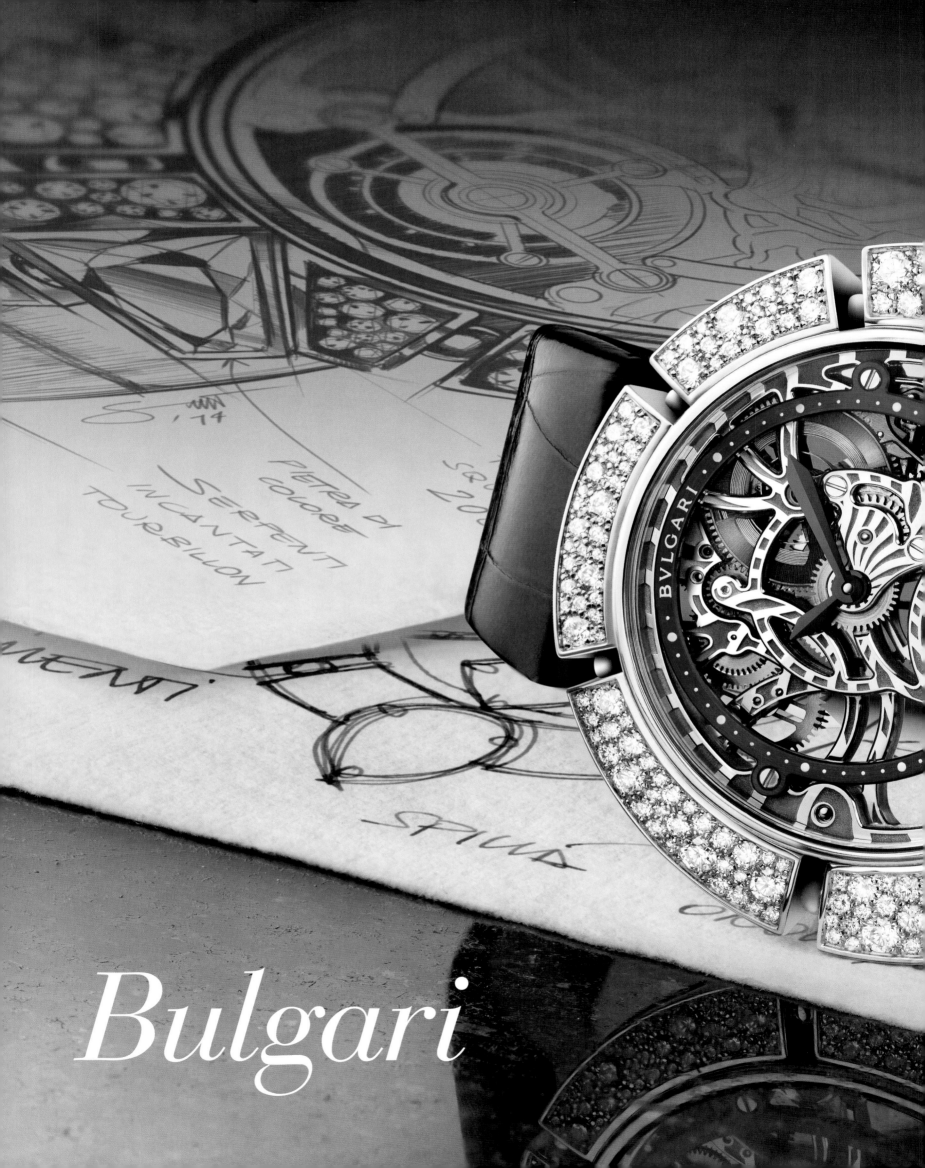

Bulgari

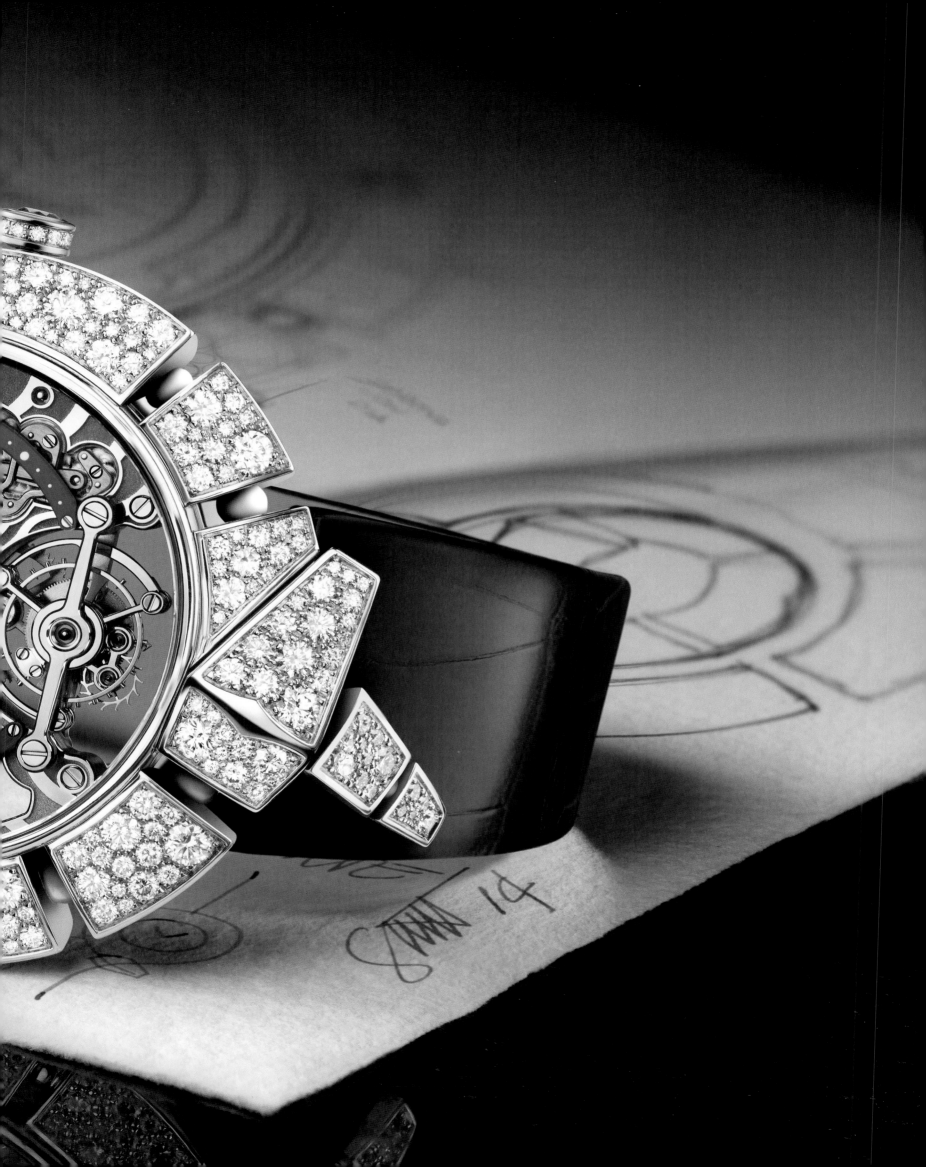

Italian Watch Luxury of Swiss Provenance

The name "Bulgari" is often associated with high-carat jewelry in the cosmos of luxury, but this label's watches all too often fly under the radar. The reasons for this may have to do with the history of the company and the biography of its founder Sotirios Boulgaris. After immigrating to Naples from Greece around 1880, he Italianized his name to "Sotirio Bulgari" and began earning a living in his new homeland as a silver merchant.

The official history of the Bulgari business began when Sotirio opened his first jewelry shop on Via Sistina in Rome in 1884. Relocation to the classier venue of no. 29 Via dei Condotti followed ten years later. Discriminating customers frequented the new shop, where they could chose among sparkling treasures, but timepieces weren't yet part of the firm's portfolio. Watches likewise remained absent when Sotirio moved his business again in 1905, reopening at no. 10 Via dei Condotti, near the famous Spanish Steps. Not until the early 1920s could upper-crust ladies select wristwatches with geometric platinum cases, linked bracelets and ample encrustations of diamonds. These timepieces were fabricated in France, but the words "Bulgari Roma" graced their dials.

After Sotirio died in 1932, his sons Giorgio and Costantino continued their father's passion for high-quality jewelry. Comprehensive renovation work coincided with the introduction of the distinctive BVLGARI logo in 1934. This insignia was also found on the slim pocket watches that Audemars Piguet delivered in the late 1930s. The subsequent decade witnessed Bulgari's creation of feminine wristwatches with flexible snakeskin wristbands. Swiss suppliers provided the movements and dials. Thanks to their uniquely ornamental look, these watches have remained en vogue decade after decade.

A new watch era, characterized by sustainability and innovative dynamism, began in 1975. Imaginative product designers rose to the challenge posed by the Quartz Revolution and conceived the luxurious "Bulgari Roma" with its unprecedented combination of a classically styled case and a liquid-crystal display. Following the example first set by Roman emperors, who demonstrated their power by having their names struck into coins, the words "Bvlgari" and "Roma" were engraved along the bezel. But this was only a modest beginning. The family business debuted the really big classic with a bright future in 1977. Along with a thoroughly optimized basic design, the "Bulgari Roma" also boasted the label's logo spelled out not once, but twice. Instant acceptance of the "Bulgari Bulgari" as a style icon practically demanded professionalization, so the label's watch-related activities were entrusted to Bulgari Time SA, which was established in Neuchâtel, Switzerland in 1982. Bulgari acquired ample competence in mechanical watchmaking by acquiring the little Gérald Genta and Daniel Roth manufactories at the turn of the millennium. The engineers, technicians and watchmakers in Vallée de Joux were and are thoroughly experienced in every conceivable facet of their métiers. Bulgari annually produced and sold more than 200,000 timepieces at this time. Sales of watches comprised 47 percent of total revenues, far outperforming the traditional jewelry division. After this acquisition, Bulgari started an unprecedented process leading toward a greater vertical range of manufacturing. The Romans acquired 50 percent of the shares of the dial maker Cadrans Designs SA in 2005. In October of this same year, they also bought a majority share of Prestige D'Or SA, a leading fabricator of steel and precious metal wristbands. The Bulgari Group became sole owner of both firms in 2009. The road to the brand's first basic self-winding movement was paved by a developmental agreement signed in 2007 with Leschot SA, which is likewise headquartered in Neuchâtel. Caliber BVL 168 debuted inside the case of the "Bulgari Sotirio" in 2010. The company is now no less fully integrated than the experienced case manufacturer Finger SA. The logical consequence of these activities followed in 2010 with the use of the unified signature "Bulgari" for all watches. Daniel Roth and Gérald Genta now belonged to the past. The retrospective ended in 2011, when the French luxury concern LVMH bought the traditional Italian company, which makes its watches exclusively in Switzerland.

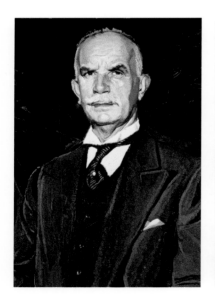
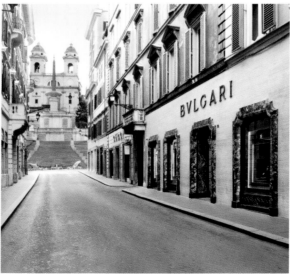

From left: Sotirio Bulgari ◦ Via dei Condotti, Italy ◦ Bulgari Manufacture de Cadrans

A person who wants to see what goes on at Bulgari's various production sites must first get behind the steering wheel of an automobile, drive to the secluded Vallée de Joux, and park the car near the railway station in Le Sentier, where Bulgari's experts cultivate the utmost in the watchmaker's art. Among their finest products is a 1.95-millimeter-tall one-minute tourbillon with a "flying" (i.e., cantilevered) rotating carriage. This minimal overall height defines only the carriage, inside of which the balance, hairspring and escapement continually turn their circles. To create the superlative movement known as "BVL 268," Bulgari eliminated the usual bearing jewels, as well as the jewels for the pivots of the balance's staff, and replaced them with seven miniature bearings. Craftspeople combine nearly 250 components for each movement. This device's little sister is Caliber BVL 128, a classical hand-wound movement with a height of just 2.23 millimeters: this extraordinary slimness qualifies as a horological complication. The third movement in the trio debuted at Baselworld in 2016. It can be triggered to audibly announce precious time to the nearest minute. Connoisseurs describe this complication as a "minute repeater." Without exaggeration, the "Octo Finissimo Minute Repeater" can be lauded as a unique achievement. The movement is just 3.12 millimeters tall; the titanium case is 6.85 millimeters thick, 40 millimeters in diameter, equipped with a transparent window in the back, and resists water pressure to five bar. A silent centrifugal-force regulator assures the equal length of intervals between consecutives chimes. As is true for all of Bulgari's first-rate chronometric products, the 362 components that comprise Caliber BVL 362 are meticulously finely processed by hand. A dexterous artisan requires up to 20 hours to put the finishing touches on the tourbillon cage in Caliber BVL 268. Patient craftsmanship culminates in the creation of superlative chronometric products that are much more than the sum of their parts. Blank components for the simpler "Solotempo" self-winding Calibers BVL 191 and BVL 193 are fabricated in the heights of the Jura region in western Switzerland. Man and machine collaborate along the modern assembly line where the calibers are decorated, assembled and finely adjusted. Automated machinery is used wherever machines can do more work —and above all better work—than a human hand. Cases and wristbands are built in the little town of Saignelégier in the Jura region; the dials are born in La Chaux-de-Fonds. Depending on the complexity, 100 or more work phases may be required for each of these little discs, which serve as the backgrounds for tirelessly orbiting hands. All of the threads conjoin at Neuchâtel, where Bulgari's headquarters are situated beside a picturesque lake. Design, planning and coordination of the products are undertaken in close consultation with the Italian headquarters. Qualified suppliers provide whatever Bulgari cannot produce on its own. Comprehensively trained colleagues in light-flooded ateliers work with the utmost conscientiousness to guarantee that each watch (regardless of whether its name is "Bulgari Bulgari," "Diagono," "Lucea," "Octo" or "Serpenti") upholds the manufactory's rigorous quality standards. After all, Bulgari has an illustrious reputation to defend. ○

Top: Cal. Finissimo BVL 128 SK
Bottom, from left: Lucea Il Giardino Paradiso, 2016 ○ Piccola Lucea, 2016

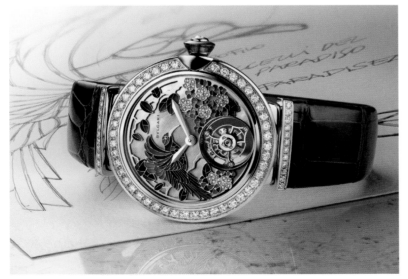

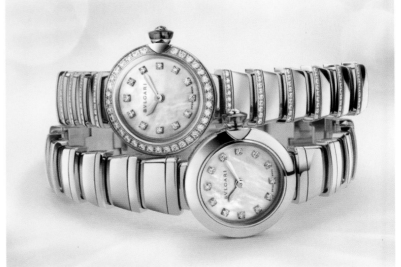

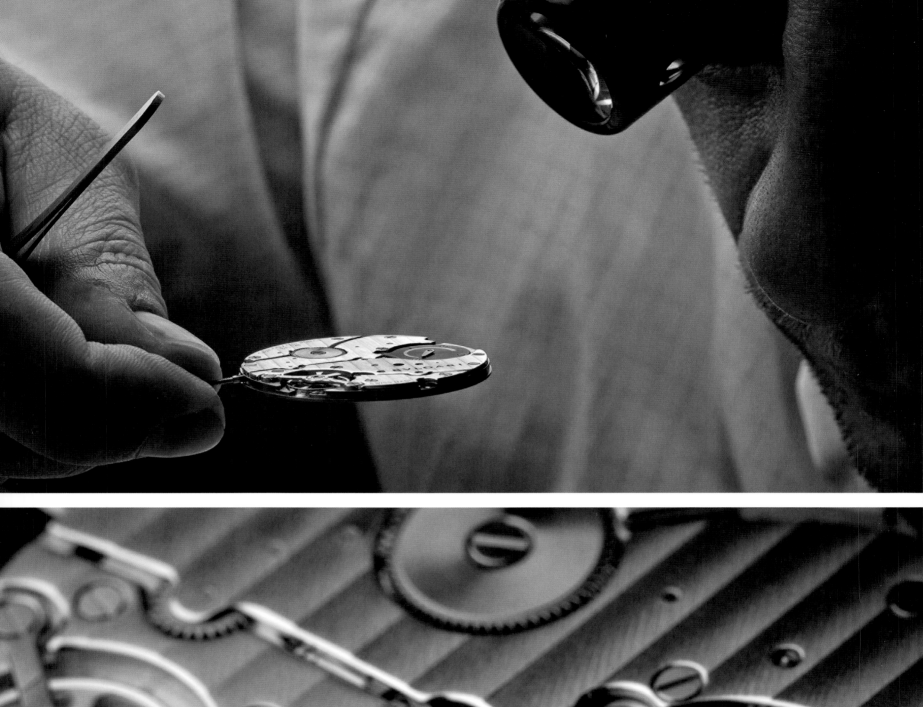
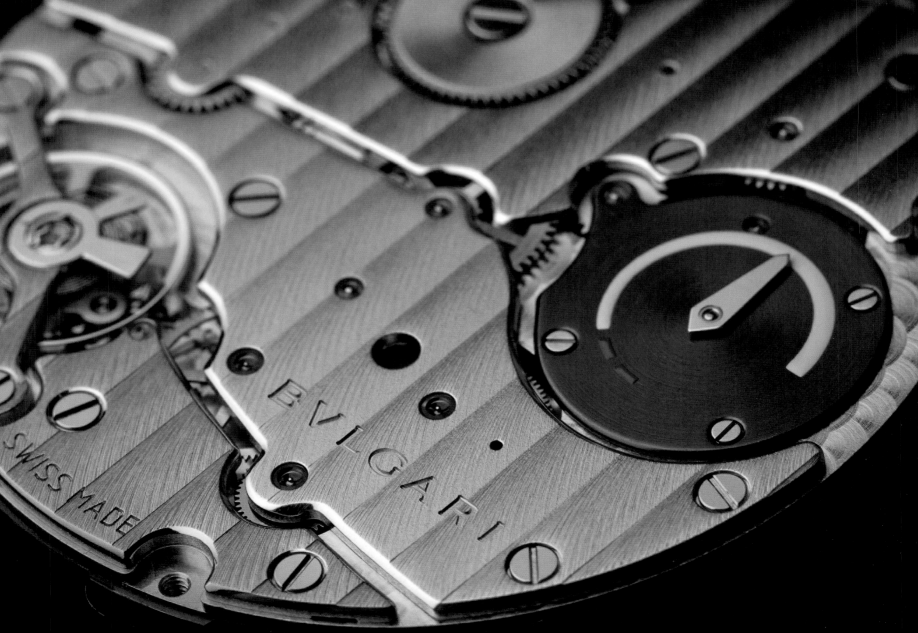

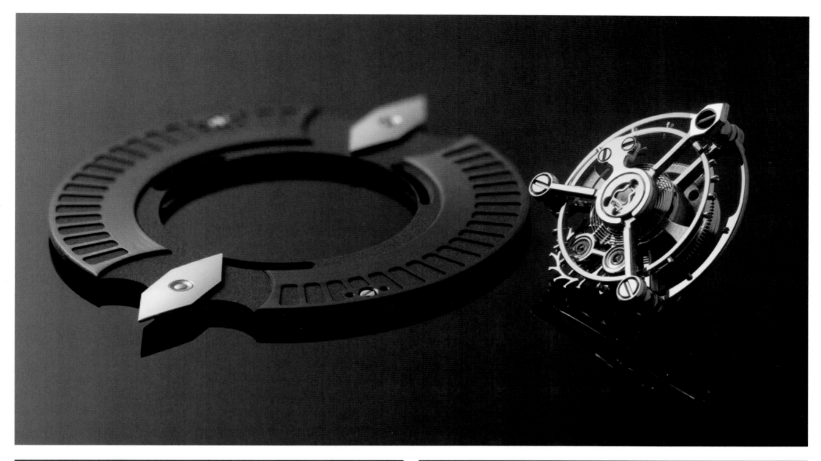

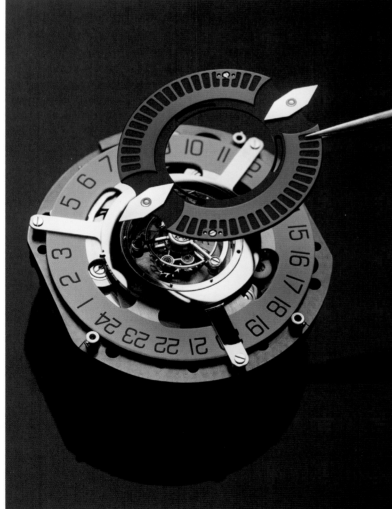

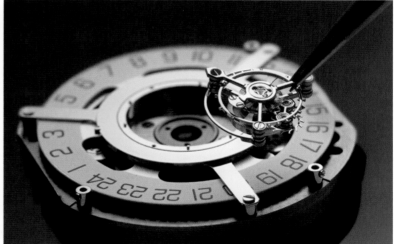

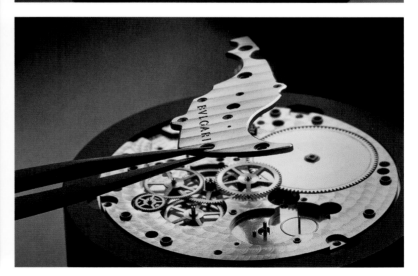

Movement manufacturing ◦ *Montage des Uhrwerks* ◦ *Réalisation de mouvements*

Italienischer Uhren-Luxus eidgenössischer Provenienz

Im Luxuskosmos verknüpft sich der Name Bulgari oftmals mit hochkarätigem Schmuck. Uhren stehen bei manchen Zeitgenossen hingegen weniger im Rampenlicht. Die Gründe sind möglicherweise in der Unternehmensbiographie zu suchen und im Firmengründer Sotirios Boulgaris. Nach seiner Emigration begegnete man dem gebürtigen Griechen ab 1880 in Neapel. Und zwar nun unter dem italienischen Namen Sotirio Bulgari. Den Lebensunterhalt verdiente der Wahlitaliener mit dem Handel von Silberwaren.

Mit der Eröffnung eines ersten Schmuckgeschäfts in der Via Sistina in Rom nahm 1884 die offizielle Bulgari-Firmengeschichte ihren Lauf. Zehn Jahre später erfolgte der Umzug in die deutlich mondänere Via dei Condotti. Im Haus mit der Nummer 29 konnten sich anspruchsvolle Kundinnen an exquisiten Preziosen erfreuen. Uhren waren definitiv kein Thema. Auch nicht 1905, als Sotirio seine Aktivitäten in die Via dei Condotti 10 nahe der Spanischen Treppe verlegte. Erst zu Beginn der 1920er Jahre konnten sich die Damen der besseren Gesellschaft an Armbanduhren mit geometrischen Platingehäusen, Gliederbändern und reichlich Brillantbesatz erfreuen. Obwohl in Frankreich fabriziert, stand am Zifferblatt Bulgari Roma zu lesen.

Nach dem Tod des Firmengründers im Jahr 1932 propagierten die beiden Söhne Giorgio und Costantino ihre Passion für hochwertige Juwelen. Mit umfangreichen Renovierungsarbeiten ging 1934 die Einführung des markanten Logos BVLGARI einher. Selbiges fand sich auch auf flachen Taschenuhren, geliefert von Audemars Piguet in den späten 1930er Jahren. Im folgenden Jahrzehnt kreierte Bulgari feminine Armbanduhren mit flexiblem Schlangenband. Werke und Zifferblätter stammten von Schweizer Lieferanten. Wegen ihrer einzigartigen schmückenden Optik büßten diese Uhren über Jahrzehnte hinweg nichts an Aktualität ein.

Das von Nachhaltigkeit und Innovationskraft geprägte Uhren-Zeitalter begann indessen erst 1975. Einfallsreiche Produktgestalter hatten die Herausforderung der Quarz-Revolution angenommen und bei ihrer luxuriösen „Bulgari Roma" erstmals ein Flüssigkristall-Display mit klassischem Gehäusedesign kombiniert. Bei der Signatur folgten die Bulgari dem Brauch römischer Kaiser, Macht durch ihren Namenszug auf Münzen zu demonstrieren. In diesem Sinne fanden sich Bulgari und Roma auf dem Glasrand. Das war ein bescheidener Anfang. Den ganz großen Klassiker mit Zukunftspotenzial präsentierte das Familienunternehmen 1977. Zum gründlich optimierten Basisdesign der „Bulgari Roma" gesellte sich das signifikante Logo in gleich doppelter Ausführung. Die spontane Akzeptanz dieser Stilikone namens „Bulgari Bulgari" verlangte beinahe zwingend nach Professionalisierung. Seit 1982 zeichnet die Bulgari Time SA mit Sitz im eidgenössischen Neuenburg für das Uhrengeschäft verantwortlich. Jede Menge Kompetenz in Sachen Mechanik erwarb Bulgari zur Jahrtausendwende mit den kleinen Manufakturen Gérald Genta und Daniel Roth. Die Ingenieure, Techniker und Uhrmacher im Vallée de Joux waren und sind nämlich mit allen erdenklichen Wassern gewaschen. Zu diesem Zeitpunkt produzierte und verkaufte Bulgari jährlich mehr als 200 000 Zeitmesser. Damit stellte das Uhrenbusiness mit 47 Prozent

Umsatzanteil den tradierten Schmuckbereich deutlich in den Schatten. Nach dieser Akquise startete Bulgari einen beispiellosen Vertikalisierungsprozess. 2005 brachten die Römer 50 Prozent der Aktien des Zifferblattherstellers Cadrans Designs SA unter ihre Fittiche. Darüber hinaus kauften sie im Oktober des gleichen Jahres die Aktienmehrheit an der Prestige D'Or SA, einem führenden Fabrikanten von Armbändern aus Stahl und edlen Metallen. 2009 gehörten beide komplett zur Bulgari-Gruppe. Den Weg zum ersten eigenen Basis-Automatikkaliber ebnete ein 2007 geschlossenes Entwicklungsabkommen mit der ebenfalls in Neuchâtel beheimateten Leschot SA. Das BVL 168 debütierte 2010 in der „Bulgari Sotirio". Dieses Unternehmen ist mittlerweile ebenso vollständig integriert wie ein erfahrener Gehäusefabrikant namens Finger SA. Die logische Konsequenz aus diesen Aktivitäten bestand 2010 in der Verwendung einer einheitlichen Signatur für alle Uhren: Bulgari. Daniel Roth und Gérald Genta gehörten der Vergangenheit an. Der Rückblick endet 2011, als der französische Luxus-Multi LVMH das italienische Traditionsunternehmen kaufte, dessen uhrmacherische Aktivitäten ausnahmslos in der Schweiz über die Bühne gehen.

Wer erleben möchte, was Bulgari in seinen verschiedenen Produktionsstätten tut, muss sich hinter das Steuer eines Autos setzen. Im abgeschiedenen Vallée de Joux, konkret nahe dem Bahnhof von Le Sentier, übt sich Bulgari in höchster Uhrmacherkunst. Zu den Spitzenprodukten gehört ein 1,95 Millimeter flaches Minutentourbillon mit fliegend gelagertem Drehgestell. Die minimale Gesamthöhe definiert allein der Käfig, in dem Unruh, Unruhspirale und Hemmungspartie beständig ihre Kreise drehen. Für diesen Superlativ namens BVL 268 musste Bulgari die üblichen Lagersteine einschließlich jener für die Zapfen des Ankerrads durch insgesamt sieben Miniatur-Kugellager ersetzen. Für jedes Uhrwerk benötigen die Handwerker knapp 250 Komponenten. Die „kleine Schwester" heißt BVL 128. Lediglich 2,23 Millimeter baut dieses klassische Handaufzugswerk hoch, was in der Uhrmacherei als Komplikation durchgeht. Das Dritte im Bunde gab während der Baselworld 2016 seinen Einstand. Auf Wunsch schlägt es die kostbare Zeit minutengenau. Kenner sprechen von einer Minutenrepetition. Bei nur 3,12 Millimetern Werks- und 6,85 Millimetern Gesamthöhe der limitierten „Octo Finissimo Minute Repeater" kann man ohne jede Übertreibung von einzigartiger Leistung sprechen. Das 40 Millimeter große Titangehäuse mit Sichtboden ist sogar wasserdicht bis zu fünf Bar Druck. Für den gleichförmigen Ablauf der Schlagfolge sorgt ein geräuschloser Fliehkraftregler. Die 362 Werkskomponenten des Kalibers BVL 362 werden, wie es sich für alle Bulgari-Produkte der chronometrischen Spitzenklasse gehört, manuell aufs Sorgfältigste feinbearbeitet. Allein für die Finissage eines Tourbillonkäfigs im Kaliber BVL 268 benötigt ein kunstfertiger Handwerker bis zu 20 Stunden. Durch geduldige Handarbeit entstehen chronometrische Spitzenprodukte, welche deutlich mehr sind als die Summe ihrer vielen Teile. In den Höhen des Westschweizer Jura entstehen auch Roh-Komponenten für die einfacheren „Solotempo"-Automatikkaliber BVL 191 und BVL 193. Bei der Dekoration, Montage und Regulierung arbeiten Menschen und moderne Fertigungsstraßen Hand in Hand. Automaten kommen überall dort zum Zuge, wo sie mehr und vor allem Besseres

leisten. Gehäuse und Bänder stammen aus dem Jurastädtchen Saignelégier, Zifferblätter aus La Chaux-de-Fonds. Je nach Komplexität verlangt eine der kleinen Scheiben, vor der sich die Zeiger unentwegt drehen, nach 100 Arbeitsschritten oder deutlich mehr. In Neuchâtel, wo Bulgari nahe dem malerischen See sein Uhren-Hauptquartier unterhält, laufen alle Fäden zusammen. Produktdesign, -planung und -steuerung erfolgen in enger Abstimmung mit der italienischen Zentrale. Was Bulgari nicht selber produzieren kann, steuern qualifizierte Zulieferer bei. In lichtdurchfluteten Ateliers geben umfassend geschulte Mitarbeiterinnen und Mitarbeiter ihr Bestes, damit ausnahmslos alle Uhren, egal ob sie beispielsweise „Bulgari Bulgari", „Diagono", „Lucea", „Octo" oder „Serpenti" heißen, den rigorosen Qualitätsstandards der Manufaktur entsprechen. Bulgari hat schließlich einen Ruf zu verlieren. ◦

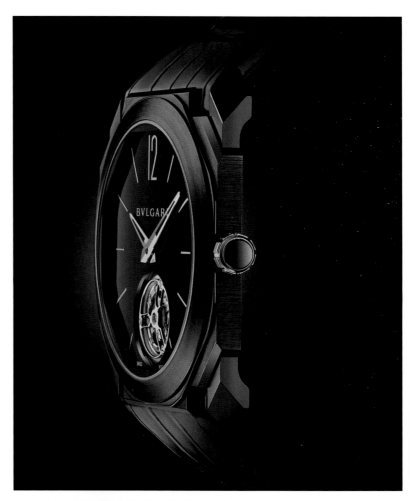

Clockwise from top right:
Octo Finissimo Ultranero Tourbillon, 2016 ◦
Octo Finissimo Skeleton, 2016 ◦ Octo Ultranero Solotempo, 2016

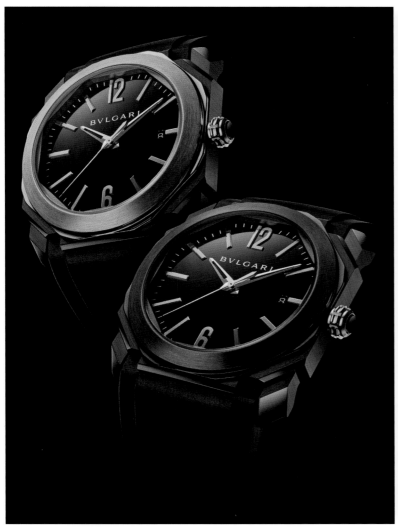

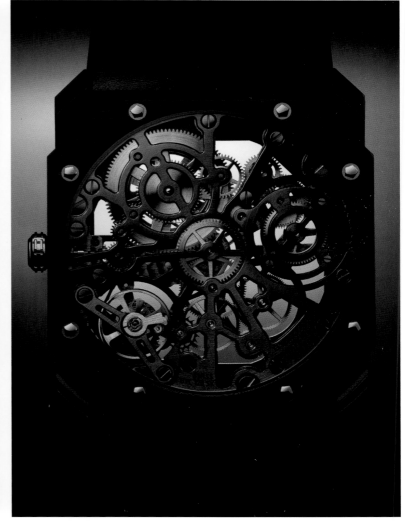

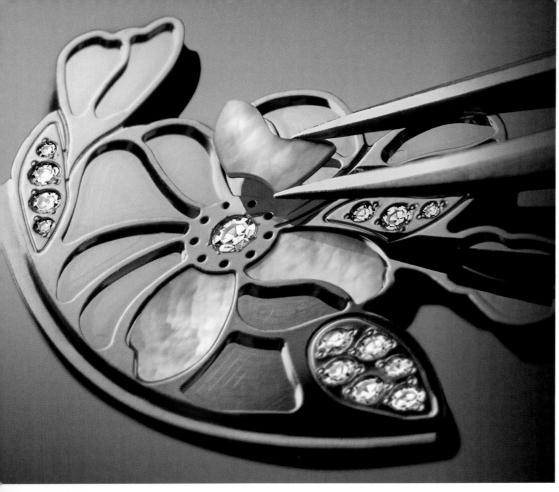

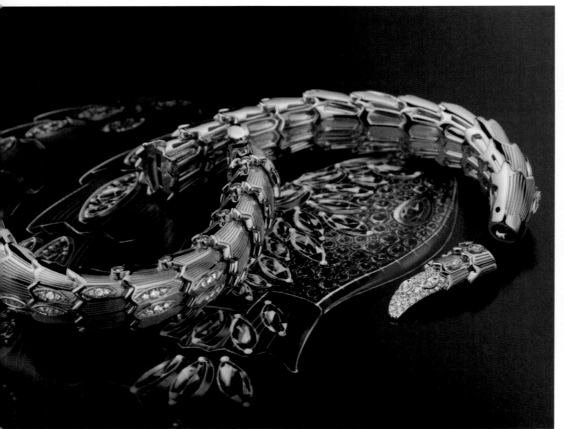

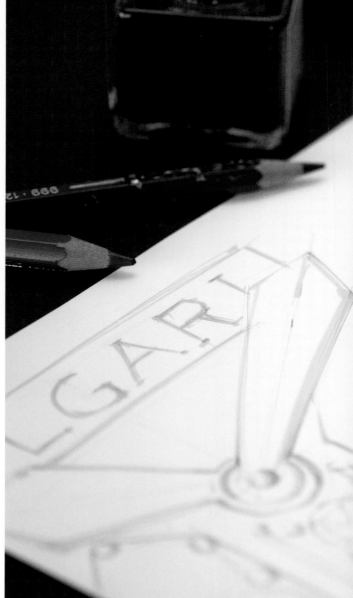

*All of the high-jewelry watch creations are crafted in Italy and Switzerland:
the jewelry work is performed in Bulgari's specialized artisanal workshops in Italy;
the watch components are fabricated and assembled in Neuchâtel, Switzerland.*
*Alle Schmuckuhren werden in Italien und der Schweiz hergestellt. Die Juwelenarbeiten
stammen aus handwerklichen Betrieben, die sich auf Bulgari spezialisiert haben.
Die Uhrwerke werden in Neuchâtel in der Schweiz gefertigt.*
*La réalisation artisanale des montres de haute joaillerie se partage entre l'Italie et la Suisse.
Le travail de joaillerie est accompli en Italie, dans les ateliers artisanaux spécialisés de Bulgari,
tandis que la montre proprement dite est usinée et assemblée à Neuchâtel (Suisse).*

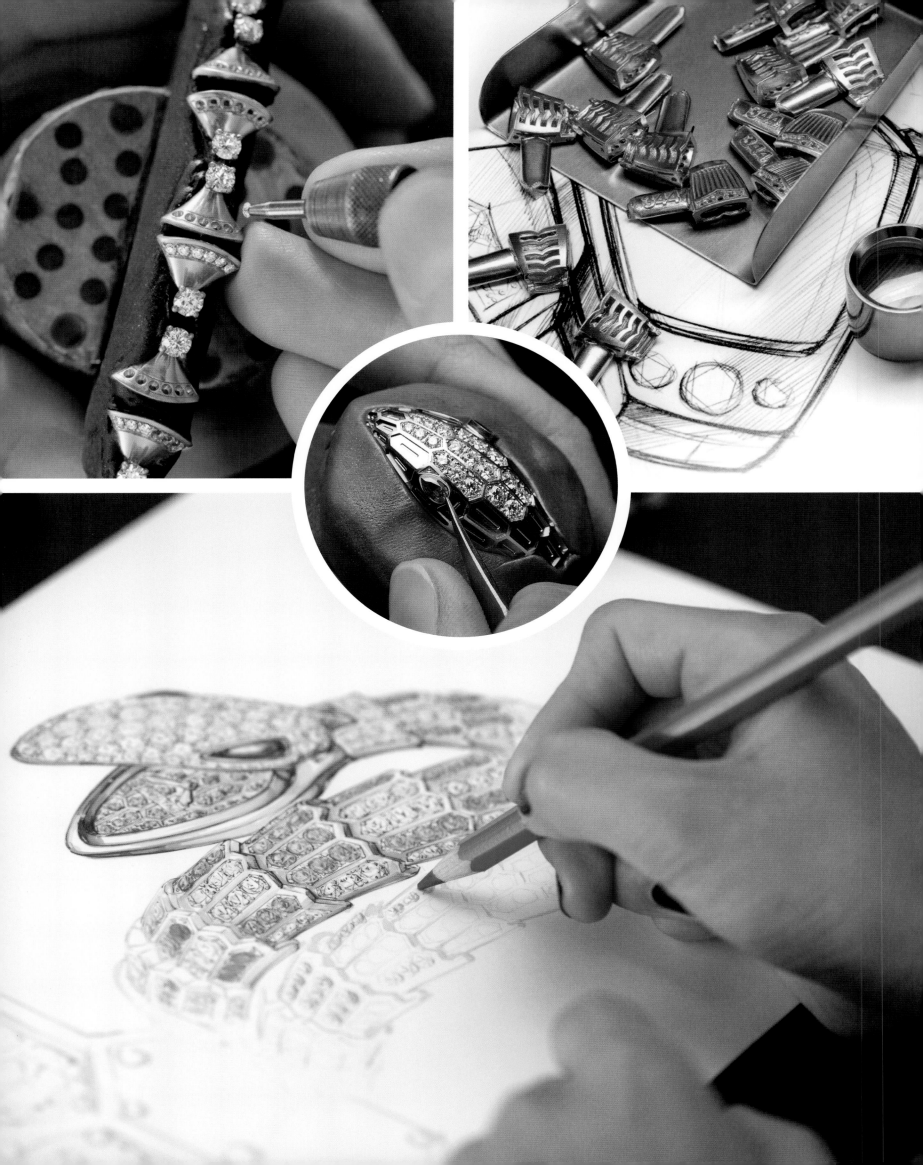

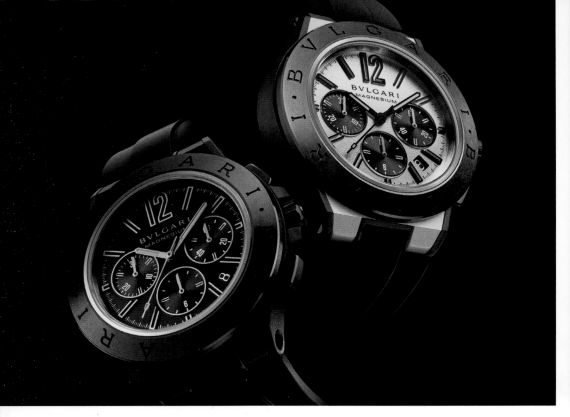
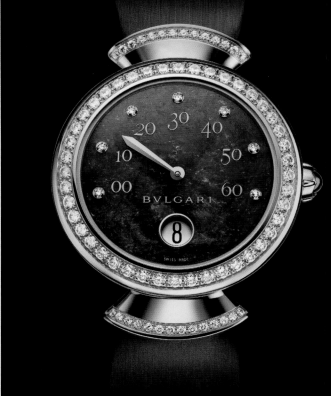

Luxe à l'italienne swiss made

Français

Dans l'univers du luxe, on associe souvent le nom Bulgari à de somptueux bijoux, les montres de la marque ne bénéficiant pas d'une attention comparable de la part de certains de nos contemporains. Cela tient peut-être à l'histoire de l'entreprise et à la personnalité de son fondateur, Sotirios Boulgaris. Ce Grec qui a pris le chemin de l'émigration s'installe en 1880 à Naples, sous un nom italianisé, Sotirio Bulgari. Dans sa patrie d'adoption, il vend de l'orfèvrerie d'argent.

L'ouverture d'une première joaillerie via Sistina à Rome, en 1884, signe l'acte de naissance de la maison Bulgari. Dix ans plus tard, la boutique est transférée à une adresse bien plus chic, la via dei Condotti. Au numéro 29, les clientes difficiles sont comblées par des joyaux exquis. À l'époque, les montres ne sont aucunement d'actualité. Elles ne le sont pas davantage en 1905, lorsque Sotirio Bulgari transfère ses activités au numéro 10 de cette même rue, près de l'escalier de la Trinité-des-Monts. Ce n'est qu'au début des années 1920 que Bulgari propose des montres-bracelets pourvues de boîtiers géométriques en platine, de bracelets à maillons et de brillants à foison, pour la plus grande joie des femmes du monde. Bien qu'il s'agisse de produits fabriqués en France, le cadran porte la mention « Bulgari Roma ».

Après le décès du fondateur en 1932, ses deux fils Giorgio et Costantino laissent libre cours à leur passion pour les bijoux de luxe. En 1934, d'importants travaux de rénovation vont de pair avec l'introduction de BVLGARI, un logo marquant également apposé sur les montres de poche plates fournies par Audemars Piguet à la fin des années 1930. Au cours de la décennie suivante, Bulgari crée des montres-bracelets pour dames pourvues de mouvements et de cadrans achetés auprès de fournisseurs suisses ainsi que d'un bracelet « serpent » souple. Parce qu'elles ont des allures de bijoux, ces montres ne se démoderont pas au cours des décennies suivantes.

Cependant, l'ère horlogère placée sous le signe de la durabilité et de la capacité d'innovation ne débutera qu'en 1975. Relevant le défi de la révolution du quartz, d'ingénieux concepteurs associent pour la première fois un affichage à cristaux liquides à un boîtier au design classique dans leur luxueuse « Bulgari Roma ». Cette signature se rattache à une pratique des empereurs romains, qui affichaient leur puissance en apposant leur nom sur les monnaies. Bulgari et Rome sont ainsi réunis sur la lunette du cadran, un début modeste. C'est en 1977 que l'entreprise familiale présente son très grand classique à l'avenir prometteur. L'optimisation en profondeur du design de base de la « Bulgari Roma » s'accompagne de l'introduction du marquant logo, gravé en double. Face au succès rapide de cette icône du style répondant au nom « Bulgari Bulgari », une professionnalisation s'impose presque. À partir de 1982, toutes les activités horlogères sont entre les mains de Bulgari Time SA, société sise à Neuchâtel, en Suisse. Au début du XXIe siècle, Bulgari se dote de compétences étendues en matière de mécanique en s'adjoignant les petites manufactures Gérald Genta et Daniel Roth. En effet, les ingénieurs, techniciens et horlogers de la vallée de Joux sont depuis toujours rompus à toutes les tâches. Bulgari produit alors plus de 200 000 garde-temps par an, soit 47 pour cent de son chiffre d'affaires. L'horlogerie éclipse la joaillerie, qui a constitué jusqu'alors le cœur de métier de Bulgari. Cet achat est le point de départ d'un processus de verticalisation sans précédent : en 2005, l'entreprise romaine prend sous son aile 50 pour cent des actions du fabricant de cadrans Cadrans Designs SA ; en octobre de la même année, elle prend une participation majoritaire dans Prestige d'Or SA, qui figure parmi les leaders sur le marché des bracelets en acier et en métaux précieux. En 2009, ces deux entreprises sont intégrées au groupe Bulgari. Un contrat de développement passé en 2007 avec l'entreprise neuchâteloise Leschot SA ouvre la voie à la conception du premier calibre automatique de base maison, le BVL 168, qui fait ses débuts dans la « Bulgari Sotirio ». Leschot SA

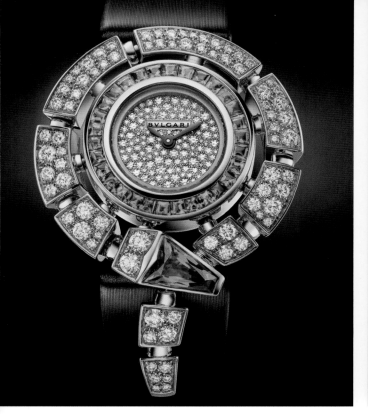
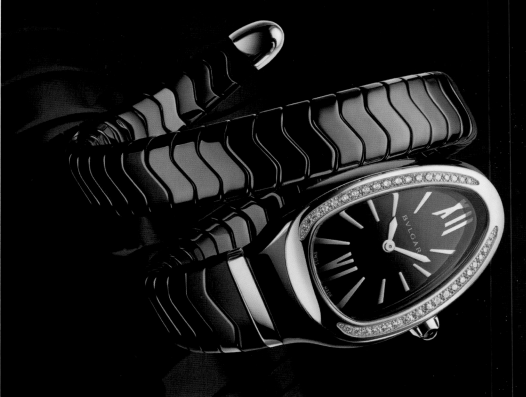

From left: Diagono Magnesium Chronograph, 2016 ◦ Diva's Dream, Retrograde Minutes, and Jumping Hour, Heart of Ruby Dial, 2016 ◦ Serpenti Incantati Jewellery, 2016 ◦ Serpenti Tubogas Ceramic and Rose Gold, 2016

est désormais intégrée à Bulgari, au même titre qu'un fabricant de cadrans chevronné, Finger SA. Ces mesures débouchent logiquement en 2010 sur l'apposition d'une seule et même signature sur toutes les montres : Bulgari. C'en est fini de Daniel Roth et Gérald Genta. Notre rétrospective s'arrête en 2011, année du rachat par LVMH, multinationale française du luxe, de la maison de tradition italienne, dont toutes les activités horlogères sans exception se déroulent sur le sol suisse.

Qui a envie de voir Bulgari à l'œuvre dans ses différents ateliers de production doit se rendre dans la vallée de Joux. Près de la gare ferroviaire du Sentier, plus précisément, Bulgari s'adonne à l'art horloger au plus haut niveau. Parmi ses produits phares figure un tourbillon minute à cage mobile tournante affichant 1,95 millimètre d'épaisseur. Cette faible hauteur totale correspond à celle de la cage, dans laquelle le balancier, le spiral et l'échappement sont en constante rotation. Pour cette prouesse dénommée BVL 268, Bulgari a remplacé l'empierrage traditionnel, y compris celui des pignons de la roue d'ancre, par sept roulements à billes miniatures. L'assemblage d'un mouvement requiert près de 250 composants. BVL 128, son « cadet », est un mouvement à remontage manuel classique de seulement 2,23 millimètres de hauteur, une prouesse créditée du statut de complication horlogère. Le « benjamin » a fait son entrée dans le monde à l'occasion du Salon mondial de l'horlogerie à Bâle (Baselworld) 2016. Il sonne les minutes à la demande, une complication que les connaisseurs appellent la répétition minutes. Affichant une épaisseur de mouvement réduite à 3,12 millimètres pour une épaisseur totale de boîtier de 6,85 millimètres, le modèle « Octo Finissimo Minute Repeater » est, sans exagération aucune, une performance exceptionnelle. Le boîtier titane à fond en verre est même étanche jusqu'à une pression de 5 bars. Grâce à un régulateur centrifuge silencieux, la sonnerie des minutes s'égrène avec régularité. Les 362 composants

du mouvement du calibre BVL 362 sont le fruit d'un travail artisanal extrêmement soigné. Par ailleurs, le finissage d'une cage de tourbillon équipant un calibre BVL 268 représente à lui seul jusqu'à 20 heures de travail pour un artisan chevronné. Résultat d'un travail manuel minutieux, les garde-temps d'exception sont bien plus que la somme de leurs nombreux composants. Les hautes vallées du Jura, en Suisse occidentale, abritent également la fabrication de composants bruts pour des calibres automatiques plus simples, tels le BVL 191 de la montre « Solotempo » et le BVL 193. Leurs ornementation, assemblage et réglage résultent d'une étroite interaction entre des hommes et des lignes de production modernes. Des robots sont à tous les postes de production où ils sont plus performants que l'homme, quantitativement mais surtout qualitativement. Les boîtiers et les bracelets proviennent de la petite localité jurassienne Saignelégier, les cadrans de La Chaux-de-Fonds. Selon leur degré de complexité, ces composants servant d'arrière-plan au mouvement régulier des aiguilles requièrent jusqu'à une 100 d'étapes de travail, voire bien davantage. C'est à Neuchâtel, là où Bulgari a établi son quartier général horloger près du pittoresque lac, que sont prises toutes les décisions en matière de design, conception et gestion des produits, et ce en étroite concertation avec la maison mère en Italie. Bulgari achète auprès de fournisseurs qualifiés tout ce qui ne peut pas être produit en interne. Dans des ateliers inondés de lumière, des salariés dûment formés donnent le meilleur d'eux-mêmes pour que toutes les montres – qu'elles s'appellent « Bulgari Bulgari », « Diagono », « Lucea », « Octo » ou « Serpenti », pour ne citer que quelques noms – répondent aux exigences de qualité de la manufacture. Bulgari tient à sa réputation. ◦

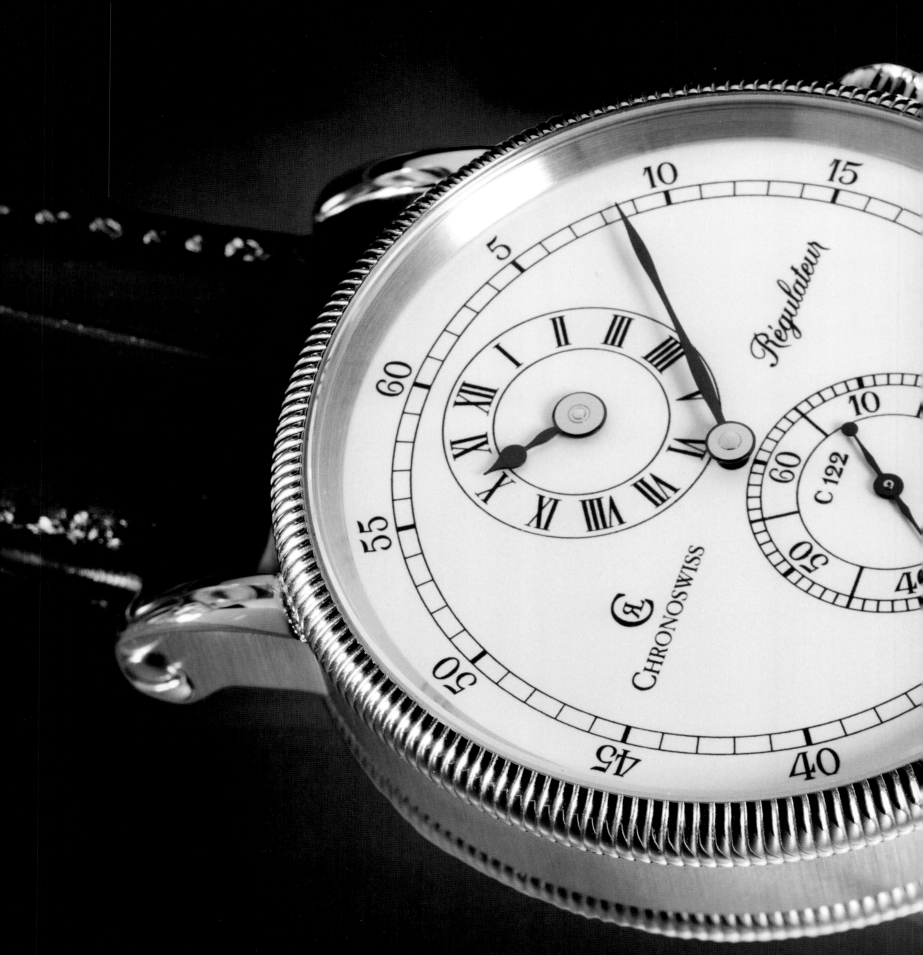

Chronoswiss

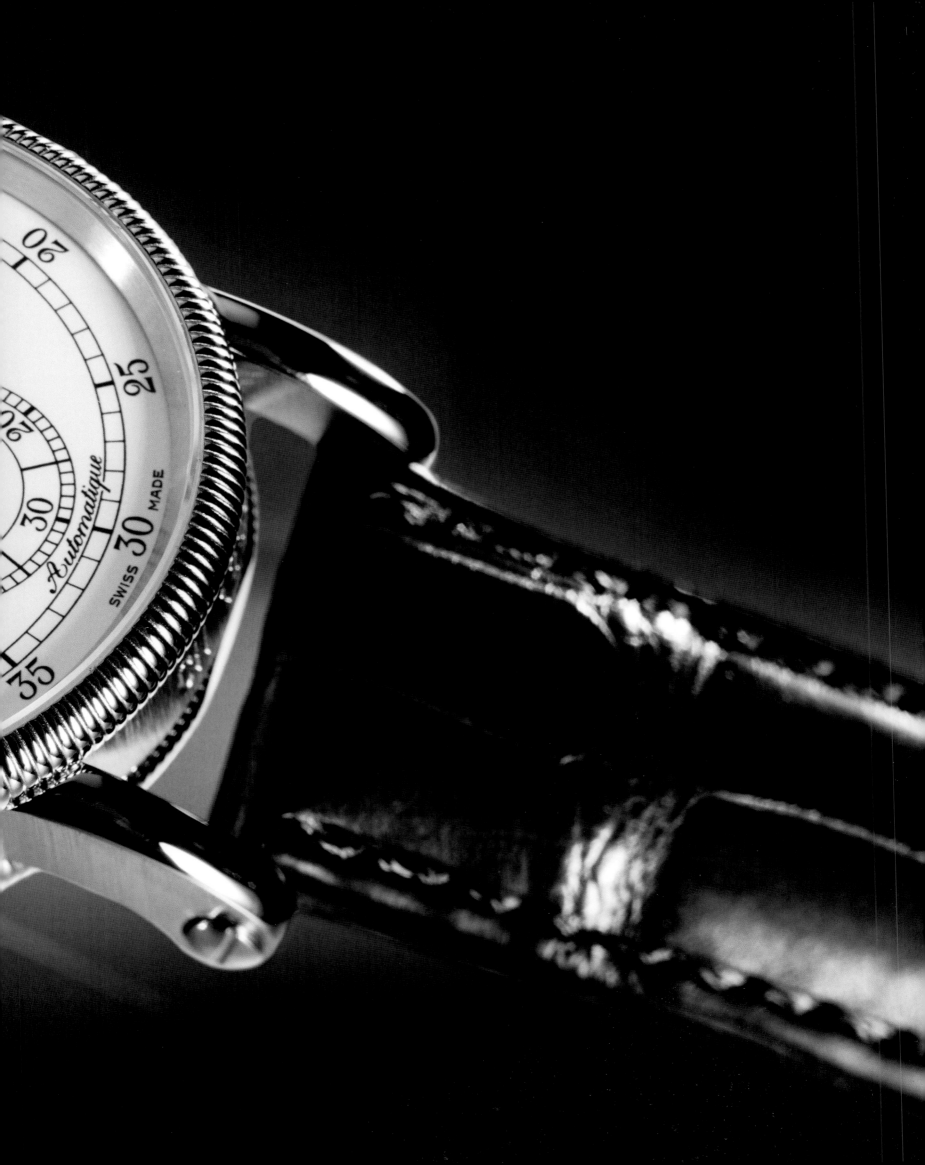

Under the Sign of the "Régulateur"

Born in 1943, Gerd-Rüdiger Lang took the daring step of starting his own business in 1981. The trained watchmaker and former director of Heuer Time (Germany) had become unemployed when that company went out of business. Necessity turned out to be the mother of invention, because Lang founded his new company in Munich with plenty of ideas, courage, decisiveness and willingness to take risks. His starting capital also included a huge stock of spare parts, including components for chronographs. The Quartz Revolution had left lasting traces in the watch scene, but this left Gerd-Rüdiger Lang singularly unimpressed and firmly convinced that good old mechanical watchmaking still held ample potential. He acted on his conviction by buying and selling conventional ticking wristwatches in retro look. His first collections of his own debuted in 1983. Although many of the wristwatches bearing Chronoswiss' name were already equipped with transparent backs, Gerd-Rüdiger Lang hadn't yet developed a characteristic style. That's why the real history of Chronoswiss began in 1987 with the premiere of the so-called "Régulateur." Not only did this wristwatch have an unconventional dial, it also featured Chronoswiss' distinctive case, which combines nineteen individual parts. The historical rationale for removing the hour-hand from the dial's center and repositioning it upward at the "12" can be traced to precise regulator clocks which watchmakers formerly relied on when finely adjusting other timepieces. For this purpose, they primarily needed to refer to the clock's second-hand. An hour-hand at the center of the clock's face made it more difficult to view the little second-hand. Clockmakers accordingly relocated the former so it could no longer obstruct their view of the latter. For the first edition of his "Régulateur," the ambitious entrepreneur used a correspondingly modified version of Unitas' hand-wound Caliber 6376 Z, which was last produced in 1984. Only a few of these calibers were available, so Chronoswiss was obliged to impose strict limits on the number of watches in this first edition. Lady Luck rewarded Gerd-Rüdiger Lang on another occasion, when the assiduous businessman's excellent connections enabled him to acquire a large stock of an automatic movement that was no longer in use. Enicar had developed the rotor-wound caliber in the 1970s, but was afterwards swallowed by the "Quartz Maelstrom." After subjecting this caliber to necessary revisions, Lang was able to launch his "Régulateur Automatique" in 1990. The "Fascination of Mechanisms," a phrase which served as the title of Chronoswiss' catalogue in 1992, was subsequently celebrated by an extensive collection of watches in which chronographs played a significant role. A revised version of Progress 6361 ticked inside the "Régulateur à Tourbillon" when it debuted in 2000. And in 2001, the aforementioned Enicar movement animated the "Chronoscope," a stopwatch with a regulator dial. Gerd-Rüdiger Lang offered collectors and fans of his brand regularly recurring opportunities to purchase strictly limited "Régulateur" editions encasing movements that were no longer manufactured. The German chapter of Chronoswiss' history ended in 2012 and the brand's future shifted to Switzerland. Due to his advanced age, Gerd-Rüdiger Lang entrusted his "baby," which had conquered an impressive eighth place in the ranking of German luxury brands, into the arms of Swiss entrepreneurs Eva Maria and Oliver Ebstein. The brand is presently headquartered in the picturesque city of Lucerne on the shores of the homonymous lake, where the House of Chronoswiss handles all of the label's activities. The brand's sporty side is represented by the distinctive "Timemaster." After the well-known case underwent a facelift, the classical line is now known as "Sirius." This eccentric icon is highlighted again in 2016, but its several versions—some with classical dials, others with three-dimensional faces—have been renamed "Regulator." ○

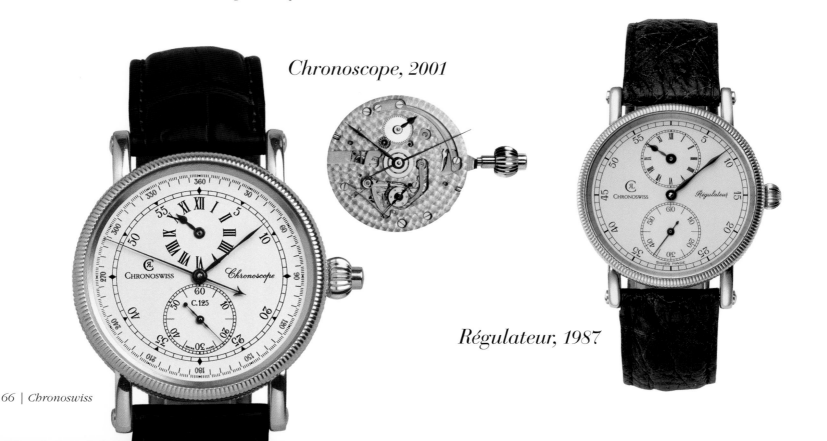

Chronoscope, 2001

Régulateur, 1987

Im Zeichen des „Régulateur"

Deutsch

Als Gerd-Rüdiger Lang, Jahrgang 1943, gezwungenermaßen den Sprung in die berufliche Selbständigkeit wagte, schrieb man das Jahr 1981. Die Liquidation der von ihm geleiteten Heuer Time (Deutschland) trieb den gelernten Uhrmacher in die Arbeitslosigkeit. Der Not gehorchend startete der Geschasste mit Ideen, Mut, Risikofreude und Entschlossenheit in München neu durch. Sein Anfangskapital: ein riesiges Lager an Ersatzteilen, darunter viele für Chronographen. Ziemlich kalt ließ ihn dabei, dass die Quarz-Revolution nachhaltige Spuren in der Uhrenszene hinterlassen hatte. Gerd-Rüdiger Lang erkannte das Zukunftspotenzial der guten alten Mechanik. Und er reagierte durch den An- und Verkauf konventionell tickender Armbanduhren im Retrolook. Ab 1983 entstanden eigene Kollektionen. Viele der Chronoswiss signierten Armbanduhren verfügten zwar schon über einen Sichtboden, zeichneten sich aber noch nicht durch eine eigenen Handschrift aus. Deshalb startete die wirkliche Chronoswiss-Geschichte im Jahr 1987 mit dem sogenannten „Régulateur". Diese Armbanduhr brachte nicht nur ein außergewöhnliches Zifferblatt, sondern auch das signifikante, aus 19 Teilen zusammengefügte Chronoswiss-Gehäuse. Natürlich hatte es seine Bewandtnis mit der Verlagerung des Stundenzeigers aus der Mitte nach oben zur „12". Diese Art der Zeitanzeige leitete sich ab von alten Präzisions-Regulatoren, welche Uhrmacher zum Regulieren ihrer Uhren nutzten. Dabei kam es in erster Linie auf die Sekunden an. Weil der mittig positionierte Stundenzeiger das Ablesen des kleinen Sekundenzeigers beeinträchtigte, musste er dorthin weichen, wo er nicht mehr stören konnte. Für die erste Edition des „Régulateur" nutzte der ambitionierte Unternehmer eine entsprechend modifizierte Version des Handaufzugskalibers Unitas 6376 Z, dessen Produktion 1984 eingestellt worden war. Wegen der nur noch begrenzten Verfügbarkeit dieses Uhrwerks musste Chronoswiss die Edition strikt limitieren. Ein weiteres Mal belohnte das Glück den Tüchtigen, als der gut vernetzte Gerd-Rüdiger Lang größere Restbestände eines nicht mehr genutzten Automatikwerks erwerben konnte. Enicar hatte dieses Rotor-Kaliber in den 1970er Jahren

entwickelt, war dann aber auch in den Quarz-Strudel geraten. Nach entsprechendem Umbau ging 1990 der „Régulateur Automatique" an den Start. In den folgenden Jahren zelebrierte Chronoswiss die 1992 zum Katalogtitel erwählte „Faszination der Mechanik" durch eine breite Uhrenkollektion, in der Chronographen eine bedeutende Rolle spielten. Auf besagtem Enicar basierte auch das 2001 vorgestellte „Chronoscope", ein Stopper mit Regulator-Zifferblatt. Ein Jahr zuvor debütierte ferner das „Régulateur à Tourbillon" unter Verwendung des umgebauten Progress 6361. Sammlern und Markenfans offerierte Gerd-Rüdiger Lang in regelmäßigen Abständen streng limitierte „Régulateur"-Editionen mit nicht mehr produzierten Uhrwerken. 2012 endete das deutsche Chronoswiss-Kapitel. Die Zukunft spielte sich in der Schweiz ab. Aus Altersgründen hatte Gerd-Rüdiger Lang sein „Baby", das im Ranking deutscher Luxusmarken einen bemerkenswerten achten Platz erobern konnte, in die Arme des Schweizer Unternehmerpaars Eva Maria und Oliver Ebstein gelegt. Mittlerweile residiert die Marke im Herzen der malerischen Stadt Luzern am Vierwaldstätter See. Alle Aktivitäten gehen im House of Chronoswiss über die Bühne. Die sportliche Seite der Marke repräsentiert der markante „Timemaster". Nach einem Facelift des bekannten Gehäuses nennt sich die klassische Linie „Sirius". 2016 steht einmal mehr im Zeichen der exzentrischen Ikone. Allerdings bekamen die verschiedenen Ausführungen – teils mit klassischen, teils mit dreidimensionalen Zifferblättern – einen neuen Namen: „Regulator". ○

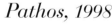

Pathos, 1998

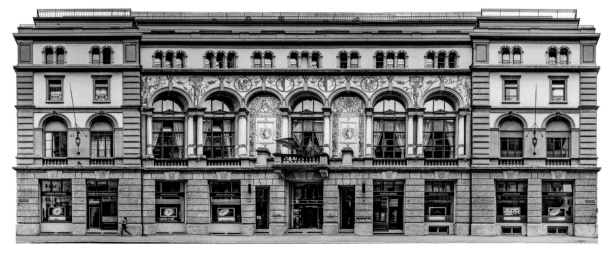

Opposite page, top:
Grand Régulateur, 1994

House of Chronoswiss, Lucerne

Sous le signe du « Régulateur »

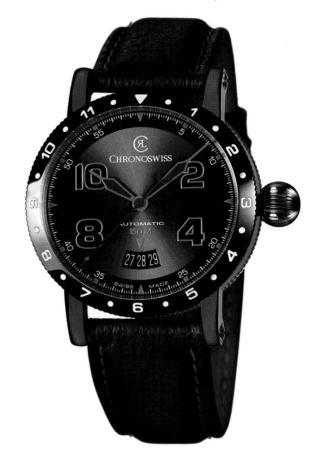

Timemaster 150, 2016

En 1981, Heuer Time Allemagne est mis en liquidation, entraînant le licenciement de son directeur, Gerd-Rüdiger Lang. Horloger de métier, il s'installe contraint et forcé à son compte, à 38 ans. Nécessité faisant loi, cet homme déchu prend un nouveau départ à Munich grâce à ses idées, son courage, son goût du risque et sa détermination. Son capital de départ : un énorme stock de pièces détachées, essentiellement pour chronographes. Assez indifférent à l'empreinte durable laissée sur le monde de l'horlogerie par la révolution du quartz, Gerd-Rüdiger Lang reconnaît le potentiel d'avenir de la bonne vieille mécanique et décide d'acheter et de vendre des montres-bracelets mécaniques au look rétro. Puis, à partir de 1983, il crée ses propres collections. Nombre des premières montres-bracelets signées Chronoswiss possèdent déjà un fond transparent, mais pas encore de style propre. L'histoire de Chronoswiss ne débute donc vraiment qu'en 1987, avec le « Régulateur ». Ce modèle marque l'apparition non seulement d'un cadran inédit, mais aussi du célèbre boîtier Chronoswiss à 19 composants. Son signe caractéristique, c'est bien sûr l'aiguille des heures, qui n'est plus au centre mais à midi. Ce type d'indication du temps est inspiré des anciennes horloges de précision que les horlogers utilisaient pour régler leurs montres. Les secondes jouaient alors un rôle prépondérant. L'aiguille des heures au centre gênant la lecture de la petite aiguille des secondes, il fallait la placer à un endroit où elle ne pouvait plus déranger. Pour la première édition de son « Régulateur », l'ambitieux entrepreneur utilise une version adaptée du calibre à remontage manuel Unitas 6376 Z, dont la production a été arrêtée en 1984. Avec les quelques exemplaires encore disponibles de ce mécanisme d'horlogerie, Chronoswiss sort une édition strictement limitée. Puis, la chance sourit une nouvelle fois aux audacieux. Gerd-Rüdiger Lang, qui dispose d'un bon réseau, fait l'acquisition des stocks inutilisés d'un mouvement mécanique à remontage automatique, un calibre à rotor mis au point dans les années 1970 par la marque Enicar, avant qu'elle aussi ne soit happée par le tourbillon du quartz. Ce mouvement, modifié comme il se doit, donne naissance en 1990 au « Régulateur Automatique ». En 1992, pour célébrer la sortie du catalogue intitulé « Fascination de la mécanique », Chronoswiss présente une vaste collection de montres, essentiellement des chronographes. En 2000, le « Régulateur à Tourbillon », fabriqué à partir d'un calibre Progress 6361 revisité, fait ses débuts. Présenté en 2001, le « Chronoscope », un chronographe à cadran de type régulateur, repose également sur le calibre Enicar évoqué plus haut. Gerd-Rüdiger Lang propose ainsi régulièrement aux collectionneurs et aux inconditionnels de la marque des éditions du « Régulateur » en séries très limitées, en s'appuyant sur des mouvements qui ne sont plus produits. Chronoswiss ayant refermé le chapitre allemand de son histoire en 2012, l'avenir de la marque se joue désormais en Suisse. En raison de son âge, Gerd-Rüdiger Lang confie son « bébé », qui a atteint une remarquable huitième place au classement des marques horlogères de luxe en Allemagne, au couple d'entrepreneurs suisses Eva Maria et Oliver Ebstein. Toutes les activités se déroulent désormais au nouveau siège de la marque (House of Chronoswiss), dans la pittoresque ville de Lucerne, sur les rives du lac des Quatre-Cantons. Si la « Timemaster » représente le volet sportif de la marque, « Sirius » incarne la ligne classique après le lifting du célèbre boîtier. L'année 2016 est elle aussi sous le signe de l'emblématique cadran à indication des heures décentrée. Ses nouvelles variantes – classiques ou à cadrans tridimensionnels – reçoivent toutefois un nouveau nom : « Regulator ». ◦

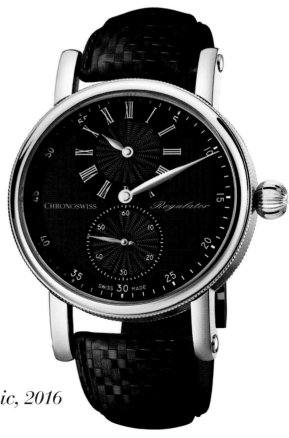

Regulator Classic, 2016

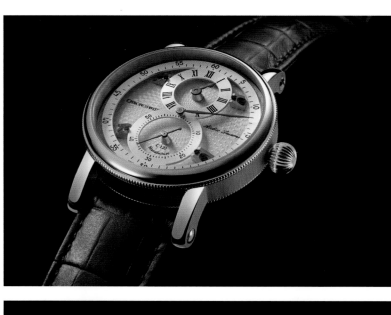

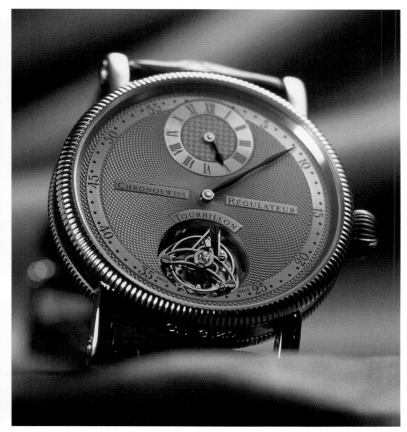

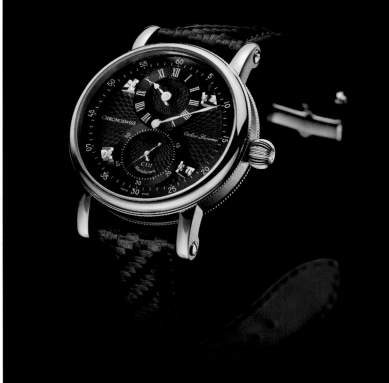

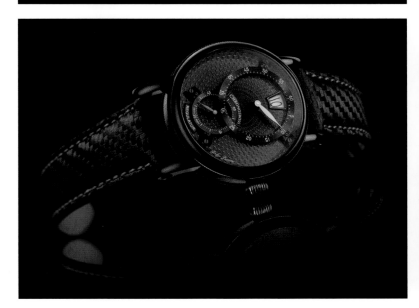

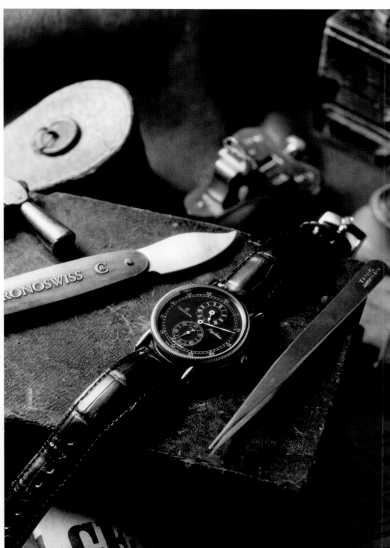

Clockwise from top left: Flying Regulator Manufacture, 2016 ◦ Régulateur à Tourbillon, 2000 ◦ Régulateur Automatique, 1990 ◦
Flying Regulator Jumping Hour, 2016 ◦ Flying Regulator Manufacture, 2016

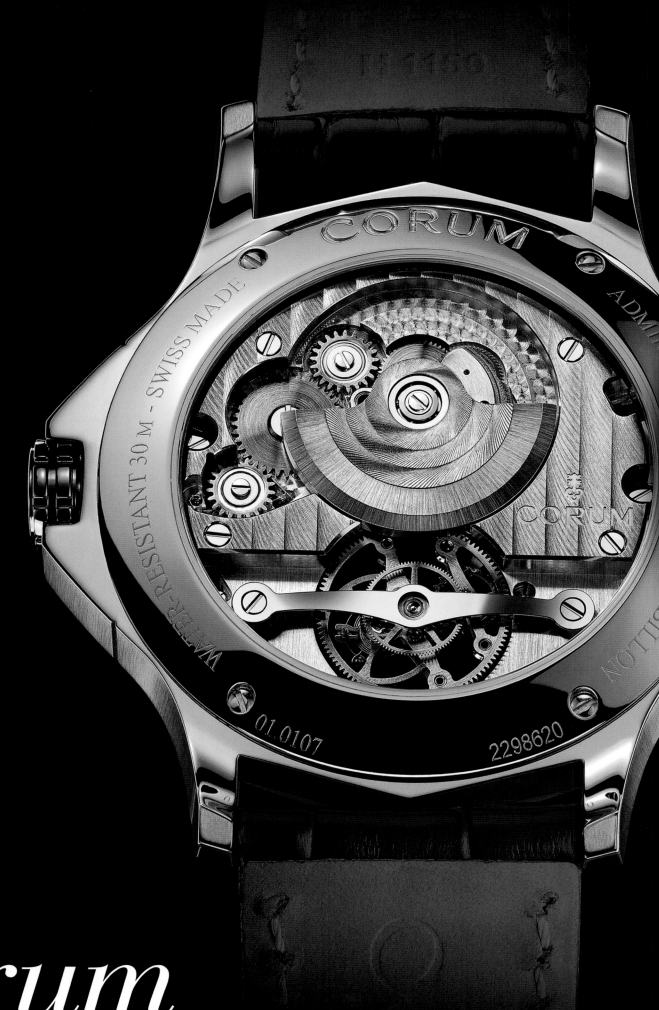

Corum

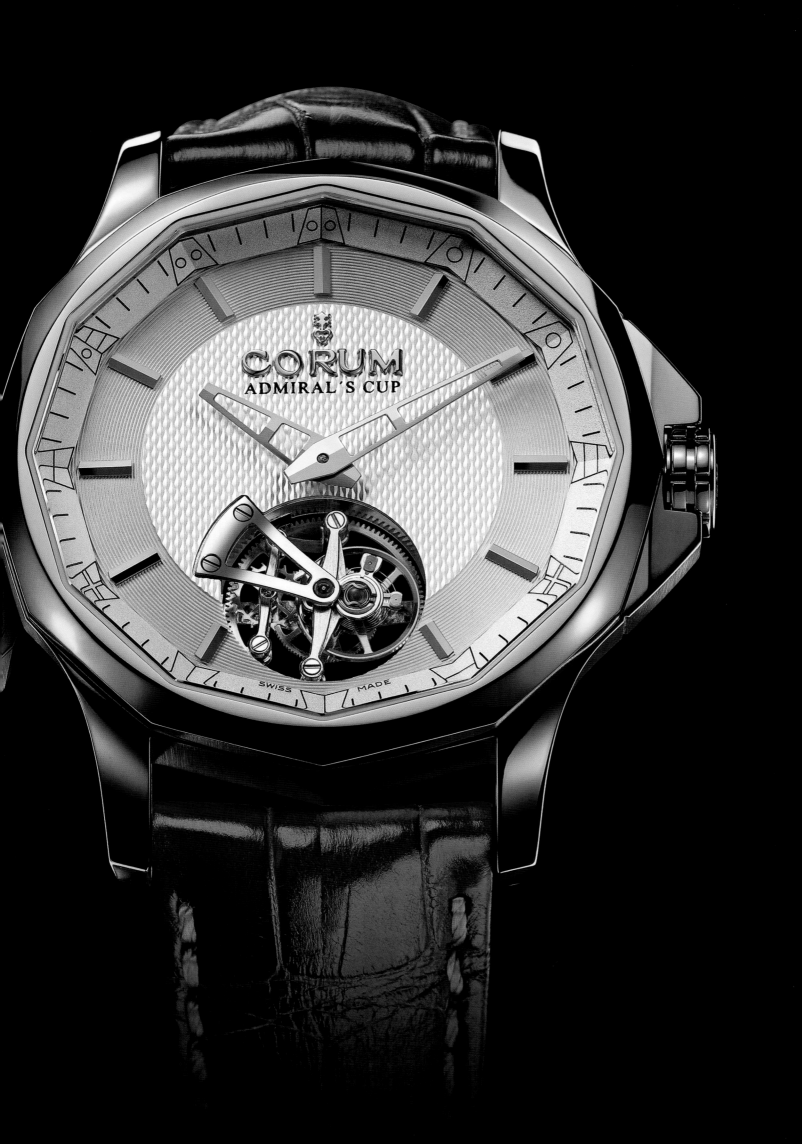

Key to Success

English

Watch design was a consuming passion for René Bannwart, a Swiss native who gained relevant experiences at Patek Philippe starting in 1933 and at Omega beginning in 1940. In 1955, he eagerly accepted an invitation from his uncle Gaston Ries and Ries's daughter Simone to join them as co-director of the watch factory that Gaston had established at La Chaux-de-Fonds in 1924. The small business delivered perfect merchandise, but because of the tradition of making watches on commission for third parties, it had neither a distinctive profile nor an attractive name. The latter, initially "Quorum," evolved from the team spirit of the executive board, but the name was difficult to pronounce in some languages and less than optimally readable on the international stage so it morphed into "Corum." The easily remembered logo (a vertical key) symbolizes "the key to beautiful time." This same key also opened the door to Corum's success, which has been based since 1956 on creating designs that set themselves appealingly apart from their competitors. This tradition continued with the 1958 debut of the "Chapeau Chinois": this model was aptly named because its broad bezel, which rises toward the middle part of the case, resembles a Chinese hat. Avidly discussed models followed with the "Sans Heures" in 1958, the "Coin Watch" in 1964 and the "Romulus" in 1966. A definitive classic debuted in 1977, when the young watchmaker Vincent Calabrese showed Bannwart the prototypes of a baton-shaped movement. After thorough evaluation, this led to the "Golden Bridge," which remained the brand's undisputed leader until 1980. Corum had to develop special machines to fabricate this watch's delicate mechanisms, but the effort earned the family business the right to describe itself as a full-fledged manufactory. The "Admiral's Cup" premiered in 1960 and has enriched the market with new interpretations since 1983. The Asian market had become increasingly important to Corum, but this dependency precipitated a crisis in the 1990s. Assistance from the Middle Eastern Alfardan Group in 1998 brought only temporary improvement. Corum was sold in 1999 to the American businessman Severin Wunderman, who had sold his Gucci Timepieces to the Amsterdam-based Gucci Group for 170 million dollars in 1997. The new owner developed a significantly more fashionable yet nonetheless idiosyncratic style that noticeably changed the face of the Corum brand. After Severin Wunderman's death in 2008, his American foundation began to entertain the idea of selling Corum, which came under the aegis of the Chinese Citychamp Group in May 2013. The company presents exclusive mechanisms in the several variants of the "Bridge" line. And the timekeeping "Bubble," which debuted in 2000, celebrated a successful comeback in 2016. ○

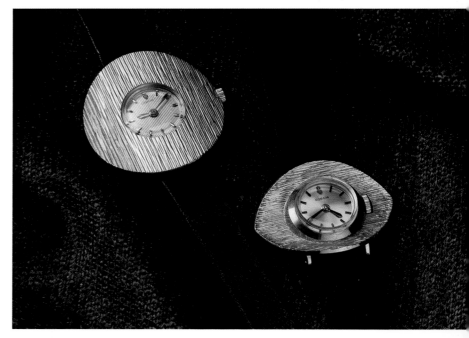

From top: Simone Ries and René Bannwart, 1955 ○
Chapeau Chinois, 1958 ○ Coin Watch, 1964

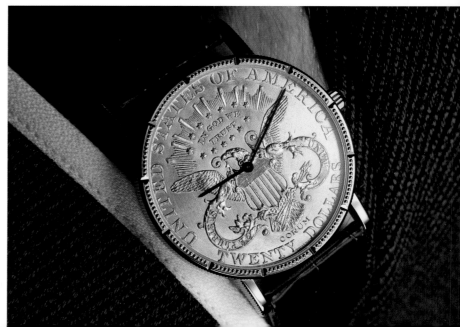

Schlüssel zum Erfolg

Deutsch

Uhrendesign war die große Passion von René Bannwart. Einschlägige Erfahrungen hatte der Schweizer ab 1933 bei Patek Philippe und insbesondere ab 1940 im Hause Omega gesammelt. Deshalb kam 1955 der Lockruf seines Onkels Gaston Ries und dessen Tochter Simone gerade recht, zusammen mit ihnen die Leitung der 1924 von Ries gegründeten Uhrenfabrik in La Chaux-de-Fonds zu übernehmen. Das kleine Unternehmen leistete zwar perfekte Arbeit, besaß aber wegen der Tradition, Uhren im Lohnauftrag für andere zu fertigen, weder ein ausgeprägtes Profil noch einen zugkräftigen Namen. Letzterer erwuchs aus dem Teamgeist der Führungsmannschaft und lautete zunächst Quorum. Weil das „Qu" Aussprache und Lesbarkeit auf internationaler Bühne beeinträchtigen würde, mutierte das Wort zu Corum. Das einprägsame Firmenlogo, der stehende Schlüssel, symbolisiert „The key to beautiful time". Der Schlüssel der schönen Zeitmessung ist zugleich auch jener des Erfolgs, welcher ab 1956 darin bestand, sich gestalterisch vom Üblichen abzuheben. Dem trug beispielsweise der 1958 vorgestellte „Chapeau Chinois" Rechnung. Die breite, zur Gehäusemitte ansteigende Lünette erinnert tatsächlich an einen Chinesenhut. 1958 brachte mit „Sans Heures", 1964 mit der „Coin Watch" und 1966 mit „Romulus" heiß diskutierte Uhrenmodelle. Der Klassiker schlechthin geht auf das Jahr 1977 zurück, als der junge Uhrmacher Vincent Calabrese mit dem Prototypen eines stabförmigen

Uhrwerks bei Bannwart vorsprach. Nach gründlicher Evaluation entstand daraus bis 1980 der unangefochtene Markenleader „Golden Bridge". Zur Herstellung der delikaten Mechanik musste Corum spezifische Maschinen entwickeln. Fortan durfte sich das Familienunternehmen Manufaktur nennen. In der „Admiral's Cup"-Linie kommen seit 1983 Neuinterpretationen des erstmals 1960 erschienenen Modells auf den Markt. In den 1990er Jahren geriet die immer stärker auf das Asiengeschäft ausgerichtete Firma kräftig ins Schlingern. Das Engagement der mittelöstlichen Alfardan-Gruppe brachte 1998 nur eine vorübergehende Linderung. 1999 erfolgte der Verkauf an Severin Wunderman, einen amerikanischen Geschäftsmann, welcher 1997 seine Gucci Timepieces für 170 Millionen Dollar an die Amsterdamer Gucci-Gruppe veräußert hatte. Der neue Eigentümer entwickelte einen deutlich modischeren, aber auch eigenwilligen Stil, welcher das Gesicht der Marke Corum merklich veränderte. Nach dem Tod von Severin Wunderman im Jahr 2008 trug sich dessen amerikanische Stiftung immer stärker mit Ausstiegsgedanken. Seit Mai 2013 befindet sich Corum unter dem Dach der chinesischen Citychamp. Exklusive Mechanik praktiziert das Unternehmen bei den verschiedenen Varianten der „Bridge"-Kollektion. Und 2016 feierte die 2000 lancierte Zeit-Blase namens „Bubble" ein erfolgreiches Comeback. ○

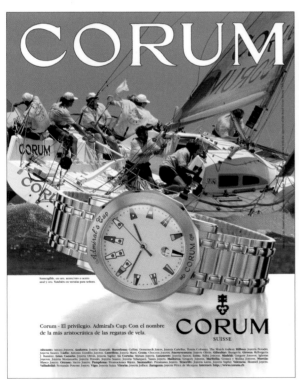

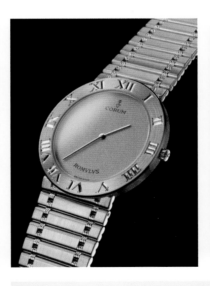

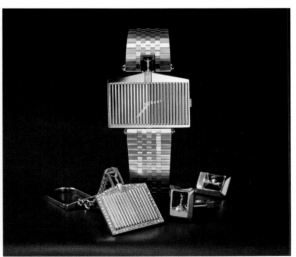

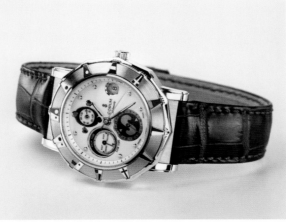

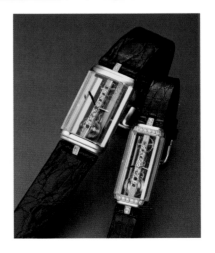

Clockwise from top left: Admiral's Cup, 1983 ○
Romulus, 1966 ○ Rolls-Royce, 1976 ○
Golden Bridge, 1980 ○ Admiral's Cup Tides, 1993

La clé du succès

Passionné de design de montres, le Suisse René Bannwart fait ses premières armes chez Patek Philippe, où il entre en 1933. Il parfait son expérience à partir de 1940 au sein de la maison Omega. Aussi, en 1955, la proposition alléchante que lui font son oncle Gaston Ries et sa fille Simone de tenir avec eux les rênes de la fabrique de montres fondée par Gaston Ries en 1924 à La Chaux-de-Fonds vient-elle à point nommé. Cette petite entreprise excelle dans son travail mais elle n'a ni une identité affirmée – elle réalise depuis toujours des montres pour le compte de tiers – ni un nom accrocheur. Elle s'appelle au départ Quorum, par référence à l'esprit d'équipe de sa direction, mais la combinaison de lettres « qu » se révélant difficile à prononcer et à lire sur la scène internationale, on adopte la graphie Corum. Son logo marquant, une clé dressée vers le ciel, symbolise « The key to beautiful time ». Cette « clé de la belle mesure du temps » est aussi celle du succès, qui tient à partir de 1956 à des designs d'avant-garde, comme le « Chapeau Chinois », présenté en 1958 : sa large lunette qui va s'évasant jusqu'à mi-hauteur du boîtier rappelle effectivement le fameux couvre-chef conique. Sortis respectivement en 1958, 1964 et 1966, les modèles « Sans Heures », « Coin Watch » et « Romulus » déchaînent les passions. Le modèle classique par excellence remonte à 1977, année où le jeune horloger Vincent Calabrese se présente chez Bannwart avec un prototype de mouvement baguette. Après une évaluation approfondie, Corum met au point sur cette base « Golden Bridge », le fer de lance incontesté de la marque, qui sort en 1980. Pour la fabrication de la délicate mécanique, Corum doit développer des machines spéciales. L'entreprise familiale peut désormais prétendre à l'appellation manufacture. Le modèle « Admiral's Cup » sorti en 1960 sera réinterprété à plusieurs reprises à partir de 1983. L'entreprise, qui mise de plus en plus sur les marchés asiatiques, entre en zone de fortes turbulences dans les années 1990. L'intervention en 1998 du groupe Alfardan, basé au Moyen-Orient, n'apporte qu'une amélioration passagère. Corum est vendue en 1999 à l'homme d'affaires américain Severin Wunderman, qui a cédé deux ans plus tôt ses garde-temps Gucci au groupe Gucci d'Amsterdam pour la somme de 170 millions de dollars. Le nouveau propriétaire développe un style nettement plus tendance, mais aussi plus original, qui change en profondeur le visage de la marque. Après le décès de Severin Wunderman en 2008, sa fondation aux États-Unis envisage de plus en plus sérieusement de céder l'affaire. Dans le giron du groupe chinois Citychamp depuis 2013, Corum équipe de mouvements mécaniques exclusifs ses différentes variantes de la collection « Bridge ». En 2016, la montre « Bubble » à verre bombé lancée en l'an 2000 fait un retour triomphal. ○

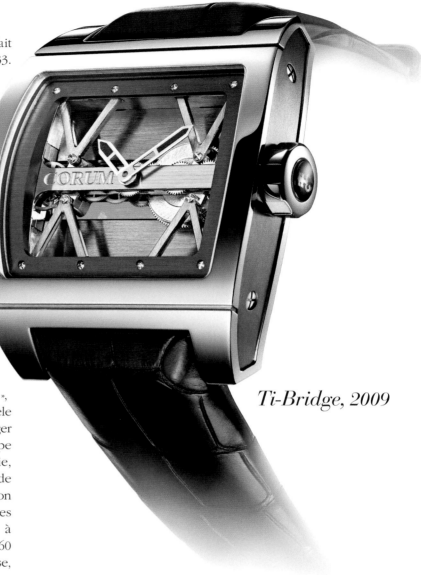

Ti-Bridge, 2009

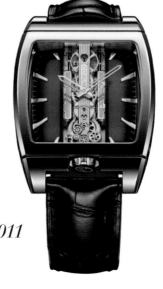

Golden Bridge Automatic, 2011

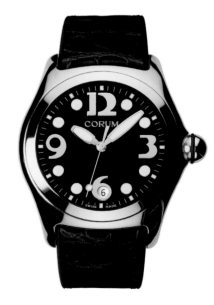

Bubble, 2000

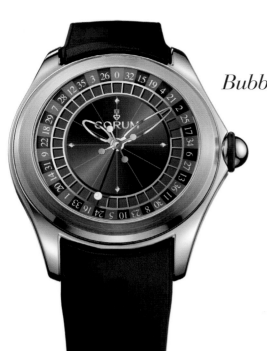

Bubble Roulette, 2016

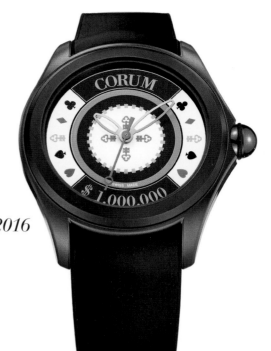

Bubble Casino Chip, 2016

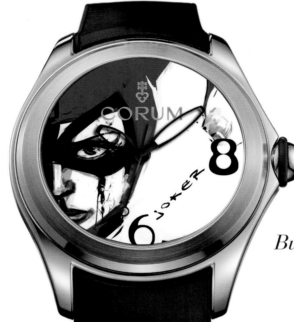

Bubble Joker, 2016

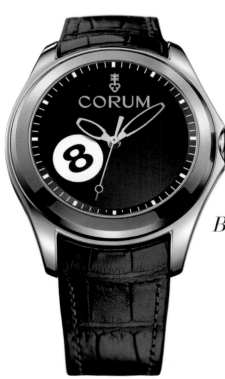

Bubble 8 Ball, 2016

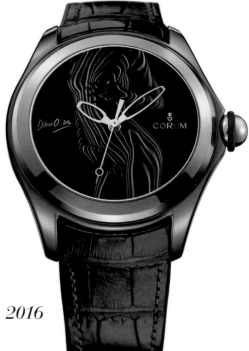

Bubble Dani Olivier, 2016

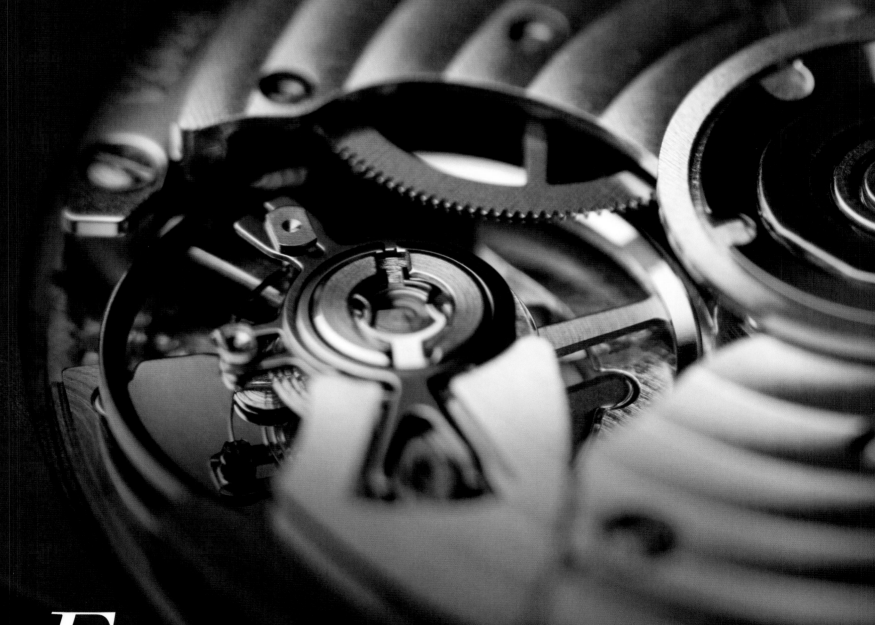

Eterna

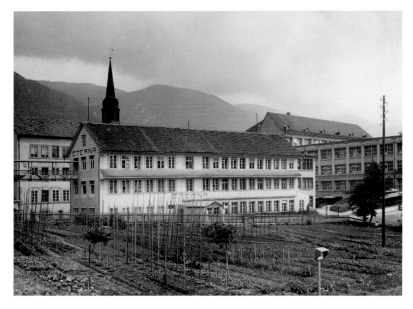

From left: Dr. Josef Girard ○ Urs Schild ○ Eterna's factories, 1910 ○ Von links: Dr. Josef Girard ○ Urs Schild ○ Eterna-Werke, 1910 ○
De gauche à droite : Le docteur Josef Girard ○ Urs Schild ○ La fabrique Eterna, 1910

Back to the Future

Eterna has faced many challenges during the past few decades. Turbulence repeatedly shaped events at this venerable Swiss watch brand. The most recent chapter began when the family of the late designer Ferdinand Alexander Porsche (who acquired Eterna in October 1995 and died in 2012) announced the brand's sale to the China Haidian corporate group, now known as Citychamp. Eterna had been the property of the industrialist Franz Wassmer, who took it over from the forerunner of the Swatch Group in September 1984. The enterprise was established by the physician Dr. Josef Girard and the schoolteacher Urs Schild, who were eager to reduce joblessness in the formerly insignificant town of Grenchen near Solothurn. On November 7, 1856, the duo established the "Dr. Girard & Schild" ébauche factory, from which the Eterna watch manufactory would later emerge. Noteworthy successes ensued in 1863 and thereafter. Girard left the company in 1866. Automated machinery was installed in 1870. And the first Eterna watches left the ateliers in 1876. When "Eterna-Werke, Gebrüder Schild & Co." was established as a limited partnership in 1906, the name that had been written on the dials was also transferred to the company per se. Numerous inventions and world premieres earned worldwide fame for Eterna in the 20th century. For example, the label debuted its first wristwatch with a built-in alarm in 1914, followed by the smallest serially manufactured wristwatch with a baguette movement in 1930. Series production of a relatively small and slim self-winding movement began in 1942. Eterna set a global standard, which remains valid today, with the 1948 premiere of a self-winding movement with a rotor borne atop reliable, low-maintenance, miniature ball bearings. Another innovation was a click-wheel polarizing mechanism to efficiently use the rotor's kinetic energy in both its directions of rotation. The "Golden Heart," which debuted in 1958, encased its epoch's smallest automatic movement with solid gold oscillating weight. Caliber 3000 followed in 1962 as the slimmest wristwatch

with a centrally positioned oscillating weight and a date display. Theodor Schild agreed to divide his watch factory into two separate joint-stock companies in 1932: Eterna AG for the fabrication of precise watches and Eta AG for the production of ébauches. In recognition of its contributions to Europe's reputation throughout the world, an international jury in 1980 awarded Eterna the Grand Prix de l'Excellence Européenne, which had been established by the Noble Peace Prize laureate René Cassin.

Under the direction of its Chinese owners, Eterna now plans to pursue a two-track strategy. The entry-level price segment will be covered by watches encasing movements from third-party suppliers, e.g., calibers from Eterna's former affiliate Eta (which has belonged to the Swatch Group and its predecessor for more than 30 years) or clones from Sellita. Alongside this first track, Eterna will continue to function as a veritable manufacture. Uncommon versatility distinguishes movement family 39xx: it's fabricated by the Eterna Movement Company (EMC), which was established in 2012. Eighty-eight variants are currently available: the spectrum ranges from a simple hand-wound movement to an automatic chronograph. The latter, column-wheel Caliber 3916A, animates the "Super KonTiki." This sporty wristwatch was born in 1947, when the then 32-year-old Norwegian ethnologist Thor Heyerdahl sailed a balsawood raft across the Pacific. Eterna honored him in 1958 by launching the "KonTiki 20," which resists water pressure to 20 bar. It's not surprising to find that the "KonTiki" line ranks among the icons of the house of Eterna. ○

*Alarm wristwatch,
patented in 1914*

Zurück in die Zukunft

Leicht hatte es Eterna während der vergangenen Jahre wirklich nicht. Turbulenzen bestimmten das Geschehen rund um die altehrwürdige Schweizer Uhrenmarke. Das vorerst letzte Kapitel begann, als die Familie des 2012 verstorbenen Designers Ferdinand Alexander Porsche, welche Eterna im Oktober 1995 erworben hatte, den Verkauf an die Unternehmensgruppe China Haidian, heute Citychamp, verkündete. Seit September 1984 hatte sich das Unternehmen im Eigentum des Industriellen Franz Wassmer befunden, welcher es seinerseits vom Vorläufer der heutigen Swatch Group übernommen hatte. Die Gründung des Unternehmens geht zurück auf Dr. Josef Girard und Urs Schild. Dem Arzt und dem Schullehrer war es ein Anliegen, die gravierende Arbeitslosigkeit in der damals eher bedeutungslosen Ortschaft Grenchen nahe Solothurn zu mindern. Am 7. November 1856 rief das Duo die Rohwerkefabrik Dr. Girard & Schild ins Leben, aus der später die Uhrenmanufaktur Eterna hervorgehen sollte. Nennenswerte Erfolge waren ab 1863 zu berichten. 1866 zog sich der Mediziner zurück. Fertigungsautomaten hielten 1870 ihren Einzug. Und 1876 verließen erste Eterna-Uhren die Ateliers. Mit Gründung der Kommanditgesellschaft Eterna-Werke, Gebrüder Schild & Co. wurde der eingeführte Zifferblattname 1906 auch auf die Firma selbst übertragen. Im 20. Jahrhundert trugen zahlreiche Erfindungen und Weltpremieren diesen Namen in alle Welt. In diesem Sinne präsentierte Eterna 1914 die erste Armbanduhr mit Wecker oder 1930 die damals kleinste serienmäßig hergestellte Armbanduhr mit Baguettewerk. 1942 startete die Serienproduktion eines relativ kleinen und flachen Automatikwerks. Den bis heute gültigen Weltstandard für Uhrwerke mit Rotoraufzug lancierte Eterna 1948 durch die Verwendung eines zuverlässigen und wartungsarmen Miniatur-Kugellagers. Ebenfalls neu: ein Klinkenrad-Wechselgetriebe zur effizienten Nutzung der kinetischen Energie des Rotors in beiden Drehrichtungen. In der 1958 vorgestellten „Golden Heart" tickte das seinerzeit kleinste Automatikwerk mit massivgoldener Schwungmasse. Schließlich führte das 1962 fertiggestellte Kaliber 3000 zur flachsten Armbanduhr mit zentral angeordneter Schwungmasse und Datumsanzeige. Bereits 1932 hatte Theodor Schild nolens volens der Aufteilung seiner Uhrenfabrik in zwei getrennte Aktiengesellschaften zugestimmt: die Eterna AG zur Fertigung von Präzisionsuhren und die Eta AG, welche sich um die Fabrikation von Rohwerken kümmerte. Für ihre Verdienste um das Ansehen Europas in der ganzen Welt verlieh eine international besetzte Jury der Eterna 1980 den vom Friedensnobelpreisträger René Cassin gestifteten Grand Prix de l'Excellence Européenne.

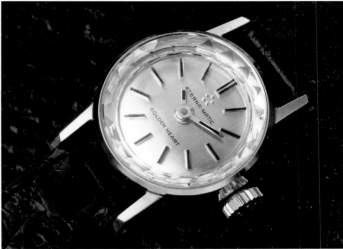

Unter chinesischer Regie wird Eterna zukünftig zweigleisig fahren. Im Einstiegs-Preissegment ticken durchweg zugekaufte Uhrwerke, also beispielsweise Kaliber der ehemaligen Schwester Eta, welche seit mehr als 30 Jahren zur heutigen Swatch Group gehört, oder Klone von Sellita. Daneben betätigt sich Eterna inzwischen auch wieder als Manufaktur. Durch besondere Vielseitigkeit zeichnet sich hier die Werkefamilie 39xx aus. Für deren Fabrikation zeichnet die 2012 gegründete Eterna Movement Company (EMC) verantwortlich. Derzeit sind 88 Varianten erhältlich, angefangen vom einfachen Handaufzugswerk bis hin zum Automatik-Chronographen. Letzterer, konkret das Schaltrad-Kaliber 3916A, beseelt die „Super KonTiki". Diese sportliche Armbanduhr erinnert ans Jahr 1947, als der damals 32-jährige norwegische Ethnologe Thor Heyerdahl mit einem Balsaholzfloß über den Pazifik segelte. Ihm zu Ehren hatte Eterna u. a. 1958 die bis 20 Bar wasserdichte „KonTiki 20" auf den Markt gebracht. Kein Wunder also, dass die „KonTiki"-Linie zu den Ikonen des Hauses Eterna gehört. ○

From top: Eterna's headquarters in Grenchen ○ Golden Heart, 1958 ○
Enamel sign, 1920 ○ Advertisement, 1949 ○ Von oben: Eterna-Hauptsitz
in Grenchen ○ Golden Heart, 1958 ○ Emailleschild, 1920 ○ Werbung, 1949 ○
De haut en bas : Le siège d'Eterna à Granges ○ Golden Heart, 1958 ○
Pancarte émaillée, 1920 ○ Publicité, 1949

Retour vers le futur

Les choses n'ont pas été faciles du tout pour Eterna au cours de ces dernières années, quelque peu tumultueuses pour cette vénérable marque horlogère suisse. Ce qui est provisoirement le dernier chapitre dans son histoire débute lorsque la famille du concepteur de voitures Ferdinand Alexander Porsche (décédé en 2012), qui a racheté Eterna en 1995, annonce sa cession au groupe chinois Haidan, connu aujourd'hui sous le nom de Citychamp. Depuis septembre 1984, l'entreprise appartient à l'industriel Franz Wassmer, qui l'a rachetée à la SMH, devenue par la suite le Swatch Group. La création de l'entreprise remonte au docteur Josef Girard et à l'instituteur Urs Schild. Soucieux de résoudre le grave problème d'emploi dans la localité plutôt insignifiante de Granges, près de Soleure, ces deux hommes fondent le 7 novembre 1856 la fabrique d'ébauches Dr. Girard & Schild, qui donnera naissance à la manufacture horlogère Eterna. L'entreprise enregistre ses premiers succès notables en 1863. Le médecin se retirera des affaires en 1866.

La production est mécanisée en 1870, et la première montre de manufacture sort des ateliers en 1876. À la fondation de la société en commandite Eterna-Werke, Gebrüder Schild & Co, en 1906, le nom Eterna apposé sur le cadran est aussi adopté comme nom de société. Au XIXᵉ siècle, de nombreuses inventions et premières mondiales feront connaître ce nom dans le monde entier. Eterna présente ainsi en 1914 la première montre-bracelet réveil ou encore en 1930 la plus petite montre-bracelet équipée d'un mouvement baguette qui soit fabriquée en série. En 1942, la société lance la production en série d'un mouvement automatique relativement petit et plat. En 1948, elle introduit ce qui est demeuré une référence mondiale en matière de mouvement à remontage automatique : un dispositif à roulement à billes miniature fiable et requérant peu de maintenance. Autre innovation, une transmission dotée d'une roue à rochet permet de tirer parti de l'énergie cinétique du rotor dans les deux sens de rotation. La « Golden Heart » présentée en 1958 est animée par ce qui est à l'époque le plus petit mouvement mécanique doté d'une masse oscillante en or massif. Enfin, le calibre 3000 parachevé en 1962 permet de réaliser la montre-bracelet la plus plate au monde, à date et masse oscillante centrale.

Dès 1932, Theodor Schild avait accepté bon gré mal gré la scission de sa fabrique horlogère en deux sociétés anonymes distinctes : Eterna SA, fabricant de montres de précision, et ETA SA, spécialisée dans la fabrication d'ébauches. En 1980, un jury international décerne à Eterna pour sa contribution au rayonnement de l'Europe dans le monde entier le Grand Prix de l'excellence européenne, récompense créée par le lauréat du prix Nobel de la paix René Cassin.

Désormais en des mains chinoises, Eterna poursuivra une stratégie reposant sur deux piliers. Les produits d'entrée de gamme sont animés par des mouvements achetés, notamment des calibres de l'ancienne entreprise sœur Eta, qui fait partie depuis plus de 30 ans de l'actuel Swatch Group, ou leurs clones livrés par Sellita. Parallèlement, Eterna a repris son activité de manufacture. La famille de calibres 39xx, dont la fabrication est entièrement assurée par Eterna Movement Company (EMC), société fondée en 2012, se distingue par sa très grande polyvalence : elle comprend à l'heure actuelle 88 variantes, du mouvement à remontage manuel simple jusqu'aux chronographes automatiques. C'est d'ailleurs le calibre 3916A équipé d'une roue à colonnes qui anime la « Super KonTiki ». Cette montre-bracelet sportive évoque le souvenir du radeau en rondins de balsa sur lequel l'ethnologue norvégien Thor Heyerdahl, alors âgé de 32 ans, a traversé le Pacifique en 1947. En son honneur, Eterna a commercialisé entre autres en 1958 la montre « KonTiki 20 » étanche jusqu'à 20 bars. Rien d'étonnant donc à ce que la ligne « KonTiki » fasse partie des icônes de la maison Eterna. ◦

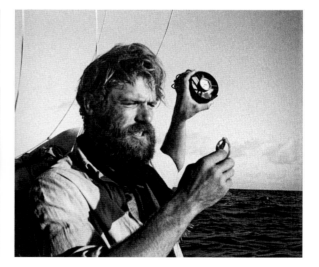

Top: Cal. 3916A ◦ From left: Grand Prix de l'Excellence Européenne, 1980 ◦ Thor Heyerdahl

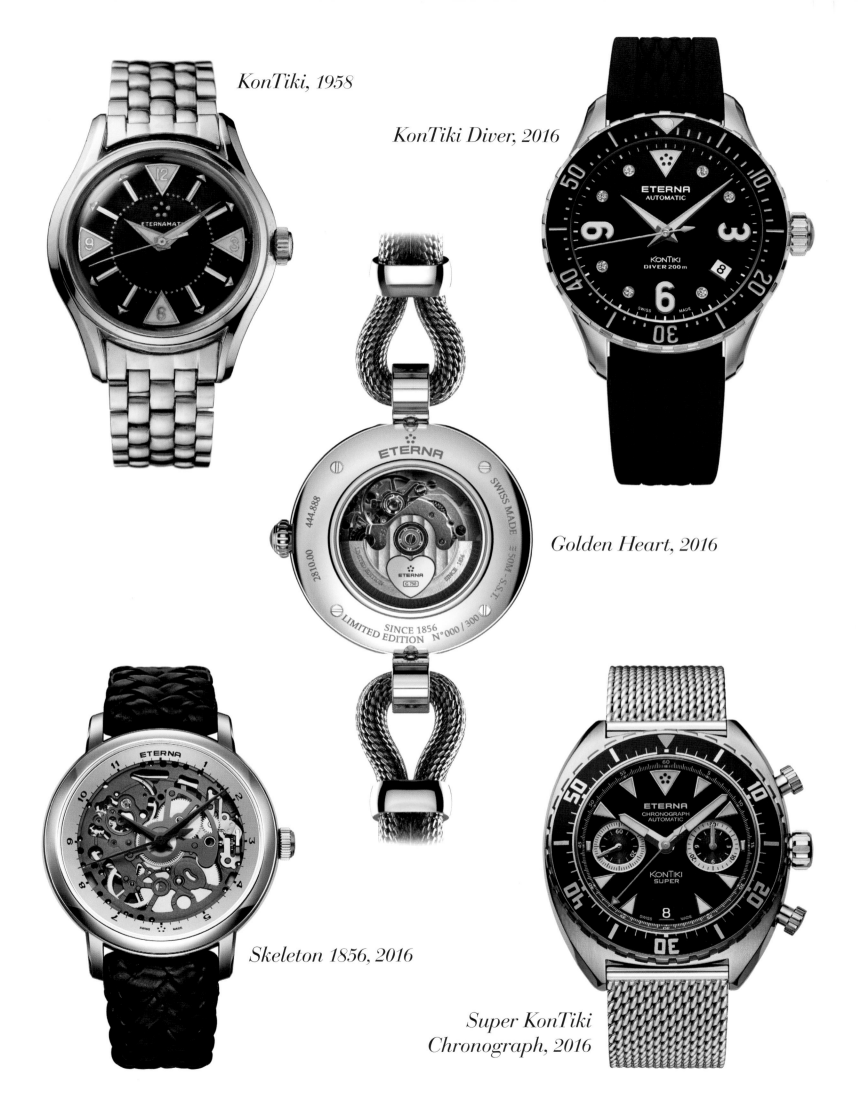

KonTiki, 1958

KonTiki Diver, 2016

Golden Heart, 2016

Skeleton 1856, 2016

*Super KonTiki
Chronograph, 2016*

Frédérique Constant

The Passionate Heartbeat of a Youthful Manufactory

A memorable line in the novel *War and Peace* declares: "It is impossible to eradicate the passions; we can only strive to pilot them toward a noble goal." Leo Tolstoy's words were evidently taken to heart by Peter C. Stas and Aletta Stas-Bax, whose entrepreneurial activities began with an insatiable passion for wristwatches, e.g., the ones this Dutch couple admired during skiing holidays in the Swiss Alps. At some point, they had nearly no other choice but to sacrifice their secure jobs at global corporations on the altar of watch-related activities. But let's take our story one step at a time…. The mid 1980s found the two young people living in Hong Kong, a very special watch Mecca. Alongside his "day job," Peter Stas started a company for design software in 1988. Among other projects, he used this software to design wristwatches because he felt that watches produced in China looked absolutely awful. Old books and catalogues served him as a basis. Aletta Stas chose the watch fair in Hong Kong as the venue for the premiere of the first prototypes, which she and Peter had screwed together, so to speak, in their kitchen. Shortly before the end of the fair, a Japanese wholesaler ordered 350 timepieces, which sold surprisingly well and led to follow-up orders for another 1,100 watches. The next year witnessed a collection of prototypes consisting of six models: each was equipped with a quartz movement, but all six were assembled in Switzerland from Swiss components. These "children" likewise thrived and soon needed a suitable name. Aletta's great-grandmother Frédérique Schreiner and Peter's great-grandfather Constant Stas served as namesakes, and the two ancestors' first names were combined to create "Frédérique Constant." Founded with starting capital of 60,000 Swiss francs, the Frédérique Constant SA and its external partners collaboratively produced more than 1,000 Swiss-made wristwatches in 1992. Brisk sales motivated the company to attempt greater exploits. A stroke of good luck came in the form of a meeting with Miguel Garcia, who was sales director at Sellita at this time. In the course of their conversation, they realized that the dial side of Eta's relatively tall self-winding Caliber 2836 could be opened to directly reveal "the heartbeat of human culture." This formed the basis for the 1994 debut of the "Heart Beat" collection, which was not protected by patent and thus soon copied. The youthful company achieved larger quantities and more favorable cost structures through private-label production, which was later discontinued. A business plan drawn up in 1996 envisioned Geneva as the location of the firm's headquarters, so the Stases applied for permission to work in Switzerland. Their request was granted, but only under the condition that a staff of at least twelve employees would be established within five years. This goal was reached within just 2½ years—and entirely through self-financed growth. Clear visions, and the desire to make something of their own that could stand beside calibers purchased from third parties, led in 2001 to the start of developmental work for their first hand-wound manufacture caliber. Peter Stas initiated cooperation with specialists from two watchmaking schools, one in Geneva and the other in Holland, for this ambitious project. Frédérique Constant surprised the watch world in 2004 with the premiere of the Heart Beat FC-910-1. Its astonishingly large balance oscillated under an aperture cut in the dial at the "6." The moon-phase version FC-915 debuted in 2005, followed in 2006 by an exclusive self-winding model designated as FC-930. New materials debuted in 2007. A specially designed silicon escape-wheel oscillates in automatic Caliber FC-935 Silicium with moon-phase and hand-type date. A visionary developmental step is embodied in the variant with the cryptic designation "FC-935SZABS4H9" that was sold at the

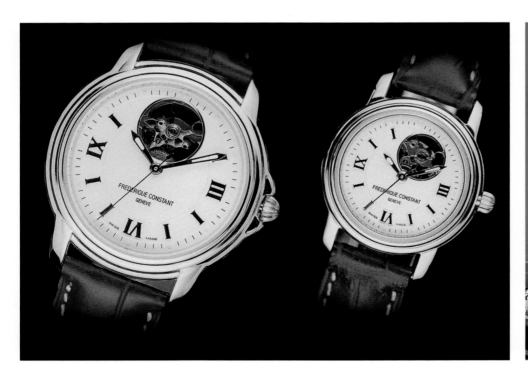

Left: Original Heart Beat models from 1994 ○ *Links: Heart Beat, Originalmodelle von 1994* ○ *À gauche : Modèles originaux Heart Beat de 1994* ○
Right: Peter C. Stas and Aletta Stas-Bax

"One of a Kind" charity auction in Monte Carlo in September 2007. Alongside its silicon escape-wheel, this unique timepiece is also equipped with a totally innovative balance made from Zerodur, a glass-ceramic composite. Another of the brand's own watches, the "Heart Beat Tourbillon," debuted in a limited edition of 188 specimens in 2008. Its special features: balance-stop function, intelligent Smart-Screw system to perfectly poise the tourbillon's cage, and an antimagnetic silicon escape-wheel. Over 80 percent of the components needed for automatic Caliber FC-980-1 were fabricated at the firm's headquarters in Plan-les-Ouates, which was inaugurated in 2006 and commands a view of several renowned traditional Genevan watch manufactories. Despite ongoing improvements and expansions in its machine park, Frédérique Constant continues to rely on external suppliers to satisfy its demand for larger quantities. However, fine processing, assembly and quality control all take place exclusively under the firm's own roof. The youthful manufactory produced 90,000 watches in 2008. Revenues doubled within just a few years' time, partly thanks to greater net value added. Of course, compared to the industry as a whole, manufactory-made products occupied and continue to occupy a small niche. The philosophy of the firm's founders, i.e., to offer affordable luxury for customers around the globe, is primarily based on elegant timepieces encasing third-party movements. If the calibers are mechanical, they're ennobled according to standards defined by the firm. Most such calibers are supplied by Selitta. Frédérique Constant celebrated the tenth anniversary of its own manufacture caliber in 2014. The product spectrum already includes fifteen calibers in two families. Calibers numbered 9xx show their escapements under the dials. Rotors automatically wind the mainsprings of FC-7xx calibers, which do not reveal their beating hearts. Basic Caliber FC-710 with central second-hand combines 137 components, has a diameter of 30 millimeters and is 6.2 millimeters tall. Its central rotor winds the mainspring in both directions of rotation. The fully wound barrel stores sufficient energy to keep the balance oscillating at a pace of four hertz for 42 hours.

A sensational manufactory highlight debuts in 2016. The "Slimline Perpetual Calendar Manufacture," which includes a calendar mechanism that won't need manual correction until 2100, encases exclusive automatic Caliber FC-775. Watchmakers need fully 78 components to create the complex switching mechanism under this model's dial. The price is unique too: circa 8,000 euros.

A wholly new chapter—namely, an electronic chapter—began in 2015 with the "Horological Smartwatch," which has analogue displays for the time and the functions. Connectable with Android and iOS telephones, this Swiss-made watch resulted from collaboration with specialists in the USA. Frédérique Constant was able to bring more than 16,000 of these watches to male (75 percent) and female wrists in just one year. Thanks to the dedication of twelve engineers in Switzerland, Peter Stas would like to significantly expand this project. The numbers of units are likewise scheduled to increase. If all goes as planned, the counters will tally circa 145,000 wristwatches by the end of 2016. There's only one word for that: Success! ∘

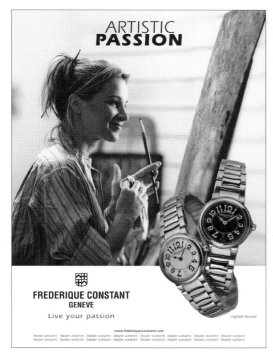
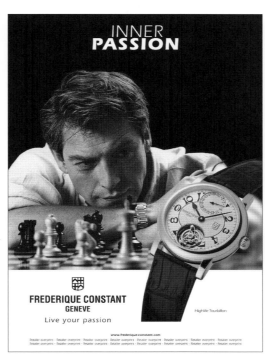
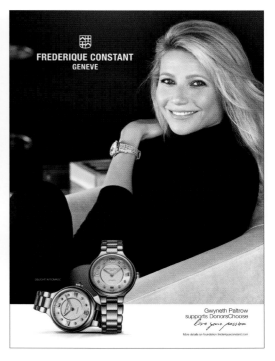

From left: Advertisement, 2004 ∘ 2004 ∘ 2016 ∘ Von links: Werbung, 2004 ∘ 2004 ∘ 2016 ∘ De gauche à droite : Publicité, 2004 ∘ 2004 ∘ 2016

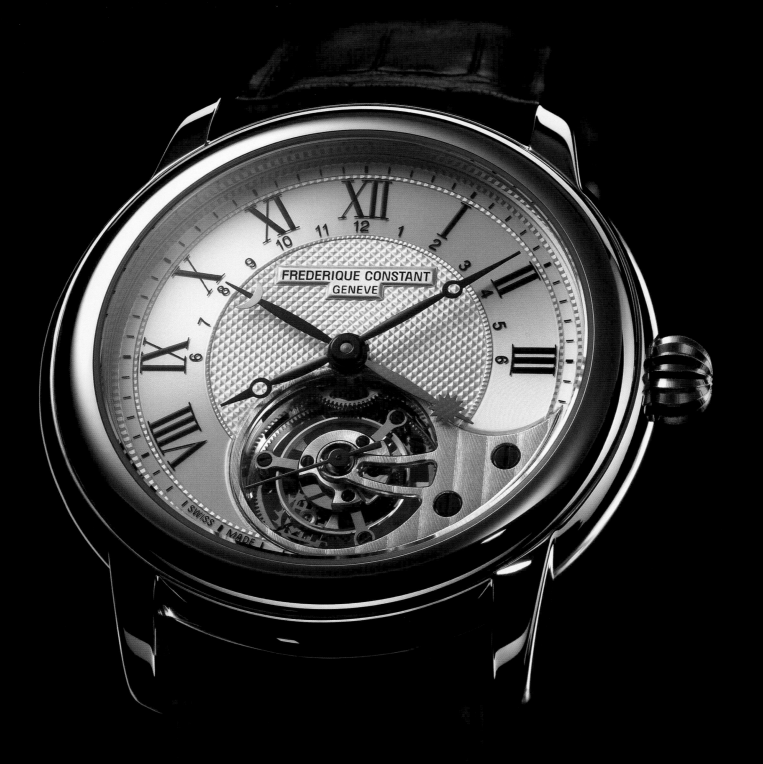

Manufacture Tourbillon,
FC-98OMC4M9, 2008

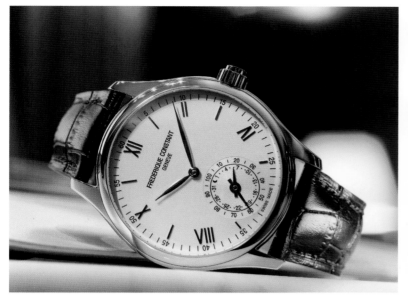

Horological Smartwatch, FC-285V5B4, 2015
When tradition meets technology
Wenn Tradition auf Technologie trifft
Le mariage entre tradition et technologie

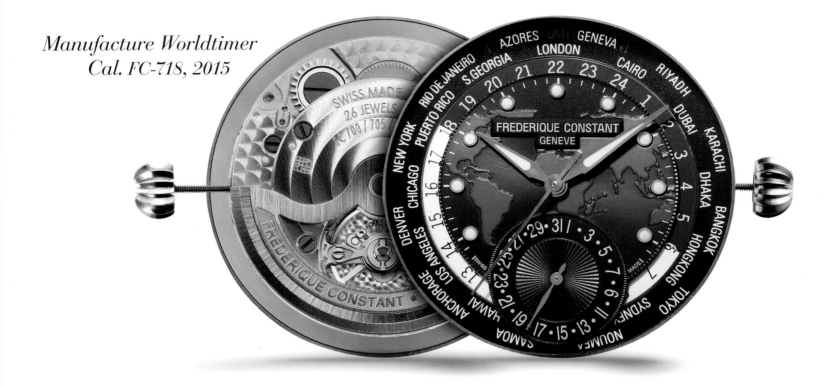

Passionierter Herzschlag einer jungen Manufaktur

Im Roman *Krieg und Frieden* steht zu lesen: „Es ist unmöglich, die Leidenschaften auszurotten; wir müssen nur darauf bedacht sein, sie auf ein edles Ziel zu lenken." Diese Worte von Leo N. Tolstoi haben Peter C. Stas und Aletta Stas-Bax ganz offensichtlich verinnerlicht. Ihr unternehmerisches Handeln begann nämlich mit einer unstillbaren Passion für Armbanduhren. Solche bewunderte das holländische Ehepaar während seiner Ski-Urlaube in den Schweizer Bergen. Irgendwann blieb fast keine andere Wahl, als die sicheren Jobs bei Weltkonzernen auf dem Altar eigener Uhr-Aktivitäten zu opfern. Aber schön der Reihe nach: Mitte der 1980er Jahre lebten die beiden in Hongkong, einem sehr speziellen Uhrenmekka. 1988 gründete Peter Stas nebenberuflich eine kleine Firma für preiswerte Design-Software. Letztere nutzte er auch zur Gestaltung von Armbanduhren, denn das in China Produzierte sah in seinen Augen ganz schrecklich aus. Als Grundlage dienten alte Bücher und Kataloge. Die allerersten, sozusagen in der heimischen Küche zusammengeschraubten Prototypen präsentierte Aletta Stas 1991 während der Uhrenmesse in Hongkong. Kurz vor Schluss orderte ein japanischer Grossist 350 Exemplare, die sich erstaunlich gut verkauften und Orders für weitere 1 100 Uhren nach sich zogen. Das Folgejahr stand bereits im Zeichen einer kleinen Prototypen-Kollektion mit insgesamt sechs Modellen. Alle wiederum ausgestattet mit Quarzwerken, montiert nun aber schon in der Schweiz aus eidgenössischen Komponenten. Auch diese Kinder gediehen prächtig, brauchten jedoch irgendwann einen passenden Namen. Als Paten dienten Alettas Urgroßmutter Frédérique Schreiner und Peters Urgroßvater Constant Stas. Beide Vornamen verschmolzen zu Frédérique Constant. Die mit einem Kapital von 60 000 Schweizer Franken gegründete Frédérique Constant SA produzierte 1992

zusammen mit externen Partnern schon mehr als 1 000 Swiss-Made-Armbanduhren. Zügige Abverkäufe motivierten zu größeren Taten. Als Glücksfall erwies sich die Begegnung mit Miguel Garcia, damals noch Verkaufsleiter von Sellita. Im Gespräch zeigte sich die Möglichkeit, das relativ hoch bauende Automatikkaliber Eta 2836 vorne zu öffnen und den Herzschlag der menschlichen Kultur unmittelbar vor Augen zu führen. Auf dieser Grundlage ging 1994 die nicht geschützte und deshalb rasch kopierte Kollektion namens „Heart Beat" an den Start. Größere Quantitäten und günstigere Kostenstrukturen erreichte das junge Unternehmen durch die später wieder eingestellte Private-Label-Produktion. Mit dem 1996 verfassten Businessplan für eine Genfer Firmenzentrale ging der Antrag auf Arbeitserlaubnis in der Eidgenossenschaft einher. Erteilt wurde sie unter der Bedingung, innerhalb von fünf Jahren einen Stamm von mindestens zwölf Beschäftigten aufzubauen. Bereits nach zweieinhalb Jahren war dieses Ziel ausschließlich durch selbst finanziertes Wachstum erreicht. Klare Visionen und der Drang, den zugekauften Kalibern etwas Eigenes zur Seite zu stellen, führten 2001 zum Start der Entwicklung eines ersten Manufaktur-Handaufzugskalibers. Für dieses ehrgeizige Projekt suchte Peter Stas die Kooperation mit Spezialisten zweier Uhrmacherschulen, der in Genf und einer in Holland. 2004 überraschte Frédérique Constant mit dem Heart Beat FC-910-1. In einem prominent bei der „6" positionierten Zifferblattausschnitt oszillierte eine erstaunlich große Unruh. Auf die 2005er Mondphasen-Version FC-915 folgte 2006 ein exklusives Automatikkaliber namens FC-930. 2007 stand im Zeichen neuer Materialien. Das Automatikkaliber FC-935 Silicium mit Mondphasenindikation und Zeigerdatum besitzt ein speziell gestaltetes Silizium-Ankerrad. Einen visionären Entwicklungsschritt markierte

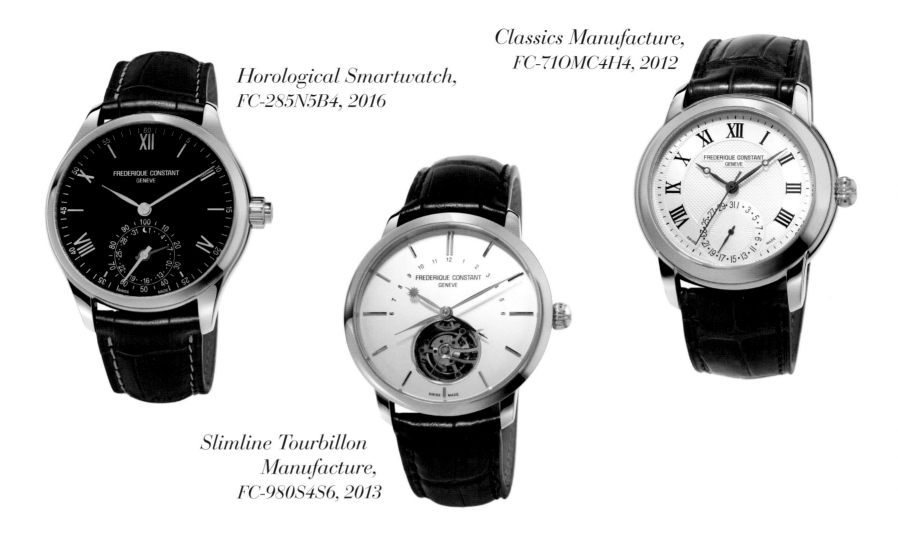

Horological Smartwatch,
FC-285N5B4, 2016

Classics Manufacture,
FC-710MC4H4, 2012

Slimline Tourbillon
Manufacture,
FC-980S4S6, 2013

die Variante mit der kryptischen Bezeichnung FC-935SZABS4H9, welche im September 2007 während der Wohltätigkeitsauktion „One of a Kind" in Monte Carlo unter den Hammer gelangte. Neben dem Silizium-Ankerrad verfügt das Unikat über eine völlig neuartige Unruh aus dem glaskeramischen Werkstoff Zerodur. Das ebenfalls hauseigene „Heart Beat Tourbillon" debütierte 2008 in limitierter Edition von 188 Stück. Seine Besonderheiten: Unruhstopp, intelligentes Smart-Screw-System zur perfekten Balance des Käfigs sowie ein amagnetisches Silizium-Ankerrad. Im 2006 eingeweihten Genfer Firmendomizil im Ortsteil Plan-les-Ouates mit Blick auf renommierte Traditionsmanufakturen entstanden für das Automatikkaliber FC-980-1 bereits gut 80 Prozent der nötigen Komponenten. Bei größeren Quantitäten muss sich Frédérique Constant trotz des kontinuierlich aufgerüsteten und ausgebauten Maschinenparks bis heute der Hilfe externer Teilezulieferer bedienen. Die Feinbearbeitung, Montage und Qualitätskontrolle geschieht jedoch ausnahmslos unter dem eigenen Dach. 2008 verbuchte die junge Manufaktur bereits 90 000 fertiggestellte Uhren. Nicht zuletzt auch dank höherer Wertschöpfung hatte sich der Umsatz innerhalb weniger Jahre verdoppelt. Im Vergleich zum Ganzen bewegten und bewegen sich die Manufakturprodukte verständlicherweise in einer Nische. Die Philosophie der Firmeninhaber, ihren Kundinnen und Kunden rund um den Globus erschwinglichen Luxus bieten zu wollen, stützt sich in erster Linie auf elegante Zeitmesser mit zugekauften und, sofern Mechanik, entsprechend selbst definierter Standards veredelten Uhrwerken. Die meisten der Kaliber stammen in diesem Fall von Selitta. 2014 feierte Frédérique Constant das zehnjährige Jubiläum der eigenen Manufakturkaliber. Mittlerweile umfasste das

Produktspektrum bereits 15, in zwei Familien gebündelte Kaliber. Alle mit 9xx stellen den Gangregler vorne zur Schau. Ohne sichtbaren Herzschlag präsentieren sich die ausschließlich mit Rotor-Selbstaufzug ausgestatteten FC-7xx. Das Basiskaliber FC-710 mit Zentralsekunde besteht aus 137 Komponenten, besitzt einen Durchmesser von 30 Millimetern und misst 6,2 Millimeter in der Höhe. Der zentral angeordnete Rotor spannt die Zugfeder in beiden Drehrichtungen. Nach Vollaufzug lässt der Energiespeicher die Unruh 42 Stunden lang mit vier Hertz oszillieren.

Einen echten Manufakturhöhepunkt und eine Sensation zugleich bringt das Jahr 2016. In der „Slimline Perpetual Calendar Manufacture", deren Kalenderwerk erst 2100 einer manuellen Kalender-Korrektur bedarf, tickt das exklusive Automatikkaliber FC-775. Allein für das aufwendige Schaltwerk unter dem Zifferblatt benötigen die Uhrmacher 78 Komponenten. Einzigartig ist der Preis: rund 8000 Euro.

Auf einem ganz anderen, nämlich elektronischem Blatt Papier steht schließlich die 2015 vorgestellte „Horological Smartwatch" mit analoger Zeit- und Funktionsanzeige. Diese Armbanduhr eidgenössischer Provenienz, welche sich mit Android- und iOS-Telefonen verbinden lässt, entstammt einer Zusammenarbeit mit US-amerikanischen Spezialisten. In nur einem Jahr konnte Frédérique Constant mehr als 16000 Exemplare an männliche (75 Prozent) und weibliche Handgelenke bringen. Durch das Engagement von zwölf Ingenieuren in der Schweiz möchte Peter Stas dieses Projekt fortan noch deutlich ausbauen. Weiter auf Wachstumskurs sind schließlich auch die Stückzahlen. Ende 2016 sollen die Zähler bei rund 145000 Armbanduhren stehen. Das nennt man Erfolg. ◦

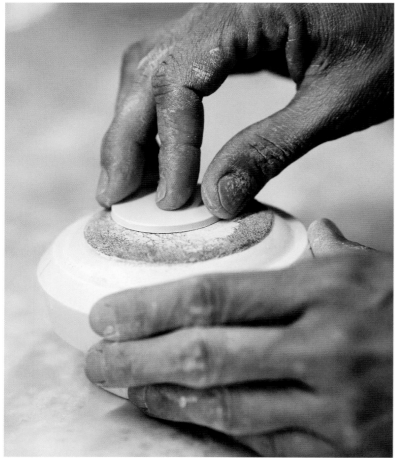

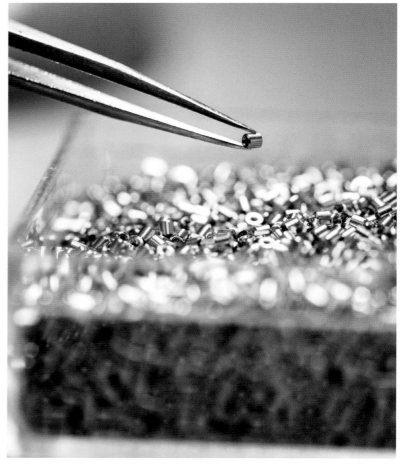

Clockwise, from top: Watchmaker's tools ○ Components ○ Manufacturing process of a porcelain dial ○ Von oben im Uhrzeigersinn:
Uhrmacherwerkzeuge ○ Komponenten ○ Herstellung eines Porzellanzifferblatts ○ Dans le sens horaire, en partant du haut :
Outils d'horlogers ○ Composants ○ Processus de fabrication d'un cadran en porcelaine

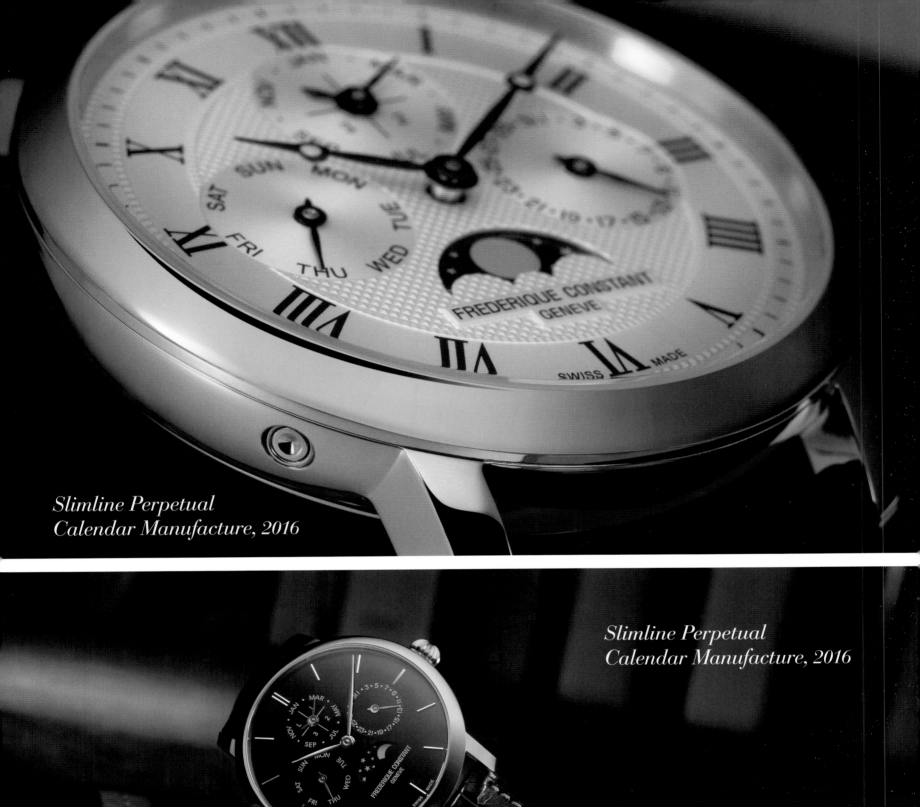

*Slimline Perpetual
Calendar Manufacture, 2016*

*Slimline Perpetual
Calendar Manufacture, 2016*

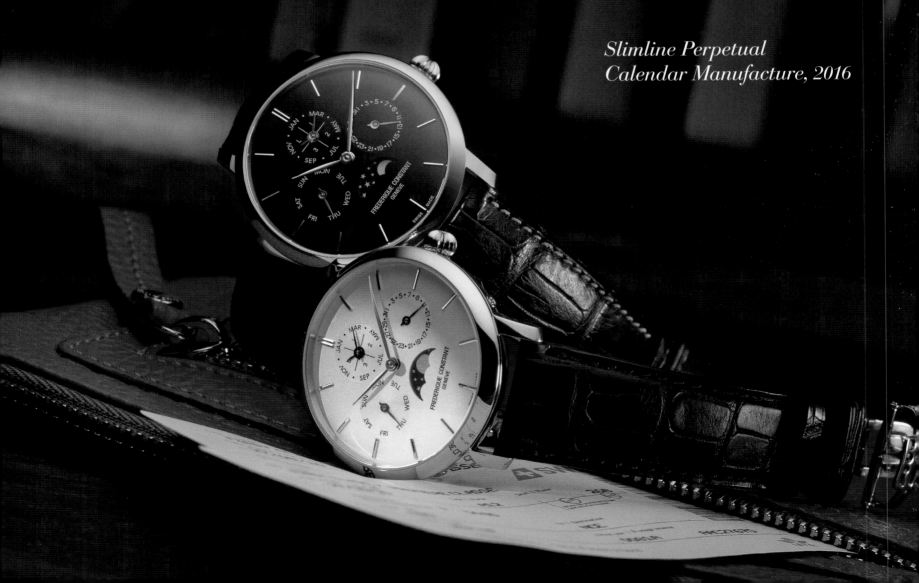

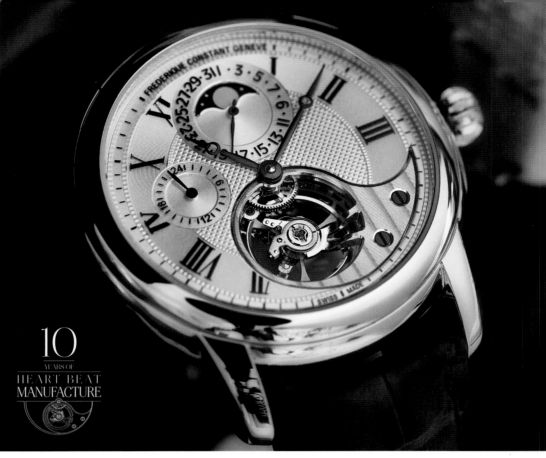

Le pouls vibrant d'une jeune manufacture

Dans le roman *Guerre et Paix*, on peut lire : « Il est impossible d'éradiquer les passions ; nous devons simplement nous attacher à les mobiliser en vue d'atteindre un objectif noble. » Peter C. Stas et Aletta Stas-Bax ont fait leurs ces paroles de Léon Tolstoï. Leur activité en entreprise débute en effet par une passion insatiable pour les montres-bracelets, celles que ce couple de Hollandais admire durant des vacances au ski en Suisse. Un beau jour, un choix s'impose à eux, et ils sacrifient leurs emplois sûrs dans des entreprises internationales pour démarrer leurs propres activités horlogères. Mais prenons une chose après l'autre. Au milieu des années 1980, ils vivent tous deux à Hong Kong, haut lieu des montres plutôt singulier. En 1988, Peter Stas crée parallèlement à son activité salariée une petite entreprise de logiciels de CAO abordables. Il s'en servira plus tard pour créer des montres-bracelets, car l'apparence de celles produites en Chine le rebute vraiment. Il puise son inspiration dans de vieux livres et catalogues. Les tous premiers prototypes, pour ainsi dire assemblés sur un coin de table, sont présentés en 1991 par Aletta au Salon de l'horlogerie de Hong Kong. Peu avant la clôture de la manifestation, un grossiste japonais prend commande de 350 montres. Celles-ci se vendant étonnamment bien, il en commandera 1 100 exemplaires supplémentaires. L'année qui suit est marquée par une petite collection de prototypes qui compte au total six modèles. S'ils sont encore tous dotés de mouvements à quartz, ils sont déjà assemblés en Suisse, à partir de composants locaux. Ces nouvelles productions prospèrent bien elles aussi, mais elles ont bientôt besoin d'un nom intéressant. Frédérique Schreiner, l'aïeule d'Aletta, et Constant Stas, l'aïeul de Peter, serviront de marraine et de parrain, la réunion de leurs deux prénoms donnant Frédérique Constant. Constituée avec un capital de 60 000 francs suisses, Frédérique Constant SA

produit dès 1992, avec des partenaires externes, plus de 1 000 montres-bracelets de fabrication suisse. La rapidité à laquelle elles se vendent les motive à voir plus grand. La rencontre avec Miguel Garcia, alors directeur des ventes chez Sellita, est un coup de chance. En discutant, ils découvrent qu'il est possible d'ouvrir sur le devant le calibre à remontage automatique Eta 2836 relativement épais pour dévoiler le pouls de la culture humaine. Ainsi naît en 1994 « Heart Beat », une collection non protégée et par conséquent rapidement copiée. La fabrication sous label privé (plus tard abandonnée) et en grandes quantités permet à la jeune manufacture de produire avec des structures de coûts plus avantageuses. En 1996, celle-ci dépose en Suisse un projet d'entreprise accompagné d'une demande d'autorisation d'exercer dans la Confédération en vue de transférer le siège de la société à Genève. L'autorisation leur est accordée, à la condition qu'elle constitue un socle d'au moins douze employés en cinq ans. Cet objectif est atteint en seulement deux ans et demi, et ce exclusivement par une croissance autofinancée. Des visions claires et le désir d'ajouter une touche personnelle aux calibres achetés conduisent Frédérique Constant en 2001 à développer un premier calibre de manufacture pour montres-bracelets. Pour ce projet ambitieux, Peter Stas s'adjoint la collaboration de spécialistes de deux écoles horlogères, celle de Genève et une autre en Hollande. En 2004, Frédérique Constant crée la surprise avec Heart Beat FC-910-1. Dans un large guichet à 6 heures oscille un balancier étonnamment grand. La version FC-915 Phase de lune et date de 2005 est suivie en 2006 par le FC-930, un modèle à mouvement mécanique et remontage automatique. L'année 2007 est placée sous le signe des nouveaux matériaux. Le calibre automatique FC-935 Silicium à indication de phase de lune et quantième à aiguille possède une roue d'échappement spécialement conçue

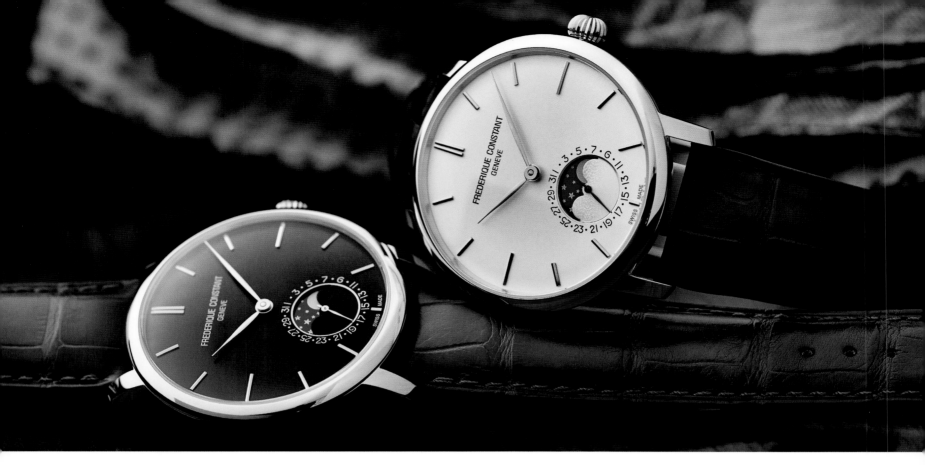

From left: CNC machine tools ◦ Heart Beat Manufacture, 2014 ◦ Slimline Moonphase Manufacture, 2014 ◦ *Von links: CNC-Werkzeugmaschinen ◦ Heart Beat Manufacture, 2014 ◦ Slimline Moonphase Manufacture, 2014 ◦* **De gauche à droite : Machines-outils à commande numérique ◦ Heart Beat Manufacture, 2014 ◦ Slimline Moonphase Manufacture, 2014**

en silicium. La variante portant un nom aux allures de code secret FC-935SZABS4H9, adjugée lors de la vente aux enchères caritative « One of a Kind » de septembre 2007 à Monte Carlo, est caractérisée par une évolution visionnaire. Outre une roue d'échappement en silicium, cette pièce unique dispose d'un balancier d'un type entièrement nouveau constitué d'un matériau céramique appelé Zerodur. Également dotée d'un calibre de manufacture, la montre « Heart Beat Tourbillon » fait ses débuts en 2008 dans une édition limitée à 188 exemplaires. Ses particularités : un stop balancier, un système intelligent « Smart-Screw » pour un parfait équilibre de la cage et une roue d'échappement amagnétique en silicium. C'est au siège genevois de la société, inauguré en 2006 dans le quartier de Plan-les-Ouates avec ses célèbres manufactures, que sont créés plus de 80 pour cent des composants du calibre à remontage automatique FC-980-1. Même avec un parc de machines sans cesse modernisé et étoffé, la société Frédérique Constant doit encore et toujours faire appel à des fournisseurs de pièces externes pour les grands volumes. Les opérations de finissage, d'assemblage et de contrôle qualité sont toutefois toutes réalisées au sein de la manufacture genevoise. En 2008, la jeune entreprise s'enorgueillit d'une production de 90 000 montres, son chiffre d'affaires doublant en quelques années, notamment grâce à la grande valeur ajoutée de ses produits. Sur l'ensemble du marché, ils occupent et continuent bien sûr d'occuper un créneau privilégié. La philosophie des propriétaires de la société, qui consiste à offrir à leur clientèle du monde entier un luxe abordable s'appuie essentiellement sur des garde-temps élégants dont les mouvements ont été produits par des tiers et améliorés au niveau mécanique, conformément aux normes définies en interne. La plupart de ces mouvements proviennent de Sellita. Mais en 2014, Frédérique Constant célèbre la dixième année de production de calibres de manufacture.

La gamme de produits comprend désormais 15 mouvements regroupés en deux familles. Sur les calibres numérotés 9xx, le régulateur de marche est visible sur le devant. Sur les calibres numérotés FC-7xx, tous dotés d'un remontage automatique par rotor, il ne l'est pas. Le calibre de base FC-710 à seconde centrale comporte 137 composants, mesure 30 millimètres de diamètre et 6,2 millimètres de haut. Le rotor en position centrale tend les spiraux dans les deux sens de rotation. Après remontage complet, l'énergie emmagasinée permet au balancier d'osciller 42 heures à une fréquence de quatre Hertz.

L'année 2016 est marquée par une avancée sensationnelle en termes de fabrication. La « Manufacture Quantième Perpétuel » de la collection Slimline, dont le quantième perpétuel ne devrait pas exiger de correction manuelle avant 2100, est animée par le calibre de manufacture FC-775. Pour le seul mécanisme complexe sous le cadran, 78 pièces sont nécessaires aux horlogers. Le tout à un prix exceptionnel : environ 8 000 euros.

Présentée en 2015, la montre « Horological Smartwatch », qui intègre une partie électronique, donne le temps en mode analogique et propose diverses fonctions. Cette montre-bracelet, qui communique avec les smartphones Android et iPhone, est le fruit d'une collaboration avec des spécialistes américains. En seulement un an, 16 000 exemplaires de ce modèle Frédérique Constant seront portés par des poignets masculins (75 pour cent) et féminins. Peter Stas souhaite développer encore davantage ce projet en engageant douze ingénieurs en Suisse. La tendance est également à la hausse pour le volume de production. Fin 2016, les ventes devraient être de l'ordre de 145 000 montres-bracelets. Voilà ce qu'on peut appeler une réussite. ◦

Girard-Perregaux

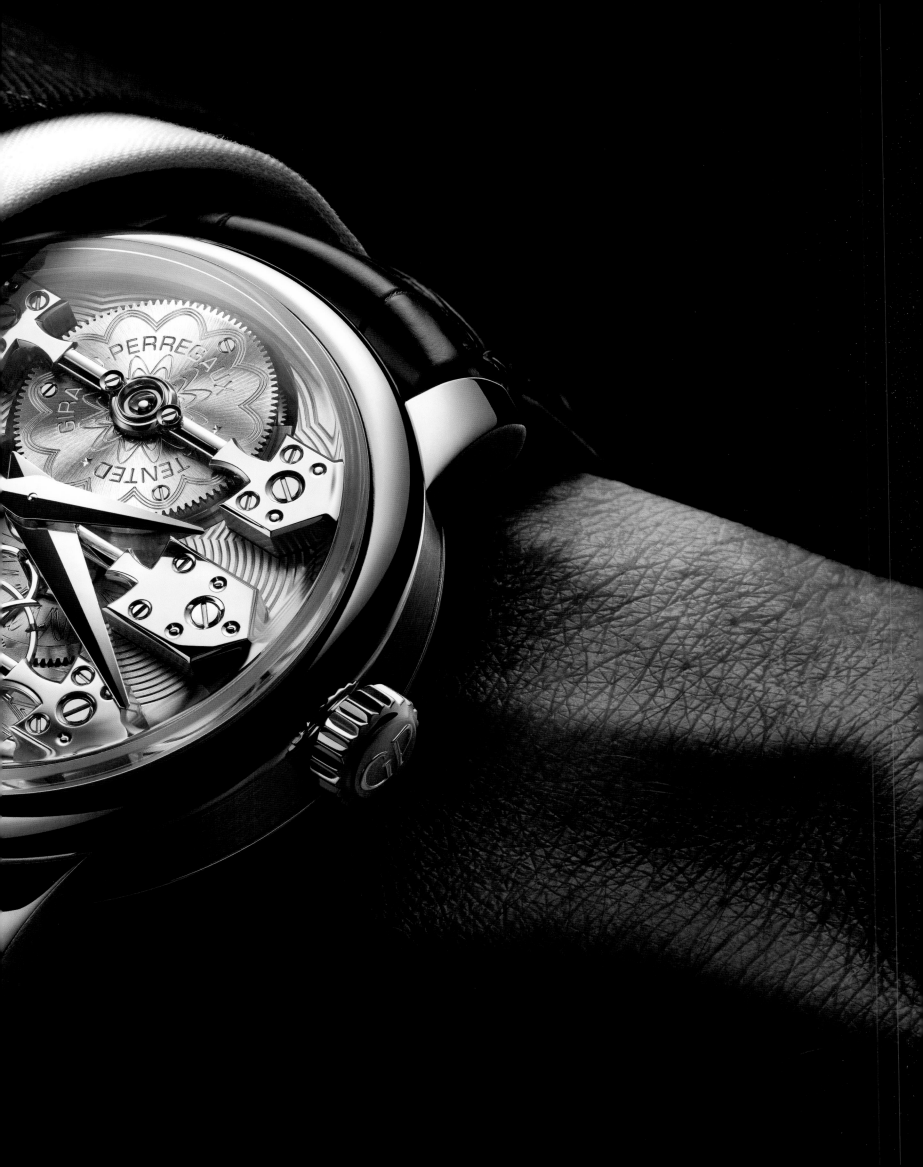

One of the Oldest Swiss Watch Manufactories

There is undoubtedly more than one answer to the question about the origins of the wristwatch. One of them involves the Great Industrial Exposition of Berlin, which took place on the exhibit area at Lehrter railway station in 1879. Girard-Perregaux displayed numerous watches as its contributions to this exhibition of internationally relevant technological innovations. This appearance earned an interesting commission for the Swiss manufacture: the imperial German navy needed readily legible timepieces for its officers, and Girard-Perregaux had the solution in the guise of a circular wristwatch with a chain wristband and a protective grid to shield the fragile glass crystal. The prototype impressed the German decision makers, who duly ordered 2,000 of these watches, each of which encased a 13-ligne hand-wound movement. This timepiece, which is arguably the first serially produced wristwatch, is only one of many chronometric milestones in the long and occasionally turbulent history of the house of Girard-Perregaux. The chronicle began in 1791 with the watchmaker Jean-François Bautte and the signature on his first pocket watches. Bautte's master Jacques Dauphin Moulinier was so impressed by the quality of his apprentice's work that he soon invited the assiduous young man to become a junior partner at his watch business in Geneva. Moulinier's noble clientele was enchanted by Bautte's elegant savoir vivre: for example, he perfumed the stairs of the shop and arranged to have his firewood artistically turned on lathes. After Bautte's death in 1837, the company was taken over by his son and son-in-law. The reins passed to Felipe Hecht in 1897 and later to Hecht's son Juan Hecht. The latter transferred his inheritance in 1906 to a friend and relative: Constant Girard-Gallet, who had operated a watch factory in La Chaux-de-Fonds since 1852 and who, together with his wife Marie Perregaux, had cofounded Girard-Perregaux (GP) in 1856. Wholly devoted to uncompromising precision, they repeatedly won chronometer competitions at Neuchâtel Observatory between 1851 and 1876. By 1889, GP had collected no fewer than 13 gold medals and diplomas at international exhibitions. In 1903, their eldest son Louis-Constant took the helm as the last in the Girard line. In the wake of liquidation in 1928, the brand rights and Jean-François Bautte's old ledger became the property of the Société de Banque Suisse (SBS). The Graef Family, which was of German extraction, purchased both for 30,000 Swiss francs the following year. Under their aegis, watches were produced with the Girard-Perregaux signature, as well as other timepieces labeled "MIMO." Approximately 200,000 watches were manufactured in 1951. For lack of heirs, the family business was sold to Desco von Schulthess, an international mercantile house, in 1979. A management buyout followed in 1988, but the new owners weren't very successful. Fortunately, the Italian Luigi Macaluso and his Sowind Group arrived with calmness and visionary ideas for the future in 1992. PPR, the French luxury conglomerate (now Kering) acquired a 23 percent share in the spring of 2008. Annual production at this time totaled circa 20,000 watches in the luxury price segment. Most of them encased movements that had been made at the brand's own manufacture in La Chaux-de-Fonds. The purchase contract already envisioned a further increase in the share to more than 50 percent. After Luigi Macaluso's unexpected death in October 2010, Kering availed itself of this option in the wake of a recapitalization.

The manufactory's horological highlights inarguably include the legendary tourbillon with three bridges. Girard-Perregaux registered 27 specimens of this model at Neuchâtel Observatory between 1865 and 1911. The patent for the parallel arrangement of three solid gold bridges on the plate dates from March 25, 1884. An especially precious version known as "La Esmeralda" was presented at the Fourth Paris International Exposition of 1889. Before GP repurchased this watch in the 1960s, it had belonged to Mexico's President Porfirio Díaz (1830–1915). This exceptional tourbillon finally debuted in the case of a wristwatch in 1991. Various versions with manual or automatic winding would become fixed features in Girard-Perregaux's collection in ensuing years. "La Esmeralda" found its way to the wrist in 2016, just in time to celebrate the firm's 225th anniversary. The filigreed tourbillon cage, which concatenates 80 components, weighs a mere 0.305 gram.

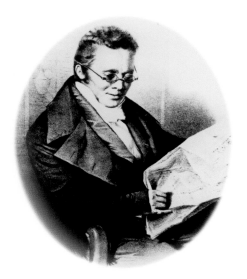 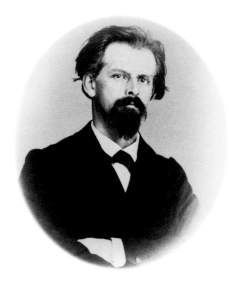 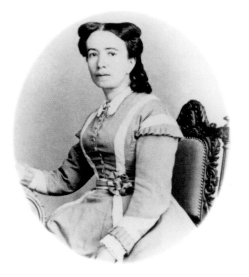

From left: Jean-François Bautte ◦ Constant Girard-Gallet ◦ Marie Perregaux

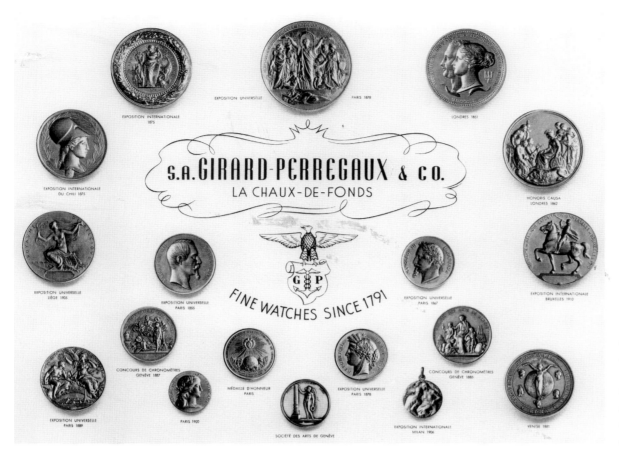

GP launched a mechanical world premiere in 1966: automatic Calibers 31.7 and 32.7 use the innovative Clinergic escapement, which has a balance that completes 36,000 semi-oscillations per hour. The manufacture was awarded Neuchâtel Observatory's Jubilee Prize in recognition of this superlative achievement in the service of a more highly accurate rate. Unlike many other brands in the early 1970s, GP opted not to rely on its own competence for the development of an electronic quartz movement. Exclusive Caliber GP 350 anticipated the currently valid industrial standard, i.e., its quartz resonator oscillates inside a little vacuum tube at a frequency of 32,768 hertz. This caliber was encased inside the "GP Quartz," which debuted at the watch fair in Basel in 1971. Greater emphasis was again placed on the theme of mechanical timekeeping after Luigi Macaluso acquired the business. He consistently expanded the necessary ateliers, purchased new machinery and, after approximately two years of developmental work, brought caliber family 3xxx to the market in 1994. The basic caliber (GP3000) is 23.9 millimeters in diameter and a mere 2.98 millimeters tall, which made it one of the slimmest of its kind. Despite its low height, it provides sufficient space for a jumping date display with rapid switching. Caliber GP3200 is 3.2 millimeters tall and 26.2 millimeters in diameter. The third movement in the trio is the equally tall GP3300: its diameter is 25.6 millimeters. The largest of GP's own automatic movements (GP1800) spent many years "on ice." It finally debuted with a diameter of 30.6 millimeters and a height of 4.16 millimeters. Girard-Perregaux currently offers it in an "ordinary" and a skeletonized version. It's housed in the classically round cases of the longstanding and highly successful "1966" line which debuted, needless to say, in 1966. Aficionados of angular cases appreciate the nostalgic-looking "Vintage 1945." The purest retro look is also embodied by the "Heritage Anniversary 1957," which debuts in 2016. Its constant-force escapement, which premiered in 2009 and has undergone continual improvements ever since, bears witness to unflagging power of innovation. This complex ensemble would have been absolutely impossible without the use of silicon as its raw material.

Only 225 specimens exist of the anniversary model "Heritage Anniversary Place Girardet." The name recalls the square in La Chaux-de-Fonds where Girard-Perregaux maintains its headquarters. A uniquely individualized dial is the special feature of this wristwatch, which encases automatic Caliber GP1800-0005 and displays its Microvar balance on the dial side. Each dial is marked with a date between 1791 and 2016, together with an event that occurred in that year. For example, 1808 recalls Beethoven and his Fifth Symphony, and 1963 commemorates the first woman to fly in outer space. The current apex of the watch portfolio is represented by the "Minute Repeater Tourbillon with Bridges," a tourbillon watch with minute repeater and innovative bridges. Due to the timepiece's extreme complexity, Girard-Perregaux has limited production of this mellifluously named titanium wristwatch to just 30 specimens. In 2017 and thereafter, Girard-Perregaux will display many aspects of its rich past and creative present in the firm's stylish museum at number 129 Rue du Progrès in La Chaux-de-Fonds. Would-be visitors are requested to schedule their visits in advance. ◦

Vintage 1945 Small Second, 2015

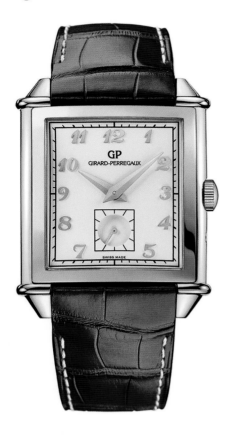

Vintage 1945 Tourbillon, 2015

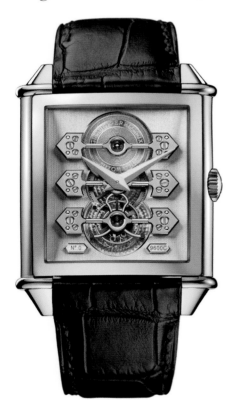

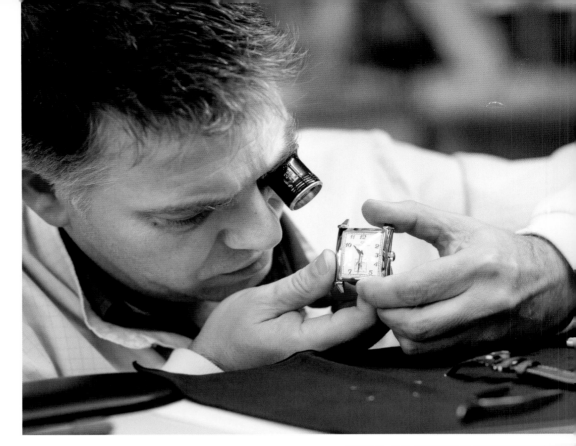

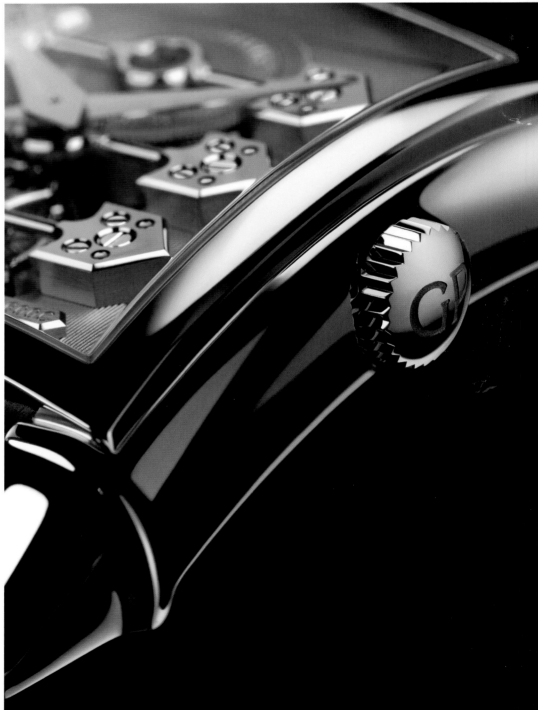

Top: *Final assembly and quality control*
Oben: Endmontage und Kontrolle
En haut : Assemblage final et contrôle

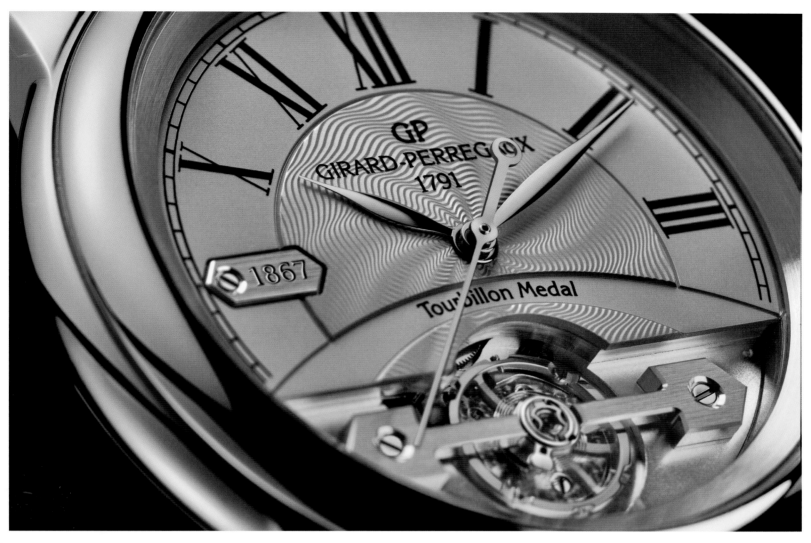

Heritage Anniversary Place Girardet 1867, 2016

Heritage Anniversary
Place Girardet 1999, 2016

Heritage Anniversary
Place Girardet 2016, 2016

Heritage Anniversary
Place Girardet 1880, 2016

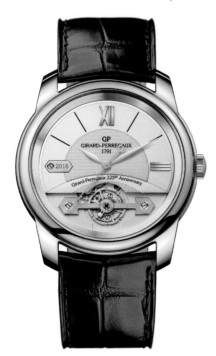

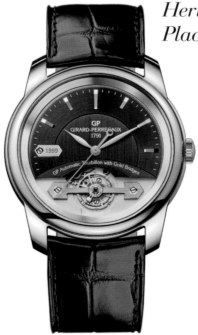

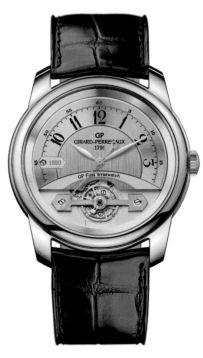

Eine der ältesten Schweizer Uhrenmanufakturen

Die Frage nach den Anfängen der Armbanduhr lässt zweifellos mehrere Antworten zu. Eine hängt mit der Berliner Gewerbeausstellung zusammen, welche 1879 im Ausstellungspark am Lehrter Bahnhof stattfand. Girard-Perregaux bereicherte die Leistungsschau technischer Innovationen von überregionaler Bedeutung mit etlichen Uhren. Dieser Auftritt bescherte der Schweizer Manufaktur einen interessanten Auftrag. Für ihre Offiziere benötigte die deutsche Kaiserliche Marine leicht ablesbare Zeitmesser. Und Girard-Perregaux hatte die Lösung in Gestalt einer runden Armbanduhr mit Kettenband und Schutzgitter über dem bruchempfindlichen Kristallglas. Der positiv bewertete Prototyp führte zu einer Bestellung von 2000 Exemplaren mit 13-linigem Handaufzugswerk. Die vermutlich erste Serien-Armbanduhr ist nur einer von vielen chronometrischen Meilensteinen in der langen, teilweise recht turbulenten Biographie des Hauses Girard-Perregaux. Sie beginnt 1791 mit dem Uhrmacher Jean-François Bautte und der Signatur erster Taschenuhren. Lehrmeister Jacques Dauphin Moulinier überzeugte die Qualität so sehr, dass er seinem geschäftstüchtigen Schüler schon kurz darauf Anteile an seinem Genfer Uhrengeschäft offerierte. Bautte entzückte die adelige Kundschaft durch seine elegante Lebensart. Beispielsweise parfümierte er die Treppen seines Geschäfts oder ließ das Brennholz kunstvoll drechseln. Nach seinem Tod im Jahr 1837 übernahmen sein Sohn und Schwiegersohn, 1897 Felipe Hecht und schließlich dessen Sohn Juan Hecht die Firma. Letzterer übereignete sein berufliches Erbe 1906 einem Freund und Verwandten. Constant Girard-Gallet hatte sich seit 1852 in La Chaux-de-Fonds als Uhrenfabrikant betätigt und 1856 zusammen mit Ehefrau Marie Perregaux die Firma Girard-Perregaux (GP) gegründet. Deren Maximen galten kompromissloser Präzision. Zwischen 1851 und 1876 gewann sie mehrfach die Chronometer-Wettbewerbe des Observatoriums Neuchâtel. Bis 1889 konnte GP nicht weniger als 13 Goldmedaillen und Diplome bei internationalen Ausstellungen erringen. 1903 nahm der älteste Sohn Louis-Constant als letzter Girard das Ruder in die Hand. 1928 gingen im Zuge der Liquidation die Markenrechte und das alte Hauptbuch von Jean-François Bautte an die Société de Banque Suisse (SBS). Beides kaufte die deutschstämmige Familie Graef im Folgejahr für 30000 Schweizer Franken. Unter ihrer Ägide entstanden parallel Uhren mit den Signaturen Girard-Perregaux und MIMO. Für das Jahr 1951 zeigten die Produktionszähler circa 200000 Uhren. Mangels familiärer Nachkommen gelangte die Traditionsmanufaktur 1979 unter das Dach des internationalen Handelshauses Desco von Schulthess. 1988 stand im Zeichen eines Management-Buyout. Die neuen Eigentümer wirtschafteten jedoch wenig erfolgreich. Ruhe und visionäre Gedanken für die Zukunft brachten 1992 der Italiener Luigi Macaluso und seine Sowind-Gruppe. Im Frühjahr 2008 beteiligte sich der französische Luxus-Multi PPR (heute Kering) mit 23 Prozent. Zu diesem Zeitpunkt lag die Jahresproduktion bei rund 20000 im preislichen Luxussegment angesiedelten Uhren. In den meisten tickten Uhrwerke aus eigener Manufaktur in La Chaux-de-Fonds. Schon der damalige Kaufvertrag sah eine weitere Erhöhung des Anteils über 50 Prozent hinaus vor. Von dieser Option machte Kering nach dem überraschenden Ableben von Luigi Macaluso im Oktober 2010 im Zuge einer Kapitalerhöhung Gebrauch.

Zu den uhrmacherischen Highlights der Manufaktur gehört zweifellos das legendäre Tourbillon mit drei Brücken. Zwischen 1865 und 1911 ließ Girard-Perregaux 27 Exemplare beim Observatorium Neuchâtel registrieren. Das Patent für die parallele Anordnung der drei massivgoldenen Brücken auf der Platine datiert auf den 25. März 1884. Besonders kostbar präsentierte sich 1889 während der Pariser Weltausstellung „La Esmeralda". Bevor GP die Uhr in den 1960er Jahren zurückkaufte, hatte sie u. a. dem mexikanischen Präsidenten Porfirio Díaz (1830–1915) gehört. 1991 debütierte dieses Ausnahme-Tourbillon endlich auch in einem Armbanduhrgehäuse. Seitdem ist es in unterschiedlichen Ausführungen mit manuellem oder automatischem Aufzug fester Bestandteil der Girard-Perregaux-Kollektion. Zum 225. Firmenjubiläum findet „La Esmeralda" 2016 auch ans Handgelenk. In diesem Fall wiegt der filigrane, aus 80 Komponenten zusammengefügte Tourbillonkäfig nur 0,305 Gramm.

1966 lancierte GP eine mechanische Weltpremiere. In den Automatikkalibern 31.7 und 32.7 mit innovativer Clinergic-Hemmung vollzog der Gangregler stündlich 36000 Halbschwingungen. Für diese überragende Leistung im Dienste höherer Ganggenauigkeit erhielt die Manufaktur den Jubiläumspreis des Observatoriums Neuchâtel. Anders als viele andere Marken setzte GP Anfang der 1970er bei der Entwicklung eines elektronischen Quarzwerks nicht auf eigene Kompetenz. Das exklusive Kaliber GP 350 nahm den heutigen Industriestandard vorweg, das heißt der Quarzresonator oszillierte in einer kleinen Vakuumröhre bereits mit 32768 Hertz. Die damit ausgestattete „GP Quartz" gab 1971 während der Basler Uhrenmesse ihren Einstand. Dem Thema Mechanik-Manufaktur verlieh Luigi Macaluso nach dem Erwerb des Unternehmens beachtliche Impulse. Er baute die entsprechenden Ateliers konsequent aus, kaufte neue Maschinen und brachte 1994 nach rund zweijähriger Entwicklungsarbeit die Kaliberfamilie 3xxx auf den Markt. Das Basis-Kaliber GP3000 besitzt einen Durchmesser von 23,9 Millimetern. Mit nur 2,98 Millimetern Bauhöhe gehört es zu den flachsten seiner Art. Immerhin ist darin auch eine springende Datumsanzeige mit Schnellschaltung enthalten. Das Kaliber GP3200 misst bei 3,2 Millimetern Bauhöhe insgesamt 26,2 Millimeter. Dritter im Bunde ist das gleich hohe GP3300 mit 25,6 Millimetern Durchmesser. Jahrelang auf Eis lag das größte der eigenen Automatikwerke, GP1800 genannt. Sein Durchmesser beträgt 30,6 Millimeter, seine Höhe 4,16 Millimeter. Girard-Perregaux bietet es aktuell in „normaler" sowie skelettierter Version an. Und zwar in der klassisch runden, seit Jahren höchst erfolgreichen Linie „1966", deren Ursprünge in besagtem Jahr zu finden sind.

Full-calendar movement GP3300

Liebhaberinnen und Liebhaber kantiger Gehäuseformen kommen bei der nostalgischen „Vintage 1945" zu ihrem Recht. Retro-look in Reinkultur verstrahlt seit 2016 schließlich auch die „Heritage Anniversary 1957". Von ungebrochener Innovationskraft zeugt eine 2009 vorgestellte und seitdem kontinuierlich verbesserte Hemmung mit konstanter Kraft. Ohne Verwendung des Werk-stoffs Silizium wäre das komplexe Gebilde absolut unmöglich.

Lediglich 225 Exemplare gibt es von dem Jubiläumsmodell „Heritage Anniversary Place Girardet". An diesem Platz in La Chaux-de-Fonds ist Girard-Perregaux zu Hause. Die Besonderheit dieser Armband-uhr mit dem Automatikkaliber GP1800-0005 und vorne sichtbarer Microvar-Unruh besteht in der einzigartigen Individualisierung des Zifferblatts. Auf jedem sind eine Jahreszahl zwischen 1791 und 2016 sowie eine dazu passende Begebenheit verewigt. 1808 erinnert beispielsweise an Beethoven und seine 5. Sinfonie, 1963 an die erste Frau im Weltraum. Die gegenwärtige Spitze des Uhren-Portfolios repräsentiert das „Minute Repeater Tourbillon with Bridges", ein Tourbillon mit Minutenrepetition und Neo-brücken. Wegen der hohen Komplexität hat Girard-Perregaux die Produktion dieser wohlklingenden Titan-Armbanduhr auf nur 30 Exemplare limitiert. Viele Aspekte der reichen Vergangenheit und kreativen Gegenwart wird Girard-Perregaux ab 2017 im stilvollen Firmenmuseum, Rue du Progrès 129, La Chaux-de-Fonds, zeigen. Ein Besuch ist allerdings nur nach vorheriger Anmeldung möglich. ◦

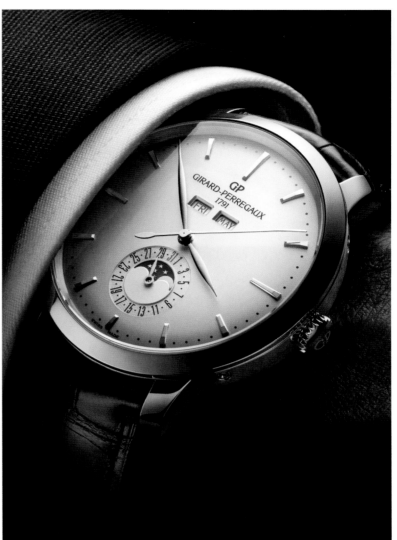

1966 Skeleton, 2016

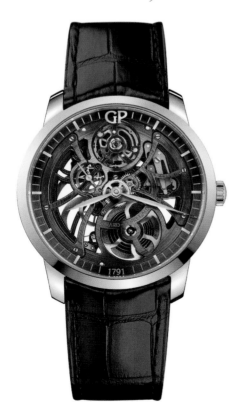

1966 Full Calendar, 2016

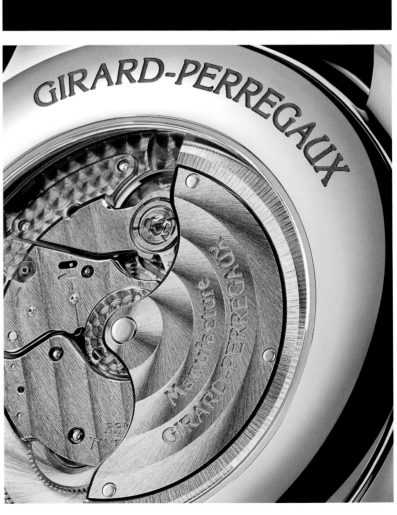

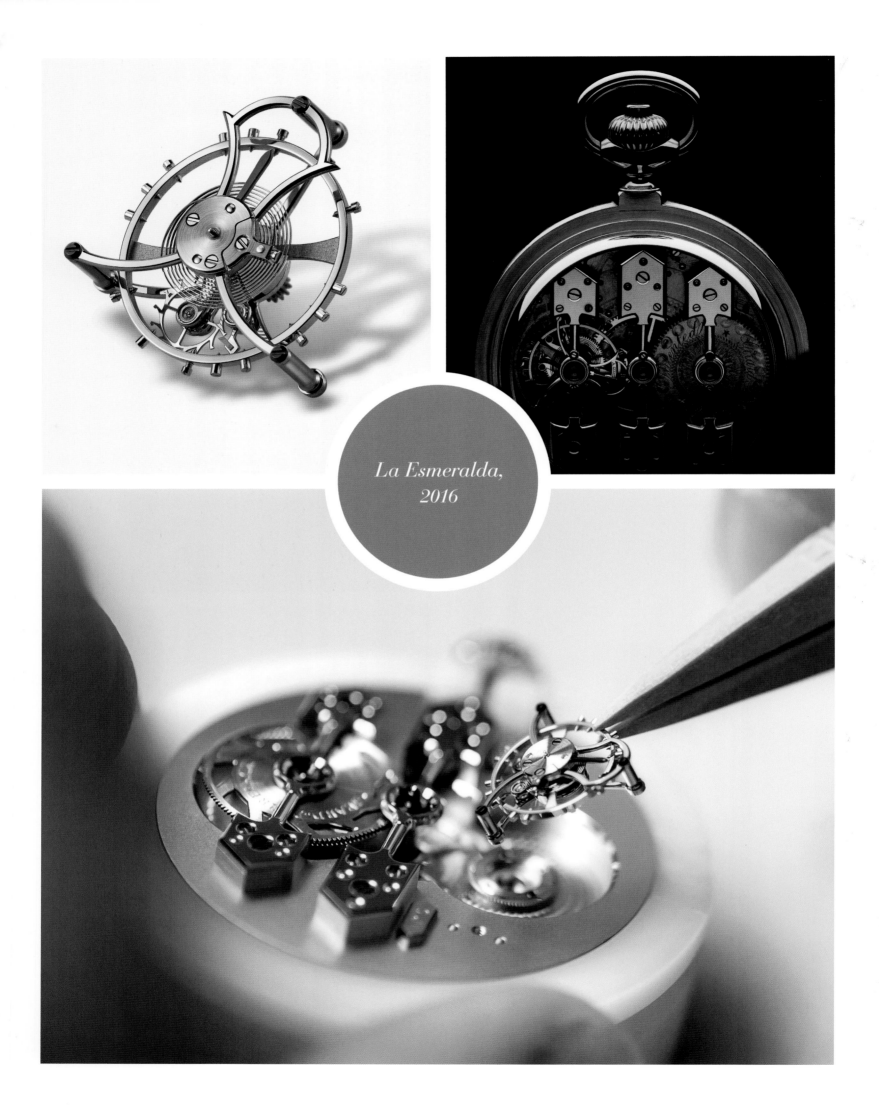

La Esmeralda,
2016

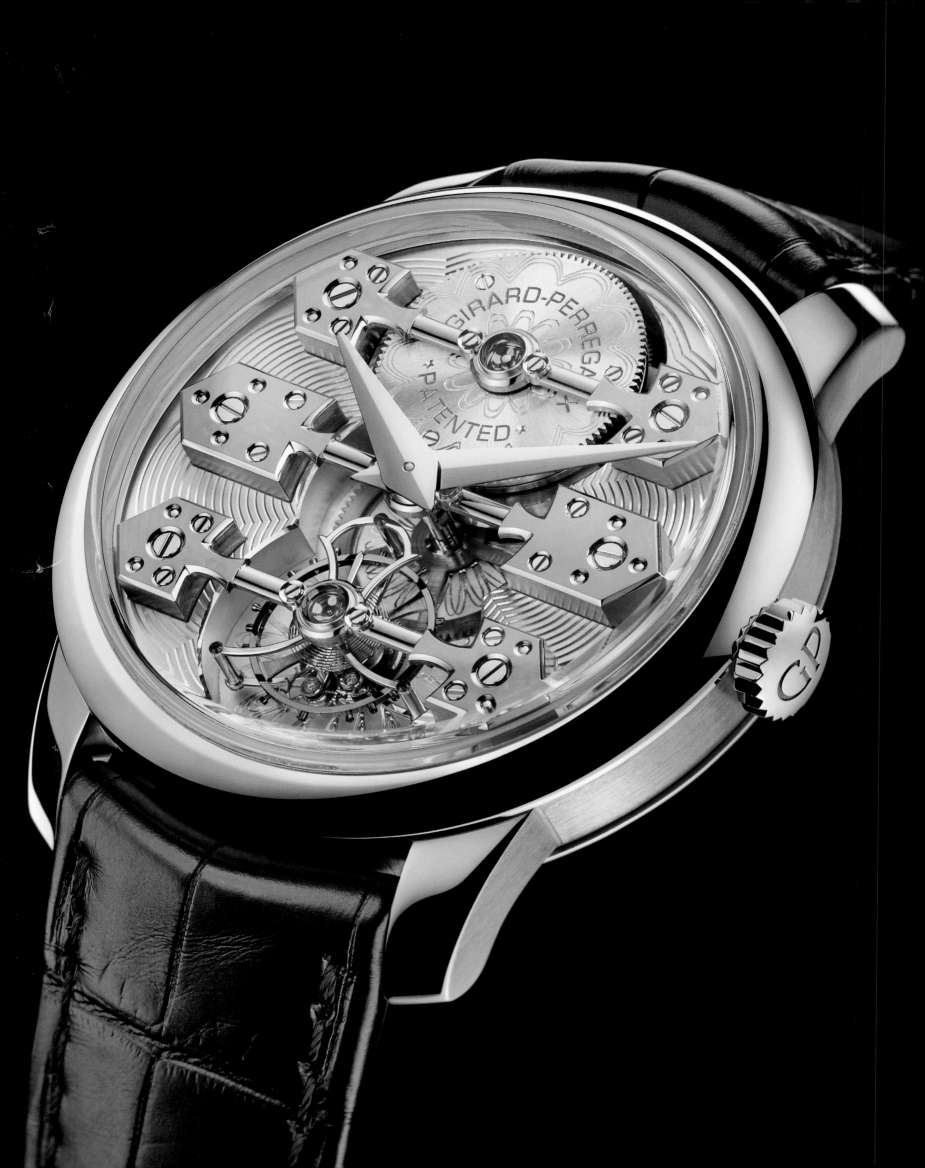

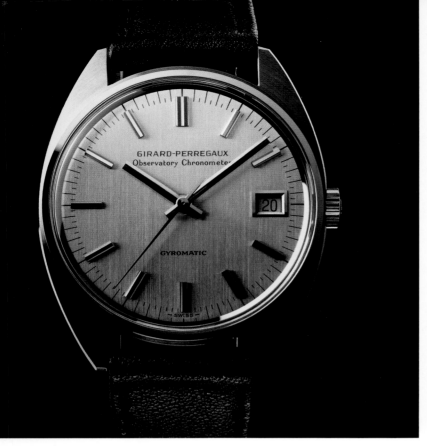
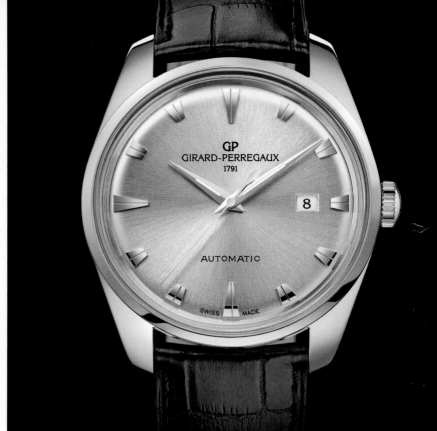

L'une des plus anciennes manufactures horlogères suisses

Français

La question de l'origine des montres-bracelets appelle assurément diverses réponses. Celles-ci pourraient remonter à la foire-exposition organisée en 1879 à Berlin dans le parc proche de la gare de Lehrte. Girard-Perregaux contribue alors par diverses montres à cette exposition d'innovations techniques d'une portée internationale, prestation qui lui rapporte une commande intéressante. Les officiers de la marine impériale ont besoin de garde-temps faciles à consulter. Girard-Perregaux leur apporte la solution : une montre-bracelet ronde à chaîne et grille protégeant le fragile verre en cristal. Convaincue par le prototype, l'armée commande 2 000 unités équipées de mouvements 13''' à remontage manuel. Cette montre-bracelet, peut-être la première fabriquée en série, n'est qu'un jalon dans l'histoire riche et parfois tumultueuse de la maison Girard-Perregaux. Elle débute en 1791 avec l'horloger Jean-François Bautte, qui signe les premières montres de poche. Fortement séduit par la qualité proposée par son élève Bautte, également très doué pour les affaires, le maître-horloger Jacques Dauphin Moulinier lui offre peu après des parts dans sa boutique d'horlogerie à Genève. Bautte ravit la clientèle noble par son style de vie élégant, faisant par exemple parfumer les escaliers de sa boutique ou façonner artistiquement au tour son bois de chauffage. À son décès en 1837, la boutique est reprise par son fils et son gendre. Elle revient en 1897 à Felipe Hecht, qui la transmettra à son fils Juan Hecht. En 1906, ce dernier transfère la propriété de son héritage professionnel à un ami proche, Constant Girard-Gallet. Fabricant de montres depuis 1852 à La Chaux-de-Fonds, il a fondé en 1856 avec sa femme Marie Perregaux la manufacture Girard-Perregaux (GP). Leur devise : une précision sans compromis. De 1851 à 1876, la manufacture remporte plusieurs concours de chronomètres de l'observatoire de Neuchâtel. Jusqu'en 1889, GP reçoit pas moins de 13 médailles d'or et diplômes lors d'expositions internationales. En 1903, Louis-Constant, le fils aîné, prend les rênes de la manufacture, en tant que dernier des Girard. En 1928, la manufacture est mise en liquidation. Les droits de propriété des marques et l'ancien grand-livre de Jean-François Bautte échoient à la Société de Banque Suisse (SBS). La famille d'origine allemande Graef les rachète l'année suivante pour 30 000 francs suisses. Sous son égide, des montres signées Girard-Perregaux et des garde-temps MIMO sont fabriqués en parallèle. En 1951, environ 200 000 montres sont produites. Faute d'héritier, cette manufacture de tradition passe en 1979 dans le giron de la maison de commerce international Desco von Schulthess. 1988 est marquée par un rachat par les dirigeants, mais les nouveaux propriétaires n'ont pas une gestion satisfaisante. En 1992, l'Italien Luigi Macaluso et le groupe Sowind ramènent calme et stabilité, et proposent des idées visionnaires. Au printemps 2008, la multinationale du luxe PPR (actuelle Kering) entre dans le capital à hauteur de 23 pour cent. La production annuelle s'élève à environ 20 000 montres haut de gamme en termes de prix. La plupart sont animées par des mouvements fabriqués à La Chaux-de-Fonds. Le contrat de vente prévoyant à l'origine la possibilité d'augmenter la participation à plus de 50 pour cent, Kering saisit cette occasion dans le cadre d'une augmentation de capital, après le décès soudain de Luigi Macaluso en octobre 2010.

Le légendaire Tourbillon sous trois ponts d'or compte assurément parmi les produits phares de la manufacture. Entre 1865 et 1911, Girard-Perregaux en fait certifier 27 exemplaires par l'observatoire de Neuchâtel. Le brevet portant sur la disposition parallèle des trois ponts en or massif sur la platine est délivré le 25 mars 1884. En 1889, « La Esmeralda », montre de poche particulièrement précieuse, est présentée à l'Exposition universelle de Paris.

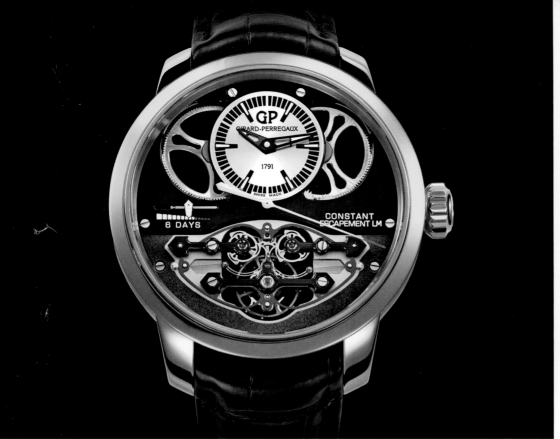
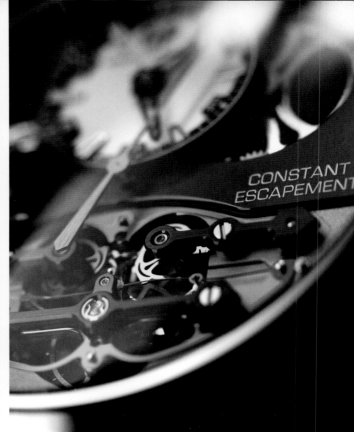

Opposite page: Gyromatic HF, 1965 ◦ Heritage Anniversary 1957, 2016 ◦ This page: Constant Escapement, 2016

Changeant plusieurs fois de mains, notamment celles du président mexicain Porfirio Díaz (1830–1915), elle est rachetée dans les années 1960 par GP. En 1991, ce tourbillon d'exception trouvera enfin le chemin d'un boîtier de montre-bracelet. Déclinée en différentes versions, avec remontage manuel ou automatique, c'est un pilier de la collection. Pour les 225 ans de GP en 2016, « La Esmeralda » est aussi proposée en montre-bracelet. Le délicat tourbillon constitué de 80 composants ne pèse que 0,305 gramme.

L'année 1966 est marquée par une première mondiale pour GP dans le domaine mécanique. Dans les calibres automatiques 31.7 et 32.7 dotés d'un échappement innovant baptisé Clinergic, le balancier réalise 36 000 alternances par heure. Cette extraordinaire performance permettant d'augmenter la précision de marche est récompensée par le prix du Centenaire de l'observatoire de Neuchâtel. Au début des années 1970, à l'inverse de bien des marques, GP ne s'appuie pas que sur ses propres compétences pour créer un mouvement à quartz. Avec son résonateur à quartz oscillant à 32 768 Hertz dans un tube à vide, le calibre exclusif GP 350 préfigure le standard universel pour les montres à quartz. Ainsi équipée, la « GP Quartz » fait ses débuts en 1971 au Salon mondial de l'horlogerie à Bâle. Luigi Macaluso reprend alors la manufacture et donne une impulsion considérable au développement de mouvements mécaniques, par un agrandissement considérable des ateliers concernés et l'achat de nouvelles machines. En 1994, après environ deux ans de développement, la famille de calibres 3xxx est sur le marché. Le diamètre du calibre de base GP3000 est de 23,9 millimètres. Avec un record de minceur de 2,98 millimètres, c'est l'un des plus plats du genre. Malgré cette finesse, il dispose de la fonction date sautante. Le calibre GP3200 mesure 26,2 millimètres de diamètre pour une épaisseur de 3,2 millimètres. Troisième de la série, le GP3300 est aussi mince que

le GP3200, mais avec un diamètre de 25,6 millimètres. Plus grand mouvement automatique de manufacture GP avec un diamètre de 30,6 millimètres et une épaisseur de 4,16 millimètres, le GP1800 restera longtemps en attente. Girard-Perregaux le propose actuellement en version « normale » ou squelette, ajouré en suivant les formes rondes traditionnelles de la ligne à grand succès « 1966 », lancée cette même année. Les amoureux de boîtiers anguleux apprécient un modèle empreint de nostalgie, le « Vintage 1945 ». Mais depuis 2016, un look rétro en concentré irradie également du modèle « Heritage Anniversary 1957 ». L'échappement à force constante présenté en 2009, depuis sans cesse amélioré, témoigne d'une inlassable capacité d'innovation. Sans le silicium, ce mécanisme complexe n'aurait en aucun cas pu être réalisé.

Pour célébrer ses 225 ans, la manufacture sort en 2016 en édition limitée à 225 exemplaires la montre « Heritage Anniversary Place Girardet », du nom de la place de La Chaux-de-Fonds où se situe le siège de GP. Cette montre-bracelet à calibre automatique GP1800-0005 et balancier Microvar visible à 6 heures se distingue par une individualisation très singulière des cadrans. Chacun d'eux porte une date de 1791 à 2016 et la mention d'un événement marquant associé. Ainsi, le cadran 1808 rappelle-t-il Beethoven et sa 5e symphonie ou 1963 la première femme dans l'Espace. Le chef-d'œuvre actuel du portefeuille horloger est assurément la « Répétition minutes Tourbillon sous ponts d'or ». Compte tenu de sa haute complexité, Girard-Perregaux a limité à seulement 30 exemplaires la production de cette montre-bracelet au boîtier en titane et au son pur. À partir de 2017, Girard-Perregaux présentera de nombreuses facettes de son riche passé et de son actualité créative dans l'élégant musée de la marque, 129 rue du Progrès, à La Chaux-de-Fonds. Une réservation préalable sera obligatoire. ◦

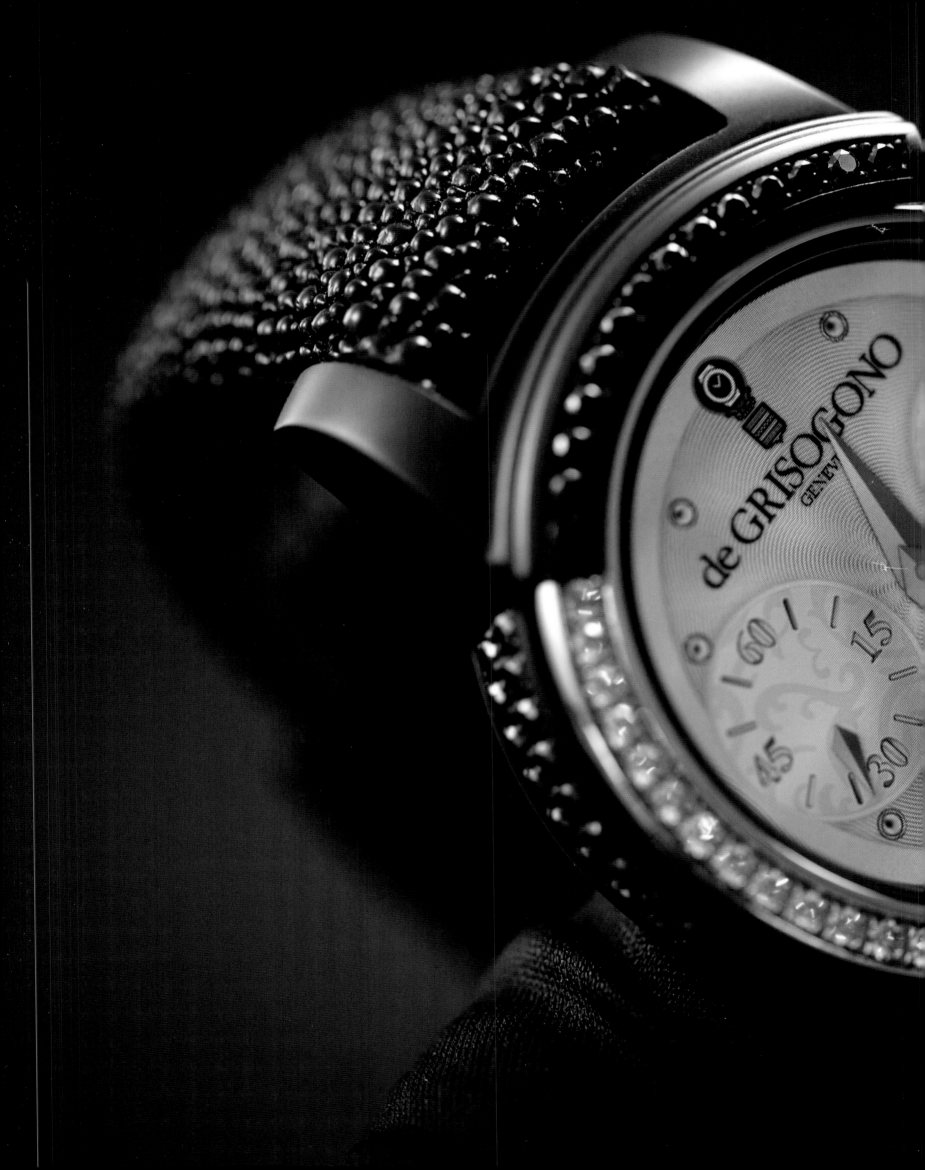

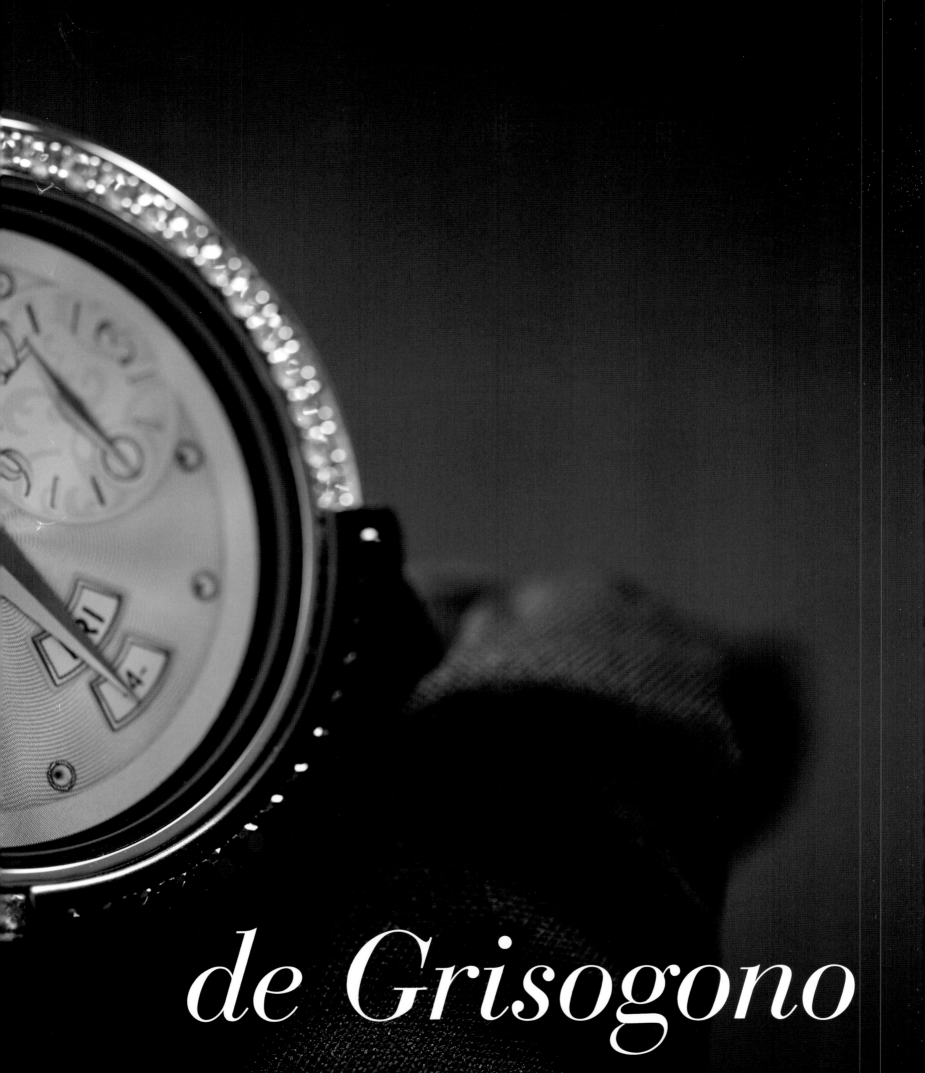

de Grisogono

Preferably Creative

Fawaz Gruosi, an Italian native, is an intuitive man, and the course of his career reflects this innate practicality. Florence, his hometown, helped shape his insatiable love for the fine arts, so it wasn't surprising that his first employer was a Florentine jeweler. His subsequent professional life took him to London, Saudi Arabia, New York and Geneva. Fawaz Gruosi worked for Harry Winston and later for Bulgari. When Gianni Bulgari left the family business, Gruosi likewise felt that the time had come to venture onto paths of his own. Together with his partners, he founded his own jewelry store in the center of Geneva in 1993. The dream of his own brand came closer to fruition. Of course, each partner wanted the label to bear their own name. One of the partners ultimately prevailed with the name of her mother, a marquise de Grisogono. The label's name also remained unchanged after Fawaz Gruosi separated from his erstwhile partners in 1995. He had been responsible for product design from the brand's earliest beginnings, and he continued in this capacity as sole entrepreneur. The next chapter in the firm's biography is distinguished by the "Black Orlov" because this 195-carat gem enflamed the passion for black diamonds. De Grisogono celebrated its watch debut at Baselworld in 2000. "Instrumento N° Uno," which combined a reliable self-winding Eta caliber and an exclusive additional mechanism, immediately appealed to a surprisingly large number of buyers: Fawaz Gruosi was able to fabricate and sell more than 5,000 specimens. "My strength in the watch genre is that I'm not really an expert, so I can tackle things relatively without bias. Although I'm surrounded by many competent people, I'm not easily convinced that something is impossible." The truth of this was reconfirmed by a minute-repeater wristwatch in 2005: the "Occhio" (Italian for "eye") was created in cooperation with Christophe Claret, an

acknowledged specialist for horological mechanisms. When the wearer slides the trigger on the flank of the case, an aperture consisting of twelve ceramic flaps glides open and the movement, which combines 324 individual components, chimes the time on three gongs. Gruosi / de Grisogono premiered the rectangular "FG One" with automatic movement and unconventional time-zone mechanism in 2006. The following year, the brand's watchmakers assembled more than 651 parts to create a hand-wound movement encased in the limited-edition "Meccanico dG," which has an unprecedented double time display. Women as well as men were impressed by the remarkable "Otturatore": prioritizing under-statement, this angular wristwatch relies on a patented aperture mask behind the hour-hand and minute-hand. The owner presses a large push-piece to select among several indicators in the background: small seconds, date window, moon phase, or power-reserve display. The creative master-mind suffered no lack of bright ideas in ensuing years. This is clearly confirmed by three current wristwatches. For gents, Fawaz Gruosi created the "New Retro," a 50- by 44-millimeter self-winding watch. Its rectangular case, which lies along rather than across the wrist, and its crown at the "12" call to mind the auto-mobile driver's watches that were very popular in the 1930s. Ladies appreciate the lavishly gemstone-encrusted watches in the "Grappoli" line: the total weight of the gems on each of these timepiecs is approximately 73 carats. And for aficionadas with an affinity for high tech, the creative Italian collabo-rated with Samsung to develop a dressy smartwatch: compatible with most Samsung-brand smartphones, the "Samsung Gear S2 by de Grisogono" brings a broad spectrum of functions to its wearer's wrist. ○

Instrumento N° Uno, 2000

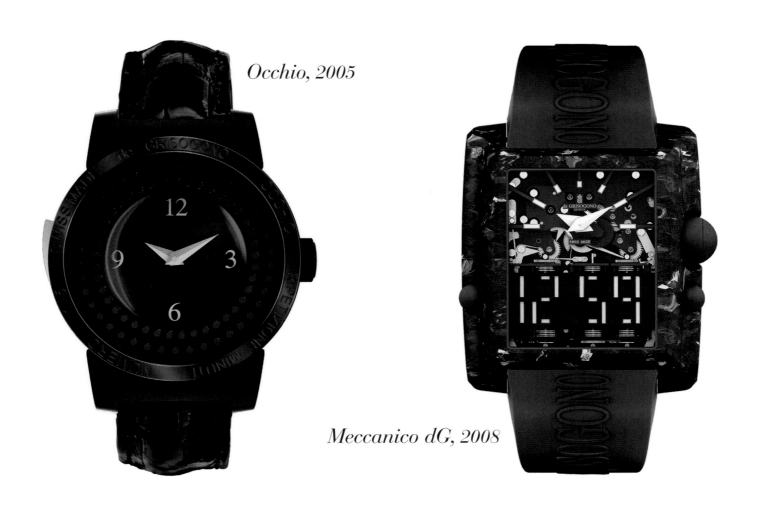

Occhio, 2005

Meccanico dG, 2008

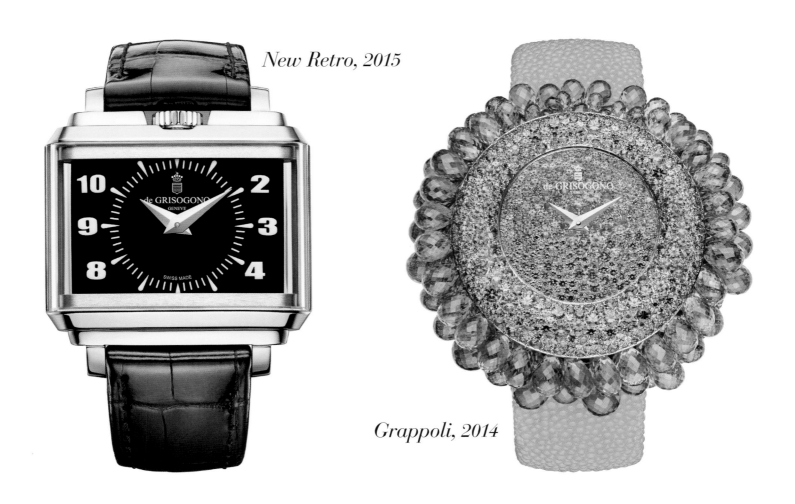

New Retro, 2015

Grappoli, 2014

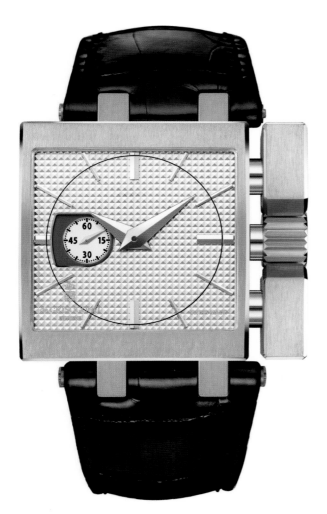
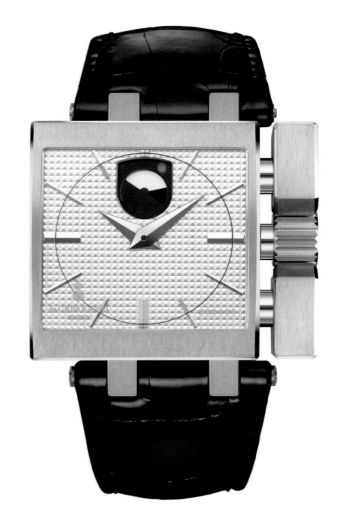

Otturatore, 2011

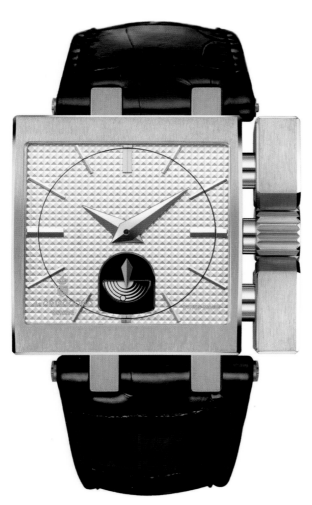
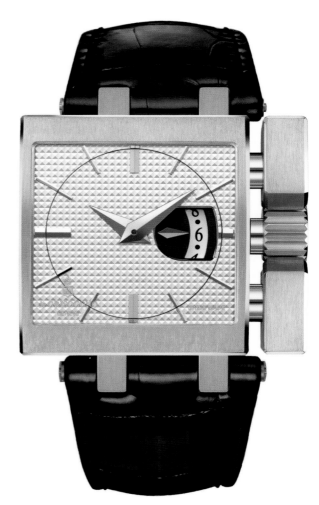

Am liebsten kreativ

Deutsch

Der gebürtige Italiener Fawaz Gruosi war und ist ein Mann der Praxis. Dementsprechend verlief auch die Karriere. Seine Heimatstadt Florenz prägte die unstillbare Liebe zu den schönen Künsten. Da lag der erste Job bei einem Florentiner Juwelier förmlich auf der Hand. Weitere Stationen des beruflichen Lebens: London, Saudi-Arabien, New York und Genf. Fawaz Gruosi arbeitete für Harry Winston und später für Bulgari. Als sich Gianni Bulgari vom Familienunternehmen trennte, waren auch für Gruosi eigene Wege angezeigt. Gemeinsam mit zwei Partnern gründete er 1993 ein eigenes Juweliergeschäft im Zentrum von Genf. Der Traum von einer eigenen Marke rückte näher. Natürlich wünschte sich damals jeder seinen eigenen Namen. Am Ende setzte sich der Name der Mutter von einem der Partner durch, einer Marquesa de Grisogono. Dabei blieb es auch 1995 nach der Trennung von den Partnern. Fawaz Gruosi hatte von Anbeginn für das Produktdesign verantwortlich gezeichnet und tat das fortan auch als Alleinunternehmer. Die weitere Firmenbiographie prägte der „Black Orlov", denn die 195-Karat-Preziose weckte die Leidenschaft für schwarze Diamanten. 2000 ging das Uhrendebüt während der Baselworld über die Bühne. „Instrumento N° Uno", ein Mix aus bewährter Eta-Automatik und exklusiver Zusatz-Mechanik, brachte es spontan auf erstaunliche Stückzahlen. Mehr als 5 000 Exemplare konnte de Grisogono herstellen und verkaufen. „Meine Stärke auf dem Gebiet der Uhren ist, dass ich kein wirklicher Experte bin. Somit packe ich die Dinge relativ unvoreingenommen an. Obwohl ich viele kompetente Menschen um mich habe, lasse ich mir ungern einreden, dass irgendetwas nicht geht." Der Kern dieser Aussage bestätigte sich 2005 in einer Armbanduhr mit Minutenrepetition. „Occhio", das Auge, entstand in Kooperation mit dem anerkannten Mechanik-Spezialisten Christophe Claret.

Nach Betätigung des Auslöseschiebers im Gehäuserand öffnet sich eine Blende aus zwölf Keramikklappen. Gleichzeitig beginnt das aus 324 Teilen komponierte Œuvre die Zeit auf insgesamt drei Tonfedern zu schlagen. 2006 brachte Gruosi / de Grisogono die rechteckige „FG One" mit Automatikwerk und außergewöhnlichem Zeitzonen-Mechanismus auf den Markt. Mehr als 651 Teile assemblierten die Uhrmacher ab dem Folgejahr für ein Handaufzugswerk in der limitierten „Meccanico dG" mit nie dagewesener Doppel-Zeitanzeige. Selbst Frauen beeindruckte der markante „Otturatore", denn die kantige Armbanduhr übte sich in Zurückhaltung, hervorgerufen durch den Effekt einer patentierten Wechselblende hinter den Zeigern für Stunden und Minuten. Mit ihrer Hilfe können die Besitzer nach Belieben aus dem hintergründig vorhandenen Anzeigespektrum wählen: kleine Sekunde, Fensterdatum, Mondphasenindikation oder Gangreserveanzeige. Auch danach mangelte es dem Kreativchef nicht an Ideen. Was zu belegen ist an drei aktuellen Armbanduhren: Für die Herren der Schöpfung hat Fawaz Gruosi die „New Retro" geschaffen, eine 50 x 44 Millimeter große Automatik-Armbanduhr. Das quer am Handgelenk liegende Rechteck und die Krone bei der „12" wecken Erinnerungen an die unter anderem in den 1930er Jahren sehr beliebten Autofahrer-Armbanduhren. Frauen kommen einmal durch „Grappoli" zu ihrem Recht, eine opulent mit Schmucksteinen ausgefasste Linie. Jedes Exemplar zieren Edelsteine mit einem Wert von ungefähr 73 Karat. Für technikaffine Zeitgenossinnen entwickelte der kreative Italiener zusammen mit Samsung eine schmückende Smartwatch. Die „Samsung Gear S2 by de Grisogono" verbindet sich am liebsten mit Smartphones dieses Herstellers und bietet am Handgelenk ein breites Funktionsspektrum. ◦

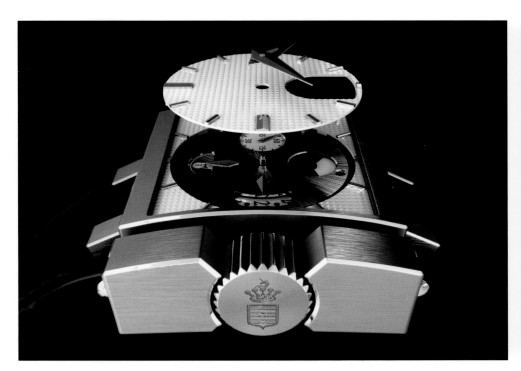

From left: Otturatore, 2011 ◦ Fawaz Gruosi

Un net penchant pour la créativité

De mère italienne, Fawaz Gruosi est un homme intuitif, à l'esprit résolument pratique, comme en témoigne sa carrière. Florence, sa ville d'élection, a forgé son amour inextinguible pour les beaux-arts. Rien de surprenant donc à ce que son premier employeur soit un joaillier florentin. Sa vie professionnelle le conduit ensuite à Londres, en Arabie saoudite, à New York et à Genève. Fawaz Gruosi travaille pour Harry Winston puis pour Gianni Bulgari. Lorsque ce dernier se sépare de son entreprise familiale, c'est pour Fawaz Gruosi le signe qu'il doit suivre sa propre voie. Avec des partenaires, il fonde en 1993 une joaillerie dans le centre de Genève, et le rêve d'une marque en propre est prêt de se réaliser. Chaque associé veut bien sûr qu'elle porte son nom. Mais l'un de ses partenaires finira par imposer celui de sa mère, la marquise de Grisogono. Ce nom ne changera plus, même après la séparation des associés en 1995. Responsable dès le début de la création artistique, Fawaz Gruosi le restera une fois seul aux commandes. La suite de l'histoire de la société est marquée par « Black Orlov », une pierre précieuse de 195 carats qui déchaîne une passion pour les diamants noirs. Fawaz Gruosi fait ses débuts dans l'horlogerie lors du salon Baselworld en 2000. « Instrumento N° Uno », qui associe un mouvement automatique Eta éprouvé et des éléments mécaniques complémentaires raffinés, trouve rapidement un nombre étonnant d'acheteurs. Plus de 5 000 exemplaires sont ainsi fabriqués et vendus. « Ma force dans le domaine des montres tient au fait que je ne suis pas vraiment un spécialiste. J'aborde donc les choses plutôt sans préjugé, et les nombreuses personnes compétentes qui m'entourent ont bien du mal à me convaincre que quelque chose est impossible. » Le créateur confirme ces propos en créant en 2005 une montre-bracelet à répétition minute. « Occhio » (œil, en italien) naît de la coopération avec Christophe Claret, éminent spécialiste en mécanique horlogère. L'activation du poussoir sur la tranche du boîtier entraîne l'ouverture d'un diaphragme composé de douze volets en céramique. Le mouvement composé de 324 éléments sonne alors l'heure sur trois timbres. En 2006, Fawaz Gruosi / de Grisogono sort sur le marché la « FG One », une montre rectangulaire à mouvement automatique et guichet affichant un second fuseau horaire. L'année suivante, les horlogers de la marque assemblent plus de 650 composants pour créer le mouvement de la montre-bracelet en édition limitée « Meccanico dG », dotée d'un double affichage du temps unique en son genre. Les femmes comme les hommes sont impressionnés par la remarquable « Otturatore ». Cette montre-bracelet anguleuse joue la carte de la retenue grâce à un obturateur séquentiel breveté à l'arrière-plan des aiguilles des heures et des minutes. Au moyen de larges poussoirs, le porteur de la montre sélectionne une des complications suivantes : petites secondes, guichet de date, phase de lune ou réserve de marche. Le directeur artistique continue de faire preuve d'inventivité, ce que démontrent trois nouvelles montres-bracelets. Pour la gent masculine, Fawaz Gruosi crée la « New Retro », une montre-bracelet à remontage automatique de 50 x 44 millimètres. Le boîtier rectangulaire plus large que haut et la couronne à midi font penser aux montres-bracelets très populaires, dans les années 1930 notamment, auprès des automobilistes. Les femmes apprécient la ligne « Grappoli », richement sertie de pierres précieuses, pour un poids d'environ 73 carats par montre. Pour la femme moderne passionnée de technique, le créateur italien met au point avec Samsung une élégante montre connectée. Parfaitement compatible avec les smartphones de ce fabricant, la « Samsung Gear S2 by de Grisogono » offre un large éventail de fonctions directement au poignet de sa propriétaire. ○

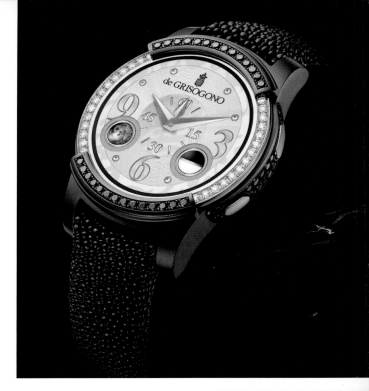

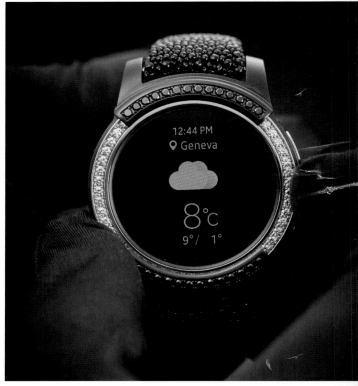

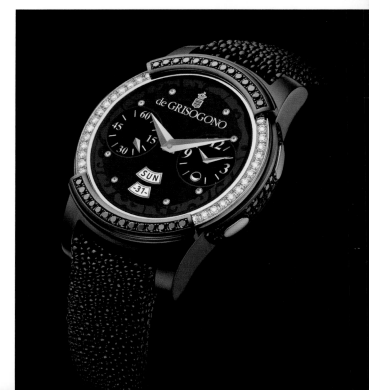

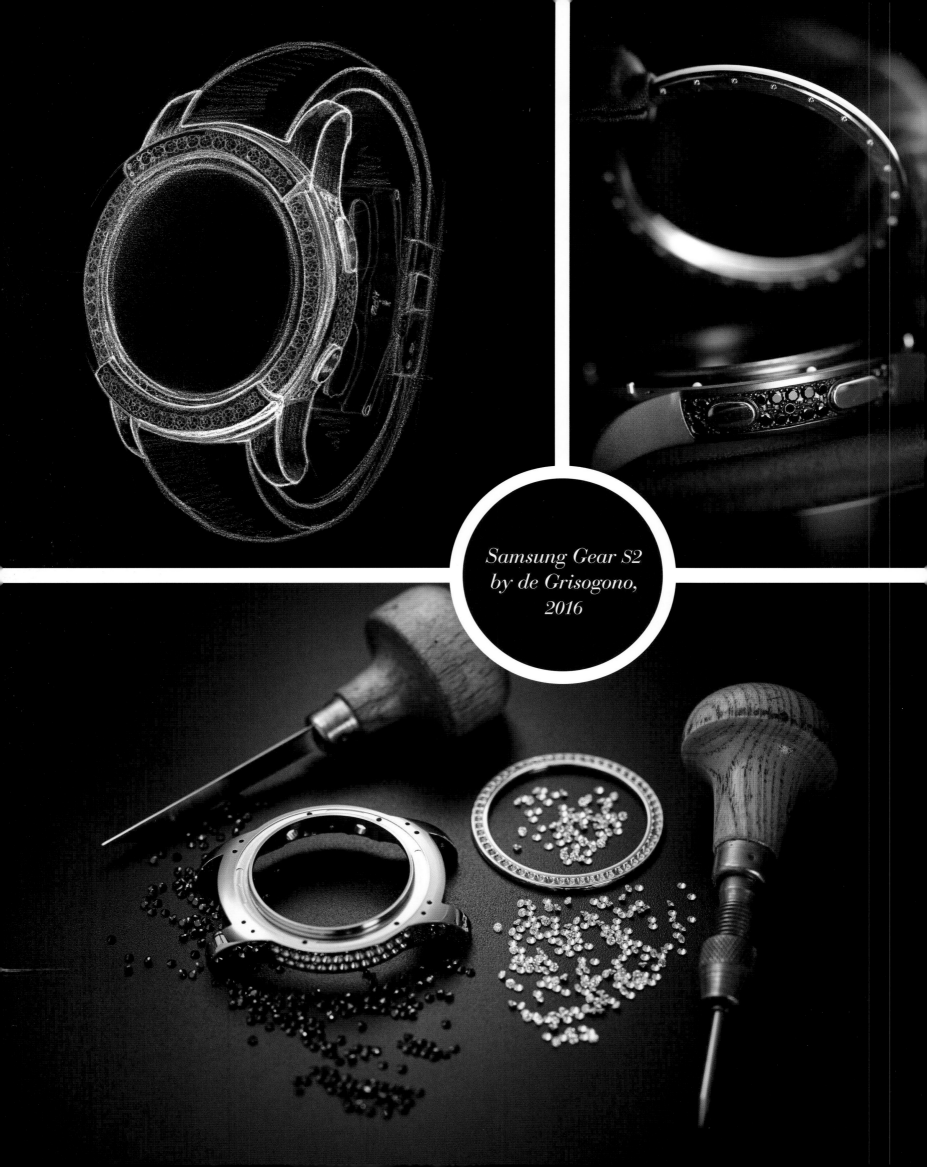

*Samsung Gear S2
by de Grisogono,
2016*

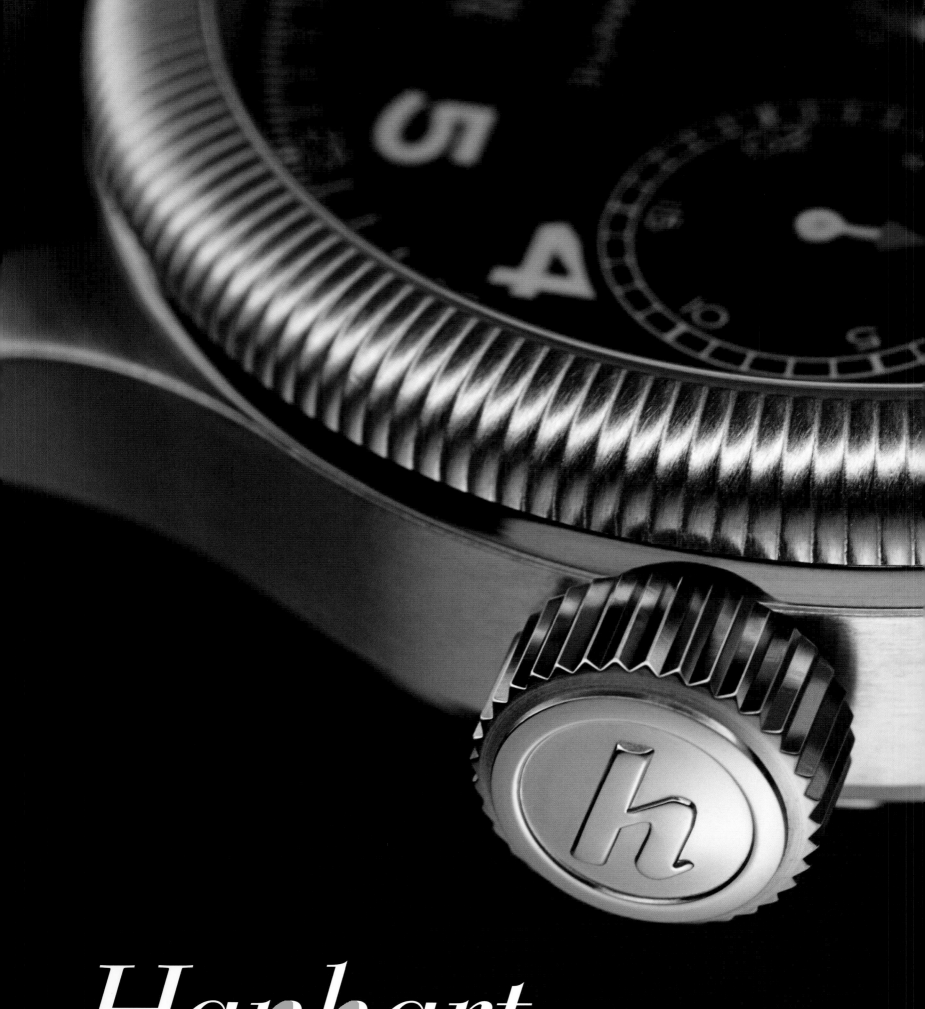

Hanhart

Memories of the Future

When watch aficionados hear the name "Hanhart," they usually think of a masculine chronograph with a red zero-reset button. The history of this distinctive push-piece began in the 1940s. The manufactory, which was established in 1882, already offered a very comprehensive portfolio of products prior to World War Two. Prewar catalogues listed 48 wristwatch models, six pocket watches, eight stopwatches, two sport watches, and one watch in a carrying case. The spectrum accordingly provided a clear preview of future product priorities. Hanhart began developing its first chronographs with the brand's own caliber family 4x in 1938. The diameter of these hand-wound movements was 15½ lignes, i.e., 35 millimeters. Hanhart offered: Caliber 40 with a single button to control the chronograph's start, stop and zero-return functions; Caliber 41 with two buttons for additive stopping; and top-of-the-line Caliber 42 with speedy switching, nowadays known as the "flyback" function. All three calibers included classical chronographic attributes such as column-wheel control and horizontal geared coupling. Caliber 41 can be recognized by the asymmetrical positioning of the two buttons above and below the winding and hand-setting crown. The distinctive red button at "4 o'clock" enlivened specimens destined for duty in military cockpits. To minimize the danger that the zero-return button might be inadvertently operated in the heat of battle to mistakenly trigger the flyback function, a pilot's wife simply daubed it with her red nail polish. Thus began a chronographic legend that was further distinguished by a bright red dot on the fluted rotatable bezel. This mark reminded the user that an interval had elapsed which was longer than could be tallied by the 30-minute totalizer.

Much more can be learned about this brand's colorful history by visiting its little museum at Gütenbach in the Black Forest. Hanhart, which once led the global market for stopwatches, remains the most important manufacturer of mechanical handheld stopwatches, which are fabricated in the brand's own manufactory. The cornerstone for this ticking empire was laid in Diessenhofen in 1882, when the label's founder Johann Adolf Hanhart opened a modest little shop selling watches and jewelry. The small town wasn't large enough to satisfy Hanhart's big ambitions, so he began searching for a new location with greater potential. In 1902, Hanhart relocated to the up-and-coming watch city of Schwenningen am Neckar, where his company thrived and became the region's largest artisanal business. In 1920, Hanhart's 18-year-old son Wilhelm "Willy" Julius declared that only strong familial pressure could persuade him to join the burgeoning family business. He simply wasn't interested in watchmaking or in selling time-measuring instruments. Despite his initial disinterest, Willy went on to successively lead the house of Hanhart into an exceedingly flourishing future because the athletic young man discovered a valuable niche: the shortage of affordably priced stopwatches on the German market. Hanhart capitalized on this opportunity with the 1924 launch of the first German-made "people's stopwatch." Although this model surely couldn't claim to embody haute horlogerie, its movement boasted extremely reliable mechanisms and could run for 24 hours between windings. The stopwatch business was primarily seasonal, leaving the factory with unprofitable downtime in the offseason, so Willy Hanhart also began making inexpensive pocket watches and wristwatches. His spectrum of products included, for example: 10-ligne Caliber 34 with four jewels and a pin-lever escapement; 19-ligne pocket-watch Calibers 22 and 27; and 8¾-ligne lever Caliber 36 with 15 jewels. Hanhart augmented the operation in Schwenningen by opening a small subsidiary in Gütenbach in 1934. The Black Forest community soon made him a tempting offer to relocate his firm's headquarters. Hanhart accepted and settled his business there in 1938.

Hanhart debuted the innovative "Sans Souci" alarm wristwatch toward the end of the 1940s. A product catalogue from 1950 lauded this time-honored pilot's chronograph as a "practical watch for engineers and plant managers." The American actor Steve McQueen numbered among the most famous fans of the "Hanhart 417 ES Flyback". Hanhart ceased production of wristwatches in 1962 and continued to produce only mechanical stopwatches. Electronic timekeeping became dominant in Gütenbach in the 1970s. Although Hanhart created its own quartz movement, which was manufactured in the millions, the family business couldn't lastingly compete with cheaply priced Far Eastern competitors. Jack W. Heuer proposed a merger in the early 1980s, but Hanhart refused. Stopwatches rescued its independence. Klaus Eble, a son-in-law of the Hanhart Family, joined three entrepreneurs from Munich as majority shareholders of Hanhart in 1992. The ensuing reorientation was aptly embodied by the "Replika" (1997) as a representative of the new generation. The specialists in Gütenbach revived the traditional watchmaker's art and launched this pilot's chronograph as an authentic replica of the historical model from 1939. An intermezzo began under the aegis of the Swiss investment company Gaydoul Group in 2010, but in 2014 Hanhart again became the property of the same Munich-based businessmen's group that had piloted it from 1992 to 2008. Once again headquartered in Gütenbach, Hanhart presently pursues a two-track sales strategy: cooperation with traditional specialized dealers is one track; the other is online sales, although the latter includes the former.

Considering the turbulent historical events of the past fourteen decades, it's all the more remarkable that Hanhart has existed and manufactured its products uninterruptedly since 1882. An important contributor to its success is the fact that Hanhart's products are traditionally "made in Germany." Some 12,000 mechanical stopwatches are built annually, and each encases a genuine manufacture caliber. These timepieces are highly appreciated as "classic timers" by fans of vintage automobiles and participants in rallies for classic motorcars. The distinctive collection of wristwatch chronographs is divided into three lines, each with its own specific aims. "Primus" combines traditional elements (e.g., the well-known red button) with progressive design and high-quality technologies. With boldly styled dials, the "Racemaster" line highlights close affiliations with motorsport of the 1960s and '70s. Unostentatious but effective high technology adds impressive scratch-resistance to the cases of the models in the "Racemaster GT," "Racemaster GTM" and "Racemaster GTF" lines. Hanhart uses patented, nickel-free, extremely corrosion-resistant steel known as HDS-Pro for these high-end cases. The surface of this alloy is at least three times harder than the surface of conventional stainless steel, which makes the cases

approximately 100 times more resistant to scratches. Incidentally: the thermal annealing process doesn't detract from the appearance of the material, which still looks like classical steel.

Last but not least, the "Pioneer" line celebrates a contemporary retro look. Like the three aforementioned "Racemaster" models, the "TwinDicator" recalls Hanhart's grand chronographic legacy. The manufactory's hand-wound movements have become things of the past, so Hanhart cooperates with the experienced Swiss mechanical specialists at La Joux-Perret, who modify reliable Valjoux/Eta 7750 or Sellita SW 500 calibers by adding additional gears or other special features in harmony with the original look, e.g., the push-pieces are positioned at unequal distances from the crown, just as they were on the original models. The front-mounted module suggests that, as in the good old days, here too a voluminous caliber ticks inside the case. An additional counter for 12 elapsed hours is positioned concentrically with the small seconds at "9 o'clock." In keeping with tradition, one button is colored bright red. Needless to say, Hanhart again offers a version with the time-honored flyback function to delight aficionados of perfect nostalgia on the wrist. ○

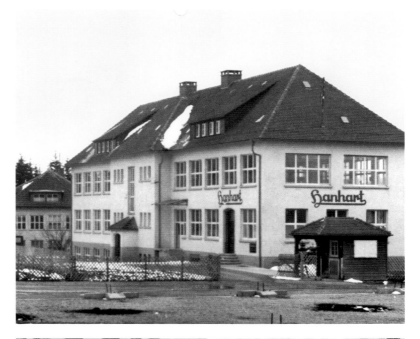

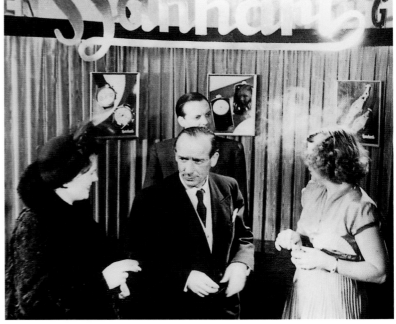

From top: The Hanhart building in Schwenningen, c. 1902 ○
Willy Hanhart at Baselworld, 1952 ○ A view of production at
the Hanhart watch factory in Gütenbach, c. 1930 ○
Von oben: Hanhart-Gebäude in Schwenningen, ab 1902 ○
Willy Hanhart bei der Baselworld, 1952 ○ Einblick in die Produktion
der Hanhart-Uhrenmanufaktur in Gütenbach, um 1930 ○
De haut en bas : Site Hanhart de Schwenningen, à partir
de 1902 ○ Willy Hanhart au Salon mondial de l'horlogerie
à Bâle en 1952 ○ Aperçu de la production dans la manufacture
de Gütenbach, vers 1930

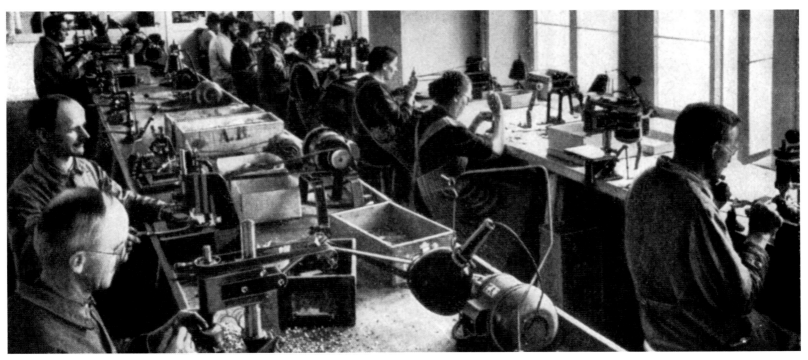

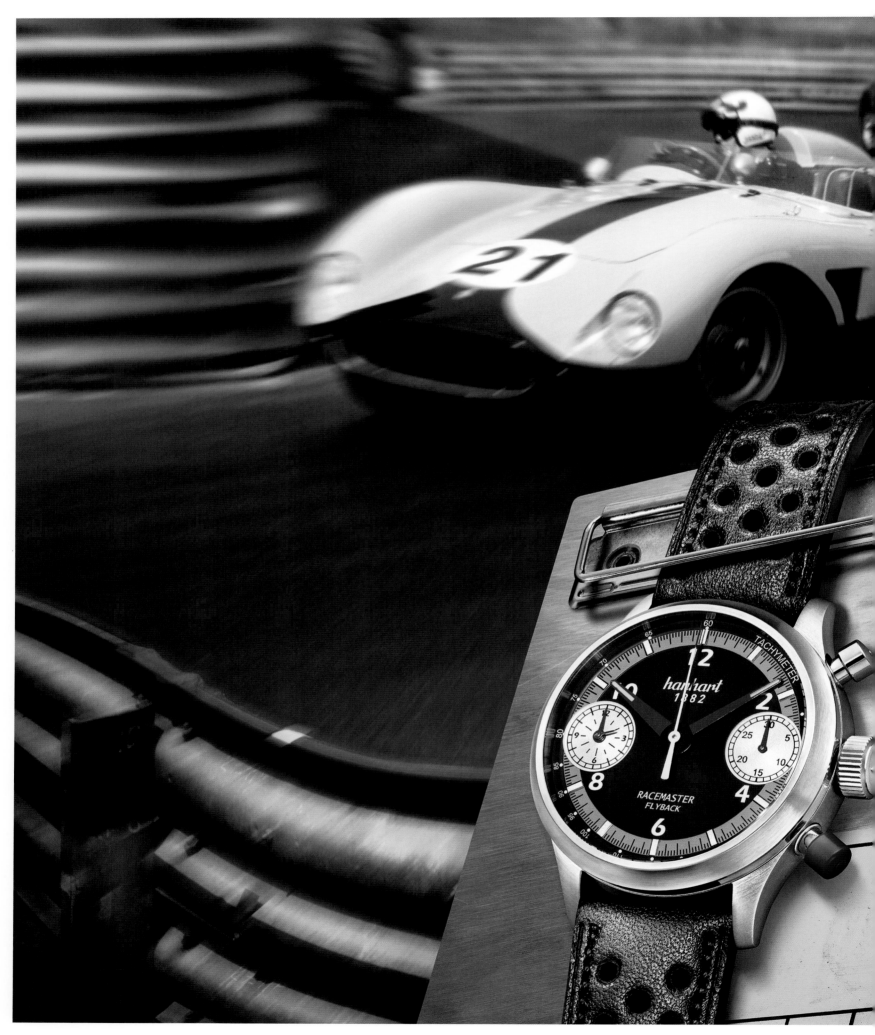

RACEMASTER, 2013

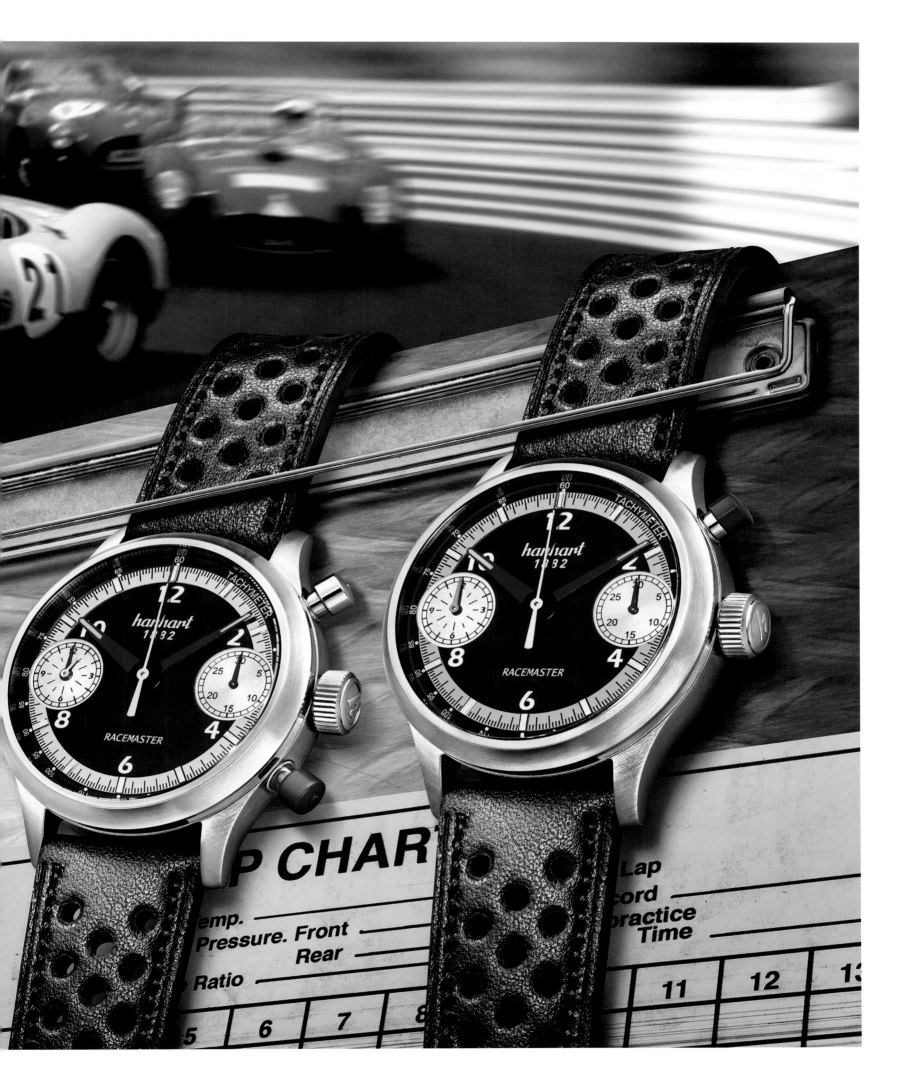

Erinnerungen an die Zukunft

Hanhart – mit dieser deutschen Traditionsmarke verknüpfen Uhrenliebhaber in aller Regel maskuline Chronographen mit rotem Nullstelldrücker. Selbiger hat natürlich seine spezielle Geschichte, welche in den 1940er Jahren spielt. Bereits vor Ausbruch des Zweiten Weltkriegs hatte die 1882 gegründete Manufaktur einen neuen, sehr umfassenden Verkaufskatalog präsentiert. Darin fanden sich insgesamt 45 Armbanduhr-Modelle, sechs Taschen-, acht Stopp- und zwei Sportuhren sowie eine Etuiuhr. Die künftigen Produktprioritäten waren damit ganz klar vorgezeichnet. 1938 startete die Entwicklung erster Chronographen mit der hauseigenen Kaliberfamilie 4x. Die gemäß Uhrmacherjargon 15½-linigen Handaufzugswerke maßen stattliche 35 Millimeter. Hanhart offerierte sie als Kaliber 40 mit nur einem Drücker für alle drei Funktionen Start, Stopp und Nullstellung, als 41 mit zwei Drückern für Additionsstoppungen sowie als Top-Version 42 mit Temposchaltung, was im modernen Sprachgebrauch eine sogenannte Flyback-Funktion meint. Besondere Kaliber-Kennzeichen des Trios waren klassische Chronographen-Merkmale wie Schaltradsteuerung und horizontale Räderkupplung. Das Kaliber 41 erkannte man an asymmetrisch ober- und unterhalb der Aufzugs- und Zeigerstellkrone positionierten Drückern. Bei den für militärische Cockpits bestimmten Exemplaren kommt nun der signifikant rote Drücker bei der „4" ins Spiel. Hierbei handelt es sich um den Nullstelldrücker, welchen man speziell bei der Ausführung mit Temposchaltung im Eifer des Gefechts bloß nicht versehentlich betätigen sollte. Also färbte ihn die besorgte Gattin eines Piloten kurzerhand mit ihrem roten Nagellack ein. Und damit war eine zeitschreibende Legende geboren, welche sich auch noch durch einen roten Farbtupfer auf der gerändelten Drehlünette auszeichnete. Dieser Merkpunkt erinnerte beispielsweise an den Ablauf eines längeren Zeitintervalls, das der Chronograph mit seinem 30-Minuten-Totalisator nicht erfassen konnte.

Mehr über die lange, sehr bewegte Geschichte des Unternehmens erfährt man bei einem Besuch des kleinen Museums in Gütenbach im Schwarzwald. Hanhart war einstmals Weltmarktführer im Stoppuhrenbereich und ist auch heute noch der bedeutendste Hersteller mechanischer Handstopper, die in der hauseigenen Manufaktur am Firmensitz gefertigt werden. Den Grundstein für dieses tickende Imperium hatte der Gründer Johann Adolf Hanhart 1882 in Diessenhofen durch ein schlichtes Uhren- und Schmuckgeschäft gelegt. Weil der ausgeprägte Geschäftssinn Hanharts in der relativ kleinen Ortschaft nur unzureichend zur Geltung kam, hielt der ambitionierte Unternehmer Ausschau nach adäquaten Entfaltungsmöglichkeiten. 1902 begab er sich in die aufstrebende Uhrenstadt Schwenningen am Neckar. Dort gedieh Hanhart zum größten handwerklichen Unternehmen der Region. 1920 erklärte sich der gerade einmal 18-jährige Sohn Wilhelm Julius, genannt Willy, nur unter familiärem Druck bereit, in das aufstrebende Unternehmen einzusteigen. Er hielt nicht sonderlich viel von der Uhrmacherei und dem Handel mit Zeitmessinstrumenten. Das anfängliche Desinteresse änderte nichts an der Tatsache, dass gerade er das Haus Hanhart sukzessive in eine überaus erfolgreiche Zukunft steuern sollte. Denn der sportive Juniorchef erkannte eine Lücke. Dem deutschen Markt mangelte es an preiswerten Stoppuhren. Hanhart nutzte dieses Defizit und lancierte 1924 die erste Volks-Stoppuhr deutscher Provenienz. Von hoher Uhrmacherkunst war dieses Modell weit entfernt. Dafür zeichnete sich das Uhrwerk mit einer Gangautonomie von 24 Stunden durch eine höchst zuverlässige Mechanik aus. Weil das primär saisonal ausgerichtete Stoppuhren-Geschäft den Fertigungsbetrieb nicht auslastete, setzte Willy Hanhart auf preiswerte Taschen- und Armbanduhren. Sein Fertigungsspektrum umfasste beispielsweise das 10-linige Kaliber 34 mit vier Steinen und Stiftanker-Hemmung, die 19-linigen Taschenuhr-Kaliber 22 und 27 sowie das 8¾-linige Anker-Kaliber 36 mit 15 Steinen. 1934 ergänzte Hanhart den Schwenninger Betrieb zunächst nur um eine kleine Filiale in Gütenbach. Als die abgelegene Schwarzwald-Gemeinde ein verlockendes Angebot zur Verlagerung des Firmensitzes unterbreitete, zog Hanhart im Jahr 1938 dorthin um.

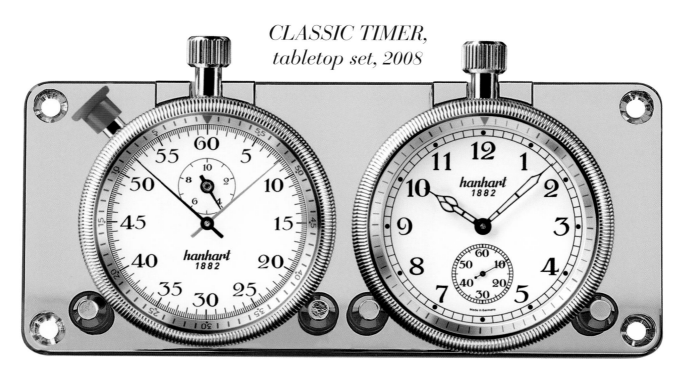

CLASSIC TIMER,
tabletop set, 2008

Ende der 1940er Jahre stellte Hanhart den innovativen Armband-wecker „Sans Souci" vor. Den bewährten Flieger-Chronographen pries der Produktkatalog 1950 als „zweckmäßige Uhr für den Ingenieur und Betriebsleiter" an. Zu den berühmtesten Fans der „Hanhart 417 ES Flyback" gehörte der amerikanische Schauspieler Steve McQueen. 1962 endete vorerst einmal die Herstellung von Armbanduhren zugunsten mechanischer Stoppuhren. Ab den 1970er Jahren dominierte in Gütenbach die Elektronik. Hanhart kreierte ein eigenes, millionenfach verkauftes Quarzwerk. Trotz-dem konnte das Familienunternehmen im permanenten Wettkampf mit fernöstlichen Billigkonkurrenten nicht dauerhaft bestehen. Anfang der 1980er Jahre lehnte es ein Fusionsangebot von Jack W. Heuer ab. Stoppuhren retteten die Unabhängigkeit. 1992 übernahmen Klaus Eble, Schwiegersohn der Familie Hanhart, sowie drei Münchner Unternehmer die Mehrheit der Hanhart-Anteile. Im Zeichen des Aufbruchs stand 1997 die „Replika" als Repräsentant einer neuen Generation. Die Gütenbacher griffen die traditionelle Uhrmacherkunst wieder auf und stellten mit dem Fliegerchronographen einen originalgetreuen Nachbau des historischen Modells von 1939 vor. Nach einem Intermezzo unter dem Dach der schweizerischen Beteiligungsgesellschaft Gaydoul Group, welches 2010 begann, befindet sich Hanhart seit 2014 erneut im Eigentum der Münchner Unternehmergruppe, welche das Unternehmen bereits von 1992 bis 2008 begleitet hatte. Aktuell fährt das wieder in Gütenbach ansässige Unternehmen eine zweigleisige Vertriebsstrategie. Zur Kooperation mit dem tradierten Fachhandel gesellt sich eine Online-Schiene, welche ersteren jedoch angemessen einbindet.

Angesichts turbulenter geschichtlicher Ereignisse gerät oftmals in Vergessenheit, dass Hanhart seit 1882 ohne jede Unterbrechung existiert und produziert hat. Hoch im Kurs steht jenes „Made in Germany", welches traditionsgemäß zu der Marke gehört. Jährlich entstehen weiterhin rund 12000 mechanische Stoppuhren mit echten Manufakturkalibern, als „Classictimer" hoch geschätzt unter anderem von Oldtimer-Fans und Vintage-Rallye-Clubs. Die markante Arm-bandchronographen-Kollektion gliedert sich in drei Linien mit ganz unterschiedlichen Ansprüchen. „Primus" kombiniert traditio-nelle Elemente wie den bekannten roten Drücker mit progressivem Design und hochwertigen Technologien. „Racemaster" weist beispiels-weise durch markante Zifferblätter auf die engen Verbindungen zum Motorsport in den 1960er und 1970er Jahren hin. Unauffällige,

aber wirkungsvolle Hochtechnologie verhilft den Gehäusen der Modelle „Racemaster GT", „Racemaster GTM" und „Racemaster GTF" zu beeindruckender Kratzfestigkeit. Für die High-End-Schalen verwendet Hanhart einen patentierten, nickelfreien und extrem korrosionsbeständigen Stahl namens HDS-Pro. Selbiger besitzt eine mindestens drei Mal härtere Oberflächenstruktur als konven-tioneller Edelstahl, was die Gehäuse rund 100-mal kratzbeständiger macht. Die Optik leidet unter der thermischen Vergütung übrigens nicht. Das Ganze sieht weiterhin aus wie klassischer Stahl.

Schließlich präsentiert sich die „Pioneer"-Linie in zeit-gemäßem Retrolook. Wie bei den drei genannten „Racemaster"-Modellen erinnert auch hier der „TwinDicator" an das große chronographische Erbe. Weil das Manufaktur-Handaufzugswerk aus mehreren Gründen der Vergangen-heit angehört, kooperiert Hanhart mit dem erfahrenen Schweizer Mechanik-Spezialisten La Joux-Perret, welcher die zuverlässigen Kaliber Valjoux/Eta 7750 oder Sellita SW 500 durch zusätzliche Zahnräder und andere Kniffe im Sinne der ursprünglichen Optik modifiziert, ergo stehen die Drücker wie bei den Originalen unterschiedlich weit von der Krone ab. Und das vorderseitig montierte Modul lässt vermuten, im Gehäuse-inneren ticke – wie einst – ein voluminöseres Kaliber. Konzentrisch zur kleinen Sekunde bei „9" rotiert ein zusätzlicher 12-Stunden-Totalisator. Getreu großer Tradition erstrahlt ein Drücker in leuchtendem Rot. Selbstverständlich offeriert Hanhart Verfechtern perfekter Nostalgie am Handgelenk auch wieder ein Exemplar mit überlieferter Flyback-Funktion. ○

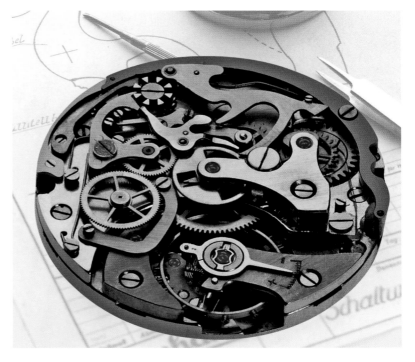

Top: Cal. 40 ○ Right: Cal. 41

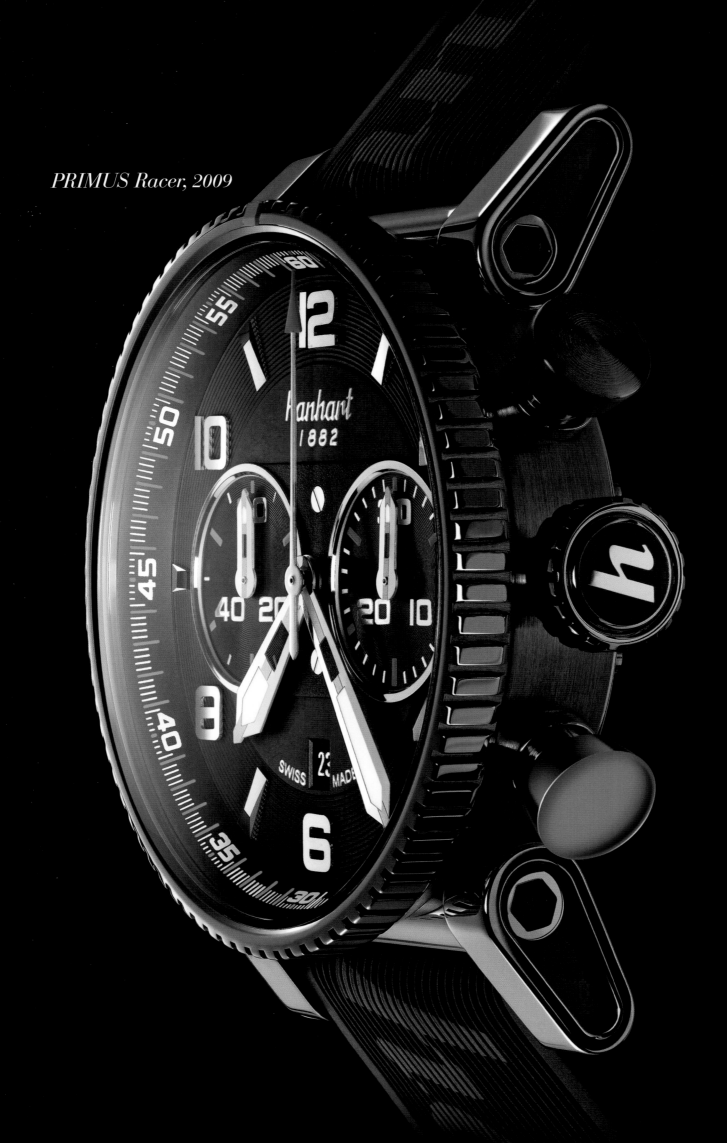

PRIMUS Racer, 2009

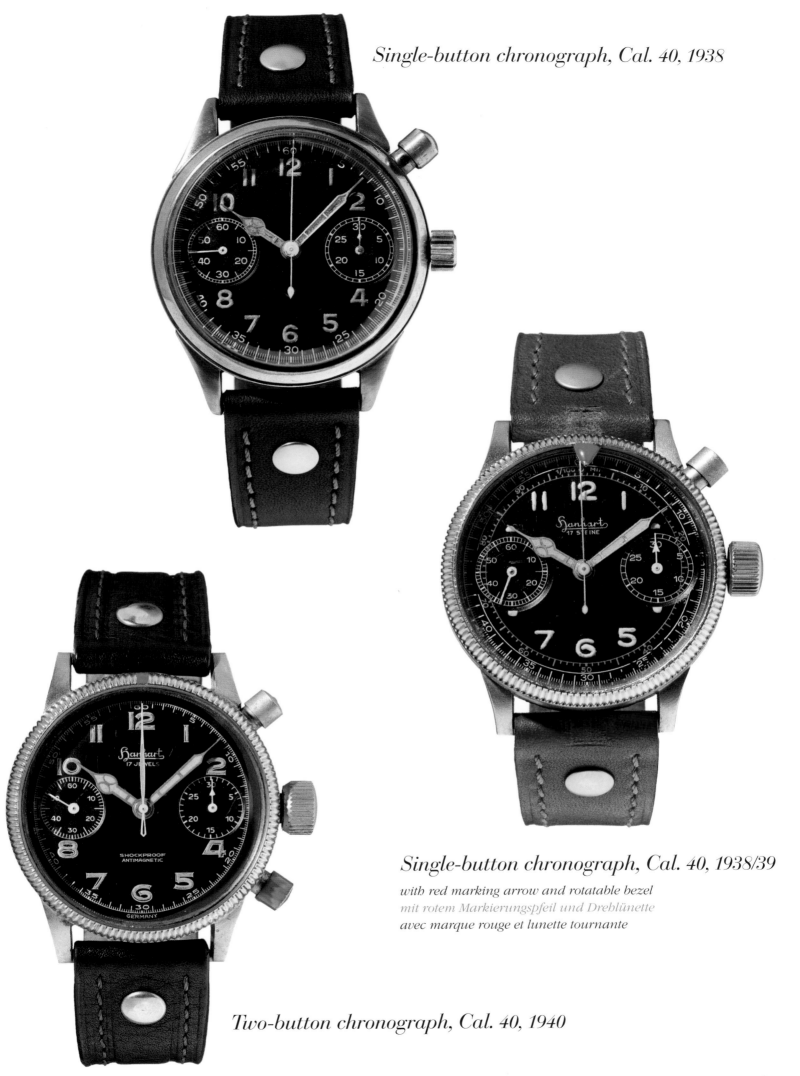

Single-button chronograph, Cal. 40, 1938

Single-button chronograph, Cal. 40, 1938/39

with red marking arrow and rotatable bezel
mit rotem Markierungspfeil und Drehlünette
avec marque rouge et lunette tournante

Two-button chronograph, Cal. 40, 1940

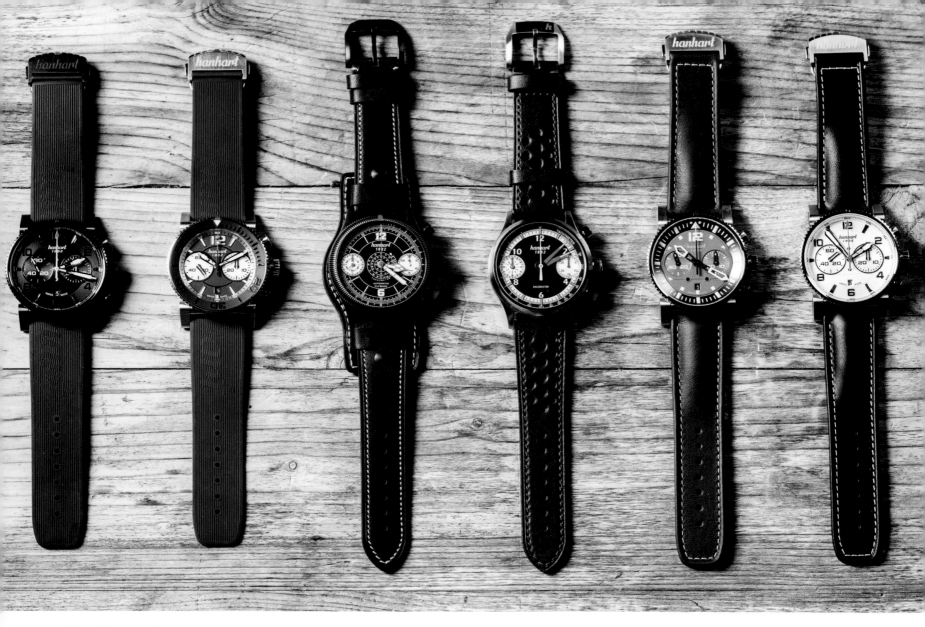

PRIMUS Racer, 2009; PRIMUS Diver, 2009; PIONEER Stealth 1882, 2012; RACEMASTER GT, 2013; PRIMUS Pilot, 2009; PRIMUS Racer, 2009

Souvenirs du futur

Les passionnés de montres associent généralement à la marque allemande de tradition Hanhart des chronographes pour hommes équipés d'un poussoir de remise à zéro rouge. Pour la petite histoire, il faut remonter aux années 1940 : avant même la Seconde Guerre mondiale, cette manufacture fondée en 1882 sort un nouveau catalogue, très complet, qui comporte au total 45 montres-bracelets, six montres de poche, huit chronomètres et deux montres pour sportifs ainsi qu'une montre-étui. Les priorités futures en termes de production sont ainsi clairement esquissées. Les premiers chronographes développés par la marque à partir de 1938 sont équipés de la famille de calibres 4x produits en interne. Les mouvements à remontage manuel 15'''½, comme on les appelle dans le jargon horloger, mesurent pas moins de 35 millimètres de diamètre. Hanhart les décline en plusieurs versions : avec le calibre 40 et un poussoir unique pour les trois fonctions mise en marche, arrêt et remise à zéro ; avec le calibre 41 et deux poussoirs pour les mesures successives ; et enfin, une version hautement sophistiquée

avec le calibre 42 doté ce qu'on appelle communément la fonction Flyback ou retour-en-vol. Ces trois calibres présentent des caractéristiques typiques des chronographes, à savoir la roue à colonnes et l'engrenage horizontal. Le calibre 41 se reconnaît à la disposition asymétrique des poussoirs au-dessus et au-dessous de la couronne de remontage et de mise à l'heure. C'est alors qu'entre en scène le poussoir rouge significatif situé à 4 heures, observable sur les exemplaires destinés à l'aviation militaire. Il s'agit là du poussoir de remise à zéro, qu'il ne faut en aucun cas actionner par inadvertance dans le feu du combat, en particulier sur les modèles dotés de la fonction Flyback. Aussi une femme de pilote inquiète l'a-t-elle tout simplement badigeonné de vernis à ongles rouge, donnant ainsi naissance à un chronographe de légende. Ce dernier se caractérise aussi par un point rouge sur la lunette tournante crantée, lequel signale notamment un intervalle de temps supérieur aux 30 minutes que le chronographe peut enregistrer avec son totalisateur.

Pour en savoir plus sur la longue histoire très mouvementée de l'entreprise, on ne peut que recommander une visite au petit musée municipal de Gütenbach, en Forêt-Noire. Jadis leader mondial sur le marché des chronographes, Hanhart est aujourd'hui encore le premier fabricant de chronomètres à main, qui sont produits dans la manufacture maison au siège même de l'entreprise. Tout commence en 1882 à Diessenhofen, par la création d'une simple bijouterie-horlogerie. Ne pouvant guère réaliser tout son potentiel commercial dans cette petite localité, l'ambitieux Johann Adolf Hanhart transfère son entreprise en 1902 à Schwenningen am Neckar (capitale horlogère dans le sud de l'Allemagne), où elle deviendra la plus grande manufacture de la région. Cédant à la pression parentale, Wilhelm Julius Hanhart dit Willy rejoint en 1920 l'entreprise en plein essor. Il a tout juste 18 ans et il fait peu de cas de l'horlogerie et du commerce des garde-temps. En dépit de ce désintérêt initial, il sera justement l'artisan de la réussite exceptionnelle de la maison Hanhart. En effet, ce sportif identifie un créneau dans le marché allemand, celui des chronographes abordables. Sautant dans la brèche, il lance en 1924 le premier chronographe grand public d'origine allemande. Si ce modèle est loin de répondre aux exigences de la haute horlogerie, son mouvement qui lui assure une réserve de marche de 24 heures n'en est pas moins extrêmement fiable. Avant tout saisonnière, la demande en chronographes ne permet pas de faire tourner les ateliers de fabrication à plein rendement. Willy Hanhart mise alors sur les montres de poche et les montres-bracelets abordables, parmi lesquelles le calibre 34 10''' renfermant quatre pierres et un échappement à ancre à chevilles, les calibres 22 et 27 19''' pour montres de poche, ainsi que le calibre 36 8'''¾ à ancre doté de 15 pierres. En 1934, Willy Hanhart commence modestement par adjoindre au site de production de Schwenningen une petite succursale à Gütenbach. Conquis par une offre séduisante de cette municipalité retirée de Forêt-Noire, il y transfère le siège de l'entreprise en 1938.

À la fin des années 1940, Hanhart présente la « Sans Souci », montre-bracelet innovante à réveil intégré. Le catalogue de 1950 vante le chronographe d'aviation éprouvé dans les termes suivants : « une montre qui répond aux besoins de l'ingénieur et du chef d'entreprise ». Les inconditionnels du modèle « 417 ES Flyback » comptent dans leurs rangs des célébrités, parmi lesquelles l'acteur de cinéma américain Steve McQueen. En 1962, la fabrication de montres-bracelets cède pour un temps la place à celle des chronomètres mécaniques. À partir des années 1970, Gütenbach entre dans l'ère de l'électronique, et Hanhart crée son propre mouvement à quartz, qui se vend à des millions d'exemplaires. L'entreprise familiale ne peut cependant pas contrer durablement la concurrence permanente de fabricants asiatiques pratiquant des prix très bas. Elle reçoit au début des années 1980 une proposition de fusion de la part de Jack W. Heuer, mais elle la refuse et conserve son indépendance grâce aux chronomètres. En 1992, trois entreprises munichoises prennent une participation majoritaire dans la manufacture aux côtés de Klaus Eble, gendre de la famille Hanhart. Ouvrant une ère nouvelle en 1997, les « répliques » sont les emblèmes d'une nouvelle génération. Renouant avec la haute horlogerie traditionnelle, la manufacture de Gütenbach présente un chronographe d'aviation qui est la fidèle réplique du modèle original de 1939. Après un intermède de 2010 à 2014 dans le giron de la holding suisse Gaydoul Group, la manufacture Hanhart est

de nouveau propriété du groupe d'entreprises munichoises qui l'a déjà accompagnée de 1992 à 2008. De nos jours, Hanhart, qui a de nouveau son siège à Gütenbach, s'appuie sur deux canaux de distribution, qui coopèrent étroitement : son réseau bien établi de revendeurs spécialisés et une boutique en ligne.

Les vicissitudes de l'Histoire font souvent oublier que depuis sa fondation, en 1882, Hanhart a existé et produit sans aucune interruption. Le « Made in Germany », dont la marque s'est fait une tradition, est très prisé. Hanhart continue de produire annuellement environ 12 000 chronomètres mécaniques équipés d'authentiques calibres de manufacture ; ces « Classictimer » sont très recherchés des amateurs de voitures anciennes et des clubs organisant des rallyes d'automobiles de collection. Par ailleurs, la gamme remarquable de chronographes-bracelets se décline en trois collections répondant à des attentes très différentes. « Primus » allie des éléments traditionnels comme le célèbre poussoir rouge à un design progressiste et à des technologies de pointe. « Racemaster » rend hommage aux liens étroits unissant la marque au sport automobile dans les années 1960 et 1970, notamment avec ses cadrans caractéristiques. Grâce à une technologie avancée, aussi discrète qu'efficace, les boîtiers des modèles « Racemaster GT », « Racemaster GTM » et « Racemaster GTF » présentent une résistance aux éraflures impressionnante. Ces boîtiers haut de gamme sont en HDS-PRO, un acier breveté, sans nickel et extrêmement résistant à la corrosion. Sa structure de surface étant au minimum trois fois plus dure que celle de l'acier inoxydable conventionnel, les boîtiers sont environ 100 fois plus résistants aux éraflures. Le traitement thermique n'altère en rien l'aspect du matériau, qui a encore tout d'un acier classique. La troisième collection, « Pioneer », arbore un look rétro dans l'air du temps. Comme les trois modèles « Racemaster », le « TwinDicator » de cette collection s'inscrit lui aussi dans la lignée des chronographes Hanhart. Le mouvement à remontage manuel de la manufacture étant pour différentes raisons dépassé, Hanhart coopère avec le grand spécialiste de mécanique horlogère suisse La Joux-Perret, qui ajoute aux calibres éprouvés Valjoux/ETA 7750 ou encore Sellita SW 500 des engrenages et divers détails, de façon à recréer l'apparence d'origine, avec notamment la disposition asymétrique des poussoirs de part et d'autre de la couronne. La face avant laisse supposer que le boîtier abrite, comme autrefois, un calibre relativement volumineux. Le cadran auxiliaire situé à 9 heures comprend, outre la petite seconde, un totalisateur 12 heures supplémentaire. Dans la plus grande tradition, un poussoir rouge lumineux brille de mille feux. Pour les adeptes de la nostalgie totale à leur poignet, Hanhart propose bien sûr encore un modèle doté de la fonction retour-en-vol conventionnelle. ○

PIONEER TwinDicator, 2011

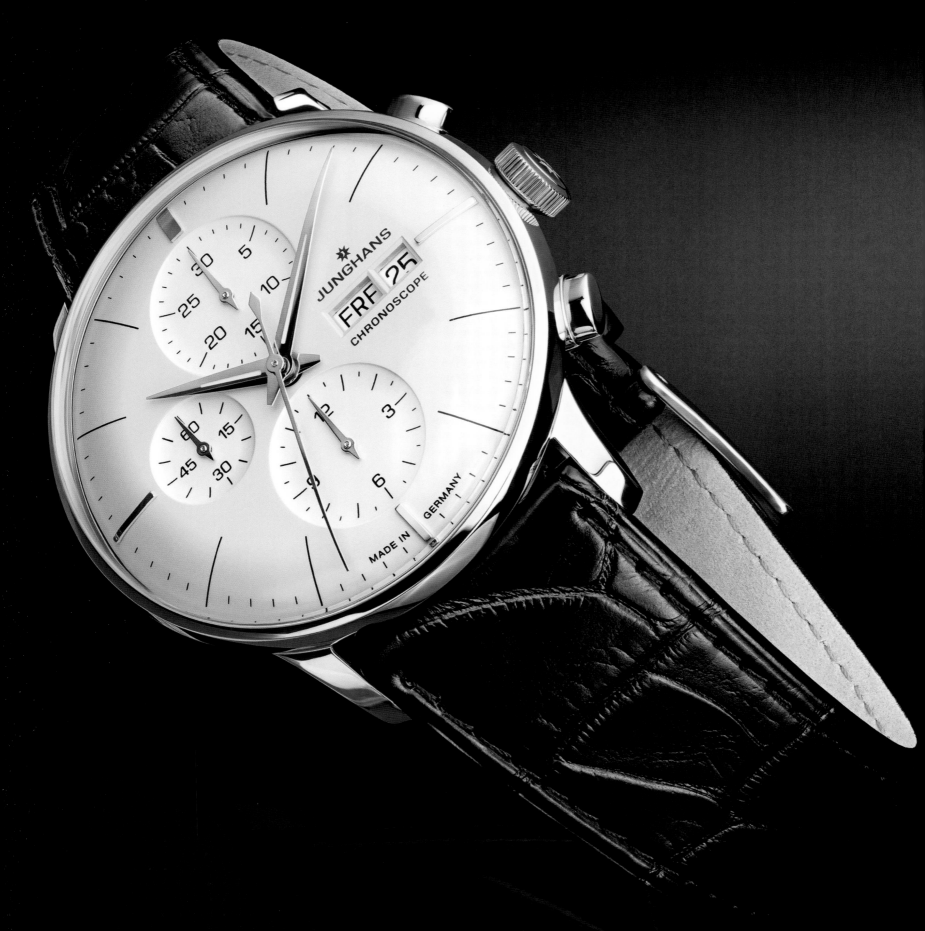

Junghans

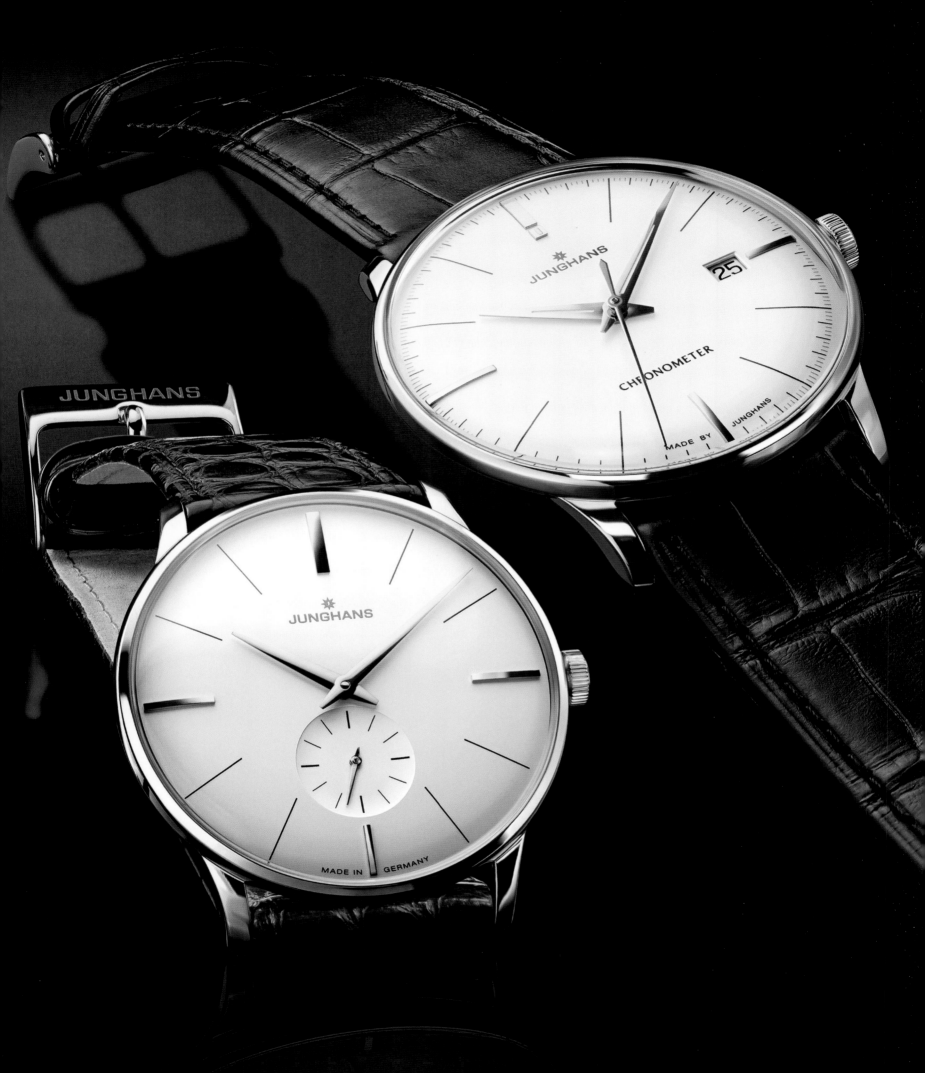

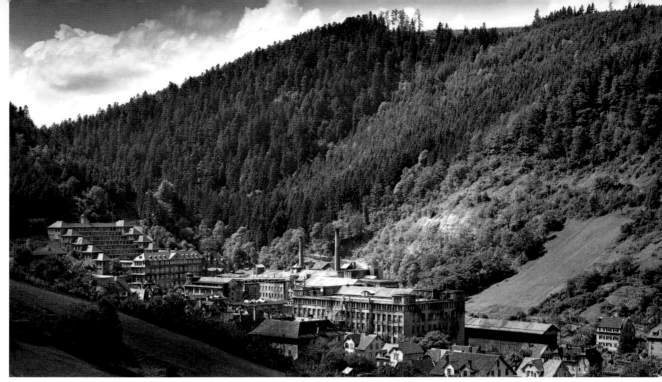

A Traditional German Brand with Innovative Dynamism

English

Erhard Junghans was equally uninterested in traditional horological values and in the fabrication of pocket watches. The factory that he established in Schramberg in 1861 initially produced afford-ably priced components for popular Black Forest clocks. American mass-production methods were introduced as early as 1862. The next step was to build complete clocks using efficient American division of labor and precise machinery. Larger quantities went hand in hand with a broader spectrum of products. With over 3,000 employees producing an incredible 9,000 timepieces per day, Junghans was the world's largest manufacturer of timepieces in 1903. German watch aficionados welcomed the first pocket watches with luminous dials in 1912, but no one in Schramberg had begun thinking about wristwatches at this early date because the decision makers at Junghans were initially dubious about this variety of timepiece. This skepticism was finally overcome under the aegis of Helmut and Siegfried Junghans. On November 22, 1930, the advertising department ran an advertisement with the headline: "The Junghans wristwatch is here!" From this moment on, watches for the wrist would be inseparably linked with the brand's further evolution. The management announced the establish-ment of a research center for timekeeping in 1944. Caliber J88, the manufactory's first postwar movement, debuted in 1949: equipped with a classical column wheel to control its chronograph and a Breguet hairspring, this caliber first animated the official pilot's chronograph for the newly founded German military in 1955. No fewer than 852 patent applications between 1949 and 1956 bear witness to Junghans' extraordinary creativity. At least one of these patents related to the "Minivox" alarm wristwatch, which rang loudly on its wearer's wrist for the first time in 1951, the same year that Junghans premiered its first self-winding caliber. A long-term change in standards of precision for one part of the collection

began with the launch of the legendary Junghans chronometer in 1951. Prior to sale, each of these watches underwent an official test to verify the accuracy of its timekeeping. The success of this initiative proved Junghans right: by the end of 1954, the manufactory's ledgers recorded no fewer than 7,000 Junghans chronometers. The manu-factory had quietly evolved into Germany's largest manufacturer of officially certified wristwatch chronometers with hand-wound and automatic movements. Junghans occupied an honorable third place behind Rolex and Omega in the international ranking of producers of officially certified timepieces. This fact and many others obviously fascinated a Nuremberg businessman named Karl Diehl, whose company acquired the majority of shares in Junghans on December 15, 1956. The Quartz Era dawned at Junghans in the 1970s. With the debut of the "Astro-Quartz" in 1970, the German flagship company began vying with powerful Japanese and Swiss competitors. As it had at the 1936 Olympics, Junghans again served as official timekeeper at the Summer Olympics in Munich in 1972. Needless to say, quartz-controlled technology for athletic timekeeping had progressed in Schramberg. In accord with the spirit of the times, Junghans discontinued production of mechanical calibers for wristwatches in 1976. Over 150 exclusive mechanical move-ments had been manufactured during the preceding 46 years—a feat which made Junghans an extraordinarily versatile manufactory of mechanical timepieces. The company first caused an apprecia-tive furor with ultra-precise radio-controlled quartz clocks in 1985. These high-performance receivers were miniaturized to wristwatch format five years later in 1990: the wristband of the "Mega 1" provided space for its indispensable antenna and all data were presented digitally on a liquid crystal display. Ecologically advanced solar technology was integrated into radio-controlled

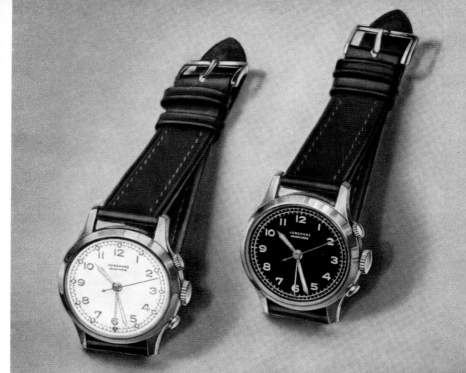

wristwatches in 1993. Another quantum leap followed in 1995, when Junghans premiered the "Mega Solar Ceramic" with analogue time display, solar technology, six-month power reserve, time-zone adjustment and scratch-resistant ceramic case. Under the aegis of Egana Goldpfeil, Junghans occupied itself with the most widely diverse state-of-the-art technologies at the beginning of the 21st century. But the specialists in the Black Forest simultaneously realized that good old mechanical timekeeping cannot be killed. Thanks to the rich trove in its archive, Junghans readily participated in the mechanical renaissance. An especially important legacy was bequeathed to Junghans by Max Bill (1908–1994), a Swiss architect, sculptor, painter and product designer who ranked among the best-known protagonists and theorists of Concrete art. He expressed his philosophy of creating "useful objects that are humble in a beautiful way" through a series of four dials which he designed in the early 1960s. Wristwatches with these handsome dials are coveted collectors' items nowadays, so it's not surprising that they inspired Junghans' designers to create the classical and bestselling wristwatches in the "Max Bill by Junghans" line. The instantaneous success of this line of watches proved that genuine classics never go out of style.

Paying due homage to the firm's founder, the "Erhard Junghans" embodied the top of the line in the mechanical collection in 2006. Its distinctively designed case houses a Seiko movement that's reserved for Junghans. The entry level is defined by Caliber J830 with a rotor for the self-winding mechanism and a date window. The undisputed pinnacle in this line remains chronograph Caliber J890, a meticulously finished chronograph movement with a column wheel. Junghans is by no means content merely to purchase finished calibers: instead, the brand's specialists fabricate and finely finish a large number of components (e.g., bridges, ratchets, gold *châtons*, and fine adjustment mechanisms) for Calibers J325 and J330. The latter is also equipped with a blue

Breguet hairspring made from Nivarox by the Carl Haas firm in Schramberg. These movements tick inside the "Erhard Junghans 1" and "Erhard Junghans 2," each of which is available in a limited edition of twelve models.

The insolvency of its mother company Egana Goldpfeil in 2008 also had some inarguably positive aspects for Junghans. The reins were passed early in 2009 to the Steims, a family of business-people in Schramberg. The new owners recognized the existing and partly dormant values of the venerable watch brand. The Steims' mechanical timekeeping philosophy cultivates tradition and offers affordable horological luxury of German provenance. Alongside the "Erhard Junghans" and the "Max Bill by Junghans," the "Junghans Meister" evokes many memories of this brand's mechanical tradition. Clear, frill-free design had distinguished the watches in this collection in the past. Today too, there isn't the slightest reason to depart from this winning formula. In this sense, the "Meister Driver" models that debuted at Baselworld in 2016 celebrate nostalgia in its purest form, either with a classical hand-wound movement or as the "Chronoscope," in which Junghans encases automatic Caliber J.880.3, a combination of time-honored Eta 2892-A2 and chronograph module 2030 from Dubois Dépraz. Equally reliable basic Caliber Eta 2824-2 ticks inside the "Meister Pilot," which harkens back to the year 1955 and the official chrono-graph of the German military. All this expresses loyalty to the motto which asserts that those who can look back upon strong past needn't be concerned about the future. ○

Pilot's watch, Cal. J88, 1955

Deutsche Traditionsmarke mit Innovationskraft

Mit tradierten uhrmacherischen Werten hatte Erhard Junghans 1861 ebenso wenig am Hut wie mit der Herstellung von Taschenuhren. Die von ihm in Schramberg gegründeten Uhrenfabriken Gebrüder Junghans AG lieferten zunächst preiswerte Komponenten für die beliebten Schwarzwälder Uhren. Bereits 1862 hielten amerikanische, d.h. großserielle Fertigungsmethoden Einzug. In einem nächsten Schritt folgte die Produktion kompletter Zeitmesser nach amerikanischen, sprich arbeitsteiligen Vorgehensweisen unter Verwendung präziser Maschinen. Mit steigenden Quantitäten weitete sich auch die Produktpalette aus. 1903 durfte sich Junghans mit über 3000 Mitarbeitern und einer unglaublichen Tagesproduktion von 9000 Zeitmessern weltweit größter Uhrenhersteller nennen. Gleichzeitig herrschte an Innovationen niemals Mangel. Das Jahr 1912 bescherte deutschen Uhrenliebhabern die ersten Taschenuhren mit Leuchtzifferblättern. Von Armbanduhren war in Schramberg allerdings noch keine Rede. Bei Junghans glaubte man zuerst nicht an diesen Typus Zeitmesser. Die Skepsis legte sich erst unter der Ägide von Helmut und Siegfried Junghans. Am 22. November 1930 schaltete die Werbeabteilung eine Anzeige mit der Überschrift: „Die Junghans Armband-Uhr ist da!" Ab da verknüpfte sich dieser Uhrentyp unlösbar mit der weiteren Entwicklung des Hauses. 1944 verkündete das Management die Einrichtung eines Forschungszentrums für Zeitmessung. Und 1949 präsentierte die Manufaktur das erste Nachkriegs-Kaliber J88. Dieses Uhrwerk mit klassischer Schaltradsteuerung und Breguetspirale beseelte ab 1955 auch die offiziellen Fliegerchronographen der damals neu gegründeten deutschen Bundeswehr. Von ungemeiner Kreativität zeugen nicht weniger als 852 Patentanmeldungen zwischen 1949 und 1956. Mindestens eine davon bezog sich auf den Armbandwecker „Minivox", der ab 1951 lautstark an den Handgelenken bimmelte. Im gleichen Jahr debütierte auch das erste Junghans-Kaliber mit automatischem Aufzug. Mit der Lancierung der legendären Junghans-Chronometer änderte sich ab 1951 der Präzisionsanspruch für einen Teil der Kollektion. Vor dem Verkauf musste jede dieser Uhren eine amtliche Genauigkeitsprüfung bestehen. Der Erfolg dieser Initiative war durchschlagend. Ende 1954 standen bereits 7000 Junghans-Chronometer in den Büchern. Still und leise hatte sich die Manufaktur zum größten deutschen Hersteller offizieller Armbandchronometer mit Handaufzugs- oder Automatikwerken entwickelt. Im internationalen Ranking der Produzenten amtlich zertifizierter Zeitmesser belegte Junghans einen ehrenvollen dritten Platz hinter Rolex und Omega. Das und etliches mehr faszinierte ganz offensichtlich den Nürnberger Unternehmer Karl Diehl. Am 15. Dezember 1956 übernahm seine Firma die Aktienmehrheit bei Junghans. In den 1970er Jahren hielt das Quarz-Zeitalter seinen Einzug. Mit der „Astro-Quartz" trat das deutsche Vorzeigeunternehmen ab 1970 gegen die mächtige japanische und schweizerische Konkurrenz an. Bei den Olympischen Sommerspielen 1972 in München tat sich Junghans zum zweiten Mal nach 1936 als offizieller Zeitnehmer hervor. Die Entwicklung der durchweg quarzgesteuerten Technologie zur Sportzeitmessung war selbstverständlich in Schramberg über die Bühne gegangen. Den Zeichen der Zeit folgend, stellte Junghans 1976 die Fertigung mechanischer Armbanduhrkaliber unwiderruflich ein. Im Laufe von 46 Jahren waren mehr als 150 exklusive Werke entstanden, was den Titel einer äußerst vielseitigen Mechanik-Manufaktur rechtfertigt. Ab 1985 sorgte Junghans mit ultrapräzisen, weil funkgesteuerten Quarz-Zeitmessern für Furore. Nur fünf Jahre später, also 1990, passte der Hochleistungs-Empfänger erstmals in ein Armbanduhr-Gehäuse. Das Armband der bahnbrechenden „Mega 1" bot Platz für die unverzichtbare Antenne. Alle Informationen erschienen digital auf einem Flüssigkristall-Display. Die ökologisch fortschrittliche Solartechnologie hielt 1993 ihren Einzug in die Funkarmbanduhren. Einen weiteren Quantensprung verkörperte 1995 die Junghans

From left: Astro-Quartz, 1970 ○ Official timekeeper at the Olympic Games in Munich, 1972 ○ Mega 1, the world's first radio wristwatch, 1990 ○
Von links: Astro-Quartz, 1970 ○ Offizieller Zeitnehmer bei den Olympischen Spielen in München, 1972 ○ Weltweit erste Funkarmbanduhr
Mega 1, 1990 ○ De gauche à droite : Montre Astro-Quartz, 1970 ○ Chronométreur officiel des Jeux olympiques à Munich, 1972 ○ Mega 1,
la première montre-bracelet radiopilotée au monde, 1990

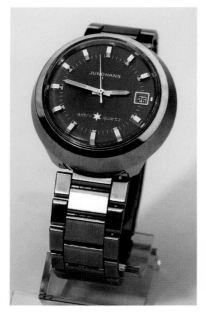 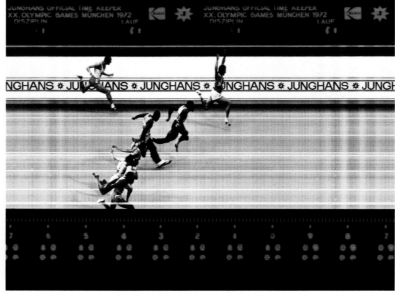 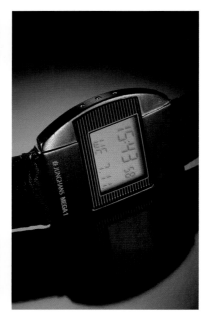

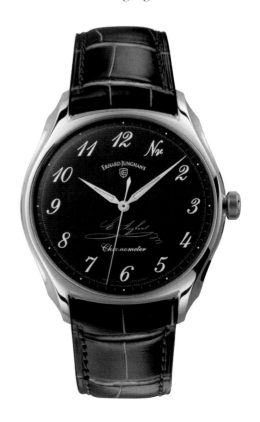

Cal. J890

„Mega Solar Ceramic" mit analoger Zeit-anzeige, Solartechnologie, sechsmonatiger Gangautonomie, Zonenzeitverstellung sowie kratzfestem Keramikgehäuse. Unter dem Dach der Holding Egana Goldpfeil beschäftigte sich Junghans zu Beginn des 21. Jahrhunderts einerseits mit unterschiedlichsten Zukunftstechnologien. Zum anderen zeigte sich auch im Schwarzwald, dass die gute alte Mechanik nicht umzubringen ist. Angesichts prall gefüllter Archive fiel die Renaissance nicht sonderlich schwer. Als besonders bedeutsam erwies sich das Erbe von Max Bill (1908–1994). Der Schweizer Architekt, Bildhauer, Maler und Produktgestalter gehörte bekanntlich zu den wichtigsten Vertretern und Theoretikern der konkreten Kunst. Seine Philosophie, „das Nützliche, das auf schöne Art Bescheidene" zu schaffen, hatte er Anfang der 1960er Jahre in einer Serie von vier Zifferblättern zum Ausdruck gebracht. Die damit ausgestatteten Armbanduhren galten und gelten als gesuchte Sammlerobjekte. Kein Wunder, dass sich die Produktverantwortlichen ihrer besannen und „Max Bill by Junghans" kreierten. Diese spontan erfolgreiche Uhrenlinie trat den schlagkräftigen Beweis an, dass echte Klassiker nie aus der Mode kommen.

Als Hommage an den Firmengründer repräsentierte ab 2006 „Erhard Junghans" die Spitze der Mechanik-Kollektion. Im Inneren der markanten Gehäuse tickten für Junghans reservierte Kaliber aus dem Hause Seiko. Den Einstieg markierte das J830 mit Rotor-Selbstaufzug und Fensterdatum. Ganz oben rangiert bis heute der sorgfältig feinbearbeitete Schaltrad-Chronograph J890. Dabei begnügt sich Junghans keineswegs mit dem Einkauf fertiger Werke, sondern fertigt und finissiert für die Kaliber J325 und J330 eine Vielzahl der Komponenten, unter anderem Brücken, Gesperre, Goldchatons und Fein-regulierungen. Das Kaliber J330 ist zudem mit einer blauen, aus Nivarox gefertigten Breguetspirale der Schramberger Firma Carl Haas ausgestattet. Diese Werke finden sich in den auf jeweils zwölf Exemplare limitierten Modellen „Erhard Junghans 1" und „Erhard Junghans 2".

Die Insolvenz des Mutterkonzerns Egana Goldpfeil im Jahr 2008 hatte für Junghans auch ihre unbestreitbar positiven Seiten. Anfang 2009 übernahm die Schramberger Unternehmerfamilie Steim das Ruder. Die neuen Eigentümer erkannten die existenten und teilweise brach liegenden Werte der altehrwürdigen Uhrenmarke. Ihre Mechanik-Philosophie zielt auf Pflege der Tradition und bezahlbaren uhrmacherischen Luxus aus deutschen Landen. Neben „Erhard Junghans" und „Max Bill by Junghans" weckt „Junghans Meister" jede Menge Erinnerungen an die Mechanik-Tradition des Hauses. Klares, schnörkelloses Design zeichnete die Uhren dieser Kollektion in früheren Jahren aus. Und es gibt heutzutage nicht den geringsten Grund, daran irgendwie zu rütteln. In diesem Sinn verstrahlen die 2016 während der Baselworld vorgestellten „Meister Driver"-Modelle Nostalgie pur – mit klassischem Handaufzugswerk oder als „Chronoscope". Hierin verbaut Junghans das Automatikkaliber J.880.3, einen Mix aus dem bewährten Eta 2892-A2 und dem Chronographenmodul 2030 von Dubois Dépraz. Das nicht minder zuverlässige Basiskaliber Eta 2824-2 findet sich im „Meister Pilot". Hier leben das Jahr 1955 und der Dienst-Chronograph der deutschen Bundeswehr wieder auf. Getreu dem Motto, dass sich um die Zukunft keine Sorgen machen muss, wer eine derart starke Vergangenheit besitzt. ◦

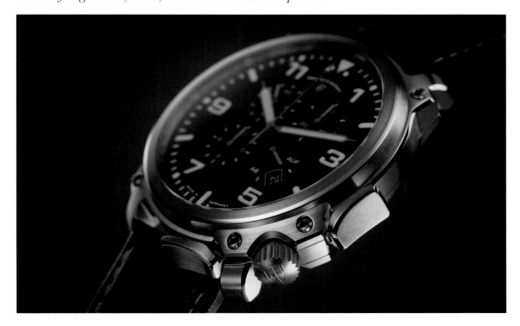

Left: Aerious Chronoscope, 2007 ◦ Right: Erhard Junghans 2, 2011, limited to twelve timepieces ◦ Erhard Junghans 2, 2011, limitiert auf zwölf Exemplare ◦ Erhard Junghans 2, 2011, limitée à douze exemplaires

Tradition et force d'innovation à l'allemande

En 1861, les valeurs horlogères traditionnelles sont tout aussi étrangères à Erhard Junghans que la fabrication de montres de poche. Gebrüder Junghans AG, la fabrique de montres qu'il fonde à Schramberg, commence par fournir des composants bon marché pour les célèbres coucous de Forêt-Noire. Dès 1862, il adopte les méthodes de production américaines : il introduit la fabrication en grandes séries, avant de passer à la production complète d'instruments de mesure du temps selon le principe de division du travail et le recours à des machines de précision. L'augmentation du volume de production va de pair avec l'élargissement de la palette de produits. En 1903, avec plus de 3 000 salariés et une impressionnante fabrication journalière de 9000 produits horlogers, Junghans peut s'arroger le titre de plus grand fabricant de montres au monde. Parallèlement, les innovations vont bon train. L'année 1912 voit la sortie des premières montres de poche à cadrans luminescents, à la grande joie des amateurs de montres allemandes. À Schramberg, les montres-bracelets sont encore une chimère. Dans un premier temps, Junghans ne croit pas à ces produits horlogers. C'est seulement sous l'égide de Helmut et Siegfried Junghans que le scepticisme se dissipe. Le 22 novembre 1930, le département publicité fait passer une annonce intitulée : « La montre-bracelet Junghans est arrivée ! » Ce type de montre deviendra indissociable de l'évolution future de la maison. En 1944, la direction annonce la création d'un centre de recherche sur la mesure du temps. En 1949, la manufacture présente son premier calibre de l'après-guerre, le J88. Ce mouvement à roue à colonnes et spiral Breguet animera à partir de 1955 également les chronographes d'aviateurs officiels de la Bundeswehr créée cette année-là. Le chiffre impressionnant de 852 dépôts de brevet effectués entre 1949 et 1956 témoigne d'une créativité inouïe. L'un d'entre eux concerne la montre-bracelet réveil « Minivox » qui, à partir de 1951, retentit au poignet de ceux qui la possèdent. La même année voit la sortie du premier calibre Junghans à remontage automatique. Avec le lancement de ses légendaires chronomètres, la manufacture revoit alors à la hausse ses exigences en matière de précision pour une partie de la collection. Avant sa commercialisation, chaque exemplaire des modèles concernés est testé par un organisme officiel. Cette initiative est on ne peut plus heureuse : avec déjà 7000 chronomètres vendus fin 1954, Junghans est devenu sans tambour ni trompette le fabricant allemand numéro un de chronomètres-bracelets à remontage manuel ou automatique certifiés chronomètres. Au classement international des fabricants de garde-temps officiellement certifiés, Junghans occupe alors une honorable troisième place, derrière Rolex et Omega. Visiblement fasciné par ce score et bien d'autres prouesses, Karl Diehl, entrepreneur de Nuremberg, acquiert une participation majoritaire dans la manufacture le 15 décembre 1956. À l'ère du quartz, qui débute dans les années 1970, l'entreprise allemande modèle se mesure, notamment avec l'« Astro-Quartz », à des concurrents de taille, japonais et suisses. À l'occasion des Jeux olympiques de 1972 à Munich, Junghans s'illustre comme chronométreur officiel de la manifestation, pour la deuxième fois depuis 1936. Schramberg est bien sûr passé au développement du tout-quartz pour le chronométrage sportif. Sacrifiant à l'air du temps, Junghans cesse définitivement en 1976 de produire des calibres de montres-bracelets mécaniques. Avec plus de 150 mouvements exclusifs développés en 46 ans, Junghans peut prétendre au titre de manufacture mécanique extrêmement diversifiée. À partir de 1985, Junghans fait sensation avec des horloges à quartz radiopilotées et de ce fait ultraprécises. Seulement cinq ans plus tard, en 1990, le récepteur de haute performance est miniaturisé pour pouvoir loger dans un boîtier de montre-bracelet. L'indispensable antenne est intégrée dans le bracelet de l'innovante « Mega 1 », à affichage numérique sur écran à cristaux liquides. Le solaire, qui représente un progrès sur le plan écologique, s'impose dans les montres-bracelets radio-guidées en 1993. Incarnant une formidable avancée technologique, la « Mega Solar Ceramic », sortie en 1995, s'appuie sur la technologie solaire et dispose d'un affichage de l'heure analogique, d'une réserve de marche de six mois, d'une fonction GMT ainsi que d'un boîtier céramique inrayable. Dans le giron de la holding Egana Goldpfeil, Junghans s'intéresse en ce début de XXIe siècle aux techniques d'avenir les plus diverses. Parallèlement, il s'avère aussi en Forêt-Noire que la bonne vieille mécanique n'a pas dit son dernier mot. Grâce à des archives très riches, la renaissance n'est pas trop difficile. L'héritage de Max Bill (1908–1994) se révèle particulièrement intéressant. Cet architecte, sculpteur, peintre et designer de produits suisse compte parmi les représentants et théoriciens majeurs de l'Art concret. Il avait exprimé sa philosophie consistant à créer des « objets utiles, modestes mais beaux » dans une série de quatre cadrans. Les montres-bracelets qui en disposaient étaient et sont encore considérées comme des objets de collection recherchés. Aussi n'est-il pas étonnant que les responsables produits se soient souvenus de ces cadrans pour créer « Max Bill by Junghans ». Le succès inattendu de cette ligne de montres apporte la preuve éclatante que les vrais classiques ne se démodent pas. Hommage au fondateur de l'entreprise, « Erhard Junghans » représente à partir de 2006 le summum de la collection mécanique. Les boîtiers remarquables abritent des calibres fournis par la maison Seiko spécifiquement pour Junghans. L'entrée de gamme est représentée par le J830 à remontage automatique et guichet dateur, tandis que le chronographe à roue à colonnes J890 ayant bénéficié d'une finition très soignée figure, aujourd'hui encore, en tête de gamme. Or, Junghans ne se contente aucunement d'acheter des mouvements finis, mais assure en interne la fabrication et le finissage de nombreux composants pour les calibres J325 et J330, notamment des ponts, des arrêtages, des chatons or et des dispositifs de réglage de précision. Le calibre J330 est en outre pourvu d'un spiral Breguet en Nivarox bleu fabriqué par Carl Haas, spécialiste de la mécanique de précision également établi à Schramberg. Ce sont ces mouvements qui animent les modèles « Erhard Junghans 1 » et « Erhard Junghans 2 », limités chacun à douze exemplaires.

Meister Kalender, 2012

La mise en liquidation de la maison-mère Egana Goldpfeil en 2008 présente sans conteste également des avantages pour Junghans, qui est reprise au début de l'année 2009 par une entreprise familiale de Schramberg, Steim. Les nouveaux propriétaires reconnaissent les atouts existants, en partie inexploités, de la vénérable marque horlogère. La philosophie des Steim en matière de mécanique repose sur la promotion de la tradition et les produits horlogers haut de gamme made in Germany. Aux côtés de « Erhard Junghans » et de « Max Bill by Junghans », « Junghans Meister » s'inscrit parfaitement dans la tradition de garde-temps mécaniques de Junghans. Les toutes premières montres de cette collection se caractérisaient déjà par un design épuré, sans fioritures, et il n'y a de nos jours pas la moindre raison d'y changer quoi que ce soit. En ce sens, les modèles « Meister Driver » – avec remontage manuel classique ou en version « Chronoscope » – présentés en 2016 lors du Salon mondial de l'horlogerie à Bâle (Baselworld) font renaître toute une époque. La version « Chronoscope » est équipée du calibre automatique J.880.3, synthèse du mouvement Eta 2892-A2 éprouvé et du module de chronographe 2030 de Dubois Dépraz. C'est le calibre de base non moins fiable Eta 2824-2 qui anime le « Meister Pilot », réminiscence de l'année 1955 et du chronographe de service de la Bundeswehr. Qui a un passé aussi solide n'a pas à se soucier de l'avenir. ∘

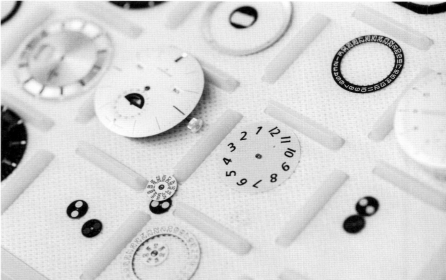

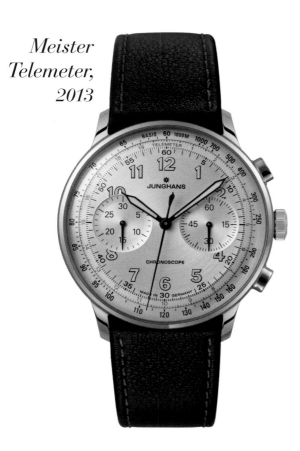

Meister Telemeter, 2013

Engineered, components fabricated, and designed in Schramberg ∘ *Konstruktion, hauseigene Teilefertigung und Design in Schramberg* ∘ *Conception, fabrication des pièces et design en interne à Schramberg*

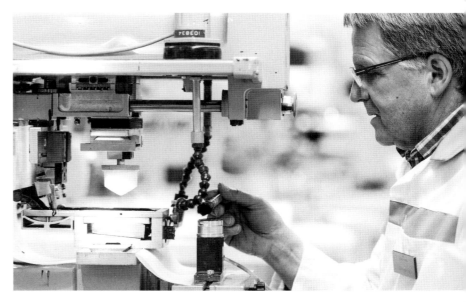

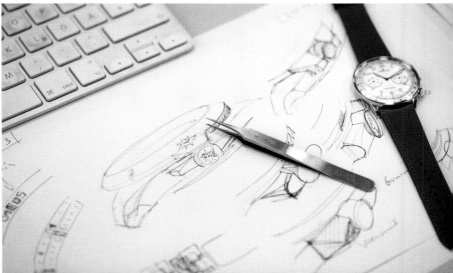

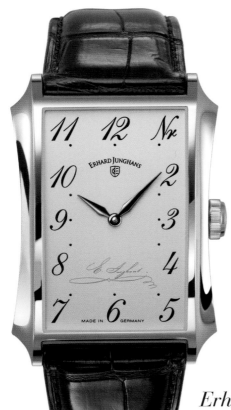

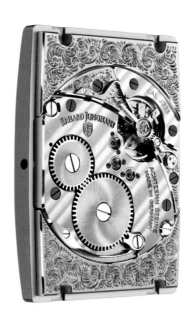

Cal. J325

Erhard Junghans 1, 2008

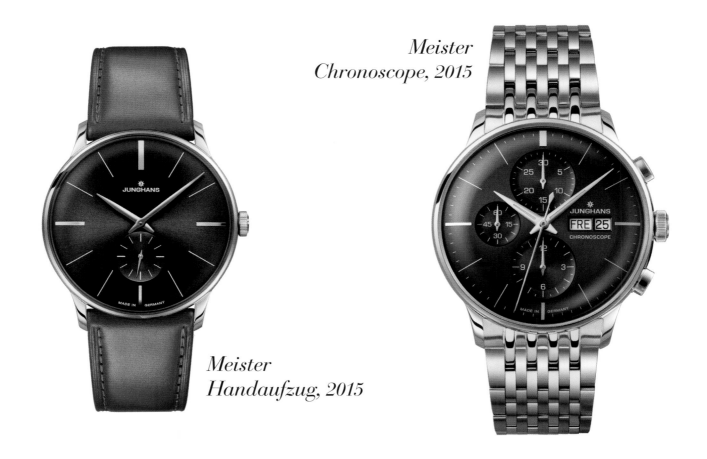

*Meister
Chronoscope, 2015*

*Meister
Handaufzug, 2015*

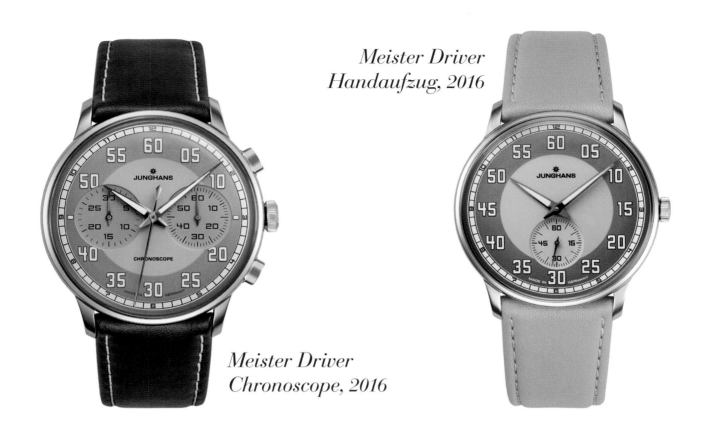

*Meister Driver
Handaufzug, 2016*

*Meister Driver
Chronoscope, 2016*

Meister Pilot, 2016

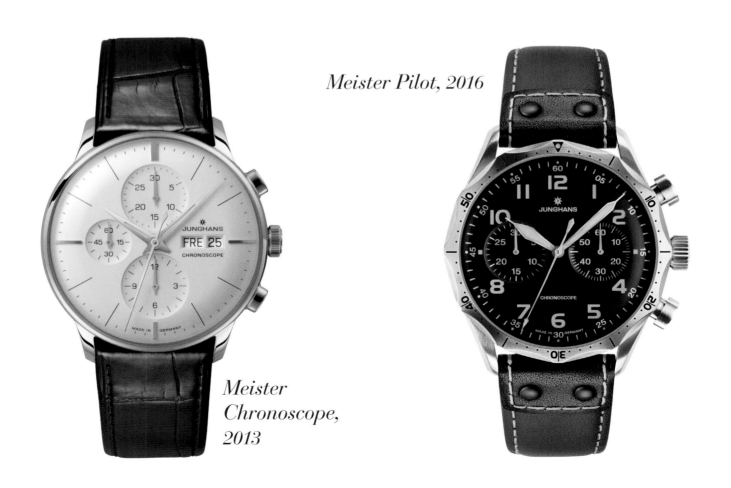

*Meister
Chronoscope,
2013*

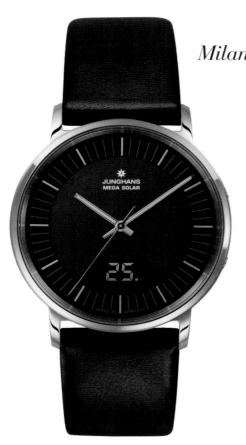

Milano Mega Solar, 2012

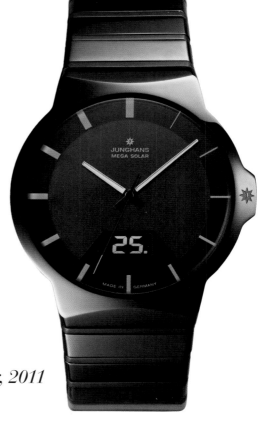

Force Mega Solar, 2011

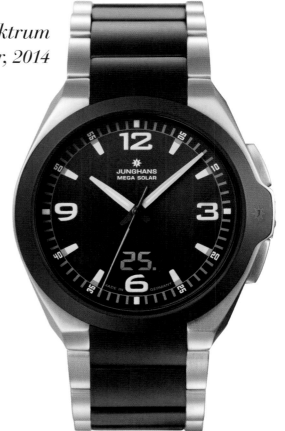

*Spektrum
Mega Solar, 2014*

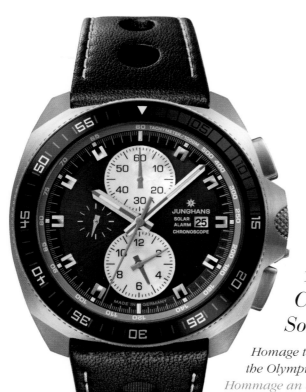

*1972
Chronoscope
Solar, 2012*

Homage to timekeeping at
the Olympic Games in 1972
*Hommage an die Zeitmessung
der Olympischen Spiele 1972*
*L'hommage au chronométrage
des Jeux olympiques de 1972*

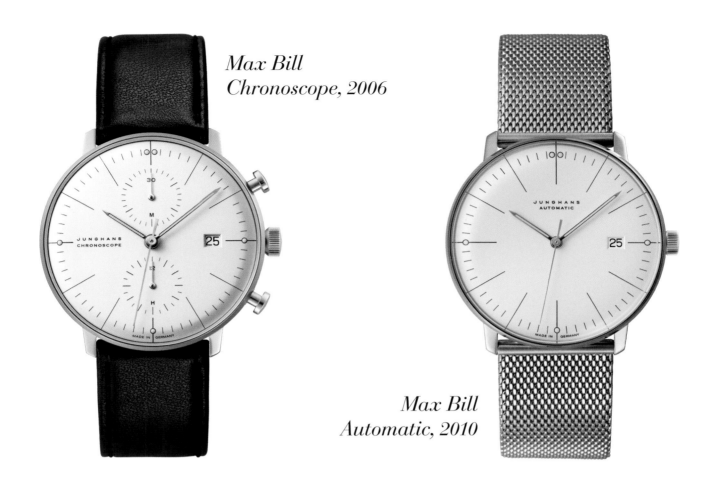

Max Bill
Chronoscope, 2006

Max Bill
Automatic, 2010

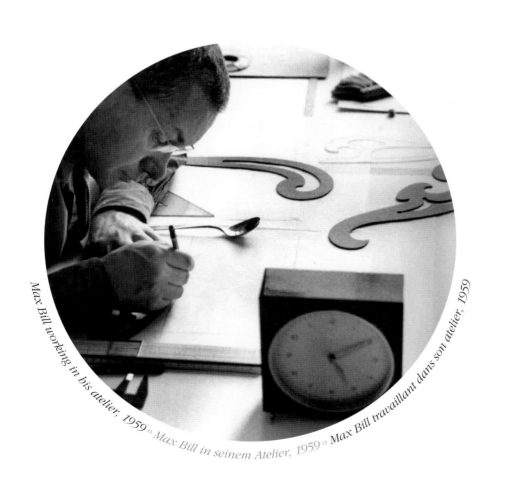

Max Bill working in his atelier, 1959 ○ Max Bill in seinem Atelier, 1959 ○ Max Bill travaillant dans son atelier, 1959

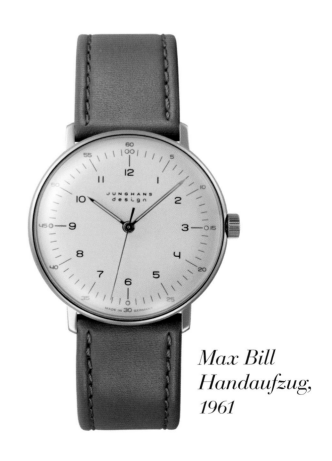

Max Bill
Handaufzug,
1961

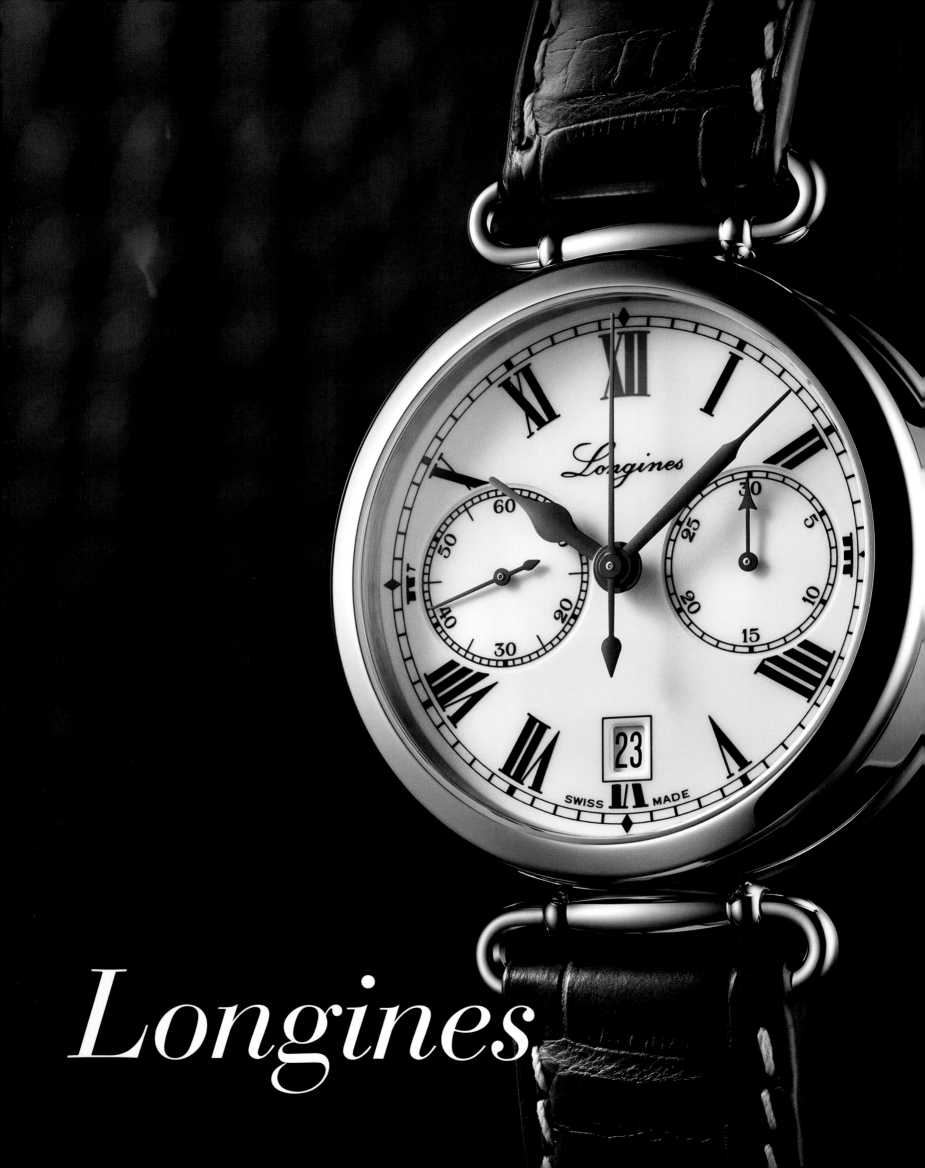

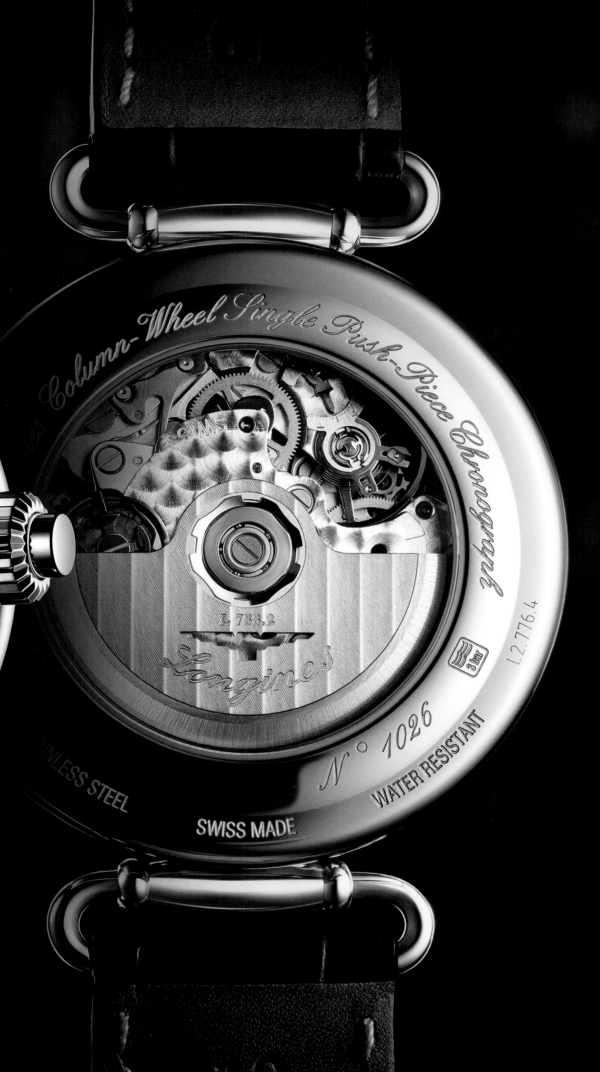

In Saint-Imier Since 1832

English

Sometimes a statistic is proof of success: for example, the fact that Longines manufactured approximately one million timepieces in 2015. The manufacturing spectrum primarily includes wristwatches characterized by a remarkably good value for the money. A look into the history of Longines, which was founded on August 14, 1832, reveals that this company has alternately undergone fat and lean years. More or less resounding successes regularly recurred. The greatest crisis, which was sparked by the Quartz Revolution in the 1970s, brought Longines in 1983 under the aegis of what is now the Swatch Group. The traditional Longines brand, which annually earns an estimated 1.5 billion Swiss francs, currently ranks second behind first-place Omega as the Swatch Group's strongest source of revenue. Longines' history began with Auguste Agassiz, a 23-year-old merchant who went into business for himself by opening a flourishing watch *comptoir* in the village of Saint-Imier in Switzerland's Jura region in 1832. Health issues prompted him take Ernest Francillon on board in 1852. Two years later, this 20-year-old newcomer was already serving as executive director. Despite thriving business deals, Francillon had to admit that *comptoir* watchmaking had become obsolete. One way or another, each watch arrived in its owner's hands as a handmade one-of-a-kind artifact. Series manufacturing, problem-free interchangeability of components for repairs, and speedy customer service were accordingly inconceivable. With the goal of improving this situation and ultimately establishing large-scale industrialized watchmaking, Ernest Francillon erected his first factory building on a plot of land known as "Les Longines" (i.e., "The Long Meadows") on the shores of the Suze River in 1866. He displayed the first watches bearing the signature "E. Francillon, Longines, Suisse" at the Exposition Universelle in Paris one year later. To protect his products against imitators, Francillon began using the winged sandglass as his logo in 1874. Official protection was granted to Longines' signature in combination with the eye-catching logo in 1889. The Swiss Federal Institute of Intellectual Property cites this as the oldest registration, which has undergone only marginal alternations over the years. The trademark is also registered with the World Intellectual Property Organization (WIPO). Longines unveiled its first chronographs, which now comprise a specialty for Longines, in 1878. In subsequent decades, the manufactory developed diverse chronograph calibers, all of which are avidly coveted by contemporary collectors. The legendary 13.33Z for wristwatches debuted in 1913. Timepieces for the wrist have been part of Longines' collection since 1905. Longines revolutionized athletic timekeeping in 1912, when it developed the broken-thread system to automatically measure time at races. Longines first served as official timekeeper for the Olympic Games in Helsinki forty years later. Collaboration with Charles A. Lindbergh, who piloted the first solo flight across the Atlantic on May 21, 1927, led to the development in 1931 of the famous "Hour Angle Watch," which helped pilots with the difficult task of airborne navigation. Longines' first self-winding movement (Caliber 22A) debuted in 1945, followed by the world's first portable quartz timepiece in 1954, the slimmest wristwatch caliber with electromagnetic power in 1960, and the world premiere of a liquid crystal display for quartz wristwatches in 1972. The manufacture put a crowning touch on its portfolio of automatic movements with the 1977 debut of ultra-slim Caliber L990. Longines announced the sale of its fifteen millionth watch in 1967. As a member of the Swatch Group, Longines no longer fabricates its own movements. This brand's cases now contain either mechanical or electronic movements supplied by Longines' affiliate Eta. These also include exclusive developments such as a chronograph caliber with a classical column-wheel and rocking-pinion coupling. Caliber L688 and its derivatives tick inside modernly styled wristwatches and in numerous retro models: the latter recall Longines' long history in service of time measurement. ○

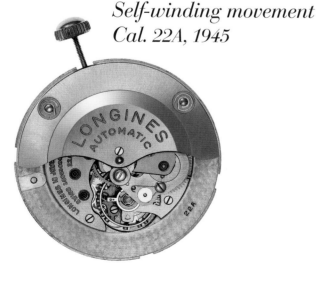

Self-winding movement Cal. 22A, 1945

Chronograph Cal. 13.33Z, 1913

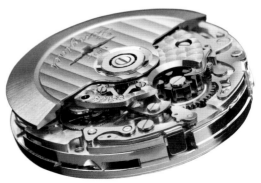

Cal. L688, 2012

Seit 1832 in Saint-Imier

So etwas nennt man Erfolg: Rund eine Million Zeitmesser stellte Longines 2015 her. Das Fertigungsspektrum umfasst größtenteils Armbanduhren, welche sich durch ein bemerkenswert gutes Preis-Leistungs-Verhältnis auszeichnen. Beim Blick zurück in die Geschichte zeigt sich, dass Longines seit der Gründung am 14. August 1832 sehr wechselvolle Perioden erlebt hat. Mehr oder minder große Erfolge wechselten sich mit schöner Regelmäßigkeit ab. Die größte Krise, ausgelöst durch die Quarz-Revolution in den 1970er Jahren, führte Longines 1983 unter das Dach der heutigen Swatch Group. Dort findet sich das Traditionsunternehmen mit geschätzten 1,5 Milliarden Schweizer Franken Umsatz heute nach Omega auf Platz zwei. Die biographischen Anfänge sind mit Auguste Agassiz verknüpft, einem 23-jährigen Kaufmann, der sich in besagtem Jahr 1832 im Juradorf Saint-Imier mit einem florierenden Uhren-Comptoir selbständig machte. Gesundheitliche Probleme brachten 1852 Ernest Francillon an Bord. Zwei Jahre später fungierte der gerade einmal 20-Jährige bereits als verantwortlicher Direktor. Trotz blühender Geschäfte musste er eingestehen, dass sich die Comptoir-Uhrmacherei überlebt hatte. Irgendwie gelangte jede Uhr als handgearbeitetes Unikat zum Kunden. An Serienfertigung, die problemlose Austauschbarkeit der Komponenten im Servicefall und einen zügigen Kundendienst war so nicht zu denken. In diesem Sinn ließ Ernest Francillon, dem eine groß angelegte Uhrenfertigung vorschwebte, 1866 am unter dem Namen Les Longines („die länglichen Wiesen") bekannten Gelände am Ufer des Flüsschens Suze sein erstes Fabrikgebäude errichten. Schon ein Jahr später nahm er mit den ersten Uhren mit der Signatur E. Francillon, Longines, Suisse an der Weltausstellung in Paris teil. Zur Abwehr von Nachahmern nutze Francillon ab 1874 die geflügelte Sanduhr als Logo. Der offizielle Schutz des Schriftzugs Longines in Verbindung mit dem signifikanten Logo erfolgte 1889. Das Eidgenössische Institut für Geistiges Eigentum spricht von der ältesten, im Laufe der Zeit nur marginal veränderten Registrierung, welche übrigens auch bei der Weltorganisation für geistiges Eigentum (World Intellectual Property Organization, WIPO) hinterlegt ist. Den ersten Chronographen, eine anerkannte Domäne des Unternehmens, präsentierte Longines im Jahr 1878. In den anschließenden Jahrzehnten entwickelte die Manufaktur ganz unterschiedliche, bei Sammlern äußerst begehrte Kaliber dieser Art. 1913 debütierte das legendäre 13.33Z für Armbanduhren. Zeitmesser fürs Handgelenk finden sich seit 1905 in der Kollektion. 1912 revolutionierte das von Longines entwickelte Fadenriss-System zur automatischen Zeiterfassung die Sportzeitmessung. Vierzig Jahre später trat Longines in Helsinki erstmals als offizieller Zeitnehmer bei Olympischen Spielen auf. Eine Kooperation mit Charles A. Lindbergh, der am 21. Mai 1927 im Alleinflug den Atlantik überquert hatte, führte zur berühmten Stundenwinkel-Armbanduhr. Ab 1931 erleichterte sie vielen Piloten die schwierige Navigation in den Lüften. 1945 brachte das erste Automatikwerk von Longines, Kaliber 22A genannt, 1954 die weltweit erste transportable Quarzuhr, 1960 das damals flachste Armbanduhr-Kaliber mit elektromagnetischem Antrieb und 1972 als Weltpremiere die Flüssigkristallanzeige in Quarz-Armbanduhren. 1977 krönte die Manufaktur ihre Palette an Automatik-Uhrwerken mit dem ultraflachen Kaliber L990. Den Verkauf seiner 15-millionsten Uhr hatte Longines im Jahr 1967 verkündet.

Als Mitglied der Swatch Group fertigt Longines keine eigenen Uhrwerke mehr. In definitiv allen Gehäusen finden sich heutzutage mechanische oder elektronische Uhrwerke der Schwester Eta. Dazu gehören auch exklusive Entwicklungen wie zum Beispiel ein Chronographenkaliber mit klassischer Schaltradsteuerung und Schwingtrieb-Kupplung. Das L688 und seine Derivate ticken in Armbanduhren mit modernem Outfit ebenso wie in zahlreichen Retromodellen, welche an die lange Geschichte im Dienste der Zeitmessung erinnern. ◦

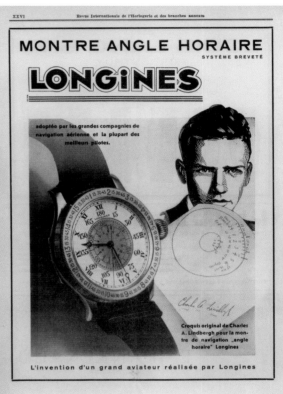

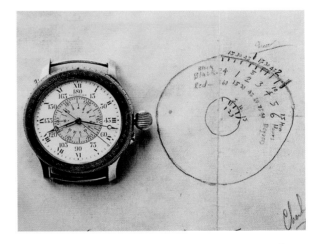

First chronograph, 1878

From top: Auguste Agassiz and Ernest Francillon ◦ Advertisement featuring Charles A. Lindbergh, 1931 ◦ Longines Lindbergh, 1931 ◦ Von oben: Auguste Agassiz und Ernest Francillon ◦ Werbemotiv mit Charles A. Lindbergh, 1931 ◦ Longines Lindbergh, 1931 ◦ De haut en bas : Auguste Agassiz et Ernest Francillon ◦ Publicité avec Charles A. Lindbergh, 1931 ◦ Longines Lindbergh, 1931

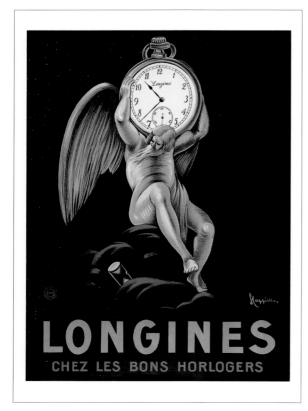

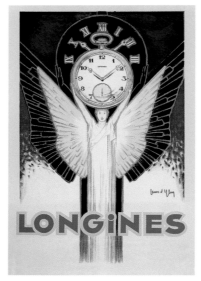

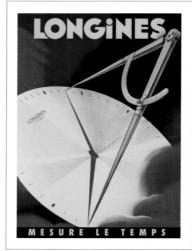

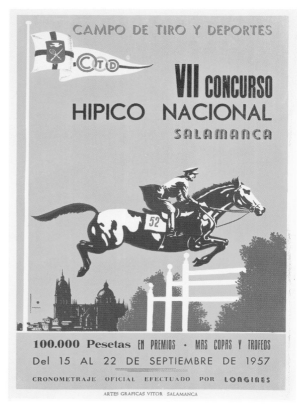

1911

1957

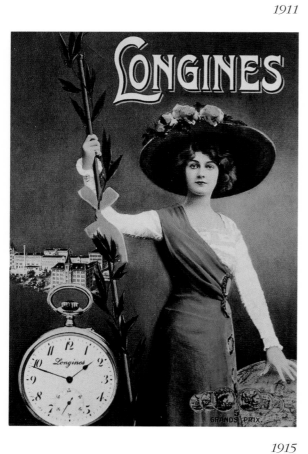

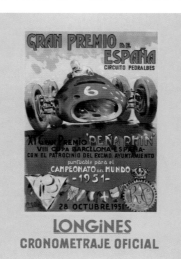

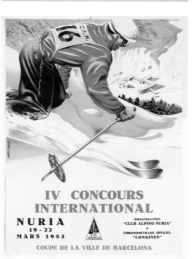

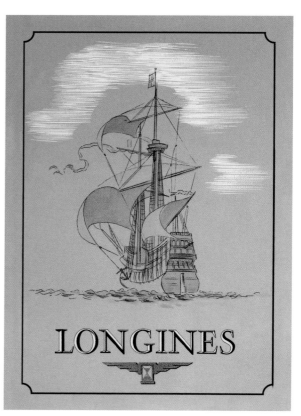

1915

1960

From top: 1929, 1945, 1951, 1953

À Saint-Imier depuis 1832

Environ un million de montres en 2015, c'est indéniablement un succès. Dans la gamme de produits, on trouve en majorité des montres-bracelets au rapport qualité-prix remarquable. Un retour sur l'histoire de la marque permet de constater qu'elle a connu des hauts et des bas depuis sa création, le 14 août 1832. Des succès plus ou moins importants se sont succédé avec une belle régularité. La plus grande crise, déclenchée par la révolution du quartz dans les années 1970, a conduit Longines en 1983 dans le giron de Swatch Group. Entreprise de tradition au chiffre d'affaires estimé à 1,5 milliard de francs suisses, Longines est aujourd'hui deuxième au sein de la multinationale, derrière Omega. Les débuts remontent à Auguste Agassiz, un commerçant de 23 ans qui s'établit à son compte en cette année 1832 en ouvrant un comptoir horloger prospère dans le village jurassien de Saint-Imier. Des problèmes de santé l'amènent à engager Ernest Francillon en 1852. À peine deux ans plus tard, à tout juste 20 ans, celui-ci dirige le comptoir. Malgré des affaires florissantes, il doit reconnaître que l'horlogerie de comptoir appartient au passé. Chaque montre livrée étant un spécimen unique monté à la main, on ne peut envisager ni de fabrication en série, ni de remplacement facile de composants en cas de réparation, ni de service rapide. Aussi, Ernest Francillon, qui rêve de fabriquer des montres à grande échelle, fait édifier en 1866 une première usine sur le terrain des Longines (« les prairies allongées ») qui borde le petit cours d'eau de la Suze. Un an plus tard seulement, il présente à l'Exposition universelle de Paris les premières montres signées « E. Francillon, Longines, Suisse ». Pour se démarquer, il utilise dès 1874 comme logotype le sablier ailé. Cet emblème caractéristique et le nom Longines seront officiellement déposés en 1889. L'Office fédéral de la propriété intellectuelle (OFPI) indique que Longines est la plus ancienne marque enregistrée sans interruption ni modification majeure au cours du temps et qu'elle est par ailleurs déposée auprès de l'Organisation mondiale de la propriété intellectuelle (OMPI). En 1878, Longines présente sa première création dans un de ses domaines forts, les chronographes. Durant les décennies suivantes, la manufacture produit une large gamme de calibres de ce type, très prisés des collectionneurs. En 1913 sort le légendaire 13.33Z pour montres-bracelets, qui figurent d'ailleurs dès 1905 dans la collection. En 1912, Longines révolutionne le chronométrage sportif par le système électromécanique selon le système du fil coupé. Quarante ans plus tard, Longines est chronométreur officiel des Jeux olympiques d'Helsinki. De la coopération avec Charles A. Lindbergh, qui le 21 mai 1927 survole l'Atlantique en solitaire et sans escale, naît la célèbre montre Lindbergh à angle horaire. Dès 1931, elle facilite la navigation pour de nombreux aviateurs. En 1945 paraît le premier mouvement à remontage automatique de Longines, référencé 22A, en 1954 la première horloge à quartz portative au monde, en 1960 le plus mince calibre de montre-bracelet à entraînement électromagnétique jamais conçu, et en 1972, première mondiale, l'affichage numérique sur écran à cristaux liquides pour montres-bracelets à quartz. En 1977, le calibre ultraplat L990 couronne la palette de composants de mouvements automatiques. La 15 millionième montre de la marque est sortie en 1967. Mais Longines, membre de la multinationale Swatch Group, ne fabrique plus elle-même ses mouvements. Tous les boîtiers sans exception sont désormais équipés de calibres mécaniques ou électroniques de la société sœur Eta SA. Parmi ces mouvements figurent des réalisations exclusives, notamment un calibre de chronographe à traditionnels roue à colonnes et pignon oscillant. Le calibre L688 et ses dérivés animent aussi bien les montres-bracelets à l'habillage moderne que de nombreux modèles rétro, témoins d'une longue histoire au service de la mesure du temps. ◦

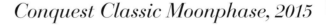

Conquest Classic Moonphase, 2015

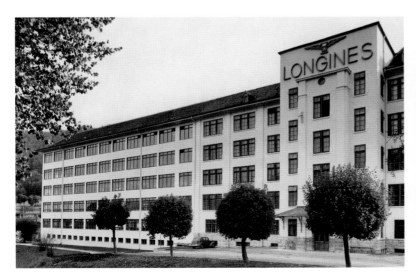

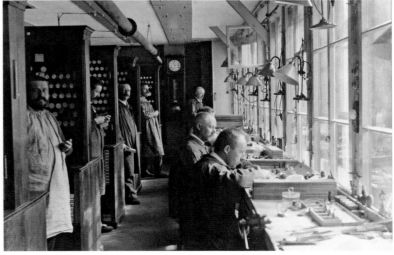

Left: Longines factory, 1950 ◦ Longines workshop, 1900 ◦ Links: Longines-Fabrik, 1950 ◦ Blick in die Werkstatt, 1900 ◦ De gauche à droite : Fabrique Longines, 1950 ◦ Atelier Longines, 1900

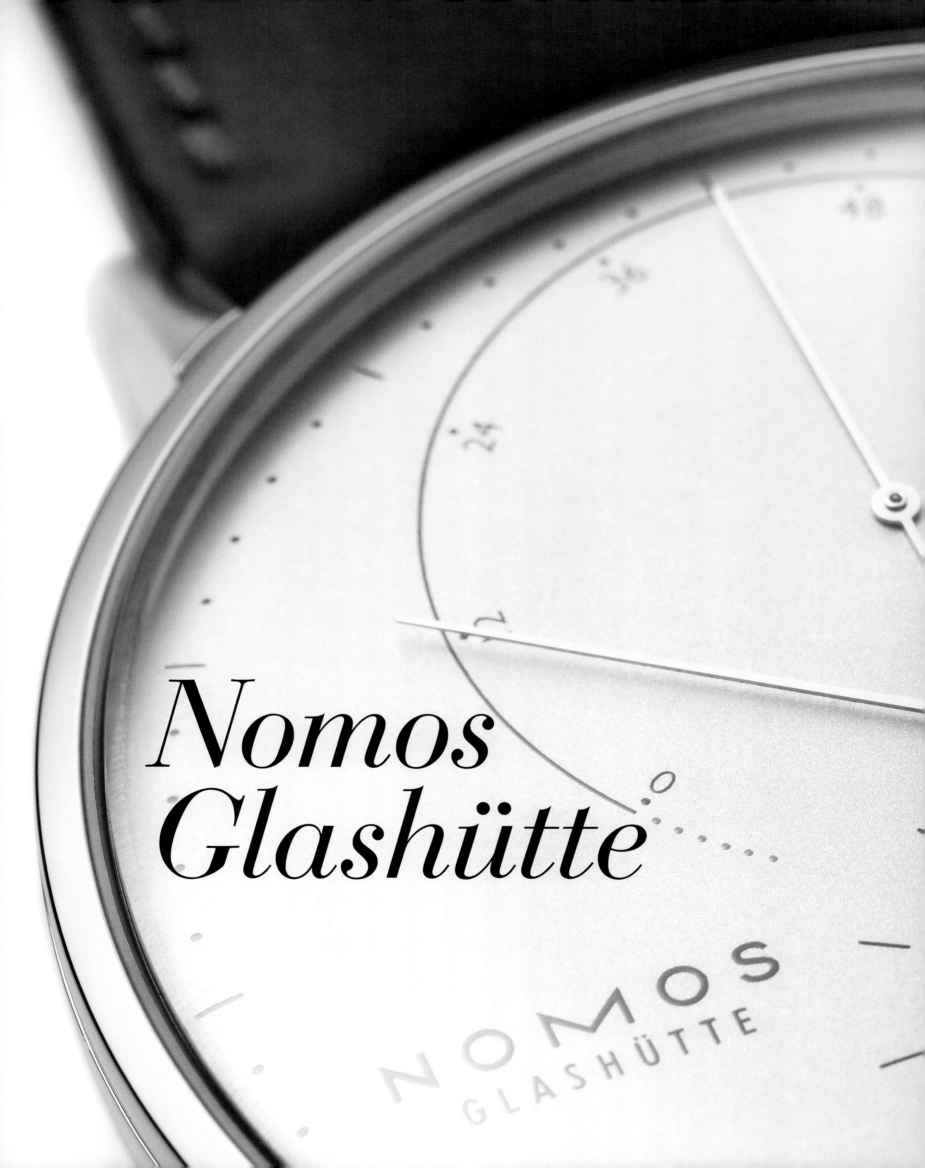

Nomos Glashütte

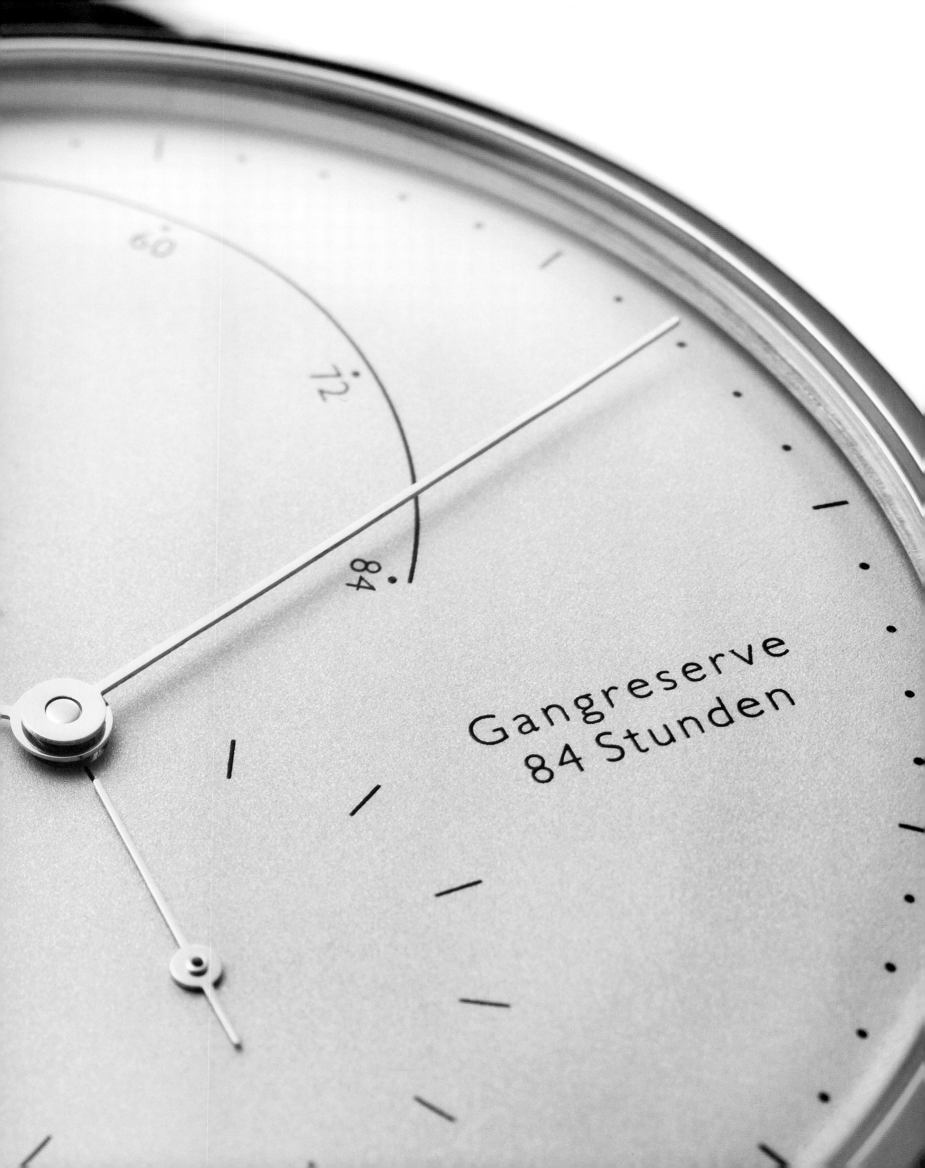

60

12

84

Gangreserve
84 Stunden

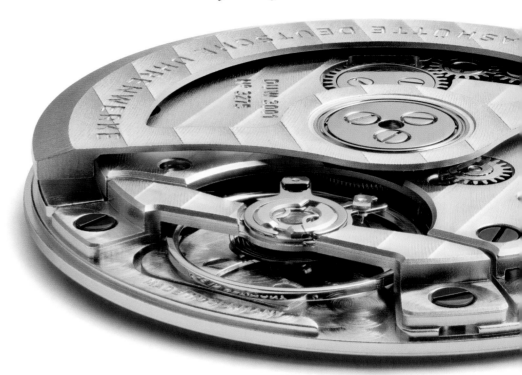

Automatic manufactory Cal. DUW 3001

Hand-wound Cal. Alpha

Affordable Luxury in Watches from Germany

Following A. Lange & Söhne and Glashütte Original, Nomos Glashütte inarguably holds third place among Glashütte's watch brands. The family-owned business traditionally doesn't disclose exact statistics, but it seems likely that approximately 40,000 to 50,000 watches were shipped from the brand's factories in Saxony's Müglitz Valley in 2015. The payroll currently includes more than 250 employees, and additional colleagues regularly join the growing workforce. Ever since this label's renaissance in 1990, quartz watches have never been in its portfolio. Suffice it to say the following about the brand and its history: calendars around the world read "1906" when Clemens Guido Müller and his brother-in-law Karl Nierbauer put their business idea into practice. Their concept was to import Swiss watches and to sell them with the prestigious additional signature "Glashütte" on their dials. But A. Lange & Söhne, as the firmly established top dog in town, was not pleased and filed a law suit against the upstarts. The verdict, handed down in 1910, proposed a compromise: Nomos Glashütte would be permitted to sell its remaining stock; afterwards, however, no further reference to the German watchmaking Mecca near Dresden would be permitted on its products. Bankruptcy was unavoidable. No one so much as mentioned the name of Nomos Glashütte in ensuing decades. After the fall of the Berlin Wall, Roland Schwertner discovered the forgotten watch brand. His attempt to imitate his predecessors— i.e., to put the finishing touches on Swiss movements in Glashütte, to encase the calibers, and then to sell them with the signature "Nomos Glashütte" on their dials—similarly sparked strong opposition from his big neighbors. But the West German businessman was ultimately able to prove that more than 50 percent of the value had been added to his products in Glashütte. Discussions of this sort are no longer on the agenda because Nomos Glashütte has made

all of its movements at its own manufacture for more than a decade. The entry into the world of Nomos Glashütte is made possible by hand-wound Caliber α (Alpha), which was originally derived from the time-honored Peseux 7001 and which naturally has a Glashütte three-quarter plate. In the meantime, even the gears for this movement are manufactured on the brand's premises. The other end of the hand-wound scale is occupied by Caliber DUW 1001, which is reserved for the gold watches in the "Lambda" line. Incidentally: DUW is the acronym for "Deutsche Uhrenwerke." All calibers with this designation include the so-called "Nomos Swing System." The brand's own escapement subassembly—which consists of the balance, hairspring, pallet lever and escape wheel—gave Nomos Glashütte its long-sought independence from Swiss suppliers. The indispensable blanks for the hairsprings are produced in a cooperative venture between Nomos Glashütte and Haas, a recognized specialist. The newest member of the family of Nomos Glashütte's own calibers is the ultra-slim DUW 3001 with ball-borne central rotor. This movement is 28.8 millimeters in diameter and a mere 3.2 millimeters tall. A total of 157 components are assembled to create each one. The sleekly simple "Tangente," which was launched in 1992, remains a longstanding bestseller in the product portfolio. Its purist design can be traced back to the 1930s. Other watch lines are named "Ahoi," "Club," "Ludwig," "Lux," "Metro," "Tetra", and "Zürich." Finally, Nomos Glashütte also offers a horological complication: thanks to a well-conceived time-zone display, cosmopolites can take an uncomplicated journey through time with either the "Tangomat GMT" or the "Zürich Weltzeit." Over 130 awards and commendations from around the world are the well-earned rewards for more than two decades of dedication to the art of Glashütte-style watchmaking. ◦

Bezahlbarer Uhr-Luxus aus deutschen Landen

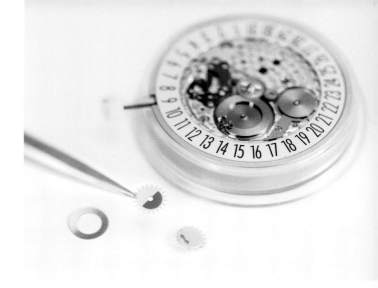

Unter den Glashütter Uhrenmarken ist Nomos Glashütte nach A. Lange & Söhne sowie Glashütte Original die unangefochtene Nummer drei. 2015 dürften schätzungsweise 40 000 bis 50 000 Uhren die Fabrikationsstätten im sächsischen Müglitztal verlassen haben. Genaue Zahlen gibt das Familienunternehmen traditionsgemäß nicht bekannt. Auf der Gehaltsliste stehen gut 250 Mitarbeiterinnen und Mitarbeiter, Tendenz weiterhin steigend. Quarzuhren sind für die Sachsen seit der Renaissance des Labels im Jahr 1990 kein Thema. Zur Marke und ihrem geschichtlichen Hintergrund nur so viel: Man schrieb das Jahr 1906, als Clemens Guido Müller und sein Schwager Karl Nierbauer ihre Geschäftsidee realisierten. Diese basierte auf dem Import Schweizer Uhren samt deren Vertrieb mit der imageträchtigen Zusatzsignatur Glashütte. Genau das ließ sich der etablierte Platzhirsch A. Lange & Söhne nicht gefallen. Seine Klage endete 1910 mit einen Vergleich. Ihm zufolge durfte Nomos Glashütte seinen Lagerbestand noch verkaufen. Danach hatte jeglicher Hinweis auf das deutsche Uhrenmekka nahe Dresden zu unterbleiben. Ein Konkurs der Firma war unausweichlich. In den folgenden Jahrzehnten sprach niemand mehr von Nomos Glashütte. Nach dem Mauerfall entdeckte Roland Schwertner die vergessene Uhrenmarke. Sein Versuch, es den Vorgängern gleichzutun, also Schweizer Werke in Glashütte zu finissieren, einzuschalen und unter der Signatur Nomos Glashütte zu verkaufen, zog einmal mehr heftiges Abwehrfeuer der großen Nachbarn nach sich. Letzten Endes konnte der westdeutsche Unternehmer jedoch nachweisen, dass mehr als 50 Prozent der Wertschöpfung vor Ort erfolgt. Diskussionen dieser Art sind längst kein Thema mehr, denn seit mehr als zehn Jahren fertigt Nomos Glashütte ausnahmslos alle Uhrwerke in eigener Manufaktur. Den Einstieg in die Welt von Nomos Glashütte ermöglicht das ursprünglich einmal vom bewährten Peseux 7001 abgeleitete Handaufzugskaliber α (Alpha), das natürlich eine Glashütter Dreiviertelplatine besitzt. Bei diesem Uhrwerk stammen mittlerweile sogar die Zahnräder aus eigener Fertigung. Am anderen Ende der Handaufzugsskala findet sich das DUW 1001, welches der goldenen Uhrenlinie „Lambda" vorbehalten bleibt. Apropos: DUW ist das Kürzel für Deutsche Uhrenwerke. Alle Kaliber mit dieser Bezeichnung besitzen als Besonderheit das sogenannte Nomos-Swing-System. Das hauseigene Assortiment, bestehend aus Unruh, Unruhspirale, Anker und Ankerrad, beschert die intendierte Unabhängigkeit von eidgenössischen Zulieferungen. Die unverzichtbaren Rohspiralen sind das Produkt einer Kooperation zwischen Nomos Glashütte und dem einschlägig erfahrenen Spezialisten Haas. Neuestes Mitglied der Familie eigener Kaliber ist das ultraflache DUW 3001 mit kugelgelagertem Zentralrotor. Bei 28,8 Millimetern Durchmesser baut dieses Automatikwerk lediglich 3,2 Millimeter hoch. Für ein Exemplar braucht es 157 Komponenten. Zu den Bestsellern im Produktportfolio gehört weiterhin die schlichte, bereits 1992 lancierte „Tangente". Ihr puristisches Design geht auf die 1930er Jahre zurück. Weitere Uhrenlinien heißen „Ahoi", „Club", „Ludwig", „Lux", „Metro", „Tetra" oder „Zürich". Eine uhrmacherische Komplikation bietet Nomos Glashütte schließlich auch. Dank eines durchdachten Zeitzonen-Dispositivs können sich Kosmopoliten entweder mit der „Tangomat GMT" oder der „Zürich Weltzeit" auf unkomplizierte Zeit-Reise begeben. Verdienter Lohn für über zwei Jahrzehnte Engagement rund um die Glashütter Uhrmacherkunst sind mehr als 130 Auszeichnungen aus aller Herren Länder. ○

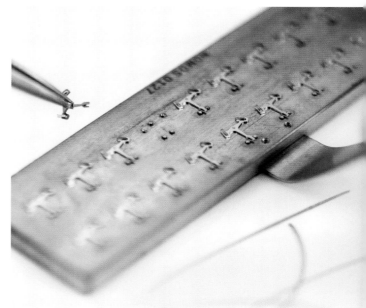

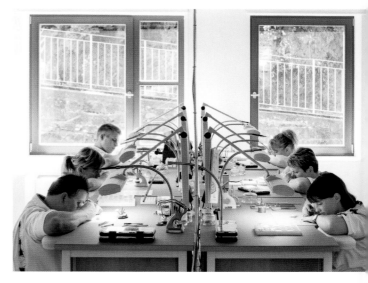

From top: Date and power-reserve displays ○ Installing the pallet lever ○
Watchmakers at work ○ Nomos' founder Roland Schwertner
Von oben: Datums- und Gangreserveanzeige ○ Montage der Anker
Uhrmacherei ○ Nomos-Gründer Roland Schwertner ○
De haut en bas : indication de la date et de la réserve de marche ○
Montage de l'ancre ○ Atelier d'horlogerie ○ Roland Schwertner, fondateur de Nomos

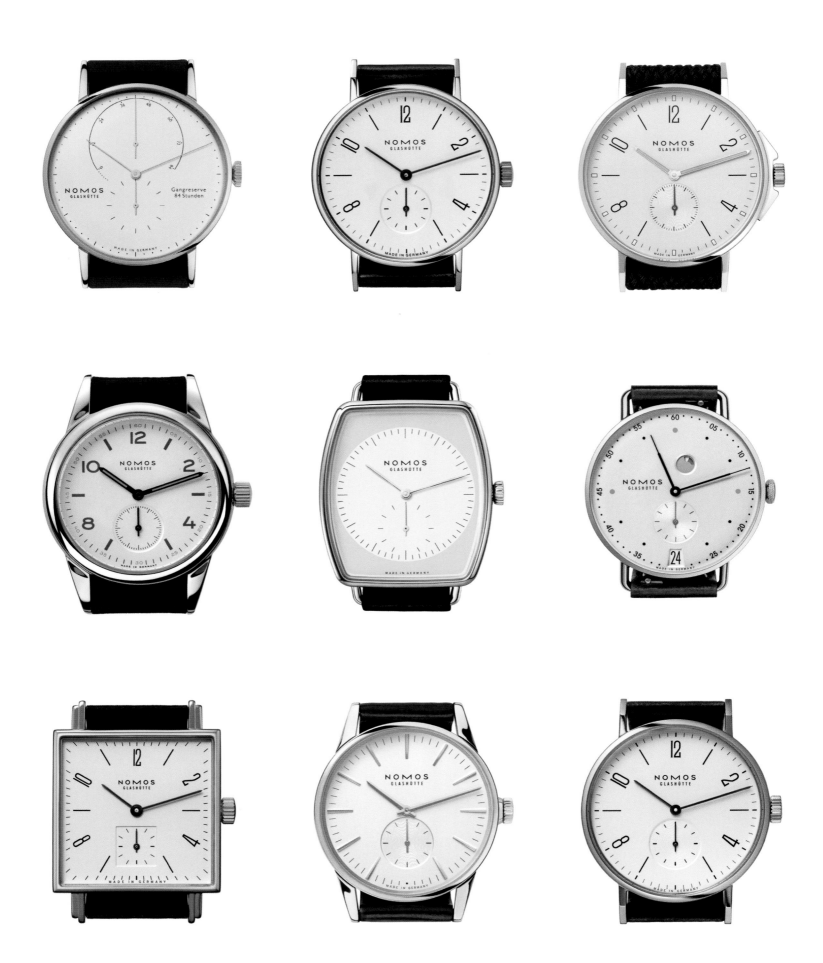

*This page: A selection of watches from Nomos' collection ◦ Diese Seite: Ausschnitt aus der Nomos-Kollektion ◦
Cette page : Extrait de la collection Nomos ◦ Opposite page, top: Cal. DUW 1001*

Luxe horloger abordable made in Germany

Parmi les marques horlogères de Glashütte, Nomos Glashütte figure sans conteste à la troisième place, derrière A. Lange & Söhne et Glashütte Original. Le nombre de montres fabriquées dans ces ateliers de la localité de Müglitztal (Saxe) est estimé entre 40 000 et 50 000. Cette entreprise familiale a en effet coutume de ne jamais donner de chiffres précis. L'entreprise compte plus de 250 salariés, et la tendance est à la hausse. Depuis la renaissance du label en 1990, il n'est plus question de quartz. Mais reprenons l'histoire de la marque depuis le début. En 1906, Clemens Guido Müller et son beau-frère Karl Nierbauer concrétisent leur idée commerciale, à savoir importer et distribuer des montres suisses, qu'ils revêtent de la prestigieuse signature Glashütte. Mais c'est précisément ce que le numéro un de la place, A. Lange & Söhne, n'est pas disposé à accepter. La plainte qu'il dépose aboutira en 1910 à un arrangement. Nomos Glashütte sera autorisée à écouler ses stocks, mais toute référence au haut lieu de l'horlogerie allemande proche de Dresde lui sera dorénavant interdite. La faillite de la société est inévitable et, dans les années qui suivent, on n'entend plus parler de Nomos Glashütte. Après la chute du Mur, Roland Schwertner redécouvre la marque horlogère oubliée. Sa tentative d'imiter ses prédécesseurs, c'est-à-dire de procéder au finissage et à la mise en boîtiers de mouvements suisses puis de les vendre avec la signature Nomos Glashütte entraîne de nouveau une levée de boucliers chez ses illustres voisins. Finalement, l'entrepreneur ouest-allemand réussit à démontrer que la valeur est créée sur place à plus de 50 pour cent. Mais les débats de ce type n'ont plus cours depuis longtemps. Depuis plus de dix ans en effet, tous les mouvements Nomos Glashütte sans exception sont fabriqués en interne. En entrée de gamme,

Nomos Glashütte propose le mouvement à remontage manuel α (Alpha), lequel s'appuie sur un mouvement éprouvé, le Peseux 7001, et possède bien sûr une platine trois-quarts de Glashütte. Sur le mouvement, même les pignons sont désormais « maison ». À l'autre extrémité de la gamme de mouvements à remontage manuel, on trouve le DUW 1001, dédié à la collection de montres en or « Lambda ».

Tous les mouvements DUW (abréviation de Deutsche Uhrenwerke, « mouvements horlogers allemands ») se caractérisent par un système d'échappement propre baptisé Nomos-Swing-System. L'assortiment de pièces fabriqué en interne (balanciers, spiraux, ancres et roues d'ancre) fournit l'indépendance recherchée par rapport aux fournisseurs suisses. Les indispensables spiraux bruts sont le produit d'une collaboration entre Nomos Glashütte et Haas, spécialiste dans le domaine. Le dernier-né des calibres de manufacture est le DUW 3001 ultraplat à rotor central amorti par roulements à billes. Nécessitant 157 composants pour sa fabrication, il mesure 28,8 millimètres de diamètre et seulement 3,2 millimètres d'épaisseur. Parmi les best-sellers de la gamme de produits figure également « Tangente », collection lancée en 1992 dont les lignes épurées remontent aux années 1930. Les autres collections ont pour noms « Ahoi », « Club », « Ludwig », « Lux », « Metro », « Tetra » ou « Zürich ». La société Nomos Glashütte propose elle aussi une complication horlogère : un astucieux dispositif d'affichage de fuseaux horaires permet aux globe-trotters d'effectuer aisément un voyage dans le temps avec la « Tangomat GMT » ou la « Zürich Weltzeit ». Plus de 130 distinctions et prix du monde entier sont venus récompenser à juste titre deux bonnes décennies d'engagement en faveur de l'art horloger de Glashütte. ○

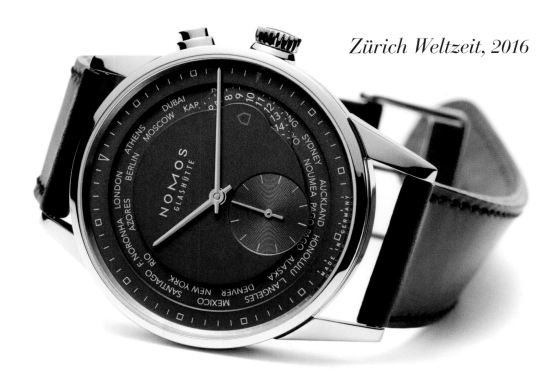

Zürich Weltzeit, 2016

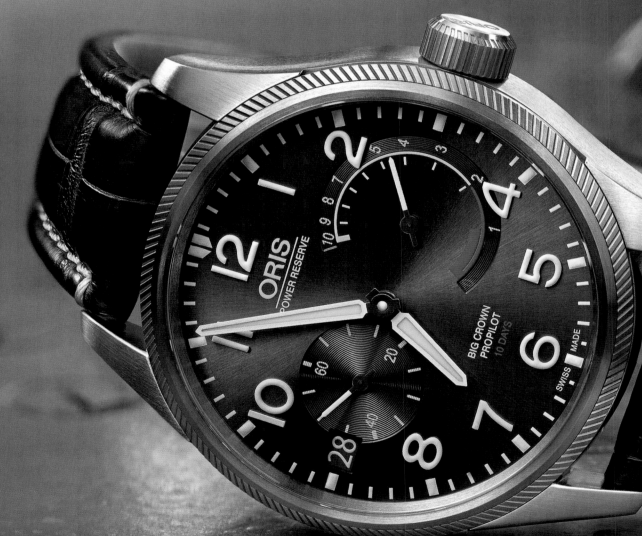

Oris

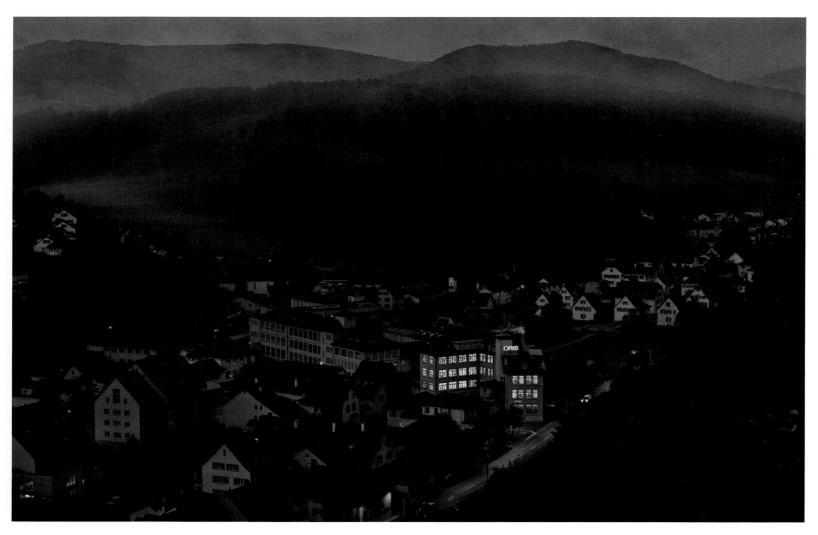

Oris factory at dawn, 2015 ○ Oris-Fabrik in der Morgendämmerung, 2015 ○ La manufacture Oris à l'aube, 2015

Under the Sign of "High Mech"

The town of Hölstein, which is located southeast of Basel, was a sleepy little hamlet in the early years of the 20th century. A first attempt to bolster the weak infrastructure in this region was undertaken with the opening of a watchmaking factory, but the venture failed a mere two years later. All that survived was the name "Oris," which was borrowed from a nearby stream and registered as a trademark for timepieces in 1903. Paul Cattin and Georges Christian hoped for better luck in 1904. Their venture succeeded so well that by 1910 three-hundred families were fed by breadwinners who worked for the Manufacture d'Horlogerie de Hölstein, Cattin & Christian, which made affordably priced pin-pallet watches "for the people." After its founders' deaths, the company was sold in the late 1920s to a group of investors which included Georges Christian's widow and Jacques-David LeCoultre from the Vallée de Joux, who was a friend of the Christian Family. Watches bearing the Oris insignia repeatedly proved that pin-pallet calibers, if they're painstakingly designed and meticulously assembled, can be just as reliable and precise as their counterparts with traditional Swiss lever escapements. The reward for ongoing optimization was forthcoming in 1968, when Caliber Oris 652 became the first pin-pallet caliber to earn a rate certificate from Neuchâtel Observatory.

This movement strategy had shown its Achilles' heel in 1934, when a Swiss law, designed to rescue the confederation's ailing watch industry from demise, specified that each firm must restrict its product spectrums to their current status. But these restrictions could stop neither Oris's creativity nor its success. Beginning in 1936, the company also fabricated its pin-pallet models in Holderbank, Como, Courgenay, Ziefen, Herbetswil, and Bienne. The payroll included the names of circa 1,000 employees, many of whom lived in homes owned by Oris. Others rode the company's buses each morning and evening for the 25-kilometer commute between Basel and Hölstein.

Caliber 373 "Pointer" was first marketed in 1938. Afterwards, every Oris collection included at least one model with a centrally axial date-hand. Oris's first automatic watch with a bidirectionally active rotor raised appreciative eyebrows in 1952. A power-reserve display at the "12" highlighted the efficiency of the self-winding mechanism. When the restrictive watch statute finally ended in 1966, Oris quickly took action and brought Caliber 645, its first automatic movement with a classical Swiss lever escapement, to maturity for series production. Caliber 645 and other outstanding

From left: Paul Cattin ◦ Georges Christian ◦ Ulrich W. Herzog

achievements elevated Oris into the elite circle of the great names in the international watch industry. Oris shipped no fewer than 1.2 million mechanical watches and alarm timepieces from its various factories in 1970.

The following year, when the long shadow of the Quartz Revolution was beginning to darken the skies over Switzerland, Oris came under the aegis of the Allgemeine Schweizer Uhren AG (ASUAG), a super-holding that had been founded in 1931 and that merged in 1985 with the equally ailing SSIH to become the SMH (Schweizerische Gesellschaft für Mikroelektronik und Uhrenindustrie AG).

To make a long story short: newfangled electronic timekeeping drove nearly 900 Swiss watchmaking companies into bankruptcy in the late 1970s. Approximately two-thirds of the employees lost their jobs. Oris was among the victims. When ASUAG wanted to shut down its factories in 1982, its CEO Dr. Rolf Portmann and its marketing director Ulrich W. Herzog assured its survival with a management buyout. The erstwhile Oris Watch Co. SA became the smaller Oris SA.

Finally, a few statistics from Oris's illustrious history: from 1919 to 1987, the firm's production sites in Hölstein and elsewhere fabricated no fewer than 96,850,000 watches. Top ratings were achieved during the glory days from 1919 to 1928 (27.5 million timepieces) and from 1929 to 1948 (39 million timepieces). The company developed a total of 279 calibers or modules for existing movements between 1904 and 1981.

Naysayers smirked patronizingly in 1985 when Oris took the almost visionary decision to manufacture only mechanical watches. Relying on time-honored Eta calibers and partly also on modules that Oris had engineered, the brand developed a wide spectrum of affordably priced wristwatches. These included collectible retro models, some with built-in alarm mechanisms, and the exclusive "Worldtimer," which debuted in 1997 with a useful display for other time zones. A totally updated look for the brand and the catchy slogan "It's High Mech" underscored the new focus on mechanical timekeeping.

Punctually in time for its 110th birthday in 2014, Oris revived its manufactory activities, which some people thought the brand had forgotten. Hand-wound Caliber 110, which was developed and fabricated in collaboration with the Technicum in Le Locle and other experienced partners, embodied Oris's first own creation in 35 years. A gaze through the transparent back of this 34-millimeter-diameter opus reveals a positively gigantic energy reservoir. The 1.80-meter-long mainspring inside the big barrel provides power for ten days of uninterrupted running. The patented power-reserve display on the dial is particularly creative. The hand on this indicator moves relatively slowly at first, but its tempo increases as the mainspring slackens. The first limited edition of the wristwatch that was equipped with this powerhouse sold out in a proverbial blink of an eye. Oris followed this debutante with the premiere of an unlimited successor in 2015: Caliber 111, which was produced entirely with the brand's own tools. Along with the previous movement's features, this newcomer also offered a large date window at the "9." The latest phase in the evolutionary process is Caliber 112, which is encased in "Artelier Calibre 112," which debuted in 2016. To the delight of frequent flyers, this version has a user-friendly time-zone function.

Of course, wristwatches with this exclusive caliber represent only the crowning mound of whipped cream atop this broadly diverse collection. In addition to these, Oris also offers reasonably priced watches to satisfy nearly every requirement. Divers, for example, can opt for the nostalgic-looking "Divers Sixty-Five." But the 2,000 watches that debuted in 2016 in the "Carl Brashear Limited Edition" are already sold out. The "Aquis Depth Gauge" is equipped with a practical bathometer. The counterpart for pilots is the "Big Crown ProPilot Altimeter," which naturally includes an altimeter. Automobile fans will appreciate Audi or Williams models. And jazz lovers will enjoy the latest "Thelonious Monk Limited Edition." Oris offers just about everything—except watches with quartz movements. If you're looking for one of those, look elsewhere. ◦

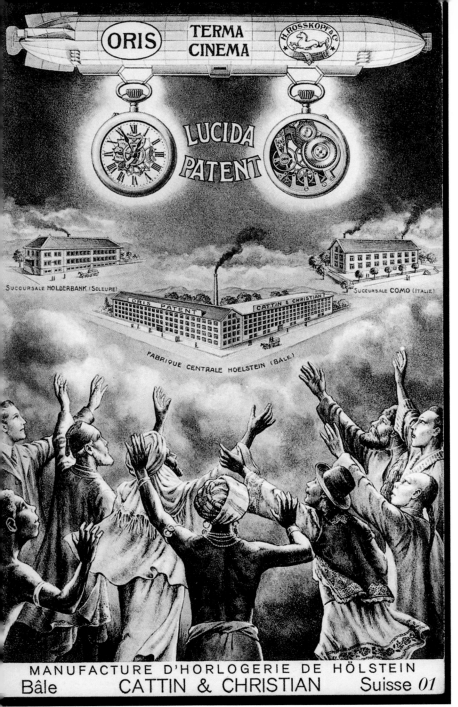

ORIS TERMA CINEMA H.ROSSKOPF&C

LUCIDA PATENT

Succursale HOLDERBANK (Soleure) Succursale COMO (Italie)

GRIS PATENT CATTIN & CHRISTIAN

FABRIQUE CENTRALE HOELSTEIN (BÂLE)

MANUFACTURE D'HORLOGERIE DE HÖLSTEIN
Bâle CATTIN & CHRISTIAN Suisse 01

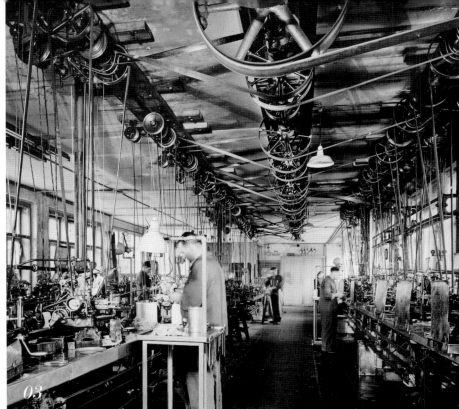

03

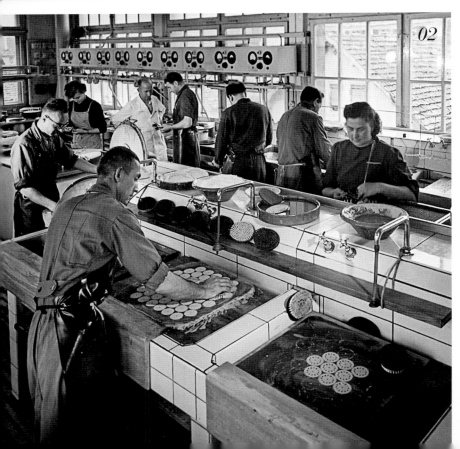

02

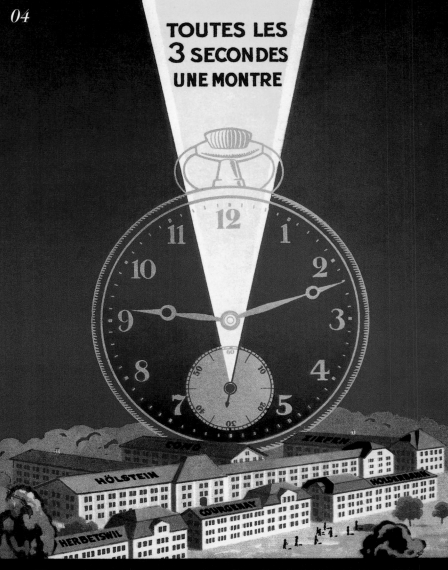

04

TOUTES LES
3 SECONDES
UNE MONTRE

HÖLSTEIN CONO ZIEFEN HOLDERBANK
HERBETSWIL COURROENAY

ORIS WATCH Co
HÖLSTEIN (SUISSE)
MONTRES ROSKOPF & CYLINDRE
MARQUES: ORIS, TERMA, BREVO, FIDES, FIDO, FIXOR
COLOMBUS, ELSINE, RIO, LUCIDA, BABEL, VIRTUS, VALDORIS
VOIR AU VERSO

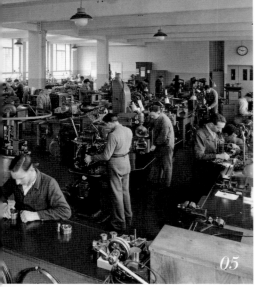

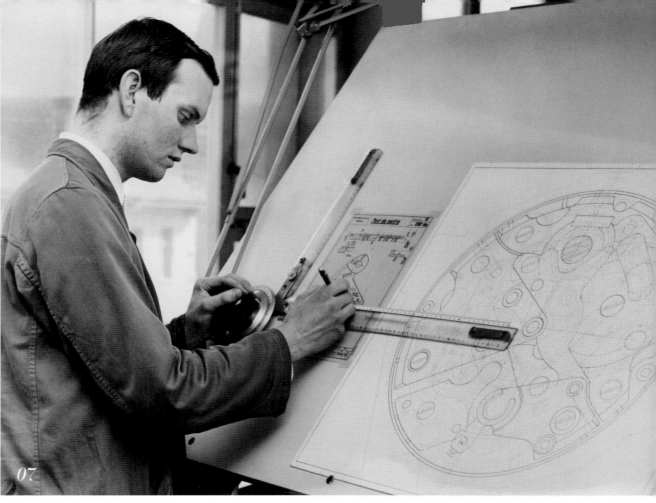

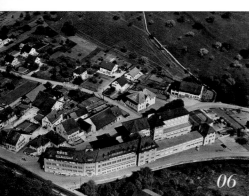

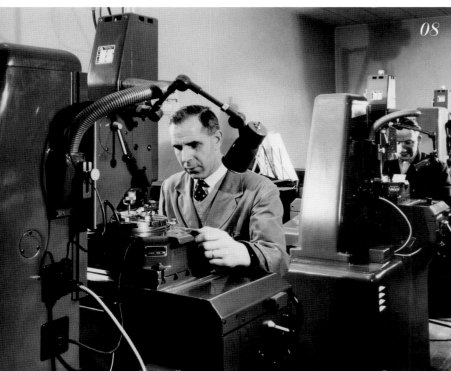

01: Postcard, 1910 ○ *Postkarte, 1910* ○ Carte postale, 1910 ○
02: Oris electroplating factory at Herbetswil, 1925 ○ *Oris-Galvanisier-fabrik in Herbetswil, 1925* ○ L'usine de galvanoplastie Oris à
Herbetswil, 1925 ○ 03: Production line, 1930s ○ *Fertigungslinie, 1930er* ○
La chaîne de production, années 1930 ○ 04: Advertising, 1926 ○
Werbung, 1926 ○ Publicité, 1926 ○ 05: Mechanical production, 1938 ○
Mechanische Fertigung, 1938 ○ Fabrication mécanique, 1938 ○
06: Headquarters in Hölstein, 1953 ○ *Hauptsitz in Hölstein, 1953* ○
Le siège social à Hölstein, 1953 ○ 07: Oskar Mohler working on a
technical drawing, 1968 ○ *Oskar Mohler beim Erstellen einer tech-nischen Zeichnung, 1968* ○ Oskar Mohler planchant sur un dessin
technique, 1968 ○ 08: Oris factory, 1969 ○ *Oris-Fabrik, 1969* ○
La manufacture Oris, 1969 ○ 09: Painting of Oris factories, 1929 ○
Gemälde der Oris-Fabriken, 1929 ○ Peinture représentant
la manufacture Oris, 1929 ○ 10: Pointer Calendar, 1938

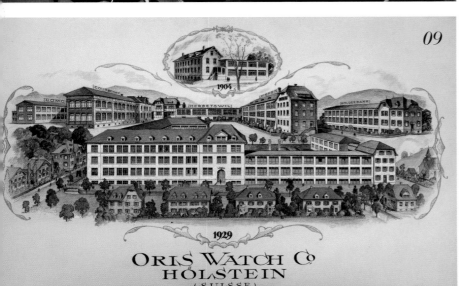

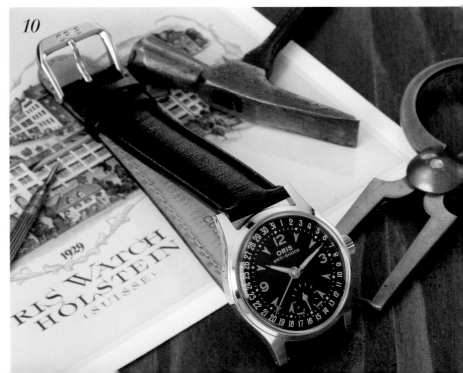

Im Zeichen von „High Mech"

Deutsch

Salopp könnte man sagen, dass sich zu Beginn des 20. Jahrhunderts in der südöstlich von Basel gelegenen Gemeinde Hölstein die Füchse und die Hasen Gute Nacht sagten. Ein erster Versuch, die missliche Situation in der strukturschwachen Gegend durch den Aufbau einer Uhrenfertigung zu bessern, scheiterte schon nach zwei Jahren. Was blieb, war der 1903 für Zeitmesser geschützte, von einem Bach in der Nähe entliehene Name Oris. 1904 wollten es die Herren Paul Cattin und Georges Christian besser machen. Und das Unterfangen gelang. 1910 ernährten die Manufacture d'Horlogerie de Hölstein, Cattin & Christian und ihre preiswerten Stiftanker-Uhren „fürs Volk" bereits 300 Familien. In den späten 1920er Jahren, nach dem Tod der Gründer, gelangte das Unternehmen ins Eigentum einer Investorengruppe um die Witwe von Georges Christian mit Jacques-David LeCoultre aus dem Vallée de Joux, einem Freund der Familie. Regelmäßig stellten die Oris signierten Uhren unter Beweis, dass Stiftanker-Kaliber bei sorgfältiger Konstruktion und Ausführung genauso zuverlässig und präzise sind wie solche mit traditioneller Schweizer Ankerhemmung. Den Lohn für kontinuierliche Optimierung gab es 1968. Als erstes Stiftanker-Kaliber überhaupt erhielt das Oris 652 ein Gangzeugnis des Observatoriums in Neuchâtel.

1934 hatte sich aber auch die Achillesferse dieser Werkestrategie gezeigt. Damals zementierte ein Schweizer Bundesgesetz, welches die kriselnde Uhrenindustrie vor dem Untergang bewahren sollte, das Produktspektrum der Firmen auf den aktuellen Status. Bei Oris tat Beschränkung weder der Kreativität noch dem Erfolg einen Abbruch. Ab 1936 produzierte das Unternehmen seine Stiftanker-Modelle auch in Holderbank, Como, Courgenay, Ziefen, Herbetswil und Biel. Auf der Gehaltsliste standen rund 1000 Mitarbeiterinnen und Mitarbeiter. Etliche lebten in Oris-Häusern. Viele reisten jedoch auch täglich mit eigenen Buslinien aus dem 25 Kilometer entfernten Basel nach Hölstein.

1938 gelangte das Kaliber 373 „Pointer" auf den Markt. Anschließend beinhaltete jede Oris-Kollektion mindestens ein Modell mit zentralem Zeigerdatum. Die erste Oris-Automatikuhr mit beidseitig wirkendem Rotoraufzug machte 1952 von sich reden. Eine Gangreserveanzeige bei der „12" führte die Effizienz des Selbstaufzugs vor Augen. 1966, als das lähmende Uhrenstatut endlich endete, schritt Oris unverzüglich zur Tat. Noch im gleichen Jahr erlangte das erste Automatikwerk mit klassischer Schweizer Ankerhemmung seine Serienreife. Mit diesem Kaliber 645 und anderen Spitzenleistungen gelang Oris der Anschluss an die Größten des internationalen Uhrenbusiness. 1970 verließen 1,2 Millionen mechanische Uhren und Wecker die verschiedenen Fabriken.

Im Folgejahr, die Quarz-Revolution warf ihre Schatten voraus, gelangte Oris unter das Dach der 1931 gegründeten Superholding Allgemeine Schweizer Uhren AG (ASUAG), welche 1985 mit der nicht minder kränkelnden SSIH zur SMH (Schweizerische Gesellschaft für Mikroelektronik und Uhrenindustrie AG) fusionierte.

Dazu so viel in aller Kürze: In den späten 1970er Jahren hatte die zeitbewahrende Elektronik knapp 900 Schweizer Uhr-Unternehmen in den Konkurs getrieben. Etwa zwei Drittel der Belegschaft verlor ihren Job. Betroffen war auch Oris. Als die ASUAG den Betrieb 1982 schließen wollte, sicherten Geschäftsführer Dr. Rolf Portmann und der damalige Marketingleiter Ulrich W. Herzog das Überleben durch einen Management-Buyout. Aus der ehemaligen Oris Watch Co. SA wurde die natürlich kleinere Oris SA.

Zum Schluss noch einige Zahlen zur illustren Oris-Geschichte: Von 1919 bis 1987 entstanden in Hölstein und den zugehörigen Produktionsstätten nicht weniger als 96 850 000 Uhren. Spitzenränge nahmen die glanzvollen Epochen von 1919 bis 1928 (27,5 Millionen Exemplare) und 1929 bis 1948 (39 Millionen Exemplare) ein. Außerdem entwickelte das Unternehmen zwischen 1904 und 1981 insgesamt 279 Kaliber oder Module zu existenten Uhrwerken.

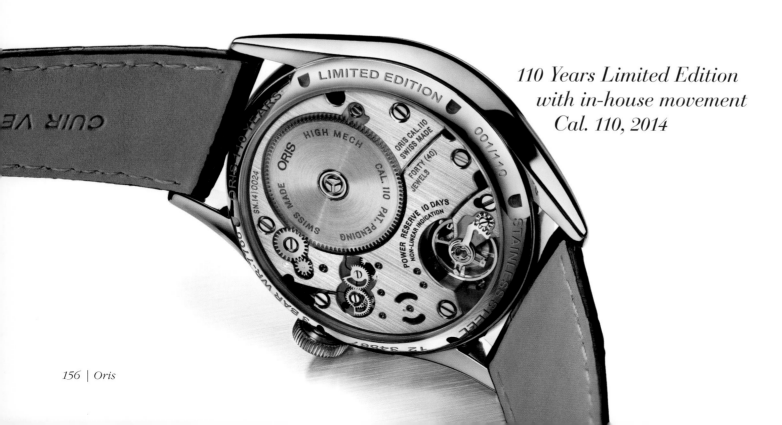

110 Years Limited Edition
with in-house movement
Cal. 110, 2014

Als Oris im Jahre 1985 fast schon visionär entschied, nur noch mechanische Uhren herzustellen, wurde das Unternehmen von manchen Seiten belächelt. Auf der Basis bewährter Eta-Kaliber und zum Teil selbstentwickelter Module entstand ein breites Spektrum preiswerter Armbanduhren. Dazu gehörten sammelnswerte Retro-Modelle beispielsweise mit Wecker oder 1997 der exklusive „Worldtimer" mit hilfreichem Zeitzonen-Dispositiv. Ein völlig neuer Markenauftritt unter dem Slogan „It's High Mech" unterstrich die auf Mechanik fokussierte Neuausrichtung.

Pünktlich zum 110. Geburtstag im Jahr 2014 belebte Oris seine vergessen geglaubten Manufaktur-Aktivitäten. Das Handaufzugskaliber 110, entwickelt und gefertigt gemeinsam mit dem Technikum in Le Locle sowie einschlägig erfahrenen Partnern, repräsentierte die erste Eigenkreation seit 35 Jahren. Beim Blick auf die Rückseite des 34 Millimeter großen Œuvres sticht der geradezu riesige Energiespeicher ins Auge. Die darin aufgewundene 1,80 Meter lange Zugfeder liefert Kraft für zehn Tage ununterbrochenen Lauf. Besonders kreativ: die patentierte Gangreserveanzeige auf dem Zifferblatt. Ihr Zeiger bewegt sich anfangs relativ langsam und steigert sein Tempo mit nachlassender

Federkraft. Die erste limitierte Edition der damit ausgestatteten Armbanduhr war im Handumdrehen ausverkauft. 2015 präsentierte Oris das fortan mit eigenen Werkzeugen unlimitiert produzierte 111. Hier gesellt sich zum Bestehenden ein angenehm großes Fensterdatum bei der „9". Die letzte Evolutionsstufe heißt 112, zu finden in der 2016 vorgestellten „Artelier Calibre 112". Zur Freude vielfliegender Kosmopoliten besitzt diese Version eine leicht handhabbare Zeitzonen-Funktion.

Armbanduhren mit diesem exklusiven Uhrwerk repräsentieren freilich nur die Sahnehaube der breit gefächerten Kollektion. Darüber hinaus bedient Oris zu vernünftig kalkulierten Preisen nahezu jeden Anspruch. Taucher können sich an der sehr nostalgisch anmutenden „Divers Sixty-Five" erfreuen. Die 2 000 Exemplare der „Carl Brashear Limited Edition" von 2016 sind jedoch längst vergriffen. Über einen praktischen Tiefenmesser verfügt die „Aquis Depth Gauge". Das Piloten-Pendant mit Höhenmesser heißt „Big Crown ProPilot Altimeter". Autofans kommen durch Audi- oder Williams-Modelle zu ihrem Recht, Jazzliebhaber zum Beispiel durch die aktuelle „Thelonious Monk Limited Edition". Alleine bei Uhren mit Quarzwerk muss Oris schlichtweg passen. ◦

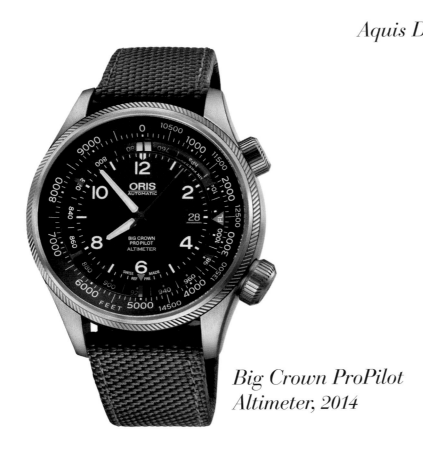

Big Crown ProPilot
Altimeter, 2014

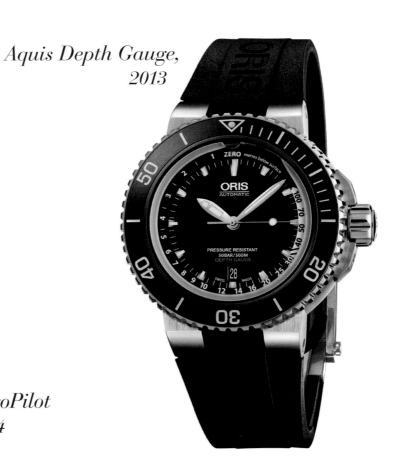

Aquis Depth Gauge,
2013

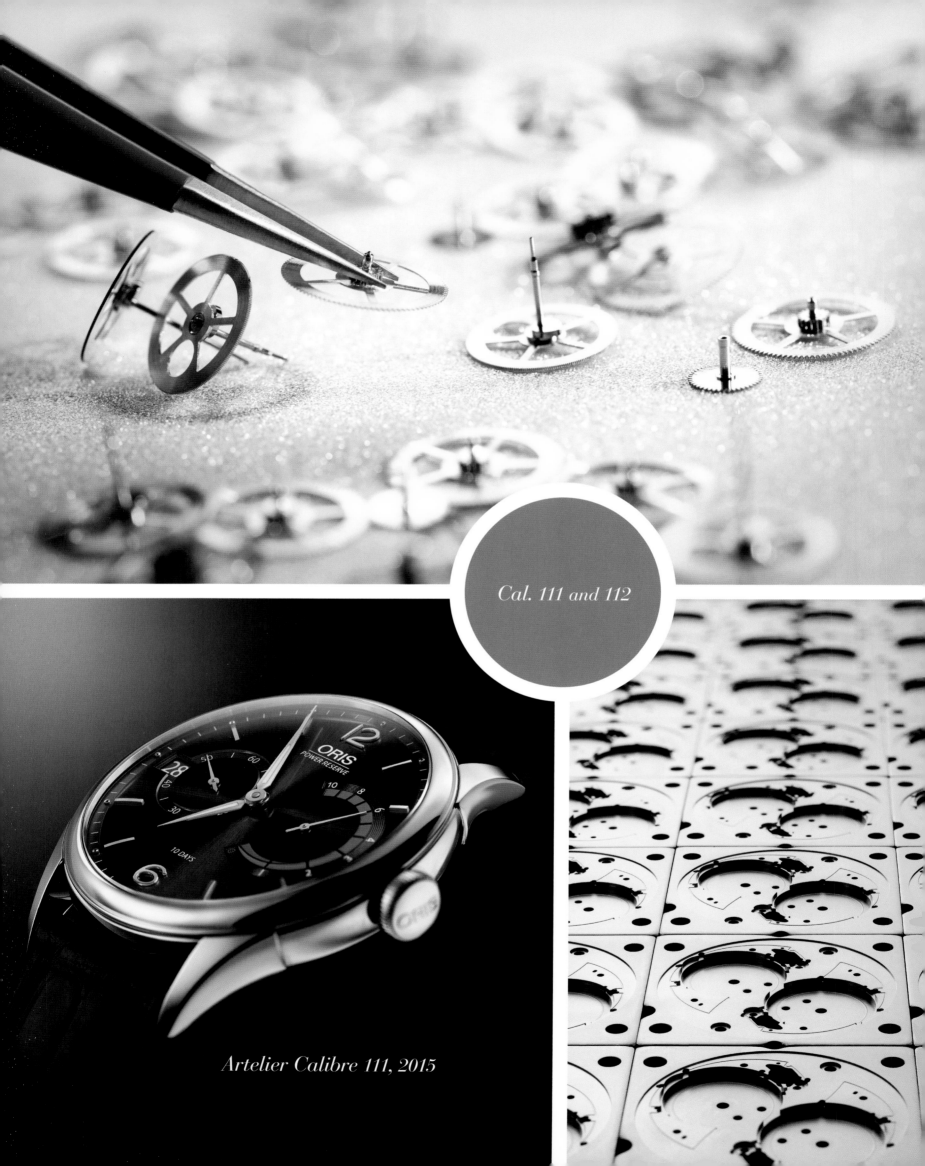

Cal. 111 and 112

Artelier Calibre 111, 2015

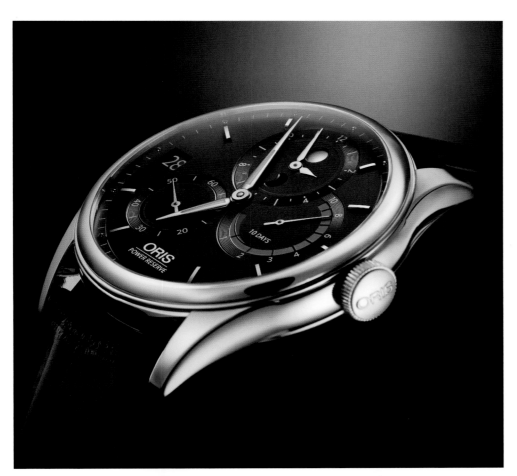
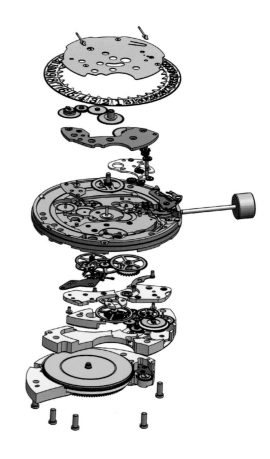
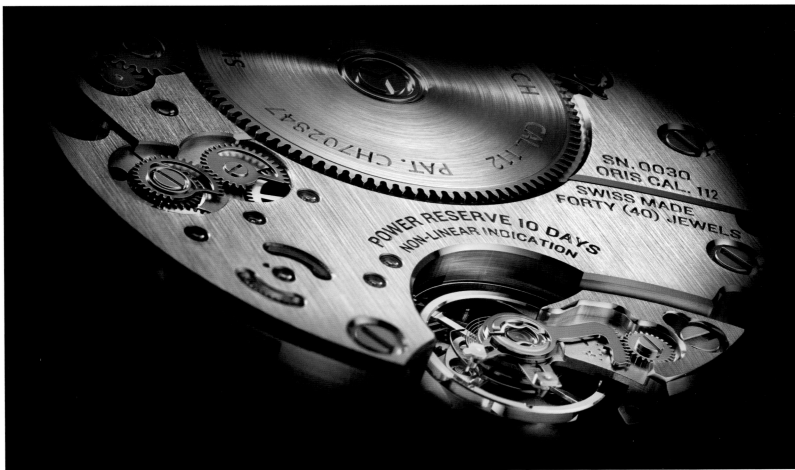

Clockwise from top left: Artelier Calibre 112, 2016 ◦ Exploded view of Caliber 111, 2016 ◦ In-house movement 112 with worm gear on the left for non-linear power-reserve indication (Oris patent) ◦ Von oben links im Uhrzeigersinn: Artelier Calibre 112, 2016 ◦ Explosionsdarstellung von Kaliber 111, 2016 ◦ Hausintern entwickeltes Kaliber 112 mit Schneckengetriebe auf der linken Seite für nicht-lineare Gangreserveanzeige (Oris-Patent) ◦ *Dans le sens horaire, en partant du haut, à gauche : Artelier Calibre 112, 2016 ◦ Vue en éclaté d'un calibre 111, 2016 ◦ Mouvement de manufacture 112 avec vis sans fin sur la gauche pour l'indicateur de réserve de marche à affichage non-linéaire (brevet Oris)*

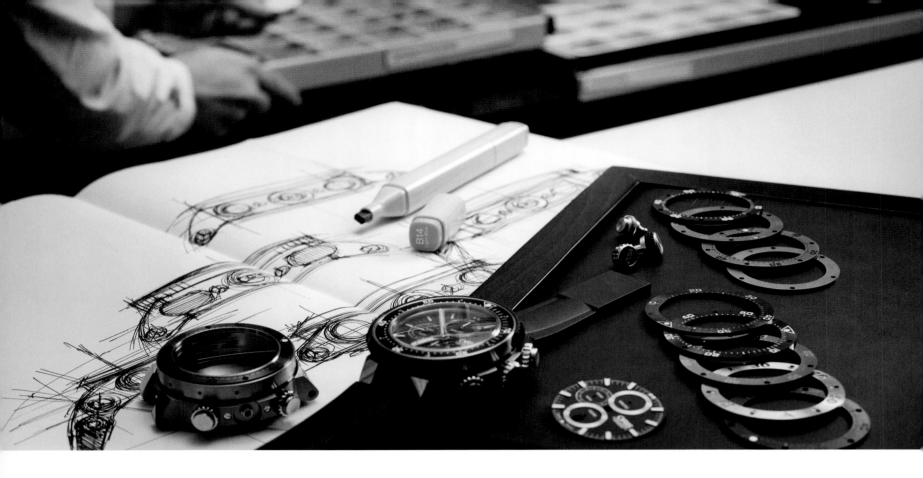

Sous le signe de la « High Mech »

Au début du XXᵉ siècle, Hölstein, commune située au sud-est de Bâle, est pour ainsi dire encore en pleine cambrousse. Une première tentative pour remédier à cette fâcheuse situation en établissant une manufacture horlogère dans cette région défavorisée s'avère être un échec après seulement deux ans. Tout ce qu'il en reste, c'est Oris, le nom d'un ruisseau du voisinage déposé à titre de marque en 1903 pour des garde-temps. En 1904, Paul Cattin et Georges Christian espèrent plus de succès, et leur tentative réussit. Dès 1910, la Manufacture d'Horlogerie de Hölstein Cattin & Christian et ses montres « populaires » abordables dotées d'échappements à ancre à chevilles font vivre 300 familles. À la fin des années 1920, après le décès des fondateurs, l'entreprise devient la propriété d'un groupe d'investisseurs réunis autour de la veuve de Georges Christian et d'un ami de la famille, Jacques-David LeCoultre de la vallée de Joux. Régulièrement, les montres signées Oris démontrent que les calibres à ancre à chevilles sont tout aussi fiables et précis que ceux équipés d'un échappement à ancre suisse classique, à condition d'avoir été correctement conçus et réalisés. Des optimisations permanentes sont récompensées en 1968 : le calibre Oris 652 est le premier mouvement à échappement à chevilles à obtenir un certificat de chronomètre de l'observatoire astronomique et chronométrique de Neuchâtel.

En 1934, toutefois, cette stratégie en matière de mouvements montre ses limites. À l'époque, une loi fédérale suisse censée sauver l'industrie horlogère en crise, gèle les gammes de produits des manufactures. Mais cette limitation ne portera atteinte ni à la créativité ni au succès d'Oris. À compter de 1936, l'entreprise produit des modèles à échappement à chevilles également à Holderbank, Côme, Courgenay, Ziefen, Herbetswil et Bienne. Elle compte 1 000 employés, dont bon nombre vivent dans des logements construits par Oris. Mais nombreux sont aussi ceux qui empruntent quotidiennement la ligne privée de bus de l'entreprise pour parcourir les 25 kilomètres séparant Bâle d'Hölstein.

En 1938, le calibre 373 « Pointer » arrive sur le marché. Chaque collection de la marque comportera dès lors au moins un modèle avec calendrier à aiguille central. La première montre automatique Oris à remontage par rotor bidirectionnel sort en 1952. L'indication de réserve de marche à 12 heures dévoile l'efficacité du remontage automatique. En 1966, lorsque le carcan du Statut horloger se desserre, Oris passe aussitôt à l'action. La même année, le premier mouvement automatique à échappement à ancre suisse classique est fabriqué en série. Grâce à ce calibre 645 et à d'autres prouesses, Oris rejoint le club des grands du marché international des montres. En 1970, 1,2 million de montres et de réveils mécaniques quittent les différentes usines de l'entreprise.

L'année suivante, alors que se profile l'ombre de la révolution du quartz, Oris passe dans le giron de l'ASUAG (Allgemeine Schweizer Uhren AG), superholding de l'industrie horlogère fondée en 1931, qui fusionnera en 1985 avec la non moins chancelante SSIH (Société suisse pour l'industrie horlogère) pour former la SMH (Société suisse de microélectronique et d'horlogerie).

Mais revenons brièvement sur cette situation : à la fin des années 1970, les garde-temps électroniques conduisent près de 900 entreprises horlogères suisses à la faillite. Les deux tiers environ du personnel horloger perdent leur emploi. Et cette crise touche également Oris. Lorsque l'ASUAG veut fermer l'entreprise en 1982, le président

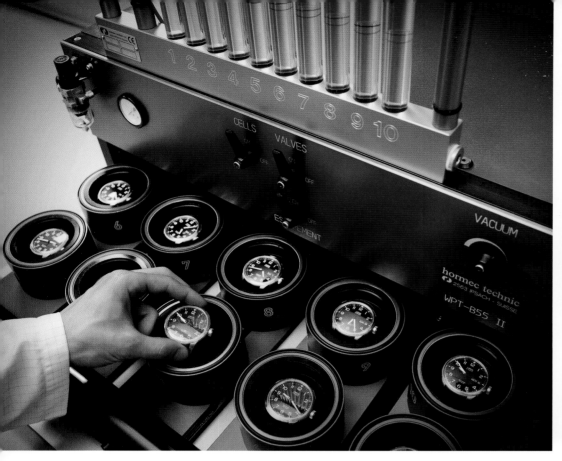
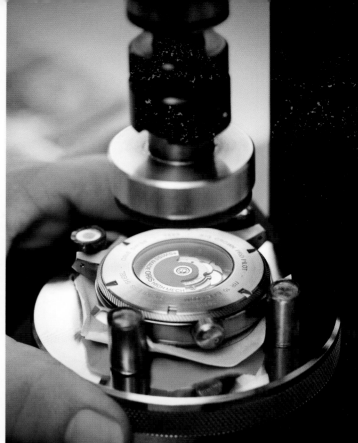

From left: Redesign work for ProDiver chronograph ○ Each watch passes a water-resistance check before leaving the factory ○ Closing the screwed case back ○ Von links: Neugestaltung des Modells ProDiver Chronograph ○ Jede Uhr wird auf Wasserdichtigkeit getestet, bevor sie die Fabrik verlässt ○ Schließvorgang bei verschraubter Gehäuserückseite ○ De gauche à droite : Travail de refonte du chronographe ProDiver ○ Chaque montre subit un contrôle d'étanchéité avant de quitter l'usine ○ Opération de fermeture du fond de boîtier vissé

Rolf Portmann et le directeur général Ulrich W. Herzog assurent sa survie en la rachetant. Oris Watch Co. SA devient Oris SA, avec bien sûr des effectifs moins nombreux.

Pour terminer, quelques chiffres encore sur la célèbre histoire d'Oris : de 1919 à 1987, pas moins de 96 850 000 montres sortent de la manufacture de Hölstein et des autres sites de production. Dans les époques fastes de 1919 à 1928 (27,5 millions d'exemplaires) et de 1929 à 1948 (39 millions d'exemplaires), la production est à son maximum. Entre 1904 et 1981, l'entreprise met en outre au point 279 calibres et modules pour les mouvements.

En 1985, la décision quasi-visionnaire d'Oris de ne plus fabriquer que des montres mécaniques fait sourire certains. Mais la manufacture parvient, à l'aide de calibres Eta éprouvés et de modules en partie fabriqués en interne, à se constituer une gamme respectable de montres-bracelets abordables. Parmi ces dernières figurent des modèles rétro pour collectionneurs, équipés notamment d'un réveil, ou encore le « Worldtimer » exclusif avec son dispositif bien utile d'affichage des fuseaux horaires. Un tout nouveau positionnement de la marque avec pour devise « It's High Mech » vient souligner cette nouvelle orientation résolument axée sur la mécanique.

En 2014, date précise de son 110e anniversaire, Oris fait revivre ses activités de manufacture que l'on croyait disparues. Le calibre 110 à remontage manuel, conçu et fabriqué en collaboration avec le technicum du Locle et une équipe de partenaires dûment expérimentés, constitue la première création de la manufacture depuis 35 ans. Au revers de ce chef-d'œuvre de 34 millimètres de diamètre, le dispositif assez conséquent chargé d'emmagasiner la force motrice saute aux yeux. Le ressort de 1,80 mètre enroulé fournit assez d'énergie pour dix jours d'autonomie de marche. Caractéristique particulièrement innovante : l'indication de réserve de marche brevetée, sur le cadran. L'aiguille se déplace au début plutôt lentement puis accélère au fur et à mesure que la tension du ressort diminue. La première série limitée de montres-bracelets ainsi équipées se vend en un rien de temps. En 2015, Oris présente le calibre 111, produit en série illimitée par l'entreprise avec son propre équipement. Un guichet dateur d'une taille appréciable à 9 heures vient compléter les caractéristiques habituelles. Au dernier stade de l'évolution, le calibre 112 anime la montre « Artelier Calibre 112 », présentée en 2016. À la grande joie des personnes qui enchaînent les trajets en avion, cette version dispose d'une fonction GMT simple d'utilisation.

Les montres-bracelets équipées de ce mouvement exclusif ne représentent toutefois que la crème de la crème de la gamme très étendue de la marque. Oris répond en outre quasiment à tous les désirs à des prix raisonnables. La « Divers Sixty-Five », qui incite fortement à la nostalgie, fait la joie des plongeurs. Les 2000 exemplaires de la « Carl Brashear Limited Edition », sortie en 2016, sont pour leur part depuis longtemps épuisés. Le modèle « Aquis Depth Gauge » dispose d'un profondimètre bien utile. Baptisé « Big Crown ProPilot Altimeter », son homologue pour pilotes est équipé d'un altimètre. Si les passionnés d'automobile trouvent leur compte avec les modèles Audi ou Williams, les amoureux de jazz sont comblés par l'intemporelle « Thelonious Monk Édition limitée ». Il n'y a que sur les montres à quartz qu'Oris doive tout bonnement faire l'impasse. ○

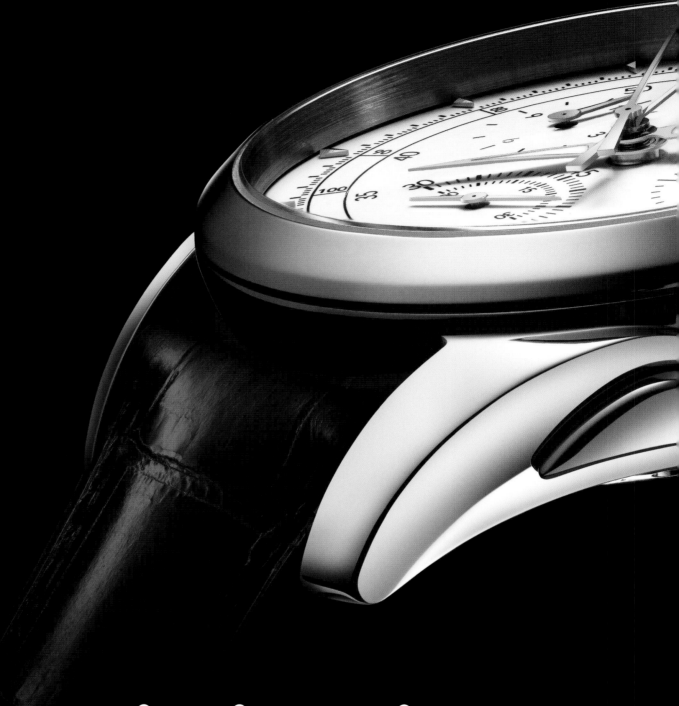

Parmigiani Fleurier

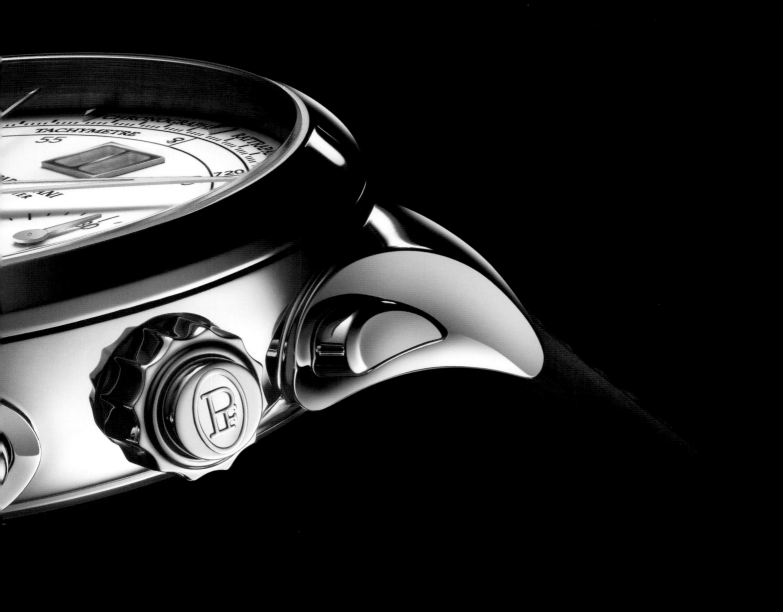

Craftsmanship in Service of Time

English

The first few decades of his life were quite challenging for Michel Parmigiani, who was born in 1950. He began his career at the school of watchmaking in Fleurier, the same town that's now the home of the watch brand which bears his name. The son of Italian parents, Parmigiani continued his education at the technical institute in the watch metropolis of La Chaux-de-Fonds and at the school of engineering in Le Locle. This master watchmaker was employed by a small watch factory, where he was a reluctant eye-witness to the decline of classical mechanical watchmaking in the early 1970s. But this frustrating period from 1973 to 1975 in the life of a characteristically demure horological artist was not without its positive aspects. Michel Parmigiani had no choice but to ask himself why the Quartz Revolution was shaking the foundations of traditional values. More or less overnight, functionality took precedence over aesthetics, commercial considerations eclipsed quality, and mental doggedness was valued above creativity. The talented craftsman was unwilling to participate in these supposedly innovative trends, so he shunned the mainstream and began a career as a freelance watchmaker. Now that traditional mechanisms were becoming increasingly rare in new watches, he dedicated himself to loveable artifacts from bygone epochs. A wide variety of precious timepieces around the world were in need of competent and meticulous restoration. Here was a field of endeavor in which Parmigiani, who admittedly has a perfectionist streak, could uninhibitedly pursue his calling. Fascinating commissions soon arrived. Atelier Parmigiani, which was an exclusively one-man show until 1980, accepted every request, no matter how intricate. The horological soloist achieved widespread public acclaim with his successful repair of a valuable "Pendule Sympathique," which had been crafted by Abraham-Louis Breguet and which most experts had dismissed as irreparable. His restoration of a tourbillon of the same provenance for the Museo Poldi Pezzoli in Milan not only earned cult status for the talented craftsman, but also won him the full confidence of the Sandoz Family, which not only makes pharmaceuticals, but also cultivates a penchant for the fine arts. The ticking treasures that were serviced or restored by Parmigiani and his growing team of dedicated employees formatively influenced the next phase in his career. This naturalized Swiss citizen was increasingly often asked to provide developmental assistance for the theoretical and/or practical realization of interesting time-related projects. In 1994, the watch collector Pierre Landolt urged Michel Parmigiani to devote more time and effort to his own watches. Acting in accord with the expressed will of the foundation's founder Edouard-Marcel Sandoz, the chairman of the Sandoz Foundation decided to participate in the new Michel Parmigiani watch manu-facture in 1996. Needless to say, the mellifluous name of the firm's founder remained unaffected by the foundation's participation. Though it was surely not a simple task, Parmigiani's creation of his own watch collection was a stimulating and fascinating exercise. The successful premiere took place in Lausanne on May 29, 1996 in front of an audience of circa 450 connoisseurs. The spectators immediately understood the clear and impressive philosophy: small numbers of timepieces, artistic handcraftsmanship, the finest quality, the utmost fidelity to detail, and luxury in its purest form. But even more lies behind the name "Parmigiani Fleurier." Parmigini designs and engineers, fabricates, embellishes and assembles his own movements, thus fully justifying his use of the prestigious term "manufacture." The experts in his ateliers daily reconfirm the truth of the adage which states that "time respects nothing which doesn't require plenty of time in its creation." But time hasn't stood still for Parmigiani. Under Sandoz's aegis, the 21st century has penetrated into his ateliers in the form of modern computer-guided machines, which assist the artisans who craft a wide variety of diverse components and ébauches. These specialists, however, don't work only in Parmigiani's ateliers, but also in the buildings of the affiliated companies Vaucher, Atokalpa and Elwin. This team of acknowledged experts achieves a vertical depth of fabrication of more than 90 percent. The palette of products ranges from extremely elaborate plates to seemingly unimpressive but highly sophisticated *assortiments*, i.e., kits for escapements. Even the tiniest screws and pinions are made on the premises. Two years of development were required for the hairsprings, which the company now also delivers to renowned competitors. All this notwithstanding, Michel Parmigiani places great importance on the fact that an ébauche contributes less than ten percent to a completed watch. The lion's share of its value is added by the time-consuming artisanal fabrication and fine processing of the components, their assembly and fine tuning, and ultimately the meticulous adjustment of the finished movement to assure that it keeps time with an optimally accurate rate.

The diverse spectrum of Parmigiani's own calibers began in 1998 with the debut of *tonneau*-shaped Caliber PF110, a manually wound movement that can run for nearly 200 hours between windings. Mastery of automatic winding in an ultra-slim construction is proven by the 2.6-millimeter-tall microrotor Calibers PF701 and 705 (skeletonized). A centrally positioned oscillating weight automati-cally winds the mainspring of Caliber PF331, which is nonetheless just 3.5 millimeters tall. When an exclusive perpetual calendar is added to this movement, its name changes to Caliber PF333. Version PF377 is equipped with a practical time-zone display, which includes a day/night indicator. Caliber PF517 set a world record which will surely remain difficult to break: although it's equipped with a self-winding mechanism and a one-minute tour-billon, this superlative caliber is a mere 3.4 millimeters tall.

Apropos tourbillons: the never-ending striving toward horological perfection is beautifully expressed by hand-wound Calibers PF500 and PF511. Their tourbillon requires only 30 seconds to complete each rotation. Doubling the rotational speed goes hand in hand with markedly improved precision. A patented power-reserve display is positioned at the "12." And this extraordinary movement also boasts a centrally positioned second-hand. Incidentally: the tourbillon remains visible when one slips this watch off the wrist, turns it over, and peers through the pane of sapphire crystal in the back of its case.

Inspired by a predecessor from the late 18th century, the "Ovale Pantographe" is absolutely unique. Its slender telescoping hands automatically extend and slowly retract so they continually conform to the ovoid shape of its case. These complex hands very likely also gave a few grey hairs to the watchmakers who were involved in their development and fabrication! The lengthening and shortening of the hands is powered by time-honored hand-wound shaped Caliber PF111, which provides an eight-day power reserve.

Complex hand-wound Caliber PF361 was ready for series manufacture punctually in time for the firm's 20th anniversary in Fleurier. Its bearing parts (i.e., its plates, bridges and cocks) are made of solid gold. Alongside the chronograph with classical column-wheel control and innovative friction coupling, this horological opus includes a balance paced at five hertz and a split-seconds mechanism. The latter can be used, for example, to measure intermediate times at athletic events. Each of the 25 timepieces in the limited series of "Tonda Chronor Anniversaire" watches features a large and eye-catching date display. Simultaneously with the presentation of the ultra-sporty Bugatti Chiron at the automobile salon in Geneva in 2016, this small and very fine manufacture also unveiled a matching concept wristwatch. Caliber PF390, which is encased crosswise to serve as the "engine," has two barrels and a "flying" (i.e., cantilevered) one-minute tourbillon. A central planetary gear powers the dial train. The console-like dial enables the wearer to check time's progress without taking his hands off his car's steering wheel.

Parmigiani Fleurier has unveiled many delightful surprises during the past two decades. And we have every reason to believe that this will continue in the future. ○

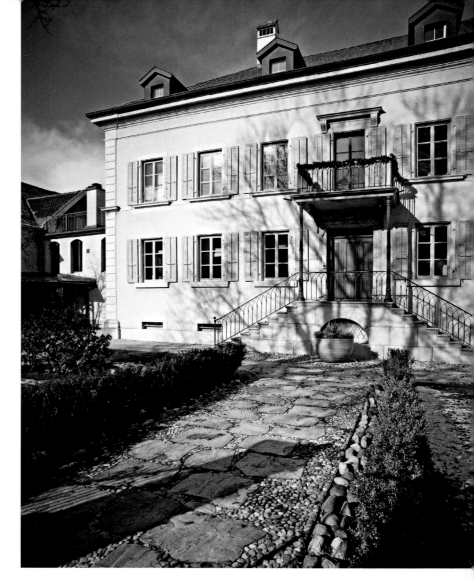

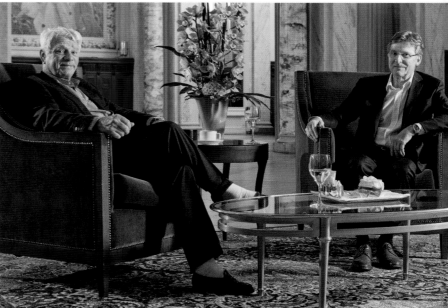

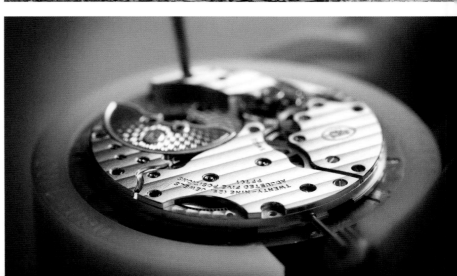

*Top: The manufactory in Fleurier ○ Manufaktur in Fleurier ○
La manufacture de Fleurier ○ Middle and bottom: Pierre Landolt
and Michel Parmigiani ○ Cal. PF701*

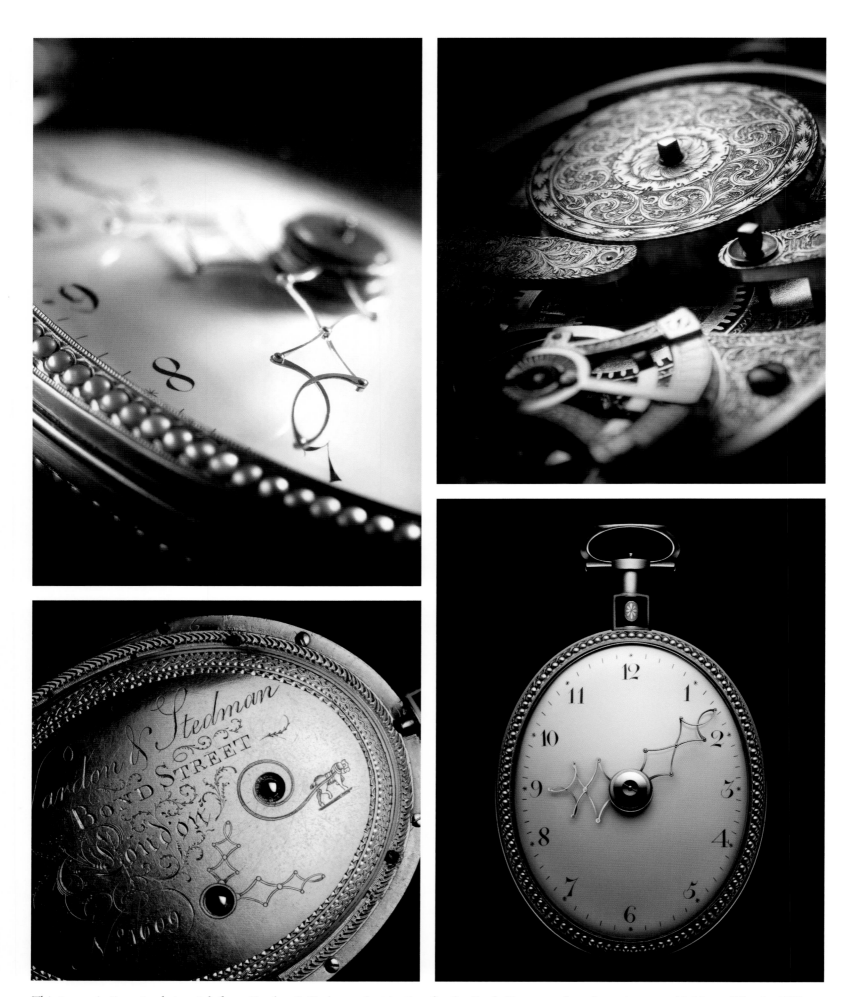

This page: Antique pocket watch from Vardon & Stedman, inspiration for the Ovale Pantographe ◦ Opposite page: Making of Tonda 1950 Tourbillon, PF517 ◦ *Diese Seite: Antike Taschenuhr von Vardon & Stedman, Vorbild für die Ovale Pantographe ◦ Gegenüberliegende Seite: Fertigung des Tourbillons Tonda 1950, Kaliber PF517* ◦ Ci-dessus : Montre de poche ancienne signée Vardon & Stedman, qui a inspiré le modèle Ovale Pantographe ◦ Page ci-contre : Fabrication de la Tonda 1950 Tourbillon, PF517

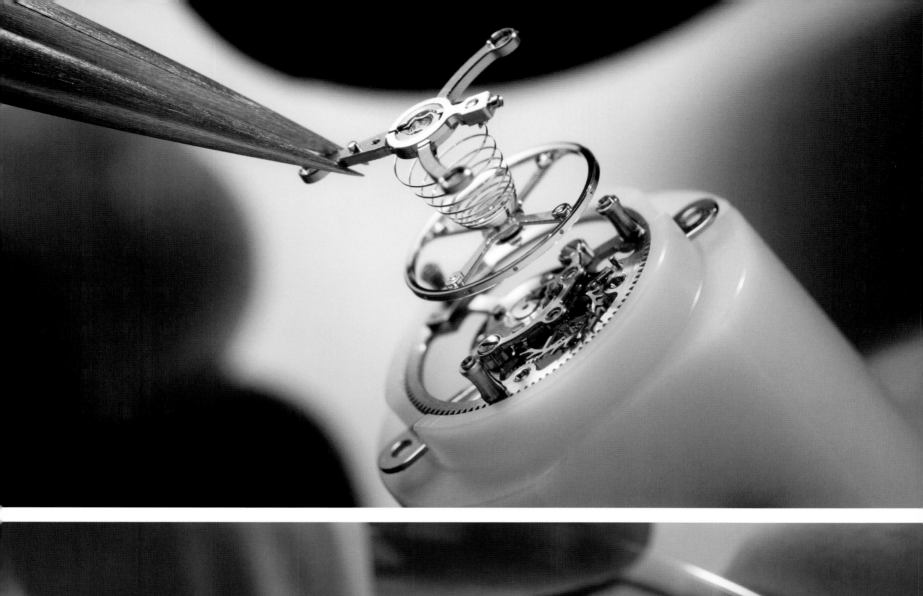
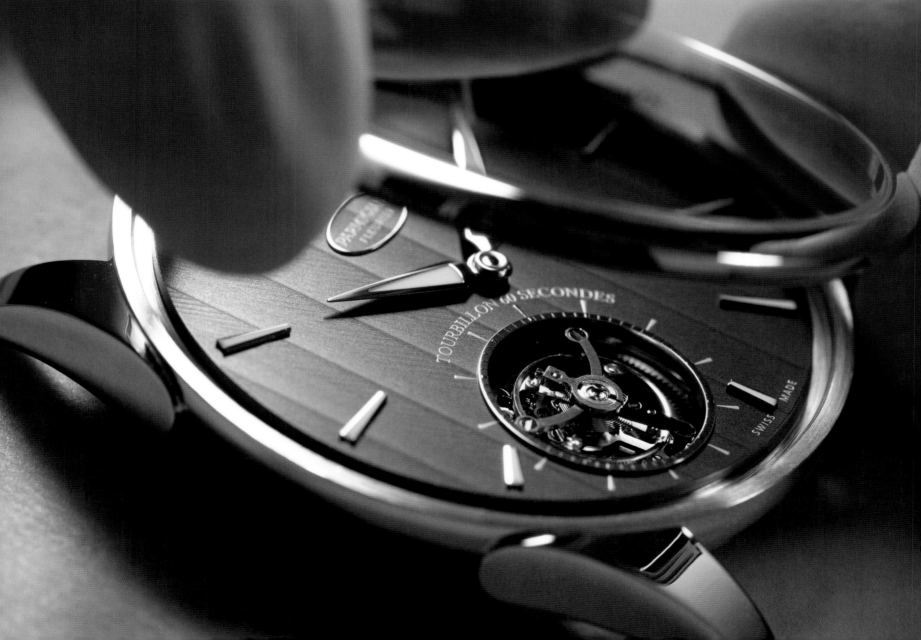

Handwerkskunst rund um die Zeit

Leicht hatte er es nicht, der 1950 geborene Michel Parmigiani. Seine Karriere startete an der Uhrmacherschule jener Ortschaft, in der man heute die Uhrenmarke seines Namens findet: Fleurier. Seine Ausbildung komplettierte der Sohn italienischer Eltern am Technikum der Uhrenmetropole La Chaux-de-Fonds sowie in der Ingenieurschule Le Locle. Anfang der 1970er Jahre musste der Meister-Uhrmacher den Niedergang der klassischen mechanischen Uhrmacherei als Mitarbeiter einer kleinen Uhrenfabrik hautnah miterleben. Diese frustrierende, von 1973 bis 1975 während Periode im Leben des stets zurückhaltend auftretenden Uhren-Künstlers hatte aber auch ihre positiven Seiten. Michel Parmigiani musste sich damit auseinandersetzen, warum die Quarz-Revolution an den Grundfesten überlieferter Werte rüttelte. Quasi über Nacht rangierte Funktionalität vor Ästhetik, Kommerzdenken vor Qualität und mentale Beharrlichkeit vor Kreativität. Diesen vermeintlich innovativen Tendenzen konnte und wollte der begnadete Handwerker nicht folgen. Also suchte er sein Heil als selbständiger Uhrmacher. Nachdem die traditionelle Mechanik in neuen Uhren nur noch ein Schattendasein fristete, widmete er sich liebenswerten Objekten aus vergangenen Epochen. Weltweit harrte ein breites Spektrum kostbarer Zeitmesser gleichermaßen kompetenter wie liebevoller Restaurierung. Auf diesem Gebiet konnte sich der ausgeprägte Hang zur Perfektion endlich ungehemmt entfalten. Faszinierende Aufträge ließen nicht lange auf sich warten. Das Atelier Parmigiani, in dem bis 1980 ausschließlich der Meister selbst tätig war, schreckte vor keinem einzigen zurück. Öffentliche Wahrnehmung erzielte die One-Man-Show durch die Wiederherstellung einer kostbaren, von Experten als irreparabel titulierten „Pendule Sympathique" von Abraham-Louis Breguet. Durch die Restaurierung eines Tourbillons gleicher Provenienz für das Museo Poldi Pezzoli in Mailand erlangte Michel Parmigiani Kultstatus und das uneingeschränkte Vertrauen der kunstsinnigen Pharma-Familie Sandoz. Deren tickende Kostbarkeiten, welche der Chef und eine kontinuierlich steigende Zahl engagierter Angestellter fachkundig betreuten, beeinflussten den weiteren Lebensweg. Immer öfter leistete der naturalisierte Schweizer Entwicklungshilfe bei der theoretischen und/oder praktischen Umsetzung interessanter Zeit-Projekte. 1994 wirkte der Uhrensammler Pierre Landolt auf

Michel Parmigiani ein, künftig verstärkt an eigenen Uhren zu arbeiten. Durch eine Beteiligung an der neuen Uhrenmanufaktur Michel Parmigiani erfüllte der Vorsitzende der Sandoz-Stiftung im Jahr 1996 den erklärten Willen des Stiftungsgebers Edouard-Marcel Sandoz. Selbstverständlich blieb der klangvolle Name des Firmengründers unangetastet erhalten. Die Kreation einer eigenen Uhrenkollektion war keine leichte, dafür aber ausgesprochen spannende und faszinierende Übung. Das erfolgsgekrönte Debüt ging am 29. Mai 1996 in Lausanne vor rund 450 Kennern über die Bühne. Das Auditorium hatte die klare, einprägsame Philosophie auf Anhieb verstanden: geringe Stückzahlen, kunstfertige Handarbeit, feinste Qualität, höchste Detailtreue und Luxus pur. Hinter dem Namen Parmigiani Fleurier verbirgt sich freilich noch weit mehr. Die Konstruktion, Fertigung, Finissage und Terminage eigener Uhrwerke rechtfertigt den imageträchtigen Titel Manufaktur mit Fug und Recht. In den Ateliers gilt die bewährte Spruchweisheit, dass die Zeit nichts respektiert, was ohne sie geschaffen wurde. Gleichwohl ist die Zeit auch bei Parmigiani nicht stehen geblieben. Unter der Ägide von Sandoz hielt das 21. Jahrhundert seinen Einzug in Form moderner computergesteuerter Maschinen, welche die Produktion einer großen Vielfalt verschiedener Komponenten und Rohwerke unterstützen. Allerdings agieren sie nicht bei Parmigiani selbst, sondern in den Gebäuden der Schwesterfirmen Vaucher, Atokalpa und Elwin. Der Verbund ausgewiesener Spezialisten bringt es auf eine Fertigungstiefe von mehr als 90 Prozent. Die Produktpalette reicht von den teilweise extrem aufwendigen Platinen bis hin zu dem unscheinbaren, aber höchst anspruchsvollen Assortiment. Selbst kleinste Schrauben und Zahntriebe entstehen in eigener Regie. Hinter den Unruhspiralen, die das Unternehmen auch an renommierte Mitbewerber liefert, stecken zwei Jahre Entwicklungszeit. Ungeachtet dessen legt Michel Parmigiani größten Wert auf die Feststellung, dass der Anteil eines Rohwerks an der fertigen Uhr gerade einmal zehn Prozent beträgt. Den weitaus überwiegenden Teil der Wertschöpfungskette beanspruchen die zeitaufwendige, weil in traditioneller Weise von Hand ausgeführte Feinbearbeitung der Komponenten, die Assemblage und Feinstellung des Ganzen sowie die Regulierung des fertigen Uhrwerks auf optimale Ganggenauigkeit.

Ovale Pantographe, 2013

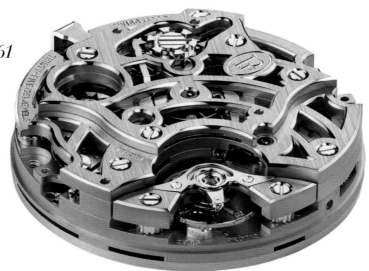

Cal. PF361

Den Anfang der mittlerweile breit gefächerten Palette eigener Kaliber markierte 1998 das tonneauförmige PF110 mit manuellem Aufzug und knapp 200 Stunden Gangautonomie. Die Beherrschung des automatischen Aufzugs in ultraflacher Bauweise demonstrieren die nur 2,6 Millimeter hoch bauenden Kaliber PF701 und 705 (skelettiert) mit Mikrorotor. Demgegenüber verfügt das PF331, Bauhöhe 3,5 Millimeter, über eine zentral positionierte Schwungmasse. Ausgestattet mit einem exklusiven ewigen Kalendarium heißt dieses Uhrwerk PF333. Die Version PF377 verfügt über ein hilfreiches Zeitzonen-Dispositiv inklusive Tag-Nacht-Indikation. Einen sicher nur schwer zu brechenden Weltrekord repräsentiert das PF517. Ausgestattet mit Selbstaufzug und Minutentourbillon misst der Superlativ lediglich 3,4 Millimeter in der Höhe.

Apropos Tourbillon: Ausdruck des fortwährenden Strebens nach uhrmacherischer Vollendung sind die Handaufzugskaliber PF500 und PF511. Ihr Drehgang benötigt für eine komplette Umdrehung nur 30 Sekunden. Die doppelte Umlaufgeschwindigkeit bringt eine spürbar bessere Präzision mit sich. Patentiert ist die Gangreserveindikation bei der „12". Und noch etwas zeichnet dieses Uhrwerk aus: der zentral angeordnete Sekundenzeiger. Das Tourbillon bleibt übrigens auch dann sichtbar, wenn man die damit ausgestattete Armbanduhr vom Handgelenk nimmt und durch den Saphirglasboden blickt.

Absolut einzigartig ist die „Ovale Pantographe", deren Vorbild aus dem späten 18. Jahrhundert stammt. Entsprechend der Form des Gehäuses dehnen sich ihre filigranen Teleskopzeiger, deren Herstellung den involvierten Uhrmachern regelmäßig graue Haare wachsen lässt, entweder aus, oder sie ziehen sich wie von Geisterhand bewegt ganz langsam zusammen. Den Antrieb liefert das bewährte Handaufzugs-Formkaliber PF111 mit acht Tagen Gangautonomie.

Pünktlich zum 20. Firmenjubiläum ist in Fleurier das komplexe Handaufzugskaliber PF361 zur Serienreife gediehen. Seine tragenden Teile, also die Platinen, Brücken und Kloben, bestehen aus massivem Gold. Neben dem Chronographen mit klassischer Schaltradsteuerung und innovativer Friktionskupplung besitzt das mit fünf Hertz tickende Œuvre auch noch einen Schleppzeiger-Mechanismus beispielsweise zum Erfassen von Zwischenzeiten bei sportlichen Wettkämpfen. Markant schließlich auch das Großdatum der auf zwei Mal 25 Exemplare limitierten „Tonda Chronor Anniversaire". Parallel zur Vorstellung des ultrasportiven Bugatti Chiron auf dem Genfer Autosalon 2016 präsentierte die kleine, aber feine Manufaktur eine passende Konzept-Armbanduhr. PF390 heißt der quer angeordnete „Motor" mit zwei Federhäusern und „fliegendem" Minutentourbillon. Einem zentralen Planetengetriebe obliegt der Antrieb des Zeigerwerks. Das pultförmig angeordnete Zifferblatt gestattet die Wahrnehmung der fortschreitenden Zeit mit beiden Händen am Lenkrad.

In den zurückliegenden zwei Jahrzehnten war Parmigiani Fleurier für viele Überraschungen gut. Und daran wird sich auch in Zukunft nichts ändern. ◦

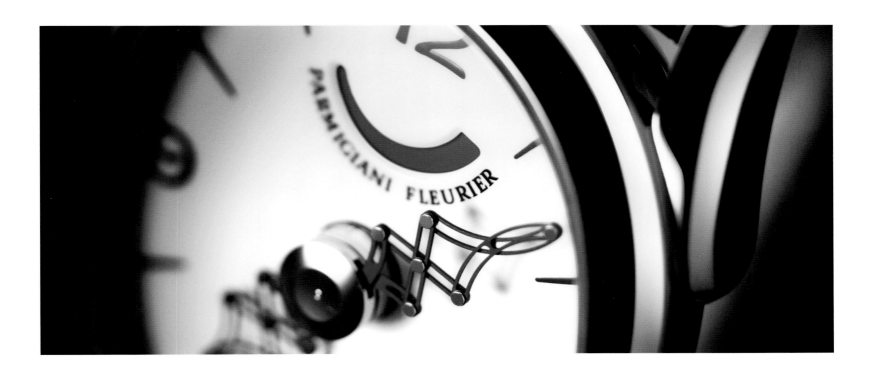

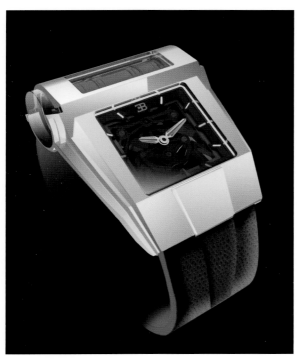

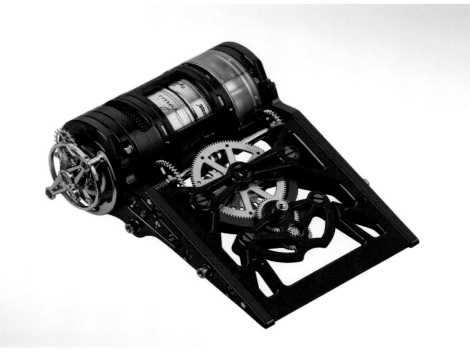

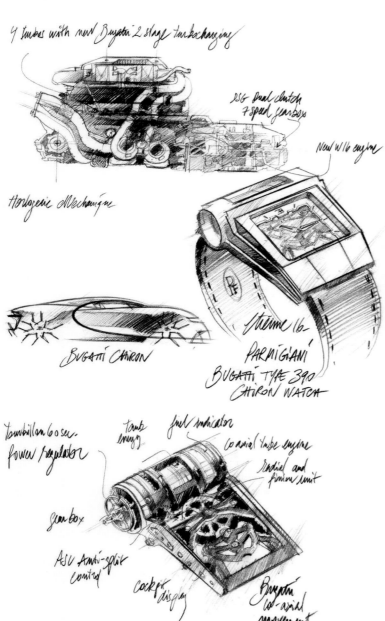

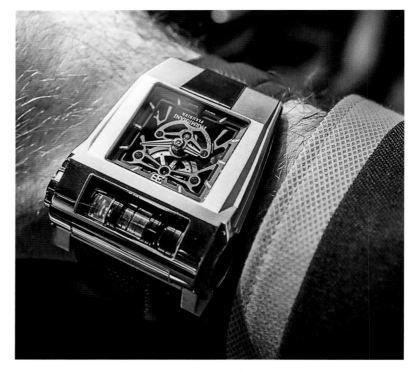

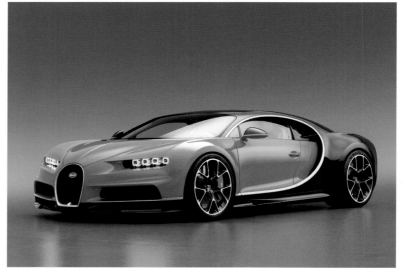

Bugatti PF390, 2016

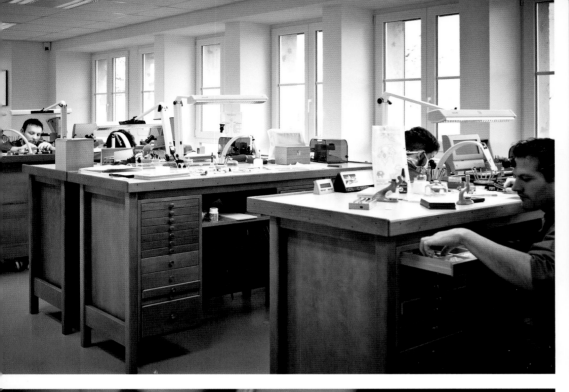

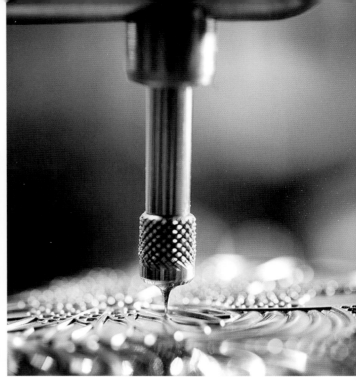

Clockwise from top left: Haute horlogerie atelier ○
Fibonacci watch ○ Haute horlogerie watchmaker ○
Case production ○ The design of a Tonda 1950 ○
Circle: Perrin Frères pocket watch restoration ○
*Von oben links im Uhrzeigersinn: Haute-Horlogerie-
Atelier ○ Taschenuhr Fibonacci ○ Haute-Horlogerie-
Uhrmacher ○ Gehäuseproduktion ○ Design einer
Tonda 1950 ○ Kreis: Restaurierung einer Taschenuhr
von Perrin Frères ○* Dans le sens horaire, en partant
du haut, à gauche : Atelier de haute horlogerie ○
Montre Fibonacci ○ Maître-horloger ○ Fabrication
de boîtiers ○ Dessin d'une Tonda 1950 ○ Au centre :
Restauration d'une montre de poche Perrin Frères

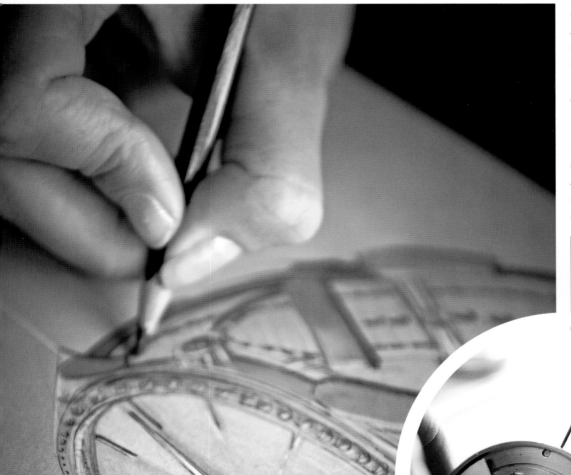

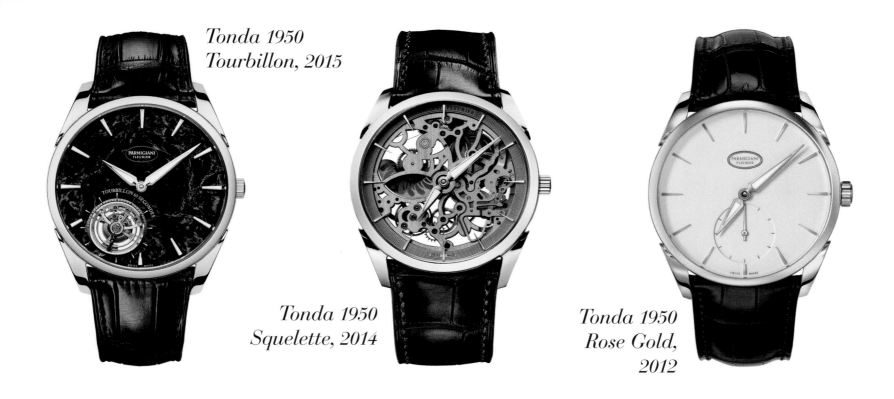

Tonda 1950
Tourbillon, 2015

Tonda 1950
Squelette, 2014

Tonda 1950
Rose Gold,
2012

Toute une époque d'artisanat d'art

Français

Pour Michel Parmigiani, rien n'est facile. Né en 1950 de parents italiens, il s'initie au métier à l'école horlogère de Fleurier, la localité où se trouve aujourd'hui la manufacture qui porte son nom. Il complète sa formation dans les métropoles horlogères suisses, au technicum de La Chaux-de-Fonds puis à l'école d'ingénieurs du Locle. Au début des années 1970, ce maître-horloger alors employé d'une petite horlogerie subit de plein fouet le déclin des traditionnelles montres mécaniques. Cette période, qui s'étend de 1973 à 1975, est frustrante pour cet artisan horloger d'un naturel réservé, mais elle aura aussi des côtés positifs. Michel Parmigiani est en effet contraint d'essayer de comprendre pourquoi la révolution du quartz ébranle les bases des valeurs traditionnelles. Pour ainsi dire du jour au lendemain, l'esthétique, la qualité et la créativité ont cèdent le pas à la fonctionnalité, au mercantilisme et à l'étroitesse de vues. Cet artisan exceptionnellement doué ne peut ni ne veut suivre ces supposées tendances novatrices. C'est pourquoi il cherche le salut en tant qu'horloger indépendant. La mécanique traditionnelle ne jouant plus qu'un rôle mineur dans les nouvelles montres, il se tourne vers d'admirables objets d'époques passées. Dans le monde entier, nombre de garde-temps attendent d'être restaurés avec compétence et amour. Son inclination marquée pour la perfection peut enfin s'exprimer à loisir. Des commandes passionnantes ne tardent pas à se présenter. Aucune d'elles n'effraie l'atelier Parmigiani, dans lequel il officiera seul jusqu'en 1980. Cet homme-orchestre gagne la reconnaissance publique en restaurant une pièce considérée irréparable par les experts, la « pendule sympathique » d'Abraham-Louis Breguet. La restauration d'un tourbillon du même créateur pour le compte du musée Poldi Pezzoli de Milan lui vaut d'obtenir la consécration, ainsi que la confiance sans limite de la Fondation de famille Sandoz, mécène des arts et de la culture. Leurs précieux garde-temps, dont il s'occupe avec professionnalisme, secondé par un nombre sans cesse croissant d'employés investis, vont influencer son avenir.

Michel Parmigiani, qui a pris la nationalité suisse, contribue de plus en plus souvent à la mise en œuvre théorique et/ou pratique de projets horlogers intéressants. En 1994, le collectionneur de montres Pierre Landolt le convainc de se concentrer sur ses propres créations. En prenant en 1996 une participation dans la nouvelle manufacture de montres de Michel Parmigiani, le président de la Fondation réalise ainsi le vœu de son créateur, Édouard-Marcel Sandoz. Naturellement, le nom du fondateur de la marque est conservé tel quel, car il sonne bien. Si créer sa propre collection de montres n'est pas chose facile, c'est une tâche absolument passionnante et fascinante. Ses débuts, couronnés de succès, ont lieu le 29 mai 1996 à Lausanne, devant 450 connaisseurs. Le public comprend immédiatement la philosophie claire et simple de la nouvelle marque : séries limitées, travail artisanal minutieux, qualité exceptionnelle, souci extrême du détail et luxe à l'état pur. Mais derrière le nom Parmigiani Fleurier se cachent assurément bien d'autres valeurs encore. La conception, la fabrication, le finissage et l'achevage de ses propres mouvements justifient pleinement le titre prestigieux de manufacture. Le travail dans les ateliers est régi par la proverbiale formule selon laquelle le temps ne respecte pas ce qui se fait sans lui. Néanmoins, le temps ne s'est pas arrêté pour la manufacture Parmigiani. Sous l'égide de Sandoz, le XXIe siècle fait son entrée sous la forme de machines modernes assistées par ordinateur, qui facilitent la fabrication d'un large éventail de composants et mouvements très divers. Ces machines ne tournent toutefois pas dans les locaux de Parmigiani, mais dans les bâtiments des manufactures affiliées Vaucher, Atokalpa et Elwin. Grâce à la mise en commun de compétences spécialisées, plus de 90 pour cent des pièces requises pour fabriquer les montres sont réalisées en interne. La gamme des produits concernés s'étend des platines parfois très complexes aux échappements, peu spectaculaires mais hautement sophistiqués. Même les plus petits engrenages et vis sont produits en interne. Les spiraux de balancier, que l'entreprise fournit également à des

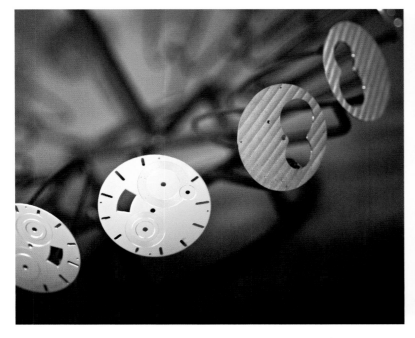
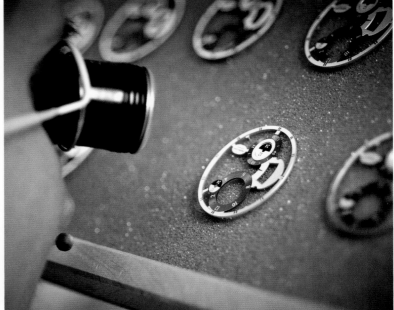

Dial production ◦ *Zifferblattproduktion* ◦ **Fabrication de cadrans**

concurrents renommés, exigent deux ans de développement. Mais Michel Parmigiani est parfaitement conscient du fait que l'ébauche représente tout juste dix pour cent de la montre terminée. La partie de loin la plus considérable de la chaîne de création de valeur est liée au finissage des composants, à l'assemblage et à l'ajustage de l'ensemble, opérations chronophages car réalisées à la main, mais aussi au réglage du mouvement terminé pour une fiabilité optimale.

Premier de la gamme aujourd'hui très étendue de calibres de manufacture, le PF110 à remontage manuel et environ 200 heures de réserve de marche a la forme d'un tonneau. Avec les PF701 et PF705 (squelette) à microrotor, l'entreprise démontre sa maîtrise des calibres à remontage automatique dans un boîtier ultraplat (2,6 millimètres). Le PF331, de 3,5 millimètres d'épaisseur, présente une masse oscillante en position centrale. Équipé d'un quantième perpétuel exclusif, il donne le PF333. La version PF377 est équipée d'un utile dispositif d'affichage des fuseaux horaires avec indication jour-nuit. Le PF517 enfin représente un record certainement très difficile à battre. Équipé d'un remontage automatique et d'un tourbillon minute, ce concentré de technique atteint seulement 3,4 millimètres d'épaisseur.

En parlant de tourbillon, les calibres à remontage manuel PF500 et PF511 sont l'expression de la recherche permanente de la perfection horlogère. Leur tourbillon n'a besoin que de 30 secondes pour effectuer une révolution complète. Cette vitesse de rotation doublée procure une précision bien meilleure. L'indicateur de réserve de marche, situé à 12 heures, est breveté. Une chose encore caractérise ce calibre : la position centrale de l'aiguille des secondes. Le tourbillon reste visible lorsque l'on retire de son poignet la montre-bracelet qui en est équipée pour regarder à travers le fond saphir.

Le modèle « Ovale Pantographe », qui s'inspire d'un garde-temps de la fin du XVIIIᵉ siècle, est absolument unique. Les aiguilles télescopiques, qui donnent régulièrement des cheveux blancs aux horlogers chargés de les fabriquer, s'allongent et se rétractent en suivant les contours elliptiques du boîtier, comme par enchantement. L'entraînement est assuré par un calibre éprouvé à remontage manuel disposant de huit jours d'autonomie de marche, le PF111.

Le complexe à remontage manuel PF361 a atteint le stade de la fabrication en série précisément pour le 20ᵉ anniversaire de l'entreprise sise à Fleurier. Les éléments de soutien de l'ensemble des composants, autrement dit la platine et les différents ponts, sont en or massif. Outre le chronographe doté d'une classique roue à colonnes et d'un embrayage à friction innovant, ce chef-d'œuvre dont le cœur bat à cinq Hertz possède un mécanisme à ratrappante pour mesurer les temps intermédiaires, notamment dans les compétitions sportives. La grande date du modèle « Tonda Chronor Anniversaire », sorti en édition limitée à deux fois 25 exemplaires, est remarquable. La petite mais non moins remarquable manufacture propose cette concept watch en parallèle à la présentation de l'ultra-sportive Bugatti Chiron au salon de l'automobile de Genève de 2016. Le « bloc moteur » associé au cadran positionné perpendiculairement avec deux barillets et un tourbillon minute « volant » est baptisé PF390. La transmission se fait à l'aide d'un train de rouage planétaire avec rouage central. Le cadran disposé comme un pupitre permet de voir l'heure tout en gardant les mains sur le volant.

Ces vingt dernières années, Parmigiani Fleurier nous a réservé de nombreuses surprises. Et il devrait continuer sur sa lancée. ◦

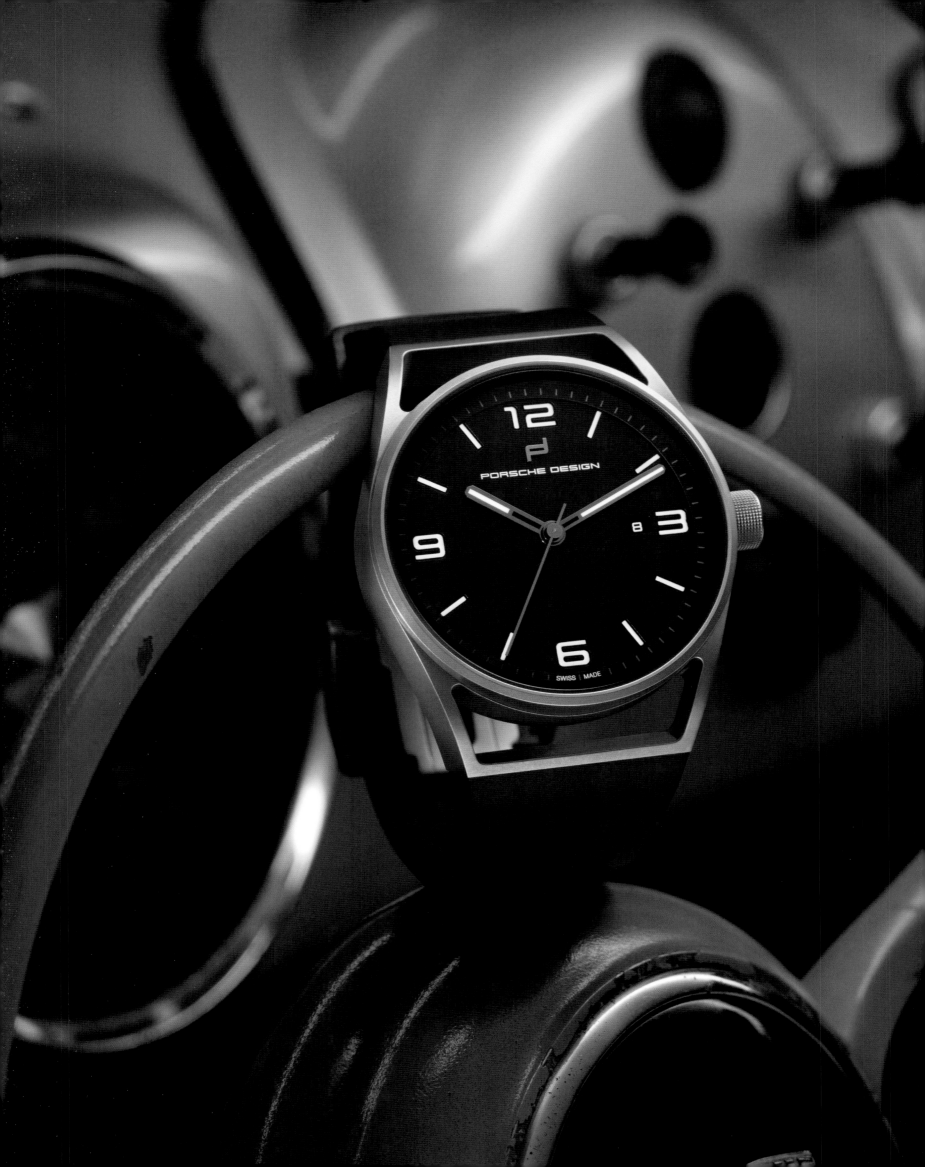

Porsche Design

Creative Power That Makes Itself Useful

To stand still is to take a step backward. The automobile industry is well aware of this. And the decision makers at Porsche Design are likewise keenly conscious of it too. Time never stands still when watches are involved because humankind's most precious resource has always been subject to change. Remarkable steps in a new stylistic direction were taken at Porsche Design in 2016, but the innovators never lost sight of their inheritance from the legendary Professor Ferdinand Alexander Porsche, who believed that form ought to follow function and that titanium, thanks to its excellent physical properties, is the ideal material for watch cases. These convictions are expressed in the new "1919 Collection." The date in the name was a logical choice because the famous designer had profoundly internalized the tenets of the Bauhaus, which was founded in 1919. The explicit goal of renowned Bauhaus protagonists such as Walter Gropius, Paul Klee and Mies van der Rohe was to overcome the separation between artisans and artists, a division which was often perceived as discriminating. This applied especially to the design and fabrication of objects for use in daily life. The innovative fusion led to the creation of chairs, tables, lamps, vases and many other items that "spoke" an autonomous language of forms and colors. These artifacts were functionally designed and reduced to the bare essentials, exactly as "F.A." did when he created his first wristwatch and as he continued to do on subsequent "time projects" in ensuing years. The circular shape, which he cultivated throughout his life, is archetypically appropriate for watches because the circle represents a departure from the origin and a return to it. Based on the doctrines articulated by Paul Klee and Vasily Kandinsky, color took its rightful place alongside form. Here too, Prof. F.A. Porsche had very clear notions. His ideas revolved around a puristic, instrumental look derived from the cockpit of the classic Porsche 911 automobile, which he had created in 1963.

It's no wonder that the newcomer which debuted in the "1919 Collection" at the watch fair in Basel in 2016 pays homage to the philosophy of a puristic appearance that can justifiably be described as minimalistic. The French pilot and author Antoine de Saint-Exupéry believed that "perfection doesn't happen when nothing more can be added, but when nothing more can be taken away." This is the viewpoint from which one can best admire, for example, the "1919 Datetimer Eternity." Notwithstanding all its sleek simplicity and modernity, the design of this wristwatch also reveals a kinship with the Porsche 356 and the stylistic elegance of the 1950s. Authentic and high-quality materials, including browned titanium for the lightweight case, underscore the brand's traditions and values. Self-winding Caliber Sellita SW200 is entrusted with the tasks of keeping the time and knowing the date. Like Prof. F.A. Porsche's first creation, here too black is the preferred color for the dial of the "1919 Datetimer Eternity Black Edition," which encases the abovementioned caliber. Aficionados of chronographs with understated styling will appreciate the "1919 Chronotimer." This synthesis of architectural design, sportiness and horological functionality is available in pure titanium or in PVD-coated titanium and with either a titanium bracelet or a rubber strap. A pane of sapphire crystal in the back of the case offers a clear view of time-honored self-winding Caliber Sellita SW500, a clone of the venerable Valjoux 7750, with which the history of wristwatches began at Porsche Design in 1972. This was the year when the shareholders of the Porsche AG decided to entrust the handling of the business to external managers. "This decision," Prof. F.A. Porsche said, "was congruent with my personal desire for stylistic freedom." Two years after the founding of Porsche Design, he accordingly relocated from Stuttgart-Zuffenhausen to picturesque Zell am See in Austria, where the Porsche Family has lived for many generations.

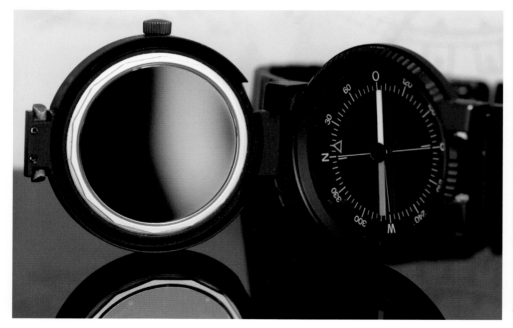

Left: Compass watch, 1978 ○ Links: Kompassuhr, 1978 ○ A gauche : Montre-boussole, 1978 ○
Right: Professor Ferdinand Alexander Porsche

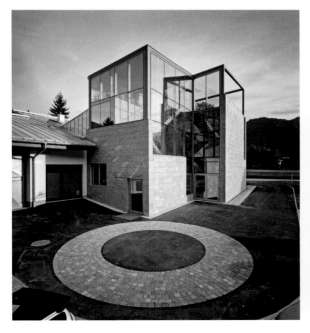

Cal. Sellita SW200

For his first chronographic opus, he asked himself how a chronograph could be made differently. Considering the Quartz Revolution, a new approach was urgently needed. "I imagined a wristwatch to match the automobile. The face would be black, like the speedometer and tachometer aboard the 911, because a black dial doesn't cause blinding glare when a driver glances at it." Prof. F.A. Porsche's certainty that black isn't a color, but a state of being, detracted not one iota from the success of this ticking timepiece with a tachymeter scale for convenient calibration of average speeds. More than 50,000 of these watches quickly found their way to the wrists of design-conscious sportcar fans. Clay Regazzoni and other Formula One drivers likewise appreciated this ticking star in the design firmament, which celebrated the product designer's profound contempt for frills and gags. "A formally consistent product needs neither embellishment nor exaggeration; it should be elevated by pure form alone. The form should live through minimalism, should present itself understandably, and should not distract from the product and its function." This same mode of thought was expressed in subsequent milestones that positively revolutionized the watch market. These included the Compass Watch, which was conceived in 1976 and ultimately realized in cooperation with IWC of Schaffhausen in 1978, as well as the titanium chronograph, which debuted in 1980 with large, planar and accordingly ergonomically shaped push-pieces. This chronograph wristwatch inaugurated a new era in watch history because it impressively demonstrated what's possible when the right partners find one another. The talented watch designer become a watch industrialist when he acquired the traditional Swiss Eterna brand in 1995. This era, which came to its end in 2013, is also recalled by a chronographic monument known as the "Indicator." A quick glance at its dial suffices to show what it has timed. It can measure intervals up to nine hours and 59 minutes in length, which it displays in gigantic numerals. Three engines (i.e., three barrels) provide the power. Three "cruise controls" (i.e., centrifugal governors) coordinate the speed with which the mainsprings release their tension. And the "gas gauge" is a power-reserve display controlled by an elaborate differential gear-train. It's not surprising that this automatic movement requires more than 800 components.

A new era began with the founding of Porsche Design Timepieces AG in Solothurn, Switzerland in 2014. This subsidiary of the Porsche Design Group is responsible for the technical development and production of understatedly designed yet nonetheless distinctive wristwatches with an extremely high recognition value. Along with this new beginning, steel as a material for cases was summarily abandoned. The present and the future belong to titanium—either purist, coated, or otherwise processed. One pillar of the product portfolio is the "Chronotimer Collection," which pays homage to the stylistic legacy of the brand's founder, which is continually updated or further refined at Studio F.A. Porsche in Zell am See. The second pillar, which closes the circle, is written in large numerals: "1919 Collection."

Without exception, all wristwatches in this collection result from German, Austrian and Swiss activities. Planned in Germany, designed in Austria and "made in Switzerland," they unite the best from three neighboring nations. ◦

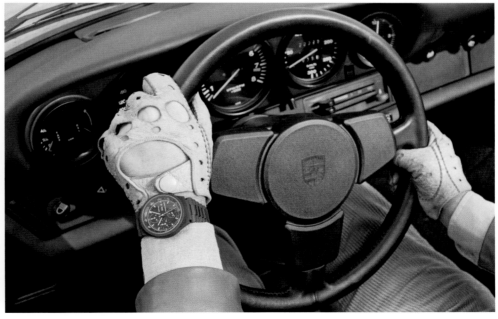

From left: Studio F.A. Porsche ◦ Chronograph I (1972) in a 911 Turbo 3.0, 1975 ◦ Von links: Studio F.A. Porsche ◦ Chronograph I (1972) in einem 911 Turbo 3.0, 1975 ◦ De gauche à droite : Studio F. A. Porsche ◦ Chronograph I (1972) dans une 911 Turbo 3.0, 1975

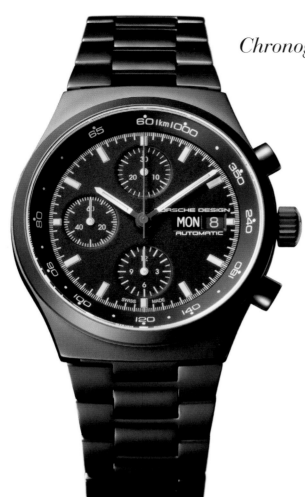

Chronograph I, 1972

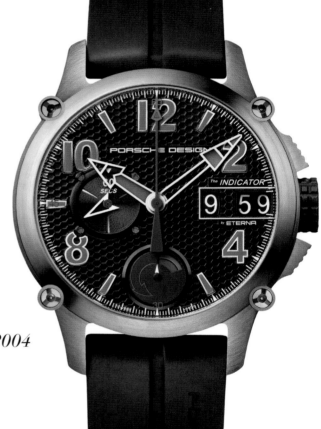

The Indicator, 2004

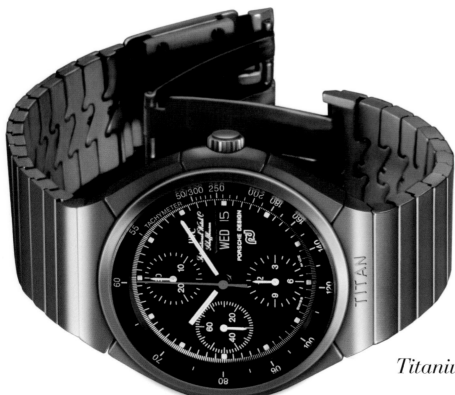

Titanium Chronograph, 1980

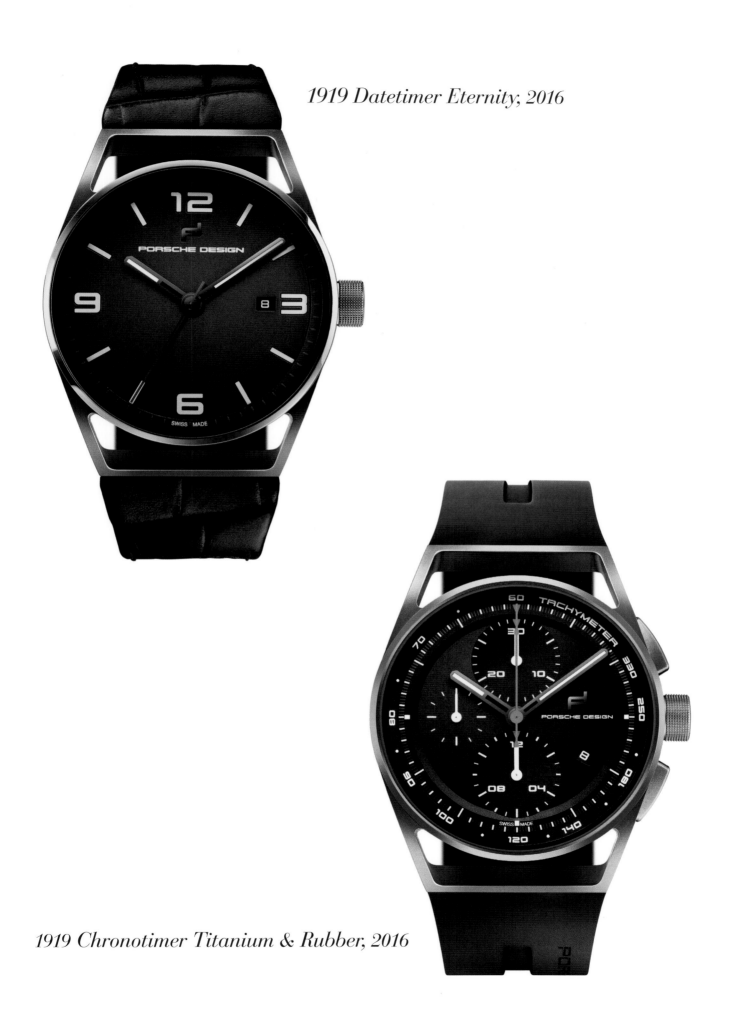

1919 Datetimer Eternity, 2016

1919 Chronotimer Titanium & Rubber, 2016

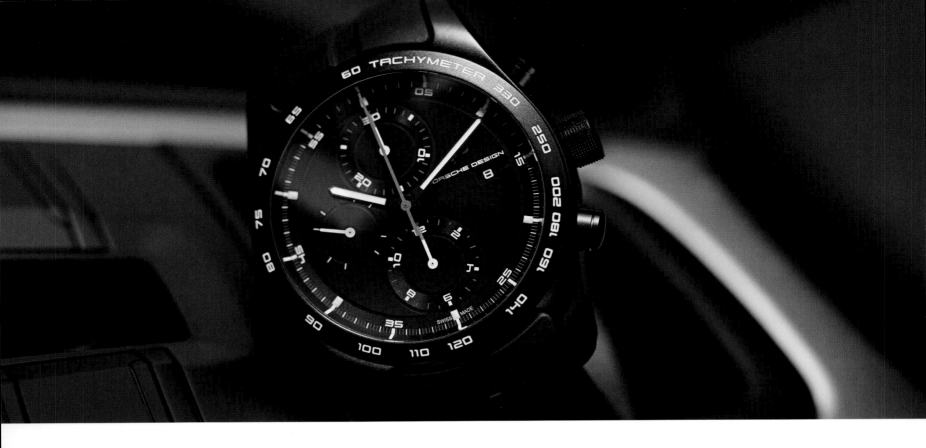

Gestaltungskraft, die sich nützlich macht

Stillstand bedeutet Rückschritt. Das weiß die Autoindustrie nur zu gut. Und die Verantwortlichen von Porsche Design sind sich dieser Tatsache ebenfalls bewusst. Wenn es um das Thema Uhren geht, bleibt die Zeit bekanntlich niemals stehen, denn zum kostbarsten Gut der Menschheit gehört seit eh und je der Wandel. Nicht zuletzt deshalb brachte das Jahr 2016 bei Porsche Design bemerkenswerte Schritte in eine neue gestalterische Richtung, ohne dass dabei das Vermächtnis des legendären Professors Ferdinand Alexander Porsche aus den Augen verloren wurde. Dessen nach wie vor gültiges Credo, dass die Form der Funktion zu folgen hat und Titan wegen seiner vorzüglichen Materialeigenschaften der ideale Werkstoff für Uhrengehäuse ist, beseelt die neue Linie „1919 Collection". Die Jahreszahl kommt nicht von ungefähr: 1919 wurde das Bauhaus gegründet, dessen Schule der Designpapst zutiefst verinnerlicht hatte. Das erklärte Ziel bekannter Bauhaus-Protagonisten wie Walter Gropius, Paul Klee und Mies van der Rohe bestand in der Überwindung der immer wieder als diskriminierend empfundenen Trennung von Handwerkern und Künstlern. Dies galt insbesondere beim Entwurf und bei der Fertigung von Gegenständen des täglichen Lebens. So entstanden in einem neuartigen Miteinander Stühle, Tische, Lampen, Vasen und vieles mehr mit eigenständiger Formen- und Farbensprache. Alles funktional gestaltet und auf das Wesentliche reduziert. Exakt so, wie es „Eff-A" bei der Kreation seiner ersten Armbanduhr und in den folgenden Jahren bei vielen anderen Zeit-Projekten tat. Seine lebenslang gepflegte Form, das Rund, passt idealtypisch zu Uhren, denn sie repräsentiert das Ausgehen von sowie die Rückkehr zu den Ursprüngen. Basierend auf den Lehren von Paul Klee und Wassily Kandinsky gesellte sich zur Form die Farbe. Auch hier hatte Prof. F. A. Porsche klare Vorstellungen. Seine Ideen kreisen um einen puristischen Instrumentenlook, abgeleitet vom Cockpit des automobilen Klassikers Porsche 911, welchen er 1963 geschaffen hatte.

Kein Wunder also, dass die während der Basler Uhrenmesse 2016 vorgestellten Newcomer in der Linie „1919 Collection" der Philosophie eines puristischen, man könnte fast sagen minimalistischen Auftritts huldigen. „Vollkommenheit entsteht nicht dann, wenn sich nichts mehr hinzufügen lässt", pflegte der französische Pilot und Schriftsteller Antoine de Saint-Exupéry zu sagen, „sondern dann, wenn man nichts mehr wegnehmen kann." Aus diesem Blickwinkel muss man beispielsweise den „1919 Datetimer Eternity" betrachten. Trotz aller Schlichtheit und Modernität lässt das Design dieser Armbanduhr auch eine gewisse Nähe zum Porsche 356 und der stilistischen Eleganz der 1950er Jahre erkennen. Authentische und vor allem hochwertige Materialien – dazu gehört gebräuntes Titan für das leichte Gehäuse – unterstreichen die Traditionen und Werte des Unternehmens. Für die Bewahrung der Uhrzeit und des Datums ist ein selbstverständlich individualisiertes Automatikwerk vom Kaliber Sellita SW200 zuständig. Schwarz wie das Erstlingswerk von Prof. F. A. Porsche präsentiert sich das Zifferblatt der „1919 Datetimer Eternity Black Edition" mit dem gleichen Uhrwerk. Liebhaber zurückhaltend gestalteter Zeitschreiber kommen beim „1919 Chronotimer" zu ihrem Recht. Diese Synthese aus architektonischem Design, Sportlichkeit und uhrmacherischer Funktionalität gibt es in purem oder PVD-beschichtetem Titan mit Titan- oder Kautschukband. Hinter dem Saphirglas-Sichtboden tickt das bewährte Automatikkaliber Sellita SW500, ein Klon des altbewährten Valjoux 7750, mit dem die Geschichte der Armbanduhren von Porsche Design 1972 begann. Damals hatten sich die Gesellschafter der Porsche AG dafür entschieden, die Geschäftsführung externen Managern anzuvertrauen. „Diese Entscheidung", so Prof. F. A. Porsche, „deckte sich mit meinem persönlichen Verlangen nach gestalterischer Freiheit." Konsequenterweise zog er bereits zwei Jahre nach der Gründung von Porsche Design in Stuttgart-Zuffenhausen ins malerische Zell am

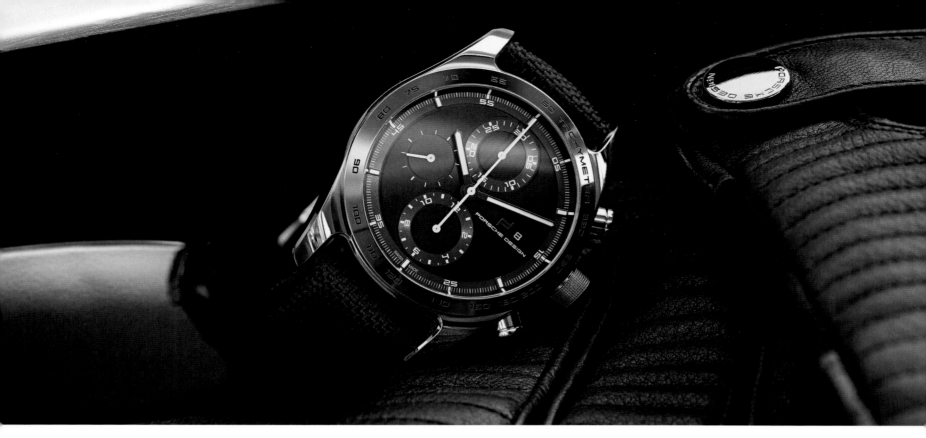

From left: Chronotimer Series 1 Sportive Black, 2015 ∘ Chronotimer Series 1 Deep Blue, 2015

See in Österreich, wo die Familie seit Generationen domizilierte. Bei seinem chronographischen Erstlingswerk hatte er sich die simple Frage gestellt, wie man ein solches schlichtweg anders machen könne. Im Angesicht der Quarz-Revolution war dies auch bitter nötig. „Mir schwebte eine Uhr zum Auto vor. Schwarz wie die Tachometer und Drehzahlmesser des 911er, weil das beim Ablesen nicht blendet." Seine innere Überzeugung, dass Schwarz keine Farbe, sondern ein Zustand ist, tat dem Erfolg des tickenden Boliden mit Tachymeterskala zum unkomplizierten Erfassen von Durchschnittsgeschwindigkeiten über einen Kilometer hinweg nicht den geringsten Abbruch. Erstaunlich schnell fanden mehr als 50 000 Exemplare an die Handgelenke designbewusster Sportwagenfans. Auch Formel-1-Piloten wie Clay Regazzoni schätzten den Design-Star am Chronographenhimmel, welcher die tiefe Abneigung des Produktgestalters gegen Schnörkel und Gags zelebrierte. „Ein formal stimmiges Produkt braucht keine Verzierung, keine Erhöhung, es soll durch die reine Form erhöht werden. Die Form sollte durch das Minimum leben, sich verständlich präsentieren, nicht ablenken vom Produkt und dessen Funktion." Dieser Denkweise folgten auch die weiteren Meilensteine, welche den Uhrenmarkt förmlich revolutionierten. Dazu gehörte die bereits 1976 angedachte und in Kooperation mit der Schaffhauser IWC 1978 endlich realisierte Kompassuhr. Oder der 1980 vorgestellte Titan-Chronograph mit großflächigen und deshalb besonders ergonomischen Bedientasten. Dieser Stopper läutete eine neue Ära in der Uhrengeschichte ein, denn er demonstrierte auf eindrucksvolle Weise, was möglich ist, wenn die richtigen Partner zusammenfinden. 1995 schlüpfte der begnadete Uhrendesigner durch den Erwerb der Schweizer Traditionsmarke Eterna ins Gewand eines Uhr-Unternehmers. An diese Ära, welche 2013 zu Ende ging, erinnert unter anderem ein chronographisches Monument namens „Indicator". Hier weiß Mann mit einem Blick, was er gestoppt hat.

Die Messwerte bis zu neun Stunden und 59 Minuten stechen durch die riesigen Ziffern ins Auge. Drei Motoren, sprich Federhäuser, liefern die Kraft, drei „Tempomaten" (Fliehkraftregler) steuern die Ablaufgeschwindigkeit. Als Tankuhr dient die von einem aufwendigen Differenzialgetriebe angesteuerte Gangreserveanzeige. Kein Wunder, dass jedes Automatikwerk nach mehr als 800 Komponenten verlangt.

Die Neuzeit startete 2014 mit Gründung der Porsche Design Timepieces AG im eidgenössischen Solothurn. Diese Tochter der Porsche Design Group zeichnet verantwortlich für die technische Entwicklung und Produktion der puristisch gestalteten und trotzdem markanten Armbanduhren mit extrem hohem Wiedererkennungswert. Mit diesem Neubeginn hat Stahl als Gehäusematerial definitiv ausgedient. Die Gegenwart und Zukunft gehören Titan. Und zwar entweder puristisch, beschichtet oder wie auch immer verarbeitet. Eine Säule des Produktspektrums, „Chronotimer Collection" genannt, huldigt dem gestalterischen Nachlass der Gründerpersönlichkeit, aktualisiert oder verfeinert bei Studio F. A. Porsche in Zell am See. Auf der zweiten Säule, und damit schließt sich der Kreis, steht in großen Ziffern „1919 Collection".

Ausnahmslos alle Armbanduhren dieser Kollektion sind ebenfalls das Ergebnis deutscher, österreichischer und eidgenössischer Aktivitäten. Geplant in Deutschland, designt in Österreich und „made in Switzerland", vereinen sie so das Beste aus drei benachbarten Ländern. ∘

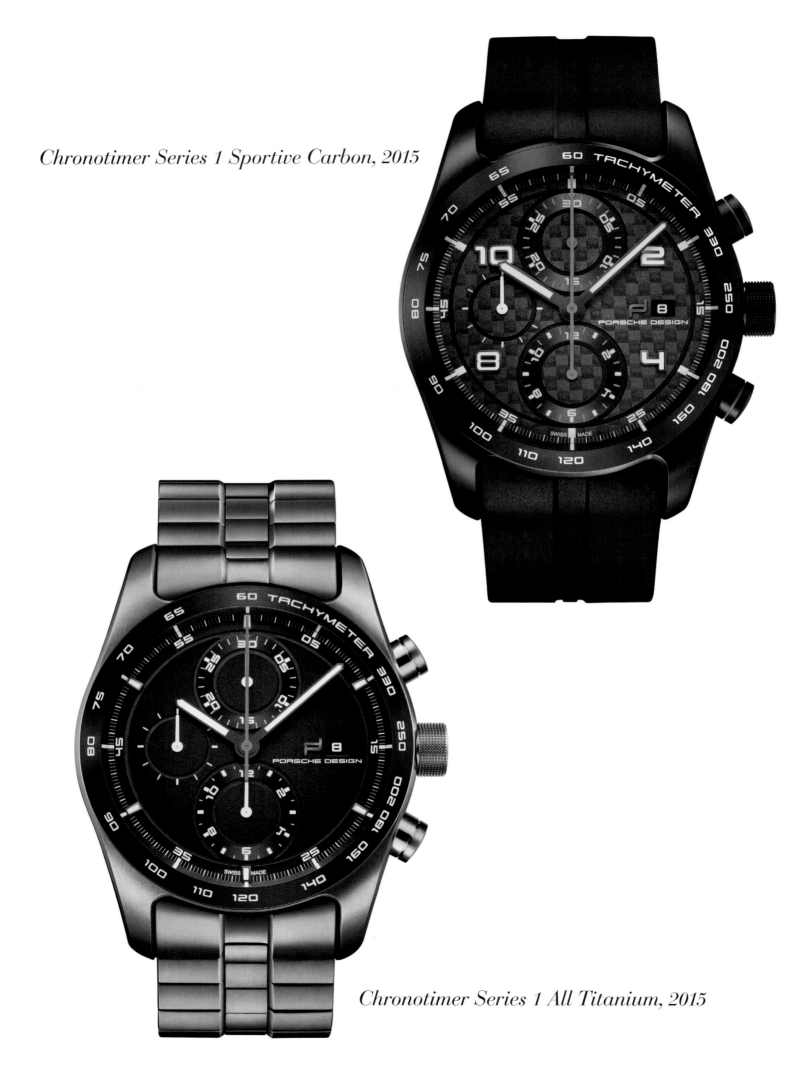

Chronotimer Series 1 Sportive Carbon, 2015

Chronotimer Series 1 All Titanium, 2015

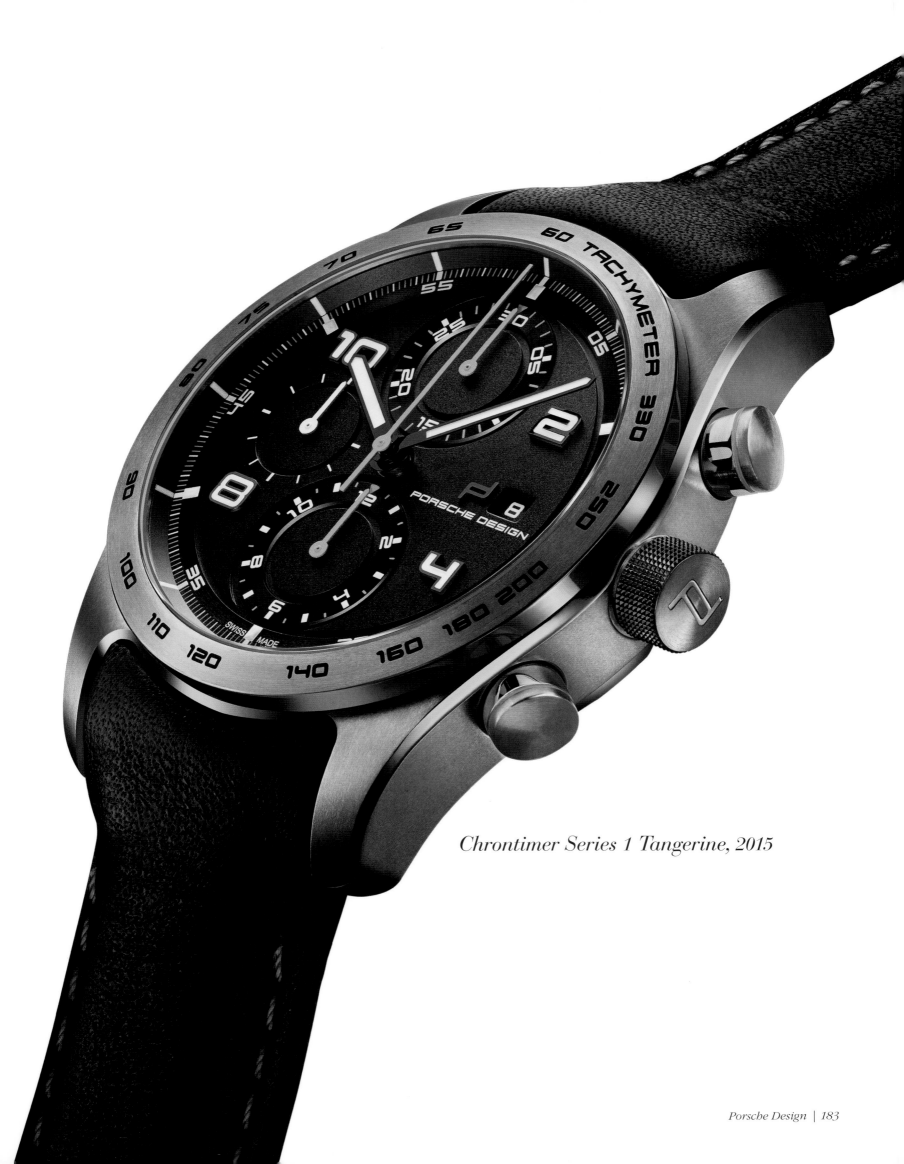

Chrontimer Series 1 Tangerine, 2015

Une capacité de conception axée sur l'utilité

Français

Stagner équivaut à régresser. Cette vérité, que l'industrie automobile connaît trop bien, n'est pas non plus inconnue des responsables de Porsche Design. Lorsqu'il s'agit de montres, on le sait, le temps ne s'arrête jamais. L'évolution est en effet depuis toujours le bien le plus précieux de l'humanité. C'est en grande partie pour cette raison que Porsche Design s'est engagé en 2016 dans une nouvelle voie créatrice, sans toutefois perdre de vue l'héritage du légendaire professeur Ferdinand Alexander Porsche. La fidélité à la maxime intemporelle selon laquelle la forme suit la fonction, et la conviction que le titane est le matériau idéal pour les boîtiers de montres, inspirent la nouvelle ligne « 1919 Collection ». Le millésime 1919 n'est pas le fruit du hasard : il correspond à l'année de la fondation du Bauhaus, mouvement dont les principes ont fortement marqué ce maître du design. L'objectif déclaré des grandes figures du Bauhaus, dont Walter Gropius, Paul Klee et Mies van der Rohe, est de surmonter la distinction partout ressentie comme discriminatoire entre artisans et artistes. Cela s'applique en particulier à la conception et à la fabrication d'objets de la vie courante. Naissent alors, grâce à une coopération d'un nouveau type, des chaises, des tables, des lampes, des vases et bien d'autres créations avec un langage propre en termes de formes et de couleurs. Toutes ces créations sont fonctionnelles et réduites à l'essentiel. C'est précisément l'esprit dans lequel « Eff-A » crée sa première montre-bracelet et réalise de nombreux projets horlogers au cours des années suivantes. La forme circulaire, qu'il affectionne depuis toujours, est idéale pour les montres, car elle représente aussi bien le départ des origines que le retour à ces dernières. S'appuyant sur les enseignements de Paul Klee et de Vassily Kandinsky, il associe couleur et forme. Une fois encore, le professeur F. A. Porsche sait précisément ce qu'il veut. Il imagine un look épuré, inspiré du tableau de bord du grand classique automobile, la Porsche 911, qu'il a conçue en 1963.

*Chonotimer Series 1
Matte Black, 2015*

Rien d'étonnant donc à ce que les nouveaux modèles de la ligne « 1919 Collection » présentés lors du Salon mondial de l'horlogerie à Bâle (Baselworld) 2016 s'inscrivent dans cette philosophie des lignes épurées, voire du minimalisme. « Il semble que la perfection soit atteinte, non quand il n'y a plus rien à ajouter, mais quand il n'y a plus rien à retrancher », aimait à dire l'aviateur et écrivain Antoine de Saint-Exupéry. C'est par ce prisme que l'on doit par exemple admirer la montre-bracelet « 1919 Datetimer Eternity ». Malgré toute sa simplicité et sa modernité, elle est proche par son design de la Porsche 356 et de l'élégance des années 1950. Des matériaux authentiques et surtout de grande qualité – parmi lesquels le titane bruni du boîtier léger – soulignent les traditions et les valeurs de l'entreprise. Pour conserver la date et l'heure, on choisit bien sûr un mouvement automatique personnalisé, le calibre Sellita SW200. Comme sur la première création horlogère du professeur F. A. Porsche, le cadran de la « 1919 Datetimer Eternity Black Edition » équipée du même mouvement est noir. Le « 1919 Chronotimer » séduit quant à lui les amateurs de chronographes au design épuré. Modèle conciliant design architectural, caractère sportif et performances horlogères, il est proposé en titane non traité ou noirci, avec un bracelet titane ou caoutchouc. Derrière le fond saphir transparent oscille le calibre automatique éprouvé Sellita SW500, clone d'un mouvement des premières montres-bracelets Porsche Design en 1972, le célèbre Valjoux 7750. À cette époque, les associés de Porsche AG ont confié la direction de la société à des responsables externes. « Cette décision, indique le professeur F. A., correspond à ma volonté de pouvoir créer en toute liberté. » Dans le droit fil de cette décision, deux ans seulement après la création de Porsche Design à Stuttgart-Zuffenhausen, il part s'installer dans la pittoresque ville autrichienne de Zell am See, où sa famille est établie depuis des générations.

En créant sa première montre, le professeur F. A. Porsche se pose une question simple, à savoir comment réaliser quelque chose de carrément nouveau. Face à la révolution du quartz, c'est d'ailleurs plus que nécessaire. « Je rêvais d'une montre qui aille avec une auto, noire comme le tachymètre et le compte-tours de la 911, que l'on peut consulter sans être ébloui. » Son intime conviction que le noir n'est pas une couleur mais un état ne porte pas le moindre préjudice au succès de ce garde-temps d'exception dont l'échelle tachymétrique permet d'obtenir aisément la vitesse moyenne au kilomètre. Avec une étonnante rapidité, plus de 50 000 exemplaires rejoindront les poignets d'amateurs de sport automobile épris de design. Des pilotes de Formule-1 comme Clay Regazzoni apprécieront eux aussi cet astre du design au firmament des chronographes, qui célèbre le profond rejet par son créateur des fioritures et gadgets. « Un produit cohérent dans sa forme n'a pas besoin d'être orné ou rehaussé, il doit se distinguer par sa seule forme. Celle-ci doit exister à minima, se présenter de manière compréhensible, ne pas détourner l'attention du produit et de sa fonction. » Cette façon de penser sera suivie d'autres jalons, qui révolutionneront littéralement le marché des montres. C'est le cas de la montre-boussole, imaginée dès 1976 et finalement réalisée en 1978 en collaboration avec IWC Schaffhausen. C'est aussi, en 1980, le cas du chronographe en titane, que ses larges boutons poussoirs rendent particulièrement ergonomique. Ce dernier annonce une nouvelle ère dans l'histoire des montres, car il démontre de manière impressionnante que tout est affaire de bon partenariat. En 1995, ce concepteur au talent exceptionnel endosse le costume d'entrepreneur en horlogerie en se portant acquéreur de la marque suisse de tradition Eterna. Cette période, qui s'achève en 2013, est entre autres marquée par un monument parmi les chronographes, le modèle « Indicator ». Avec celui-ci, on voit d'un coup d'œil le résultat du chronométrage. Les valeurs de mesure jusqu'à neuf heures et 59 minutes sautent aux yeux avec leurs chiffres énormes. Trois moteurs, autrement dit barillets, fournissent l'énergie, et trois « tempomat » (régulateurs) pilotent la vitesse de défilement. Le rôle de la jauge de carburant est joué par une indication de réserve de marche commandée par un système différentiel complexe. Rien d'étonnant à ce que chaque mouvement automatique nécessite plus de 800 composants.

Une nouvelle ère encore débute en 2014 avec la création de Porsche Design Timepieces AG à Soleure, en Suisse. Cette filiale de Porsche Design est chargée de développer et fabriquer des montres-bracelets épurées et malgré tout marquantes, reconnaissables entre toutes. Avec ce nouveau départ, l'acier disparaît définitivement des boîtiers. Le présent et l'avenir appartiennent au titane, pur, plaqué ou traité d'une toute autre manière. Un des piliers de la gamme, le « Chronotimer Collection », rend hommage à l'héritage conceptuel du fondateur, mis au goût du jour ou perfectionné à Zell am See par Studio F. A. Porsche. Bouclant la boucle, le second pilier arbore en gros caractères « 1919 Collection ».

Toutes les montres-bracelets de la collection sans exception sont le produit du travail d'intervenants allemands, autrichiens et suisses. Programmées en Allemagne, conçues en Autriche et « made in Switzerland », elles réunissent le meilleur de ces trois pays voisins. ○

Chonotimer Series 1 Matte Black, 2015

Seiko

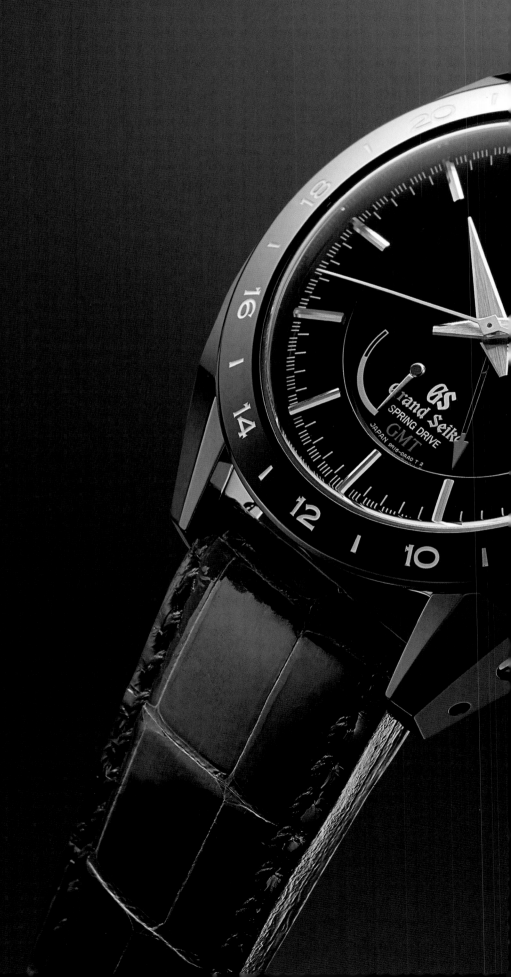

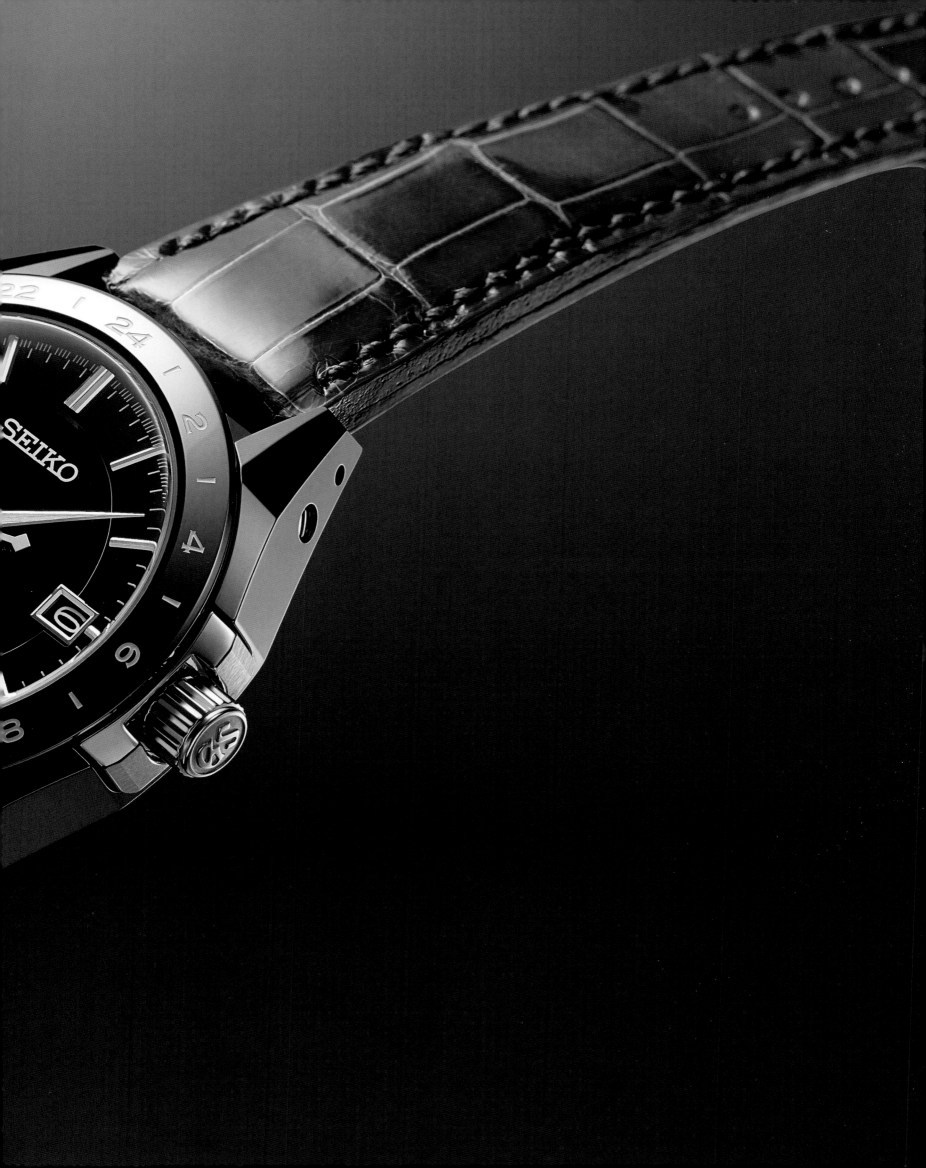

Everything from Japanese Manufactories

When Kintaro Hattori founded K. Hattori & Co. Ltd. in 1881, he probably never even dared to dream that his company would develop in the course of time into one of the world's largest watch manufacturers. Fully 43 years came and went before Seiko, the brand name that he had chosen, would adorn the dial of a timepiece. When the 22-year-old first started his business, he had nothing else in mind except to produce timepieces. He sold many different sorts of clocks and watches at his little shop in Tokyo. The lion's share of his merchandise was provided by importers based in the harbor city of Yokohama. Goods of Japanese provenance were in short supply in those years. He also occupied himself with repairs. His business flourished. In 1887, he was able to open a much more impressive store in the Ginza neighborhood, which was the up-and-coming business and shopping district in the Japanese capital city. He bought the building formerly occupied by the Choya newspaper soon afterwards. After thorough renovation, expansion and the installation of a new "Western-style" façade, Kintaro Hattori officially inaugurated the premises in 1895 as the new headquarters of a sizeable and impressive company. The building soon acquired landmark status, thanks in large measure to its circa 16-meter-tall clock tower, which could be seen from far and wide. Long before his Japanese competitors began to think likewise, its owner had already recognized the necessity of being able to fabricate his own timepieces. The starting shot for the Seikosha factory was fired in 1892. ("Seiko" is the Japanese word for "exact.") The necessary machinery was scarce or unavailable in Japan, so the businessman embarked on a shopping trip to Europe and the United States. With the help of imported machinery, the number of units produced began to increase with astonishing speed. Hattori developed his own alarm clocks in 1899. By 1910, K. Hattori & Co. Ltd. occupied an outstanding position in the Land of the Rising Sun. Seikosha was the only Japanese factory that simultaneously manufactured wall clocks, table clocks and pocket watches, as well as hairsprings and mainsprings. The age of the wristwatch arrived with the little circular "Laurel" in 1913. Thereafter, between 30 and 50 of these models, which Hattori had equipped with his own enamel dial, were produced each day. By 1922, 60 percent of Seikosha's manufacturing capacity was devoted to pocket watches and wristwatches. A severe setback came in 1923, when the Great Kanto Earthquake, which destroyed his warehouse and factory, put a sudden end to production. Hattori was hard hit, but not discouraged. Despite some warnings, he presented the first wristwatches with the Seiko signature one year later—and their positive reception proved him right.

Rapid growth necessitated the construction of an additional factory in 1937. Given the logical name "Daini Seikosha," which means "Second Seikosha," it was the birthplace of diverse small timepieces. These included the pocket chronographs that the Japanese military urgently needed during the Second World War. It seems likely that Seiko relied on Swiss assistance to fill this order.

The "Marvel" began a new chapter, dedicated to precision, in Seiko's illustrious biography. In 1957, it was the first Japanese wristwatch to outperform its Swiss competitors and win an accuracy competition sponsored by the Asian subsidiary of the American Horological Society. A self-winding version debuted in 1959. Caliber 290 in the so-called "GyroMarvel" is the first Seiko movement with its own automatic subassembly. Just one year later, the grapevine was abuzz with talk about the legendary "Grand Seiko," the label's undisputed precision flagship. The staff at the manufacturing site in Suwa, west of Tokyo, had devoted intensive work toward optimizing this wristwatch. The results of their efforts were expressed in hand-wound Caliber 3180. Each watch encasing this caliber underwent extraordinarily strict tests before delivery. Seiko's self-imposed standards of precision were even more rigorous than their counterparts at the COSC, i.e., Switzerland's chronometer-testing authority. And this hasn't changed even one iota in the "Grand Seiko" to the present day. Further innovations, premieres, and superlative achievements followed in rapid succession. To coincide with the 1964 Summer Olympics, Seiko debuted the first hand-wound chronograph of Japanese provenance. One year later, the watch giant unveiled the first "made in Japan" professional diver's watch. A rotatable bezel was affixed atop its 38-millimeter-diameter steel case,

An observatory trial certificate from the Geneva Observatory ○ Prüfzertifikat vom Genfer Observatorium ○ Bulletin de marche de l'observatoire de Genève

which remained water-resistant to a pressure of 15 bar. Specially designed hand-wound Caliber 052 first won honors in chronometer competitions in 1966. It and high-frequency Caliber 5740, which debuted in 1967, both had balances paced at 36,000 semi-oscillations per hour. The "Bell-Matic," the first Japanese alarm wristwatch, made headlines the same year, when the starting shot was fired for an ambitious project designated by the numbers 6138 and 6139. Seiko joined the competition to create the world's first self-winding movement with built-in chronograph mechanism. After two years of intensive research in this complex topic, the first specimens of the "Seiko 5 Speed Timer" went on sale in May 1969. It was the world champion with regard to maturity for series manufacturing and marketing introduction. Ten years of research and development preceded the release of another world premiere: sales of the "Astron 35SQ," the world's first quartz wristwatch, began on December 25, 1969. Now let's fast-forward to 1999. After several strenuous attempts, Seiko unveiled a much-acclaimed synthesis of mechanical and electronic technologies. The "Spring Drive," a mechanical quartz watch without a battery, uses the power stored in its barrel to generate electrical energy for its quartz regulator, which oscillates at a pace of 32,768 hertz. The "Spring Drive Automatic" with rotor winding followed in 2005: one hour of motion on the wearer's wrist generates enough power to keep

this watch running for more than three hours. Things got really complicated in 2006, which saw the debut of the "Credor Sonnerie," a version of the "Spring Drive" with an elaborate automatic striking mechanism. A minute-repeater followed in 2010. One year before, in 2009, Seiko had celebrated 30 years of automatic chronographs with the debut of the "Ananta," which encased totally newly developed automatic Caliber 8R28, each of which concatenates no fewer than 292 components. The "Astron GPS Solar" has expressed electronic excellence since 2012: this wristwatch feels perfectly at home all over the globe because it "knows" a total of 39 time zones; when its wearer travels, it automatically resets itself to show the correct time in each new time zone. These are only a few of many examples which demonstrate the creativity and competence of this big brand from the Far East. Seiko's appeal is also due to its versatility. The spectrum of mechanical watches ranges from simple but reliable automatic movements to *grandes complications*, which are available in selected markets under the name "Credor." The vertical depth of manufacturing for the movements is very nearly 100 percent And as far as the precision watchmaking that's built into every "Grand Seiko" is concerned, the clever Japanese are fully on a par with their Swiss colleagues. In the small but very fine Shizukuishi Watch Studio, where this exceptional timepiece is built, time really seems to stand still. ◦

Clockwise, from top left: Kintaro Hattori, 1890 ◦ Advertisement, 1881 ◦ Clock shop, 1895 ◦
Von oben links im Uhrzeigersinn: Kintaro Hattori, 1890 ◦ Werbeanzeige, 1881 ◦ Uhrengeschäft, 1895 ◦
Dans le sens horaire en partant de la gauche : Kintaro Hattori, 1890 ◦ Publicité, 1881 ◦ Horlogerie, 1895

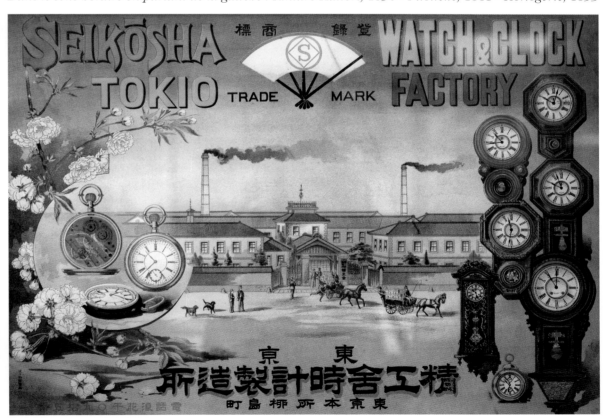

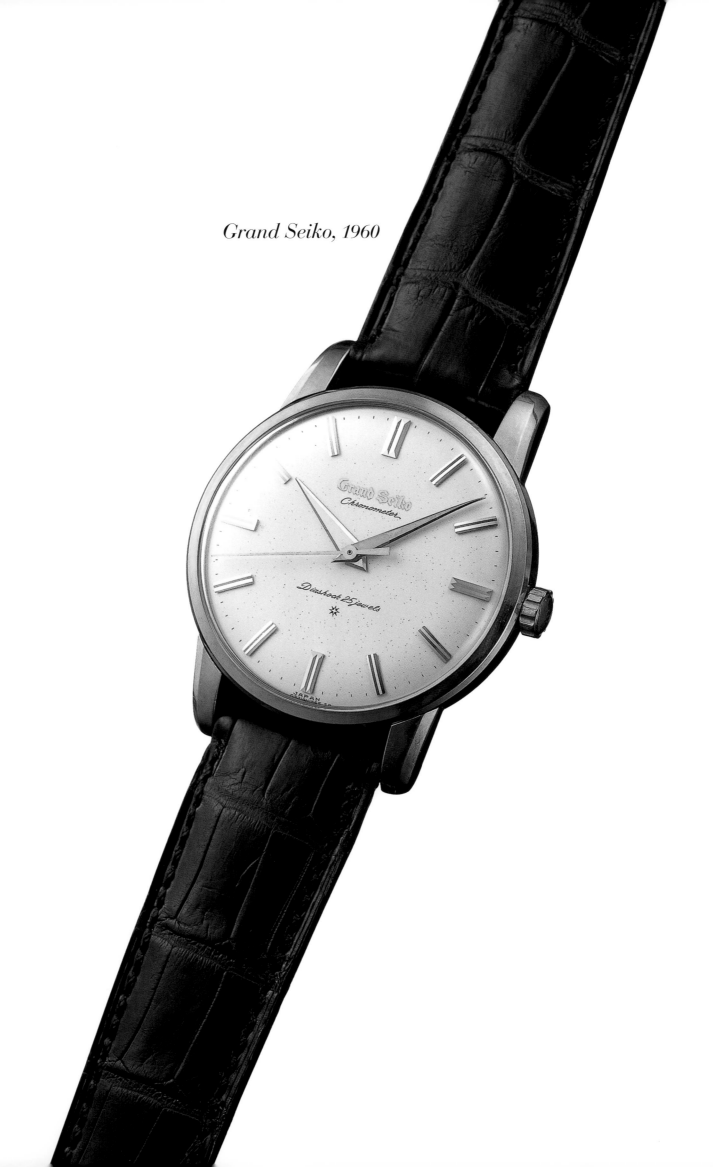

Grand Seiko, 1960

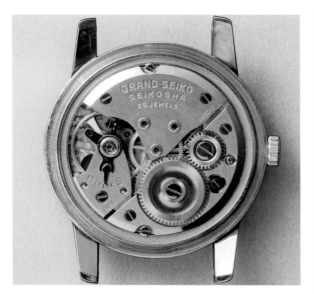

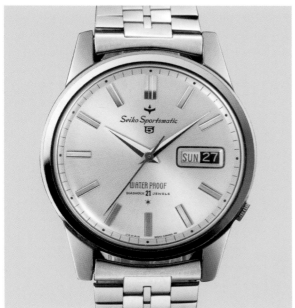

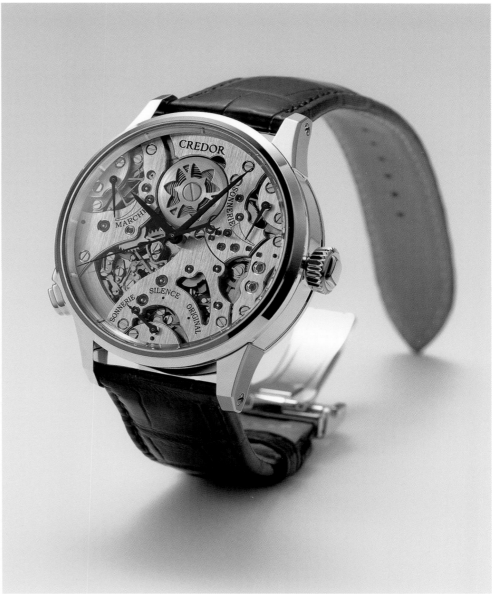

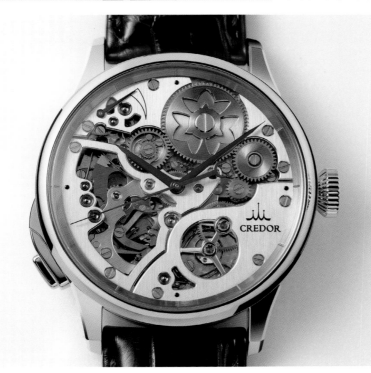

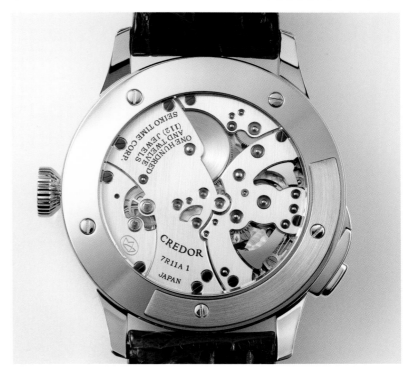

Clockwise from top left: First Grand Seiko, Cal. 3180, 1960 ◦ Credor Spring Drive Sonnerie, 2006 ◦
Credor Spring Drive Minute Repeater (back), 2010 ◦ Credor Spring Drive Minute Repeater, 2010 ◦ Sportsmatic 5, 1963

Alles aus japanischer Manufaktur

Deutsch

Daran, dass sich seine K. Hattori & Co. Ltd. im Laufe der Jahrzehnte zu einem der weltweit größten Uhrenhersteller entwickeln würde, wagte Kintaro Hattori 1881 vermutlich nicht einmal im Traum zu denken. Zunächst einmal dauerte es nach der Firmengründung schon ganze 43 Jahre, bis der von ihm erkorene Markenname Seiko erstmals das Zifferblatt einer Uhr zierte. Anfänglich hatte der 22-Jährige auch anderes im Sinn als eine Uhrenproduktion. In seinem kleinen Tokioter Laden verkaufte er Zeitmesser unterschiedlichster Art. Der Löwenanteil seiner Ware stammte von Importeuren aus der Hafenstadt Yokohama. Erzeugnisse japanischer Provenienz waren damals noch Mangelware. Daneben beschäftigte er sich auch mit Reparaturen. Das Geschäft florierte. Bereits 1887 konnte er ein deutlich repräsentativeres Lokal im Ginza-Viertel eröffnen, dem rapide aufstrebenden Geschäfts- und Einkaufsdistrikt der japanischen Hauptstadt. Wenig später erwarb er das Gebäude der Zeitung Choya. Nach gründlicher Renovierung, Erweiterung und der Fassadengestaltung im „Western-Style" konnte es Kintaro Hattori 1895 als neuen Stammsitz des mittlerweile stattlichen Unternehmens einweihen. Der entwickelte sich nicht zuletzt wegen des rund 16 Meter hohen Uhrturms zu einem weithin sichtbaren Wahrzeichen. Deutlich schneller als seine japanischen Mitbewerber hatte der Patron dann doch die Notwendigkeit eigener Uhrenfertigung erkannt. Das Startsignal für die Fabrik Seikosha war 1892 gefallen. „Seiko" bedeutet nichts anderes als „genau". Weil es in Japan noch an den nötigen Maschinen mangelte, begab sich der Unternehmer auf Einkaufstour nach Europa und in die Vereinigten Staaten von Amerika. Mit Hilfe importierter Anlagen kletterten die Stückzahlen erstaunlich schnell. 1899 lancierte Hattori selbst entwickelte Wecker. Gegen 1910 nahm die K. Hattori & Co. Ltd. im Land der aufgehenden Sonne schon eine herausragende Position ein. Als einzige Fabrik fertigte Seikosha Wand-, Tisch- und Taschenuhren gleichzeitig. Daneben entstanden auch Unruhspiralen und Zugfedern unter dem eigenen Dach. Das Zeitalter der Armbanduhr brach 1913 mit der kleinen runden „Laurel" an. Von diesem Modell, welches Hattori mit eigenem Emailzifferblatt ausstattete, entstanden fortan täglich 30 bis 50 Exemplare. 1922 lasteten Taschen- und Armbanduhren schon insgesamt 60 Prozent der Seikosha-Fertigungskapazitäten aus. Ein deutlicher Rückschlag war 1923 zu verzeichnen. Das große Kanto-Erdbeben zerstörte Lagerbestände und Fabrik, brachte die Produktion zum Erliegen. Doch Hattori ließ sich nicht entmutigen. Trotz mancher Warnungen präsentierte er schon ein Jahr später die ersten Armbanduhren mit der Signatur Seiko. Und die positive Resonanz gab ihm recht.

Ungestümes Wachstum verlangte 1937 nach Errichtung einer weiteren Fabrik. Logischerweise erhielt sie den Namen Daini Seikosha. In der „zweiten Seikosha" spielte sich fortan die Herstellung von Kleinuhren ab. Dazu gehörten auch Taschen-Chronographen, nach denen das japanische Militär während des Zweiten Weltkriegs dringend verlangte. Hierfür bediente sich Seiko aber vermutlich noch eidgenössischer Assistenz.

1956 leitete die „Marvel" ein neues, mit Präzision überschriebenes Kapitel der illustren Seiko-Biographie ein. Als erste japanische Armbanduhr gewann sie 1957 den Genauigkeitswettbewerb des fernöstlichen Ablegers der American Horological Society. Die Schweizer Konkurrenz musste sich geschlagen geben. Die Variante mit Selbstaufzugswerk kam 1959 in den Handel. Beim 290 in der sogenannten „GyroMarvel" handelte es sich um das erste Seiko-Kaliber mit eigener Automatik-Baugruppe. Danach dauerte es nur noch ein Jahr, bis das unangefochtene Präzisions-Flaggschiff in Gestalt der legendären „Grand Seiko" von sich reden machte. Bei der Kreation dieser Armbanduhr hatten sich Mitarbeiter in Suwa, einer Fertigungsstätte westlich von Tokio, intensiv mit Optimierungsmöglichkeiten beschäftigt. Das Resultat ihrer Bemühungen kam im Handaufzugskaliber 3180 zum Ausdruck. Jede der damit ausgestatteten Armbanduhren hatte sich vor der Lieferung außerordentlich strengen Tests zu unterziehen. Die selbst gesteckten Genauigkeitsanforderungen überstiegen sogar noch jene der amtlichen Schweizer Kontrollbehörde COSC. Und daran hat sich bei „Grand Seiko" bis heute kein Jota geändert. Weitere Innovationen, Premieren und Bestleistungen folgten Schlag auf Schlag. Anlässlich der Olympischen Sommerspiele 1964 stellte Seiko den ersten Handaufzugschronographen japanischer Provenienz vor. Nur ein Jahr später wartete der Uhrengigant mit der ersten professionellen Taucher-Armbanduhr „made in Japan" auf. Dem nassen Element widerstand das 38 Millimeter große Stahlgehäuse mit Drehlünette bis zu 15 Bar Druck. Ab 1966 punktete das speziell gestaltete Handaufzugskaliber 052 bei Chronometerwettbewerben. Stündlich 36 000 Unruh-Halbschwingungen waren auch eines der Kennzeichen des Hochfrequenz-Kalibers 5740 von 1967. Im gleichen Jahr machte der erste japanische Armbandwecker namens „Bell-Matic" von sich reden. Und es fiel der Startschuss für ein ehrgeiziges Projekt mit den Nummern 6138 und 6139. Seiko trat in den Wettstreit um das weltweit erste Automatikwerk mit integriertem Chronographen. Nach zwei Jahren intensiver Auseinandersetzung mit der komplexen Materie waren erste Exemplare des „Seiko 5 Speed Timer" im Mai 1969 käuflich zu erwerben. Er war der Weltmeister hinsichtlich Serienreife und Markteinführung. Ganze zehn Jahre Forschungs- und Entwicklungsarbeit waren einer weiteren Weltpremiere vorangegangen. Am 25. Dezember 1969 gelangte die „Astron 35SQ" als weltweit erste Quarz-Armbanduhr in den Handel. Wir springen ins Jahr 1999: Nach mehreren anstrengenden Anläufen wartete Seiko mit einer viel beachteten Synthese aus Mechanik und Elektronik auf. „Spring Drive", eine mechanische Quarzuhr ohne Batterie, nutzt die im Federhaus gespeicherte Antriebskraft zum Generieren elektrischer Energie für den mit 32 768 Hertz oszillierenden Quarz-Regulator. Die „Spring Drive Automatic" mit Rotoraufzug folgte 2005. Eine Stunde Bewegung am Handgelenk generiert Kraft für mehr als drei Stunden Funktion. Richtig kompliziert wurde es 2006 mit der „Credor Sonnerie", einer „Spring Drive" mit aufwendigem Selbstschlag-Mechanismus. Die Version mit Minutenrepetition gesellte sich 2010 hinzu. 30 Jahre Automatik-Chronograph zelebrierte Seiko 2009 mit „Ananta" und

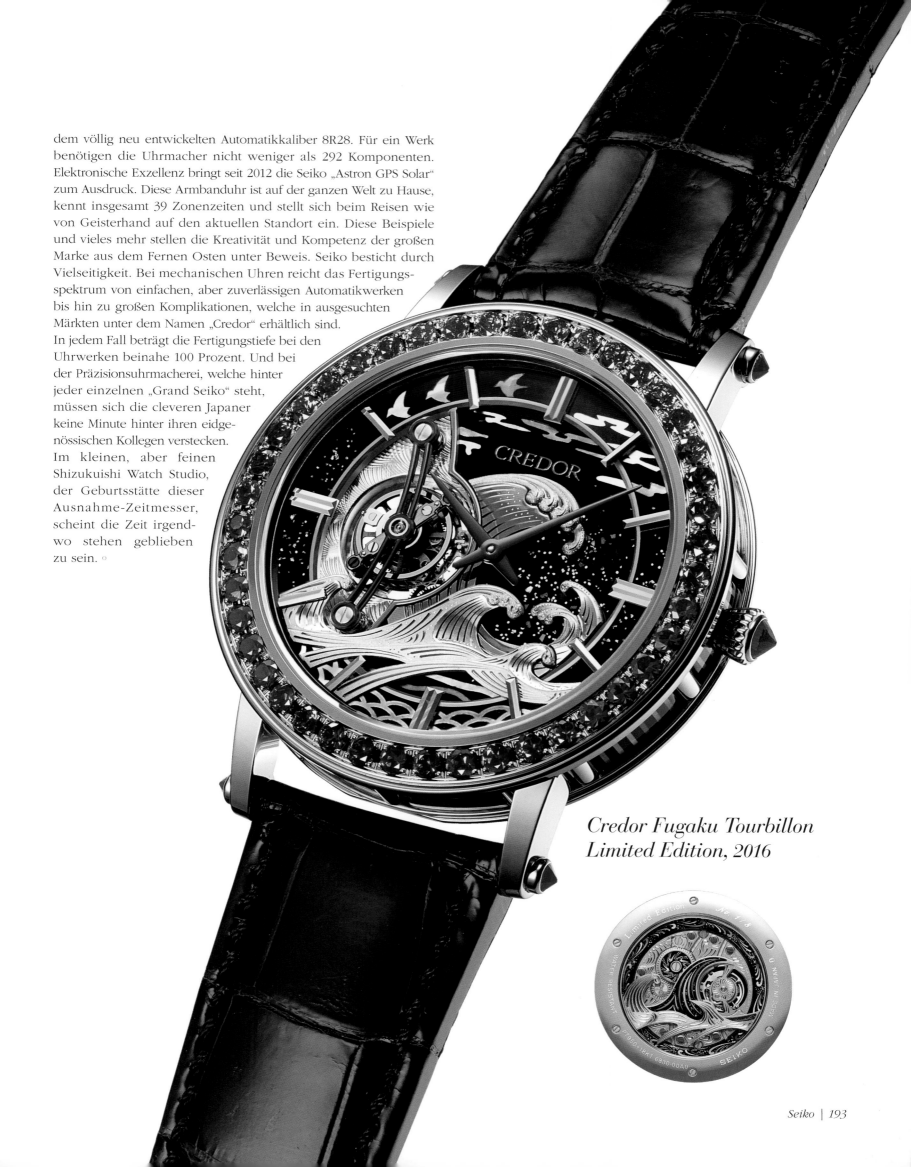

dem völlig neu entwickelten Automatikkaliber 8R28. Für ein Werk benötigen die Uhrmacher nicht weniger als 292 Komponenten. Elektronische Exzellenz bringt seit 2012 die Seiko „Astron GPS Solar" zum Ausdruck. Diese Armbanduhr ist auf der ganzen Welt zu Hause, kennt insgesamt 39 Zonenzeiten und stellt sich beim Reisen wie von Geisterhand auf den aktuellen Standort ein. Diese Beispiele und vieles mehr stellen die Kreativität und Kompetenz der großen Marke aus dem Fernen Osten unter Beweis. Seiko besticht durch Vielseitigkeit. Bei mechanischen Uhren reicht das Fertigungsspektrum von einfachen, aber zuverlässigen Automatikwerken bis hin zu großen Komplikationen, welche in ausgesuchten Märkten unter dem Namen „Credor" erhältlich sind.

In jedem Fall beträgt die Fertigungstiefe bei den Uhrwerken beinahe 100 Prozent. Und bei der Präzisionsuhrmacherei, welche hinter jeder einzelnen „Grand Seiko" steht, müssen sich die cleveren Japaner keine Minute hinter ihren eidgenössischen Kollegen verstecken. Im kleinen, aber feinen Shizukuishi Watch Studio, der Geburtsstätte dieser Ausnahme-Zeitmesser, scheint die Zeit irgendwo stehen geblieben zu sein. ◦

Credor Fugaku Tourbillon
Limited Edition, 2016

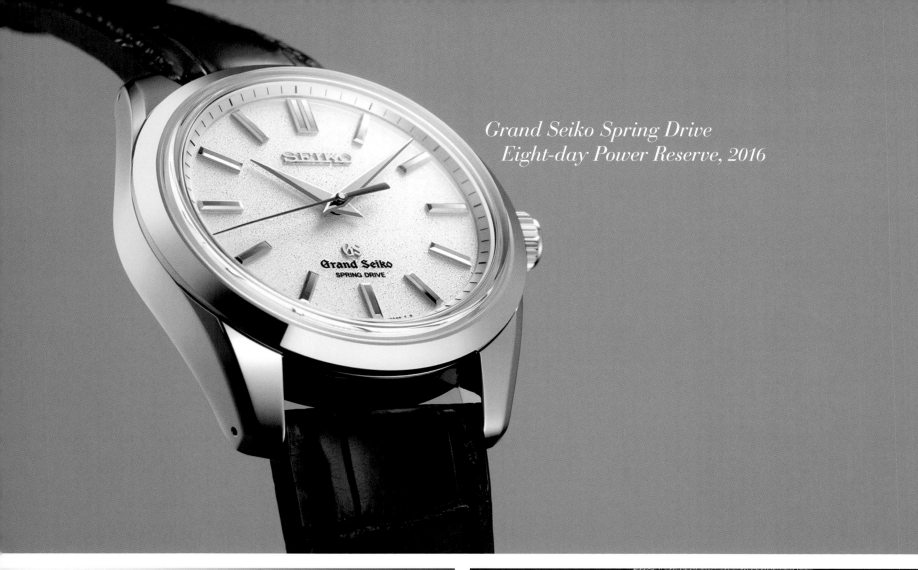

Grand Seiko Spring Drive
Eight-day Power Reserve, 2016

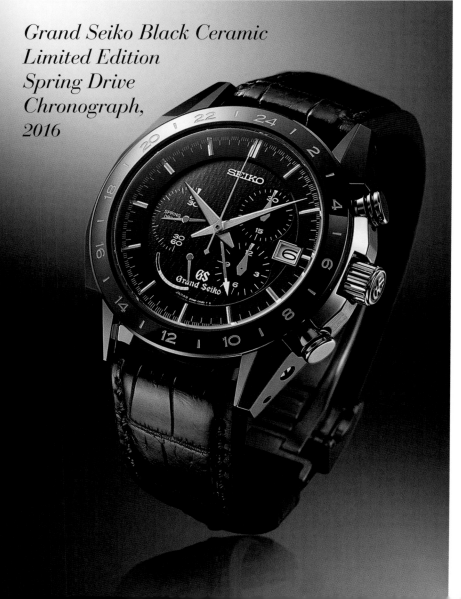

Grand Seiko Black Ceramic
Limited Edition
Spring Drive
Chronograph,
2016

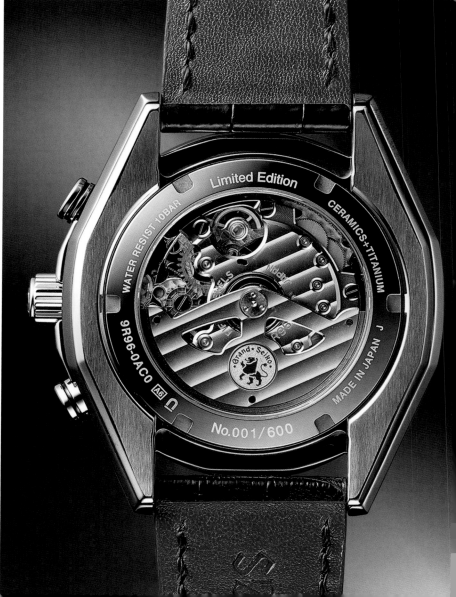

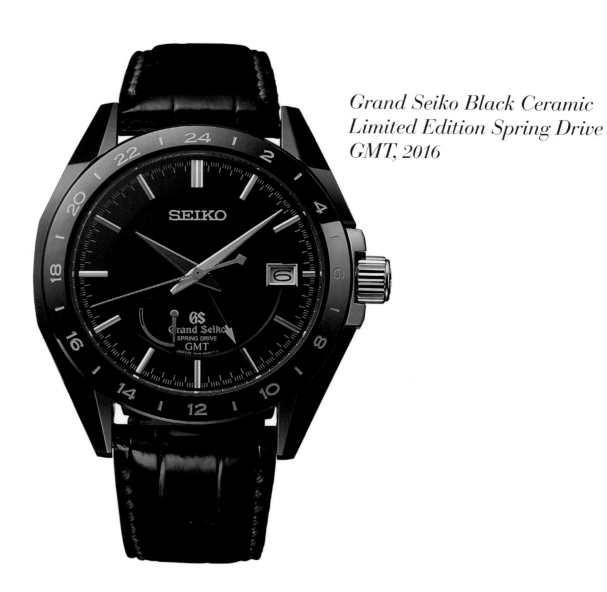

*Grand Seiko Black Ceramic
Limited Edition Spring Drive
GMT, 2016*

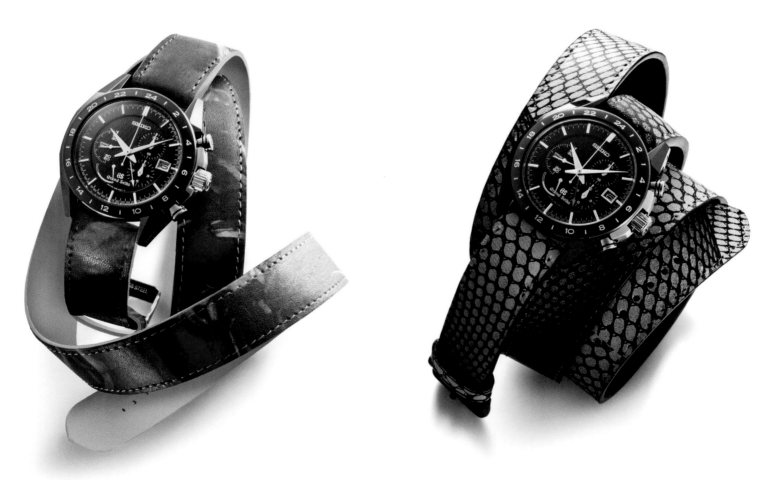

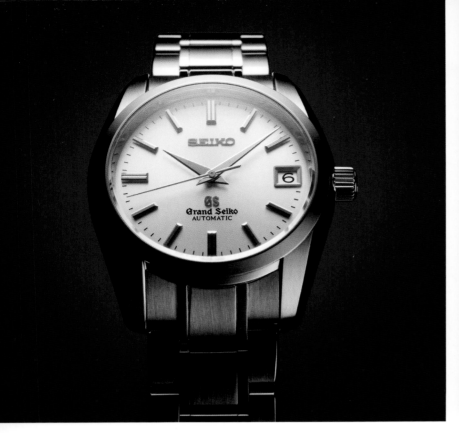
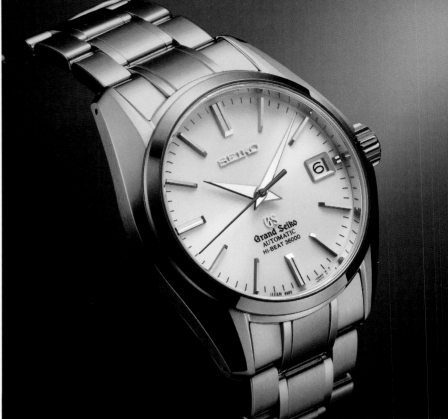

Fabrication japonaise sur toute la ligne

Français

En 1881, Kintaro Hattori est probablement à mille lieues d'imaginer que l'atelier d'horlogerie (K. Hattori & Co. Ltd.) qu'il vient de créer deviendra des décennies plus tard l'une des plus grandes manufactures de montres au monde. Dans un premier temps, 43 ans s'écouleront avant que Seiko, le nom de marque qu'il a choisi, n'orne le cadran d'une montre. Au début, ce jeune entrepreneur de 22 ans a d'autres projets que la fabrication de montres. Dans sa petite boutique à Tokyo, il vend des garde-temps de types très divers, provenant pour la plupart d'importateurs de la ville portuaire de Yokohama, car les produits d'origine japonaise sont encore rares à l'époque. Il effectue également des réparations. Ses affaires sont si florissantes que, dès 1887, il ouvre un local commercial nettement plus représentatif à Ginza, le quartier du commerce et des affaires en plein essor de la capitale japonaise. Peu de temps après, il acquiert le bâtiment du journal Chôya Shimbun. Celui-ci est entièrement rénové, agrandi et doté d'une façade dans le « style occidental » et, en 1895, Kintaro Hattori peut inaugurer le nouveau siège de son entreprise de taille désormais respectable. Le bâtiment devient un emblème local visible de loin, notamment grâce à son horloge culminant à environ 16 mètres. Kintaro Hattori a reconnu bien plus vite que ses concurrents japonais la nécessité de fabriquer également ses propres montres. Aussi, dès 1892, l'heure de créer la manufacture Seikosha (de « seiko », dont on associe la sonorité au succès et à la finesse) a-t-elle sonné. Comme il ne trouve pas les machines nécessaires au Japon, le jeune entrepreneur part s'approvisionner en Europe et aux États-Unis. Grâce aux machines importées, la production de montres augmente étonnamment vite. En 1899, K. Hattori lance des réveils de sa fabrication. Vers 1910, K. Hattori & Co. Ltd. occupe déjà une position prépondérante au pays du Soleil-Levant. Seikosha est la seule manufacture à fabriquer à la fois des horloges murales, des pendulettes et des montres de poche. Des spiraux et des ressorts de barillet sont également

réalisés en interne. L'ère des montres-bracelets débute en 1913 avec la « Laurel », une petite montre ronde que K. Hattori dote d'un cadran en émail de sa fabrication. La production journalière est de 30 à 50 exemplaires. En 1922, les montres de poche et les montres-bracelets absorbent déjà 60 pour cent des capacités de production de la manufacture. L'année 1923 est marquée par un net recul. En détruisant les stocks et la manufacture, le terrible séisme de Kanto porte un coup d'arrêt à la production. Mais K. Hattori ne se laisse pas décourager. Passant outre les avertissements de certains, il présente dès l'année suivante les premières montres-bracelets signées Seiko. L'écho positif reçu lui donne raison.

Une deuxième manufacture est construite en 1937 pour faire face à une croissance exponentielle. Elle est logiquement baptisée Daini Seikosha ou « deuxième Seikosha ». C'est là que seront dorénavant fabriquées les montres, ainsi que les chronographes de poche que l'armée japonaise réclame instamment durant la Seconde Guerre mondiale. Pour ces derniers toutefois, Seiko fait probablement encore appel aux services d'entreprises suisses.

En 1956, la « Marvel » marque dans l'illustre histoire de Seiko le début d'un nouveau chapitre caractérisé par la précision. Première montre-bracelet japonaise, elle remporte en 1957 le concours de précision organisé par la branche extrême-orientale de l'American Horological Society. La concurrence suisse doit s'avouer vaincue. C'est en 1959 qu'est commercialisée la version équipée d'un mouvement à remontage automatique. Sur la « GyroMarvel », le 290 est le premier calibre Seiko à mouvement automatique. Un an plus tard seulement, la légendaire « Grand Seiko », fleuron incontesté de la précision, fait sensation. Pour créer cette montre-bracelet, des collaborateurs de l'usine de Suwa, à l'ouest de Tokyo, ont beaucoup travaillé sur les possibilités d'optimisation. Le fruit de leurs

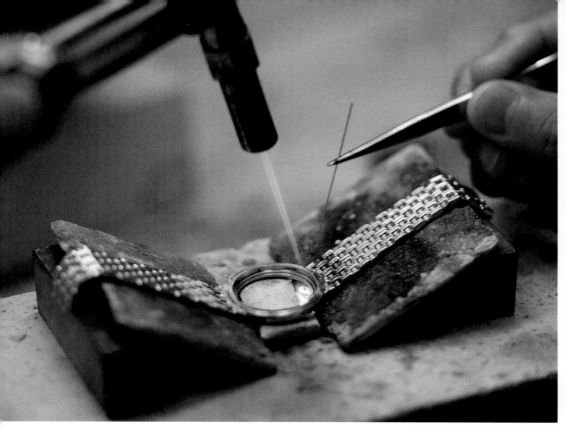
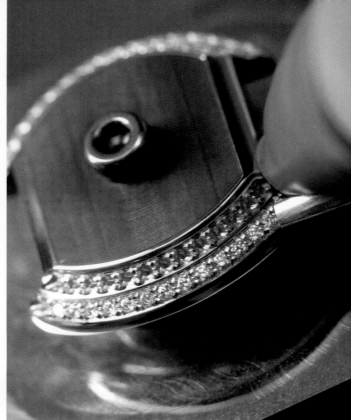

Opposite page, from left: Grand Seiko Automatic, 2015 ○ Grand Seiko Automatic Hi-Beat, 2009 ○ This page, from left: Gold welding ○ Diamond setting ○ Diese Seite, von links: Goldschweißen ○ Einsetzen der Diamanten ○ Cette page, de gauche à droite : Soudage de l'or ○ Sertissage de diamants

efforts est le calibre à remontage manuel 3180. Chaque montre-bracelet qui en est équipée doit subir des tests extrêmement sévères avant livraison. Les exigences que la marque s'impose en matière de précision dépassent même celles du Contrôle officiel suisse des chronomètres (COSC). Et jusqu'à aujourd'hui ces règles sont restées les mêmes, notamment pour la « Grand Seiko ». D'autres innovations, premières mondiales et performances record se succèdent à un rythme soutenu. Les Jeux olympiques de 1964 sont pour Seiko l'occasion de présenter le premier chronographe à remontage manuel de fabrication japonaise. Un an plus tard seulement, ce géant du monde horloger propose la première montre-bracelet de plongée professionnelle « made in Japan ». Le boîtier en acier de 38 millimètres à lunette tournante résiste en plongée à une pression de 15 bars. À partir de 1966, le calibre à remontage manuel 052, de conception spéciale, marque des points dans des concours de chronomètres. Le calibre de haute fréquence 5740, sorti en 1967, se caractérise entre autres par les 36 000 alternances horaires de son balancier. La même année, la « Bell-Matic », première montre-réveil japonaise, est un succès. C'est aussi la date de lancement d'un projet ambitieux, avec les calibres 6138 et 6139. Seiko affronte alors ses rivaux internationaux pour devenir la première manufacture au monde à créer un mouvement automatique à chronographe intégré. Au terme de deux ans d'études sur un sujet aussi complexe, les premiers exemplaires du « Seiko 5 Speed Timer » sont commercialisés en mai 1969. De tous les concurrents mondiaux, c'est le modèle le plus apte à être fabriqué en série et commercialisé. Dix bonnes années de recherche et développement ont précédé une autre première mondiale : le 25 décembre 1969, l'« Astron 35SQ » est la première montre-bracelet à quartz commercialisée dans le monde. Mais transportons-nous maintenant en 1999 : après plusieurs essais éprouvants, Seiko propose une synthèse très remarquée entre mécanique et électronique.

La « Spring Drive » est une montre à quartz mécanique sans pile qui utilise la force motrice emmagasinée dans le barillet pour générer l'énergie électrique nécessaire à son régulateur à quartz qui oscille à 32 768 Hertz. Elle est suivie en 2005 par la « Spring Drive Automatic », une montre à système de remontage par rotor. Portée une heure au poignet en mouvement, elle génère suffisamment de force motrice pour fonctionner plus de trois heures sans qu'il soit nécessaire de la remonter. La complexité technique atteint des sommets en 2006 avec la « Credor Sonnerie », une montre « Spring Drive » équipée d'un coûteux mécanisme de sonnerie à barillet propre. Une version à répétition minute viendra rejoindre en 2010 les deux modèles précédents. En 2009, Seiko célèbre 30 ans de chronographes automatiques avec la collection « Ananta » et le 8R28, un nouveau calibre automatique entièrement repensé. Rien moins que 292 composants sont nécessaires aux horlogers pour réaliser un mouvement. Depuis 2012, la Seiko « Astron GPS Solar » incarne l'excellence de la marque en matière électronique. Partout chez elle dans le monde, cette montre-bracelet connaît 39 fuseaux horaires et se règle en voyage comme par magie sur le lieu où se trouve son propriétaire. Ces exemples et bien d'autres caractéristiques encore démontrent la créativité et les compétences de la grande marque d'Extrême-Orient. Seiko séduit par sa diversité. Sa gamme de montres mécaniques s'étend de modèles à mouvements automatiques simples mais fiables à des modèles à grandes complications, proposés sous la dénomination « Credor » sur des marchés confidentiels. Dans chaque cas, la proportion de pièces fabriquées en interne sur les mouvements atteint quasiment 100 pour cent. Et dans l'horlogerie de précision, à la base de chaque modèle « Grand Seiko », les géniaux horlogers japonais n'ont absolument rien à envier à leurs collègues suisses. Le temps semble s'être arrêté dans le petit, mais non moins raffiné, atelier horloger de Shizukuishi, berceau de ce garde-temps d'exception. ○

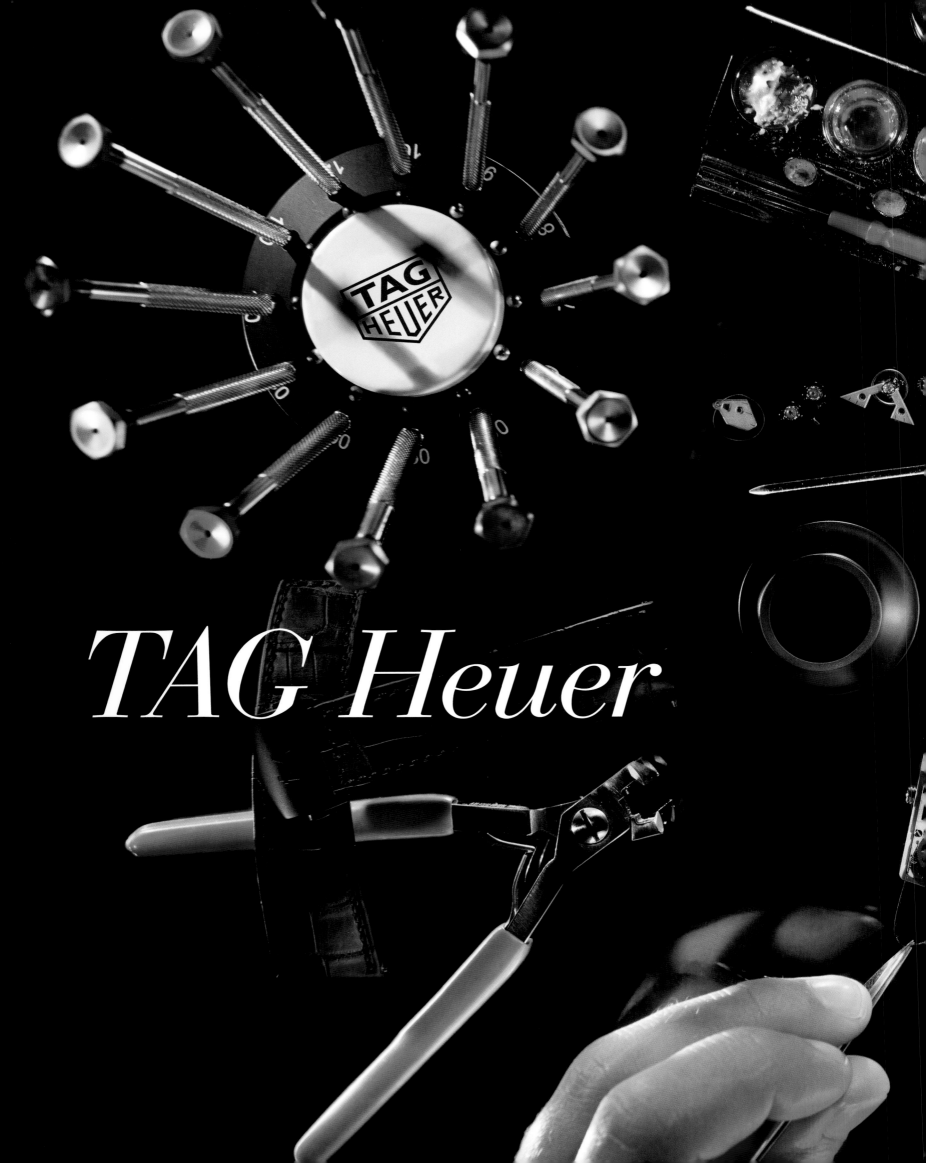

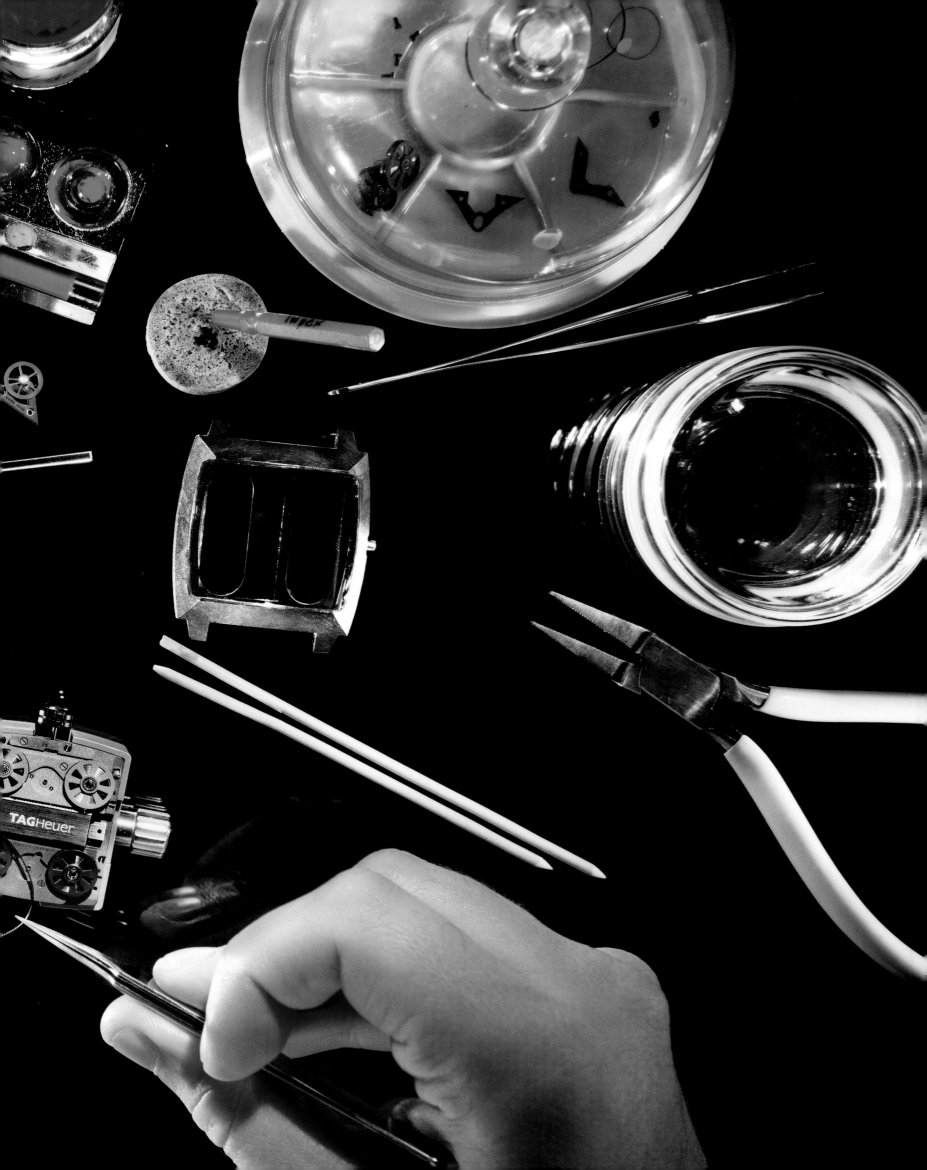

From Maker of Chronographs to Chronograph Manufacture

Heuer Becomes TAG Heuer

English

The chronograph runs like Ariadne's thread through the lives of Edouard Heuer (born in 1840) and his successors. Heuer became a watchmaker's apprentice at age 14. After acquiring his first professional experiences, the newly married young watchmaker went into business for himself at age twenty. His firm could be found in Bienne starting in 1865. It was here that he developed a crown winding for watches that made winding keys superfluous and culminated in his first patent in 1869. Various crises made it clear to him that success lay in specialization. That's why starting in 1882, his collection featured chronographs of his own provenance, including some which had been awarded patent protection. On Christmas Eve of the year 1886, Edouard Heuer applied for a patent to protect a modern oscillating pinion coupling which has not survived to the present day. Other relevant inventions followed.

Heuer was awarded a silver medal for his comprehensive spectrum of watches at the Exposition Universelle in Paris in 1889. When he died unexpectedly on April 30, 1892, he left a sizeable estate valued at 552,750 Swiss francs.

This financial basis enabled his sons Jules-Edouard and Charles-Auguste to continue the firm's activities. After the death of his brother on July 12, 1911, the responsibilities lay solely on the shoulders of Charles-A. Heuer, whose subsequent credits include a chronograph with a pulsometer scale and the "Mikrograph." The latter, which debuted in 1916, was a revolutionary stopwatch that achieved the unprecedented feat of accurately measuring elapsed intervals to the nearest 100th of a second. It and its derivatives convinced the timekeepers at the Olympic Games in 1920, 1924, and 1928. Wristwatches bearing the Heuer signature first became available in 1913. The next generation, embodied by Charles-Edouard II and Hubert-Bernard Heuer, took pains to systematically expand their activities on important markets. They acquired the Jules Jürgensen watch brand in 1919, which they kept until 1936. Heuer was obliged to cope with turbulent conditions after 1929 and during the ensuing global economic crisis. The label survived thanks to creative products, including stopwatches and chronographs for a wide variety of purposes. Prince Wilhelm of Sweden and designated US president Harry S. Truman adorned their wrists with golden wristwatches from Heuer in 1947.

The last generation is represented by Jack William Heuer, who was born in 1932. The son of Charles-Edouard Heuer II, Jack William Heuer studied engineering and afterwards acquired practical experience in the USA, thus qualifying for the executive post that we would later hold at Heuer, which he joined in 1958. As a shareholder in the family business, he merged Heuer with Leonidas to create Heuer-Leonidas in 1964. The ledgers record revenues of ten million Swiss francs in 1968; twice as much was earned a mere two years later in 1970. Urgent need for capital prompted the company to offer shares on the stock market.

Afterwards, Jack W. Heuer, who ranked among the undisputed pioneers of electronic chronographs, was obliged to generate dividends. But the generally poor situation and cheap Far Eastern competition repeatedly upset his plans. The consequences of the Quartz Crisis struck in 1976, followed by the aftermath of an unsuccessful stopwatch deal with China in 1981. The last official general meeting of Heuer-Leonidas SA convened on June 25, 1982. Jack W. Heuer, who refused to accept bankruptcy, along with the other owners of registered shares, had no choice but to agree to write off their share capital and dissolve existing reserves. Nouvelle Lemania and its associated shareholders, including the house of Piaget, became new majority shareholders. Starting in 1985, the majority of shares belonged to the internationally active TAG Group (Techniques d'Avant-Garde) and Heuer became TAG Heuer. Significantly more commercial watches, mostly encasing electronic quartz movements, along with skilful marketing (including the Formula One car race) and fresh advertising campaigns enabled TAG Heuer to resurrect itself like the proverbial phoenix from the ashes. Beginning in 1996, shares of TAG Heuer SA were again traded on the stock exchange. With annual sales of 715,000 watches and revenues of nearly 420 million Swiss francs in 1996, TAG Heuer advanced to fifth place among watch manufacturers in Switzerland. Jack W. Heuer returned as a consultant in 1997, the same year that witnessed a comeback of the legendary "Carrera" from 1963. TAG Heuer celebrated the renaissance of the avant-garde "Monaco" in 1998.

In September 1999, the French luxury group LVMH paid nearly 1.2 billion Swiss francs to acquire the traditional sport watch brand. Under LVMH's roof, TAG Heuer ascended to the status of a genuine watch manufactory with a large number of innovative calibers and a total of four production sites in the Jura region of western Switzerland. Jean-Christophe Babin, who is presently CEO of Bulgari, took the reins in November 2000. He initiated high-frequency chronographs such as the "360," "Mikrograph," "Mikrogirder", and "MikrotourbillonS." The "V4" concept watch, which was launched in 2004, brought the physicist and mathematician Guy Sémon on board. He can be thanked for numerous horological revolutions. A genuine sensation debuted in 2016. The big structural change began on March 1, 2014 with Jean-Claude Biver. The coordinating headman of Hublot, TAG Heuer and Zenith saw that action was urgently required. After becoming CEO at the beginning of 2015, he thoroughly revised the traditional Swiss brand. His credo: "TAG Heuer must offer watches that are priced appropriately for the buying power of its classical customers," i.e., at prices between 1,000 and 5,000 Swiss francs. Well-known brand ambassadors such as Cara Delevingne, Chris Hemsworth, David Guetta, or Tom Brady, the distinctive "Carrera Heuer 01," the successful "Connected" smartwatch, the aggressively priced "Carrera Heuer 02" tourbillon chronograph, and cooperation with the Red Bull Racing Team clearly show the direction in which this brand is headed. ○

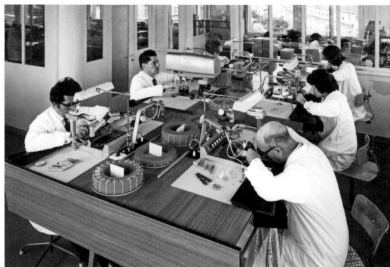

Clockwise from top left: Jack Heuer's childhood home, Bienne, c. 1940 ◦ Edouard Heuer, c. 1890 ◦ Jack Heuer, 2003 ◦ Jack Heuer and his father Charles-Edouard, 1958 ◦ Heuer in Bienne, 1968 ◦ Von oben links im Uhrzeigersinn: Jack Heuers Elternhaus, Biel, ca. 1940 ◦ Edouard Heuer, ca. 1890 ◦ Jack Heuer, 2003 ◦ Jack Heuer und sein Vater Charles-Edouard, 1958 ◦ Heuer in Biel, 1968 ◦ Dans le sens horaire en partant du haut, à gauche : Maison parentale de Jack Heuer, Bienne, vers 1940 ◦ Édouard Heuer, vers 1890 ◦ Jack Heuer, 2003 ◦ Jack Heuer et son père Charles-Édouard, 1958 ◦ Heuer à Bienne, 1968

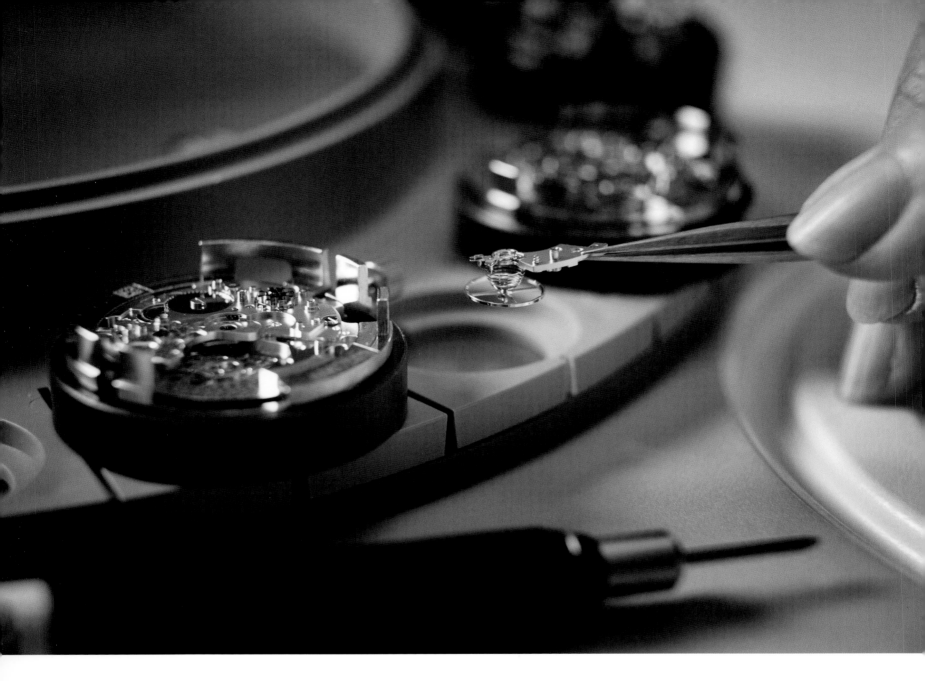

Movements, Cases and Dials

No legally unambiguous definition exists to define precisely what a watch manufactory is, but the company's products should include at least one caliber of its own. Furthermore, a firm that claims to be a manufacture should also fabricate the movement's bearing components, i.e., the plates, bridges, and cocks. The prestigious bell tolled for TAG Heuer with the debut of license Caliber 1887 in 2010. The reader should bear in mind that chronographs are especially demanding because of their complex functional inter-relationships. Swiss expertise expressed itself through differentiated analysis and optimization of the Japanese basic caliber. Achievements entirely of its own, on the other hand, are represented by self-winding Caliber Heuer 02 with chronograph and an innovative one-minute tourbillon, which has a rotating carriage made of light-weight and very sturdy carbon.

A mechanical timekeeping microcosm is strictly organized, and so too is a watch manufactory. Product developers, engineers, and designers collaborate at the brand's headquarters in La Chaux-de-Fonds. Whether the task involves a case, dial, hands, wristband, or movement, these specialists capably handle whatever comes their way. Movements fabricated in one's own manufactory are necessarily more costly than calibers purchased from third-party suppliers, so due to its capacity and to keep its prices competitive, TAG Heuer primarily also encases time-honored devices from Eta and Sellita. Prototype-makers likewise work at the brand's head-quarters. And the "torturers" occupy an extensive laboratory, where they impose the most extreme torments on prototypes destined for serial production.

The fabrication of T0 components takes place at Chevenez, a secluded village near the French border where workers can be found more easily. Milling and processing the plates, bridges, and cocks is entrusted to computer-guided and extremely adaptable manufacturing centers of the newest generation. Afterwards, the specialists in the neighboring T1 atelier require about 100 work steps to transform quality-tested components into finished chrono-graph movements. Here too, automation ensures optimally high quality. After thorough reorganization, the vertical range of manu-facture for the label's own movements now exceeds 50 percent.

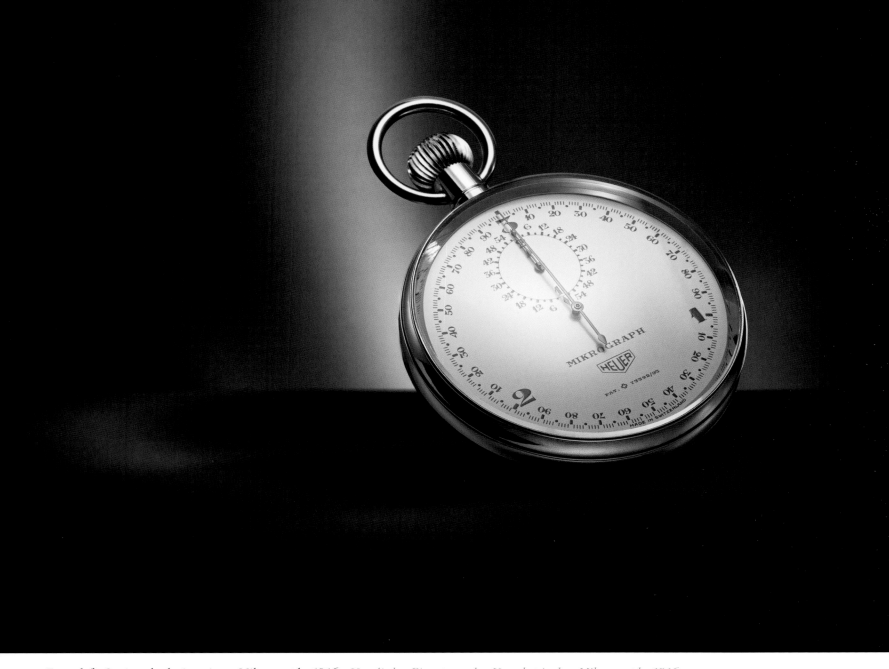

From left: Setting the hairspring ○ Mikrograph, 1916 ○ Von links: Einsetzen der Unruhspirale ○ Mikrograph, 1916 ○
De gauche à droite : Pose du spiral ○ Mikrograph, 1916

Purchasers of wristwatches bearing the TAG Heuer signature also get protective cases from the brand's own manufactory. The label operates a highly modern case factory at Cornol near Chevenez with a workforce of circa 140 individuals who primarily produce steel cases for timepieces ranging from the "Aquaracer" to the "Monza." Most of the noise here is generated by menacing-looking stamping presses, but the computer-guided manufacturing centers are likewise impossible not to hear. Indefatigable robots and expert artisans share the tasks involved in the final polishing. After thorough quality control, which includes verification of watertightness, each case is sent to the assembly department.

The third member of the trio is ArteCad, a traditional dial factory. Nothing is too exotic for the specialists at this subsidiary of TAG Heuer. Their expertise also includes familiarity with techniques that were thought to have been forgotten. Complexity has drastically increased in recent years for new dials, e.g., for the face of the "Carrera Heuer 01" or the "Carrera Heuer 02T." These "faces of time" are veritable multipart three-dimensional artworks. Machines and manual craftsmanship go hand in hand in Tramelan.

The goal is absolute perfection because the dial and the hands that turn above it are usually the first details one notices when one scrutinizes at a watch.

The staff at the workshops in La Chaux-de-Fonds is responsible for the assembly and final control of the entire timepiece, which, of course, is considerably more than sum of its many parts. The watches that leave these ateliers are sent to destinations around the globe. TAG Heuer has traditionally been an international brand, and Jean-Claude Biver would like to significantly expand its presence throughout the world. ○

Chronometric and Chronographic High Points Since 1887

The first highlight is undoubtedly the pocket chronograph with oscillating-pinion coupling, which was patented in 1887. The oscillating pinion performs the same function as a conventional gear coupling with swiveling lever, but significantly reduces the costs for a watch movement with a built-in chronograph.

Heuer's first pilot's watch won admirers thanks to the large ensemble formed by its dial and hands, which remains optimally legible even in unfavorable lighting conditions. The "Time of Trip" was first installed in the cockpits of aircraft and automobiles in 1911. The crew of the R34 rigid airship consulted this timepiece in 1919 during the first airborne crossing of the North Atlantic. Hugo Eckener followed their lead when he flew around the Earth aboard his "Graf Zeppelin" in 1929.

Development of the world's first stopwatch for extremely short intervals began in 1914. The patent was granted on October 2, 1916. To measure elapsed intervals to the nearest 100th of a second, the little balance oscillated at a pace of 50 hertz. According to the catalogue of models, the "Mikrograph" was suitable for "measuring the flights of projectiles and other short-term tests." Its price was 100 Swiss francs or 120 US dollars.

Collectors avidly covet Heuer's dashboard clocks. The "Autavia," a combined clock and stopwatch, first appeared in 1933 on instrument panels, where it reliably assisted drivers in races and rallies. Aircraft pilots and ships' captains likewise relied on timekeeping accessories from Bienne, which were known as "Rally-Master" starting in the late 1950s.

The 1930s also saw Heuer's specialists devoting intensive work to water-protected cases for chronographs. Wristwatch chronographs with water-resistant cases were exactly what the Swiss military wanted. Production of watertight military chronographs with black dials commenced in 1942.

Heuer's catalogue described the "Solunar" as a patented wristwatch "for fishermen, hunters, sailors, seamen, sportsmen, naturalists, scientists, physicians, farmers, bird breeders, gardeners, and foresters." In addition to the time of day or night, this watch also showed the moon's position, the lunisolar periods, and the tides. A push-piece could be pressed to synchronize the "Solunar" with published tables of local tides.

During the crucial prestart phases of a regatta, yachtsmen could rely on the "Yachting Timer," which was launched in 1962. After it had been switched on, the stopwatch reliably showed the current status of the countdown.

The "Autavia," which has an easily remembered name, celebrated a comeback in 1962, when it was released as a wristwatch chronograph with a rotatable bezel that clicked firmly into place atop the watertight steel case. This watch was available in various versions, e.g., for pilots, sport divers, or scientists.

Jack W. Heuer personally took care of the official timekeeping at the famous "12 Hours of Sebring" race, where he first heard about the legendary Carrera Panamericana racing event on open roads. That's why he chose the name "Carrera" for his chronograph creation, which debuted in 1963 with a spaciously planar and three-dimensional dial. The seconds scale was marked along a convex Plexiglas flange.

For the first time in the history of the chronograph, Heuer began marketing a specimen with a mono-window date display in 1965. Only hand-type or double-window date displays had been available prior to this debut. It was only logical that the chronographic world buzzed with gossip about the "Carrera 45 Dato."

Heuer's debut of the world's first modular chronograph with a microrotor for automatic winding, oscillating-pinion coupling and coulisse lever system coincided with the release of a new line of watches. The square case of the "Monaco" was also watertight. The Formula One pilot Jo Siffert was its optimal ambassador. Steve McQueen accordingly wore a "Monaco" on his wrist and an authentic pair of Jo Siffert racing coveralls when performed in the film *Le Mans.*

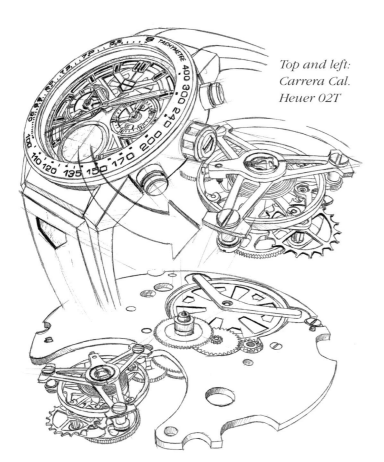

Top and left:
Carrera Cal.
Heuer 02T

Carrera Cal.
Heuer 01, 2016

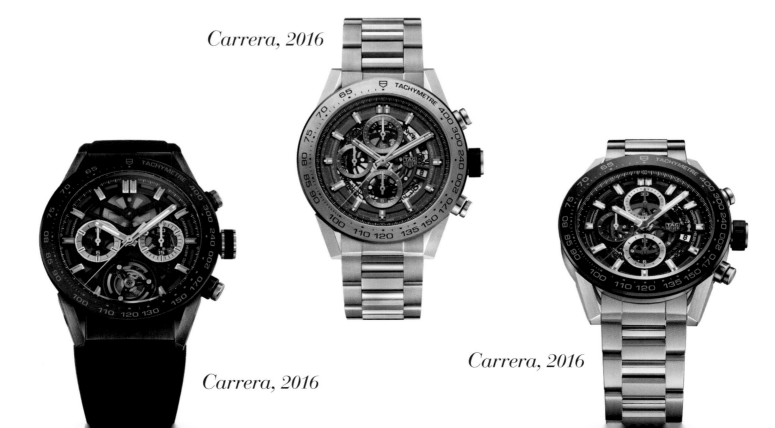

Carrera, 1963

Among the target group for the 1,000 series from 1992 were divers who had to work under extreme pressure conditions. Despite its remarkable watertightness (up to 100 bar), the case made do without a conventional helium-escape valve.

"Kirium Ti5," designed by Jörg Hysek, inaugurated a new design era. Its salient feature was the fluently organic transition between the case and the wristband. Furthermore, TAG Heuer introduced new high-performance materials: carbon was used for the dial, and titanium for the case and bracelet.

Mechanical or electronic? The "Monaco Sixty Nine" from 2003 answered this question with a simple "yes." Its innovative reversible case housed both a ticking mechanical caliber and a quartz-paced movement.

The "V4" debuted as a concept watch in 2004. It became a reality in 2009. Two micro-toothed belts with metal "souls" convey kinetic energy from the linear oscillating body to four barrels. A conventional balance steadily subdivides precious time into equal intervals.

The "Carrera Calibre 360 LE," a wristwatch with two movements, celebrated its world premiere in 2006. One caliber indicated the ordinary time of day, while the other could measure elapsed intervals to the nearest 100th of a second.

TAG Heuer returned to the status of a horological manufactory in 2010, which was also the year of its 150th anniversary. The engineers who designed automatic Caliber 1887 with oscillating-pinion chronograph relied on a Seiko movement. The 320 components that comprise this opus were fabricated entirely in Switzerland.

Born in 2011, the mechanical "Mikrotimer Flying 1000 Concept Chronograph" could measure elapsed intervals to the nearest 1,000th of a second. Analogously to its 100th-of-a-second predecessors, this wristwatch has two separate power trains, each with its own oscillating and escapement system. Applications for ten patents testify to the ample inventiveness that culminated in its debut.

The mechanical "Mikrogirder" accurately measures brief intervals to the nearest 5/10,000th or 1/2,000th of a second. No conventional rate regulator can complete 7,200,000 semi-oscillations per hour, so three perpendicularly arranged metal blades collaborate in this construction, which was registered for ten patents and born in 2012.

This same year saw the "MikrotourbillonS2" add the crowning touch to the philosophy of ultra-fast oscillation. Each of the two tourbillons rotates at a different speed from its companion: the balance in the speedier tourbillon is paced at 50 hertz and serves as the pacemaker to precise measure elapsed intervals to the nearest 1/100th of a second. The more conventionally paced balance in the other tourbillon is responsible for the ordinary time display.

The "Carrera Heuer 01," which debuted in 2015, is based on Caliber 1887. Nothing is concealed by the specially designed front side. The transparent back likewise hides no details. Twelve parts create the modularly conceived "Carrera" case, which is watertight to ten bar. Its multipart architecture enables designers to combine diverse materials, surfaces, and colors.

Last but not least, we have the "Carrera" tourbillon chronograph from 2016. Jean-Claude Biver and his team demonstrate with Caliber Heuer 02T that complicated manufactory work, including an automatic chronograph and tourbillon, needn't be astronomically unaffordable. The unlimited version with a titanium case costs less than 15,000 euros. ◦

Carrera, 2016

Carrera, 2016

Carrera, 2016

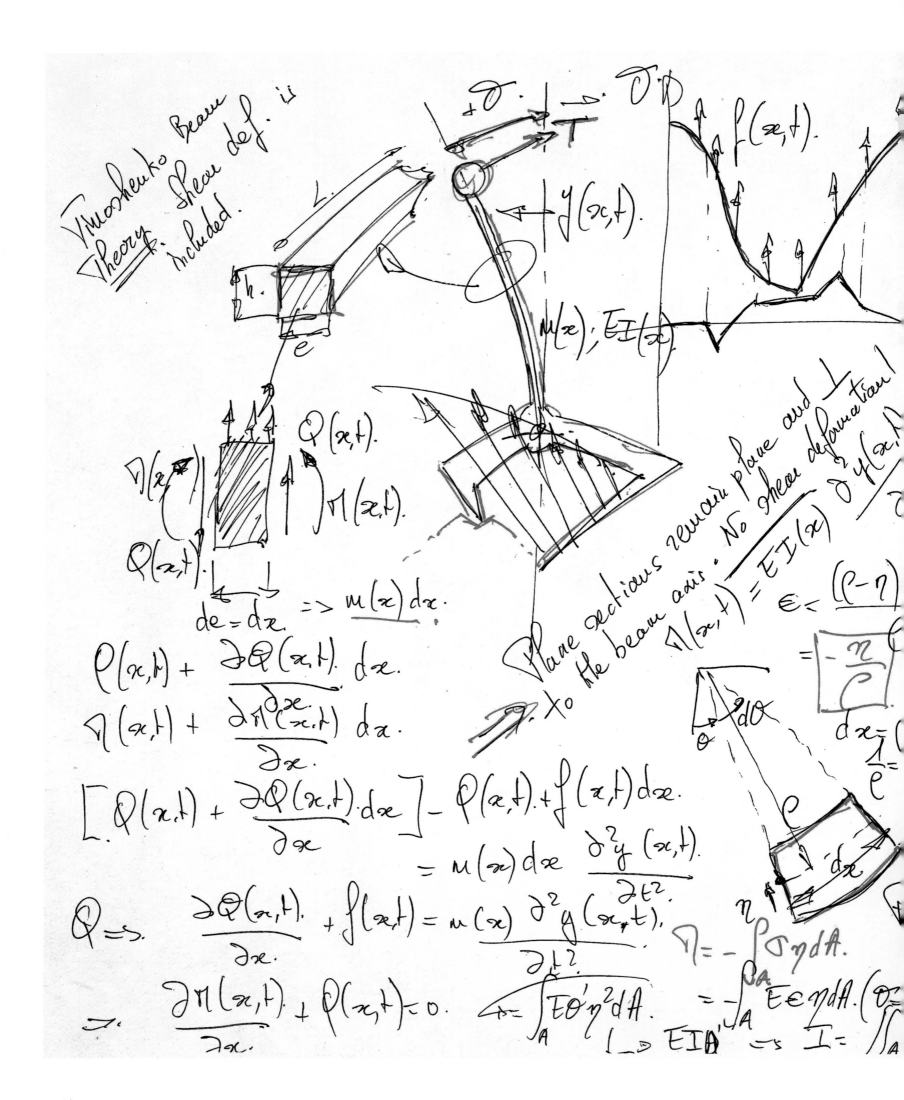

Timoshenko Beam def. is
Theory. shear def.
included.

L

h

e

$Q(x,t)$

$M(x,t)$

$M(x,t)$

$Q(x,t)$

$de = dx$ $\Rightarrow m(x)dx.$

$Q(x,t) + \dfrac{\partial Q(x,t)}{\partial x} dx.$

$M(x,t) + \dfrac{\partial M(x,t)}{\partial x} dx.$

$\left[Q(x,t) + \dfrac{\partial Q(x,t)}{\partial x} dx \right] - Q(x,t) + f(x,t)dx.$

$\qquad = m(x)dx \dfrac{\partial^2 y(x,t)}{\partial t^2}.$

$Q \Rightarrow \dfrac{\partial Q(x,t)}{\partial x} + f(x,t) = m(x)\dfrac{\partial^2 y(x,t)}{\partial t^2}.$

$\Rightarrow \dfrac{\partial M(x,t)}{\partial x} + Q(x,t) = 0.$

Plane sections remain plane and \perp
to the beam axis. No shear deformation.

$M(x,t) = EI(x) \dfrac{\partial^2 y(x,t)}{\partial x^2}$

$\varepsilon = \dfrac{(\rho - \eta)}{\rho}$

$= \boxed{-\dfrac{\eta}{\rho}}$

$d\theta$

$dx = $

$\dfrac{1}{\rho} =$

η

dx

$\eta = -\int_A \sigma \eta \, dA.$

$= -\int_A E\varepsilon\eta \, dA. \left(\theta = \right.$

$\Rightarrow \int_A E\theta'\eta^2 \, dA.$

$\rightarrow EIA' \Rightarrow I = \int_A$

Free vibration $-\dfrac{\partial^2}{\partial x^2}\left[EI(x)\dfrac{\partial^2 y(x,t)}{\partial x^2}\right] =$

$m(x)\cdot\dfrac{\partial^2 y(x,t)}{\partial t^2}$, $-\dfrac{d^2}{dx^2}\left[EI(x)\dfrac{d^2 Y(x)}{dx^2}\right]\cdot F(t) =$

$m(x)\,Y(x)\,\dfrac{d^2 f(t)}{dt^2}$. Where.

$Y(0)=0;\quad \dfrac{dY(x)}{d(x)}\Big|_{x=0}=0.\quad \dfrac{d^2Y(x)}{d(x)^2}\Big|_{x=L}=0.$

$\dfrac{d}{dx}\left[EI(x)\dfrac{d^2Y(x)}{dx^2}\right]\Big|_{x=L}\quad \boxed{=0}\quad \left(-\omega^2\right)$

$-\dfrac{1}{m(x)\,Y(x)}\dfrac{d^2}{dx^2}\left[EI(x)\dfrac{d^2Y(x)}{dx^2}\right]=\dfrac{1}{F(t)}\dfrac{d^2F(t)}{dt^2}$

$\Rightarrow F(t)=A\sin\omega t+B\cos\omega t=C\cos(\omega t+\varnothing).$

Matrix Boundary Conditions $Y(x)$

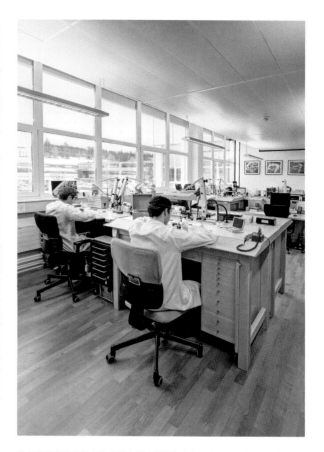

$\begin{bmatrix} 0 & 1 & 0 & 1 \\ 1 & 0 & 1 & 0 \\ -\sin\beta L & -\cos\beta L & \sinh\beta L & \cosh\beta L \\ -\cos\beta L & \sin\beta L & \cosh\beta L & \sinh\beta L \end{bmatrix}\begin{Bmatrix} Y'(x) \\ Y''(x) \\ Y'''(x) \end{Bmatrix}\begin{Bmatrix} A \\ B \\ C \\ D \end{Bmatrix}$

Non-Trivial Solutions

$\det\begin{bmatrix} 0 & & & \\ 1 & & & \\ -\sin\beta L & & & \\ -\cos\beta L & & & \end{bmatrix}=0.$

$1+\cos(\beta L)\cosh(\beta L)=0.$

$\beta^2\sqrt{\dfrac{EI}{m}}$ Solutions: Eigenvalues

$\omega_1=1.875^2\dfrac{EI}{mL^4}$ etc... $\omega_2,\ \omega_3\ \dots$

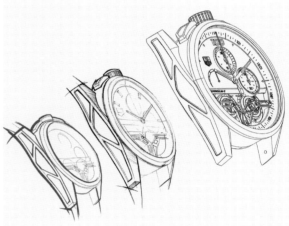

response $y(x,t)=\displaystyle\sum_{r=1}^{\infty} Y(x)\,\eta_r(t).$ $Y_r(x).\Rightarrow$ Man normalized mode shapes.

$\ddot\eta_s(t)+\omega_s^2\eta_s(t)=---$

$s(t)=\displaystyle\sum_0 ---.$

$M=EI\,y''$

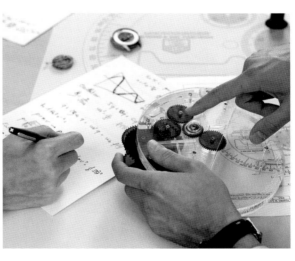

The art of manufacturing
Die Kunst der Manufakturarbeit
L'art de la manufacture

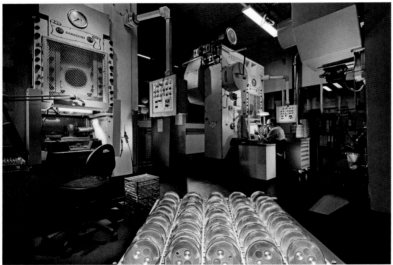

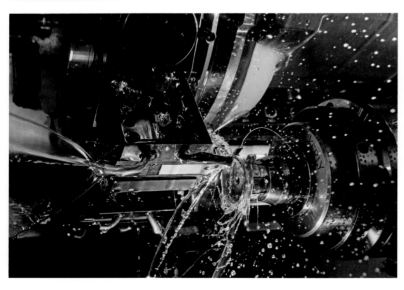

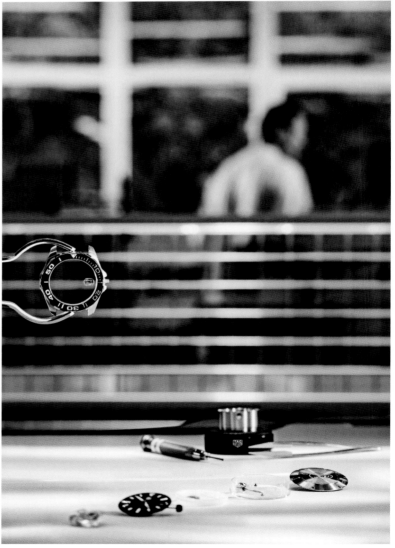

Clockwise from top: The home of TAG Heuer movements in Chevenz ◦ Casing workshop ◦ Machining and drilling holes in the cases ◦ Dial creation ◦ Von oben im Uhrzeigersinn: Heimat der Uhrwerke von TAG Heuer in Chevenez ◦ Gehäusefertigung ◦ Bearbeitung der Gehäuse ◦ Zifferblattherstellung ◦ Dans le sens horaire en partant du haut : Manufacture des mouvements TAG Heuer à Chevenez ◦ Emboîtage à La Chaux-de-Fonds ◦ Usinage à Cornol ◦ Frappe des cadrans chez ArteCad

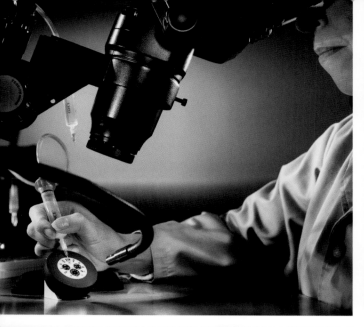

Clockwise from top left: Fitting the indices ○ Furnace ○
Machine tools ○ Sealing tests ○ The bridges and main plates
are fitted by ultra-modern machines ○ Electroplating ○
Circle: The quality laboratory tests new models ○
Von oben links im Uhrzeigersinn: Aufsetzen der Indizes ○
Härtungsofen ○ Werkzeugmaschinen ○ Dichtheitsprüfung ○
Die Brücken und Platinen werden von modernsten
Maschinen montiert ○ Galvanisierung ○ Kreis:
Im Qualitätslabor werden neue Modelle getestet ○
Dans le sens horaire, en partant du haut, à gauche :
Pose SLN chez ArteCad ○ Boîtes de montres à Cornol ○
Outillage à Chevenez ○ Étanchéité à La Chaux-de-Fonds ○
Garnissage à Chevenez ○ Galvanoplastie chez ArteCad ○
Au centre : Laboratoire qualité à La Chaux-de-Fonds

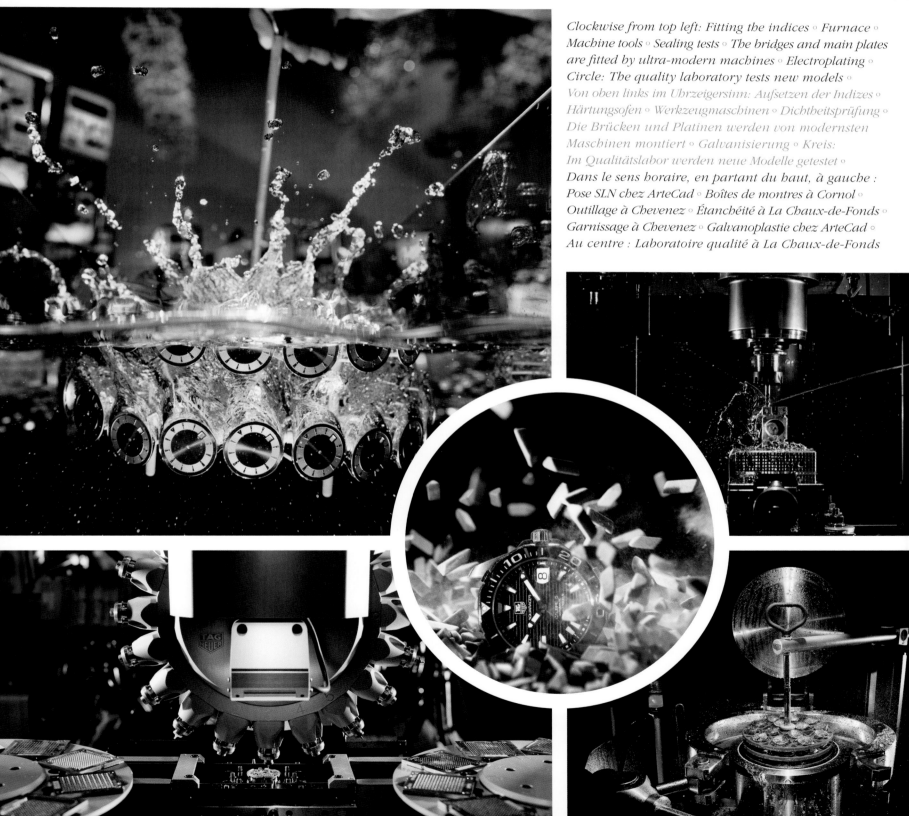

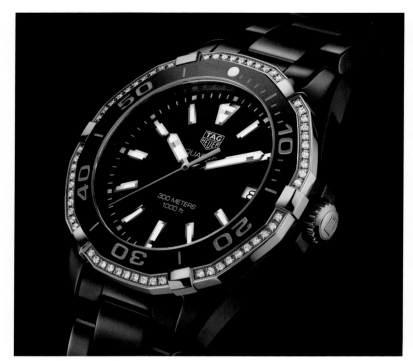
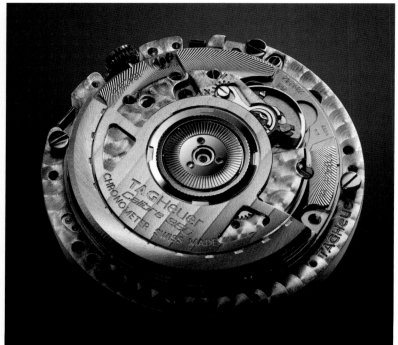

From left: Aquaracer 300M Ladies, 2016 ◦ Cal. 360

Von der Chronographenmanufaktur zur Chronographenmanufaktur

Aus Heuer wird TAG Heuer

Deutsch

Chronographen durchziehen das Leben von Edouard Heuer, Jahrgang 1840, und das seiner Nachfahren wie ein roter Faden. Mit 14 erhielt er seine Ausbildung zum Uhrmacher. Nach ersten beruflichen Erfahrungen und Eheschließung machte er sich mit 20 selbständig. Ab 1865 fand man seine Firma in Biel. Dort entwickelte er einen Kronenaufzug für Uhren, der die Schlüssel überflüssig machte und 1869 in sein erstes Patent mündete. Krisenzeiten führten ihm vor Augen, dass das Heil in der Spezialisierung zu suchen war. Ab 1882 beinhaltete die Kollektion deshalb auch – teilweise patentierte – Zeitschreiber eigener Provenienz. Am Heiligabend des Jahres 1886 beantragte Edouard Heuer Schutz für die moderne Schwingtriebkupplung, welche sich bis heute nicht überlebt hat. Weitere einschlägige Erfindungen folgten.

1889 konnte der Patron während der Weltausstellung in Paris eine Silbermedaille für sein umfassendes Uhrenspektrum entgegennehmen. Als er am 30. April 1892 überraschend verstarb, hinterließ er ein stattliches Nettovermögen von 552 750 Schweizer Franken.

Auf diesem finanziellen Fundament konnten die Söhne Jules-Edouard und Charles-Auguste I. die Aktivitäten fortführen. Nach dem Tod des Bruders am 12. Juli 1911 lastete die Verantwortung allein auf den Schultern von Charles-A. Heuer. Ihm sind u. a. ein Chronograph mit Pulsometer-Skala oder der „Mikrograph" von 1916 zu verdanken. Mit der revolutionären Stoppuhr konnte man erstmals

auf die Hundertstelsekunde genau stoppen. Sie und ihre Derivate überzeugten die Zeitnehmer bei den Olympischen Spielen 1920, 1924 und 1928. Seit 1913 gab es auch Armbanduhren mit der Signatur. Die nächste Generation in Person von Charles-Edouard II. und Hubert-Bernard kümmerte sich um den systematischen Ausbau wichtiger Märkte. 1919 legten sie sich (bis 1936) die Uhrenmarke Jules Jürgensen zu. Nach 1929 und der daraus resultierenden Weltwirtschaftskrise musste Heuer etliche Turbulenzen überstehen. Das Überleben sicherten kreative Produkte, darunter Stoppuhren und Chronographen für sehr unterschiedliche Zwecke. 1947 schmückten Prinz Wilhelm von Schweden sowie der designierte US-Präsident Harry S. Truman ihre Handgelenke mit goldenen Armbanduhren von Heuer.

Die letzte Generation repräsentierte der 1932 geborene Jack William Heuer. Durch sein Ingenieurstudium und Praxiserfahrung in den USA qualifizierte sich der Sohn von Charles-Edouard II. für die spätere Leitungsfunktion. 1958 trat er in die Fußstapfen seiner Vorfahren. Als Teilhaber am Familienunternehmen fusionierte er Heuer 1964 mit Leonidas zu Heuer-Leonidas. 1968 standen zehn Millionen Franken Umsatz in den Büchern, 1970 bereits das Doppelte. Dringender Kapitalbedarf führte zum Gang an die Börse. Fortan musste Jack W. Heuer, der zu den unangefochtenen Pionieren elektronischer Kurzzeitmesser gehörte, Dividenden erwirtschaften. Aber die allgemein schlechte Situation und die fernöstliche

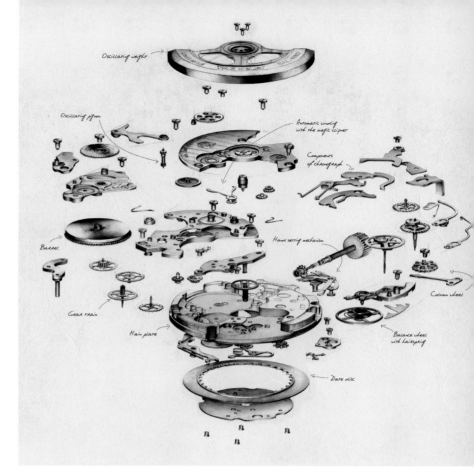

Billigkonkurrenz machten dicke Striche durch die Rechnung. Ab 1976 trafen ihn die Folgen der Quarz-Krise und 1981 die Auswirkungen eines misslungenen Stoppuhren-Geschäfts mit China. Die letzte öffentliche Generalversammlung der Heuer-Leonidas SA ging am 25. Juni 1982 über die Bühne. Jack W. Heuer, der einen Konkurs ablehnte, und die übrigen Inhaber von Namensaktien mussten der Abschreibung ihres Aktienkapitals und der Auflösung vorhandener Reserven zustimmen. Neue Hauptaktionäre wurden die Nouvelle Lemania und ihr nahestehende Anteilseigner, darunter das Haus Piaget. Ab 1985 gehörte die Aktienmehrheit der international tätigen TAG-Gruppe (Techniques d'Avant-Garde). Aus Heuer wurde TAG Heuer. Deutlich kommerziellere Uhren, meist mit elektronischen Quarzwerken, gekonntes Marketing unter Einbeziehung der Formel 1 und frische Werbekampagnen ließen TAG Heuer auferstehen wie Phoenix aus der Asche. Ab 1996 wurden die Aktien der TAG Heuer SA erneut an der Börse gehandelt. Mit jährlich über 715 000 verkauften Uhren und einem Umsatz von knapp 420 Millionen Schweizer Franken war TAG Heuer 1996 in der Schweiz zur Nummer fünf unter den Uhrenherstellern avanciert. 1997 brachte nicht nur Jack W. Heuer als Berater zurück, sondern auch die legendäre „Carrera" von 1963.

1998 zelebrierte TAG Heuer die Renaissance der avantgardistischen „Monaco".

Im September 1999 erwarb der französische Luxusmulti LVMH die traditionsreiche Sportuhrenmarke für knapp 1,2 Milliarden Schweizer Franken. Unter seinem Dach erlebte TAG Heuer den Aufstieg zur echten Uhrenmanufaktur mit einer Vielzahl innovativer Kaliber und insgesamt vier Produktionsstandorten im Westschweizer Jurabogen. Ab November 2000 lenkte Jean-Christophe Babin, aktuell Bulgari-CEO, die Geschicke. Er initiierte Hochfrequenz-Stopper wie „360", „Mikrograph", „Mikrogirder" und „MikrotourbillonS". Die 2004 lancierte Konzept-Armbanduhr „V4" brachte den studierten Physiker und Mathematiker Guy Sémon ins Haus. Ihm sind zahlreiche uhrmacherische Revolutionen zu verdanken. Eine echte Sensation steht noch 2016 ins Haus. Der große Strukturwandel begann am 1. März 2014 mit Jean-Claude Biver. Der koordinierende Chef von Hublot, TAG Heuer und Zenith entdeckte dringenden Handlungsbedarf, übernahm Anfang 2015 die Funktion des CEO und krempelte die Schweizer Traditionsmarke gründlich um. Sein Credo: „TAG Heuer muss Uhren anbieten, welche der Kaufkraft des klassischen Kunden gerecht werden." Und das ist eine Größenordnung zwischen 1 000 und 5 000 Schweizer Franken. Bekannte Markenbotschafter wie Cara Delevingne, Chris Hemsworth, David Guetta oder Tom Brady, die markante „Carrera Heuer 01", die erfolgreiche Smartwatch „Connected", der preisaggressive Tourbillon-Chronograph „Carrera Heuer 02" oder die Kooperation mit dem Red Bull Racing Team lassen erkennen, wohin die Reise künftig gehen wird. ○

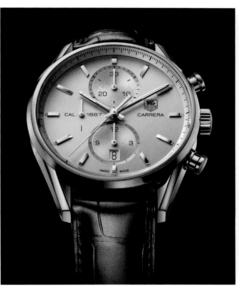

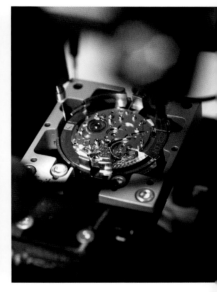

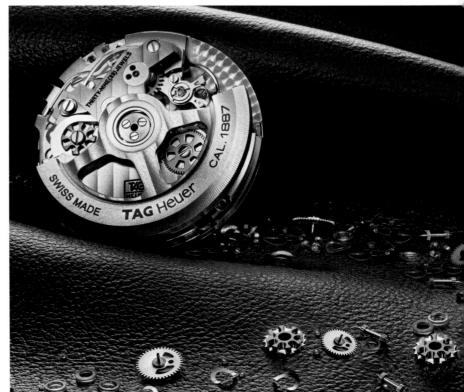

Cal. 1887

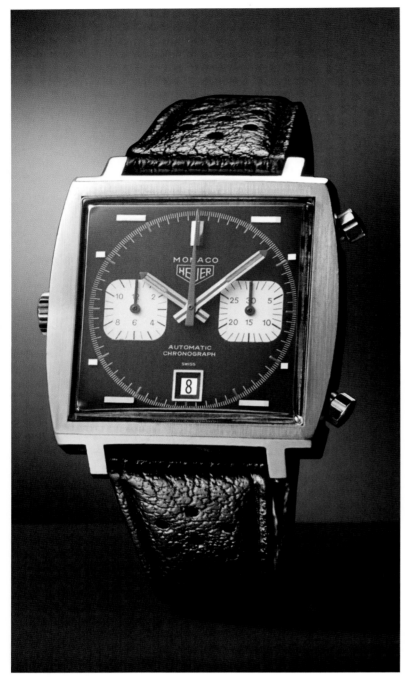

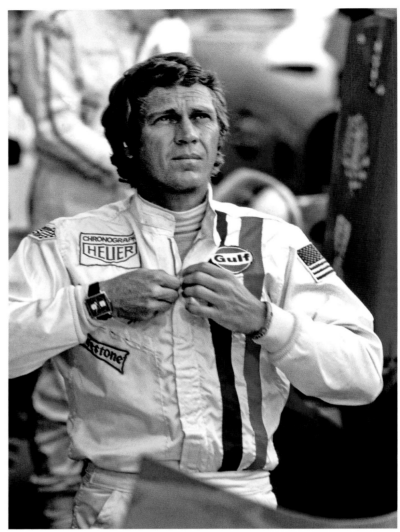

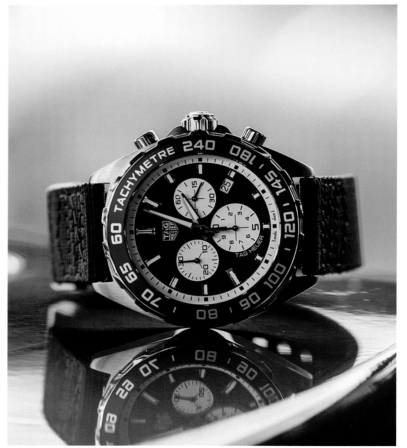

*Clockwise from top left: Original Monaco, 1969 ◦ Steve McQueen, 1970 ◦ Formula 1 Red Bull Special Edition, 2016 ◦
Jack Heuer and Jo Siffert in Bienne, 1970*

Werke, Gehäuse und Zifferblätter

Deutsch

Eine rechtlich eindeutige Definition dessen, was eine Uhrenmanufaktur ist, existiert nicht. Mindestens ein eigenes Kaliber sollte aber schon vorhanden sein. Darüber hinaus sollte eine Firma, welche diesen Anspruch für sich erhebt, mindestens auch die tragenden Teile, sprich die Platine, Brücken und Kloben des Uhrwerks fertigen. Die Stunde eigenen Tuns schlug bei TAG Heuer 2010 mit dem Lizenz-Kaliber 1887. Dabei gilt es zu wissen, dass Chronographen wegen der komplexen Funktionszusammenhänge besonders hohe Ansprüche stellen. Der eidgenössische Sachverstand zeigte sich in differenzierter Analyse und tiefgreifender Optimierung der japanischen Basis. Komplett eigene Leistung repräsentiert hingegen das Kaliber Heuer 02 mit Selbstaufzug, Chronograph und innovativem Minutentourbillon, dessen Drehgestell aus leichtem, hoch belastbarem Karbon besteht.

So geordnet, wie es in einem mechanischen Mikrokosmos zugeht, ist auch eine Manufaktur strukturiert. Bei TAG Heuer agieren die Produktentwickler, Konstrukteure und Designer am Hauptsitz in La Chaux-de-Fonds. Egal ob Gehäuse, Zifferblatt, Zeiger, Armband oder Uhrwerk: Sie kümmern sich um alles. Aus Gründen der Kapazität und kompetitiver Preise – Werke aus eigener Manufaktur sind grundsätzlich teurer als zugekaufte – verbaut TAG Heuer überwiegend auch Bewährtes von Eta und Sellita. Auch die Prototypisten erledigen ihren Job in der Zentrale. Ferner unterziehen die „Folterknechte" in einem ausgedehnten Labor alles, was in die Serienfertigung gehen soll, extremen Torturen.

In Chevenez, einem abgelegenen Dorf nahe an der französischen Grenze, wo sich Arbeitskräfte leichter finden lassen, geht die Teileproduktion T0 über die Bühne. Das Fräsen und Bearbeiten der Platinen, Brücken und Kloben obliegt computergesteuerten und extrem flexiblen Fertigungszentren der neuesten Generation. Anschließend benötigt das benachbarte Atelier T1 rund 100 Arbeitsschritte, damit aus qualitätsgeprüften Komponenten fertige Chronographenwerke werden. Automatisierung sorgt auch hier für ein Optimum an Güte. Nach gründlicher Reorganisation erreicht die Fertigungstiefe bei den eigenen Werken inzwischen mehr als 50 Prozent.

Käufer einer Armbanduhr mit der Signatur TAG Heuer erhalten auch die schützende Schale aus eigener Manufaktur. In Cornol nahe Chevenez unterhält das Unternehmen eine hochmoderne Gehäusefabrik mit gegenwärtig circa 140 Beschäftigten. Sie produzieren in erster Linie Stahlgehäuse für Zeitmesser von „Aquaracer" bis „Monza". Martialisch anmutende Stanzen verursachen den meisten Lärm. Aber auch die computergesteuerten Fertigungszentren sind unüberhörbar. Die finale Politur teilen sich nimmermüde Roboter und Fachkräfte mit hoher Expertise. Nach gründlicher Kontrolle geht es an die Montage inklusive abschließendem Check auf Wasserdichte.

Dritte im Bunde ist ArteCad, eine traditionsreiche Zifferblattfabrik. Dieser Tochter von TAG Heuer ist nichts fremd. Das gilt auch für vergessen geglaubte Techniken. Bei neuen Zifferblättern, beispielsweise für die „Carrera Heuer 01" und „Carrera Heuer 02T", ist die Komplexität in den vergangenen Jahren sprunghaft angestiegen. Hier sind die „Gesichter der Zeit" vielteilige dreidimensionale Kunstwerke. Maschinelles und manuelles Tun gehen in Tramelan Hand in Hand. Ziel ist absolute Perfektion, denn jeder Blick auf die Uhr gilt in erster Linie dem Zifferblatt und den davor drehenden Zeigern.

Für die Assemblage und finale Kontrolle des Ganzen, welches bekanntlich mehr ist als die Summe seiner vielen Teile, sind schließlich die Werkstätten in La Chaux-de-Fonds zuständig. Von dort nehmen die fertigen Uhren ihren Weg in die ganze Welt. TAG Heuer ist traditionsgemäß eine internationale Marke. Aber Jean-Claude Biver möchte die Präsenz rund um den Globus noch deutlich ausbauen. ○

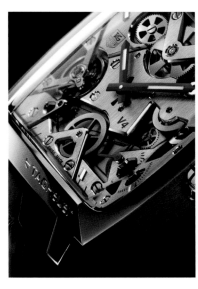 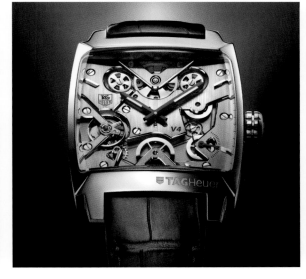 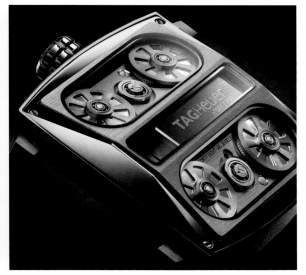

Monaco V4 Platinum, 2004

Chronometrische und chronographische Höhepunkte seit 1887

Deutsch

Als erstes Highlight kann zweifellos der 1887 patentierte Taschen-Chronograph mit Schwingtrieb-Kupplung gelten. Letztere erfüllte die gleiche Funktion wie die gängige Räderkupplung mit Schwenk-hebel, minderte die Kosten für ein Uhrwerk mit Chronograph jedoch erheblich.

Die erste Borduhr von Heuer bestach durch ein großes, selbst bei ungünstigen Lichtverhält-nissen bestens ablesbares Ensemble aus Zifferblatt und Zeigern. Ab 1911 fand man den „Time of Trip" in den Cockpits von Flugzeugen und Autos. 1919, bei der ersten Nordatlantiküberquerung eines Luftschiffs, blickte die Crew der R34 auf diese Uhr. Hugo Eckener tat Gleiches, als er die Erde 1929 mit dem Luftschiff „Graf Zeppelin" umrundete.

Die Entwicklung des weltweit ersten Tempo-Stoppers startete 1914. Das Patent datiert auf den 2. Oktober 1916. Für Hundertstelsekunden-Stoppgenauigkeit oszillierte die kleine Unruh mit 50 Hertz. Der „Mikrograph" eignete sich laut Modellkatalog „zum Erfassen der Flüge von Projektilen und andere Kurzzeittests". Sein Preis lag bei 100 Schweizer Franken oder 120 US-Dollar.

Hoch im Kurs bei Sammlern stehen die Dashboard-Zeitmesser von Heuer. Ab 1933 fand sich „Autavia", eine Kombination aus Uhr und Stopper, an vielen Armaturenbrettern. Dort unterstützte sie zum Beispiel Renn- und Rallyefahrer. Daneben vertrauten aber auch Flugzeugpiloten und Bootskapitäne auf die Zeit-Accessoires aus Biel, die ab den späten 1950er Jahren „Rally-Master" hießen.

Ebenfalls in den 1930ern beschäftigte sich Heuer sehr intensiv mit wassergeschützten Gehäusen für Chronographen. Der vorgestellte Armbandchronograph mit wasserabweisender Schale kam den Schweizer Militärs sehr entgegen. 1942 startete die Produktion wasserdichter Militär-Chronographen mit schwarzem Blatt.

1949 brachte mit der „Solunar" die patentierte Armbanduhr „für Fischer, Jäger, Segler, Seeleute, Sportsleute, Naturforscher, Wissen-schaftler, Mediziner, Landwirte, Vogelzüchter, Gärtner, Forstmeister", wie im Modellkatalog zu lesen stand. Neben der Zeit stellte sie auch die Mondstellung, die Solunar-Perioden und die Gezeiten dar. Per Drücker erfolgte die Synchronisation mit lokal veröffent-lichen Tabellen.

Regattaseglern in der schwierigen Vorstart-Phase half der 1962 lancierte „Yachting Timer". Nach dem Starten informierte der Stopper zuverlässig über den aktuellen Stand des Countdown.

Ein Comeback des einprägsamen Namens „Autavia" ist für 1962 zu verzeichnen. Und zwar in Gestalt eines Armbandchronographen. Die rastende Drehlünette am wasserdichten Stahlgehäuse war in unterschiedlichen Versionen beispielsweise für Piloten, Sport-taucher oder Wissenschaftler zu haben.

Bei den berühmten 12-Stunden-Rennen von Sebring kümmerte sich Jack W. Heuer höchstpersönlich um die offizielle Zeitnahme. Dort hörte er von dem legendären Straßenrennen Carrera Panamericana. Deshalb erhielt seine 1963 eingeführte Chronographen-Kreation mit großflächig und drei-dimensional gestaltetem Zifferblatt den Namen „Carrera". Der Spannring im gewölbten Plexiglas trug die Sekundenskala.

Erstmals in der Geschichte des Chrono-graphen brachte Heuer 1965 ein Exemplar mit Monofenster-Datumsanzeige auf den Markt. Bis dahin hatte es nur Zeiger- oder Doppelfensterdatum gegeben. Logischerweise machte auch die „Carrera 45 Dato" von sich reden.

Mit der Vorstellung des weltweit ersten Modul-Chronographen mit Mikrorotor-Selbstaufzug, Schwingtrieb-Kupplung und Kulissen-schaltung ging bei Heuer auch eine neue Uhrenlinie einher. Die quadratische „Monaco"-Schale war zugleich auch wasserdicht. Als Botschafter empfahl sich der Formel-1-Pilot Jo Siffert. Folglich trug auch Steve McQueen im Film *Le Mans* zum Original-Jo-Siffert-Dress die „Monaco".

Die Serie 1000 von 1992 wandte sich u. a. an Taucher, welche unter extremen Druckverhältnissen arbeiten müssen. Trotz beachtlicher Wasserdichte bis 100 Bar Druck kam die Schale ohne das übliche Heliumventil aus.

„Kirium Ti5", gestaltet von Jörg Hysek, leitete 1998 eine neue Design-Ära ein. Signifikantes Charakteristikum war der fließende, organische Übergang vom Gehäuse zum Armband. Darüber hinaus präsentierte TAG Heuer neue Hochleistungs-Werkstoffe: Karbon für das Zifferblatt und Titan für Gehäuse und Band.

Mechanik oder Elektronik? Diese Frage stellte sich nicht bei der „Monaco Sixty Nine", Jahrgang 2003. Die innovative Armbanduhr vereinte im Wendegehäuse je ein tickendes und ein quarz-gesteuertes Uhrwerk.

2004 debütierte die „V4" als Konzept-Uhr. 2009 war sie Realität. Die kinetische Energie des linearen Schwungkörpers wird über zwei Mikro-Zahnriemen mit Metallseele an gleich vier Federhäuser weitergeleitet. Den Zeittakt liefert eine konventionelle Unruh.

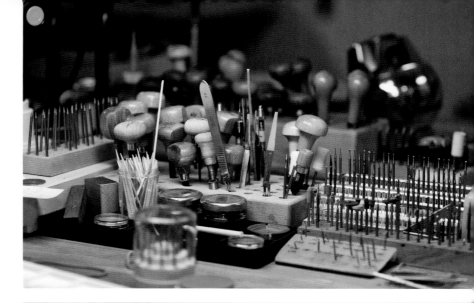

Eine Armbanduhr mit zwei Werken war 2006 die Weltpremiere namens „Carrera Calibre 360 LE". Eines indiziert die Uhrzeit, das andere stoppt Zeitintervalle auf die Hundertstelsekunde genau.

2010, im Jahr des 150. Firmenjubiläums, kehrte TAG Heuer zur uhrmacherischen Manufaktur zurück. Beim Automatikkaliber 1887 mit Schwingtrieb-Chronograph hatten die Konstrukteure auf ein Uhrwerk von Seiko zurückgegriffen. Die Fertigung des aus 320 Teilen zusammengefügten Œuvres erfolgt komplett in der Schweiz.

Auf die Tausendstelsekunde stoppt der mechanische „Mikrotimer Flying 1000 Concept Chronograph", dessen Geburtsstunde 2011 schlug. Analog zu den Hundertstelsekunden-Vorbildern besitzt die Armbanduhr zwei getrennte Getriebeketten mit je einem Schwing- und Hemmungssystem. Zehn angemeldete Patente künden vom vorangehenden Einfallsreichtum.

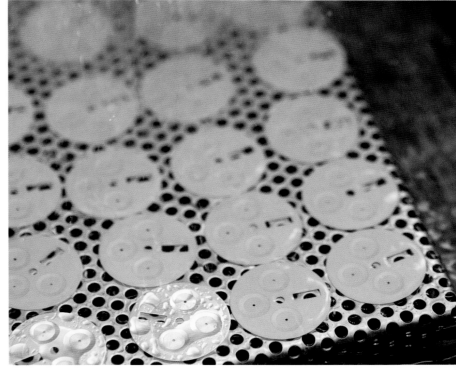

Kurzzeitmessung auf die 5/10 000stel oder 1/2 000stel Sekunde genau bietet der mechanische „Mikrogirder". Stündlich 7 200 000 Halbschwingungen leistet keiner der herkömmlichen Gangregler. Ergo kooperieren in dieser Konstruktion, für die gleich zehn Patente beantragt wurden, drei rechtwinklig angeordnete Metallklingen. Geburtsjahr war 2012.

Im gleichen Jahr krönte „MikrotourbillonS2" mit zwei unterschiedlich schnellen Tourbillons die Tempo-Philosophie. Das flottere, Unruhfrequenz 50 Hertz, liefert den Takt zum Stoppen auf die Hundertstelsekunde genau. Konventioneller Natur ist der für die Zeitanzeige zuständige Drehgang.

Auf dem Kaliber 1887 basiert die 2015 vorgestellte „Carrera Heuer 01". Die speziell gestaltete Vorderseite verbirgt nichts. Der Sichtboden ebenfalls nicht. Aus zwölf Teilen ist die bis zehn Bar wasserdichte „Carrera"-Schale modular konzipiert. Das eröffnet die Kombination unterschiedlicher Materialien, Oberflächen und Farben.

Bleibt last, but not least der „Carrera"-Tourbillon-Chronograph von 2016. Anhand des Kalibers Heuer 02T demonstrieren Jean-Claude Biver und sein Team, dass komplizierte Manufakturarbeit mit Automatikchronograph und Drehgang nicht unerschwinglich teuer sein muss. Die unlimitierte Ausführung mit Titangehäuse kostet weniger als 15 000 Euro. ◦

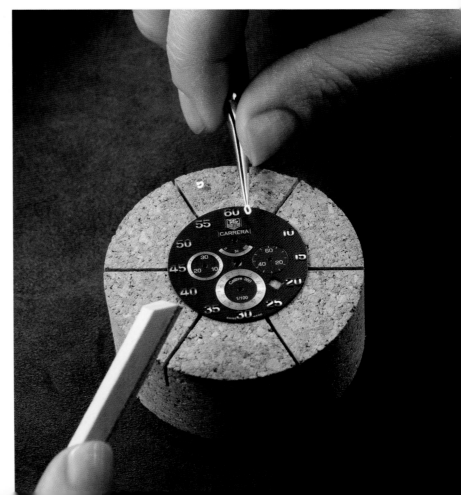

Opposite page: Time of Trip, 1911

ArteCad dial manufacturing, from top: Gemstone-setting workshop ◦ Surface treatment (sand blasting) ◦ Index setting ◦
Zifferblattfabrik ArteCad, von oben: Blick in die Werkstatt ◦ Oberflächenbehandlung (mit Sandstrahl) ◦ Zifferblattgestaltung ◦
Manufacture de cadrans chez ArteCad, de haut en bas : Atelier d'empierrage ◦ Traitement de surface (sablage) ◦ Pose des index

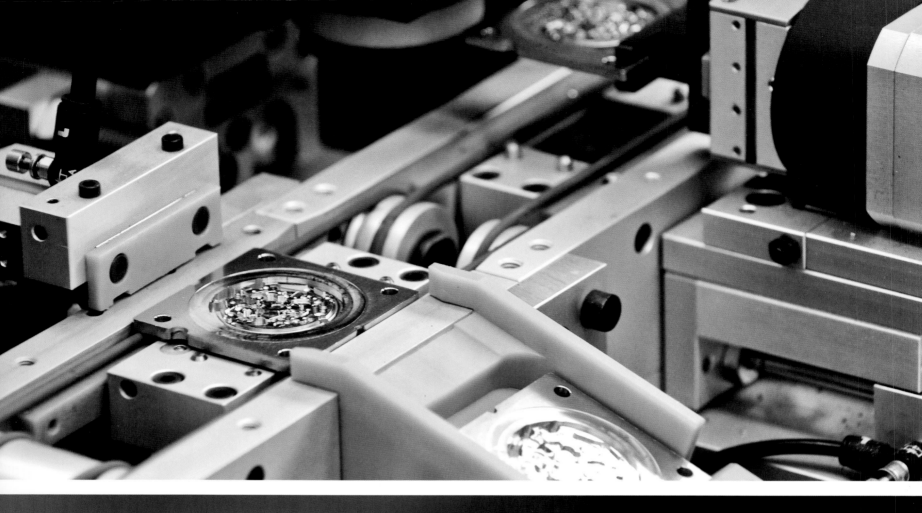
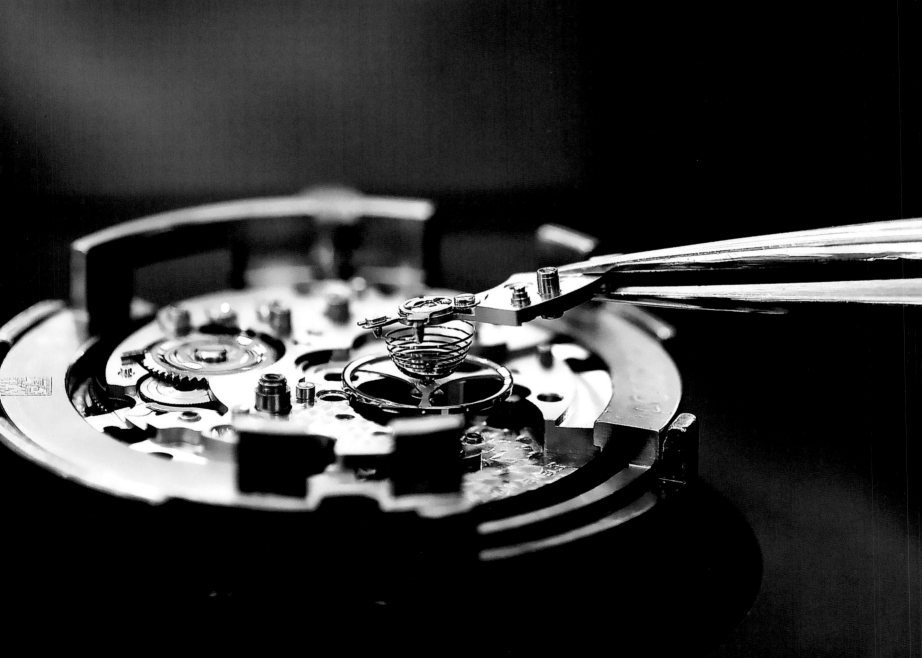

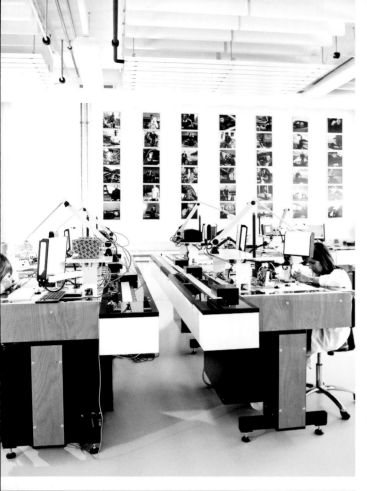

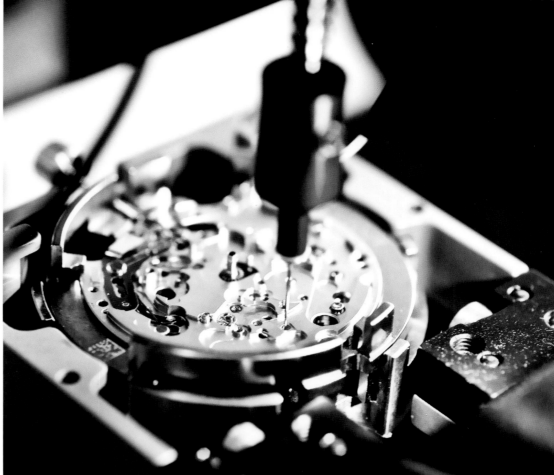

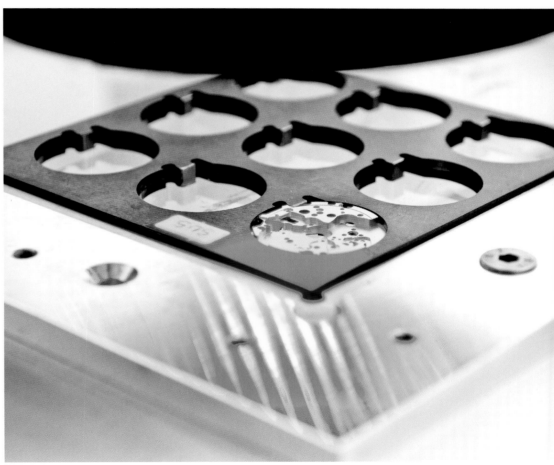

Clockwise from opposite page top left: Milling of the main plates of TAG Heuer movement ◦
Movement assembly workshop ◦ Drilling of the main plate, in-house movement ◦ Laser
controlling ◦ Hairspring setting ◦ Von oben links im Uhrzeigersinn: Fräsen der Hauptplatinen
für die Uhrwerke von TAG Heuer ◦ Uhrwerkmontage-Atelier ◦ Bohren der Hauptplatine,
Manufakturwerk ◦ Kontrolle per Laser ◦ Einsetzen der Unruhspirale ◦ Dans le sens horaire,
en partant du haut de la page ci-contre : Fraisage des platines des mouvements TAG Heuer ◦
Atelier d'assemblage des mouvements ◦ Perçage de la platine sur un mouvement
de manufacture ◦ Commande laser ◦ Pose du spiral

D'une manufacture de chronographes à l'autre

Quand Heuer devient TAG Heuer

Les chronographes sont un véritable fil rouge dans la vie d'Édouard Heuer (né en 1840) et de ses descendants. À l'âge de 14 ans, il entre en apprentissage chez un horloger. Après ses premières expériences professionnelles et son mariage, il s'installe à son compte. Il a alors 20 ans. En 1865, il s'établit à Bienne, où il élabore un remontoir à couronne qui rend toute clé inutile et lui vaudra son premier brevet, en 1869. En ces temps de crise, il prend conscience que le salut est dans la spécialisation. C'est pourquoi sa collection compte dès 1882 des chronographes – dont certains font l'objet de brevets – qu'il a lui-même fabriqués. La veille de la Noël 1886, Édouard Heuer dépose une demande de brevet pour le pignon oscillant moderne, invention restée d'actualité. D'autres inventions dans le domaine suivront.

En 1889, ce chef d'entreprise se voit décerner une médaille d'argent lors de l'Exposition universelle à Paris pour sa large gamme de montres. Lorsqu'il décède brusquement le 30 avril 1892, il laisse une confortable fortune nette de 552 750 francs suisses.

Cette base financière permet à ses fils Jules-Édouard et Charles-Auguste de poursuivre ses activités. Après le décès de Jules-Édouard le 12 juillet 1911, Charles-Auguste endosse seul la responsabilité des affaires. On lui doit entre autres un chronographe avec cadran pulsomètre et le « Mikrograph » en 1916. Cette montre stop révolutionnaire permet de chronométrer au 1/100e de seconde. Cette dernière et ses dérivées séduiront les chronométreurs des Jeux olympiques de 1920, 1924 et 1928. En 1913, Heuer signe ses premières montres-bracelets. La génération suivante, représentée par Charles-Édouard et Hubert-Bernard, s'attache à

renforcer la présence de la marque sur des marchés clés. En 1919, ils rachètent la marque horlogère Jules Jürgensen, qu'ils revendront en 1936. Après 1929 et la crise économique mondiale qui s'ensuit, Heuer doit surmonter de nombreuses turbulences. La survie de la marque est assurée par des produits innovants, notamment des montres stop et des chronographes aux fonctions très variées. En 1947, le prince Guillaume de Suède et le président américain Harry S. Truman portent des montres-bracelets Heuer en or.

La dernière génération est représentée par Jack William Heuer. Né en 1932, le fils de Charles-Édouard acquiert les qualifications requises pour ses futures fonctions de direction grâce à ses études d'ingénierie et son expérience pratique aux États-Unis. En 1958, il suit les traces de ses aïeux. En qualité d'associé dans l'entreprise familiale, il opère en 1964 la fusion de Heuer avec Leonidas, donnant naissance à Heuer-Leonidas. En 1968, les livres comptables font apparaître dix millions de francs suisses de chiffre d'affaires, et le double dès 1970. Mais un besoin urgent en capitaux entraîne l'introduction en Bourse. Jack W. Heuer, qui figure parmi les pionniers incontestés des instruments de chronométrage électronique, doit désormais dégager des dividendes. Or, la conjoncture mondiale difficile et la concurrence asiatique à bas prix contrecarrent sérieusement ses plans. À dater de 1976, il est rattrapé par la crise du quartz et, en 1981, par les conséquences de l'annulation d'une commande de chronomètres par la Chine. La dernière assemblée générale publique des actionnaires de Heuer-Leonidas SA se tient le 25 juin 1982. Jack W. Heuer, qui s'oppose à la faillite, et les autres détenteurs d'actions nominatives doivent voter l'amortissement de leur capital social et la dissolution des réserves existantes.

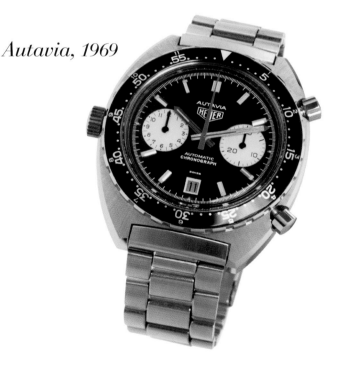

Autavia, 1969

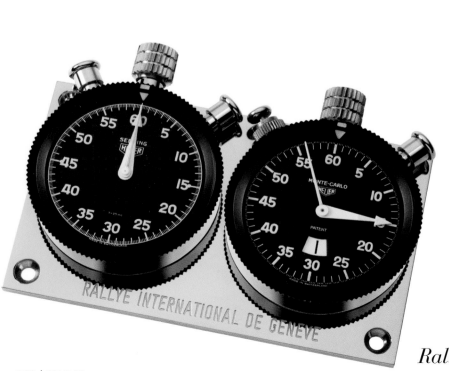

Rallye International de Genève, 1960

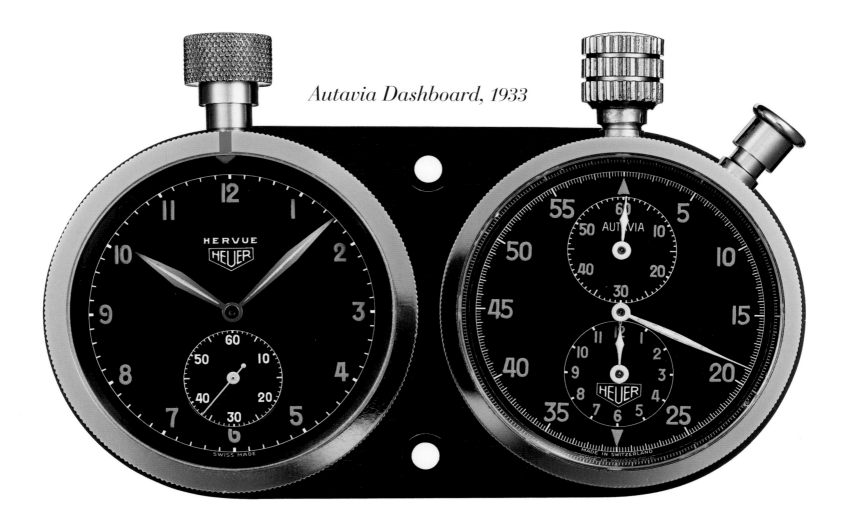

Autavia Dashboard, 1933

Les nouveaux actionnaires de contrôle sont la Nouvelle Lemania et ses propres actionnaires, dont la maison Piaget. À compter de 1985, la majorité des actions appartient au groupe d'envergure internationale TAG (Techniques d'Avant-Garde). Heuer devient TAG Heuer. Grâce à des montres nettement plus commerciales, le plus souvent dotées de mouvements électroniques à quartz, à un marketing réussi par l'association avec la Formule 1 et des campagnes publicitaires qui décoiffent, TAG Heuer renaît de ses cendres comme le Phénix. À partir de 1996, les actions TAG Heuer SA sont à nouveau négociées en Bourse. Avec plus de 715 000 montres vendues par an et un chiffre d'affaires de près de 420 millions de francs suisses, TAG Heuer devient en 1996 la cinquième société horlogère suisse. 1997 marque le retour de Jack W. Heuer comme conseiller, ainsi que de la légendaire « Carrera » de 1963.

En 1998, TAG Heuer célèbre la renaissance de l'avant-gardiste « Monaco ».

En septembre 1999, la multinationale française du luxe LVMH acquiert la marque de montres de sport riche d'une longue tradition pour près de 1,2 milliard de francs suisses. Sous son égide, TAG Heuer s'impose comme une véritable manufacture de montres, avec nombre de calibres innovants et quatre sites de production dans l'Arc jurassien en Suisse romande. À partir de novembre 2000, c'est Jean-Christophe Babin, l'actuel PDG de Bulgari, qui prend les rênes de la société. Il est à l'origine des chronomètres haute fréquence « 360 », « Mikrograph », « Mikrogirder » et « MikrotourbillonS ». L'ingénieur mathématicien Guy Sémon, à qui l'on devra de nombreuses révolutions dans le secteur de l'horlogerie, met un pied dans la maison à la faveur du développement de la concept watch révolutionnaire « Monaco V4 » lancée en 2004. La véritable sensation sera pour 2016. Une grande transformation structurelle débute le 1er mars 2014 avec Jean-Claude Biver, responsable de la coordination entre Hublot, TAG Heuer et Zenith. Découvrant qu'il est urgent de prendre des mesures, il endosse début 2015 la fonction de PDG et fait prendre un virage à 180 degrés à la marque suisse de tradition. Son crédo : « TAG Heuer doit proposer des montres à la mesure du pouvoir d'achat du client traditionnel. » Ce pouvoir d'achat est estimé entre 1 000 et 5 000 francs suisses. Les ambassadeurs célèbres de la marque, comme Cara Delevingne, Chris Hemsworth, David Guetta ou Tom Brady, ainsi que la remarquable « Carrera Heuer 01 », la montre connectée « Connected » plébiscitée, le chronographe tourbillon au prix concurrentiel « Carrera Heuer 02 » ou encore la coopération avec l'écurie Red Bull laissent deviner l'orientation qui sera prise à l'avenir. ○

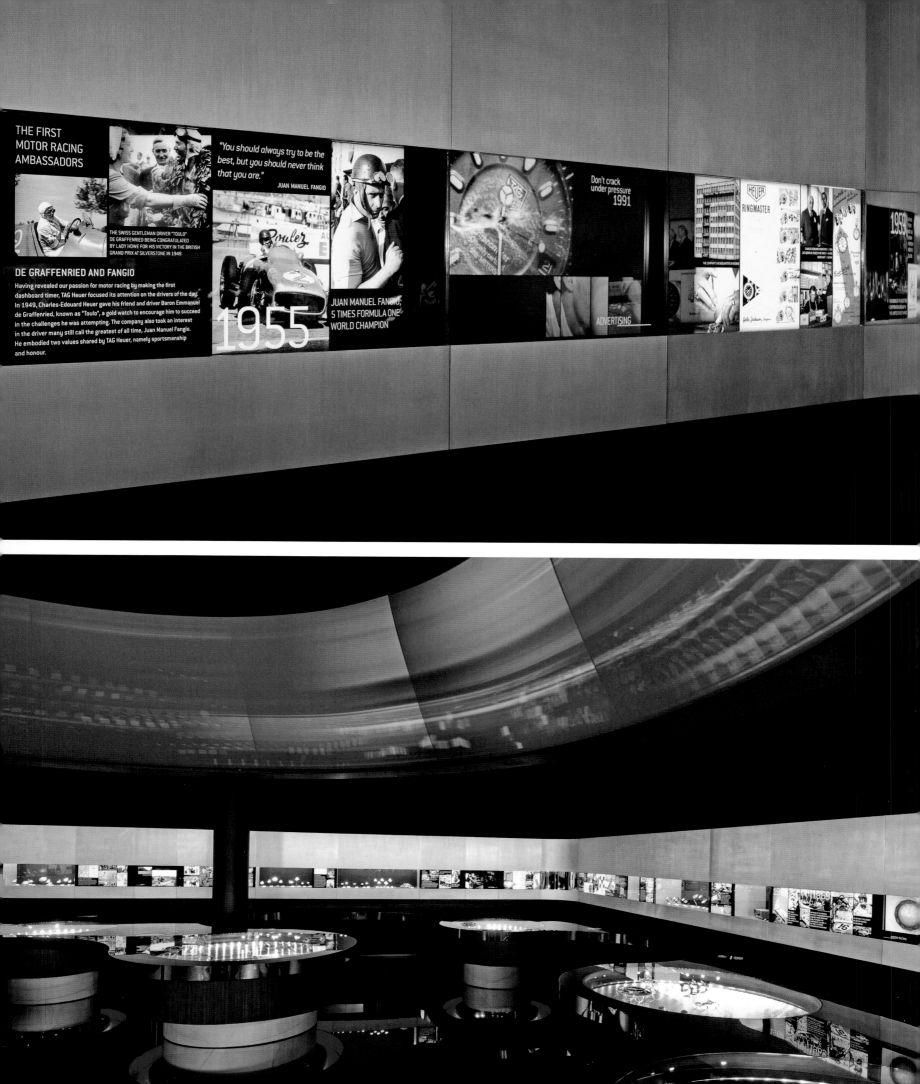

THE FIRST MOTOR RACING AMBASSADORS

"You should always try to be the best, but you should never think that you are."

JUAN MANUEL FANGIO

THE SWISS GENTLEMAN DRIVER "TOULO" DE GRAFFENRIED BEING CONGRATULATED BY LADY HOWE FOR HIS VICTORY IN THE BRITISH GRAND PRIX AT SILVERSTONE IN 1949

DE GRAFFENRIED AND FANGIO

Having revealed our passion for motor racing by making the first dashboard timer, TAG Heuer focused its attention on the drivers of the day. In 1949, Charles-Edouard Heuer gave his friend and driver Baron Emmanuel de Graffenried, known as "Toulo", a gold watch to encourage him to succeed in the challenges he was attempting. The company also took an interest in the driver many still call the greatest of all time, Juan Manuel Fangio. He embodied two values shared by TAG Heuer, namely sportsmanship and honour.

1955

JUAN MANUEL FANGIO, 5 TIMES FORMULA ONE WORLD CHAMPION

Don't crack under pressure 1991

HEUER RINGMASTER

ADVERTISING

Mouvements, boîtiers et cadrans

Juridiquement, il n'existe pas de définition claire de ce qu'est une manufacture de montres. On sait que le fabricant doit réaliser lui-même au moins un calibre. La société qui prétend à ce titre doit en outre fabriquer les éléments de soutien de l'ensemble des composants du mouvement, autrement dit la platine et les différents ponts. Pour TAG Heuer, l'heure de l'autonomie sonne en 2010, avec le calibre sous licence 1887 (Heuer 01). Il est important de savoir que les chronographes posent des défis très délicats, compte tenu des relations complexes entre les fonctions qu'ils proposent. Pour ce premier mouvement de manufacture, l'expertise suisse se manifestera dans l'analyse différenciée et l'optimisation très poussée du calibre japonais ayant servi de plateforme. Pour sa part, le calibre Heuer 02 à remontage automatique, avec son chronographe et son tourbillon minute novateur dans sa cage en carbone léger très résistant, sera entièrement réalisé en Suisse.

Une manufacture est structurée, comme tout microcosme mécanique. Chez TAG Heuer, les développeurs de produits, constructeurs et concepteurs travaillent au siège de La Chaux-de-Fonds : boîtiers, cadrans, aiguilles, bracelets et mouvements, ils s'occupent de tout. Pour des raisons de capacité et de compétitivité – les mouvements de manufacture sont foncièrement plus chers que les mouvements achetés –, TAG Heuer transforme aussi des calibres éprouvés des marques Eta et Sellita. Les prototypistes travaillent également au siège. Enfin, dans un immense laboratoire, des « tortionnaires » infligent les pires sévices aux produits destinés à la fabrication en série.

C'est à Chevenez, un village retiré près de la frontière française, où l'on trouve plus facilement la main-d'œuvre requise, qu'est créé l'atelier de fabrication (de pièces de mouvements) T0. Le fraisage et le façonnage des platines et des ponts sont confiés à des centres d'usinage flexibles de dernière génération pilotés par ordinateur. Dans l'atelier T1 voisin, une centaine d'opérations sont ensuite nécessaires pour obtenir des mouvements chronographes aboutis à partir d'éléments de qualité contrôlée. L'automatisation garantit ici aussi une qualité optimale. Suite à une réorganisation radicale, la part des composants fabriqués en interne sur les mouvements maison dépasse 50 pour cent.

Le client qui achète une montre-bracelet signée TAG Heuer bénéficie automatiquement de la protection inhérente à la production en interne. Dans la localité de Cornol, près de Chevenez, la société exploite une fabrique ultramoderne de boîtiers qui emploie actuellement environ 140 personnes. Celles-ci produisent essentiellement des boîtiers en acier pour les garde-temps de toutes les collections, de « Aquaracer » à « Monza », dans le bruit assourdissant des estampeuses à l'aspect guerrier, et dans une moindre mesure, des centres d'usinage pilotés par ordinateur. Le poli final est l'œuvre de robots infatigables et d'ouvriers hautement spécialisés. À un contrôle rigoureux succèdent l'assemblage et, pour finir, le test d'étanchéité.

Troisième membre de l'équipe, ArteCad est une manufacture de cadrans traditionnelle. Rien n'a de secret pour cette filiale de TAG Heuer installée à Tramelan, même les techniques réputées oubliées. La complexité s'est brusquement accrue ces dernières années pour les nouveaux cadrans, notamment ceux de la « Carrera Heuer 01 » et de la « Carrera Heuer 02T ». Ces « visages du temps » sont des œuvres d'art tridimensionnelles aux multiples composants. Les activités mécaniques et manuelles vont de pair chez ArteCad. L'objectif visé est la perfection absolue. Lorsqu'on jette un coup d'œil à sa montre, c'est en effet le cadran et les aiguilles tournant sur cet arrière-plan que l'on voit en premier.

L'assemblage et le contrôle final du produit, qui est comme on sait bien plus que la somme de ses multiples composants, sont assurés par les ateliers de La Chaux-de-Fonds. Les montres terminées se dispersent alors dans le monde entier. TAG Heuer a beau être déjà une marque internationale, Jean-Claude Biver souhaite encore renforcer cette présence tout autour du globe. ○

Solunar, 1949

Opposite page: TAG Heuer 360 museum, opened in 2008. More than 300 timepieces illustrating more than 150 years of history, from 1860 to the present day. Rich iconography. ○ *Gegenüberliegende Seite: Reichhaltiges Bildmaterial versammelt das TAG Heuer 360 Museum. 2008 eröffnet, präsentiert es 300 Uhren aus über 150 Jahren Geschichte – von 1860 bis heute.* ○ ***Page ci-contre :*** *Musée TAG Heuer 360, ouvert en 2008. Plus de 300 garde-temps illustrent plus de 150 ans d'histoire, de 1860 à nos jours. Riche iconographie.*

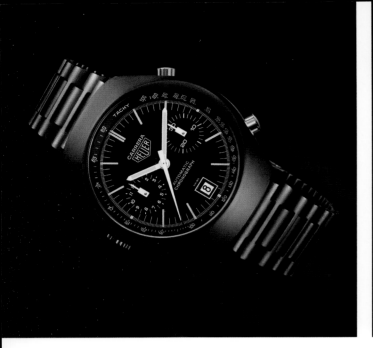
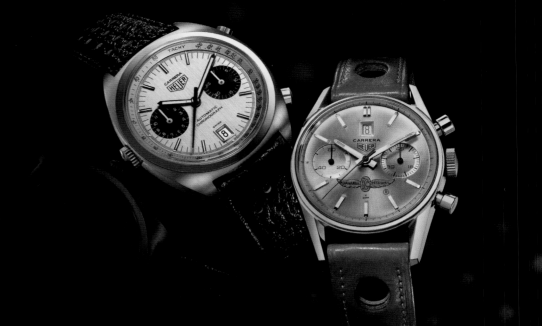

Jalons dans l'histoire des chronomètres et chronographes depuis 1887

Français

Le premier temps fort est assurément le brevet du chronographe de poche à pignon oscillant en 1887. Ce pignon remplit la même fonction que les anciennes grandes roues des mouvements tout en réduisant nettement le coût d'un mouvement à chronographe.

Le « Time of Trip », premier compteur de bord Heuer, séduit par son grand ensemble cadran-aiguilles, parfaitement lisible même par mauvaise visibilité. Dès 1911, on le trouve dans les cockpits d'avions et les habitacles d'automobiles. En 1919, lors de la première traversée de l'Atlantique en dirigeable, l'équipage du R-34 s'en servira, tout comme Hugo Eckener lors de son tour du monde à bord du « Graf Zeppelin » en 1929.

Le développement du premier compteur mécanique au monde débute en 1914. Le brevet est délivré le 2 octobre 1916. Un petit balancier oscillant à 50 Hertz permet d'atteindre une précision de 1/100ᵉ de seconde. Comme l'indique le catalogue, le « Mikrograph » est fait « pour le chronométrage de projectiles et d'autres mesures de temps courts ». Il coûte 100 francs suisses, soit 120 dollars de l'époque.

Les compteurs de bord Heuer sont très prisés des collectionneurs. À compter de 1933, « Autavia », combinaison d'une montre et d'un chronomètre, figure sur de nombreux tableaux de bord, assistant par exemple des pilotes de course et de rallyes. Les pilotes d'avion et les capitaines de navire se fient eux aussi aux accessoires de mesure du temps fabriqués à Bienne, connus sous le nom de « Rally-Master » à partir de la fin des années 1950.

Toujours dans les années 1930, Heuer se consacre activement aux boîtiers étanches pour chronographes. Son chronographe de poignet à protection étanche plaît beaucoup à l'armée suisse, et en 1942 débute la production de chronographes étanches à cadran noir pour l'usage militaire.

L'année 1949 marque la sortie de la « Solunar », une montre-bracelet brevetée « pour les pêcheurs, chasseurs, marins, sportifs, naturalistes, scientifiques, médecins, agriculteurs, éleveurs d'oiseaux, jardiniers et gardes forestiers », comme le précise le catalogue de l'époque. Outre le temps, elle indique aussi la phase de lune, les heures où les poissons se nourrissent et les marées. Une pression sur un bouton-poussoir assure la synchronisation avec les tables de marées locales.

Lancé en 1962, le « Yachting Timer » aide les régatiers dans la phase délicate précédant le début de la course. Après le signal de départ, ce chronomètre renseigne de manière fiable sur l'état d'avancement du compte à rebours jusqu'au début effectif de la course.

« Autavia », nom facile à retenir, fait son retour en 1962, sous la forme d'un chronographe de poignet. La lunette tournante à l'intérieur du boîtier en acier est disponible en plusieurs versions, notamment pour pilotes, plongeurs sous-marins et scientifiques.

Alors qu'il assure en personne le chronométrage officiel d'une célèbre course automobile, les 12 Heures de Sebring, Jack W. Heuer entend parler de la Carrera Panamericana, une compétition automobile de légende. Aussi donne-t-il le nom « Carrera » au chronographe au grand cadran tridimensionnel qu'il présente en 1963. L'échelle des secondes est placée sur le réhaut, entre le cadran et le Plexiglas incurvé.

En 1965, pour la première fois dans l'histoire des chronographes, Heuer met sur le marché un modèle à guichet dateur remplaçant le quantième à aiguille ou à double guichet. Le « Carrera 45 Dato » fait donc logiquement parler de lui.

La présentation du premier chronographe au monde à mouvement modulaire et remontage automatique à micro-rotor, pignon oscillant et groupe commandes à came annonce l'arrivée d'une nouvelle ligne de montres chez Heuer. Le boîtier carré du chronographe « Monaco » est par ailleurs étanche. Le pilote de Formule 1 Jo Siffert s'avère être un excellent ambassadeur pour ce modèle. Steve McQueen, vêtu de la combinaison originale de Jo-Siffert, le portera également dans le film *Le Mans*.

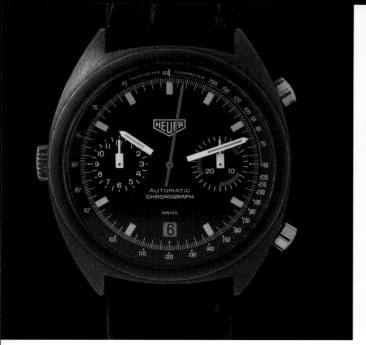 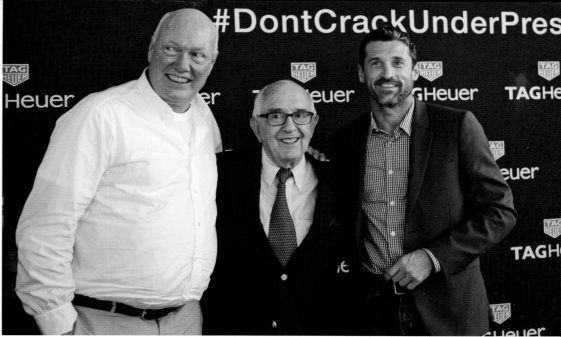

From left: Carrera, 1978 ∘ Carrera, 1969 and 1965 ∘ Heuer Monza, 1976 ∘ Jean-Claude Biver, Jack Heuer, and Patrick Dempsey, 2015

La série 1000 de 1992 s'adresse en particulier aux plongeurs sous-marins, qui doivent travailler par des pressions extrêmes. Le boîtier est d'une remarquable étanchéité jusqu'à 100 bars de pression, même sans l'habituelle valve à hélium.

Conçu par Jörg Hysek, la montre « Kirium Ti5 » marque en 1998 le début d'une nouvelle ère en matière de design. Elle se caractérise principalement par la transition organique fluide entre le boîtier et le bracelet. TAG Heuer propose en outre des matériaux ultra-performants : carbone pour le cadran, et titane pour le boîtier et le bracelet.

Mécanique ou électronique ? La question ne se pose pas pour la « Monaco Sixty Nine », sortie en 2003. Cette montre-bracelet innovante réunit dans son boîtier réversible un mouvement mécanique au recto et un mouvement à quartz au verso.

Débutant en 2004 comme concept watch, le « V4 » devient réalité en 2009. L'énergie cinétique du corps oscillant linéaire est transmise par deux courroies dentées microscopiques à âme métallique simultanément à quatre barillets. Le signal de rythme est fourni par un balancier traditionnel.

En 2006, la montre-bracelet à deux mouvements baptisée « Carrera Calibre 360 LE » est une première mondiale. Un mouvement affiche l'heure, l'autre chronomètre des intervalles de temps au 1/100e de seconde.

En 2010, année du 150e anniversaire de la société, TAG Heuer fait un retour à la fabrication en interne. Pour le calibre 1887 à remontage automatique et chronographe à pignon oscillant réalisé à la fin des années 1990, les constructeurs étaient partis d'une plateforme Seiko. Le nouveau mouvement constitué de 320 composants est cette fois entièrement fabriqué en Suisse.

Apparu en 2011, le concept chronographe mécanique « Mikrotimer Flying 1000 » mesure et affiche le 1/1000e de seconde. Comme ses prédécesseurs mesurant le 1/100e de seconde, cette montre-bracelet dispose pour l'embrayage de deux chaînes séparées, avec chacune un système d'oscillation et d'échappement. Les dix demandes de brevet déposées témoignent de la capacité d'innovation de la marque.

Le régulateur mécanique « Mikrogirder » découpe le temps au 5/10 000e (1/2 000e) de seconde. Aucun régulateur de marche existant n'avait encore atteint ses 7 200 000 alternances à l'heure. Cette construction de 2012, pour laquelle dix demandes de brevet sont en cours, fait appel à trois lamelles métalliques, dont une est perpendiculaire aux autres.

La même année, le chronographe « MikrotourbillonS », avec ses deux mécanismes de tourbillon de vitesses différentes, marque le couronnement de la philosophie de recherche de vitesse. Le tourbillon le plus rapide, qui affiche une fréquence de 50 Hertz, contrôle le chronographe au 1/100e de seconde. Le tourbillon responsable de l'affichage de l'heure se rapproche plus des tourbillons traditionnels.

Présenté en 2015, le chronographe « Carrera Heuer 01 » repose sur le calibre 1887. Côté cadran comme côté fond, le design spécialement épuré ne cache rien de la mécanique. La conception modulaire du boîtier « Carrera » étanche jusqu'à dix bars permet de jouer sur les matériaux, les surfaces et les couleurs de ses douze composants.

Le chronographe automatique avec tourbillon « Carrera » de 2016 est le dernier arrivé mais non le moindre. Avec le calibre Heuer 02T, Jean-Claude Biver et son équipe ont démontré que le travail complexe de fabrication en manufacture d'un chronographe à remontage automatique avec tourbillon ne devait pas forcément être inabordable. Les exemplaires de l'édition illimitée à boîtier en titane coûtent moins de 15 000 euros. ∘

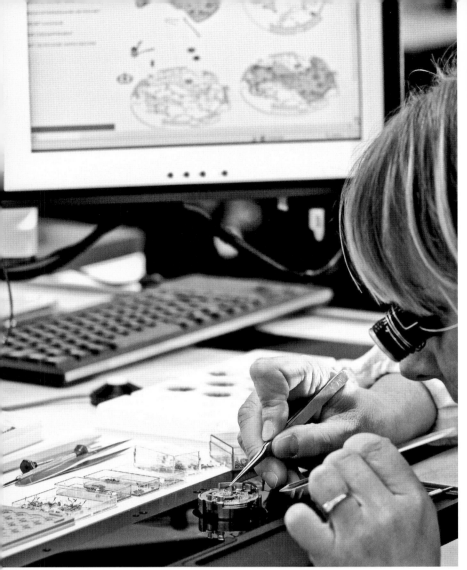

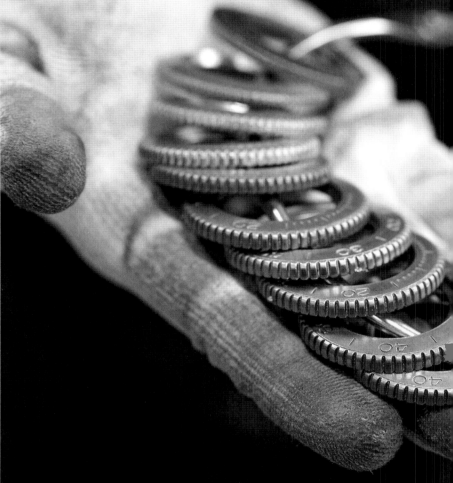
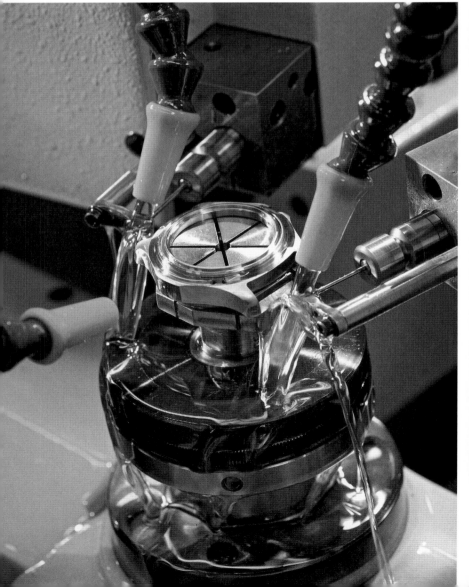
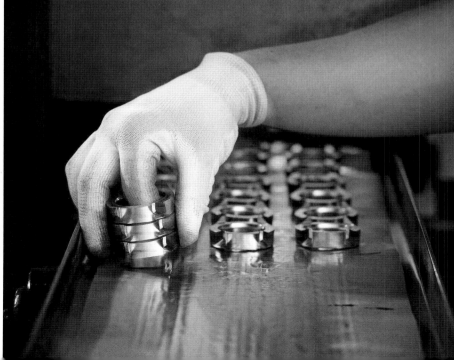

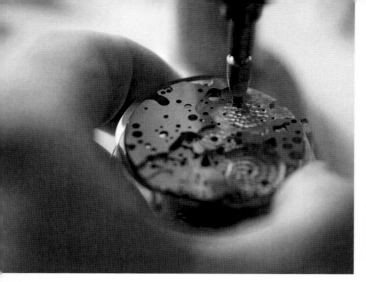
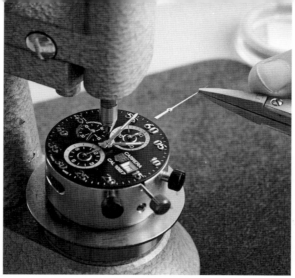
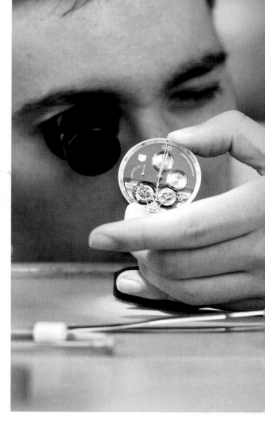
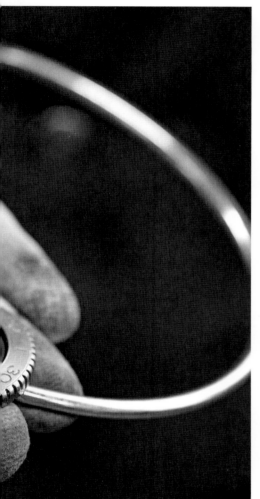
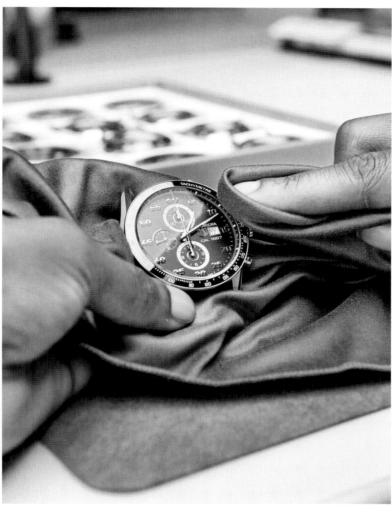

Movements, cases and dials:
TAG Heuer, as a true manufacture,
masters all the steps to produce a watch.
This extensive expertise contributes to
providing high-quality timepieces.
Uhrwerke, Gehäuse und Zifferblätter:
Als echte Manufaktur beherrscht
TAG Heuer alle Schritte der Uhren-
herstellung. Dank umfassender Expertise
entstehen hier Zeitmesser erster Güte.
Mouvements, boîtiers et cadrans :
TAG Heuer, en tant que véritable
manufacture, maîtrise toutes
les étapes de fabrication des montres.
Cette expertise étendue participe
à la production de garde-temps
d'exception.

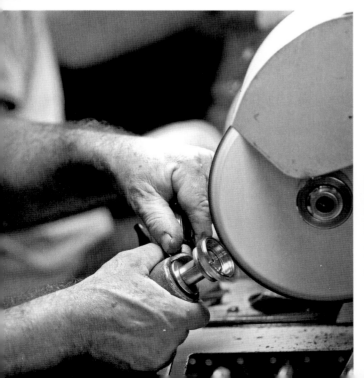
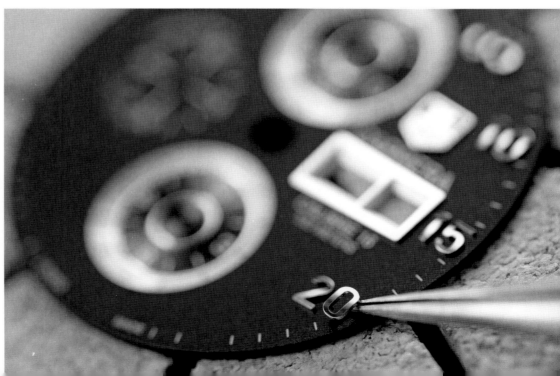

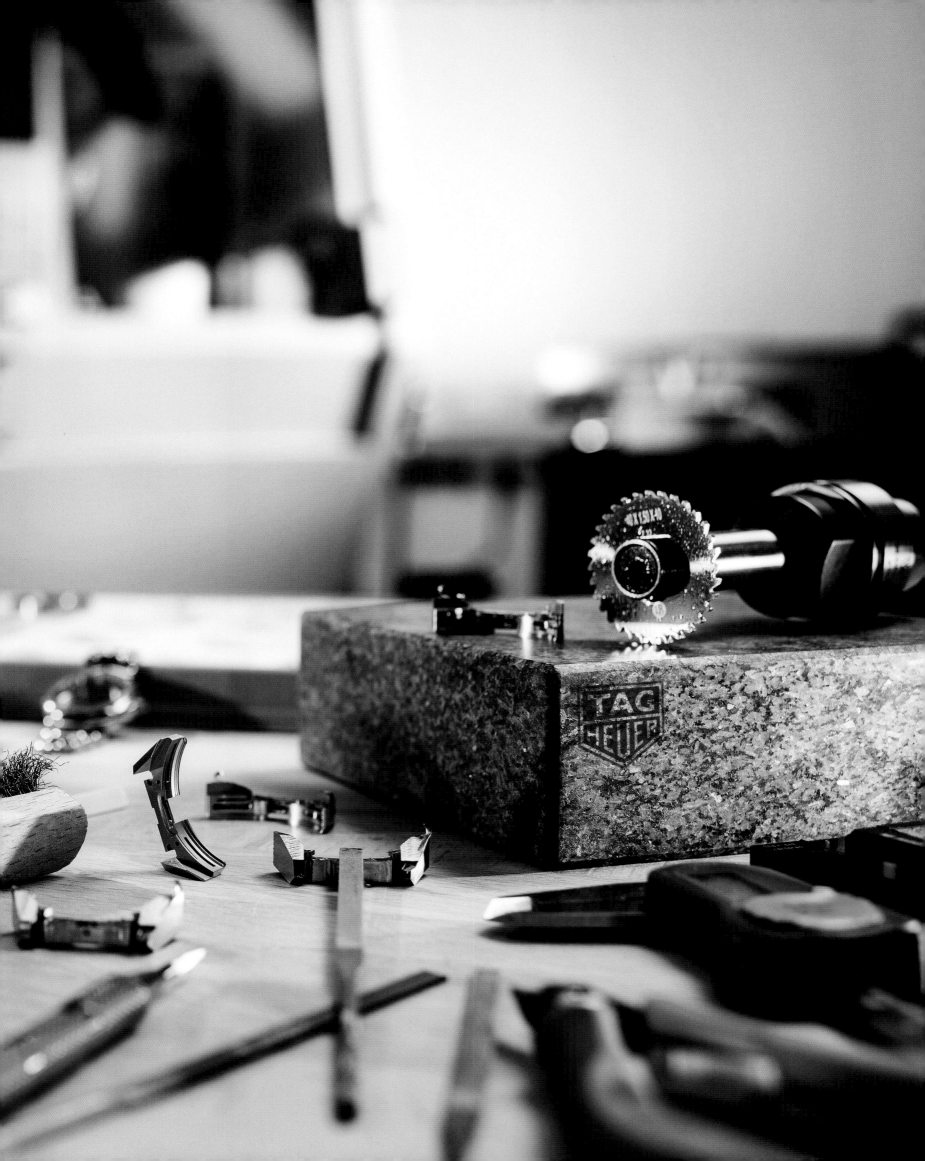

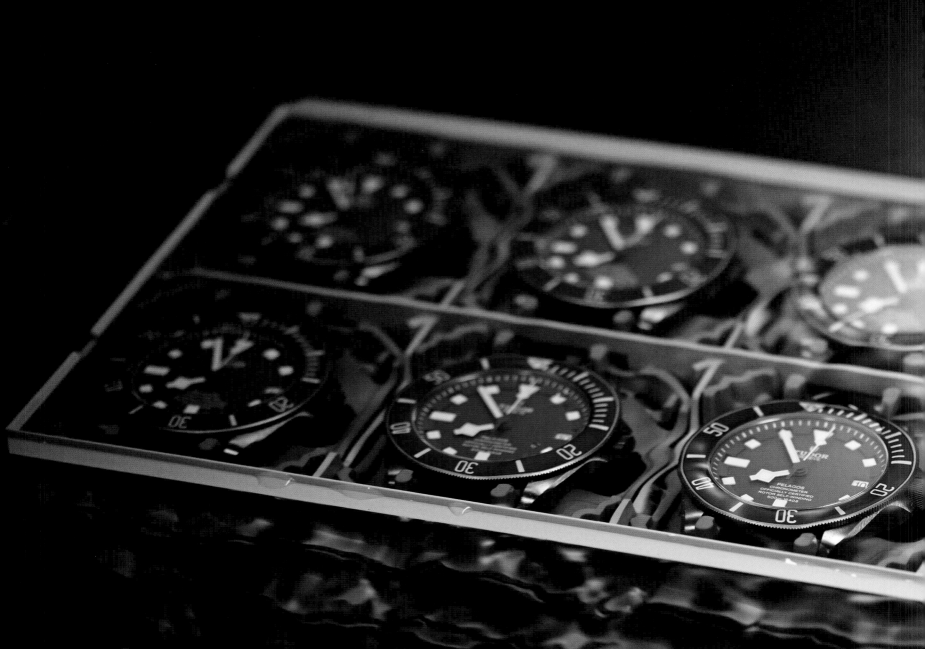

Tudor

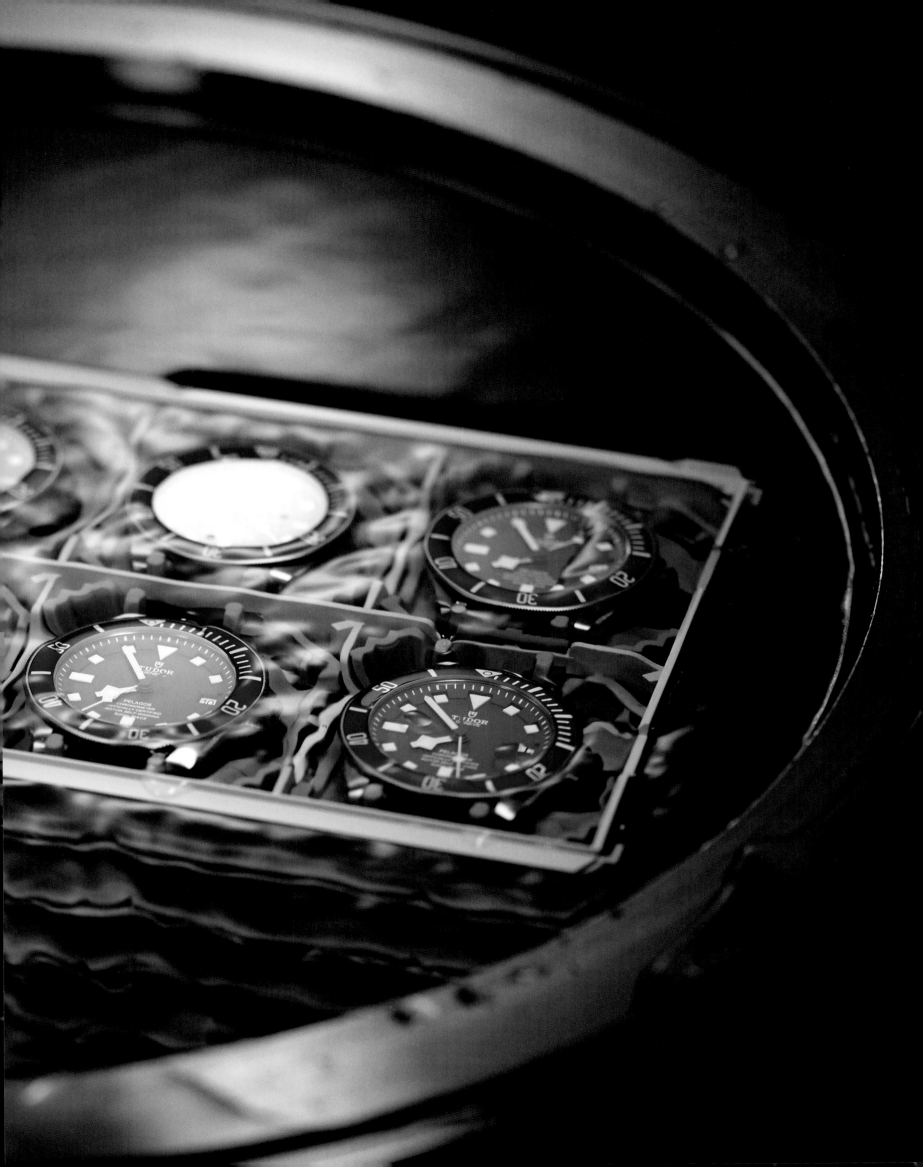

The Rolex for Beginners

Hans Wilsdorf wasn't only a marketing genius par excellence: he also cultivated a special affinity for Great Britain. It was in this island kingdom that he began his victory march into the world of precise time measurement in 1905. Three years later, this prompted him to establish the Rolex brand there. A native of Bavaria, Wilsdorf enthusiastically accepted British citizenship. It's well known that one cannot stand stably on only one leg, so Hans Wilsdorf registered a variety of brand names as protected trademarks. He ultimately used only a few of these monikers: for example, Tudor, which is the name of the English royal family that reigned from 1485 to 1603. When Hans Wilsdorf first took an interest in this name, the rights to its use where held by Isaac Blumenthal, a jewelry merchant in Geneva. A document on the letterhead of Horlogerie H. Wilsdorf and dated 1926 affirms that the Veuve de Philippe Hüther watch factory registered "The Tudor" brand for Wilsdorf's company to use on horological products of all varieties. The first timepieces bore this insignia without any additional logo. When Wilsdorf finally acquired unlimited rights in 1936, the stylized rose of the Tudor Dynasty was added as a trademark, initially with and later without a coat-of-arms. The name "Rolex SA" was engraved into the backs of the few pillow-shaped Tudor models from the 1940s. Hans Wilsdorf made no attempt to conceal the fact that watches bearing the Tudor signature were fabricated in his well-established manufactory. In 1952, Hans Wilsdorf provided a personal explanation about Montres Tudor SA, which he had founded in 1946. In this clarification, he explained that he had long studied the options for watches for ladies and gents that he could offer to his concessionaries at less costly prices than those charged for Rolex timepieces. This led him to create the new label. The "Tudor Oyster Prince" had two advantages that connoisseurs already appreciated in Rolex watches: the famous watertight Oyster case and the Perpetual rotor winding mechanism. Ladies could opt for self-winding and non-watertight models. To preserve the necessary distance between Tudor and Rolex, the product strategy was based on a synthesis of existing elements (i.e., time-honored Oyster cases) and movements from third-party suppliers (e.g., Eta). These affordably priced timepieces sold surprisingly well, especially in the Middle Kingdom. Frogmen in the French navy in the late 1960s consulted the dial of a Tudor model that looked remarkably similar to Rolex's "Submariner." The U.S. Navy Seals soon followed in the wake of their European colleagues. Collectors are eager to get their hands on the "Monte Carlo" chronograph (Reference 7159/0), which encases hand-wound column-wheel Caliber Valjoux 234. Tudor has repeatedly attracted admiring attention in recent years by recalling its illustrious historical diver's watches, which were revived in retro models like the "Pelagos" and the "Heritage Black Bay." Rolex's affiliated company acquired manufactory status in 2015 with the debut of caliber family MT56xx with rotor winding and silicon hairspring in the cases of the minimalistically styled watches of the "North Flag" line. Caliber MT5621 supports a date display and a power-reserve indicator; Caliber MT5612 offers only a date window; and Caliber MT5601, which debuted in 2016, embodies purism by animating only three hands. It ticks in various versions of the bestselling "Heritage Black Bay," including a much-acclaimed version with a bronze case. ○

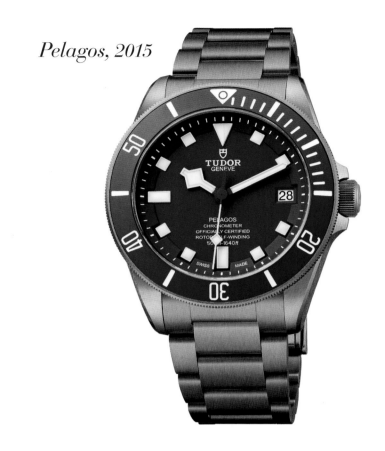

Pelagos, 2015

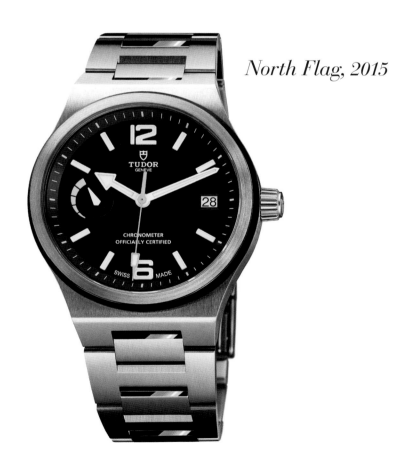

North Flag, 2015

Die Rolex für Einsteiger

Ohne jeden Zweifel besaß Hans Wilsdorf, Marketinggenie par excellence, eine besondere Affinität zum britischen Königreich. Hier nämlich hatte 1905 sein Siegeszug in die Welt der Präzisionszeitmessung begonnen, welcher drei Jahre später zur Gründung der Marke Rolex führte. Die englische Staatsbürgerschaft hatte der gebürtige Bayer ebenfalls aus innerster Überzeugung angenommen. Weil man auf einem Bein bekanntlich nicht gut steht, ließ sich Hans Wilsdorf ein beachtliches Spektrum unterschiedlicher Signaturen schützen. Genutzt hat er freilich nur wenige. So zum Beispiel Tudor, Name eines englischen Königsgeschlechts, welches von 1485 bis 1603 regierte. Als sich Hans Wilsdorf erstmals hierfür interessierte, lagen die Rechte noch beim Genfer Schmuckhändler Isaac Blumenthal. 1926 erklärte die Uhrenfabrik Veuve de Philippe Hüther auf einem Briefbogen der Horlogerie H. Wilsdorf, dass sie die Marke The Tudor für dieses Unternehmen habe registrieren lassen. Und zwar zur Nutzung auf uhrmacherischen Erzeugnissen aller Art. Die ersten Zeitmesser trugen denn auch nur diesen Schriftzug ohne weiteres Logo. Als Hans Wilsdorf 1936 endlich selbst über die uneingeschränkten Rechte verfügte, gesellte sich die stilisierte Rose der Tudor-Dynastie als Markenzeichen hinzu. Anfangs mit, später nur noch ohne Wappenschild. In den Gehäuseboden eines der wenigen kissenförmigen Tudor-Modelle aus den 1940er Jahren war noch unübersehbar der Name Rolex SA eingraviert. Hans Wilsdorf machte also keinen Hehl daraus, dass die Tudor signierten Uhren aus seiner längst etablierten Manufaktur stammten. 1952 gab Hans Wilsdorf eine persönliche Erklärung zur 1946 gegründeten Montres Tudor SA ab. Darin stand zu lesen, dass er über viele Jahre hinweg Möglichkeiten der Fabrikation einer Uhr studiert habe, welche seine Konzessionäre den Damen und Herren zu einem günstigeren Preis als die Rolex-Zeitmesser anbieten könnten. Genau aus diesem Grund sei das neue Label entstanden. Die „Tudor Oyster Prince" besitze zwei Vorteile, welche man schon von Rolex kenne: das berühmte wasserdichte Oyster-Gehäuse und den Perpetual-Rotor-Aufzug. Für Damen gebe es nicht wasserdichte und automatische Modelle. Zur Wahrung des gebotenen Abstands basierte die Produktstrategie auf einer Synthese aus Vorhandenem, also den bewährten Oyster-Gehäusen, und zugekauften Uhrwerken beispielsweise von Eta. Besonders im Reich der Mitte kamen diese preisgünstigen Armbanduhren erstaunlich gut an. In den späten 1960er Jahren blickten französische Marinetaucher auf eine Tudor, welche der „Submariner" von Rolex verblüffend ähnelte. Und die US-amerikanischen Navy Seals taten es ihren europäischen Kollegen gleich. Extrem hohen Stellenwert bei Sammlern genießt auch der Chronograph „Monte Carlo", Referenz 7159/0, mit dem Schaltrad-Handaufzugskaliber Valjoux 234. Durch die Rückbesinnung auf seine Taucheruhren-Geschichte, Retro-Modelle wie „Pelagos" und „Heritage Black Bay" erregte Tudor in den zurückliegenden Jahren immer wieder Aufmerksamkeit. 2015 begann schließlich auch bei der Rolex-Tochter das Manufaktur-Zeitalter. Die Kaliberfamilie MT56xx mit Rotoraufzug und Silizium-Unruhspirale debütierte in der reduziert gestalteten Uhrenlinie „North Flag". Das MT5621 besitzt Datums- und Gangreserveanzeige, das MT5612 lediglich ein Fensterdatum. Puristisch, das heißt nur mit drei Zeigern ausgestattet, tickt das 2016 vorgestellte MT5601 in verschiedenen Versionen des Bestsellers „Heritage Black Bay", darunter auch eine viel beachtete mit Bronzegehäuse. ○

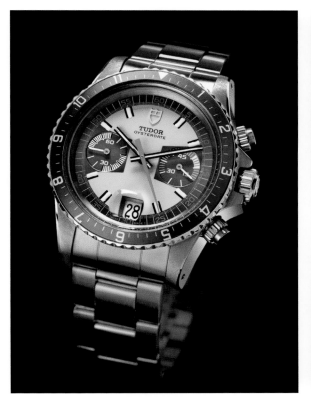 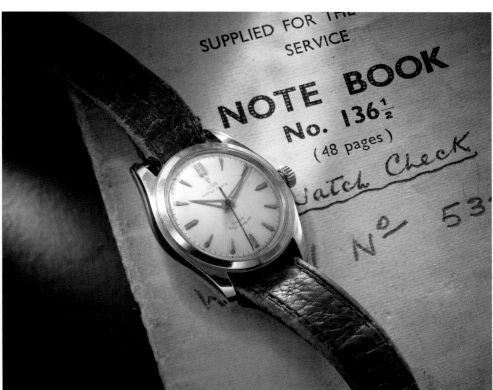

From left: Oysterdate Monte Carlo, 1973 ○ Oyster Prince, 1950s

La Rolex de l'homme de la rue

Français

Génie du marketing par excellence, Hans Wilsdorf a assurément une affinité particulière pour le royaume britannique. C'est en effet là qu'il débute en 1905 sa marche triomphale dans l'univers des garde-temps de précision, couronnée trois ans plus tard par la création de Rolex. C'est aussi une intime conviction qui conduit ce Bavarois d'origine à adopter la nationalité anglaise. Comme chacun sait, il ne faut jamais mettre tous ses œufs dans le même panier. Aussi Hans Wilsdorf dépose-t-il un large éventail de marques, dont il n'exploitera toutefois qu'un petit nombre. C'est le cas de la marque Tudor, qui évoque une dynastie ayant régné sur l'Angleterre de 1485 à 1603. Lorsque Hans Wilsdorf s'y intéresse pour la première fois, le joaillier genevois Isaac Blumenthal s'en est déjà assuré les droits. Mais, en 1926, la maison « Veuve de Philippe Hüther » déclare, sur une lettre à en-tête de l'Horlogerie H. Wilsdorf, avoir déposé, pour le compte de cette même entreprise, la marque « The Tudor » pour tous produits horlogers. Les premiers garde-temps Tudor porteront alors sur le cadran l'inscription Tudor, mais sans logotype. En 1936, lorsque Hans Wilsdorf acquiert enfin les droits exclusifs sur la marque, la rose stylisée de la dynastie des Tudors apparaît. Le blason dans lequel s'inscrit ce logotype disparaît ensuite. Sur l'un des rares modèles Tudor de forme coussin des années 1940, on voit nettement « Rolex SA » gravé sur le fond de boîte. Hans Wilsdorf ne fait donc aucun mystère de ce que les montres signées Tudor proviennent de sa manufacture depuis longtemps établie. En 1952, il fait une déclaration sur la société « Montres Tudor SA », qu'il a créée en 1946. On peut y lire qu'il a pendant de nombreuses années étudié les possibilités de fabriquer une montre que ses concessionnaires pourraient vendre à leur clientèle à un prix plus bas que les montres Rolex. C'est justement cela qui a présidé à la création du nouveau label Tudor. La « Tudor Oyster Prince » partage deux avantages exclusifs avec les Rolex : le fameux boîtier étanche Oyster et le mécanisme à rotor Perpetual. Des modèles étanches ou automatiques ne sont pas prévus pour les femmes. Pour conserver l'écart qui s'impose entre les deux marques, la stratégie produits de Tudor s'appuie sur une combinaison de l'existant, les boîtiers Oyster éprouvés, et des mouvements achetés, Eta surtout. Ces montres-bracelets abordables sont très appréciées en Chine. À la fin des années 1960, les plongeurs de la Marine nationale française sont équipés de Tudor qui ressemblent étrangement aux « Submariner » de Rolex. Plus tard, les Navy Seals de l'US Navy imiteront leurs homologues européens. Caractérisé par son calibre à remontage manuel Valjoux 234, le chronographe à roue à colonnes « Monte Carlo » (7159/0) est lui aussi très prisé des collectionneurs. Avec sa mise à jour des montres de plongée rétro « Pelagos » et « Heritage Black Bay », Tudor fait régulièrement sensation ces dernières années. Mais 2015 marque aussi pour la filiale de Rolex le passage à la fabrication maison. Les calibres MT56xx à système de remontage par rotor et spiral font leurs débuts dans la ligne de montres d'une grande sobriété « North Flag ». Le modèle MT5621 est doté de l'affichage de la date et de la réserve de marche, tandis que le MT5612 dispose simplement d'un guichet pour la date. Dans un style épuré, à savoir seulement équipé de trois aiguilles, le mouvement MT5601 présenté en 2016 anime différentes versions du best-seller « Heritage Black Bay », dont un modèle très prisé à boîtier en bronze. °

Self-winding manufactory
Cal. MT5601

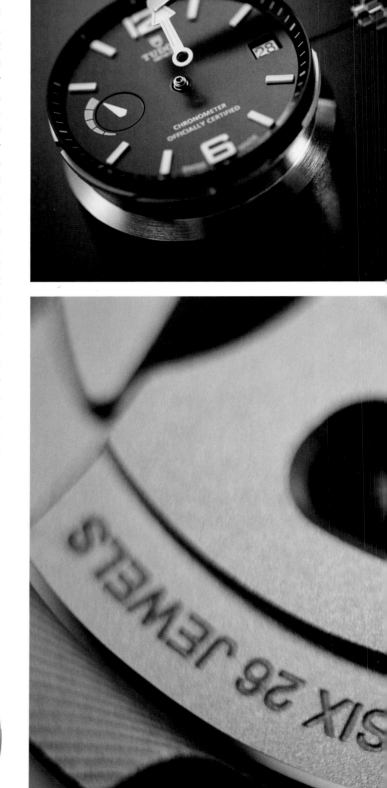

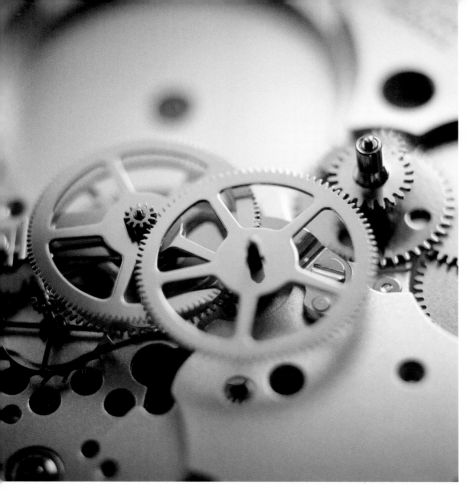

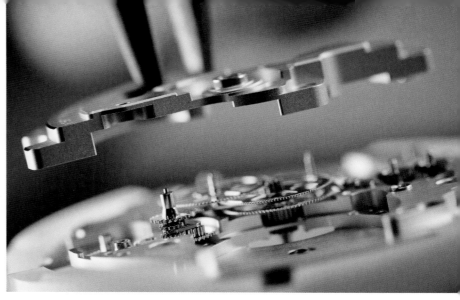

Clockwise, from top left: Installing the hour-hand on the North Flag with power-reserve display ◦ Installing the gear-train bridge of a manufactory caliber ◦ Detail of manufactory Caliber MT5612 ◦ Von oben links im Uhrzeigersinn: Montage des Stundezeigers der North Flag mit Gang-reserveanzeige ◦ Räderwerk eines Manufakturkalibers ◦ Montage der Räder-werksbrücke eines Manufakturkalibers ◦ Detail des Manufakturkalibers MT5612 ◦ Dans le sens horaire, en partant du haut, à gauche : Montage de l'aiguille des heures de la North Flag avec affichage de la réserve de marche ◦ Rouage d'un calibre de manufacture ◦ Montage du pont rouage d'un calibre de manufacture ◦ Détail du calibre de manufacture MT5612

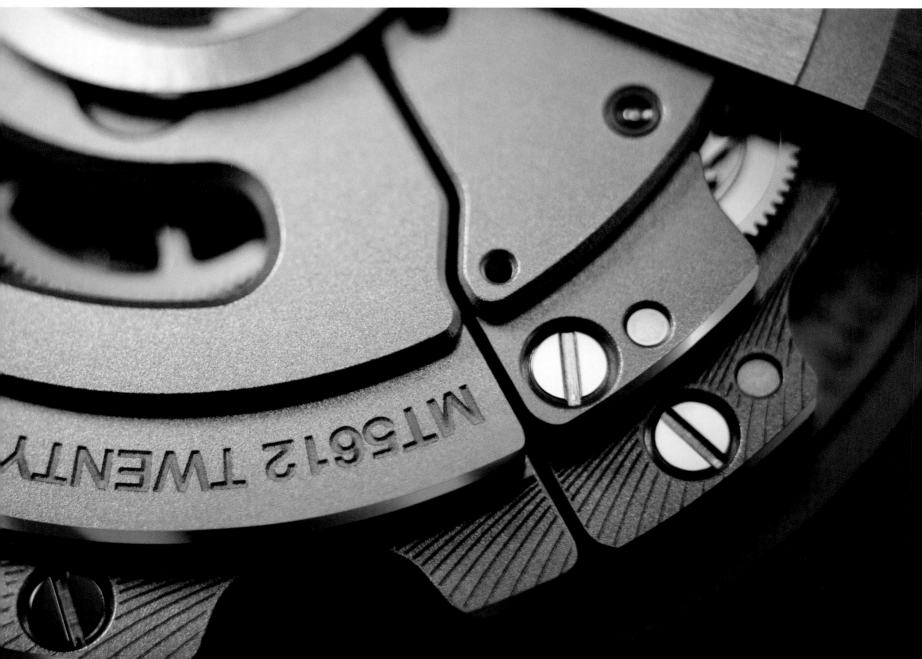

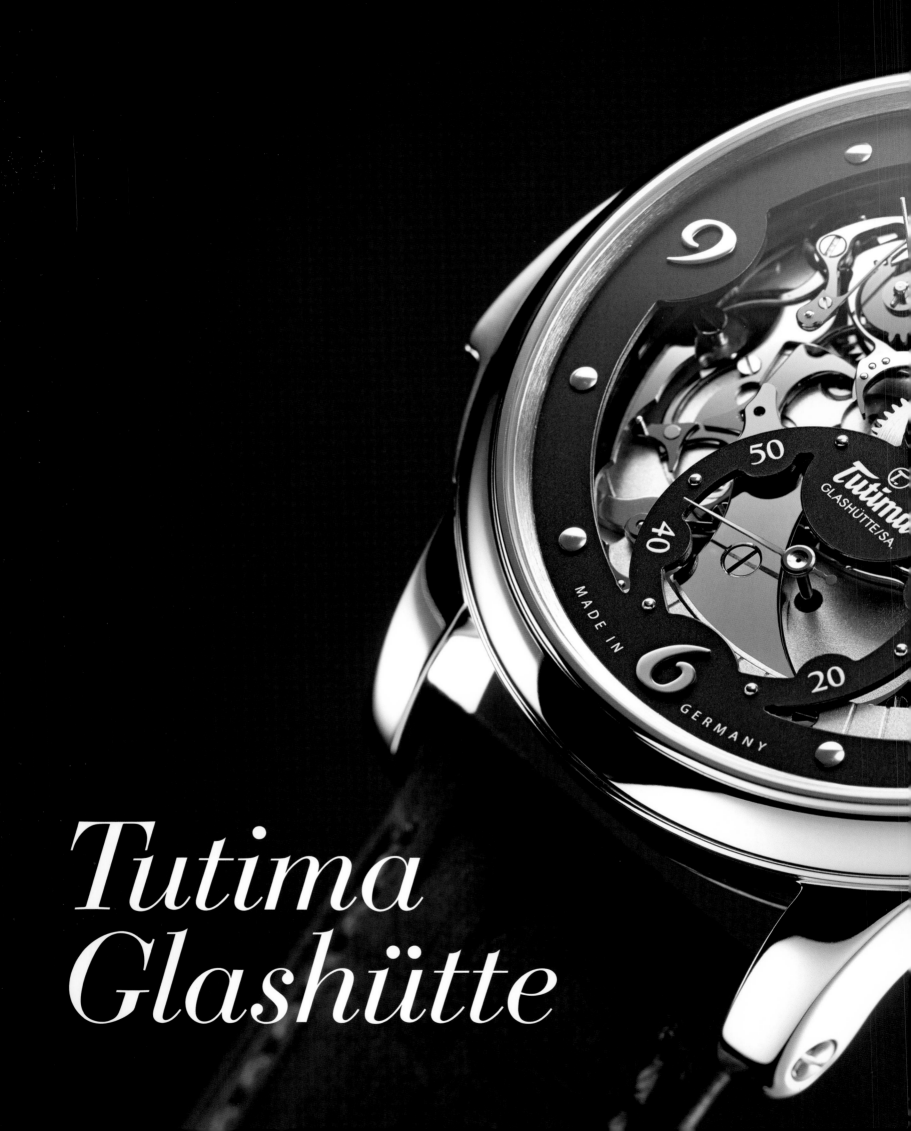

Tutima Glashütte

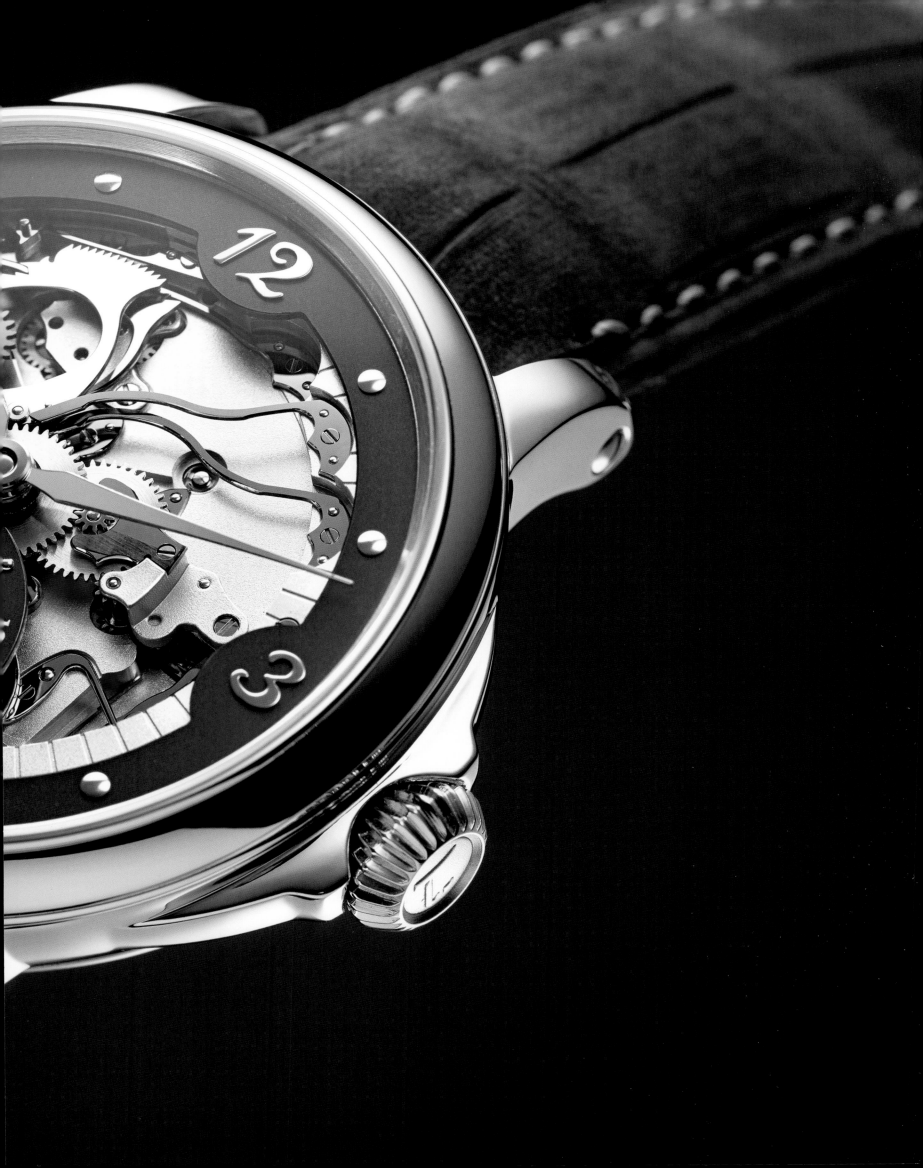

From left: Former UFAG Glashütte ◦ Dr. Ernst Kurtz ◦ Dieter Delecate ◦ Von links: Ehemalige UFAG Glashütte ◦ Dr. Ernst Kurtz ◦ Dieter Delecate ◦ De gauche à droite : Ancienne société UFAG Glashütte ◦ Dr. Ernst Kurtz ◦ Dieter Delecate

Back to Glashütte

Glashütte is undoubtedly the Mecca of German watch manufacturing, a distinction which the city has enjoyed not only since the fall of the Berlin Wall in 1989 and Germany's reunification one year later, but since 1845, when Ferdinand Adolph Lange relocated his watchmaking activities to the remote Müglitz Valley. Step by step, Lange initiated the establishment and promoted the growth of a branch of industry specializing primarily in luxurious products. Early in the 20th century, the industrialists began to realize that Glashütte's products should also appeal to broader classes of the population. The attorney Dr. Ernst Kurtz accordingly founded in 1926 a conglomerate of companies, which included among its members the Uhren-Rohwerke-Fabrik Glashütte AG (UROFA) and the Uhrenfabrik Glashütte AG (UFAG). The latter principally produced complete wristwatches. Top-quality products were launched with the signature "Tutima Glashütte." This catchy name was, of course, no mere coincidence: it was derived from the Latin adjective *tutus*, which means "secure" or "protected." The development and fabrication of affordably priced ébauches for wristwatches began under the direction of Ernst Kurtz and several competent colleagues. The purchase of a small Swiss watch factory and its transfer to Saxony compensated for lack of know-how in this field.

This led to the production of watch movements, including chronograph movements, which had no need to fear comparison with their dominant Swiss competitors. Dr. Kurtz and several of his colleagues were able to escape to the West on May 7, 1945, i.e., one day before an aerial bombardment decimated Glashütte. Beginning in 1951, the businessman and his team were again doing business at Ganderkesee in Lower Saxony. This is also where they created petite Caliber 570 for ladies' watches in 1956. Due to lack of sufficient liquidity for serial production, a former colleague from

Glashütte directed the business under the name "Norddeutsche Uhren-Rohwerkefabrik" (NUROFA). Sales and distribution of the watches were entrusted to Dieter Delecate, who was likewise one of Dr. Kurtz's former colleagues. The regime of the German Democratic Republic wasn't interested in the traditional name "Tutima," so the moniker could celebrate its glorious comeback at a new location. Dieter Delecate reintroduced the name: he registered it as a protected trademark on April 28, 1969 and afterwards established the Tutima Uhrenfabrik GmbH. Delecate deserves credit for building this business into a globally known brand. For several decades, a large portion of Glashütte's watchmaking tradition found its new home in picturesque Ganderkesee. As in the good old days, the company specialized in pilot's watches and especially aviator's watches with chronographs. Their production was based on Swiss movements from Lemania and naturally also from Eta. A successful retro model alluded to the distinctive chronograph pilot's watches that encased flyback Caliber Urofa 59, which was produced between 1941 and 1945. In the 1980s, the West German military needed an official pilot's chronograph. The military testing office drew up a precise list of specifications for the desired timepiece. After examining all submitted offers, the contract was awared to Tutima in 1983. The opulent self-winding chronograph, equipped with robust Caliber Lemania 5100, was also impressive thanks to its ergonomially shaped buttons and its optimally legible counter for up to 60 elapsed minutes, which turned at the center of the dial.

With the acquisition of a prominent building near Glashütte's railway station in May 2011, Tutima gazed self-consistently "back to the future." After it underwent thorough renovations and was equipped with an ultramodern machine park, the building was ready to welcome a staff of technicians, engineers, watchmakers

and other specialists. This new chronometric beginning in Saxony is also associated with a return to the erstwhile activities as a manufactory. To celebrate this renaissance, Dieter Delecate, his daughter Ute and his son Jörg wanted more than just the ordinary, e.g., a classical hand-wound or automatic movement. Instead, they envisioned a little mechanical jewel of a sort that had never before been exclusively "made in Glashütte." They set their sights on a wristwatch with a minute repeater. Due to its uncommon complexity, this additional function—which sequentially chimes the hours, the quarter hours, and the minutes on a pair of gongs—embodies the utmost in the art of mechanical watchmaking. The traditional excellence of Glashütte workmanship was handsomely embodied in gold-plated hand-wound Caliber T800, which is 32 millimeters in diameter and 7.2 millimeters tall. Each of this movement's 550 components is finely processed in accord with the rules and usages of horological craftsmanship. For example, all components in the cadrature for the striking mechanism have beveled edges. A tin plate is used to give Glashütte's characteristic black polish to planar surfaces. It's not surprising to learn that each of these ticking microcosms requires fully three months to assemble. The finest acoustic quality is assured by two gongs, anchored in the massive case and tuned a major third apart. To paraphrase Spinoza, "all things excellent are rare," so Tutima offers only 20 specimens of this timepiece in rose gold and five others in platinum cases. Of course, all of the responsible individuals were well aware that these watches would be reserved for the very few people whose discriminating standards insist on nothing less than the utmost exclusiveness. Tutima accordingly offers two additional movements of its own to aficionados and fans of fine Glashütte manufactory watchmaking. Purism par excellence radiates from 31-component Caliber T617 in the "Patria Small Second." This hand-wound movement has only three hands: one each for the hours, the minutes and the seconds. The solid gold trio is fabricated entirely by hand. Cosmopolites and frequent flyers appreciate the

"Patria Dual Time." This wristwatch encases upgraded Caliber T619, which amasses a 65-hour power reserve and offers a 12-hour display to indicate the time in a second time zone. After its relocation, Tutima naturally never lost sight of the traditional theme that it had cultivated for many decades. A new chronographic era began in 2013 with the "Saxon One." With regard to its functionality, this "time-writer" alludes to automatic Caliber Lemania 5100, production of which ceased long ago, and which offers a central counter for 60 elapsed minutes and an additional 24-hour hand. A special module had to be developed and manufactured to add these additional functions to time-honored Caliber Eta 7750. Both were created in the light-flooded manufacturing building in Glashütte. More than 50 percent of the value is added in Saxony, so the dials of these watches can bear both the word "Glashütte" and the phrase "made in Germany" as proof of their provenance. Traditional elements are reflected in the significantly bolder-looking version "M2," which is a successor of the identically named NATO chronograph that Tutima had developed for the German military. The color scheme for the hands aptly expresses military professionalism: eye-catching red on the three hands for the stopwatch function clearly contrasts with the white hue of the four other hands for the ordinary time of day or night.

Last but not least, the brand-new "M2 Seven Seas" feels perfectly at home in the silence of the underwater world. Its titanium case resists pressure to 50 bar, which means that this 44-millimeter-diameter titanium wristwatch can theoretically accompany its wearer to a depth of 500 meters. Tutima equips reliable automatic Caliber Eta 2836 with a specially designed rotor. On the one hand, this detail individualizes the timepiece; on the other hand, it contributes toward further increasing the amount of value added to the watch at Tutima's new home in Glashütte. ◦

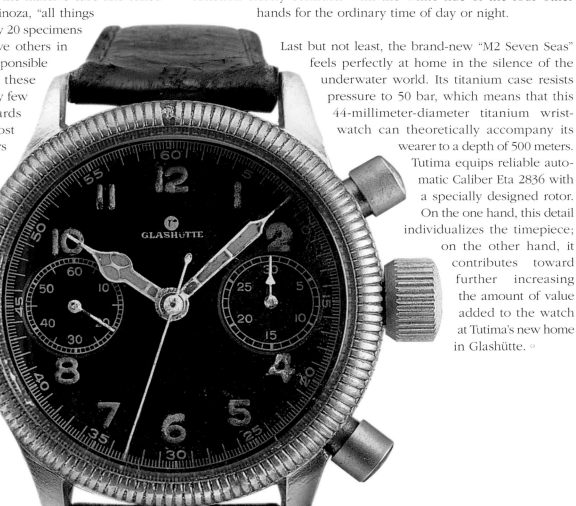

Pilot's chronograph, 1941

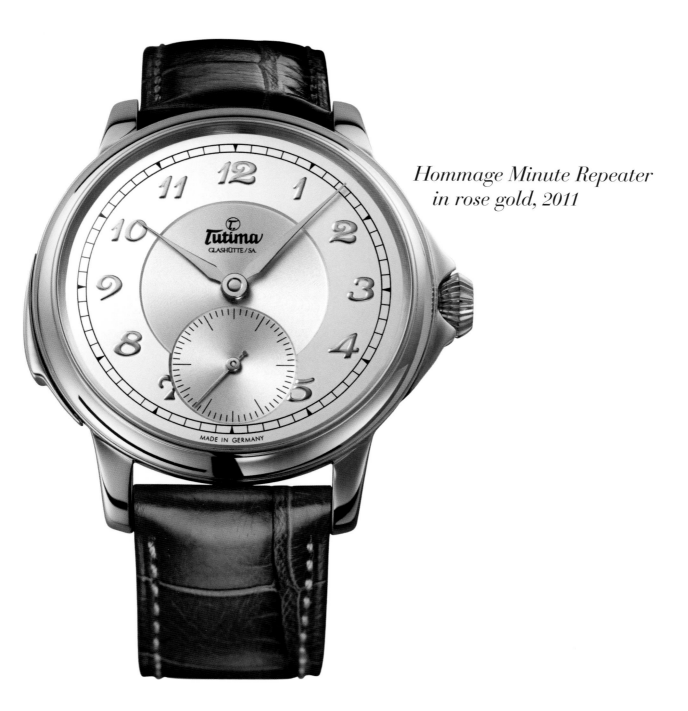

*Hommage Minute Repeater
in rose gold, 2011*

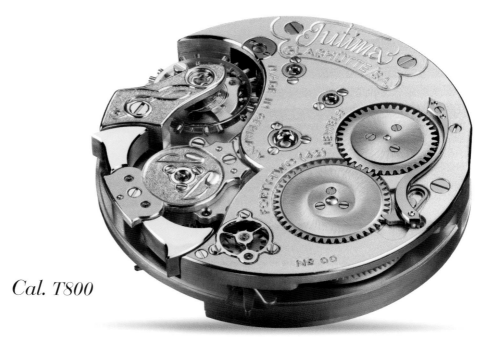

Cal. T800

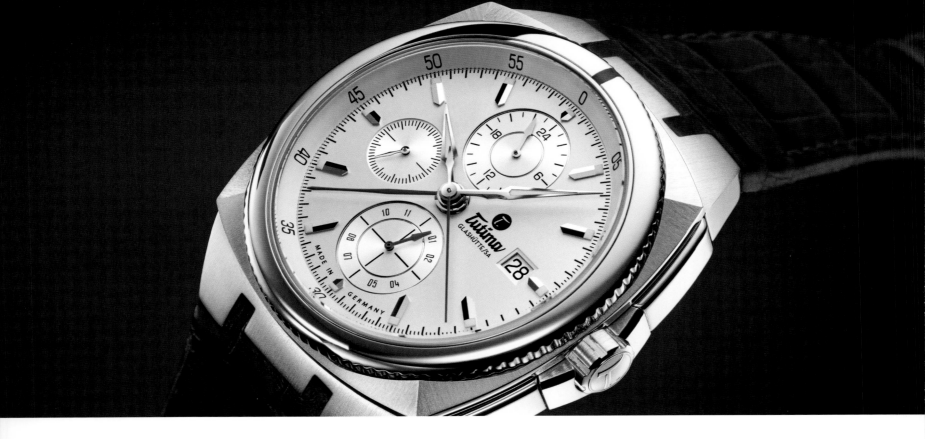

Zurück nach Glashütte

Ohne jeden Zweifel ist Glashütte das Mekka der deutschen Uhrenfertigung. Und zwar nicht erst seit dem Fall der Berliner Mauer im Jahr 1989 und der deutschen Wiedervereinigung ein Jahr später, sondern seit 1845. Damals verlegte Ferdinand Adolph Lange seine uhrmacherischen Aktivitäten ins abgeschiedene Müglitztal. Zug um Zug initiierte er den Aufbau des vornehmlich auf Luxusprodukte spezialisierten Industriezweigs. Anfang des 20. Jahrhunderts wuchs die Erkenntnis, dass Glashütter Produkte auch breitere Bevölkerungsschichten ansprechen sollten. In diesem Sinne erstellte der Jurist Dr. Ernst Kurtz 1926 ein Firmenkonglomerat, zu dem die Uhren-Rohwerke-Fabrik Glashütte AG (UROFA) sowie die Uhrenfabrik Glashütte AG (UFAG) gehörten. Letztere produzierte in erster Linie fertige Armbanduhren. Die Top-Qualitätsprodukte wurden mit der Signatur Tutima Glashütte lanciert. Der einprägsame Name kam natürlich nicht von ungefähr. Er leitet sich ab vom lateinischen Adjektiv „tutus". Und das steht für „sicher, geschützt". Unter Leitung von Ernst Kurtz und einigen kompetenten Mitstreitern begann die Entwicklung und Herstellung preiswerter Armbanduhr-Rohwerke. Der Kauf einer kleinen Schweizer Uhrenfabrik und ihr Transfer nach Sachsen kompensierten mangelndes Knowhow auf diesem Gebiet.

Auf diese Weise entstanden Uhrwerke bis hin zu Chronographen, welche den Vergleich mit der dominanten eidgenössischen Konkurrenz nicht fürchten mussten. Am 7. Mai 1945, einen Tag vor dem Bombenhagel auf Glashütte, gelang es Dr. Kurtz wie auch einigen Mitarbeitern, sich in den Westen zu retten. Ab 1951 begegnete man dem Unternehmer und seinem Team im niedersächsischen Ganderkesee. Dort entstand 1956 das kleine Kaliber 570 für Damenuhren. Mangels Liquidität zur Serienproduktion führte ein früherer Mitarbeiter aus Glashütte den Betrieb unter dem Namen Norddeutsche Uhren-Rohwerkefabrik (NUROFA) fort. Den Vertrieb der Uhren übernahm Dieter Delecate, ebenfalls früherer Mitarbeiter

von Dr. Kurtz. Da sich das Regime der Deutschen Demokratischen Republik nicht für den traditionsreichen Namen Tutima interessierte, feierte er am neuen Standort ein glorreiches Comeback. Dieter Delecate führte diesen Namen auf den Uhren wieder ein. Am 28. April 1969 meldete er den Namen auch zu seinem Schutz an. Anschließend rief er die Tutima Uhrenfabrik GmbH ins Leben. Der Aufstieg zur weltweit bekannten Marke ist ihm zu verdanken. Für mehrere Jahrzehnte fand ein bedeutender Teil der Glashütter Uhrentradition im malerischen Ganderkesee seine neue Heimat. Wie in guten alten Zeiten spezialisierte sich das Unternehmen auf Fliegeruhren und ganz besonders jene mit Chronograph. Die Produktion basierte auf Schweizer Uhrwerken von Lemania und natürlich Eta. An den markanten, zwischen 1941 und 1945 produzierten Piloten-Stopper mit dem Flyback-Kaliber Urofa 59 erinnerte ein erfolgreiches Retromodell. In den 1980er Jahren benötigte die deutsche Bundeswehr einen offiziellen Fliegerchronographen. Das Anforderungsprofil für diese Uhr hatte die militärische Erprobungsstelle exakt formuliert. Nach Prüfung der eingegangenen Offerten erhielt Tutima 1983 den Zuschlag. Der opulente Automatik-Chronograph, ausgestattet mit dem robusten Kaliber Lemania 5100, beeindruckte auch durch seine ergonomischen Bedientasten und den optimal ablesbaren, weil in der Mitte des Zifferblatts drehenden 60-Minuten-Zähler.

Mit dem Erwerb eines prominent nahe dem Glashütter Bahnhof gelegenen Gebäudes blickt Tutima seit Mai 2011 konsequent zurück in die Zukunft. Nach gründlicher Renovierung des Bauwerks sowie seiner Ausstattung mit einem hochmodernen Maschinenpark hielten Techniker, Konstrukteure, Uhrmacher und andere Facharbeiter ihren Einzug. Mit dem chronometrischen Neustart in Sachsen verknüpfte sich im weitesten Sinn auch die Rückkehr zu den einstigen Manufaktur-Aktivitäten. Etwas Normales, also ein klassisches

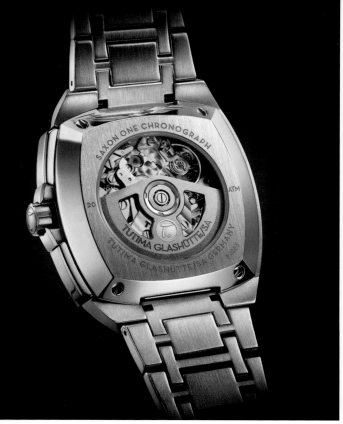

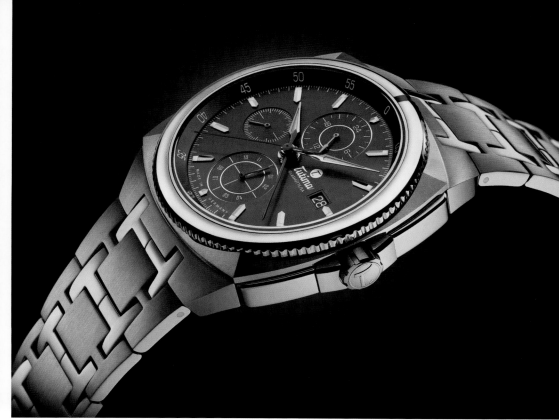

Saxon One Chronograph, 2013

Handaufzugs- oder Automatikwerk, war Dieter Delecate, Tochter Ute und Sohn Jörg anlässlich der Renaissance allerdings nicht aufregend genug. Ihnen schwebte ein mechanisches Kleinod vor, das es aus rein Glashütter Produktion noch nicht gegeben hatte. Gemeint ist eine Armbanduhr mit Minutenrepetition. Wegen ihrer ungemeinen Komplexität repräsentiert diese Zusatzfunktion, welche nacheinander Stunden, Viertelstunden und Minuten auf zwei Tonfedern schlägt, die allerhöchste Schule mechanischer Uhrmacherkunst. Das vergoldete Handaufzugswerk, Kaliber T800 mit 32 Millimetern Durchmesser und 7,2 Millimetern Bauhöhe, setzt die überlieferte Glashütter Wertarbeit ohne Einschränkung fort. Jedes der insgesamt 550 Bauteile ist nach den einschlägigen Regeln der Handwerkskunst feinbearbeitet. Zum Beispiel besitzen alle Komponenten der Schlagwerks-Kadratur anglierte Kanten. Die Oberflächen weisen eine Glashütter Schwarzpolitur mittels Zinnplatte auf. Kein Wunder, dass der Zusammenbau eines dieser tickenden Mikrokosmen drei Monate verschlingt. Für höchste Klangqualität bürgen zwei direkt im massiven Gehäuse verankerte Tonfedern mit Terz-Stimmung. Weil alles Vorzügliche selten ist, offeriert Tutima nur 20 Exemplare in Roségold und fünf in Platin. Natürlich waren sich alle Verantwortlichen der Tatsache bewusst, dass Derartiges nur ganz wenigen Menschen vorbehalten bleibt, welche das in jeder Hinsicht Besondere zum Maß ihrer hohen Ansprüche machen. Daher offeriert Tutima ausgewiesenen Kennern und Fans feiner Glashütter Manufaktur zwei weitere Uhrwerke eigener Provenienz. Purismus par excellence verstrahlt das 31 Millimeter große T617 in der „Patria Small Second". Dieses Handaufzugswerk besitzt nur drei Zeiger, je einen für die Stunden, Minuten und Sekunden. Das massivgoldene Trio ist komplett von Hand gefertigt. Kosmopoliten und Vielflieger kommen bei der „Patria Dual Time" auf ihre Kosten. In dieser Armbanduhr tickt das aufgewertete Kaliber T619 mit 65 Stunden Gangautonomie

und zusätzlicher 12-Stunden-Anzeige zur Indikation einer zweiten Zonenzeit. Selbstverständlich hat Tutima nach dem Umzug auch das jahrzehntelang gepflegte Stammthema nicht aus den Augen verloren. Bereits 2013 begann mit der „Saxon One" eine neue chronographische Zeitrechnung. Hinsichtlich seiner Funktionalität rekurriert der zeitschreibende Bolide auf das längst nicht mehr produzierte Automatikkaliber Lemania 5100 mit zentralem 60-Minuten-Zähler und zusätzlichem 24-Stunden-Zeiger. Dieser erweiterte Nutzen des bewährten Basis-Uhrwerks Eta 7750 verlangte nach Entwicklung und Fertigung eines speziellen Moduls. Beides ging und geht im lichtdurchfluteten Glashütter Manufakturgebäude über die Bühne. Wegen des sächsischen Wertschöpfungsanteils jenseits von 50 Prozent dürfen alle Zifferblätter nicht nur die Herkunftsbezeichnung „Glashütte" tragen, sondern auch den Schriftzug „Made in Germany". Überlieferte Elemente in gleich mehrfacher Hinsicht spiegelt die deutlich markantere Version „M2" als Nachfolgerin des sogenannten Nato-Chronographen wider, den Tutima für die Bundeswehr entwickelt hatte. Die farbliche Gestaltung der Zeiger bringt militärische Professionalität zum Ausdruck: Das signifikante Rot an den drei Zeigern für die Stoppfunktion hebt sich deutlich ab von den anderen vier durchgängig weißen Zeit-Zeigern.

In der Stille der Unterwasserwelt fühlt sich schließlich die brandneue „M2 Seven Seas" zu Hause. Ihr Titangehäuse ist auf eine Druckdichte bis 50 Bar ausgelegt. Ergo können die Besitzerinnen und Besitzer der 44 Millimeter großen Titan-Armbanduhr rein theoretisch bis zu 500 Meter tief abtauchen. Tutima stattet das zuverlässige Automatikkaliber Eta 2836 mit einem speziell gestalteten Rotor aus. Dieses Merkmal dient zum einen der Individualisierung und zum anderen dem Wertschöpfungsanteil in der neuen Glashütter Heimat von Tutima. ○

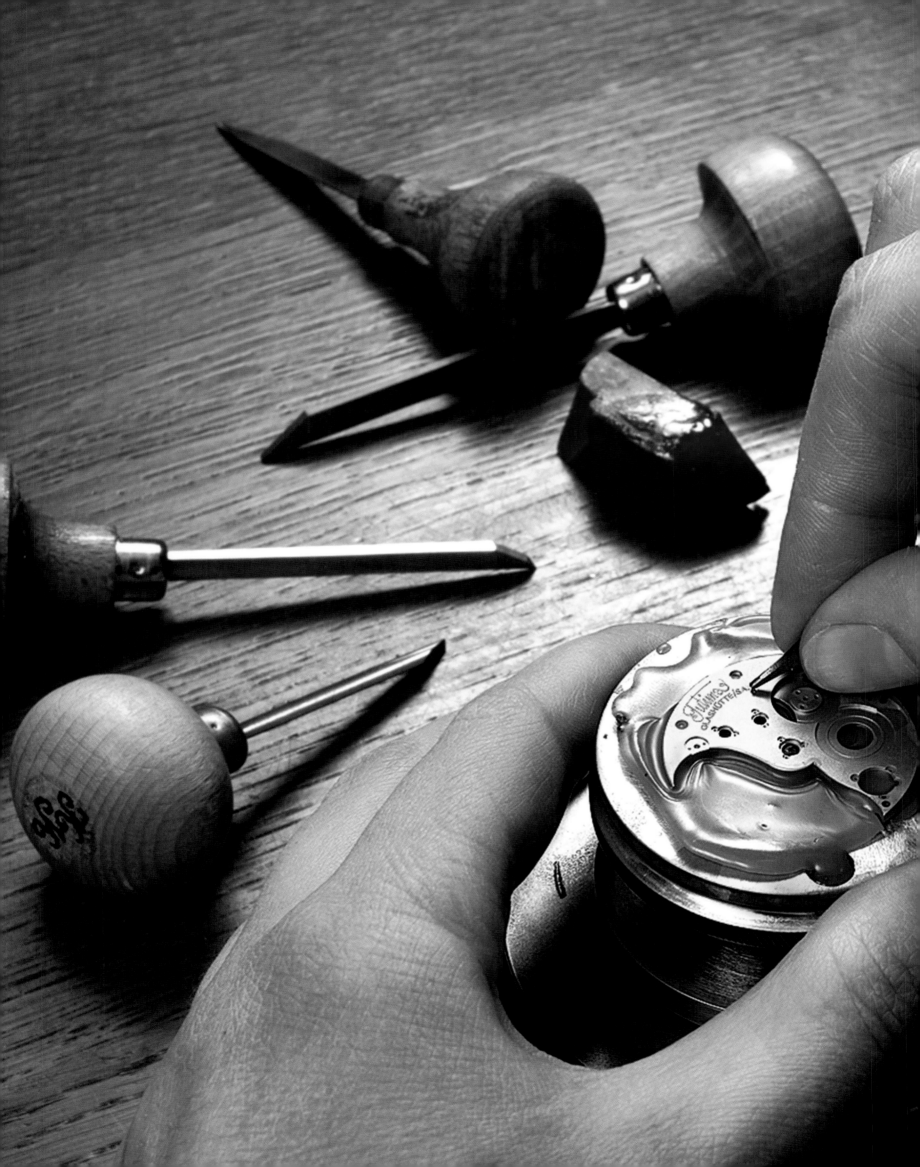

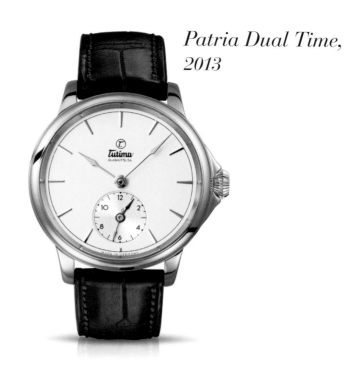

Patria Dual Time,
2013

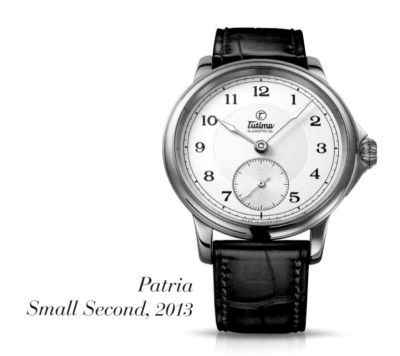

Patria
Small Second, 2013

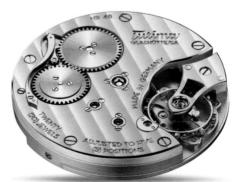

Cal. T617

Manual engraving ○ Handgravur ○ Gravure à la main

Le retour à Glashütte

Glashütte est sans conteste le haut lieu de la fabrication horlogère allemande. Et ce pas uniquement depuis la chute du Mur en 1989 et la réunification un an plus tard, mais depuis 1845, date à laquelle Ferdinand Adolph Lange transfère ses activités horlogères dans cette petite ville de la vallée reculée de la Müglitz. Progressivement, il contribue à l'extension de ce secteur industriel essentiellement spécialisé dans les produits de luxe. Mais au début du XXᵉ siècle, on prend conscience que les produits de Glashütte doivent également s'adresser à de plus larges couches de la population. C'est dans cette optique que le juriste Ernst Kurtz crée en 1926 un conglomérat dans lequel figurent les sociétés UROFA (Uhren-Rohwerke-Fabrik Glashütte AG) et UFAG (Uhrenfabrik Glashütte AG). Cette dernière est spécialisée dans les montres-bracelets, des produits de première qualité lancés sous la signature Tutima Glashütte. Ce nom facile à retenir n'a bien sûr pas été choisi au hasard : il est dérivé de l'adjectif latin tutus, qui signifie « sûr, protégé ». Sous la direction d'Ernst Kurtz et de quelques collaborateurs compétents, la société commence à développer et à fabriquer des ébauches pour montres-bracelets à des prix abordables. L'achat et le transfert en Saxe d'une petite fabrique horlogère suisse compensent le manque de savoir-faire dans ce domaine.

On voit ainsi apparaître divers produits, allant des mouvements jusqu'aux chronographes, qui tiennent largement la comparaison avec la forte concurrence suisse. Le 7 mai 1945, un jour avant la pluie de bombes qui s'abat sur Glashütte, Ernst Kurtz et quelques-uns de ses employés parviennent à se réfugier à l'Ouest. À dater de 1951, on retrouve l'entrepreneur et son équipe à Ganderkesee, en Basse-Saxe. C'est là que le petit calibre 570 destiné à des montres pour femmes voit le jour en 1956. L'entreprise, qui manque de liquidités pour la production en série, est reprise par un ancien employé du temps de Glashütte sous le nom NUROFA (Norddeutsche Uhren-Rohwerkefabrik). La vente des montres est assurée par Dieter Delecate, également ancien employé d'Ernst Kurtz. Le régime de la RDA ne s'étant jadis pas intéressé à la célèbre signature Tutima, celle-ci fait un retour triomphal sur son nouveau site. Dieter Delecate réintroduit le nom sur le cadran. Le 28 avril 1969, il le dépose à titre de marque. Dans la foulée, il crée la société Tutima Uhren-fabrik GmbH. C'est à lui qu'elle doit d'être connue dans le monde entier. Durant des décennies, une grande partie des modèles signés Glashütter Tradition sont fabriqués dans la pittoresque ville de Ganderkesee. Comme à sa belle époque, l'entreprise se spécialise dans les montres d'aviateur et plus particulièrement celles dotées d'un chronographe. La production s'appuie sur des calibres Lemania et bien sûr aussi Eta. Un modèle rétro rappelle la célèbre montre

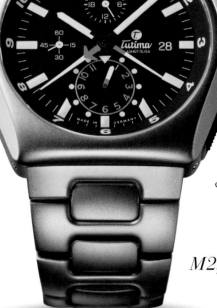

d'aviateur chronographe fabriquée entre 1941 et 1945 et son calibre retour-en-vol Urofa 59. Dans les années 1980, la Bundeswehr lance un appel d'offres pour une montre d'aviateur chronographe avec un cahier des charges précisément défini par le centre d'essai militaire. Après examen des offres, Tutima remporte le marché en 1983. Équipé du robuste calibre Lemania 5100, l'imposant chronographe automatique est impressionnant avec ses boutons poussoirs ergonomiques et son compteur 60 minutes bien en évidence parfaitement lisible.

Avec l'acquisition d'un imposant bâtiment proche de la gare de Glashütte, Tutima revient depuis mai 2011 vers son passé pour s'orienter résolument vers son avenir. Une fois soigneusement rénové et équipé d'un parc de machines ultramodernes, le bâtiment est investi par des techniciens, constructeurs, horlogers et autres spécialistes. Le renouveau des activités horlogères en Saxe est marqué dans une large mesure par le retour à l'ancienne production en manufacture. Pour marquer la renaissance de la marque, un modèle courant, à savoir un mouvement à remontage manuel ou automatique de base, n'est pas assez exaltant pour Dieter Delecate, sa fille Ute et son fils Jörg. Ils rêvent d'un bijou de mécanique, constitué, comme cela n'a encore jamais été fait, exclusivement de composants provenant de Glashütte, en l'occurrence une montre-bracelet à répétition minutes. Par sa complexité inouïe, cette fonction auxiliaire consistant à sonner les heures, les quarts d'heure puis les minutes sur deux marteaux représente le summum de l'art horloger mécanique. Le mouvement à remontage manuel doré, un calibre T800 de 32 millimètres de diamètre et 7,2 millimètres d'épaisseur, perpétue fidèlement la tradition de travail de qualité de Glashütte. Chacun des 550 composants est usiné selon les règles de l'art. Par exemple, tous les composants de la cadrature ont des arêtes anglées. Les surfaces arborent le poli miroir au bloc d'étain, typique de Glashütte. Rien d'étonnant à ce qu'il faille trois mois pour assembler l'un de ces microcosmes mécaniques. Deux timbres résonnant en tierce majeure directement intégrés dans le boîtier massif assurent une sonorité parfaite. L'excellence étant synonyme de rareté, Tutima en propose seulement 25 exemplaires, 20 en or rose et cinq autres en platine. Tous les responsables sont bien sûr conscients du fait que ces modèles sont réservés à une élite très exigeante, en mal de singularité à tous les égards. Aussi, Tutima propose-t-elle à ces fins connaisseurs et adeptes de produits raffinés de Glashütte deux mouvements fabriqués en interne. Avec son calibre T617 de 31 millimètres, le « Patria Small Second » incarne le purisme par excellence. Ce garde-temps à remontage manuel

M2, 2013

possède trois aiguilles distinctes pour les heures, les minutes et les secondes, un trio en or massif entièrement réalisé à la main. Le « Patria Dual Time » fait le bonheur de ceux qui voyagent beaucoup, notamment en avion. Cette montre-bracelet est animée par le calibre T619 revalorisé avec ses 65 heures de réserve de marche et un cadran auxiliaire des heures pour un deuxième fuseau horaire. Après son déménagement, Tutima n'oublie bien sûr pas ce qui a été son cheval de bataille des décennies durant. Dès 2013, le « Saxon One » amorce une nouvelle ère pour les chronographes maison. D'un point de vue fonctionnel, ce garde-temps d'exception s'appuie sur le calibre automatique Lemania 5100 à compteur 60 minutes et aiguille 24 heures. Mais ce dernier n'est plus produit depuis longtemps et la marque part du calibre de base éprouvé Eta 7750 pour développer et fabriquer un module spécial. Les opérations nécessaires se déroulent alors, comme aujourd'hui encore, dans les bâtiments inondés de lumière de la manufacture à Glashütte. La part de la valeur ajoutée en Saxe dépassant 50 pour cent, tous les cadrans peuvent non seulement porter l'indication de provenance « Glashütte », mais aussi l'inscription « Made in Germany ». Reprenant de nombreux éléments du chronographe OTAN, jadis développé par Tutima pour l'Armée allemande, la version « M2 » est beaucoup plus marquante. Les couleurs retenues pour les aiguilles traduisent le professionnalisme militaire : le rouge significatif sur les trois aiguilles de la fonction de chronométrage tranche nettement sur le blanc des quatre autres aiguilles.

Enfin, la toute nouvelle « M2 Seven Seas », dont le boîtier en titane est prévu pour résister à une pression de 50 bars, est faite pour le monde du silence. Les propriétaires de cette montre-bracelet de 44 millimètres de diamètre peuvent donc théoriquement plonger avec elle jusqu'à 500 mètres de profondeur. Valeur sûre, le calibre automatique Eta 2836 est équipé d'un rotor spécialement conçu pour ce modèle, qui contribue à la fois à sa personnalisation et à la valeur ajoutée que Tutima lui apporte sur son nouveau site. ◦

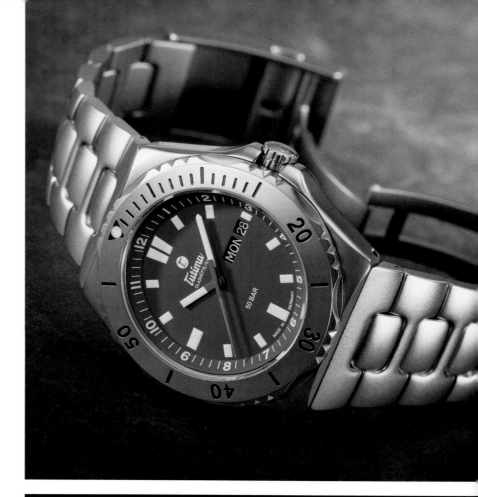

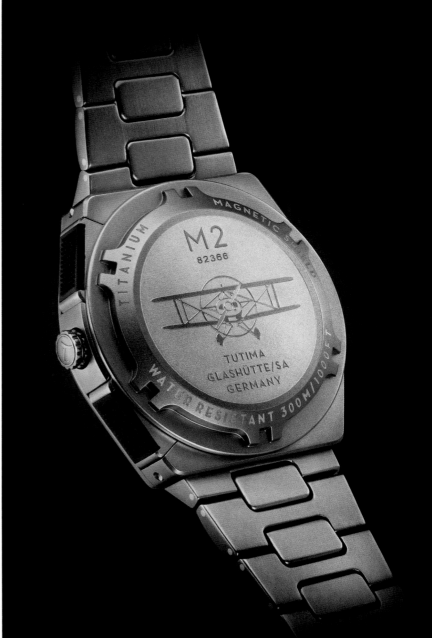

From top: M2 Seven Seas, tested to a pressure of 50 atmospheres, 2016 ◦ M2 back, 2013 ◦ Von oben: M2 Seven Seas, druckgeprüft bis 50 Bar, 2016 ◦ Rückseite der M2, 2013 ◦ De haut en bas : M2 Seven Seas, certifiée résistant à une pression de 50 bars, 2016 ◦ Revers de la M2, 2013

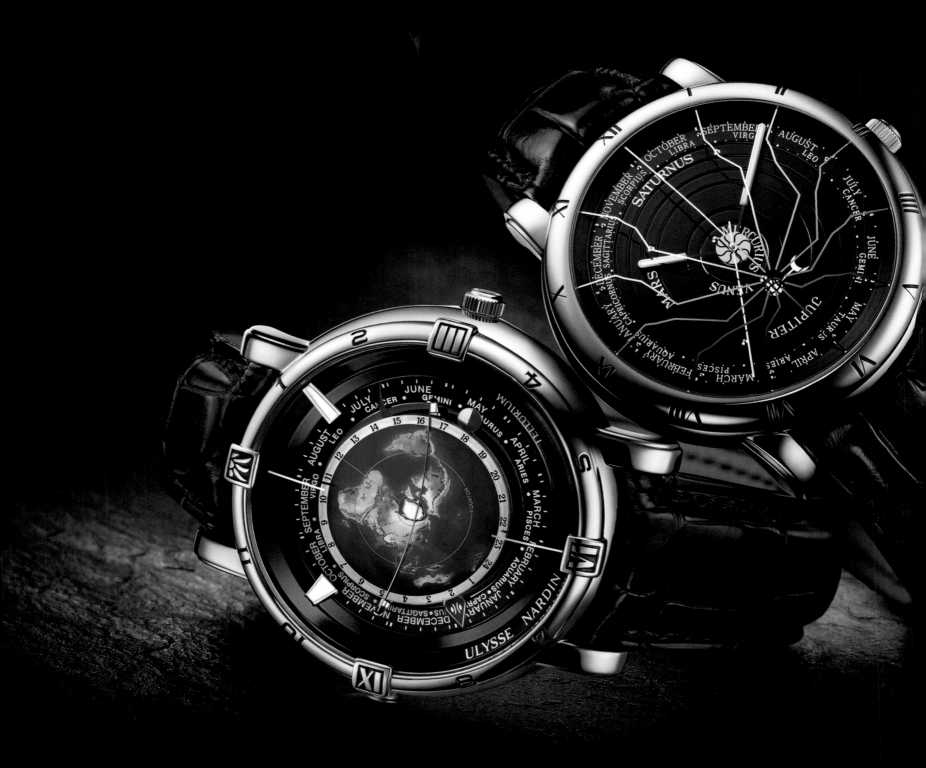

Ulysse Nardin

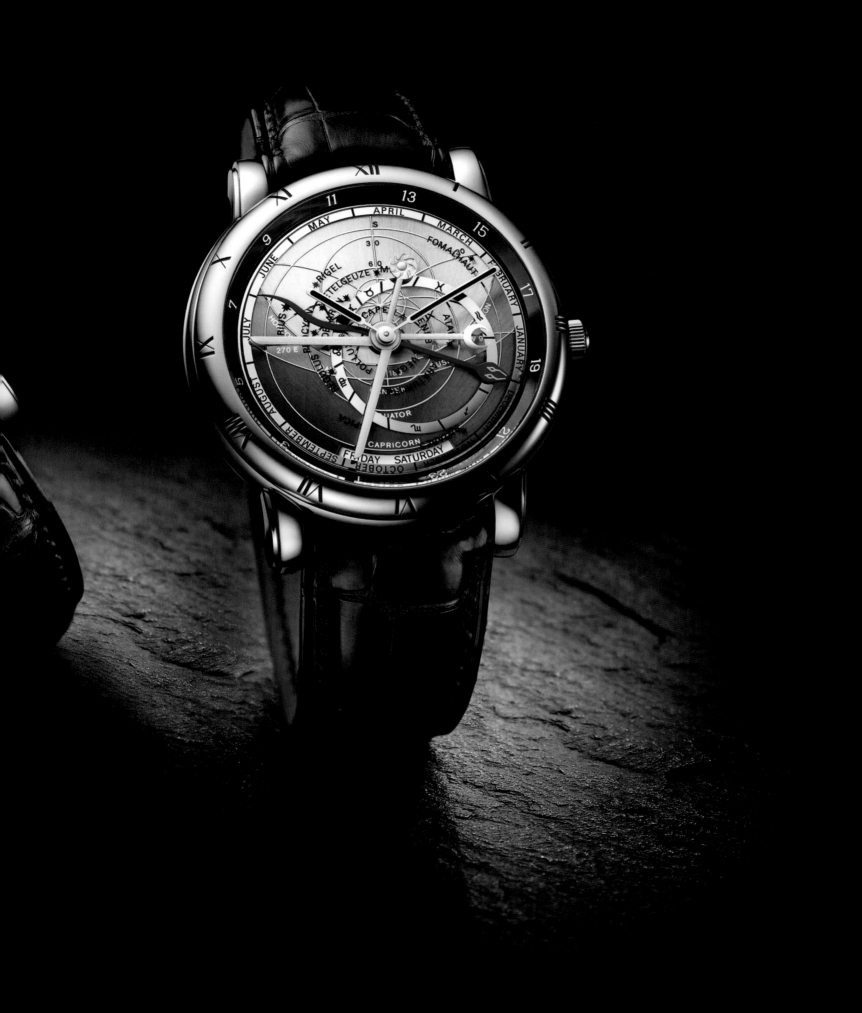

A Perfect Synthesis of Tradition and Innovation

Ulysse Nardin's history, which began in 1846, contains many high points, but the "Freak" carousel that debuted in 2001 revolutionized watchmaking in a truly unique way. Connoisseurs were particularly impressed by the innovative Dual-Direct escapement in thoroughly unconventional hand-wound Caliber UN-01, which can run for eight days between windings. Trailblazing technologies go hand in hand with unprecedented materials here. Classical components, e.g., lever and escape-wheel, can be sought in vain. Two drive wheels directly transfer energy to the rate regulator, which consists of a balance and its hairspring. For the first time ever, Ulysse Nardin fabricated the two wheels from pure silicon via the plasma method. Silicon is antimagnetic, combines the greatest possible hardness with low weight, and has very smooth surfaces which make oil superfluous. Two men stand behind this exceptional construction: Rolf Schnyder, a passionate watchmaker with a big heart, purchased the ailing firm in 1983 and transformed it into a recognized player in the art of sophisticated mechanical watchmaking; his sparring partner, the creative watchmaker and scientist Ludwig Oechslin, deserves credit for having enabled Ulysse Nardin to achieve numerous chronometric milestones.

Incidentally: the firm's founders were similarly characterized by utterly untamable inventiveness. New ideas matured in Ulysse Nardin's mind nearly every day. His creativity was commended by the jurors at the 1862 London Exhibition, who chose him to receive the highest award. The prize medal was followed by additional honors in ensuing years. This could well be why he was selected to submit one of Switzerland's contributions to the World's Columbian Exposition in Chicago in 1893. The richly decorated case of his watch recalled the Industrial Revolution of the second half of the 19th century. Its sculptor required more than 1,200 hours to complete this masterpiece. Ulysse Nardin had initially equipped his exceptional timepiece with a chronometer movement, but its later owner wanted a chronograph with a minute repeater. A nearly countless number of marine chronometers and navigator's watches earned global renown. For these genres alone, Ulysse Nardin received some 4,300 awards from various observatories and testing facilities. Wristwatches joined the collection after the turn from the 19th to the 20th century. A first chronograph for the wrist premiered at a very early date: namely, in 1912.

It seemed as though nothing could stop the series of successes—until the 1960s, when advances in electronic timekeeping gradually diminished the demand for nautical timepieces. Instead of responding appropriately, Ulysse Nardin's successors—most of whom were lawyers—languished in entrepreneurial lethargy.

Freak, 2001

To make matters worse, they totally misjudged the future of the wristwatch, so it looked as though the family business was doomed.

The proverbial knight in shining armor arrived in the guise of Rolf Schnyder, who invested a princely sum of 1.5 million Swiss francs. His intelligent revival of tradition and innovation, coupled with Ludwig Oechslin's ingenious engineering and designing, led to the creation of a trilogy of unique astronomical wristwatches in 1985. The first of these, the highly complex "Astrolabium Galileo Galilei," was depicted on the inside cover page of the 1988 edition of *The Guinness Book of Records*. This year also witnessed the debut of the "Planetarium Copernicus," which depicts the astronomical positions of five planets in relationship to the sun and the earth. The third member of the trio was the "Tellurium Johannes Kepler," which premiered in 1992.

Protected by numerous patents, the "Perpetual Ludwig" with perpetual calendar is meticulously conceived in every detail, convincingly user-friendly, and still remains state-of-the-art today. For the first time in the history of this horological complication, all indicators could be set and adjusted in both directions via the crown. Ulysse Nardin combined this mechanism and an intuitively operable time-zone display in the "GMT± Perpetual." The outsize date automatically synchronizes with trips through time zones, no matter whether the traveler journeys westward or eastward. "Sonata," which debuted in 2003, turned the history of the alarm wristwatch on its head: this watch's alarm is impossible not to hear and functions perfectly all around the globe. Needless to say, operating this technical marvel is mere child's play.

Ulysse Nardin celebrated its 160th anniversary by unveiling automatic Caliber UN-160, which the brand completely developed and fabricated in La Chaux-de-Fonds. Two of its finest features are the exclusive lubricant-free Dual-Ulysse escapement and the label's own Glucydur balance with variable moment of inertia.

This movement's debut catapulted Ulysse Nardin into the aristocratic circle of genuine manufactories. Another world premiere caused an appreciative stir in 2007: the silicon components of the Dual-Direct escapement in the "Freak DIAMonSIL" are coated with a layer of synthetic nano-crystalline diamond. This combination of materials offers the advantages of the world's hardest material, but keeps expenses at a very reasonable level. The "Moonstruck" followed in the astronomical footsteps of the "Trilogy of Time" in 2009. The utmost precision again characterized the accuracy of this watch's indicators. Approximately 100,000 years will come and go before the lunar display mistakenly shows a new moon rather than a full moon. Particularly impressive: the moon's current phase can be read exactly in relation to any desired location on the Earth's surface, and the timepiece also demonstrates the global dynamic of the tides, which are influenced by the moon and the sun. Prior to his unexpected death in 2011, Rolf Schnyder initiated the ambitious project to develop Caliber UN-118. DIAMonSIL was again the magic word in the escapement, and the balance cooperates with a freely oscillating silicon hairspring. Each of the 350 red gold

specimens of this wristwatch, which sold out long ago, has an enamel dial crafted by Donzé, a traditional specialist and a member of the Ulysse Nardin Group. After the death of its charismatic owner in 2011, Ulysse Nardin came under the aegis of the French Kering Group. CEO Patrik Hoffmann, a longstanding associate of the deceased, logically continued his predecessor's successful strategy. The purchase of chronograph Caliber 137 also assured Ulysse Nardin's autonomy in this sophisticated field of mechanical timekeeping. But extensive optimizations were necessary, including the use of silicon components for the oscillating and escapement system, before it could be deployed as Caliber UN-150. The visionary Rolf Schnyder had financially participated in the production of these components several years previously. His goal: achieve independence from suppliers of indispensable key components for mechanical watches.

Patrik Hoffmann's unmistakable "handwriting" is evident in several debutantes in 2016. The undisputed highlight among them is the "Grand Deck Marine Tourbillon." Its inlaid dial and unconventional minute-hand recall this brand's traditional affiliation with all things nautical. The minute-hand, which resembles a miniature mainsail boom, is powered by a paper-thin wire made of high-tech fiber and sweeps from left to right throughout the course of an hour. Afterwards, the gear-train and time display take into account the quick but not instantaneous motion with which this unconventional hand returns to its starting position. The "Marine Chronograph Annual Calendar" obeys Ludwig Oechslin's principle of simple but highly functional cadratures. It needs only seven additional components for its practical calendar, which automatically knows the lengths of all the months except February. The distinctive "FreakWing" expresses horological high technology coupled with the fascination of the 35th America's Cup as represented by Ulysse Nardin's partnership with Artemis Racing. In this context, the movement's upper bridge for the minutes is inspired by the internal structure of the rigid sail, while the texture of the rotating hours disc evokes the mesh net of the multihull. The bezel and case back consist of carbon fiber, a material that's omnipresent in high-level sailing. All this proves once again that the centuries-old art of mechanical watchmaking and the high technologies of the 21st century complement one another marvelously well. ○

Clockwise from top left: Rolf Schnyder ○ Ulysse Nardin ○ Patrik Hoffmann ○ Ludwig Oechslin

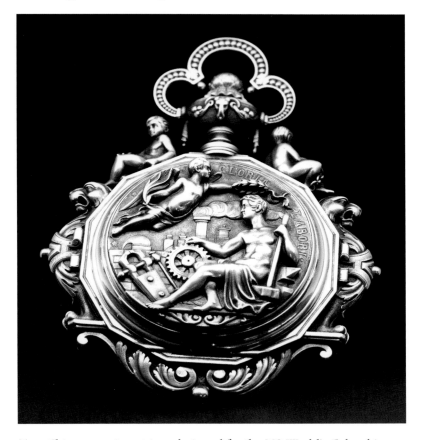

Top: Chicago, unique piece designed for the M2 World's Columbian Exposition in Chicago, 1893 ○ Left: Dual-Ulysse escapement, Cal. UN-201 ○ Oben: Chicago, Einzelstück, entworfen für die World's Columbian Exposition in Chicago, 1893 ○ Links: Dual-Ulysse-Hemmung, Kaliber UN-201 ○ Ci-dessus : Chicago, pièce unique conçue pour la World's Columbian Exposition à Chicago, 1893 ○ À gauche : Échappement Dual-Ulysse, Cal. UN-201

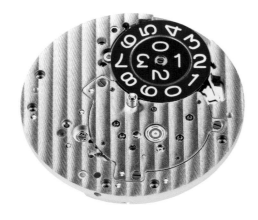
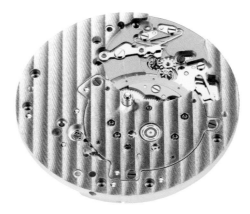
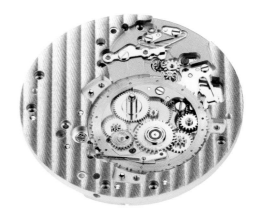

Top and middle: Automatic Cal. UN-160 ◦ Bottom: Freak DIAMonSIL, 2007

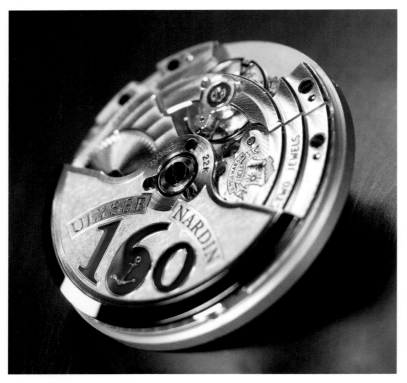
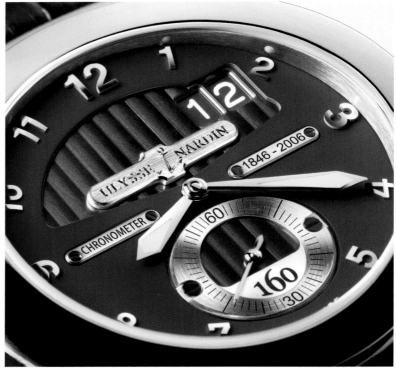
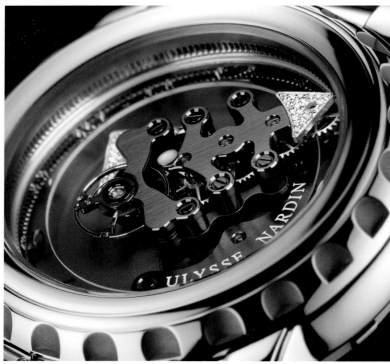
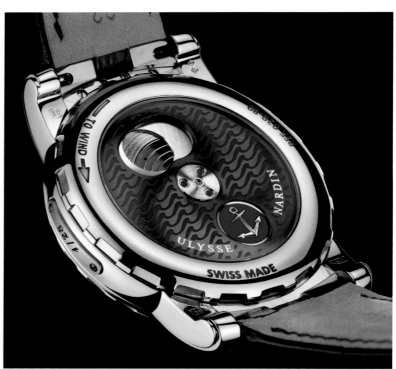

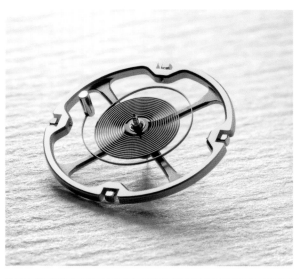

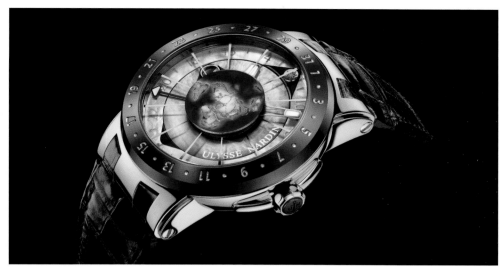

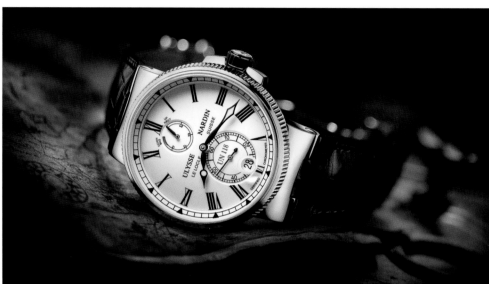

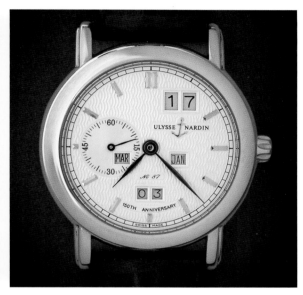

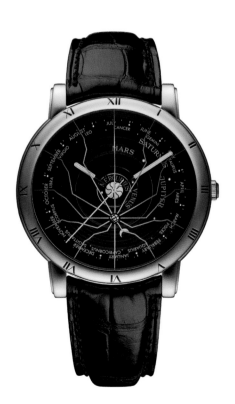

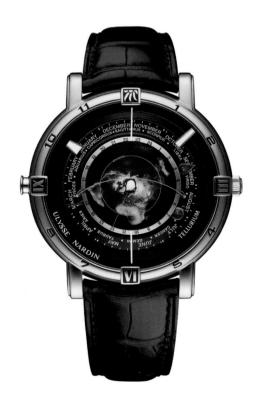

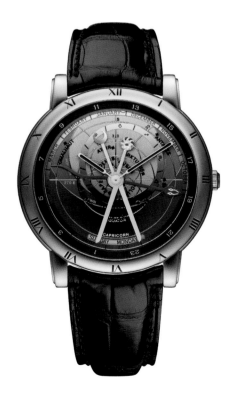

Top left: UN-118 caliber spiral balance spring ◦ Oben links: Unruhspirale, Kaliber UN-118 ◦ En haut à gauche: Spiral de balancier, calibre UN-118 ◦
Top right: Moonstruck, 2009 ◦ Middle, from left: Marine Chronometer Manufacture, 2012 ◦ Perpetual Ludwig, 1996 ◦ Bottom, from left:
Planetarium Copernicus, 1988 ◦ Tellurium Johannes Kepler, 1992 ◦ Astrolabium Galileo Galilei, 1985

Perfekte Synthese aus Tradition und Innovation

Höhepunkte gibt es definitiv viele in der bis 1846 zurückreichenden Biographie von Ulysse Nardin. Aber das 2001 vorgestellte „Freak"-Karussell hat die Uhrmacherei in wahrhaft einzigartiger Weise revolutioniert. Vor allem die innovative Dual-Direct-Hemmung des durch und durch ungewöhnlichen Handaufzugskalibers UN-01 mit acht Tagen Gangautonomie hat es in sich. Wegweisende Technologien gehen Hand in Hand mit bis dahin noch nie verwendeten Materialien. Klassische Bauteile wie beispielsweise Anker und Ankerrad sucht man vergebens. Zwei Antriebsräder übertragen die Energie direkt auf den Gangregler, bestehend aus Unruh und Unruhspirale. Erstmals überhaupt fertigt Ulysse Nardin besagtes Räderpaar im Plasmaverfahren aus reinem Silizium. Dieses amagnetische Material zeichnet sich aus durch höchstmögliche Härte bei geringem Gewicht: Besonders glatte Oberflächen machen Öl entbehrlich. Hinter dieser Ausnahme-Konstruktion stehen zwei Männer: Rolf Schnyder, ein passionierter Unternehmer mit Herz, erwarb die konkursreife Firma im Jahr 1983 und formte sie zu einer anerkannten Größe auf dem Gebiet anspruchsvoller mechanischer Uhrmacherkunst. Seinem Sparringspartner, dem kreativen Uhrmacher und Wissenschaftler Ludwig Oechslin, verdankt Ulysse Nardin zahlreiche chronometrische Meilensteine.

Schier unbändiger Einfallsreichtum hatte übrigens schon den Firmengründer ausgezeichnet. Beinahe jeden Tag reiften im Kopf von Ulysse Nardin neue Ideen. Dafür belohnte ihn die Jury der Londoner Weltausstellung 1862 mit der höchstmöglichen Auszeichnung in Gestalt einer Prize Medal. Weitere Ehrungen dieser Art folgten auf dem Fuße. Womöglich deshalb durfte er 1893 einen der Schweizer Beiträge zur Weltausstellung in Chicago, der World's Columbian Exposition, liefern. Das reich dekorierte Gehäuse seiner Uhr erinnerte an die industrielle Revolution in der zweiten Hälfte des 19. Jahrhunderts. Zur Vollendung benötigte der Skulpteur mehr als 1 200 Arbeitsstunden. Ursprünglich hatte Ulysse Nardin seinen Ausnahme-Zeitmesser mit einem Chronometerwerk ausgestattet. Der spätere Käufer dieser Uhr wünschte sich jedoch einen Chronographen mit Minutenrepetition. Weltgeltung erlangten beinahe unzählige Marinechronometer und Beobachtungsuhren. Allein hierfür konnte Ulysse Nardin sage und schreibe rund 4 300 Auszeichnungen verschiedener Observatorien und Prüfstellen entgegennehmen. Nach der Wende vom 19. zum 20. Jahrhundert fanden Armbanduhren in die Kollektion. Sehr früh, nämlich schon 1912, entstand ein erster Chronograph fürs Handgelenk.

Bis in die 1960er Jahre schien nichts die Erfolge trüben zu können. Dann aber ließen Fortschritte bei der elektronischen Zeitmessung den Bedarf an nautischen Zeitmessern sukzessive gegen null gehen. Anstatt adäquat gegenzusteuern, erstarrten die Nachfahren des Ulysse Nardin, meist Juristen von Beruf, in unternehmerischer Lethargie. Weil sie zu allem Überfluss auch noch die Zukunft der Armbanduhr völlig falsch einschätzten, schien das Ende des Familienunternehmens besiegelt.

Als sogenannter Weißer Ritter investierte Rolf Schnyder für damalige Verhältnisse stattliche 1,5 Millionen Schweizer Franken. Seine intelligente Verquickung von Tradition und Innovation sowie das konstruktive Genie von Ludwig Oechslin führten ab 1985 zu einer Trilogie einzigartiger astronomischer Armbanduhren. 1988 fand sich die Nummer eins, das hochkomplexe „Astrolabium Galileo Galilei", auf der Umschlagseite des Guinness-Buchs der Rekorde. Im gleichen Jahr debütierte das „Planetarium Copernicus", welches die astronomischen Positionen von fünf Planeten in Relation zu Sonne und Erde darstellt. Drittes im Bunde war das 1992 vorgestellte „Tellurium Johannes Kepler".

Durchdacht bis ins letzte Detail, überaus benutzerfreundlich und aktuell bis in die Gegenwart präsentierte sich der mehrfach patentierte „Perpetual Ludwig" mit ewigem Kalender. Erstmals in der Geschichte dieser uhrmacherischen Komplikation sind sämtliche Indikationen mit Hilfe der Krone in beide Richtungen einstell- und korrigierbar. Beim „GMT± Perpetual" kombinierte Ulysse Nardin diesen Mechanismus mit intuitiv handhabbarem Zeitzonen-Dispositiv. Das Großdatum folgt Zeit-Reisen ganz automatisch, egal ob in westlicher oder östlicher Richtung. „Sonata", vorgestellt 2003, stellte die Geschichte des Armbandweckers auf den Kopf. Ihr Alarm funktioniert unüberhörbar rund um den Globus. Kinderleichte Bedienung war und ist auch hier Ehrensache.

Sein 160. Firmenjubiläum zelebrierte Ulysse Nardin 2006 mit dem komplett selbst entwickelten und in La Chaux-de-Fonds gefertigten Automatikkaliber UN-160. Zwei seiner Filetstücke sind die exklusive, ohne Öl arbeitende Dual-Ulysse-Hemmung und die eigene Glucydur-Unruh mit variablem Trägheitsmoment.

Classico Schooner America, 2016

FreakWing, 2016

Mit diesem Uhrwerk katapultierte sich Ulysse Nardin in den aristokratischen Zirkel echter Manufakturen. Eine weitere Weltpremiere machte 2007 von sich reden. Im spektakulären „Freak DIAMonSIL" tragen die Silizium-Komponenten der Dual-Direct-Hemmung eine synthetische nano-kristalline Diamantschicht. Dieser Werkstoffmix bietet die Vorteile des härtesten Materials überhaupt, hält die Kosten aber in sehr überschaubarem Rahmen. An die astronomische „Trilogie der Zeit" knüpfte die „Moonstruck" von 2009. Oberste Präzision genoss einmal mehr die Anzeigegenauigkeit. Bis diese Armbanduhr anstelle des Neumonds einen Vollmond abbildet, verstreichen rund 100 000 Jahre. Besonders beeindruckend: das exakte Ablesen der aktuellen Mondphase in Relation zu einem beliebig bestimmbaren Punkt auf der Erdoberfläche sowie eine Demonstration der globalen Dynamik der von Mond und Sonne beeinflussten Gezeiten. Vor seinem überraschenden Tod im Jahr 2011, hatte Rolf Schnyder noch das ehrgeizige Kaliber-Projekt UN-118 in Angriff genommen. Bei der Hemmung lautete das Zauberwort erneut DIAMonSIL. Und die Unruh kooperiert mit einer völlig frei oszillierenden Siliziumspirale. Die 350 Rotgold-Exemplare der längst ausverkauften Armbanduhr besitzen ein Emailzifferblatt des traditionsreichen Spezialisten Donzé, einem Mitglied der Ulysse-Nardin-Gruppe. Nach dem Ableben des charismatischen Eigentümers im Jahr 2011 gelangte Ulysse Nardin unter das Dach der französischen Kering-Gruppe. Als CEO setzte Patrik Hoffmann, ein langjähriger Weggefährte des Verstorbenen, die erfolgreiche Strategie konsequent fort. Der Kauf des Chronographenkalibers 137 bescherte Ulysse Nardin Autonomie auch auf diesem anspruchsvollen Gebiet mechanischer Zeitmessung. Bevor es als Kaliber UN-150 zum Einsatz kam, waren jedoch tiefgreifende Optimierungen vonnöten, darunter die Verwendung von Silizium-Komponenten für das Schwing- und Hemmungssystem. An den Produzenten dieser Bauteile hatte sich der visionäre Rolf Schnyder schon Jahre zuvor finanziell beteiligt. Sein Ziel: Unabhängigkeit von den Zulieferern unverzichtbarer Schlüsselkomponenten mechanischer Uhren.

Die unverkennbare Handschrift von Patrik Hoffmann tragen gleich mehrere Neuheiten des Jahres 2016: Als absolutes Highlight kann das „Grand Deck Marine Tourbillon" gelten. Sein Intarsien-Zifferblatt und der außergewöhnliche Minutenzeiger erinnern an die langen chronometrischen Verbindungen zum nassen Element. Angetrieben von einem hauchdünnen Draht aus Hightech-Faser bewegt sich der einem Großbaum nachempfundene Minutenzeiger innerhalb einer Stunde von links nach rechts. Logischerweise berücksichtigen Räderwerk und Zeitanzeige die Dauer der zügigen, aber nicht springenden Rückbewegung zum Ausgangspunkt. Dem von Ludwig Oechslin stets postulierten Prinzip einfacher, trotzdem jedoch höchst funktionaler Kadraturen folgt der „Marine Chronograph Annual Calendar". Nur sieben zusätzliche Teile braucht es für das hilfreiche Kalendarium, welches die Länge aller Monate mit Ausnahme des Februars kennt. Uhrmacherische Hochtechnologie, gepaart mit der durch den Partner Artemis Racing repräsentierten Faszination des 35. America's Cup, bringt die markante „FreakWing" zum Ausdruck. In diesem Sinn ist die obere Minutenbrücke des Uhrwerks von der inneren Struktur des starren Segels inspiriert. Den Flanken des Doppelrumpf-Boliden ähnelt die Beschaffenheit der rotierenden Stundenscheibe. Schließlich bestehen Glasrand und Boden aus Kohlenstofffaser, dem Werkstoff des Top-Segelsports schlechthin. Womit erneut bewiesen wäre, dass sich jahrhundertealte mechanische Uhrmacherkunst und die Hochtechnologien des 21. Jahrhunderts in wunderbarer Weise ergänzen können. ◦

Marine Chronograph Annual Calendar, 2016

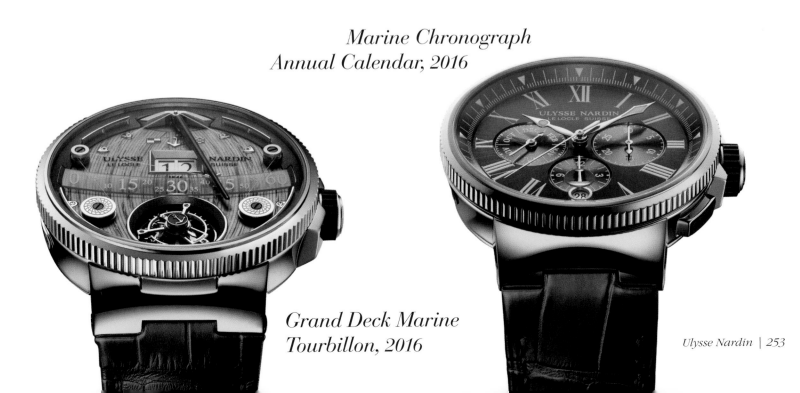

Grand Deck Marine Tourbillon, 2016

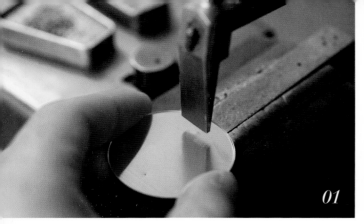

01

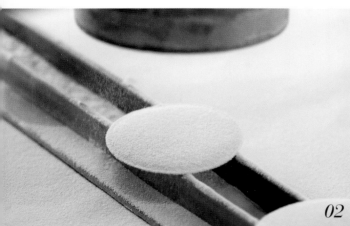

02

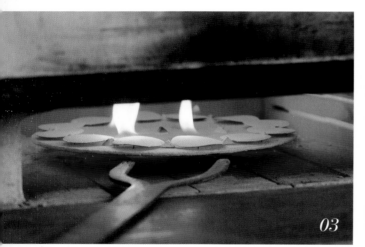

03

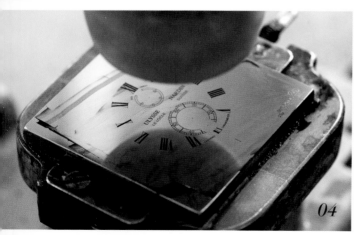

04

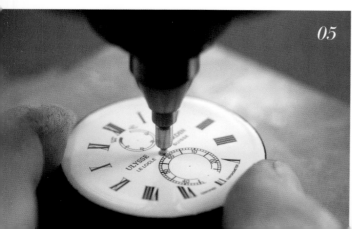

05

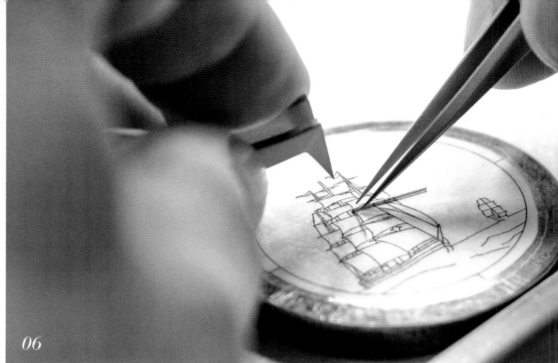

06

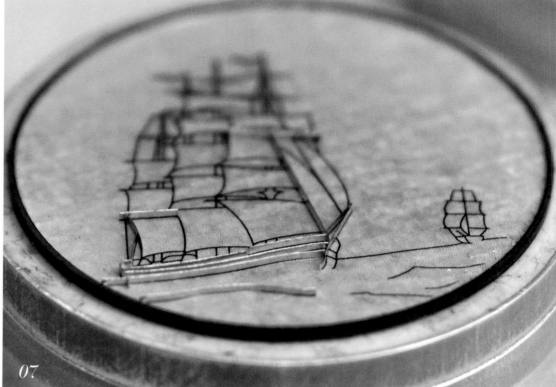

07

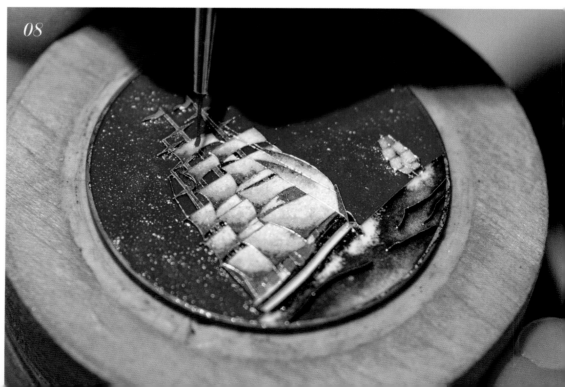

08

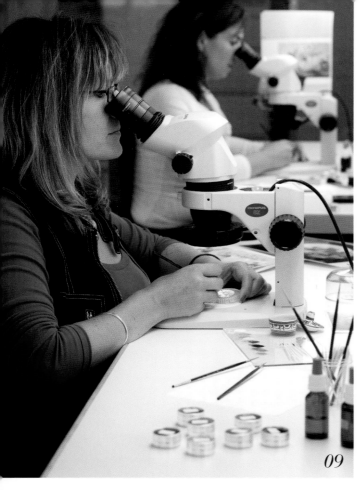

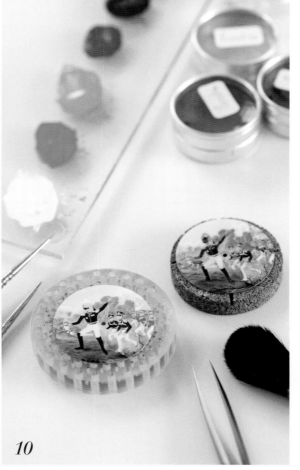

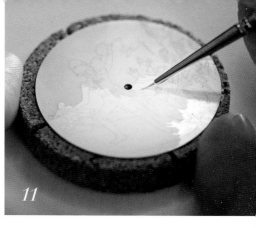

11

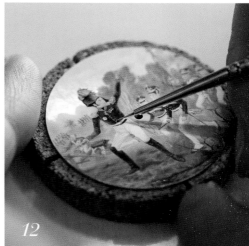

12

09 10

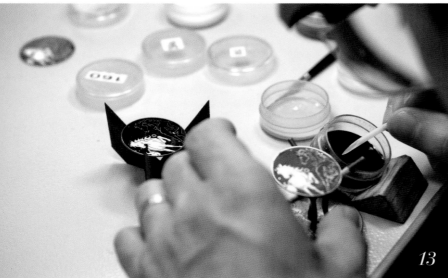

13

01–05: *Enameling process: "Grand Feu" Marine Chronometer*
Manufacture ◦ Emaillierung, Grand-Feu-Technik: Marine
Chronometer Manufacture ◦ Émaillage grand feu : Marine
Chronometer Manufacture
06–08: *Enameling process: "Cloisonné Enamel" Classico Kruzenshtern ◦*
Emaillierung, Cloisonné-Technik: Classico Kruzenshtern ◦
Émaillage cloisonné : Classico Kruzenshtern
09–12: *Miniature painting process: Classico Raevsky ◦ Miniaturmalerei:*
Classico Raevsky ◦ Peinture de miniature : Classico Raevsky
13–16: *Enameling process: "Champlevé Enamel" Classico Horse ◦*
Emaillierung, Champlevé-Technik: Classico Horse ◦
Émaillage champlevé : Classico Horse

14 15 16

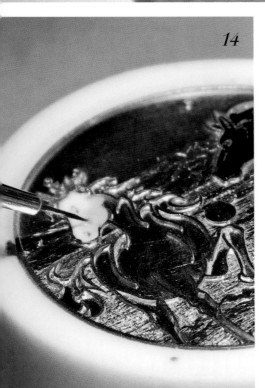

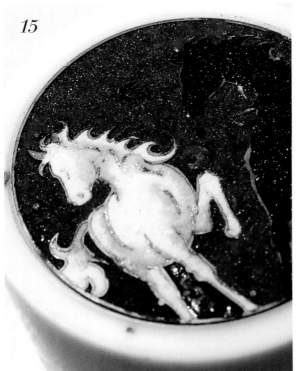

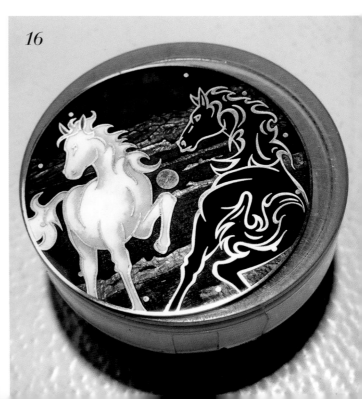

La synthèse parfaite entre tradition et innovation

Si les dates clés sont légion dans l'histoire d'Ulysse Nardin, qui débute en 1846, la sortie en 2001 du carrousel tourbillon « Freak » constitue une véritable révolution horlogère. On est particulièrement émerveillé par l'innovant double échappement direct Dual Direct du calibre à remontage manuel UN-01 totalement inédit, qui assure une réserve de marche de huit jours. Les technologies de pointe vont de pair avec l'emploi de matériaux jusqu'alors réservés à d'autres domaines. On cherchera en vain les composants classiques comme l'ancre et la roue d'échappement. Ce sont deux roues d'impulsion qui transmettent l'énergie directement à l'organe de régulation constitué par le balancier et le spiral. Ulysse Nardin réalise ces roues en silicium pur par traitement plasma, une véritable première. Ce matériau amagnétique se caractérise par une dureté extrêmement élevée pour un poids très faible, mais aussi par des surfaces lisses à tel point qu'aucun lubrifiant n'est nécessaire. Ce type de conception hors pair est l'œuvre de deux hommes. Rolf Schnyder, entrepreneur passionné et généreux, rachète en 1983 la manufacture au bord de la faillite et fait d'elle un acteur reconnu dans le segment de l'horlogerie mécanique de luxe. Son « sparring partner », le maître-horloger créatif et chercheur Ludwig Oechslin, est à l'origine de nombreuses avancées chronométriques pour le compte d'Ulysse Nardin.

Cette créativité débordante était déjà le propre du fondateur de l'entreprise : presque tous les jours, de nouvelles idées mûrissaient dans le cerveau d'Ulysse Nardin. Le jury de l'Exposition universelle de 1862 à Londres l'en récompense par la plus haute distinction, la « Prize Medal ». Et les honneurs comparables de se succéder. Cela vaut sans doute à la marque de faire partie en 1893 des contributeurs suisses à l'Exposition universelle de Chicago, également connue sous le nom de World's Columbian Exposition. Les riches ornementations du boîtier de sa montre, qui évoquent la Révolution industrielle de la seconde moitié du XIX^e siècle, ont exigé plus de 1 200 heures de travail de la part du graveur. À l'origine, ce modèle inédit est équipé d'un mouvement de chronomètre. Le futur acquéreur de la montre la fera transformer en chronographe doté d'une répétition minutes. Un nombre pour ainsi dire incalculable de chronomètres de marine et de montres d'observation atteignent à la renommée internationale. Dans ce seul domaine, la marque reçoit pas moins de 4 300 récompenses de différents observatoires et organismes vérificateurs. Au début du XX^e siècle, la collection admet en son sein des montres-bracelets. Très tôt, dès 1912, l'horloger met au point un chronographe de poignet.

Jusque dans les années 1960, rien ne semble pouvoir ternir cette réussite. Avec les progrès de la mesure électronique du temps, la demande en chronomètres de marine baisse alors progressivement jusqu'à devenir quasi nulle. Au lieu de redresser le cap, les descendants d'Ulysse Nardin, en majorité des juristes de formation, laissent l'entreprise sombrer dans la léthargie. Comme ils n'ont en outre pas su prendre la mesure de la saturation du marché de la montre-bracelet, ni anticiper son évolution, il semble que la fin de l'entreprise familiale soit scellée.

Rolf Schnyder, en véritable Chevalier blanc, investit 1,5 million de francs suisses, une coquette somme pour l'époque. Son judicieux mix de tradition et d'innovation ainsi que l'inventivité de Ludwig Oechslin sont à l'origine du développement, à partir de 1985, d'une trilogie de montres-bracelets astronomiques d'exception. En 1988, la première, le modèle « Astrolabium Galileo Galilei » à multiples complications, fait la couverture du *Livre Guinness des records*. La même année, on voit arriver sur le marché la « Planetarium Copernicus », qui affiche les positions astronomiques de cinq planètes par rapport au Soleil et à la Terre. Dernier modèle du trio, « Tellurium Johannes Kepler » sort en 1992.

Étudiée jusque dans le moindre détail, extrêmement conviviale, encore d'actualité et faisant l'objet de plusieurs brevets, la « Perpetual Ludwig » fait son entrée en scène avec un quantième perpétuel. Pour la première fois dans l'histoire de cette complication horlogère, la couronne permet l'ajustement et la rectification en avant ou en arrière de tous les indicateurs calendaires. Dans le modèle « GMT± Perpetual », Ulysse Nardin associe le quantième perpétuel à une fonction GMT activable de manière intuitive. La Grande Date s'ajuste automatiquement, que l'on voyage vers l'est ou vers l'ouest. En 2003, « Sonata » révolutionne l'histoire des montres réveils. Sa sonnerie cathédrale, qui est facilement perceptible, fonctionne indépendamment du fuseau horaire. Comme toujours, la marque se fait ici un point d'honneur à proposer des fonctions faciles à manier.

Sorti en 2006 pour célébrer le 160^e anniversaire de la manufacture, le calibre automatique UN-160 est entièrement développé et fabriqué en interne à La Chaux-de-Fonds. Deux de ses « morceaux de choix » sont l'échappement Dual Ulysse non lubrifié exclusif et le balancier maison en glucidur à moment d'inertie variable.

Ce mouvement catapulte Ulysse Nardin dans le gotha des vraies manufactures. En 2007, une nouvelle première mondiale défraye la chronique. Dans le spectaculaire « Freak DIAMonSIL », les composants en silicium de l'échappement Dual Direct sont revêtus d'une couche de diamant nanocristallin de synthèse, une solution qui permet de bénéficier des propriétés du matériau le plus dur qui soit tout en maintenant les coûts à un niveau raisonnable. Dans la lignée des trois montres astronomiques composant la Trilogie du Temps, « Moonstruck » est encore un chef-d'œuvre de précision de l'affichage : il ne faudra pas moins de 100 000 ans pour voir s'afficher une pleine lune au lieu d'une nouvelle lune. Ce modèle sorti en 2009 présente entre autres caractéristiques remarquables : la détermination exacte de la phase de lune actuelle en un point quelconque à la surface de la Terre ainsi que la visualisation du mouvement des marées résultant de l'attraction combinée de la Lune et du Soleil. Avant son décès soudain en 2011, Rolf Snyder s'attelle à l'ambitieux projet de calibre UN-118. De nouveau, la formule magique pour l'échappement est DIAMonSIL. Le balancier est couplé à un spiral silicium oscillant en toute liberté. Les 350 exemplaires en or rouge de la montre-bracelet épuisée depuis longtemps sont dotés d'un cadran émail signé Donzé, une entreprise de tradition intégrée au groupe Ulysse Nardin. Après le décès de son charismatique propriétaire en 2011, Ulysse Nardin entre dans le giron du groupe français Kering. En sa qualité de PDG, Patrik Hoffmann, compagnon de route de longue date du défunt,

poursuit cette stratégie gagnante. Avec l'achat du calibre 137 Ebel pour chronographes, Nardin devient également autonome dans ce secteur très pointu de l'horlogerie mécanique. Après de nécessaires optimisations majeures, notamment l'insertion de composants en silicium dans l'organe oscillant et l'échappement, ce calibre fait son entrée en scène sous le nom de UN-150. De nombreuses années auparavant, le visionnaire Rolf Schnyder a pris une participation financière dans les fabricants de ces composants. Son objectif : l'indépendance à l'égard des fournisseurs des incontournables composants clés de montres mécaniques.

La signature reconnaissable entre mille de Patrik Hoffmann se retrouve sur plusieurs nouveautés de l'année 2016, parmi lesquelles une véritable prouesse technologique, le « Grand Deck Marine Tourbillon ». Son cadran en marqueterie et son aiguille des minutes inédite rappellent la longue tradition des chronomètres de marine. Mue par un nanofil dans une fibre de haute technologie, l'aiguille des minutes aux allures de bôme de voilier traverse le cadran de gauche à droite en l'espace d'une heure. Les engrenages et l'affichage ne tiennent bien sûr pas compte de la durée du retour à zéro, qui est rapide mais non sautant. Le « Marine Chronograph Annual Calendar » est l'expression de la volonté constamment réaffirmée par Ludwig Oechslin de créer des cadratures à la fois simples et extrêmement performantes. Il suffit de sept composants supplémentaires pour obtenir l'utile complication du calendrier, qui reconnaît chaque mois à son nombre de jours, sauf février. L'alliance de la haute technologie horlogère et de la fascination pour la 35e Coupe de l'America, qui se traduit par un partenariat avec Artemis Racing, trouve son expression dans la très originale « FreakWing ». En l'occurrence, le pont des minutes est inspiré de la structure interne de l'aile rigide de certains catamarans. Le disque des heures rotatif rappelle par sa constitution les flancs de ces bolides à deux coques. Enfin, les bords du verre et le fond de boîte sont en fibre de carbone, le matériau par excellence des voiliers de compétition. N'est-ce pas là une fois de plus la preuve que la haute horlogerie mécanique pluricentenaire et les hautes technologies du XXIe siècle se complètent à merveille ? ○

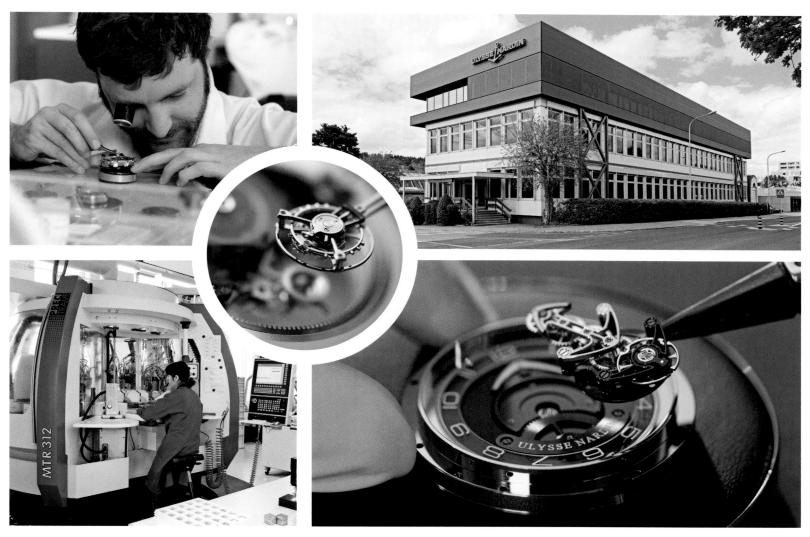

Clockwise, from top left: Complication workshop ○ La Chaux-de-Fonds ○ Freak movement assembly ○ Movements construction ○
Circle: Tourbillon carriage assembly ○ Von oben links im Uhrzeigersinn: Komplikationen-Atelier ○ La Chaux-de-Fonds ○
Montage eines Uhrwerks, Modell Freak ○ Fertigung der Uhrwerke ○ Kreis: Montage des Tourbillonkäfigs ○ Dans le sens horaire,
en partant du haut, à gauche : Atelier de complications ○ La Chaux-de-Fonds ○ Assemblage du mouvement de la Freak ○
Assemblage de mouvements ○ Au centre : Assemblage d'une cage de tourbillon

Credits

The images related to the individual companies

Alpina
Ateliers deMonaco
Baume & Mercier
Blancpain
Carl F. Bucherer
Bulgari
Chronoswiss
Corum
Eterna
Frédérique Constant
Girard-Perregaux
de Grisogono
Hanhart
Junghans
Longines
Nomos Glashütte
Oris
Parmigiani Fleurier
Porsche Design
Seiko
TAG Heuer
Tudor
Tutima Glashütte
Ulysse Nardin

come from each company's own museum or collection.
The images related to the modern wristwatches were made available
by the companies' press offices in Switzerland and Germany.
Pictures from other sources are listed below:

Junghans
(p 137) image of Max Bill courtesy of Max, Binia + Jakob Bill Stiftung,
VG Bild-Kunst, Bonn 2016;

Parmigiani Fleurier
(p 170) image of Bugatti Chiron courtesy of Bugatti Automobiles

Glossary

Glossary

Age of the moon:
An → indication showing the number of days that have elapsed since the last new moon. In a synodic month, the interval from one new moon to the next lasts exactly 29 days, 12 hours, 44 minutes, and 3 seconds.

Analogue time display:
The time is indicated by a pair of hands. The current time can be told by comparing the relative positions of the hour- and minute-hand.

Antimagnetic (correctly: nonmagnetic):
A watch is described as antimagnetic if it's protected against the negative influences of magnetic fields. It can be termed "nonmagnetic" if it continues to run in a magnetic field of 4,800 A/m (amperes per meter) and afterwards deviates from correct timekeeping by no more than 30 seconds per day.

Automatic winding:
An additional mechanism that uses energy derived from the motions of the wearer's forearm to tighten the → mainspring of a mechanical watch.

Balance:
A circular metal hoop that oscillates together with the → balance-spring in portable timepieces. Their oscillations subdivide the steady passage of time into brief segments, which are ideally of identical duration.

Balance-spring:
The balance-spring can be described as the "soul" of a mechanical watch. The inner end of this spring is attached to the balance-staff and the outer end is affixed to the balance-cock. The balance-spring's elasticity assures that the → balance oscillates regularly. The duration of each swing is determined by the active length of the balance-spring and by the moment of inertia of the balance's rim.

Beveling:
Beveled edges on steel parts are a distinguishing feature of fine watches. The edges can be beveled mechanically with the aid of a pantograph or, in the finest luxury watches, the beveling is performed manually with a file. Ideally, each angle on the edge should be precisely 45 degrees. Beveling has no effect on the movement's function.

Bezel:
This term can have various meanings in watchmaking. Strictly speaking, a bezel is an annulus surrounding the crystal of a watch's → case. The crystal is pressed into the bezel, which is then mounted on the middle part of the case. The term is often used, however, to denote rotatable rings on the fronts of watch cases.

Breguet balance-spring:
A balance-spring with a high upward curvature at its outer end to assure uniform "breathing." This type of spring is costly to manufacture, so nowadays it's installed only in very high-quality → calibers.

Cadrature:
An additional switching mechanism in complicated watches, e.g., a mechanism for a → chronograph, → repeater, or calendar. The term is derived from the French word cadran (dial). Cadratures accordingly denote traditional switching mechanisms installed on the dial side of the movement and thus under the dial. Depending on its construction, a cadrature may be integrated into a movement or mounted on a separate → plate and connected to the movement per se as an additional module.

Caliber:
The dimensions and shape of a watch movement and its parts. The caliber designation facilitates precise identification, e.g., when ordering spare parts. Manufactory calibers should be distinguished from movement-blanks furnished by suppliers of → ébauches. The former are movements that → manufactories produce for their own use. Aficionados sometimes talk about

exclusive or reserved calibers: these are movement-blanks that ébauches suppliers develop and/or produce solely for individual customers. These calibers are not available for other → établisseurs.

Case:
The protective exterior housing of a watch. Cases are made in diverse versions and materials. Two common varieties of cases for pocket watches are the open (Lépine) and closed (Savonnette) case. Water-resistant or → watertight cases are commonly used for wristwatches. Watch cases are made in many different shapes (round, square, oval, rectangular, tonneau) and materials (platinum, gold, silver, steel, titanium, carbon, aluminum, plastic).

Chaton (setting):
A circular metal disc with a hole to accept a bearing jewel. Chatons are either pressed or screwed into place in watch movements. Because of their attractive appearance, screwed chatons are again used today, especially by manufactories in Glashütte.

Chronograph:
A chronograph—or more correctly "chronoscope"—is a watch with an hour-hand, a minute-hand, and a special additional mechanism which, at the push of a button, alternately starts a (usually) centrally positioned elapsed-seconds hand, stops it, and returns it to its zero position. The ordinary time display remains unaffected. Depending on the particular version, a chronograph may also have counters to tally the minutes and hours that have elapsed since the chronograph was switched on. When the zero-return button is pressed, the counters' hands likewise return to their starting positions. Two-button chronographs have predominated since the 1930s: one button starts and stops the stopwatch; the other returns the elapsed-time hands to zero. Such chronographs facilitate additive stopping, i.e., the elapsed-second hand can be halted and restarted from its last position as often as desired. Depending on its balance's frequency, a mechanical wristwatch chronograph can measure elapsed intervals to the nearest tenth of a second.

Chronograph rattrapante:
This type of chronograph can simultaneously time two or more events that began at the same moment. The split-seconds mechanism is useful for measuring intermediate times at races.

Chronometer:
A chronometer is a precise timepiece which has proven the accuracy of its rate during a 15-day test at one of the official watch-testing authorities, e.g., the COSC (Contrôle Officiel Suisse des Chronomètres) in Switzerland. In the five → positions "crown left," "crown up," "crown down," "dial up," and "dial down," the average daily rate must remain within −4 and +6 seconds; the average daily deviation may not exceed two seconds; and the greatest deviation of rate must not be larger than five seconds. All watches are tested at 23°, 8°, and 38° Celsius. Only after a watch has passed the chronometer test does it earn the right to bear the word "chronometer" on its dial and to be marketed together with a corresponding certificate.

Column-wheel chronograph:
A rotatable component which can have five, six, seven, eight, or nine columns controls the start, stop, and zero-return functions in a classical chronograph. With each switching process, the column-wheel rotates clockwise through an exactly defined angle. If the end of the switch yoke comes to rest atop a column, the latter keeps the former lifted; if the switch yoke's end falls between two columns, gentle pressure from the spring holds it down.

Complication:
An additional mechanism in a mechanical watch, e.g., → chronograph, → perpetual calendar, or → tourbillon.

Coulisse switching:
A switching mechanism to control a → chronograph. A moveable cam, differently shaped depending on the particular → caliber, embodies the "program"

to start the chronograph, stop it, and return its elapsed-time hands to zero. Chronographs with coulisse or cam switching are technically less complex, but no less reliable than their counterparts with column-wheels.

Counterfeit:
A plagiarized imitation of a popular and usually high-quality watch. Certificates, invoices, and etuis no longer adequately protect purchasers against counterfeiters because these supplementary items can likewise be counterfeited.

Crown:
A button or knob to wind a watch, to set its hands and/or to adjust its date display. The crown was formerly also sometimes used to control the → chronograph.

Crown winding:
Until the late 19th century, many pocket watches were wound, and their hands were often set with the aid of a little key. With modern crown winding, both tasks are performed via a small → crown equipped with a mechanism to switch between the winding and setting functions.

Crystals:
Four kinds of crystals are used on wristwatches. Glass crystals are found primarily on early wristwatches: they resist scratches, but are very fragile and prone to breakage. Plexiglas progressively replaced glass for watch crystals beginning in the early 1940s: Plexiglas crystals are unbreakable, but become scratched relatively easily. Crystals made of mineral glass have a hardness of 5 on the Mohs scale and are therefore much more robust than plastic crystals. Nowadays, high-quality watches usually use → sapphire for their crystals: with a hardness of 9 on the Mohs scale, sapphire is extremely resistant to scratches and breakage, but can only be processed with special diamond-tipped tools.

Date display:
→ Indicator of the date, either in analogue form via a hand (hand-type date display) or digitally via a printed ring (window date). The watch industry uses two separate digits (one in the "tens" and another in the "ones" column) for the outsize date display. Date displays can be divided into three types: creeping, half-creeping, and jumping. The first two types are gradually advanced by the movement. Jumping indicators successively amass power from the movement throughout the day, store the energy in a → spring, and suddenly release the stored → energy exactly at midnight to power the switching mechanism.

Digital time display:
The time of day or night is shown by numerals.

Diver's watches:
Wristwatches manufactured in compliance with clearly defined standards and intended for underwater use. Professional diver's watches must be watertight to a minimum depth of 200 meters (660 feet). For the diver's safety, a jeweler should annually test the watch's watertightness and functionality.

Ébauche:
French term for "sketch." In specialized French watchmaking vocabulary, the movement-blank for a watch is also known as an ébauche or blanc.

Enamel:
A colored vitreous coating applied to a metal substrate. The enameling technique has been used on watches (e.g., the dial and the → case) for more than 350 years. An enamel dial was almost a standard feature on fine watches in the early 20th century. Enamel dials have become extremely rare nowadays, partly because of the high cost of manufacturing them.

Energy:
The ability to do work. Potential energy is needed to power watches. In mechanical timepieces, this potential energy can be stored in a tightened → mainspring (spring power) or in a manually raised weight (gravity power).

Escapement:
A mechanism that conveys the power of the → mainspring in small impulses to the watch's oscillating system (→ balance and → balance-spring) and also prevents the movement from racing ahead and exhausting its stored energy. In a watch with a balance paced at 28,800 semi-oscillations per hour, the escapement allows the gear-train to advance 691,200 times each day. This adds up to more than a billion impulses in the course of four years—approximately six times the performance of a human heart.

Établisseur:
A watchmaker who purchases components (e.g., movement, dial, hands, and → case) from specialized manufacturers and then assembles these parts to make complete watches.

Fabrication number:
Many watch manufacturers use fabrication numbers to identify their products. The makers number the movement, the → case, or both. An officially tested → chronometer must always bear a movement number. This number is also printed on the accompanying test certificate.

Faceted:
Steel and brass components in very fine watches have faceted edges (→ beveling). The bevel should ideally have an angle of 45 degrees.

Finishing:
The final decorations and processing given to a watch.

Frequency:
Oscillations per unit of time, measured in hertz (Hz). Pendulums are most commonly used to regulate the rate of stationary clocks, while mobile timepieces rely on → balances. Both components move to and fro at a particular frequency. The pendulum of a one-second pendulum clock requires exactly one second to swing from one extreme point of its arc to the other, so it has a frequency of 0.5 Hz or 1,800 semi-oscillations per hour (A/h). Early balances were paced at 7,200 or 9,000 A/h. The frequency of balances in pocket watches was increased first to 12,600 and later to the now common standard of 18,000 A/h (2.5 Hz). This frequency originally developed into the most common standard for wristwatches. To increase precision, watch manufacturers later raised the frequency to 21,600 A/h (3 Hz), 28,800 A/h (4 Hz), 36,000 A/h (5 Hz), 57,600 A/h (8 Hz), and even 72,000 A/h (10 Hz). A speedier balance frequency is associated with greater energy consumption. Higher rotational speeds must also be taken into account when lubricating the → escapement.

Full calendar:
A complete calendar showing the current day, date, and month.

Geneva waves:
An undulating pattern commonly used to decorate the bridges and cocks in fine → calibers. Generally found only on high-quality movements, Geneva waves are applied prior to galvanic ennoblement but remain visible afterwards.

GMT:
Greenwich Mean Time, also known as World or Universal Time Coordinate (UTC), is the time at zero degrees longitude, i.e., the meridian that passes through Greenwich, England. GMT is currently used as the standard time for navigation and international radio communication.

Gregorian calendar:
After lengthy preparations and the abrupt elimination of ten full days, the calendar reform instituted by Pope Gregory XIII took effect in Rome on October 15, 1582. This new calendar rectified the tiny residual error that had been accumulating since the introduction of the → Julian calendar in 45 BC, which had erroneously added 0.0078th of a day to each year. The special feature of the Gregorian calendar, which corrects this inaccuracy, is that it eliminates three leap days from the leap-year cycle every 400 years. Leap days are not included in secular years (i.e., years that begin a new century) unless the year is evenly divisible by 400. There will accordingly not be a 29th day in February in the years 2100, 2200, and 2300.

Guilloche:
The engraving of fine and sometimes artistically interwoven patterns on the → cases or dials of watches. Traditional guilloche is performed manually with the aid of antique machines.

Hallmarks:
Stamps punched into → cases specifying the type and fineness of the → precious metal, the country and sometimes also the city of origin, the year of manufacture, and the case-maker. Other punched hallmarks may represent the trademark of the manufacturing or delivering watch company, a → reference or a serial number.

Hand-wound movement:
Depending on its construction, a hand-wound movement may contain 80 or more components, which can be divided into eight main functional groups:
1. the power system as the energy-providing organ;
2. the transfer system to convey → energy to
3. the subdividing system, also known as the → escapement;
4. the regulating system;
5. the motion-work (dial-train);
6. the organs for indicating the time;
7. the hand-setting system; and
8. the winding system.

Hand-wound watch:
A timepiece in which the → mainspring must be wound by hand.

Hour counter:
A constructive feature of some → chronographs to tally the number of hours that have elapsed since the stopwatch function was triggered. Most hour counters can tally up to twelve hours. Pressing the zero-return button triggers the hand on the hour counter to return to its zero position.

Indication:
A display, e.g., of the time, date, day of the week, month, equation of time, → power reserve, or second time zone.

Jewels:
An internationally used term denoting the → stones in a watch movement.

Julian calendar:
The cycle of three 365-day years and one 366-day leap year can be traced to Gaius Julius Caesar. But the Julian year is 0.00078th of a day longer than the actual astronomical year. This error accumulated over the centuries, prompting Pope Gregory XIII to correct the Julian calendar in 1582.

Lever:
The lever is one of the most complicated parts of a mechanical watch. Its twofold task is to transfer power from the gear-train to the → balance, thus keeping the latter in oscillation, and to prevent the gear-train from racing ahead and quickly exhausting the energy stored in the mainspring.

Lever escapement:
Currently the most commonly used type of → escapement in mechanical watches. The Swiss lever escapement predominates among today's high-quality wristwatches.

Ligne:
A unit of length traditionally used to express the dimensions of watch. The ligne is derived from the pied du roi, i.e., the French foot. For example: a circular movement can have a diameter of 11 lignes and a rectangular movement may measure 8¾ by 12 lignes. One ligne is equivalent to 2.2558 millimeters.

Luminous dial:
A dial from which the time can also be read in the dark.

Mainspring:
An elastic and spirally coiled strip of steel which stores the energy needed to power a portable mechanical watch.

Manufactory (French: manufacture):
According to the unwritten laws of watchmaking, a watch manufacturer may only describe itself as a manufactory if it makes at least one → ébauche or movement-blank of its own. The industry uses the term → établisseur to denote a manufacturer who assembles watches from premade movement-blanks.

Mechanical geared clocks:
Timepieces powered by a → mainspring. The rate is regulated either by a → balance with a balance-spring or by a pendulum. The development of the geared clock probably resulted from the mechanism used to propel planetariums, which have been known since the late 13th century. The oldest mechanical geared clock in German-speaking Europe is probably the clock in Strasbourg's cathedral. This clock was completed in 1352. Functional geared clocks probably first appeared in England toward the end of the 13th century.

Moon's phases:
Depending on the relative positions of the sun, the earth, and the moon, the moon waxes through various phases from new moon through waxing half moon to full moon, then wanes through waning half moon to new moon. One lunation is equal to circa 29.5 days.

Perpetual calendar:
A complex calendar mechanism, consisting of circa 100 parts, that automatically takes into account the different lengths of the months. Most perpetual calendars won't require manual correction until February 28, 2100.

Plate:
Also known as movement plate. A metal plate bearing the bridges, cocks, and other parts of a watch movement.

Position:
Unlike pocket watches, wristwatches are worn in many different orientations, which can be divided into the following positions: "crown up," "crown down," "crown right," "dial up," and "dial down." A precise wristwatch accordingly undergoes fine adjustment in each of these five positions.

Power reserve:
Energy potential beyond the normal winding interval of a wristwatch (24 hours). The power reserve usually ranges between 10 and 16 hours. However, the propulsive force of the → mainspring declines during this remaining interval, which causes a reduction in the watch's rate performance.

Power-reserve display:
Indication of the currently remaining → power reserve in a mechanical movement.

Precious metals:
The precious metals gold, platinum, and silver are usually used for the → cases of wristwatches. Gold alloys are available in various finenesses: 333/1,000 (8 karat), 375/1,000 (9 karat), 575/1,000 (14 karat), or 750/1,000 (18 karat). Admixture of other metals (e.g., copper) determines the hue. Winding rotors are often made of 21-, 23-, or 24-karat gold. The fineness of platinum is usually 950/1,000.

Pulsometer:
A time- and work-saving scale on the dial (usually on a → chronograph) to help the wearer measure pulse rates. Depending on the calibrations, the user starts the chronograph, counts either 20 or 30 pulse beats and then stops the chronograph: the tip of the halted elapsed-seconds hand will point to the calculated pulse rate per minute.

Rate autonomy:
The entire running interval of a mechanical movement, i.e., the time that elapses from complete winding of the → mainspring to motionlessness due to its slackening.

Reference:
A manufacturer-specific combination of letters and numbers to classify various watch models. The reference number often also includes information about the type, case material, movement, dial, hands, wristband, and embellishment with gemstones.

Regulator dial:
Off-center → indication of the hours and seconds.

Repeater striking-train:
An elaborate additional function which enables a movement to audibly chime the current time with greater or lesser accuracy. Depending of the specific repeater, the timepiece may be triggered to chime every quarter hour, every eighth of an hour (i.e., every 7½ minutes), every five minutes, or every minute.

Retrograde display:
A retrograde hand advances stepwise along an arc of a circle to indicate the time, date, or day of the week and then suddenly jumps back to its starting position when it reaches the end of the arc.

Rotor:
An unlimitedly rotatable oscillating weight in watches with → automatic winding. Depending on the construction of the self-winding mechanism, the rotor acts to tighten the → mainspring in either one or both of the rotor's directions of rotation. Central rotors rotate above the entire movement; microrotors are inset into the plane of the movement.

Sapphire crystal:
A scratch-resistant crystal with a hardness of 9 on the Mohs scale. Only diamond is harder.

Satin finish:
A fine, silky, matt finish on metal surfaces.

Shock absorption:
A system to prevent breakage of the slender and thus very delicate pivots of the balance-staff. For this purpose, the ring jewel and cap jewel of the balance-staff's bearing are elastically affixed in the → plate and balance-cock. If the watch suffers a strong impact, the jewels can shift laterally and/or axially. A wristwatch with a shock-absorption system should be able to survive a plunge from a height of one meter (3.3 feet) onto an oak floor without suffering damage and without showing significant rate deviations afterwards.

Silicon:
Brass, steel, and synthetic rubies predominated for centuries in the fabrication of mechanical movements. But silicon, the basic material of electronic microchips, became acceptable in the world of haute horlogerie in 2001. In its monocrystalline form, silicon has the same crystalline structure as diamond. Silicon is 60 percent harder and 70 percent lighter than steel, → nonmagnetic, and resistant to corrosion. Even without post-processing, silicon has an extremely smooth surface which makes lubricant oil unnecessary. Silicon is elastic, but not plastically formable. Specially treated "Silinvar" expands only very minimally when warmed, so it's well suited as a material for → balance-springs. A neologism derived from the words "invariable silicon," Silinvar was co-developed by Patek Philippe, Rolex, and the Swatch Group in collaboration with the Centre Suisse d'Electronique et de Microtechnique (CSEM) and the Institut de Microtechnique of the University of Neuchâtel.

Skeletonized movement:
A watch movement in which the → plate, bridges, cocks, barrel, and sometimes also the → rotor are pierced and filed away to leave only the material that is indispensable for each component's proper function. The openwork enables connoisseurs to peer into the depths of the movement. Wristwatches with skeletonized movements first appeared in the 1930s.

Spring:
Many different types of springs are used in watch movements. Alongside the → balance-spring and → mainspring, locking springs and retainer springs are also commonly used.

Stainless steel:
A popular alloy containing the metals steel, nickel, and chrome with admixed molybdenum or tungsten. Stainless steel does not rust and is extremely resistant and → antimagnetic, but is comparatively difficult to process.

Stones:
To reduce friction in precise watches, jewels are inserted into the most important bearings, as pallet stones on the lever and on the impulse-pin.

Stop-seconds function:
A mechanism to momentarily halt the movement and/or the second-hand so the hands can be set with to-the-second accuracy.

Stopwatches:
Unlike → chronographs, stopwatches do not display the ordinary time of day. In simply constructed stopwatches, the movement is halted to stop the second-hand.

Tourbillon:
Invented by Abraham-Louis Breguet in 1795 and patented by him in 1801, the tourbillon compensates for the center-of-gravity error in the oscillating system (→ balance and → balance-spring) of a mechanical watch. The French word tourbillon means "whirlwind." In horological contexts, it refers to a construction in which the entire oscillating and escapement system is mounted inside a cage of the lightest possible weight. The cage continually and uniformly rotates around its own axis, usually completing one rotation per minute. These constant rotations compensate for the negative influences exerted by the earth's gravity on the accuracy of a watch's rate when the timepiece is in a vertical → position. The tourbillon's rotations also improve the watch's rate performance. A tourbillon has no effect on the accuracy of the rate when the timepiece is in a horizontal position.

Tourbillon cage:
Made of steel or (in modern wristwatches) also of titanium or aluminum, this delicate cage contains the oscillating and escapement system (→ balance, balance-staff, → balance-spring, → lever, escape-wheel) in a watch with a → tourbillon. The tourbillon cage usually completes one rotation around its own axis every minute. A tourbillon cage should be rigid, filigreed and as lightweight as possible. Fabricating it is one of the most challenging horological tasks.

Watertight wristwatches:
Watches can be labeled with the word "watertight" if they are resistant against perspiration, sprayed water, and rain. Furthermore, they must not allow any moisture to penetrate their → cases while submerged to a depth of one meter (3.3 feet) for 30 minutes. The additional phrase "50 meters" or "5 bar" means that these watches have been tested at the corresponding pressure by their manufacturers. Nevertheless, it is not recommendable to swim—and it is even less recommendable to dive—while wearing such watches.

World-time indication:
Watches with world-time indication normally show 24 time zones on their dials. Exceptional world-time watches indicate the time in as many as 37 different time zones.

Glossar

Analoge Zeitanzeige:
Zeitanzeige per Zeigerpaar. Die aktuelle Uhrzeit ergibt sich aus der Stellung von Stunden- und Minutenzeiger zueinander.

Anglierung:
Merkmal feiner Uhren sind u. a. die gebrochenen Kanten der Stahlteile. Die Anglierung wird entweder maschinell mit Pantographen (Storchenschnabel) angebracht oder bei Luxusuhren auf höchstem Niveau in überlieferter Form per Feile von Hand ausgeführt. Idealerweise beträgt der Kantenwinkel exakt 45 Grad. Die Anglierung besitzt keine Auswirkungen auf die Funktion des Uhrwerks.

Anker:
Eines der kompliziertesten Teile mechanischer Uhren. Seine Aufgabe besteht zum einen darin, die Kraft vom Räderwerk auf die → Unruh zu übertragen, um deren Schwingungen aufrechtzuerhalten. Andererseits verhindert er das ungebremste Ablaufen des aufgezogenen Räderwerks.

Ankerhemmung:
Heute die am meisten verbreitete → Hemmung bei mechanischen Uhren. Bei hochwertigen Armbanduhren beherrscht mittlerweile die Schweizer Ankerhemmung das Feld.

Antimagnetisch, korrekt amagnetisch:
Eine Uhr ist amagnetisch, wenn sie gegen die negativen Einflüsse magnetischer Felder geschützt ist. Sie darf dann als amagnetisch bezeichnet werden, wenn sie in einem Magnetfeld von 4800 A/m (Ampere pro Meter) weiterläuft und anschließend eine Gangabweichung von höchstens 30 Sekunden/Tag aufweist.

Automatischer Aufzug:
Zusatzmechanismus, welcher die (Arm-)Bewegungen zum Spannen der → Zugfeder einer mechanischen Uhr nutzt.

Breguet-Spirale:
→ Unruhspirale mit hochgebogener Endkurve für gleichförmigeres „Atmen". Aufgrund beträchtlicher Herstellungskosten ist sie heute nur noch in sehr hochwertigen → Kalibern zu finden.

Chaton:
Kreisrundes, gebohrtes Metallstück zur Aufnahme eines Lagersteins, durch Einpressen oder Verschrauben im Uhrwerk befestigt. Vor allem Glashütter Uhrenmanufakturen verwenden heute aus optischen Gründen wieder verschraubte Chatons.

Chronograph:
Unter Chronograph oder – sprachlich korrekter – Chronoskop versteht man eine Uhr mit Stunden- und Minutenzeiger, deren spezieller Zusatzmechanismus das Starten, Stoppen und Nullstellen eines (meist) zentral positionierten Sekundenzeigers per Knopfdruck ermöglicht. Die Zeitanzeige bleibt davon unberührt. Je nach Ausführung besitzen Chronographen zudem Zählzeiger für die seit Beginn der Stoppung verstrichenen Minuten und Stunden. Nach Betätigung des Nullstelldrückers springen auch die Zählzeiger in ihre Ausgangsposition zurück. Seit den 1930er Jahren dominierte der Zwei-Drücker-Chronograph. Ein Drücker dient dem Starten und Anhalten, der andere dem Nullstellen. Diese Chronographen ermöglichen Additionsstoppungen, d. h. der Chronographenzeiger kann beliebig oft angehalten und aus der zuletzt eingenommenen Position heraus erneut gestartet werden. Abhängig von der Unruhfrequenz können mechanische Armbandchronographen bis auf die Zehntelsekunde genau stoppen.

Chronograph-Rattrapante:
Mit seiner Hilfe lassen sich zwei oder mehr Vorgänge simultan stoppen, sofern sie gleichzeitig beginnen. Der Schleppzeiger-Mechanismus eignet sich bei Wettrennen auch zum Erfassen von Zwischenzeiten.

Chronometer:
Präzisionsuhr, welche ihre Ganggenauigkeit im Rahmen einer 15-tägigen Kontrolle bei einer offiziellen Uhrenprüfstelle (z. B. der COSC Contrôle Officiel Suisse des Chronomètres in der Schweiz) unter Beweis gestellt hat. In den fünf → Lagen „Krone links", „Krone oben", „Krone unten", „Zifferblatt oben" und „Zifferblatt unten" muss der mittlere tägliche Gang zwischen −4 und +6 Sekunden liegen; die mittlere tägliche Gangabweichung darf 2 Sekunden, die größte Gangabweichung 5 Sekunden nicht überschreiten. Alle Uhren werden bei Temperaturen von 23, 8 und 38 °C geprüft. Erst nach dem Bestehen der Chronometerprüfung darf eine Uhr auf dem Zifferblatt die Bezeichnung Chronometer tragen und mit einem entsprechenden Zertifikat vermarktet werden.

Datumsanzeige:
→ Indikation des Datums entweder analog durch einen Zeiger (Zeigerdatum) oder digital durch einen bedruckten Ring (Fensterdatum). Beim sogenannten Großdatum verwendet die Uhrenindustrie zwei separate Ziffern für die Zehner und Einer. Grundsätzlich zu unterscheiden sind schleichende, halbspringende und springende Datumsanzeigen. Erstere werden vom Werk allmählich fortgeschaltet. Springende Indikationen entziehen dem Uhrwerk im Laufe des Tages sukzessive Kraft und speichern sie in einer → Feder. Die → Energie wird exakt um Mitternacht für den Schaltvorgang freigesetzt.

Digitale Zeitanzeige:
Darstellung der Uhrzeit in Ziffern.

Drehgang:
Andere Bezeichnung für → Tourbillon.

Drehgestell:
Feiner Käfig aus Stahl oder – bei modernen Armbanduhren – auch aus Titan oder Aluminium, welcher bei Uhren mit → Tourbillon zur Aufnahme des Schwing- und Hemmungssystems (→ Unruh, Unruhwelle, → Unruhspirale, → Anker, Ankerrad) dient. Das Drehgestell rotiert in der Regel einmal pro Minute um seine Achse. Es soll fest, filigran und möglichst leicht sein. Seine Herstellung gehört zu den uhrmacherischen Herausforderungen.

Ebauche:
Französischer Begriff für Entwurf. In der französischen Uhrmachersprache wird das Rohwerk einer Uhr als blanc oder ébauche bezeichnet.

Edelmetalle:
Für die → Gehäuse von Armbanduhren werden in aller Regel die Edelmetalle Gold, Platin und Silber verwendet. Gold gibt es mit einem Feingehalt von 333/1000 (8 Karat), 375/1000 (9 Karat), 575/1000 (14 Karat) oder 750/1000 (18 Karat). Die Legierung mit anderen Metallen (z. B. Kupfer) bestimmt den Farbton. 21-, 23- oder 24-karätiges Gold findet man z. B. bei Aufzugsrotoren. Bei Platin beträgt der Feingehalt 950/1000.

Edelstahl:
Populäre Legierung aus den Metallen Stahl, Nickel und Chrom unter Beifügung von Molybdän oder Wolfram. Sie ist rostfrei, extrem widerstandsfähig und → amagnetisch, jedoch vergleichsweise schwer zu bearbeiten.

Email:
Französisches Wort für farbigen Glasfluss auf Metall. Bei Uhren (Zifferblätter und → Gehäuse) findet die Emailtechnik seit mehr als 350 Jahren Anwendung. Nach der Wende vom 19. zum 20. Jahrhundert gehörte das Email-Zifferblatt beinahe zum Standard für feine Uhren. Inzwischen ist es – nicht zuletzt auch aus Kostengründen – extrem rar geworden.

Energie:
Gespeicherte Arbeitsfähigkeit. Zum Antrieb von Uhren ist ein Energiepotenzial erforderlich. Dies kann bei mechanischen Uhren eine gespannte → Zugfeder (Federkraftantrieb) oder ein hochgezogenes Gewicht (Schwerkraftantrieb) sein.

Etablisseur:
Uhrenhersteller, welcher Komponenten (Werk, Zifferblatt, Zeiger, → Gehäuse) bei spezialisierten Fabrikanten einkauft und zu fertigen Zeitmessern verarbeitet.

Ewiger Kalender:
Komplexes Kalenderwerk, bestehend aus etwa 100 Teilen, welches die unterschiedlichen Monatslängen in aller Regel bis zum 28. Februar 2100 ohne manuelle Korrektur berücksichtigt.

Fabrikationsnummer:
Zur Identifikation ihrer Produkte greifen viele Uhrenhersteller auf Fabrikationsnummern zurück. Dabei nummerieren sie Werk oder → Gehäuse oder beides. Offiziell geprüfte → Chronometer müssen in jedem Fall eine Werksnummer tragen. Diese findet sich auf dem Prüfzertifikat wieder.

Facette:
Bei sehr feinen Uhren besitzen die Stahl- und Messingteile facettierte Kanten (→ Anglierung). Diese Kantenflächen sollten idealerweise im Winkel von 45 Grad angebracht sein.

Fälschungen:
Plagiate beliebter, in der Regel sehr hochwertiger Uhren. Zertifikate, Rechnungen und Etuis schützen vor Fehlkäufen schon lange nicht mehr. Sie werden ebenfalls massenhaft gefälscht.

Feder:
In Uhrwerken kommen Federn unterschiedlichster Natur zum Einsatz. Neben → Unruhspirale und → Zugfeder sind dies vor allem Sperr- und Haltefedern.

Finissage:
Fein- oder Fertigbearbeitung einer Uhr.

Frequenz:
Schwingungen pro Zeiteinheit, gemessen in Hertz (Hz). Bei ortsfesten Uhren findet man als gangregelndes Organ primär das Pendel, während mobile Uhren eine → Unruh besitzen. Beide bewegen sich mit einer bestimmten Frequenz hin und her. Das Pendel einer Sekundenpendeluhr benötigt von Umkehrpunkt zu Umkehrpunkt exakt eine Sekunde. Es verfügt also über eine Frequenz von 0,5 Hz oder 1800 Halbschwingungen/Stunde (A/h). Frühe Unruhschwinger brachten es auf 7200 bis 9000 A/h. Bei Taschenuhren wurde die Frequenz zunächst auf 12600 und später auf den allgemein üblichen Standard von 18000 A/h (2,5 Hz) gesteigert. Auch bei den Armbanduhren entwickelte sich diese Unruhfrequenz anfänglich zur gängigen Norm. Zur Steigerung der Präzision erhöhten die Uhrenfabrikanten die Schlagzahl auf 21600 A/h (3 Hz), 28800 A/h (4 Hz), 36000 A/h (5 Hz), 57600 (8 Hz) und sogar 72000 (10 Hz). Mit höherer Unruhfrequenz verknüpft sich steigender Energiebedarf. Außerdem verlangen zunehmende Rotationsgeschwindigkeiten Berücksichtigung beim Schmieren der → Hemmung.

Gangautonomie:
Gesamte Laufzeit eines mechanischen Uhrwerks, also der Zeitraum zwischen dem vollständigen Aufzug und dem Stehenbleiben wegen Entspannung der → Zugfeder.

Gangreserve:
Über das normale Aufzugsintervall einer Armbanduhr (24 Stunden) hinausreichendes Energiepotenzial. Üblicherweise bewegt sich die Gangreserve in einer Größenordnung zwischen 10 und 16 Stunden. Allerdings lässt die Antriebskraft der → Zugfeder in dieser verbleibenden Zeitspanne nach, was zu einer Reduzierung der Gangleistungen führt.

Gangreserveanzeige:
→ Indikation der aktuell verbleibenden → Gangreserve bei mechanischen Uhrwerken.

Gehäuse:
Schützende Hülle einer Uhr. Gehäuse gibt es in den unterschiedlichsten Ausführungen und Materialien. So unterscheidet man bei Taschenuhren u. a. zwischen offenen (Lépine) und geschlossenen Gehäusen (Savonnette). Für Armbanduhren werden z. B. wassergeschützte oder → wasserdichte Gehäuse verwendet. Außerdem gibt es eine Vielzahl unterschiedlicher Gehäuseformen (rund, quadratisch, oval, rechteckig, tonneauförmig) und -materialien (Platin, Gold, Silber, Stahl, Titan, Carbon, Aluminium, Kunststoff).

Genfer Streifen:
Häufig verwendete rippenförmige Dekoration auf den Brücken und Kloben feiner → Kaliber. Sie wird vor der galvanischen Veredelung aufgebracht, bleibt aber dennoch erkennbar. Genfer Streifen finden sich im Allgemeinen nur bei hochwertigen Werken.

Gläser:
Für Armbanduhren gibt es vier verschiedene Sorten von Gläsern: Kristallgläser kommen hauptsächlich bei frühen Armbanduhren vor. Sie sind zwar kratzfest, dafür jedoch sehr bruchempfindlich. Zu Beginn der 1940er Jahre wurden die Kristallgläser mehr und mehr von Kunststoffgläsern (Plexiglas) abgelöst. Die sind zwar unzerbrechlich, verkratzen aber relativ leicht. Mineralgläser besitzen eine Härte von 5 Mohs und sind daher wesentlich robuster als Kunststoffgläser. Heute wird in hochwertigen Uhren zumeist → Saphirglas verwendet. Bei einer Härte von 9 Mohs ist es extrem kratz- und bruchfest, jedoch nur mit speziellen Diamantwerkzeugen zu bearbeiten.

GMT:
Greenwich Mean Time; Welt- oder Universalzeit (UTC) am Greenwich-Nullmeridian. Die mittlere Zeit von Greenwich gilt heute als Standard im Navigationswesen und im internationalen Funkverkehr.

Gregorianischer Kalender:
Am 15. Oktober 1582 trat in Rom nach langen Vorarbeiten und der Eliminierung von zehn ganzen Tagen eine von Papst Gregor XIII. verfügte Kalenderreform in Kraft. Sie beseitigte den winzigen Restfehler des 45 v. Chr. eingeführten → Julianischen Kalenders. Nach diesem war das Jahr um 0,0078 Tage zu lang. Das Spezifikum des Gregorianischen Kalenders, das diesen Fehler beseitigt, besteht darin, innerhalb von 400 Jahren drei Schalttage ausfallen zu lassen – und zwar in allen nicht durch 400 teilbaren Säkularjahren (Jahre des vollen Jahrhunderts). Demnach werden die Jahre 2100, 2200 und 2300 ohne den 29. Februar auskommen müssen.

Guillochieren:
Gravieren feiner, teilweise kunstvoll verschlungener Muster in Uhrengehäuse oder Zifferblätter. Traditionelles Guillochieren geschieht von Hand mit Hilfe überlieferter Maschinen.

Handaufzugsuhr:
Zeitmesser, bei dem die → Zugfeder von Hand gespannt werden muss.

Handaufzugswerk:
Ein Handaufzugswerk besteht, je nach Konstruktion, aus 80 und mehr Teilen. Es lässt sich in acht wichtige Funktionsgruppen einteilen:
1. das Antriebssystem als energiespendendes Organ
2. das Übertragungssystem zur Weiterleitung der → Energie an
3. das Verteilungssystem, auch → Hemmung genannt
4. das Reguliersystem
5. das Zeigerwerk
6. die Organe zur Zeitanzeige
7. das Zeigerstellsystem
8. das Aufzugssystem

Hemmung:
Mechanismus, der die Kraft der → Zugfeder in kleinen Stößen an das Schwingsystem (→ Unruh und → Unruhspirale) einer Uhr weiterleitet und das ungebremste Ablaufen des Uhrwerks verhindert. Bei einer Unruhfrequenz von 28800 Halbschwingungen/Stunde lässt sie das Räderwerk täglich 691200 Mal vorrücken. Im Laufe von vier Jahren ergibt dies mehr als eine Milliarde Kraftstöße. Das entspricht etwa der sechsfachen Leistung eines menschlichen Herzens.

Indikation:
Anzeige z. B. von Zeit, Datum, Wochentag, Monat, Äquation, → Gangreserve, zweiter Zonenzeit.

Jewels:
Internationale Bezeichnung für die → Steine eines Uhrwerks.

Julianischer Kalender:
Auf Gaius Julius Cäsar geht der Rhythmus von jeweils drei Normaljahren mit 365 Tagen und einem 366-tägigen Schaltjahr zurück. Allerdings ist das Julianische Jahr gegenüber den wahren astronomischen Gegebenheiten um 0,0078 Tage zu lang. Deshalb musste Papst Gregor XIII. den Julianischen Kalender im Jahr 1582 korrigieren.

Kadratur:
Begriff für ein zusätzliches Schaltwerk komplizierter Uhren, z. B. der Mechanismus für einen → Chronographen, ein → Repetitionsschlagwerk oder ein Kalendarium. Der Name leitet sich ab vom französischen Wort cadran (Zifferblatt). Deshalb meinen Kadraturen traditionsgemäß Schaltwerke auf der Vorderseite des Uhrwerks und damit unter dem Zifferblatt. Je nach Konstruktion kann die Kadratur ins Uhrwerk integriert oder auf einer separaten → Platine montiert und als Modul additiv mit dem Uhrwerk verbunden sein.

Kaliber:
Dimension und Gestalt eines Uhrwerks und seiner Teile. Die Kaliberbezeichnung ermöglicht eine exakte Identifikation u. a. zum Zweck der Ersatzteilbestellung. Von den konfektionierten Rohwerken der → Ebauches-Lieferanten sind Manufakturkaliber zu unterscheiden. Letztere sind Uhrwerke, die → Manufakturen für ihren eigenen Bedarf produzieren. Gelegentlich ist auch von exklusiven oder reservierten Kalibern die Rede. Dahinter verbergen sich Rohwerke, welche Ebauches-Fabrikanten ausschließlich für einzelne Kunden entwickeln und/oder produzieren. Auf diese Kaliber haben andere → Etablisseure keinen Zugriff.

Komplikation:
Zusatzmechanismus bei mechanischen Uhren wie → Chronograph, → ewiger Kalender oder → Tourbillon.

Krone:
Knopf zum Aufziehen einer Uhr, zum Zeigerstellen und/oder Korrigieren von → Datumsanzeigen sowie früher auch zum Steuern von → Chronographen.

Kronenaufzug:
Bis ins späte 19. Jahrhundert erfolgten Aufzug und/oder Zeigerstellung vieler Taschenuhren mit Hilfe eines kleinen Schlüssels. Beim modernen Kronenaufzug geschieht beides über eine kleine → Krone mit Umschaltvorrichtung.

Kulissenschaltung:
Schaltwerk zur Steuerung eines → Chronographen. Ein beweglicher, je nach → Kaliber unterschiedlich ausgeformter Schaltnocken liefert das „Programm" für die Funktionen Start, Stopp und Nullstellung. Chronographen mit Kulissen- oder Nockenschaltung sind technisch weniger aufwendig, aber nicht minder zuverlässig als die Pendants mit Schalt- oder Säulenrad.

Lagen:
Armbanduhren werden im Gegensatz zu Taschenuhren in vielen verschiedenen Lagen getragen. Es sind dies die Positionen „Krone oben", „Krone unten", „Krone rechts", „Zifferblatt oben" und „Zifferblatt unten". Bei Präzisionsuhren erfolgt daher eine Regulierung in diesen fünf Lagen.

Leuchtzifferblatt:
Zifferblatt, von dem sich auch bei Dunkelheit die Zeit ablesen lässt.

Linie:
Überlieferte Maßeinheit für Uhrwerksdimensionen, abgeleitet vom „Pied du Roi", dem französischen Fuß. Beispielsweise 11''' bei runden Werken oder 8¾ x 12''' bei Formwerken. Eine Linie entspricht 2,2558 Millimetern.

Lünette:
In der Uhrmacherei ein vielschichtiger Begriff. Streng genommen versteht man darunter den Glasreif eines → Gehäuses. Dieser wird mit dem eingepressten Glas auf dem Mittelteil des Gehäuses montiert. Oft werden heute auch auf der Vorderseite von Uhrengehäusen befestigte Drehringe als Lünetten bezeichnet.

Manufaktur:
Nach den ungeschriebenen Gesetzen der Uhrmacherei darf sich ein Uhrenhersteller nur dann Manufaktur nennen, wenn er mindestens ein → Ebauche oder Rohwerk selbst fertigt. Die Fertigsteller von Uhren unter Verwendung konfektionierter Rohwerke heißen branchenintern → Etablisseure.

Mechanische Räderuhren:
Uhren, die über eine → Zugfeder angetrieben werden. Die Regulierung des Gangs erfolgt durch eine → Unruh mit Spiralfeder oder ein Pendel. Die Entwicklung der Räderuhr resultiert vermutlich aus dem Antriebsmechanismus von Planetarien, die seit dem späten 13. Jahrhundert bekannt sind. Als älteste mechanische Räderuhr des deutschsprachigen Raums kann wohl die Uhr des Straßburger Münsters gelten. Sie wurde 1352 fertiggestellt. In England gab es aber vermutlich schon gegen Ende des 13. Jahrhunderts funktionsfähige Räderuhren.

Mondalteranzeige:
→ Indikation zum Ablesen der Anzahl von Tagen, die seit dem letzten Neumond vergangen sind. Im synodischen Monat beträgt das Zeitintervall von Neumond zu Neumond exakt 29 Tage, 12 Stunden, 44 Minuten und 3 Sekunden.

Mondphasen:
Der Mond durchläuft seine von der Stellung Sonne, Mond, Erde abhängigen Licht- bzw. Mondphasen (Neumond – erstes Viertel – Vollmond – letztes Viertel – Neumond) innerhalb einer Lunation von etwa 29,5 Tagen.

Platine:
Auch Werkplatte. Eine Metallplatte, welche die Brücken, Kloben und sonstigen Bestandteile eines Uhrwerks trägt.

Pulsometer:
Arbeitserleichternde Zifferblattskalierung (meist bei → Chronographen) zum Messen der Pulsfrequenz. Abhängig von der Graduierung sind nach dem Starten des Chronographen 20 oder 30 Pulsschläge zu zählen. Die Spitze des gestoppten Chronographenzeigers zeigt dann auf die hochgerechnete Pulsfrequenz pro Minute.

Punzen:
Stempel in → Gehäusen, die Auskunft geben über die Art und den Feingehalt des verwendeten → Edelmetalls, über Herkunftsland und teilweise Herkunftsort, über das Herstellungsjahr sowie über den Gehäusemacher. Hinzu kommen häufig das Markenzeichen der herstellenden oder liefernden Uhrenfirma, eine → Referenz- und eine Seriennummer.

Referenz:
Herstellerspezifische Kombination von Buchstaben und Ziffern zur Klassifizierung seiner verschiedenen Uhrenmodelle. Die Referenznummer beinhaltet oft auch Informationen über Typ, Gehäusematerial, Werk, Zifferblatt, Zeiger, Armband und Ausstattung mit Edelsteinen.

Regulatorzifferblatt:
Außermittige → Indikation von Stunden und Sekunden.

Repetitionsschlagwerk:
Aufwendige Zusatzfunktion eines Uhrwerks, die es gestattet, die aktuelle Zeit mehr oder minder genau akustisch wiederzugeben. Je nach Ausführung des Schlagwerkes unterscheidet man zwischen Uhren mit Viertelstunden-, Achtelstunden- (bzw. 7½-Minuten-), 5-Minuten- oder Minutenrepetition.

Retrograde Anzeige:
Zeiger, der sich zur → Indikation von Zeit, Datum oder auch Wochentag schrittweise über ein Kreissegment bewegt und, am Ende der Skala angekommen, ruckartig in seine Ausgangsposition zurückspringt.

Rotor:
Unbegrenzt drehende Schwungmasse bei Uhren mit → automatischem Aufzug. Je nach Konstruktion des Selbstaufzugs wird die → Zugfeder in eine oder beide Drehrichtungen gespannt. Zu unterscheiden sind Zentral- und Mikrorotoren. Erstere drehen sich über dem ganzen Werk, letztere sind in die Werksebene integriert.

Saphirglas:
Kratzfestes Uhrenglas der Härte 9 Mohs. Eine noch größere Härte weist nur der Diamant auf.

Satinierung:
Feiner, seidiger und matter Schliff auf Metalloberflächen.

Schaltradchronograph:
Bei klassischen Chronographenkalibern erfolgt die Steuerung der Funktionen Start, Stopp und Nullstellung über ein drehbar gelagertes Bauteil mit – je nach Konstruktion – fünf, sechs, sieben, acht oder neun Säulen. Bei jedem Schaltvorgang bewegt es sich um einen exakt definierten Winkel im Uhrzeigersinn weiter. Kommt das Ende einer Schaltwippe auf einer Säule zu liegen, wird es durch diese angehoben. Fällt es hingegen zwischen zwei Säulen, sorgt leichter Federdruck für eine Absenkung.

Silizium:
Jahrhundertelang beherrschten Messing, Stahl und synthetischer Rubin die Fertigung mechanischer Uhrwerke. Seit 2001 ist auch Silizium, das Basismaterial elektronischer Mikrochips, salonfähig. In monokristalliner Form besitzt es die gleiche Kristallstruktur wie Diamant. Es ist 60 Prozent härter und 70 Prozent leichter als Stahl, → amagnetisch und korrosionsfest. Auch ohne Nachbearbeitung verfügt es über eine extrem glatte Oberfläche, die Öl entbehrlich macht. Silizium ist elastisch, aber nicht plastisch verformbar. Speziell behandeltes „Silinvar" dehnt sich bei Erwärmung so gut wie nicht aus. Somit eignet es sich auch zur Herstellung von → Unruhspiralen. Invariables Silizium „Silinvar" ist eine Gemeinschaftsentwicklung von Patek Philippe, Rolex und der Swatch Group mit dem Zentrum für Elektronik und Mikrotechnik (CSEM) und dem Institut für Mikrotechnik der Universität Neuchâtel.

Skelettwerk:
Uhrwerk, bei dem → Platine, Brücken, Kloben, Federhaus und ggf. → Rotor so weit durchbrochen werden, dass nur noch das für die Funktion unabdingbar notwendige Material übrigbleibt. Auf diese Weise kann man durch das Uhrwerk schauen. Armbanduhren mit skelettiertem Uhrwerk gibt es seit Mitte der 1930er Jahre.

Steine:
Bei Präzisionsuhren werden zur Verminderung der Reibung in den wichtigsten Lagern, an den Ankerpaletten und der Ellipse Steine eingesetzt.

Stoppsekunde:
Vorrichtung zum Anhalten von Uhrwerk und/oder Sekundenzeiger, um die Uhrzeit sekundengenau einstellen zu können.

Stoppuhren:
Im Gegensatz zu → Chronographen besitzen Stoppuhren keine Zeitanzeige. Bei einfachen Konstruktionen wird das Werk angehalten, wenn der Sekundenzeiger stoppen soll.

Stoßsicherung:
System zum Schutz der feinen und deshalb sehr empfindlichen Zapfen der Unruhwelle vor Bruch. Zu diesem Zweck sind die Loch- und Decksteine der Unruhwellenlager federnd in → Platine und Unruhkloben befestigt. Bei harten Stößen geben sie entweder lateral und/oder axial nach. Eine stoßgesicherte Armbanduhr soll einen Sturz aus einem Meter Höhe auf einen Eichenholzboden unbeschadet überstehen. Außerdem darf sie danach keine wesentlichen Gangabweichungen aufweisen.

Stundenzähler:
Konstruktionsmerkmal mancher → Chronographen zur Erfassung der seit Beginn des Stoppvorgangs verstrichenen Stunden. Meist werden bis zu zwölf Stunden gezählt. Die Betätigung des Nullstelldrückers bewirkt auch eine Rückstellung des Stundenzählers.

Taucheruhren:
Nach klar definierten Normen hergestellte Armbanduhren für Einsätze unter Wasser. Professionelle Taucheruhren müssen dem nassen Element bis mindestens 200 Meter Tiefe widerstehen. Zur eigenen Sicherheit sollte jede Taucheruhr einmal jährlich vom Juwelier auf ihre Dichtigkeit hin überprüft werden.

Tourbillon:
Von Abraham-Louis Breguet 1795 erfundene und im Jahr 1801 patentierte Konstruktion zur Kompensation von Schwerpunktfehlern im Schwingsystem (→ Unruh und → Unruhspirale) mechanischer Uhren. Beim Tourbillon (dt.: Wirbelwind) ist das komplette Schwing- und Hemmungssystem in einem möglichst leichten Käfig untergebracht. Dieser dreht sich innerhalb einer bestimmten Zeitspanne (meist eine Minute) einmal um seine Achse. Auf diese Weise können die negativen Einflüsse der Erdanziehung in den senkrechten → Lagen einer Uhr ausgeglichen und die Gangleistungen gesteigert werden. In waagrechter Lage hat das Tourbillon dagegen keinen Einfluss auf die Ganggenauigkeit.

Unruh:
Kreisrunder Metallreif, welcher in tragbaren Uhren durch seine Oszillationen gemeinsam mit der → Unruhspirale für das Unterteilen der kontinuierlich verstreichenden Zeit in möglichst gleichlange Abschnitte sorgt.

Unruhspirale:
Die Unruhspirale kann als Seele einer mechanischen Uhr bezeichnet werden. Mit ihrem inneren Ende ist sie an der Unruhwelle, mit dem äußeren am Unruhkloben befestigt. Durch ihre Elastizität sorgt sie dafür, dass die → Unruh gleichmäßig hin und her schwingt. Ihre aktive Länge bestimmt neben dem Trägheitsmoment des Unruhreifens dessen Schwingungsdauer.

Vollkalendarium:
Komplettes Kalendarium mit Anzeige von Tag, Datum und Monat.

Wasserdichte Armbanduhren:
Uhren dürfen die Bezeichnung „wasserdicht" tragen, wenn sie gegen Schweiß, Spritzwasser und Regen resistent sind. Zudem darf in einem Meter Tiefe mindestens 30 Minuten lang keine Feuchtigkeit eindringen. Der Zusatz „50 Meter" oder „5 Bar" besagt, dass diese Uhren vom Fabrikanten einem entsprechenden Prüfdruck ausgesetzt wurden. Dennoch empfiehlt es sich nicht, mit solchen Uhren zu schwimmen oder gar zu tauchen.

Weltzeitindikation:
Uhren mit Weltzeitindikation zeigen normalerweise 24, in Ausnahmefällen bis zu 37 Zonenzeiten auf einem Zifferblatt an.

Zugfeder:
Elastisches und spiralförmig aufgewickeltes Stahlband zur Speicherung der Antriebsenergie für tragbare mechanische Uhren.

Glossaire

Acier inoxydable :
Alliage répandu d'acier, de nickel et de chrome additionné de molybdène ou de tungstène, il est inoxydable, extrêmement résistant et → amagnétique, mais relativement difficile à travailler.

Affichage analogique de l'heure :
Affichage de l'heure à l'aide de deux aiguilles. La position relative de l'aiguille de l'heure et de celle des minutes donne l'heure qu'il est à un moment donné.

Affichage de l'heure universelle :
Les montres équipées de cette fonction affichent normalement 24, et, dans certains cas particuliers, jusqu'à 37 fuseaux horaires.

Affichage de la date :
→ Indication de la date par voie analogique à l'aide d'une aiguille (date à aiguille) ou numérique par un disque portant des chiffres apparaissant dans un guichet. Dans la « grande date », les chiffres du quantième sont portés par deux disques. On distingue essentiellement entre les affichages à disque traînant, semi-sautant et sautant. Dans le premier cas, la date est progressivement avancée par le mouvement. Dans le dernier cas, le disque soustrait à plusieurs reprises dans la journée de l'énergie qu'il emmagasine dans un → ressort. Cette → énergie est libérée à minuit précis pour le changement de date.

Affichage des phases de Lune :
→ Indication donnant le nombre de jours depuis la dernière nouvelle lune. Dans le mois synodique, l'intervalle séparant deux nouvelles lunes est de 29 jours, 12 heures, 44 minutes et 3 secondes.

Affichage numérique de l'heure :
Indication de l'heure par des chiffres.

Affichage rétrograde :
Aiguille servant à → l'indication de l'heure, de la date ou encore de la semaine, qui se déplace graduellement sur un segment de cercle et, une fois qu'elle a atteint la fin de l'échelle graduée, revient brusquement dans sa position initiale.

Amagnétique :
Une montre amagnétique, couramment qualifiée d'antimagnétique, ne subit pas les influences négatives des champs magnétiques. Une montre ne peut être qualifiée d'amagnétique que si, après exposition à un champ magnétique de 4800 Ampère/mètre, elle continue à fonctionner avec un écart de marche d'au plus 30 secondes/jour.

Ancre :
L'une des pièces les plus compliquées des montres mécaniques. Elle sert d'une part à transférer la force motrice du train de roues au → balancier, pour entretenir ses oscillations. Elle empêche d'autre part le déroulement incontrôlé du train de roues une fois celui-ci remonté.

Anglage :
Les montres de luxe se caractérisent entre autres par des chanfreins sur les arêtes des pièces métalliques. L'anglage est réalisé par usinage au pantographe ou à la main à l'aide d'une lime suivant la tradition, pour une finition haut de gamme. Dans l'idéal, l'angle du chanfrein est de 45 degrés. L'anglage n'influe en rien sur le fonctionnement du mouvement.

Arrêt seconde :
Dispositif permettant d'arrêter le mouvement et/ou l'aiguille des secondes pour effectuer une mise à l'heure à la seconde près.

Autonomie :
Durée de fonctionnement totale d'un mouvement mécanique, c'est-à-dire le temps s'écoulant entre le remontage complet et l'arrêt suite au relâchement du → ressort de barillet.

Balancier :
Anneau métallique qui, sur les montres de poche et les montres-bracelets, garantit par ses oscillations, avec le → spiral de balancier, que le temps qui s'écoule soit divisé en périodes de durées si possible égales.

Boîtier (ou boîte) :
Écrin protecteur d'un mouvement. On trouve des boîtiers des types les plus divers. On distingue par exemple souvent pour les montres de poche entre boîtiers ouverts (Lépine) et boîtiers fermés (Savonnette). Pour les montres-bracelets, on utilise des boîtiers imperméables ou → étanches. Les boîtiers existent dans des formes très diverses (forme ronde, carrée, ovale, rectangulaire ou tonneau) et dans différents matériaux (platine, or, argent, acier, titane, carbone, aluminium ou matériau synthétique).

Cadran de type régulateur :
→ Indication décentrée des heures et des secondes.

Cadran luminescent :
Cadran sur lequel on peut lire l'heure même dans l'obscurité.

Cadrature :
Terme désignant un mécanisme de déclenchement auxiliaire des montres à complications, notamment le mécanisme de déclenchement d'un → chronographe, d'une → répétition ou d'un calendrier. Le terme vient du mot cadran. En effet, les cadratures proprement dites sont traditionnellement sous le cadran, et par conséquent sur le dessus du mouvement. Suivant son architecture, la cadrature peut être intégrée dans le mouvement ou montée sur une → platine distincte en tant que module complémentaire du mouvement.

Cage de tourbillon :
Fine cage d'acier ou – sur les montres-bracelets modernes – également en titane ou en aluminium qui, sur les montres à → tourbillon, est destinée à recevoir la masse oscillante et l'échappement (→ balancier, axe de balancier, → spiral de balancier, → ancre, roue d'ancre). La cage pivote en règle générale une fois par minute sur son axe. Elle doit être solide, ajourée et la plus légère possible. Sa fabrication fait partie des défis posés aux horlogers.

Calendrier complet :
Calendrier de montre affichant le jour de la semaine, le quantième (date) et le mois.

Calendrier grégorien :
Entrée en vigueur le 15 octobre 1582 à Rome après de longs travaux préparatoires, la réforme du calendrier décrétée par le pape Grégoire XIII entraîne la suppression de 10 jours du calendrier. Elle supprime ainsi la faible erreur résiduelle du → calendrier julien, introduit en 45 av. J.-C. Dans celui-ci en effet, la date de l'équinoxe avançait de 0,0078 jour chaque année. L'astuce du calendrier grégorien pour corriger cette erreur est de supprimer sur une période de 400 ans trois jours intercalaires – à savoir ceux des années séculaires dont le millésime n'est pas divisible par 400. Les années 2100, 2200 et 2300 devront ainsi se passer de 29 février.

Calendrier julien :
C'est Jules César qui institue ce rythme de périodes de quatre années contenant chacune trois années communes de 365 jours et une année bissextile de 366 jours. Mais l'année julienne est plus longue de 0,0078 jour par rapport à la réalité astronomique, ce qui conduit le pape Grégoire XIII à réformer le calendrier julien en 1582.

Calibre :
Dimension et forme d'un mouvement et de ses pièces. La désignation d'un calibre permet une identification exacte, notamment pour la commande de pièces de rechange. Il faut distinguer entre ébauches confectionnées par les fournisseurs → d'ébauches et calibres de manufacture. Ces derniers sont des mouvements que les → manufactures produisent pour leurs propres besoins. On parle parfois aussi de calibres exclusifs ou réservés. Ce sont des

mouvements que les fabricants d'ébauches mettent au point et/ou produisent pour certains clients en particulier. Les autres → établisseurs ne peuvent se procurer ces mouvements.

Chanfrein :
Sur les montres haut de gamme, les composants en acier et en laiton sont chanfreinés (→ anglage). Dans l'idéal, l'angle du chanfrein sur chaque composant est de 45 degrés.

Chaton :
Bague métallique sertissant une pierre servant de coussinet ensuite fixée dans le mouvement par sertissage ou vissage. Aujourd'hui, les manufactures horlogères de Glashütte plus particulièrement recourent de nouveau à des chatons vissés pour des raisons esthétiques.

Chronographe :
Un chronographe, ou plus exactement un chronoscope, est une montre dotée d'aiguilles des heures et des minutes, et sur laquelle un mécanisme auxiliaire permet, par une action sur des poussoirs, de mettre en marche, arrêter et remettre à zéro une aiguille des secondes placée, le plus souvent, au centre du cadran. L'affichage de l'heure n'est pas modifié. Selon les versions/modèles, les chronographes peuvent disposer d'aiguilles de compteurs des minutes et heures écoulées depuis la mise en marche du chronométrage. En activant le poussoir de remise à zéro, les aiguilles des compteurs reviennent dans leur position initiale. Depuis les années 1930, le chronographe à deux poussoirs prédomine. Un poussoir sert à mettre en marche et arrêter les aiguilles des compteurs, l'autre à les remettre à zéro. Ces chronographes permettent d'effectuer des chronométrages successifs, autrement dit d'arrêter les aiguilles des compteurs et de les remettre en marche à partir de la position précédente autant de fois qu'on le souhaite. Suivant la fréquence du balancier, les chronographes mécaniques permettent des chronométrages jusqu'au dixième de seconde près.

Chronographe à roue à colonnes :
Sur les calibres de chronographes classiques, la commande des fonctions Mise en marche, Arrêt et Remise à zéro est assurée par une roue pivotante comportant – selon sa conception – cinq, six, sept, huit ou neuf colonnes. À chaque mise en marche, la roue se déplace d'un angle précis dans le sens horaire. Lorsque l'extrémité d'une bascule d'interrupteur vient se poser sur une colonne, cette dernière la fait se relever. Lorsqu'elle se pose au contraire entre deux colonnes, une légère pression de ressort la fait s'abaisser.

Chronomètre :
Contrairement aux → chronographes, les chronomètres n'ont pas d'affichage de l'heure. Sur les modèles de conception simple, le mouvement se met en marche ou s'arrête d'une pression sur un bouton lors d'un chronométrage.

Commande (ou enclenchement) à came :
Mécanisme de déclenchement pour la commande d'un → chronographe. Une came (navette) mobile de forme différente selon le → calibre fournit le « programme » des fonctions Mise en marche, Arrêt et Remise à zéro. Les chronographes commandés par came sont techniquement moins complexes, mais non moins fiables que leurs homologues à roue à colonnes.

Complication :
Mécanisme auxiliaire des montres mécaniques, du type → chronographe, → quantième (ou calendrier) perpétuel ou → tourbillon.

Compteur d'heures :
Dispositif particulier de certains → chronographes permettant de totaliser le nombre d'heures écoulées depuis le moment où l'on met en marche la trotteuse. Le plus souvent, ce mécanisme permet de comptabiliser jusqu'à 12 heures. Une pression sur le poussoir de remise à zéro fait revenir l'aiguille du compteur d'heures à son point de départ.

Contrefaçons :
Copies de montres prisées, en général de très grande valeur. Certificats, factures et écrins étant aussi très souvent contrefaits, ils ne protègent plus depuis longtemps de mauvais achats.

Côtes de Genève :
Décoration en forme de nervures sur les ponts, notamment de balancier, de → calibres haut de gamme. Appliquée avant la finition par galvanoplastie, elle reste néanmoins visible. En général, les côtes de Genève n'ornent que les mouvements de grande valeur.

Couronne :
Bouton que l'on pousse pour remonter une montre, régler les aiguilles et/ou corriger les → indications de date et autrefois aussi pour commander le → chronographe.

Ébauche :
Mouvement de montre incomplet. Les anciens horlogers genevois appelaient le mouvement d'une montre blanc ou ébauche.

Échappement :
Mécanisme qui distribue par à-coups l'énergie du → ressort de barillet à la masse oscillante (→ balancier et → spiral de balancier) d'une montre et empêche le déroulement incontrôlé du mouvement. Pour une fréquence de balancier de 28 800 alternances/heure, l'échappement fait avancer le train de roues 691 200 fois par jour, ce qui représente plus d'un milliard d'impulsions en quatre ans. Cela correspond à peu près au quadruple des performances d'un cœur humain.

Échappement à ancre :
→ L'échappement actuellement le plus répandu sur les montres mécaniques. Sur les montres-bracelets haut de gamme, c'est l'échappement à ancre suisse qui domine.

Émail :
Substance vitrifiable servant à décorer le métal. La technique de l'émaillage est utilisée depuis plus de 350 ans sur les montres (cadrans et → boîtiers). Au début du XXᵉ siècle, les cadrans émaillés étaient presque la norme pour les montres haut de gamme. Depuis – notamment pour des raisons de coûts – cette pratique est devenue extrêmement rare.

Énergie :
Capacité motrice stockée. Pour l'entraînement des montres, des réserves énergétiques sont nécessaires. Sur les montres et pendules mécaniques, elles peuvent être fournies par un → ressort de barillet (entraînement à ressort) tendu et respectivement par un poids que l'on remonte (entraînement par gravité).

Établisseur :
Fabricant d'horlogerie qui achète chez des fabricants spécialisés des éléments (mouvements, cadrans, aiguilles, → boîtiers) qu'il assemble ensuite pour réaliser des garde-temps terminés.

Finissage :
Dernières opérations d'usinage et de finition d'une montre.

Fréquence :
Nombre d'oscillations par unité de temps, mesuré en hertz (Hz). Sur les pendules, le principal organe régulateur de marche est le pendule, tandis que les montres disposent d'un → balancier. Ces deux organes se balancent d'un côté à l'autre à une fréquence donnée. L'organe oscillant d'une pendule à secondes met exactement une seconde pour aller d'un point extrême à l'autre. Sa fréquence est donc de 0,5 Hz ou 1 800 alternances/heure (A/h). Les oscillateurs à balancier anciens atteignaient de 7 200 à 9 000 A/h. Sur les montres de poche, la fréquence a d'abord été réglée sur 12 600 puis portée à 18 000 A/h (2,5 Hz), valeur la plus courante. Sur les montres-bracelets également, cette fréquence de balancier est devenue la norme dans un premier temps. Pour augmenter la précision, les fabricants de montres ont porté le nombre d'alternances à 21 600 A/h (3 Hz), 28 800 A/h (4 Hz), 36 000 A/h (5 Hz), 57 600 A/h (8 Hz) et jusqu'à 72 000 A/h (10 Hz). Une fréquence de balancier plus élevée s'accompagne d'une augmentation des besoins en énergie. Par ailleurs, des vitesses de rotation supérieures exigent plus de précautions lors du graissage de → l'échappement.

GMT :
Greenwich Mean Time ; temps universel coordonné (TUC) au méridien de Greenwich. Le temps moyen de Greenwich est aujourd'hui la norme dans la navigation et les communications radio internationales.

Guillochage :
Gravure de fins motifs, souvent entrelacés, sur le → boîtier ou le cadran d'une montre. Le guillochage traditionnel est effectué à la main, au moyen d'une lime et d'un burin.

Indication :
Affichage de l'heure, du quantième, du jour de la semaine, du mois, de l'équation du temps, → de la réserve de marche ou d'un second fuseau horaire.

Indication de réserve de marche :
→ Indication de la → réserve de marche restante sur les montres mécaniques.

Jewels :
Désignation internationale du nombre de rubis (→ pierres précieuses) d'un mouvement de montre.

Ligne :
Mesure traditionnelle utilisée pour indiquer la grandeur d'un mouvement, elle dérive du « pied du Roi » ou pied français. Exemples : 11''' pour un calibre de forme ronde et 8¾ x 12''' pour les calibres de toutes les autres formes. Une ligne équivaut à 2,2558 millimètres.

Lunette :
Terme qui en horlogerie désigne des pièces très différentes. Au sens strict, c'est l'anneau qui porte la glace d'un(e) → boîtier (boîte) de montre. Celui-ci est ajusté à cran avec la glace enchâssée sur la partie médiane (carrure) de la boîte. Aujourd'hui, on appelle aussi très souvent lunette (lunette tournante), le cercle rotatif placé sur l'avant du cadran.

Manufacture :
D'après les lois non écrites de l'horlogerie, un fabricant de montres ne peut prétendre à l'appellation manufacture que s'il fabrique lui-même au moins une → ébauche. Les fabricants de montres utilisant des ébauches produites en externe sont appelés dans le métier des → établisseurs.

Mécanisme à remontage automatique :
Mécanisme auxiliaire qui utilise les mouvements (du poignet) pour armer le → ressort de barillet d'une montre mécanique.

Métaux précieux :
Pour les → boîtiers des montres-bracelets, on utilise en général de l'or, du platine et de l'argent. On recourt à de l'or de différentes finesses : 333/1000 (8 carats), 375/1000 (9 carats), 575/1000 (14 carats) ou 750/1000 (18 carats). L'alliage avec d'autres métaux (cuivre, par exemple) détermine la teinte. On trouve de l'or titrant 21, 23 ou 24 carats dans les rotors de remontage automatique. La finesse du platine utilisé est de 950/1000.

Montre à remontage manuel :
Garde-temps dont le → ressort de barillet doit être armé à la main.

Montre-bracelet imperméable à l'eau :
Pour pouvoir porter la mention « imperméable à l'eau », une montre doit résister à la transpiration, aux éclaboussures d'eau et à la pluie. De plus, elle ne doit laisser pénétrer aucune humidité en cas d'immersion d'au moins 30 minutes à un mètre de profondeur. La mention supplémentaire « 50 mètres » ou « 5 bars » indique que ces montres ont été soumises par le fabricant à une pression d'essai correspondante. Toutefois, il n'est pas recommandé de nager, voire de plonger, avec ce type de montres.

Montre-chronomètre :
Montre dont la précision de marche a été attestée par des contrôles d'une durée de 15 jours effectués par un organisme officiel (comme le Contrôle officiel suisse des chronomètres (COSC) en Suisse). Dans les cinq → positions « couronne à gauche », « couronne en haut », « couronne en bas », « cadran dessus » et « cadran dessous », la moyenne de marche quotidienne doit rester comprise entre −4 et +6 secondes, l'écart de marche journalier moyen ne doit

pas dépasser 2 secondes, et le plus grand écart de marche 5 secondes. Toutes les montres sont contrôlées à des températures de 8, 23 et 38 °C. Seules celles ayant passé avec succès les tests de précision peuvent porter sur leur cadran la mention « chronomètre » et être commercialisées avec le certificat officiel correspondant.

Montre et horloge (à mouvement) mécanique :
Montre entraînée par un → ressort de barillet. Le réglage de la marche est assuré par un oscillateur, comme l'ensemble → balancier-spiral. L'origine de la montre mécanique remonterait au mécanisme d'entraînement des planétaires, connus depuis la fin du XIIIᵉ siècle. Le plus ancien mouvement mécanique dans la zone germanophone est assurément celui de l'horloge de la cathédrale de Strasbourg, réalisé en 1352. En Angleterre, il y aurait eu des horloges à mouvement mécanique dès la fin du XIIIᵉ siècle.

Montres de plongée :
Montres-bracelets fabriquées suivant des normes clairement établies pour des interventions sous l'eau. Les montres de plongée professionnelles doivent rester étanches au minimum jusqu'à 200 mètres de profondeur. Pour des raisons de sécurité, il faut faire vérifier l'étanchéité d'une montre de plongée au moins une fois par an par un horloger.

Mouvement à remontage manuel :
Un mouvement à remontage manuel se compose, selon sa construction, de 80 pièces ou plus. On peut le subdiviser en huit grands groupes fonctionnels :
1. système d'entraînement, organe qui fournit l'énergie
2. système de transmission qui achemine → l'énergie au
3. système de distribution, également appelé → échappement
4. système de régulation
5. minuterie
6. organes d'affichage de l'heure
7. système de réglage des aiguilles
8. système de remontage

Mouvement squelette :
Mouvement sur lequel → la platine, les ponts, le barillet et éventuellement le → rotor sont tellement ajourés qu'il ne reste plus que le matériau absolument indispensable pour le bon fonctionnement des pièces. On peut ainsi voir à travers le mouvement. On trouve des montres-bracelets à mouvement squelette depuis le milieu des années 1930.

Numéro de fabrication :
Pour identifier leurs produits, la plupart des fabricants de montres numérotent leurs mouvements ou leurs → boîtiers, voire les deux. Le numéro de mouvement doit impérativement apparaître sur les → chronomètres officiellement testés. Ce numéro est repris dans le rapport d'essai.

Pare-chocs :
Système permettant d'éviter que les fins et donc très fragiles pivots du balancier ne se cassent. Pour ce faire, les pierres glace et contre-pivots des paliers de l'axe de balancier sont maintenus dans des → platines et des coqs servant d'amortisseurs. En cas de chocs importants, ils cèdent dans un plan latéral et/ou axial. Une montre-bracelet protégée contre les chocs doit résister sans dommage à une chute d'une hauteur d'un mètre sur un parquet en chêne. Elle ne doit pas non plus accuser un écart de marche significatif.

Phases de la Lune :
Durant une lunaison, qui dure environ 29,5 jours, la Lune traverse différentes phases (d'illumination) dépendant des positions relatives du Soleil, de la Lune et de la Terre : Nouvelle Lune – Premier Quartier – Pleine Lune – Dernier Quartier – Nouvelle Lune.

Pierres précieuses :
Sur les montres de précision, des pierres précieuses sont utilisées pour réduire les frottements au niveau des principaux paliers, des palettes d'ancre et des ellipses.

Platine :
Plaque métallique qui soutient les ponts et les divers autres organes d'un mouvement.

Poinçons :

Marques dans les → boîtiers qui renseignent sur la nature et la finesse du → métal précieux utilisé, sur le pays d'origine et parfois sur le lieu d'origine, la date de fabrication et aussi sur l'identité du fabricant du boîtier. À cela s'ajoutent souvent le logo de la société qui a fabriqué ou livré la montre, un numéro de → référence et un numéro de série.

Positions :

Contrairement aux montres de poche, les montres-bracelets sont portées dans cinq positions différentes : « couronne à gauche », « couronne en haut », « couronne en bas », « cadran dessus » et « cadran dessous ». Les montres de précision sont donc vérifiées dans ces cinq positions.

Pulsomètre :

Cadran dont les divisions facilitent (généralement sur les → chronographes) la prise du pouls. Selon le type de graduation, il faut compter 20 ou 30 pulsations après la mise en marche du chronographe. L'aiguille de chronographe activée pointe sur la fréquence du pouls extrapolée sur une minute.

Quantième (ou calendrier) perpétuel :

Calendrier complexe constitué d'une centaine d'éléments qui prend généralement en compte les durées différentes des mois jusqu'au 28 février 2100 sans exiger de correction manuelle.

Rattrapante de chronographe :

Ce mécanisme permet de chronométrer simultanément deux événements ou plus, à condition qu'ils débutent au même instant. Il permet aussi de prendre les temps intermédiaires dans des compétitions.

Référence :

Combinaison de lettres et de chiffres utilisée par un fabricant de montres pour classer ses différents modèles. Le numéro de référence contient parfois aussi des informations sur le type de modèle, le matériau du boîtier, le mouvement, le cadran, les aiguilles, le bracelet et les pierres précieuses incrustées.

Remontoir :

Jusqu'à la fin du XIXe siècle, le remontage et/ou le réglage des aiguilles de nombreuses montres de poche se faisaient à l'aide d'une petite clef. Sur le remontoir moderne, ces deux opérations s'effectuent grâce à une petite → couronne à inverseur.

Réserve de marche :

Réserve d'énergie suffisante entre deux remontages d'une montre-bracelet (24 heures). Habituellement, la réserve de marche est de l'ordre de 10 à 16 heures. Toutefois, la force d'entraînement du → ressort de barillet diminuant au fil du temps, une baisse des performances est inévitable.

Ressort :

Des ressorts des types les plus divers sont utilisés dans les mouvements. Outre les → spiraux et → ressorts de barillet, ce sont principalement des ressorts de blocage et de maintien.

Ressort de barillet :

Ruban d'acier élastique enroulé en spirale servant à emmagasiner la force motrice pour les montres de poche et les montres-bracelets.

Rotor :

Masse oscillante tournant librement sur les montres à → mécanisme de remontage automatique. Suivant la conception de ce dernier, le → ressort de barillet est armé dans un seul ou dans les deux sens de rotation. On distingue les rotors centraux et les microrotors. Les premiers pivotent sur l'ensemble du mouvement, les derniers sont intégrés au niveau du mouvement.

Satinage :

Opération matifiant et adoucissant la surface d'un composant métallique au moyen d'abrasifs fins.

Silicium :

Pendant des siècles, le laiton, l'acier ou le rubis synthétique ont dominé la fabrication des mouvements. Depuis 2001, le silicium, matériau de base des micropuces électroniques, est également admis. À l'état de monocristal, il a la

même structure que le diamant. Il est 60 pour cent plus dur et 70 pour cent plus léger que l'acier, → amagnétique et résistant à la corrosion. Même sans finition particulière, il possède une surface extrêmement lisse, qui rend tout lubrifiant inutile. Le silicium est élastique, mais non malléable. Soumis à un traitement spécial, le « Silinvar » ne se dilate quasiment pas sous l'effet de la chaleur. Il se prête ainsi à la fabrication de → spiraux de balancier. Le silicium invariable « Silinvar » résulte d'un projet de développement commun entre Patek Philippe, Rolex et Swatch Group ainsi que le Centre suisse d'électronique et de microtechnique (CSEM) et l'Institut de microtechnique de l'université de Neuchâtel.

Sonnerie à répétition :

Fonction auxiliaire complexe d'un mouvement, qui produit des sons correspondant à différentes divisions de l'heure. Selon le modèle de sonnerie, on différencie entre montres répétitions à quarts, demi-quarts (soit 7½ minutes), à 5 minutes ou à minutes.

Spiral Breguet :

→ Spiral à spire extérieure relevée pour permettre au ressort de se développer régulièrement durant son expansion et sa contraction. Au vu des coûts de fabrication considérables, il n'est plus utilisé aujourd'hui que dans les → calibres de grande précision.

Spiral de balancier :

On peut dire que c'est l'âme de toute montre mécanique. Ce ressort est fixé par son extrémité intérieure au balancier et par son extrémité extérieure au coq. Par son élasticité, il assure la régularité des oscillations du → balancier. La longueur active du spiral et le moment d'inertie du balancier déterminent la durée des oscillations (ou période).

Tourbillon :

Inventé en 1795 par Abraham-Louis Breguet et breveté en 1801, ce dispositif sert à compenser les perturbations infligées par la gravité à l'organe d'oscillation (→ balancier et → spiral de balancier) des montres mécaniques. L'organe d'oscillation et l'échappement sont logés dans une cage aussi légère que possible qui fait un tour sur son axe en une durée déterminée (généralement une minute). Cela permet de compenser les écarts de marche liés à la gravité terrestre dans les → positions verticales et d'améliorer les performances de marche. En position horizontale, le tourbillon n'a en revanche aucune influence sur l'exactitude de marche.

Verre saphir :

Verre de montre résistant aux rayures et d'une dureté de 9 sur l'échelle de Mohs. Seul le diamant présente une dureté plus élevée.

Verres :

Pour les montres-bracelets, il existe quatre types différents de verres. Les verres en cristal sont surtout utilisés sur les montres-bracelets anciennes. Résistant bien aux rayures, ils sont toutefois très cassants. Au début des années 1940, les verres en cristal sont progressivement évincés par des verres en matériaux synthétiques (Plexiglas). Certes incassables, ils se rayent par contre très facilement. Avec une dureté de 5 sur l'échelle de Mohs, les verres minéraux sont nettement plus robustes que les verres synthétiques. Aujourd'hui, on monte sur les montres de grande valeur le plus souvent du → verre saphir. D'une dureté de 9 sur l'échelle de Mohs, il est extrêmement résistant aux rayures et aux cassures, mais doit être travaillé avec des outils diamantés spéciaux.

Imprint

© 2016 teNeues Media GmbH + Co. KG, Kempen

Introduction & texts by Gisbert L. Brunner

Editorial management by Regine Freyberg
Design & layout by Sophie Franke
Translation and copy editing by Hanna Lemke (German),
Howard Fine (English),
Claude Checconi & Christèle Jany (French)
Production by Nele Jansen
Photo editing & color separation by David Burghardt/db-photo.de

Published by teNeues Publishing Group
teNeues Media GmbH + Co. KG
Am Selder 37, 47906 Kempen, Germany
Phone: +49 (0)2152 916 0
Fax: +49 (0)2152 916 111
e-mail: books@teneues.com

Press department: Andrea Rehn
Phone: +49 (0)2152 916 202
e-mail: arehn@teneues.com

teNeues Publishing Company
7 West 18th Street, New York, NY 10011, USA
Phone: +1 212 627 9090
Fax: +1 212 627 9511

teNeues Publishing UK Ltd.
12 Ferndene Road, London SE24 0AQ, UK
Phone: +44 (0)20 3542 8997

teNeues France S.A.R.L.
39, rue des Billets, 18250 Henrichemont, France
Phone: +33 (0)2 48 26 93 48
Fax: +33 (0)1 70 72 34 82

www.teneues.com

International edition: ISBN 978-3-8327-3421-3
French edition: ISBN 978-3-8327-3472-5
Library of Congress Control Number: 2015940187
Printed in the Czech Republic